things as they are

BY MARY PANZER AFTERWORD BY CHRISTIAN CAUJOLLE

things as they are

WORLD
PRESS
PHOTO

50

DIE **WOCHE**

NEUE SCHWEIZERISCHE ILLUSTRIERTE ZEITUNG

Aufnahme Yvan Dalain

Wasseralarm gibt dieser Walliser Bauer, der mit seinen Kameraden seit vier Tagen bei Siders gegen das Hochwasser kämpft. Die anhaltenden Regenfälle haben vor allem im Wallis und im Jura die Bäche und Flüsse in reißende Ströme verwandelt und auch in andern Gebieten der Schweiz zu Überschwemmungen und schweren Verwüstungen geführt. (Zu unserem Bildbericht auf Seiten 16–17.)

WOCHE

Olten / Zürich, 17. Jan. — 23. Jan. 1955
Verkaufspreis 50 Rp. Deutschland 70 Pfg.
Frankreich / Saar 60 frs. Italien 100 L. Österreich 3.20 Sch.

Nr. 4

OCTOBER 4, 2004

TIME

The Tragedy of
Sudan

#BXBDJLX **********CAR-RT LOT**C-025
#1169 9995 740#ID 7532PA01 A DEC04
GEORGE R MELTON 0042
TRACOR ARSPC ELETRONIC SYSTEMS #00490
305 RICHARDSON RD P00634
LANSDALE .PA 19446-1495

In its first fifty years, World Press Photo has become a truly global platform for professional press photography. Our annual contest draws more participants than any other photography competition and the exhibition of award-winning work is shown all over the world. Until on-screen publication took off a few years ago, the printed page was always the main vehicle for the presentation of photojournalism, so it seems fitting to celebrate our first half-century with the publication of a book.

Rather than produce a commemorative anthology of World Press Photo prizewinners, we decided to look at the history of photojournalism over the period of our involvement. And while most exhibitions and books of photojournalism – including our annual contest – assess the achievements of photographers by showing images outside their original press context, here we examine the form in terms of its original production and use. We do so at a time of rapid change in the field, in order better to reflect on what photojournalism is, how it has developed and where it might go from here.

This book with its related exhibition is a celebration of photojournalism and its contributors – the photographers, of course, but also the publishers, art directors, editors and agencies that work with them to depict our societies and account for the history of the world in pictures. Unlike our annual competition, it is not intended to show 'the best', but rather to tell the story of photojournalism through the selection of published features. Here we have relied on a wide group of editors, photographers, historians and magazine collectors to suggest ingredients for this story, and on Mary Panzer, Christian Caujolle and Chris Boot to put it all together. We are proud of the selection while recognizing that such a history is inevitably partial, and that even 400 pages are far too few to do justice to everyone's involvement. We trust that this book will be accepted as we intend it – as a tribute to the endeavour of each person who has helped shape the story of photojournalism, whether or not their work is directly represented in the following pages.

This book features rather more publications from Europe and America than from other parts of the world, reflecting their dominance in the history of photojournalism to date. But things are changing. If we publish a similar book half a century from now, it will undoubtedly reflect a broader geographic spread. In the last decade, our global educational programmes have become a core World Press Photo activity, alongside the annual contest and exhibition. We currently contribute to the training of photographers and editors in many countries outside the mainstream of the traditional Western media. The exposure of work produced by our alumni in different continents is growing. The talent, dedication and quality apparent in their photography are a source of pride to us, and we hope that throughout the world we will see the emergence and growth of publishers who may do credit to their talent.

We hope too that this project will promote knowledge of photojournalism to a broad public and that alongside World Press Photo's educational programmes, it may contribute to the empowering of photographers to navigate this dynamic environment with awareness and confidence – especially those at the beginning of their careers. Above all we hope that it will challenge, excite and serve all those involved in photojournalism, upon whose labours all our activities depend.

Michiel Munneke, managing director
Gerrit Jan Wolffensperger, chairman
World Press Photo

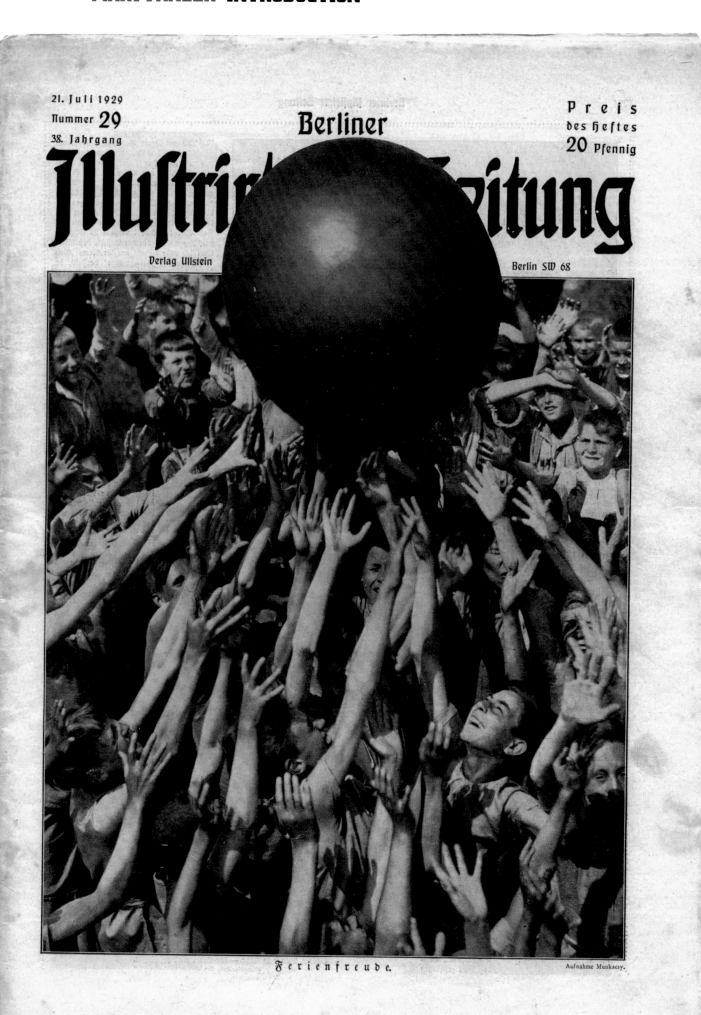

21. Juli 1929
Nummer **29**
38. Jahrgang

Berliner

Jllustrirte Zeitung

Verlag Ullstein

Berlin SW 68

Preis
des Heftes
20 Pfennig

Ferienfreude.

Aufnahme Munkacsy.

'The contemplation of things as they are, without substitution or imposture, without error and confusion, is in itself a nobler thing than a whole harvest of invention.'
Sir Francis Bacon (1561-1626)

'Photojournalism' is a term most people understand, but it has thus far defied precise definition. Harold Evans, former editor of the *Sunday Times*, defined it as 'pictures on a page' while for Wilson Hicks, long-time photo editor at *Life* magazine, it was 'words and pictures'. Dan Mich, Hicks' counterpart at *Look*, called picture stories 'the modern picture magazine's most important contribution to the art of communication', characterizing them in terms of function – 'storytelling … done by related pictures arranged in some form of continuity', accompanied by subordinate text. More recently, German photojournalist and historian Robert Lebeck, following contemporary literary critics who take the response of the audience into account, has defined photojournalism as 'the sequence of pictures on the printed page which [appears] in magazines and … actually reaches the reader'. All accept photojournalism as serving a descriptive purpose – photography with the function of recording and reporting 'things as they are'.

Here we present 120 picture stories made over the past fifty years, each one shown in the context in which it was published (in most cases, as it was first published). Although we approach our subject from the viewpoint of photographers and photography, we consider photojournalism in context; that is, as the work of many authors – the photographers who make the pictures, the writers who create the text, the editors and art directors who organize the story on the page (and who in many cases conceive and commission it), the journals that print the story, and the audiences who read it. We have chosen to look at the picture essay – the sequence of pictures – rather than the single-picture story, because we feel this better allows us to look at ideas and approaches being explored within the medium, and to see how these have changed over time. We have also focused far more on magazines than on newspapers; while magazines that present stories over many pages have been the primary vehicle for the sustained picture essay, they dominate here for more practical reasons. Magazines tend to be collected and saved in their original form, while newspapers are often preserved only on microfiche. It has been beyond the scope of this project to research and track down copies of original newspapers around the world.

Ultimately, this book reflects the combined wisdom of a community of photographers, editors, historians and collectors, deeply engaged with the history of photojournalism, whom we consulted in the process of selecting stories. Amongst all the valuable advice and suggestions we received was a sceptical response from John Szarkowski, one of the last century's most important commentators on photography: 'I thought I had made it clear in my own writing on the subject that the photojournalism experiment was on its last legs by 1955, when you begin your story. … I share your hope that I was wrong in this judgement, and that your exhibition and book will be more than one more fat compendium of the pictures that editors expect photographers to make.' His words proved a challenging starting point for the project, as we begin at precisely the moment in time often characterized as photojournalism's golden age: the year of *The Family of Man* and the era of W Eugene Smith's legendary stories for *Life* magazine – the point when photojournalism had arguably reached a zenith of sophistication and maturity. But had it already run out of ideas then, so soon after it began? Did it subsequently become a set of editorial tropes to be endlessly reproduced? Our selection criteria became, in part, an exercise in avoiding the 'pictures that editors expect photographers to make'. Whether or not the reader thinks the last fifty years prove more interesting than photojournalism's well documented beginnings, we trust we demonstrate at least that it is a dynamic, changing form. 2005 is far too soon to declare it dead.

Selecting and preparing the book's contents has been an exciting and unpredictable journey into the recent past – but perilous territory for anyone claiming to be a historian. We do not claim that this history is definitive. It is a celebration and an exploration of what photojournalism has been and has become, and while patterns and sub-plots begin to emerge, more time must pass and more work needs doing before the shape of this story and the major monuments that mark its progress can be decisively identified. Nor do we claim that what we show here is the 'best' – for each story included there are a hundred others that might work just as well in its place, and we are painfully aware of all those important contributors to the medium that are not featured and just how many stones remain unturned. After the process of assembling this book, the story of photojournalism since 1955 in context remains fresh territory still. With the related exhibition and the debates that follow, we hope it will contribute to momentum for further study.

This account invokes – and criticizes – a myth of its own: that photojournalism is a global practice in which a single community of photographers, editors, publishers, agents and readers enjoy access to every story that appears in print everywhere around the world. At times this myth appears to be true – on the corner news-stands of New York, Paris or Tokyo, with their array of international magazines; in the offices of the photo agencies; at photojournalism festivals such as Perpignan; and at the exhibition of World Press Photo's annual winners. But while selecting stories, we have repeatedly been forced to acknowledge strong obstacles to this utopian view. Access to, and knowledge of, the world's photojournalism is far from universal, even in the age of the internet. Like all journalism, it exists only in the form in which it reaches an audience, or, as Benedict Anderson calls it (in *Imagined Communities*, 1983), a community. For Anderson, that community exists largely in the

shared imagination of its particular readership; he uses the example of British imperial subjects living in Bombay who, as readers of the *Times* of London, shared a single national identity although many thousands of miles away from 'home' – for many, a place they had never seen.

In fact, wherever a community can support its own periodicals, one can construct a self-referential history of photojournalism, and many such histories exist – chronicles of fashion photography, sports photography, or of photography that has appeared before readers who share a language or a national identity. There are many moments when these communities intersect – around the work of an especially talented photographer (for example, Henri Cartier-Bresson), or a widely recognized event (the Olympics, the death of Gandhi, or the war in Vietnam). There are also individual publications – *National Geographic*, for example – that serve such a large community of readers and that are so widely available internationally, that it often appears that their pages accurately represent the medium as a whole. Yet it is clear that the world contains many communities, which for reasons of distance, language and culture are isolated from each other. In the Soviet Union, in Japan, in China, even in Brazil, one can find dozens of photographers whose interesting work has rarely been seen by outsiders – or, if seen, has been exhibited in a museum or published in a book, where the original purpose is lost,

along with the original context. Photojournalism may be a universal language, but the uses to which it is put invariably remain local. There cannot be one single history of photojournalism for there is no single goal shared by all photographers, publishers and readers. In its stead, we have a dazzling array of publications, the product of many dispersed communities.

This book has been titled with a quote from Sir Francis Bacon that was a favourite motto of documentary photographer Dorothea Lange. It served her as inspiration, and she used it to explain her work to others. It applies just as well to photojournalism: the caution against 'substitution or imposture … error and confusion', and the contrast with 'a whole harvest of invention', focus us on what exists before and beyond the creation of the photographer. Henri Cartier-Bresson used 'things as they are' to define the subject of photojournalism in his introduction to *The Decisive Moment* (1952). Meanwhile, there is a paradox in our application of the phrase to a history in which things appear not as they are, but as they were once, seen through the subjective filter of photographer and journal. Photojournalism is a collaborative project, in which photographers, writers, editors and publishers creatively interpret and translate the chaos of life into a product that can be distributed to readers. In the end, the business of representing reality is all about invention, and this book is a tribute to its value, power and persistence.

Below: *New York Daily Graphic*, 4 March 1880
Right: *Le Figaro*, 23 November 1889, photographs by Paul Nadar

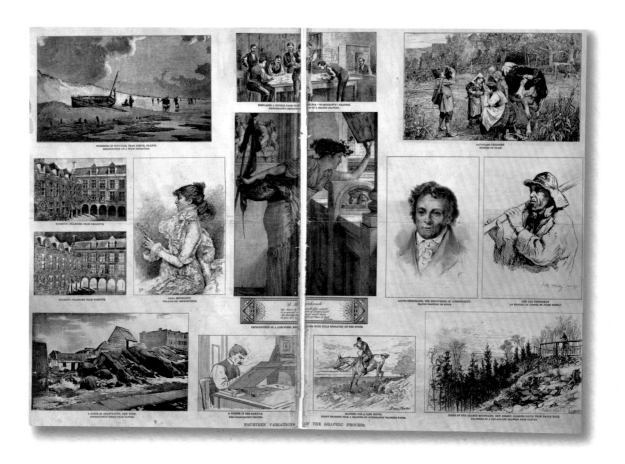

RÉDACTION DU SUPPLÉMENT
A. PÉRIVIER

SECRÉTAIRES
AUGUSTE MARCADE ET PAUL BONNETAIN

Paris — 26, rue Drouot — Paris

LE FIGARO

SUPPLÉMENT LITTÉRAIRE

Prix du Supplément avec le Numéro :
20 CENTIMES À PARIS — 25 CENTIMES HORS PARIS

Abonnement spécial du SUPPLÉMENT LITTÉRAIRE
Numéro ordinaire compris :

12 FR. PAR AN

Entrevue Photographique

Tout se renouvelle. En ce temps de tour Eiffel, de fontaines lumineuses, de téléphone et de téléphote, le journalisme doit suivre les progrès de la science. Il ne peut plus se contenter des vulgaires procédés à l'emploi desquels la plume, l'encre, le papier et la mémoire suffisent. Pourquoi le reportage ne se servirait-il point des moyens perfectionnés qui sont mis à sa disposition?

Le public d'ailleurs est devenu sceptique; il se méfie de ce qu'on lui raconte. A côté de chaque déclaration importante, il lui faudrait une preuve matérielle. Nous ne demanderions pas mieux que de le mettre en communication, quand nous lui livrons une entrevue, avec son phonographe qui lui ferait entendre la voix même du *personnage interviewé.* Cela serait possible si chaque abonné avait chez soi l'appareil auquel il n'aurait qu'à confier le dernier rouleau imaginé par Edison. En attendant que cet instrument soit devenu d'usage aussi commun que le piano, — ce qui ne saurait tarder, — le Figaro, voulant moderniser la banale interview, a imaginé non seulement d'en publier le texte, mais encore de faire photographier, graver et la scène et les personnages.

Rien de plus simple. M. Nadar fils n'est-il pas l'inventeur d'un admirable appareil qui prend instantanément la pose, le geste des interlocuteurs? M. Krakow, notre excellent graveur, n'a-t-il point capable de fixer en relief sur le métal les clichés obtenus.

Le seul tort du procédé est d'être quelque peu coûteux; mais ce n'est jamais ce détail qui a embarrassé le Figaro.

L'idée d'une entrevue photographique une fois admise, il ne s'agissait plus de s'arrêter au choix de l'interviewé.

Il fallait, pour une expérience de ce genre, montrer sous ses différents aspects un personnage qui fût assez populaire pour que le lecteur pût, pour ainsi dire, reconnaître chacun des mouvements de celui-ci; avoir, dans ses propres souvenirs, la preuve de l'authenticité de l'opération.

Le choix était facile. Quel est l'homme qui, depuis trois ans, a le plus souvent attiré l'attention parisienne, qui est le plus montré et dans nos départements et en Hollande, en Belgique, en Angleterre? On l'a déjà nommé.

Il n'y avait qu'à décider le général Boulanger à se prêter à l'expérience.

En route pour Jersey!

Et nous étions le lendemain à l'hôtel de la Pomme d'Or.

— Mon cher général, puisque la conversation que je désire avoir avec vous doit être reproduite dans le Figaro et lue conséquemment par le monde entier, il vous sera certainement indifférent de la tenir devant un tiers.

— Un tiers amené par vous ne saurait être un ennemi. C'est une raison de plus pour que je vous demande son nom?

— Paul Nadar.

Et j'explique le but de ma visite.

— Je comprends, me dit l'exilé. Vous m'interrogerez. Nous causerons. Nous tâcherons d'oublier Nadar pendant que, de temps en temps, il pressera sur une boule et enregistrera sur son appareil le moindre de mes gestes. Savez-vous bien ce que vous me demandez? La possibilité pour vous de tirer un numéro à sensation en me donnant en échange la certitude d'être encore ridiculisé. Eh bien, cela ne me fait rien. Je consens. J'ai avalé tant de crapauds que quelques-uns de plus ne me font pas peur. Aussi bien, il ne me déplaît pas de collaborer à une idée vraiment originale et de faciliter un des progrès du journalisme. Malgré ses injures, je pourrais dire par ses injures, la presse m'a assez servi pour que je ne lui en refuse. Je vous prierai seulement de bien réfléchir aux questions que vous me poserez et de me mettre à même de dire une fois de plus toute ma pensée à ceux de mes compatriotes qui me sont restés fidèles.

On a déjà remarqué que je n'ai point parlé de l'état de santé dans lequel j'ai trouvé le général Boulanger. A quoi bon? La photographie le montrera. Premier avantage du procédé. Pas de description à faire.

Je vais chercher Paul Nadar qui dissimule derrière lui son appareil et qui renouvelle connaissance avec le général.

— Nous allons, lui dit l'exilé, demander au propriétaire de l'hôtel un salon plus commode.

— A quoi bon? fait le photographe.

— Comment, c'est dans cette petite pièce que vous opérerez? Il ne vous faut pas plus de lumière?

— Celle-ci est très suffisante. Ici nous aurons l'avantage de vous prendre dans votre cadre même. Je n'ai plus qu'à vous prier, mon général, de ne pas faire attention à moi et de causer avec votre Dangeau comme vous aviez l'habitude de le faire à l'hôtel du Louvre ou rue Dumont-Durville.

— Eh bien, cher ami, me dit le général, allumons une cigarette, asseyons-nous et oublions Nadar.

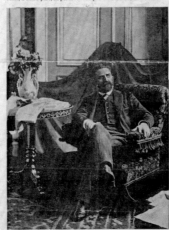

— Vous me permettez de sténographier, mon général?

— Je vous y invite. Après les grandes dépenses nécessitées par les élections, avant celles que pourra exiger l'imprévu, il m'était indispensable de faire des économies. Or, il ne faut jamais restreindre son train de maison dans l'endroit même où l'on a ouvert sa bourse sans compter. Les familiers, les visiteurs y voient une diminution de la personne.

— Mais, d'autre part, ne perdrez-vous point à avoir moins de visiteurs?

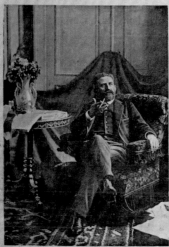

— Je commencerai, mon général, par déplorer avec tous vos amis, que vous vous soyez installé si loin de Paris. Lorsque vous étiez à Londres, huit heures seulement séparaient de vous les membres de votre parti. Ils pouvaient se mettre en route quand ils voulaient. Quelle différence aujourd'hui! Pour venir à Saint-Hélier, c'est toute une affaire. Il ne part de Granville que deux bateaux par semaine, aux heures les plus diverses.

— J'avais des raisons sérieuses pour ne pas rester à Londres et je vais vous les dire

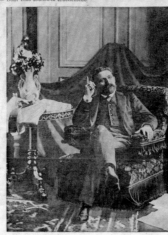

— Oui, il y aura des défections...
— Dont vous souffrirez cruellement.

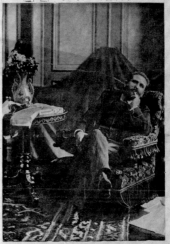

— Qu'importe! J'apprendrai ici à connaître mes vrais amis.

— Vous me permettrez néanmoins de regretter personnellement que vous ne soyez pas retourné à Bruxelles.

— Le gouvernement belge m'aurait imposé les conditions qu'il me faisait autrefois pour y rester : ne jamais convoquer mon comité, ne recevoir que des visites individuelles, ne donner lieu à aucune manifestation, n'envoyer aux journaux aucune lettre signée. Bref, un enterrement politique! Me croyez-vous disposé à me laisser mettre en bière?

— Voyez-vous, continua-t-il, un chef de parti ne doit jamais désarmer. Ne pas agir, c'est se faire oublier. Ici, je présiderai peu de banquets, mais je convoquerai mon comité, je préparerai avec lui la campagne prochaine.

— Comment! La campagne prochaine?

— Eh oui, cher ami. Combien de fois faut-il donc répéter que le boulangisme vit encore!

Le boulangisme, reprit gaiement le général, a la vie dure. Croyez-moi. Dans toute campagne il y a plusieurs combats. On ne les gagne pas tous. Nous en avons perdu deux, coup sur coup. Est-ce que nos troupes ne sont pas assez solides pour en gagner d'autres? Ceux de mes amis qui n'ont renié aucun de nos principes, aucun des dogmes du programme révisionniste, sont d'une énergie dont vous ne vous doutez pas. Ils sont, dans l'acception la plus large du mot, prêts à tout. Avec de tels hommes, que rien ne saurait abattre, le succès final est certain. Nous aurons le dernier mot, j'en réponds. Nous pourrions dire d'ailleurs que notre défaite est encore une victoire, puisque la Chambre qui ne comptait que 12 boulangistes, en compte maintenant 47. Il y en aurait bien davantage si nous n'avions à nous reprocher des fautes...

Sur ces mots, le général Boulanger se leva, faisant deux ou trois pas, les mains dans les poches. Des reproductions de chacun de ses mouvements ont été prises. Par malheur, toutes n'ont pas été également bien venues, et M. Krakow n'a gravé que les meilleures.

Celles qu'on verra plus loin sont de dimensions différentes. Il est, croyons-nous, inutile d'en expliquer la raison. M. Nadar, dont nous ne nous occupions point, allait et venait dans la pièce, tantôt s'éloignant, tantôt se rapprochant, se servant aussi parfois d'un appareil de poche.

Au moment où nous sommes, le général a la main gauche appuyée sur le dos d'un fauteuil, la main droite sur la hanche. Il semble *regarder le passé.*

Après un silence, il reprend

Photojournalism before 1955

The birth of the modern picture press can be traced to the *Illustrated London News*, which began in 1842. A year later, *L'Illustration* began in Paris and the *Leipziger Illustrirte Zeitung* in Germany. These journals inspired hundreds of imitators and competitors, publishing photographic images along with original engravings and lithographs. Before photographs could appear in printed form, engravers first had to copy them onto woodblocks, to be set in a frame along with moveable type. Captions regularly identified the image as being 'from a daguerreotype' or, eventually, 'from a photograph'. Photography combined with text on the printed page created a new form of communication that profoundly altered the relationship of the viewer to the world. In *Photography and Society* (1974), Gisèle Freund, a photojournalist and one of the medium's first (and best) historians, describes this shift by means of a simple metaphor: 'Before the first press pictures, the ordinary man would visualize only those events that took place near him, on his street or in his village. Photography opened a window, as it were. The faces of public personalities became familiar and things that happened all over the globe were his to share. As the reader's outlook expanded the world began to shrink.'

The first mechanically printed photograph, 'Shantytown', appeared in the *New York Daily Graphic* in 1880 (see page 10) – depicting squatters on the edge of Manhattan's Central Park, but in fact illustrating a story about modern forms of photographic reproduction. In Paris in 1886, *Le Journal Illustré* and *Le Figaro* began publishing what were the first photographic essays – sequences of photographs recording encounters with notable figures by Félix and Paul Nadar (see page 11). By the end of the century, photographic illustration invaded newspapers around the world. After the invention of rotogravure in Germany early in the twentieth century, many Sunday newspapers came to feature special picture sections, the forerunners of today's Sunday supplements. For use of photographs in the daily press, the widely recognized leader was the London *Daily Mirror*, which began in 1904, equating information with photography with its trademark motto: 'See the news through the camera.' Many papers followed its successful formula, increasing the demand for and value of photographic images. Newspapers competed for the pictures the way they once competed for stories, and picture agencies were set up to meet the demand. In London in 1894, the Illustrated Journals Photographic Supply Company opened, with the promise to deliver stock pictures to clients within 24 hours of placing an order. In 1898 American newspaperman George Grantham Bain established the Bain News Service to cover what we now call 'breaking news'. He sent his staff photographers to cover important stories, and sold their images to newspapers and magazines around the country. Bain's service turned photojournalism into a paid profession. (Before Bain, writers had hired their own photographers, or took their own pictures without additional compensation.)

Pictures attracted readers, and thereby enhanced the value of the commodity that all illustrated press produced – its audience of consumers. Advertisers used magazines to reach new markets, and magazines flourished as a result. In the United States, magazines like *Collier's*, *Leslie's*, *McClure's* and the *Saturday Evening Post* published illustrated articles about contemporary life at home and abroad. In France, it was *Le Journal Illustré*, *Lectures Pour Tous*, *L'Illustration*, and *Le Panorama*; in Britain the *Graphic* and *Illustrated London News*; in Germany *Die Woche*. Illustrated magazines especially designed for women blossomed in the decades before World War I: *Ladies Home Journal* in the United States, *Femina* in France, *Die Welt der Frau* and *Frauen Rundschau* in Germany, and in Britain, *Queen* and *Nash's*. Halftone illustration provided an essential element for all these magazines – not simply through illustration of stories devoted to fashion, home decoration and gardening, or through fanciful illustration for fiction, but also because halftones made effective advertisements for consumer goods like shoes, soap, corsets and cast-iron stoves.

Illustrated periodicals satisfied an essential human desire to capture and conquer the novel, the exotic, the strange. Using the language of current social critics, we can say that photographic illustration makes an ideal form through which to view 'the other'. Where was 'the other' to be found? *National Geographic* made the quest fairly simple – sending writers and photographers to record distant places and civilizations. But exotic subjects can be found at home, simply by crossing the boundaries erected by class, political affiliation and cultural taboo. Long before photography, crime and impoverishment provided highly popular subjects for illustrated books, articles, prints and engravings. Photographic studies of the streets of New York, the sewers of Paris, and the back-alleys of London, Shanghai, Calcutta and Rome continued this well-established tradition. The hellish environments created by industry provided fresh turns on old subjects, often accompanying reports on the need for reform. Street life, and especially the fate of children, became the special subjects of Jacob Riis and Lewis Hine in New York, Paul Martin in London, and Heinrich Zille in Berlin. A V Casasola, who began as a photographer covering the Mexican political elite, organized the first Mexican press agency, and compiled a private archive devoted to indigenous Indian culture. He was also known for his collected photographic documents of the Mexican Revolution.

As the illustrated press sought to increase sales, they quickly discovered that some stories sold better than others. Natural disasters proved an attractive subject, especially when the events depicted took place far away. Hurricanes, floods, volcanoes and earthquakes made compelling subjects for pictures, along with shipwrecks, train crashes and fires. And war sold journals best of all. In 1903, a leading American magazine known for its picture stories promised that 'whenever there is an army in the field and the clash of arms and bullets and the thousand tragedies of war,

there, too is a man from *Collier's*'. At the turn of the twentieth century, photojournalists documented warfare in South Africa, Mexico, Turkey and the Philippines. For the most part, these early images were surprisingly bland. Reporters (or their publishers) regularly made a tacit agreement with the authorities: in order to get access to the front, they would submit images to official censors. This practice was well established by the time World War I began. The periodical press, itself working under state control in the warring nations, published few if any truly grim pictures of life in the trenches, though plenty survived in the form of private snapshots which surfaced later.

In Germany after World War I – and especially in Berlin, one of Europe's major publishing centres – the illustrated press began to take on its recognizably modern form. Enormous political and economic turmoil had followed Germany's defeat. The social-democratic Weimar Republic replaced the German Kaiser's monarchy, bringing freedom of the press, a democratic government, and widespread dissent. Although the Republic collapsed after only fifteen years, during its brief tenure Germany witnessed an astonishing growth in art, drama, music, literature and film for avant-garde and popular audiences alike. This culture produced the political theatre of Brecht, the cinema comedies of Ernst Lubitsch and the expressionist fantasy of Franz Kafka. At the Bauhaus, photography was pushed to its abstract limits, and students applied their lessons to the concrete, practical art of advertising. The cultural leaders of this generation saw photography as a metaphor for modernity. Designer Jan Tschichold declared

(in *Fotografie und Typografie*, 1928) that photography was 'such a characteristic sign of the times that our lives would be unthinkable without it'.

What separates the German illustrated press from the illustrated periodicals that appeared before the war? As Gisèle Freund explains it, 'the task of the first photo-reporters was simply to produce isolated images to illustrate a story. It was only when the image itself became the story that photojournalism was born.' This new form of communication appeared in the pages of weekly magazines such as the *Berliner Illustrirte Zeitung* (see page 8), the *Münchner Illustrierte Presse* and the leftist journal *Arbeiter Illustrierte Zeitung*. Photojournalism also relied on the development of a kind of camera that was small, fast and easy to load. In the mid-1920s, two small cameras came on the market in Germany. The Leica first appeared in 1925; hardly bigger than a man's hand, it had a sharp 50mm lens and held a 36-image roll of 35mm movie camera film. Photographers could work easily without attracting attention, and they could manipulate their point of view with unprecedented freedom. The Ermanox, introduced in 1924, was equally important, though it was bigger than the Leica, used glass plates, and was heavy enough to require a tripod. Its large, fast lens eliminated the need for flash powder, and freed photojournalists to work indoors without noise, smoke or commotion.

The development of the photo story can be traced to a surprisingly small number of people, whose careers

UHU number 4, January 1929, photographs by Erich Salomon

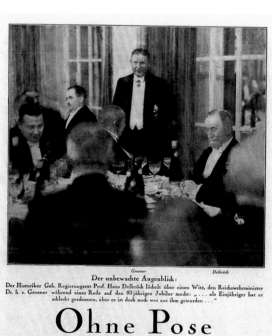

Groener Delbrück

Der unbewachte Augenblick:
Der Historiker Geh. Regierungsrat Prof. Hans Delbrück lächelt über einen Witz, den Reichswehrminister Dr. h. c. Groener während einer Rede auf den 80jährigen Jubilar macht: „… als Einjähriger hat er schlecht geschossen, aber es ist doch noch was aus ihm geworden …"

Ohne Pose

Wenn die Großen nicht wissen, daß sie photographiert werden
Aufnahmen von Festabenden, Sitzungen und Banketten
Von Dr. Erich Salomon

Der Mensch ist ein Haustier. Jedenfalls der zivilisierte Durchschnitts-Europäer ist eins. Wenn er auch nicht sein ganzes Leben im Hause verbringt, so doch den größten Teil seines Daseins. Die Nacht verbringt er fast ausnahmslos im Bett, also in einem Schlafraum, und, soweit nicht Ausflüge

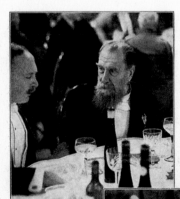

Große Juristen unter sich:
Der berühmte Strafrechtslehrer Geheimer Justizrat Wilhelm Kahl im Gespräch mit dem Reichsgerichts-Präsidenten Dr. Simons.

Man kann zwar auch den homo sapiens beim Sport und bei anderen Spielen im Freien beobachten. Aber der Sport verleiht seinen Jüngern ganz typische Gesichtsausdrücke (die Sprinter haben fast alle beim Passieren des Zieles dasselbe verkrampfte Gesicht), und wir wollen ja nicht bloß Typen kennenlernen, sondern Individuen. Und gerade die größten unter den Individuen, die Großen der Nation, tun uns nicht immer den Gefallen, Sport zu treiben, wenn es nicht gerade Engländer oder amerikanische Petroleumkönige sind, und wir interessieren uns auch nicht so

oder Reisen besondere Bedingungen schaffen, befindet er sich auch bei Tage im geschlossenen Raume, im Wohnzimmer, im Büro oder in Versammlungsräumen. Selbst auf dem Wege zu diesen Räumen sitzt er meist in geschlossenen Räumen, die nicht minder geschlossen sind, trotzdem sie sich auf Rädern befinden. Wer also den Menschen studieren will, wer seine Leidenschaften kennenlernen, wer sein Gebärdenspiel auf die Platte bannen will, der muß ihm wohl oder übel in die geschlossenen Räume folgen.

Friedliches Attentat mit der Kamera auf eine junge Berühmtheit:
Knud Eckener nach der Rückkehr von seiner Amerika-Luftfahrt in Friedrichshafen

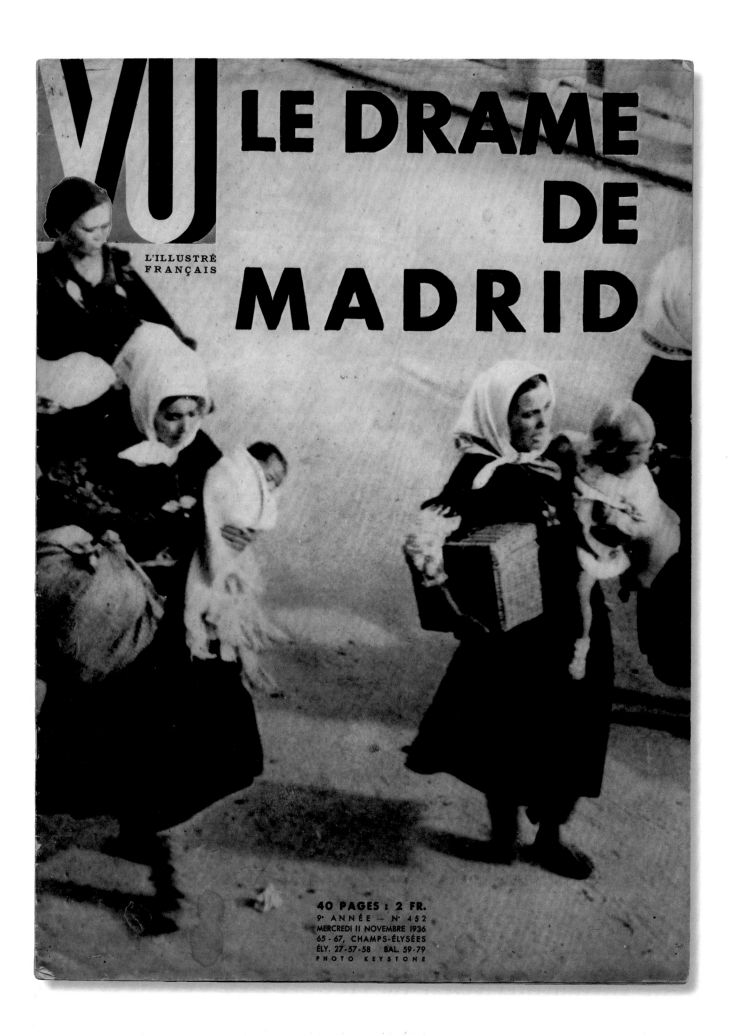

VU
L'ILLUSTRÉ FRANÇAIS

LE DRAME DE MADRID

40 PAGES : 2 FR.
9ᵉ ANNÉE — N° 452
MERCREDI 11 NOVEMBRE 1936
65-67, CHAMPS-ÉLYSÉES
ÉLY. 27-57-58 BAL. 59-79
PHOTO KEYSTONE

continued to shape photojournalism for decades to come. They include editors Kurt Korff and Kurt Safranski at the *Berliner Illustrirte Zeitung*, and Stefan Lorant at the *Münchner Illustrierte Presse*, photographer Erich Salomon in Berlin, and younger photographers such as Felix H Man, Alfred Eisenstaedt, Fritz Goro, Martin Munkacsi, Robert Capa, Tim Gidal, Lázlo Moholy-Nagy, Gisèle Freund, and 'Umbo', who established the Dephot agency where Capa – at the time known as André Friedman – got his start. Erich Salomon was among the very first photographers to use these new cameras to make new kinds of pictures for publication. He had studied law before the war, and came home to Berlin, where he joined the publishing firm Ullstein Verlag as a publicist. He took up photography in order to document his advertising campaigns. Salomon's first published photograph appeared in February 1928, when he illegally smuggled his Ermanox into a courtroom to photograph the teenage defendant in a sensational murder trial. The resulting story earned him immediate notoriety, and he soon became a full-time photographer, most closely associated with Ullstein's *Berliner Illustrirte Zeitung*.

Today Salomon is best known for his candid studies made during the Hague conferences, where the most powerful men in Europe had gathered to negotiate terms for establishing the League of Nations (see page 13). These powerful diplomats doze and gossip, utterly unaware of the camera, and Salomon's photographs seem more like Daumier's satirical cartoons than conventional newspaper pictures. While he was not the first to grab pictures of famous faces on the street or in public settings, he used the added camouflage supplied by his aristocratic bearing, his tailcoat, and his mastery of five languages to penetrate environments normally shut off from public view. His photographs still carry a thrilling sense of trespass. Salomon's career took shape quickly; he photographed the famous all over Europe, and became a celebrity in his own right. But his work ended in 1932, when he and his family fled Germany for the Netherlands. He died in a concentration camp in 1942.

In Paris, photographers contributed to many illustrated magazines that flourished between the wars, including *Marianne*, *Paris Match*, *Regards*, and *Voilà*. Photography also played a prominent role in small, avant-garde publications, such as the surrealist *Minotaure* and the magazine for graphic design, *Arts et Métiers Graphiques*. The most important was the illustrated weekly *Vu* (see left), founded in 1928 by journalist, designer and editor, Lucien Vogel. He placed photography at the centre of the new magazine, promising 'pages packed with photographs translating foreign and domestic political events into images … linking our readership with the entire world'. His art director, Alexander Liberman, experimented boldly with photomontage, and employed the best photographers – including Germaine Krull, Man Ray, André Kertész, Martin Munkacsi, Lucien Aigner and Robert Capa. Capa's famous image of the falling Spanish soldier was first

Left: *Vu*, 11 November 1936
Below: *USSR in Construction* number 3, 1931, photograph by Max Alpert

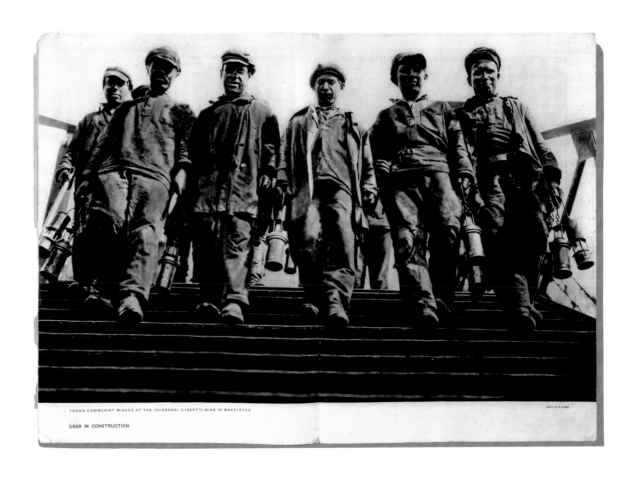

YOUNG COMMUNIST MINERS AT THE «SVOBODA» (LIBERTY) MINE IN MAKEYEVKA

USSR IN CONSTRUCTION

published in *Vu*. Vogel's left-leaning views did not win advertisers, and his special issue on the Spanish Civil War, with its strong support for the Republicans, finally alienated his Swiss backers altogether, forcing him to resign. The magazine folded in 1938.

Modernist schools of applied art offered another fertile site for this generation of photographers and designers. An important training ground was the Moscow school of applied art and architecture known as VKhUTEMAS, whose influence can be seen clearly in the dazzling pages of *USSR in Construction* (see page 15), first issued in Moscow in 1931. This is where Alexander Rodchenko, El Lissitzky, and Gustav Klutsis applied innovative graphic techniques to nation-building propaganda, in the process creating picture stories of unrivalled formal beauty. This magazine folded by 1941, but it established a graphic standard for all subsequent pictorial journalism in the Soviet Union. Its influence can be seen in bold compositions, caption-free design and forceful use of figures, echoed for years afterward in the pages of the weekly *Ogonyek*, where photography was also influenced by conventions associated with Socialist Realism.

When the rise of Fascism and war in Europe forced these creative communities to disband, many refugees found work in London and New York. Stefan Lorant came to London, working at *Weekly*

Below: *Lilliput*, September 1938
Right: *Ken*, 7 April 1938, photographs by Dorothea Lange

Illustrated and *Lilliput* (see below) before moving to *Picture Post*. Many came to New York right away: Alexander Liberman came to *Vogue* from *Vu* while sports photographer Martin Munkacsi covered fashion for *Harper's Bazaar*. In 1935, a group of émigrés led by Ernst Mayer founded the Black Star agency, which provided an important source of support for fellow refugees as they re-established their careers in a new country. By the end of World War II, the photojournalism that began in Berlin as an experiment had become an established institutional form in New York and London.

The figure of Henry Luce towers over the history of magazine publishing in America. In 1936, he started his third magazine, *Life*, with the help of Karl Korff and Alfred Eisenstaedt, who already knew the *Berliner Illustrirte Zeitung* and *Vu*. But Luce also relied on a vigorous American pictorial publishing industry, which blossomed in New York after World War I with the support of publishers like Condé Nast, advertising moguls such as J Walter Thompson and publicists such as Edward Bernays. Among the most important photographers were Edward Steichen at Condé Nast's *Vogue* and *Vanity Fair* and Margaret Bourke-White at *Fortune* (and later at *Life*), who each developed a style that worked equally well for advertising and editorial work. Steichen was chief fashion and portrait photographer for all Condé Nast magazines through the 1920s and 1930s, immediately setting a national standard with his trademark sharp focus, stark lighting and dramatic poses. The same techniques also featured in his campaigns for many of

KEYSTONE LONDON
BLACK EYE
Julian, a Bisley bull terrier
312

KEYSTONE LONDON
BLACK EYE
Neusel, the German boxer
313

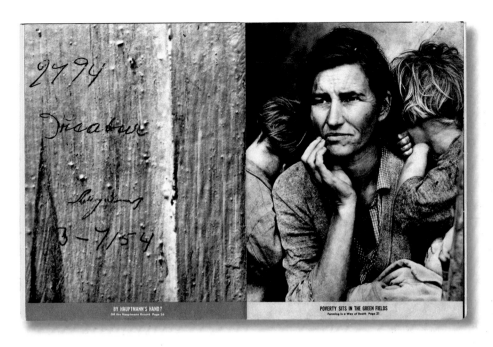

BY HAUPTMANN'S HAND?
Off the Hauptmann Record Page 26

POVERTY SITS IN THE GREEN FIELDS
Farming Is a Way of Death Page 31

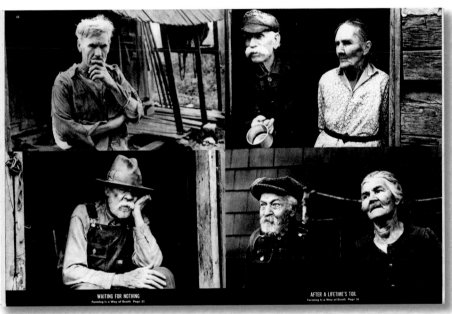

WAITING FOR NOTHING
Farming Is a Way of Death Page 31

AFTER A LIFETIME'S TOIL
Farming Is a Way of Death Page 31

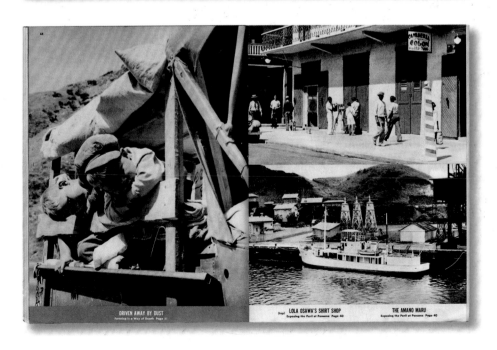

DRIVEN AWAY BY DUST
Farming Is a Way of Death Page 31

LOLA OSAWA'S SHIRT SHOP
Exposing the Peril at Panama Page 40

THE AMANO MARU
Exposing the Peril at Panama Page 40

4

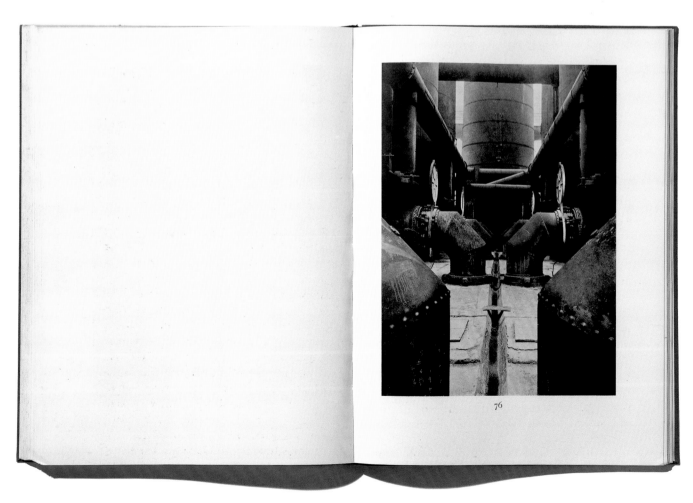

76

their advertisers. Henry Luce hired Margaret Bourke-White when he started *Fortune* in 1929, establishing the magazine's tradition of fine photography. Her essays combined artful documentation with subtle persuasion. Her photographs turned paper-mills, steel plants and industrial looms from gargantuan machines into sleek contemporary sculptures that were, implicitly, better than ordinary works of art because they produced things that people could use. In 1936, Luce commissioned her picture of Fort Peck Dam, published on the first cover of *Life* magazine. Bourke-White went on to produce dozens more covers, and she shot some of *Life*'s most dramatic war stories while stationed in Europe during the early years of World War II.

In addition to the modernist movement that favoured bold graphics and streamlined shapes, photographers, writers, film-makers and artists were strongly influenced by the powerful aesthetic that we now call 'documentary'. It permeated the art of the 1930s. The documentary movement inspired film-makers Robert Flaherty and Sergei Eisenstein, the fiction of Henry Miller and the social commentary of George Orwell, the photographic studies of Bill Brandt, and the social realism employed by photographers working for the Farm Security Administration (and published for instance in the liberal Chicago bi-weekly *Ken*, see page 17). In France this impulse to record the present became a central ingredient of surrealism – so that the surrealists were the first important champions of documentary photographer Eugène Atget, whose work inspired Berenice Abbot's subsequent architectural survey of New York City. In Germany, the documentary impulse was at the heart of an art movement known as 'Neue Sachlichkeit' – New Objectivity – led by Albert Renger-Patzsch, whose celebrated photographic manifesto was *Die Welt ist Schön* (*The World is Beautiful*, 1928, see opposite). He produced sharply focused compositions of everyday subjects, both natural and man-made – a smoke stack, a tree branch and the skin of a snake all served his aesthetic ideal.

In this context, it is easy to accept the myth of photography serving – as a matter of course – the greater knowledge of humanity. Yet in 1934 (in *The Author as Producer*) the Marxist critic Walter Benjamin presented the limitations, even dangers, of such seductive documents. He pointed out that a photograph alone, without a caption, can say one thing only: 'What a beautiful world!' And photographs could turn even the most difficult subjects into fashionable pictures, 'transforming even abject poverty … into an object of enjoyment'. To counteract this aestheticizing tendency, he asked photographers to supply information in the form of words, or narrative context, so that images might communicate something about their subject. 'What we require of the photographer is the ability to give his picture the caption that wrenches it from modish commerce

Albert Renger-Patzsch, pages from the book *Die Welt ist Schön*, 1929

and gives it a … useful value.' His challenge to photojournalists to produce more than strong pictures – to test their value as information alongside their impact as images – remains relevant today.

Until recently, most histories of photography in World War II have been written from the perspective of the big photographers and the big magazines, focusing on *Life* reporters such as Carl Mydans, Margaret Bourke-White and W Eugene Smith, the Navy work of Edward Steichen, and the many essays by Robert Capa whose reporting on the Spanish Civil War led *Picture Post*, in 1938, to call him the 'greatest war photographer in the world'. Less familiar is the work of French journalists like Julien Bryan, who worked for *Paris Match*, or the British home-front essays of Kurt Hutton or Cecil Beaton. And because the war photographs of Hans Hubmann, Hilmar Pabel and Wolfgang Weber appeared only in German magazines, they were virtually lost until Robert Lebeck recovered and published some of the best examples in *Kiosk: A History of Photojournalism* (2001).

As Lebeck points out, the mission of the photographer did not change during war-time. Virtually all journalists shared the interests of editors and publishers, and worked to promote the national interest. After the war, new choices and responsibilities arose, beginning with the challenge of representing the horrors of the Holocaust and the aftermath of the bombs dropped on Hiroshima and Nagasaki. In later wars, journalists would often find themselves caught in a vice between patriotism and morality when the needs of the nation conflicted with personal conviction. Some resolved the dilemma by choosing to make the most complete document possible: what veteran war reporter Sidney Schanberg (in his *Village Voice* essay 'Press Clips', 2005) called 'getting the story right … The goal was to come as close as possible to make the reader smell, feel, see and touch what I had witnessed that day. "Pay attention" was my mental message to the reader, "People are dying. This is important."'

The Postwar Years

After World War II, big picture magazines appeared throughout the world to signal the emergence of new consumer confidence: in Johannesburg *Drum*, in Rio de Janeiro *Manchete*, and *O Cruzeiro* (see page 20), in Tokyo *Chuo Koron*, in Italy *L'Europeo* and *Epoca* and in Germany *Kristall* and *Stern*, to cite only a few. Everywhere, these magazines assumed a paradoxical mission. Following the model of *Life* or *Paris Match*, they advertised the modern, sophisticated, international aspect of the particular nation or region of their publication. At the same time, magazines served to promote and consolidate national identities with stories about media stars, revered monuments, politics, the landscape, local heroes and scandal, applying distinctly national perspectives to international events and issues. Their audiences were mainly new: affluent enough to interest advertisers, and self-regarding enough to seek news about their own culture and politics.

Before the era of television, and before the print media fragmented into a myriad of cultural niche markets, big magazines shaped and articulated the unfolding narratives of national consciousness.

The big story of the postwar years was the Cold War, and its opposing ideologies must inform any survey of the press over the last half of the twentieth century. Its themes inform every story *Life* or *Ogonyek* published about science or the military. The same backdrop informs many stories in *National Geographic*, where the apparently innocent exploration of exotic cultures and ancient civilizations was undertaken with implicit, if unstated, support from the United States government, as they charted contested territory on the frontiers of the Cold War. Even Gordon Parks' heart-warming story of slum-kid Flavio surviving in the *favelas* of Rio (see page 91) was conceived as part of *Life*'s effort to support President John F Kennedy's fight against the prospect of Communism in South and Central America. Henri Cartier-Bresson's sympathetic view of everyday life in the Soviet Union (see page 38) becomes much more interesting when considered as a piece of sophisticated political protest, making a clear distinction between the Russian people and their system of government. In Cuba, European photographers produced romantic travel stories about the island's thriving hybrid culture, while local journalists like Raúl Corrales, Norberto Fuentes and Roberto Salas, without neglecting local scenery and culture, produced long stories on new power-plants, modern sugar cane harvests and peasant soldier-farmers that owed much to models found in *Ogonyek*.

O Cruzeiro, 16 March 1957

Historians of photography have tended to emphasize photography's role in promoting universal values that transcend geopolitics – best articulated by Edward Steichen in *The Family of Man* exhibition that opened in 1955 at the Museum of Modern Art in New York. Its title was its self-explanatory manifesto. In its installation, the museum walls resembled the pages of *Life*, with images in many sizes, accompanied by explanatory texts and short, lyrical quotes from poetry or folk-tales. Visitors walked through the exhibition as if strolling inside the pages of a magazine. John Szarkowski has called the exhibition Steichen's 'most important work of art', although comprising photographs made by others. Even while Steichen's exhibition included dark passages – images of poverty and human suffering, and including a wall-sized image of the atomic bomb's ominous mushroom cloud – it established a relentlessly idealistic, even stifling, set of expectations for photojournalism. Its persuasive strength created pressures on photojournalists to repeat its optimistic, life-affirming story, in a way that comforted both readers and advertisers. Reviewing the Paris showing of the exhibition, Roland Barthes observed that its reverent presentation of the human condition 'suppressed the determining weight of history'.

One of the memorable photographs in the exhibition was W Eugene Smith's 'The Walk to Paradise Garden', in which his camera captures a small boy and girl (his own children) walking hand in hand along a shadowed path into the light. Smith was the pre-eminent exponent of the photo story at this point. In the late 1940s, after recovering from war injuries he received in the Pacific, he rejoined the staff of *Life* to produce some of the most memorable

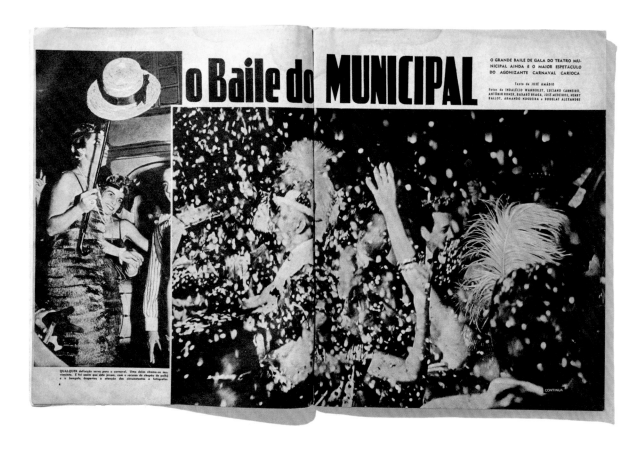

and sophisticated narratives of the genre. Refining the *Life* formula of building an issue-based story around an emblematic central protagonist, he offered photojournalists a model with 'Country Doctor' (1948, see below) and 'Nurse Midwife' (1951). 1955 marked a new departure in his career. He resigned from *Life* (over arguments about the editorial point of view given his Albert Schweitzer story, published in 1954) to join the Magnum Photos co-operative, dedicated to the artistic freedom of its photographer members. Smith and the photographers of Magnum were not alone in seeking freedom from the requirements and compromises that accompanied the security of a staff position. Most of the leading photojournalists were already freelance. Once an employed workforce charged with the responsibility of fulfilling the vision of their employers, photo-journalists increasingly insisted on recognition as creative individuals in their own right, driven by their own goals. Photojournalists and magazines remained mutually dependent; magazines supported many independent careers, and freelance photographers in turn supplied the stories needed to fill pages and lure advertisers and readers. The era of the independent creative photojournalist was underway.

Photographers impatient with the requirements of consumer periodicals began to publish their work in camera magazines aimed specifically at other photographers. These included *Popular Photography* (which first published Smith's Pittsburgh essay, see page 76) and *Modern Photography* in the USA, *Camera* in Switzerland, *Photo Magazin* in West

Life magazine, 20 September 1948, photographs by W Eugene Smith

Germany, *Photo Communiqué* in Toronto, *Die Fotografie* in East Germany, and *Fotografisk Tidskrift* in Sweden. They championed good photography across all genres in and around their columns on new equipment, tips for amateurs, and competitions. Many other specialized publications welcomed picture essays in the 1950s and 1960s. At the business magazine *Fortune*, Henry Luce hired Walker Evans as a photography editor in 1945, and Evans used the magazine to issue beautiful portfolios of images, including his first photographs in colour. He also used his position to endorse promising photographers, including Robert Frank, who produced a dark, subtle portrayal of the American businessman in a story on 'The Congressional', the deluxe train that ran from New York to Washington DC (see page 46). In Switzerland, the art magazine *Du* expanded to include photography, allowing space for long photo essays uninterrupted by advertisements; although these stories were rarely accompanied by significant amounts of text, the magazine has sustained a commitment to photojournalism ever since. In Japan's *Chuo Koron*, Tomatsu Shomei's picture essays appeared through the mid-1960s (see page 82). They balanced sharp social satire with lyrical description of postwar Japanese culture – and never claimed to be objective. The artist's contribution was always evident, in his choice of subject and idiosyncratic framing, within unsentimental investigations into the clash between traditional Japanese culture and the West.

A new form of journalism blossomed at the end of the 1950s in the men's magazine *Esquire*, where editor Harold Hayes shifted the magazine from cheesecake pictures and nondescript articles on sports and business to some of the nation's most advanced

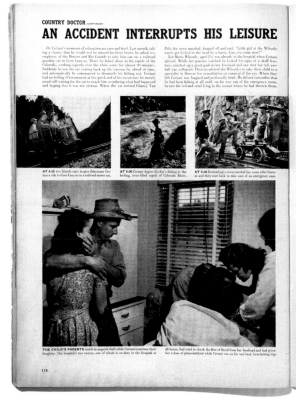
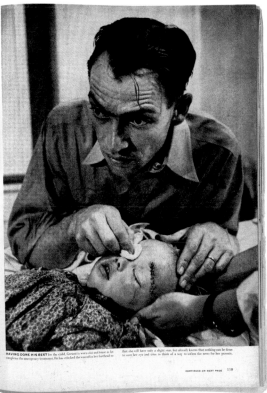

satire, fiction and political commentary. *Esquire* hired Diane Arbus to shoot picture stories (see for example page 87) and celebrity portraits. Her highly personal style matched the magazine's sophisticated sensibility – confident, critical, and offbeat. *Esquire*'s writers became known for their personal, opinionated accounts of modern life – the style was called 'new journalism' and Arbus was its photographer. In 1967, this school of journalism inspired John Szarkowski to introduce the work of Arbus, Lee Friedlander and Garry Winogrand in a show called *New Documents* at the Museum of Modern Art.

Arbus was part of a growing generation of artists who actively contributed to the construction of a new international 'counterculture' of music, poetry, fiction, fashion, art and politics. Journalists engaged with it faced a dilemma. In the style of earlier Bohemian cultures, artists and writers set out to resist the conformism of the mainstream press and to offend its middle-class audience – yet they exerted a powerful allure, making them attractive to precisely those audiences and publications they opposed. One photographer who became synonymous with the counterculture of the early 1960s was Will McBride. Working for the German youth magazine *Twen*, he developed a distinctive style that was both abstract and sexually charged. When *Twen* published 'Siddartha' in 1969 (see page 182), homosexuality was a very new pictorial subject for publications beyond the underground or pornographic press, and McBride's homoerotic presentation of male affection was far more disturbing to his first audiences than the pictures might suggest to viewers four decades later.

By the end of the 1960s, almost everyone wanted to look hip. Even photographers known in the fields of high culture and *haute couture* responded to the provocative mood. Both Irving Penn and Richard Avedon contributed to *Look* magazine's 1969 celebration of the new era (see pages 148 and 152). Penn took on the assignment for *Look* after *Vogue* turned down his offer to go to San Francisco in search of new cultural icons. In a trademark bare studio, under cool natural light, he photographed the Hell's Angels, a hippie family and two rock and roll bands, all in the same monumental style he had earlier used to portray traditional icons such as Alfred Hitchcock, Marcel Duchamp, and the Duchess of Windsor. Avedon photographed the Beatles, borrowing from Andy Warhol, Robert Rauschenberg and the language of psychedelic rock posters, to come up with a series of iconic portraits in acid colours. Photographer William Klein applied street photography to fashion work for *Vogue*, sending his models out into traffic, updating the approaches of Munkacsi and Avedon, with references to French *nouvelle vague* film, giving the fashion houses dynamic contemporary expression.

Throughout the 1960s, American magazines lost audiences and advertisers to television (although for a brief period in the mid-1960s, when federal law banned cigarette advertisements from television,

Ken Domon, pages from the book *Hiroshima*, 1958

magazines reaped considerable benefits in the form of large, sustained magazine advertising campaigns). The dominance of television as the medium for daily journalism was enhanced by the assassination of John F Kennedy in Dallas on 22 November 1963. Americans turned decisively to television for information about his shooting, and for coverage of the events that followed – which unintentionally included the live broadcast of the murder of Kennedy's accused killer, Lee Harvey Oswald. Within days, *Life* magazine published its own extended account of the events, including a spread showing frames from the footage by Abraham Zapruder, an amateur with a movie camera who was standing just yards away from the President's motorcade when the bullets hit. For years after, *Life* would cite the layout of the Zapruder stills as proof that photojournalism still provided unique and essential information about the world. But to many critics it was already clear that television had stolen the magazine's greatest single asset: its unified family of readers. This was what advertisers paid for, and it had moved to television.

The story was not the same in Europe – at least not yet. Powerful journals like *Paris Match* and *Stern* established formidable national audiences with photojournalism that did not rely on the ability to compete with television to deliver the news. These magazines were able to give over many pages to a single story when necessary, frequently extending coverage throughout an issue, or over several weeks, sometimes returning to it serially over months or even years, as for example with *Paris Match*'s coverage of the French colonial war in Algeria, and of the courtship, marriage and family life of Princess Grace and Prince Rainier of Monaco. For this form of journalism, depth and detail were more important than speed. It generally required more than one photographer. When *Paris Match* covered the 1956 uprising in Budapest (see page 50), the long story included the work of staff photographers, wire services and freelancers. The result was a complex composite whose author was *Paris Match* itself.

In considering the way photojournalists in the West became active participants in the movement to overthrow dictatorship, guarantee civil rights and promote justice during the eventful decades of the 1950s and 1960s, we can observe how stories in the media changed over the period. Early in the 1950s, political demonstrations were reported in a detached manner, as isolated incidents worthy of a single image – a burned-out bus, an isolated skirmish, a protester going to jail. By the end of the 1960s, the work of engaged photojournalists (like James Karales, Charles Moore and Flip Schulke working in the United States, Ernest Cole and Peter Magubane in South Africa, and Don McCullin and Gilles Peress in Northern Ireland) documented struggles in a way that demonstrated awareness of the broader context and in a way intended to argue for social change. At the centre of the emerging link between photojournalism and politics is the Vietnam War. Initially most Western journalists sympathized with the American

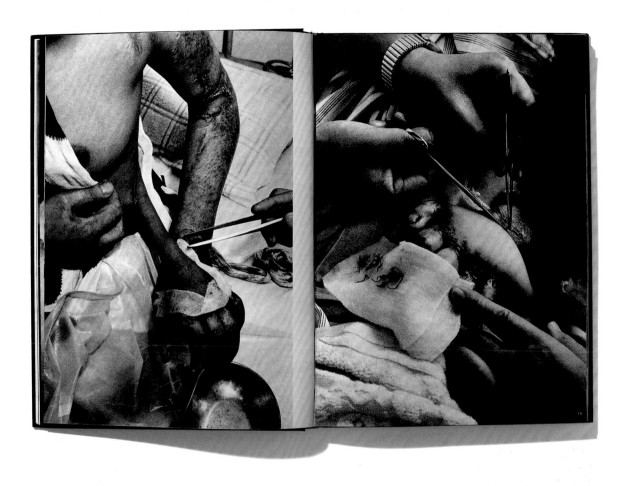

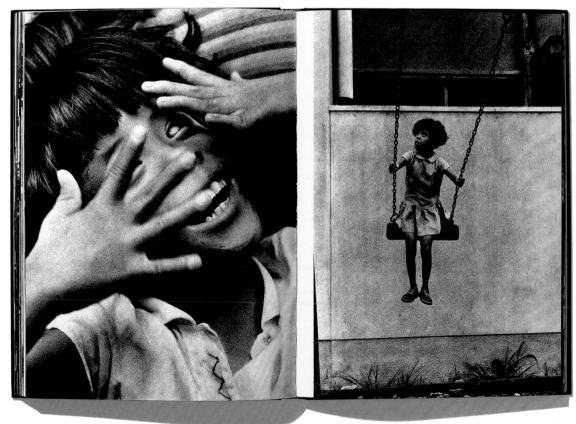

government and its soldiers. But by the time the war ended in 1975 world opinion condemned the US presence – a consensus that many attributed to the free access journalists enjoyed, and the many independent uncensored stories that appeared, especially picture stories.

Three single images made during the war in Vietnam have come to represent the power of photojournalism in the public imagination. These famous photographs are all single 'breaking news' shots, distributed by the Associated Press along with brief captions, and they appeared in newspapers all over the world. They stand apart from the feature story for a magazine or newspaper supplement, made by a writer-photographer team working over weeks or months. Their prominent place in common memory makes them significant to any story of photojournalism in the twentieth century. The first was Malcolm Browne's 1963 record of a Buddhist monk who set himself on fire in the middle of a downtown street, as a protest against the corrupt regime in Saigon (see page 37). Eddie Adams made the instantly famous picture in 1968 of a Vietnamese officer shooting a prisoner in the days following the Tet Offensive (when the Viet Cong scored their most notable victory against the American and South Vietnamese armies, see page 109). This event was also filmed by television cameramen, and broadcast widely, but critics regularly credit Adams' picture – printed on front pages around the world – with turning public opinion against the war. The third image, made by Associated Press photographer Huynh Cong 'Nick' Ut outside the village of Trangbang in 1972, shows a

William Klein, pages from the book *Life is good and good for you in New York…*, 1956

naked Phan Thi Kim Phuc, running down the road in tears, her arms outstretched, attempting to escape the napalm South Vietnamese pilots had mistakenly dropped on their own villagers (see page 108). All three images meet the requirements for what philosopher Umberto Eco (in his essay 'A Photograph', 1986) calls an 'epoch making' image where meaning 'has surpassed the individual circumstances that produced it; it no longer speaks of that single character or of those characters, but expresses [larger] concepts'. In so far as Eco's 'epoch making' images are all photographs that have attained this mythic status, they also demonstrate that, by the 1970s, audiences no longer equated photojournalism with the delivery of facts.

It was also in this period that photojournalism increasingly adopted a new idiom: colour. The transition took place easily in Europe, more slowly in the Americas. Although colour images had appeared in magazines since the late 1930s, they were normally reserved for exotic editorial subjects, advertisements and covers. (An exception was *National Geographic*, who began using colour early in the twentieth century and staked out a style that remained distinctive to that magazine alone – until the German *Geo* challenged their monopoly in the 1970s.) Until 1965, the technology to make and reproduce colour images remained awkward and expensive, although a few photojournalists of the postwar period became known for their colour reportage – among them Ernst Haas, Eliot Elisophon, Dmitri Kessel, David Douglas Duncan and Brian Brake. Their work often emphasized atmosphere, mood and design over storytelling content. Even after colour became practical for the pages of most magazines, it stayed closely identified with commercial work, considered by many less serious and more ephemeral than black

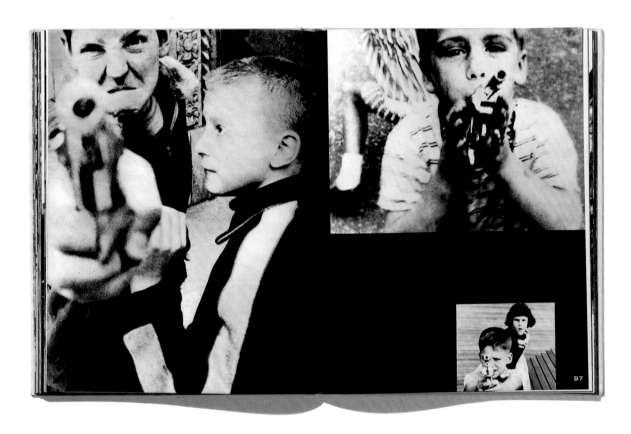

and white. Colour had also become the medium for the amateur, whether in the form of snapshots, slides or home movies. Before photographers, editors and audience could accept colour in photojournalism, these associations – more daunting than any technical obstacles – had to fade.

The most important demonstration of colour as a medium for serious photojournalism came in the mid-1960s, when Don McCullin, Larry Burrows, David Douglas Duncan and Philip Jones Griffiths produced extraordinary colour essays about the war in Vietnam for *Life*, the *Sunday Times* magazine, and the *Daily Telegraph* magazine, even while black and white photography remained their preference. McCullin and Burrows especially focused on the lives of the soldiers, using the war as a background against which to show the drama of the individuals as they fought in battle or supported one another. This approach also enabled them to avoid any overt judgement about the war itself. By the time the war ended in 1975, colour had become the common idiom for magazine war reportage.

By the 1960s, many photographers who started out working for magazines took advantage of inexpensive new forms of printing and an emerging interest in their work among book publishers. Bypassing periodicals altogether, they pursued their photo essays in book form. These include Ed van der Elsken with *Love on the Left Bank* (1956), Ken Domon with *Hiroshima* (1958, see page 23), Danny Lyon with *The Movement* (1964) and *The Bikeriders* (1967), and, at the beginning of the 1970s, Bruce Davidson with *East 100th Street* (1970) and Philip Jones Griffiths with *Vietnam Inc* (1971). Building on a tradition of photography books that includes Ilya Ehrenburg's *Moi Parizh* (1933), Brassaï's *Paris de Nuit* (1933) and Bill Brandt's *The English at Home* (1936), these books together begin to define a genre of their own quite distinct from magazine features, museum exhibitions or the photographer's portfolio.

Two figures tower over the history of the photo essay in book form, although neither is considered a photojournalist: William Klein whose *Life is good and good for you in New York* was first published in Paris in 1956 (see left), and Robert Frank, whose *The Americans* was first published in Paris in 1958 and brought out in an American edition a year later. American critics attacked Frank's book. One review called him 'a liar, perversely basking in the kind of world and the kind of misery he is perpetually seeking and persistently creating', and another 'neurotic [and] dishonest' with an 'intense personal vision marred by spite, bitterness and narrow prejudices'. Their anger stemmed from Frank's failure as a reporter, for his work abandoned all pretence at objectivity in favour of expressing his own distinct sensibility. But both his and Klein's seminal books steadily influenced the form and aesthetics of the photo essay thereafter.

In retrospect, the point when photojournalists chose to publish their work in their own books coincides with the moment when the form began to outgrow its origins. A creation of the press, the photo-journalist was beginning to claim a role beyond it. It is relevant that Robert Frank's monumental work took shape in America during the early stages of what Szarkowski refers to as photojournalism's long decline. This is also the moment when the first photographic art galleries, such as Limelight, opened in New York, and when the Museum of Modern Art established itself as the leading institution for collecting and exhibiting photography as art. While at the beginning of the period *The Family of Man* made no distinction between photojournalism and art photography, in the following years art photographers came to define their work in opposition to the narrative, representational work that appeared in magazines. Although several leading photographers – for example Henri Cartier-Bresson – worked successfully in both worlds, the view that photography could be either art or journalism, but not both, became dominant. It would be another quarter-century before these lines began to blur again.

The Last Decades

When *Life* magazine shut its doors in 1972, the press was full of sentimental memoirs and reverent obituaries – for the magazine, its illustrious staff, and the art of photojournalism in general. In the eyes of a large group of American journalists and critics, *Life* magazine had invented modern photojournalism, and when it folded, photojournalism died with it. This immensely sturdy myth has long caused critics and historians to overlook the large and often innovative volume of photojournalism produced subsequently. The world had no shortage of news to digest. Historian Eric Hobsbawm (in *The Age of Extremes*, 1994) bluntly characterized the history of the 1970s and 1980s as 'that of a world which lost its bearings and slid into instability and crisis'. And crisis continued to produce great photo opportunities.

Without doubt, photojournalists faced new obstacles. According to popular opinion, the unfettered reporting in Vietnam brought an end to public support for the war, and the US government conducted all future wars with the press on a much tighter rein. The other leading world powers never tried the same experiment with press freedom. Whereas 400 journalists had been stationed in Vietnam in 1968, only three photographers were permitted to accompany the British troops sailing for the skirmish over the Falkland Islands in 1981, with their work strictly managed through the pool system. While coping with restricted access to hard news, photographers now worked in the shadow of the television camera. Arguably, after the Vietnam War, the taste for visual drama developed into a hollow sensationalism. Writing in 1986 (on the tenth anniversary of the founding of Contact Press Images) historian and critic Fred Ritchin identified a sinister trend toward pictures that were deceptive and spectacle-laden: 'Where sensation bypasses information, photojournalism too often becomes nothing more than a perverse voyeurism, responding to nothing but the desire to be entertained, not the

desire to know.' In 1989, journalist Michel Guerrin, writing for *Photo*, disagreed, insisting that 'many photographers have negotiated difficult obstacles to photograph war in a meaningful way'. For Guerrin, the spirit of Robert Capa survived in the present, in the work of James Nachtwey, Anthony Suau, Susan Meiselas and David Turnley. The journalists he named were all Americans who were widely published in magazines outside the United States.

In the United States, photojournalism survived in news magazines – although they rarely ran photo essays, their sponsorship of photojournalism contributed to scores of major features published by magazines elsewhere – while it began to thrive in magazines serving more specialized audiences. Some took on ambitious stories, for instance when *Rolling Stone*, long identified with the incisive, intensely personal political reporting of Hunter Thompson and Tom Wolfe, assigned Richard Avedon to cover the presidential campaign season of 1976 (see page 204). Big city newspapers offered advertisers access to an audience defined by geography or region, and Sunday supplements in Boston, Los Angeles, Philadelphia, Detroit, Sacramento, Miami and many other cities published high-quality picture stories that had a local or regional hook. And as *Popular Photography* had for W Eugene Smith, the photography press opened its doors to inspiring stories that in an earlier era would have been found in the big picture magazines; in 1981, when Eugene Richards looked for a magazine that would publish the searing personal account of his wife's tragic struggle with breast cancer, no magazine would print it – until he approached *American Photographer* (see page 220).

In Europe, magazines were booming, and from the end of the 1960s Paris became the undisputed

Daily Mirror, photograph by Reuters, 30 May 1985

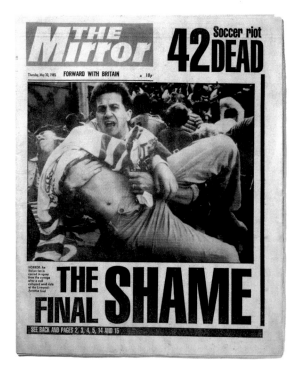

capital of photojournalism. War horse *Paris Match* led the field. It acquired a new design and a new slogan, promising readers 'the shock of the photos, the weight of the words', making text subservient to its double-page spreads for big pictures. No advertising interrupted stories that appeared in the centre section of the magazine. In the wake of the student protests of 1968, new left-wing publications began in Paris, including *Actuel* in 1968 and *Libération* in 1973. *Zoom*, a lavish bimonthly devoted to photography as art and design, was established in 1970.

An important aspect of the Parisian photo scene was the presence of new independent agencies, the most significant being Gamma, started in 1967 by Raymond Depardon, Gilles Caron, Hubert Henrotte, Jean Monteux and Hugues Vassal. The Gamma model was followed shortly by Sipa in 1969, Sygma in 1973 and Contact Press Images in 1976, all working alongside established agencies including Rapho and Magnum in Paris and Black Star in New York. Agencies supported photographers in the field, and promoted their finished stories to picture editors around the world, seeking simultaneous sales in different national and language markets where possible. They offered magazines and newspapers the sustained essays that did not come over the news wires. Picture editors competed for the chance to get hot stories, and agencies sought out strong layouts and high-paying publications. Many photographers remember the lively, competitive market of the 1980s as a new golden age, where almost any story they chose to pursue was easily sold and published. A new generation of agencies began in the late 1980s, beginning with Agence Vu in 1986 and followed by, among others, Editing in 1988 and Métis in 1989.

In 1985 Reuters, the wire service for news, began to sell photographs to subscribers (for example, see left), unsettling the equilibrium established between Associated Press, United Press International, and Agence France-Presse. The consequences for AFP were especially pointed, as they had long worked without serious competition in the French market. The improved quality and range of wire photography, and the faster speed of its delivery, increased the pressure on agency photojournalists to distinguish themselves more clearly in terms of their depth and individuality. Arguably, by the early 1990s it was the improved wire services, supplying powerful photographs to newspapers (now printing in colour) that did more to harm the broad European market for current affairs photo essays than any further encroachment by television.

In Great Britain, throughout the 1970s, the single most important publisher of photojournalism was the *Sunday Times* magazine. Under the campaigning leadership of Harold Evans and the art direction of Michael Rand, photography became a crucial component of the magazine's trademark investigative approach. From 1964 to 1986, Don McCullin covered political conflict around the globe, making stories unmatched for their emotion and clarity of purpose (see pages 156 and 192). In addition, the *Sunday Times*

bought agency stories that less courageous periodicals wouldn't or couldn't touch. In Germany, photojournalism flourished at *Stern*, with stories published over 20 pages or more by the likes of Hans-Jürgen Burkard and Sebastião Salgado. A new breed of general interest newspaper supplement such as those of the *Süddeutsche Zeitung* and the *Frankfurter Allgemeine Zeitung* offered competition by developing distinct visual approaches of their own, and in 1977 Gruner und Jahr, publishers of *Stern*, began *Geo*, updating the popular formula of *National Geographic*. Like its precursor, *Geo* was devoted to seeing the world, providing informative pictorial stories about exotic landscapes and foreign cultures. While both magazines gave many pages to a single, colour picture story, in place of the didactic style of *National Geographic*, *Geo* offered more visual drama with bolder images and layout. In turn, it influenced *National Geographic*'s approach, and a distinctive French *Geo*, launched in 1978, became a major success.

New magazines emerged throughout Europe. In Spain, the death of Franco in 1976 made it possible to publish without censorship. The result was a wide variety of new magazines, from the serious (*El País Semanal*) to the relentlessly upbeat (*¡Hola!*). In Italy, the new supplement *Sette* offered competition to the established magazines *L'Europeo* and *Epoca*. In the Soviet Union, *Ogonyek* underwent a new design, partly in response to technical changes in paper, printing and ink, bringing it closer in appearance to magazines in the West – a small early sign of the coming thaw in the Cold War. In Prague, Leipzig, Budapest, Vilnius and Minsk, photographers whose work was severely restricted in the government-controlled newspapers joined local amateur clubs, where any work that resisted official policy was justified by being deemed 'art'. Slowly, photographers trained in the Soviet Union like Antonin Kratochvil, Boris Mikhailov and Lialia Kuznetsova began to publish their work in the West, but even after 1989, as more photographers from the Soviet bloc exhibited in the West, they continued to promote their work as personal expression rather than documentation or journalism.

Japanese publications dominate the development of photography in Asia. Although the work of photographers like Ken Domon, Yonosuke Natori and Shomei Tomatsu satisfy our criteria for 'photojournalism', there are significant variations on the Western model. While mainstream Japanese newspapers published fewer photographs, and few other magazines addressed world affairs, photographers created photo essays for their own books and for radical art journals like *Provoke* (see page 178). Here text played no role, and documentary photographs were presented as personal expression rather than as factual accounts about places or events. As with photographers from the Soviet Union, those whose work did travel to the West came via the art world. Even the most journalistic reporting was stripped of historical reference. Hiroshi Hamaya's work on the rice harvest became a sentimental docu-

ment of a vanishing rural culture; Kikujiro Fukushima's photographs of Hiroshima were treated as a bold experiment in design; Takuma Nakahira and Daido Moriyama's work for *Provoke* became an expressionist statement of personal discontent.

In the postwar years, illustrated journalism flourished in Central and South America, in magazines and newspapers such as *Proceso* and *La Jornada* in Mexico, *Caretas* in Peru, *O Cruzeiro*, and *Manchete* in Brazil, *Clarín*, *La Opinión* and *La Prensa* in Argentina, and *La Nación* in Chile. But with political instability and repression, freedom of the press and the development of photojournalism suffered. Much of the memorable reporting was done by outsiders, like Susan Meiselas, who were able to publish their work in Europe and the United States. For those who stayed, publication was often impossible, or required brave and creative remedies – as in 1988 when one group of Chilean photographers made themselves into a 'living newspaper', demonstrating against General Pinochet by carrying their work through the streets.

In Argentina, a group of photographers gathered around Sara Facio and Alicia D'Amico, publishing their work in the form of books and garnering support within the art world. In the last decades of the twentieth century a similar movement in Mexico propelled the careers of many young photographers who worked in a style inspired by the 'Magic Realism' of Gabriel García Marquez, including Graciela Iturbide and Luis González Palma. Others like Oscar Molinari, borrowing from the crime photography of Enrique Metinides, created photo-novels published in *Sucesos* in the 1970s and *Luna Cornea* in the 1990s. In the context of the history of photojournalism, these strategies can be seen as a means to protect and publish photography, as also used successfully by photographers in the former Soviet Union. At the end of the century, the shift towards democracy and freedom made it possible for artists and writers to bring many hidden images and texts to light. In one example among many, photographers Vera Lentz and Mayu Mohanna joined Peru's Truth and Reconciliation Commission, which placed the collecting and exhibiting of photographs – unpublished in newspapers at the time – at the centre of a national project to identify the causes and perpetrators of violence that plagued Peru during the 1980s and 1990s (see page 28).

The growing dominance of colour pictures challenged a long list of deeply rooted assumptions about the definition of news, the visual characteristics of truth, and the capacity of photojournalists to represent stories objectively. This shift coincided with a rising scepticism towards all claims of objectivity, and was accompanied by a greater tolerance of, and interest in, the personal and contingent. This position was identified variously with new journalism, structuralism and post-modernism, and applied to all forms of representation from non-fiction writing to feature films. A group of photographers within Magnum led by Gilles Peress, participants within the press but activists against its narrative formulae,

offered a 'new photojournalism'. Its characteristics were exemplified by Peress's *Telex Iran* (1983), with its impressionistic sequences of photographs and non-conformist text (telexes exchanged with his agency, regarding deals with magazine clients, rather than captions concerning Iran). This informal movement led authors of all kinds to become more clearly present in their work; as Mary Ellen Mark explained in an interview with Janice Bultman (in *Darkroom Photography*, 1987): 'In the kind of social documentary photography I do, you're never a fly on the wall … You're as much a part of the scene as your subjects.' Meanwhile, Peress's disruption of the conventions of composition of the journalistic image influenced a generation of photographers in Europe and America, who found a new vocabulary in his work for creating dynamic, attention-grabbing frames – for example in the bold graphic approach of photographers working for the Danish newspaper *Politiken* in the 1990s (see opposite).

By the end of the period, and notably with the popular success of Sebastião Salgado's epic *Workers* exhibition that began touring in 1992, photographs once seen only on the pages of magazines appeared again on the walls of museums and galleries. What made one photograph a work of art, and another a piece of journalism? In a late interview (quoted in *On The Line: The New Color Photojournalism* by Adam Weinberg, 1986) Walker Evans placed the

Below: Octavio Infante, pages from the book *Yuyanapaq. Para Recordar*, 2003 (showing photographs of seven journalists massacred at Uchuraccayin in 1983)
Right: *Politiken*, 14 February 1998, photographs by Joachim Ladefoged

responsibility with the viewer: 'No one says "This picture is art, it belongs in a museum. This picture is journalism, it belongs in a wastebasket." The viewer can decide.' But of course it was not the viewers who decided. In Evans' own case, despite his credibility within the art world from the 1930s onwards, the colour essays that appeared in the pages of *Fortune* were not seen in a museum, and, until the 1970s, there were no museum exhibitions of colour photographs at all. Some identified the distinction as a matter of economics – journalism was bought and paid for by a publication, with art the responsibility of the artist alone.

The last years of the Cold War era were full of eventful news stories indicating the end of old orders. Tens of thousands of students and workers demonstrated for democracy in Tiananmen Square until government tanks fired on the crowd. In Berlin, a spectacular, exuberant celebration accompanied the fall of the Berlin Wall. Elections in Poland, Czechoslovakia, Hungary and Bulgaria installed democratic governments for the first time in decades. In Chile, free elections overthrew the ten-year rule of Pinochet. Another sign of change became significant only in retrospect: when journalists set out to cover the Gulf War in 1990, they could not know it would be the last major war to be recorded on film.

The Digital Age
One breaking news photograph does not differ from another simply because one travels by satellite phone, and another reaches the picture desk in the form of film carried in the pocket of a passenger on the Concorde flight to New York – a method still popular at *Newsweek* as late as 1992. Images had long been transmitted by phone line – the Associated Press first

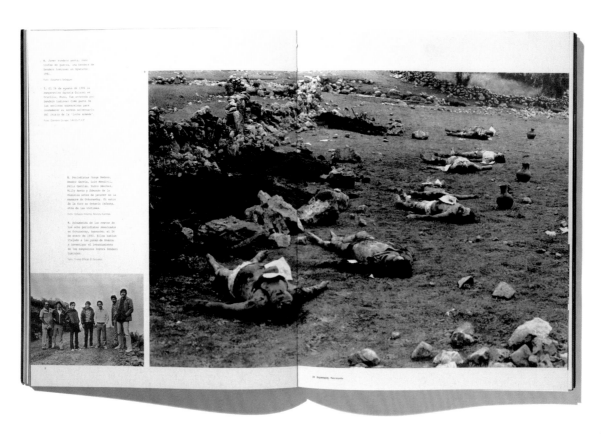

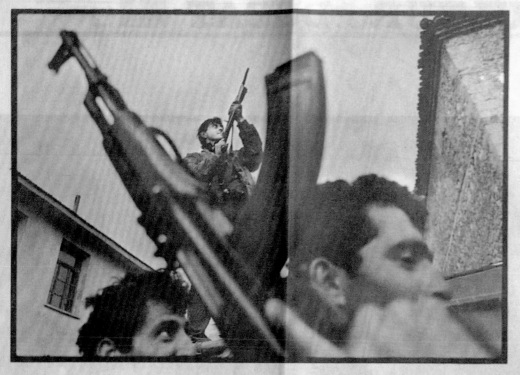

Det er helt vildt

Af Jens Kerte

Da Politikens yngste fotograf mødte på vagt i går formiddags og fik at vide, han netop havde vundet førsteprisen i World Press' store internationale fotokonkurrence, smilede han hånligt og rullede med øjnene. Der er nemlig ingen, der skal tage pis på den 27-årige Joachim Ladefoged.

Først efter flere redaktører havde aflagt ed på nyheden, troede den vantro midtjyde så småt på meldingen, men han skulle lige han og tjekke på Internettet. Den var god nok, og han faldt ned af stolen. Mere cool er han trods alt ikke.

Joachim Ladefoged er med sin førstepris Årets uofficielle verdensmester for pressefotografer i kategorien People in the News/Stories. Altså gruppen for fotoserier med nyhedsreportage og mennesker i fokus. Hæderen og de 10.000 priskroner får han for 12 sort/hvide billeder fra urolighederne i Albanien i fjor.

Fire gange besøgte han landet bevæbnet med skudklart kamera. To gange udsendt af Politiken og to gange for egen regning, før han syntes, det var færdigt arbejde han den omgang.

Gennembrud

Mens champagnepropperne sprang, og dagens første sejrsrus bredte sig til resten af redaktionen på Rådhuspladsen i København, fløj World Press' hjemmeside fra Holland over af nyheden om en ekstra hatteften til ungreporternes skaldede isse. Et af hans albanske fotografier havde også vundet 3. prisen i en kategori for enkeltfotos.

I alt deltog i år 3.627 internationale pressefotografer fra 115 lande med 36.041 billeder i konkurrencens i forskellige afdelinger, og aldrig tidligere har nogen dansk fotograf opnået så fornem global en hæder som Joachim Ladefogeds førsteplads.

Kolleger og venner strømmede til ved fotokassen på redaktionens første sal, og Joachims mobiltelefon var på eks-

plosionerne rundt. Alle ville lykønske den populære kammerat og kollega, og hver gang lød hans reaktion: 'Det er helt vildt.'

Og det er det da. For ikke alene har Joachim Ladefoged vundet verdens mest prestigefyldte konkurrence for pressefotografer. Men for bare ti år siden sad han i rullestol og havde indtil da aldrig holdt et kamera i hånden.

Mens han gik på idrætsefterskole i Himmerland, pådrog den sportstossede vildbasse sig en alvorlig lodrejet efter en infektionssygdom, og prognosen så dyster ud. Han ville næppe nogen sinde komme til at gå igen.

Men det skulle blive løgn. Han begyndte at tage naturmedicin og satte stædigt kurs mod grøntsager og fodbolden igen. Kuren hjalp, og samtidig forærede hans far ham hans første fotografiapparat.

Efter et halvt år rullede han stolen bag sig og pejlede ind mod fremtiden med kameraet om halsen. Nu havde han fået fotografiering i blodet og kom i lære på Århus Stiftstidende efter en periode som volontør hos fotogruppen Fokus i den jyske hovedstad.

Svendebrevet kom i hus for kun tre år siden, og kort efter blev Joachim ansat på Politiken i København. Så begyndte det at gå stærkt. Talentet, nysgerrigheden og interessen for den aktuelle reportage var iøjnefaldende, og hans skarpe blik for det nøgterne, præcise og originale pressebillede har allerede udstyret ham med en lille håndfuld hjemlige fotopriser.

Men at Joachims internationale gennembrud skulle komme så hurtigt, er han selv mest overrasket over. Også selv om en belgisk kollega allerede for fem dage siden løste hans billedtekster på væggen ved den europæiske Fuji konkurrence i Istanbul.

Joachim havde netop vundet det japanske fotofirmas lokale konkurrence for Danmark, men hans billeder fra Albanien blev ikke placeret i Tyrkiet. Til gengæld spåede kollegaen i østologi, at de ville komme til tops hos den naf-

hængig og non profitable World Press Photo Foundation. Den clairvoyante belgier fik ret.

Heltene

Som søn af en enlig mor med tre børn og konstant flyttetrang blev det så som så med Joachim Ladefogeds skolegang. Familien var i konstant opbrud omkring Silkeborg, Skanderborg og Århus. Han nåede at stifte bekendtskab med omkring en snes skoler, inden han efter sin sygdom sluttede 10. klasse med udvidet enkeltfag i engelsk og tysk.

Sit sprogmotme er ham til stor gavn under de mange reportagerejser i udlandet for Politiken, mens eller har han først og fremmest studeret billeder. De udenlandske helte er især reportagefotograferne omkring den berømte Magnum gruppe, mens de hjemlige inspiratorer er snere som Krass Klement, Stig Stasig og Heine Pedersen.

Nu har kærlingen faktisk overhalet de nationale mestre, og verden og fremtiden ligger ham åben. Men foreløbig passer Joachim sit arbejde her på Politiken. Om kort tid rejser han på reportagetur til Kina, og så drømmer han om på et tidspunkt at slå sig ned som freelancer et års tid i New York. Den unge verdensmester skal dog lige hjem og konferere med kisten Anne først.

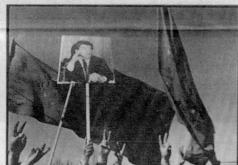

the suburbs: introduction

Narrative by Gilles Peress

Bosnia, Feb. 19
As I am walking through this destroyed landscape, through the
remains of a war now gone, I am overwhelmed by the silence, the
absence of explosions. I can hear the birds singing. The ending of
war is almost more depressing than war itself because once you
don't have to run for your life, the evidence of waste is fully
there to contemplate as slowly as you want, inch by inch, bullet
hole by bullet hole.

The sense of hangover of the day after the party, after the house
was trashed, after the family was destroyed, the children
dispersed, colors every one of my feelings. There is a bitter
taste. People in Sarajevo and in the Serbian suburbs are sullen;
there is none of the joy that one would expect from the coming of
peace.

I am listening to the BBC World Service when a sudden announcement
on the 6 o'clock news explodes like a shell in the middle of a
sunny day: the Serbs have to leave Sarajevo's suburbs within three
days. We, and I suspect they, all thought that the deadline was a
month later: the 19th of March.

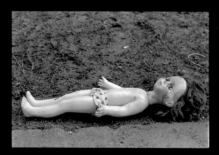

I quickly check the information; the deadline has been moved for
some of the suburbs so that the evacuations would be staggered.
The Serbian neighborhoods will go over to the Bosnian authority
one after the other at intervals of six or seven days. The first
one to go -- in three days, as announced on the radio -- is
Vogosca.

transmitted photographs by satellite in 1967 – but before digital cameras, the process was laborious. News stories in the late 1980s involved photographers making pictures during the day, processing film in the hotel bathroom during the evening, and scanning and transmitting (via imperfect phone lines) overnight. Media visionaries like Andy Grove saw that this technology was 'about where the horse and buggy business was when Henry Ford first cranked up the assembly line'. By the time the United States invaded Afghanistan in 2001, photographers still travelled by donkey across the desert, but they carried power-packs to transmit images via satellite to their distributors, able to reach any newspaper in the world in seconds. And with the war in Iraq in 2003, digital images travelled back to waiting websites as soon as exposures were made. Still pictures now beat television in the race to broadcast breaking news.

The rise of digital technology and the internet occurred following the fall of the Soviet Union and the collapse of Communism. The result of both events was what media mogul Rupert Murdoch has called 'a borderless world'. The consumer marketplace now spans every continent – kids want the same sneakers, see the same TV shows, hear the same music, whether they live in Paris, Beirut, Rio or a village in sub-Saharan Africa. Political and geographical borders have become less significant, while power shifts to global economic networks established by trans-national corporations

Left: *New York Times*, website 1996 with a page from 'Bosnia: Uncertain Paths to Peace' by Gilles Peress
Below: *Vanity Fair*, February 2002, photograph by Annie Leibovitz

such as Viacom, Sony, Bertelsmann and Disney.

While major print publications initiated new experiments with on-line storytelling – the most notable early example is the *New York Times* publication of Gilles Peress's on-line story 'Bosnia: Uncertain Paths to Peace' in 1996 (see left) – the facility to communicate on the internet and an emerging culture of do-it-yourself media have broken old monopolies over the production and distribution of news. Organizations have emerged that change the relationship between producers and consumers, one such being Médecins Sans Frontières. Founded by a group of French doctors in 1971 to deliver medical care to at-risk populations, from the outset they linked medical assistance with efforts to sway public opinion, generating stories and bringing media attention to crises that would otherwise go unreported. In their words, 'without a photograph there is no massacre'. For media historian Robert McChesney, the most serious consequence of a world without borders is the phenomenon which (in *Rich Media, Poor Democracy*, 1999) he calls 'convergence', defined as 'the manner in which digital technology eliminates the traditional distinctions between media and communication'. It is no longer easy to draw a line between the technical design of a website, its content, and its sponsors. What is an advertisement, and what is an editorial feature? What is information, and what is propaganda?

Just as significant, while owners of newspapers, magazines and television stations have never neglected the need to make a profit, they earlier viewed serious (and often expensive) journalism as a means to enhance the prestige of their organization and provide a service to their community. This

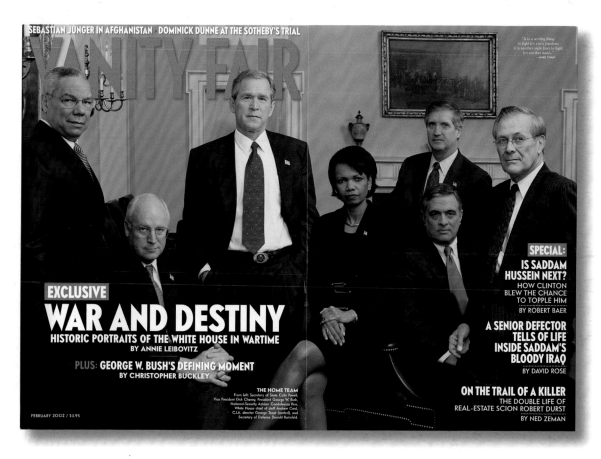

civic-mindedness declined in the early 1990s, with information services seen as one more business investment, measured in terms of profit. Expensive work was consistently cut back, with networks, magazines and newspapers putting fewer reporters and photographers on staff, and with writers and editors relying instead on the wire services and the consolidated mega-agencies Corbis and Getty for most of their international news. The kind of stories that take time and money have often been set aside in favour of today's immediate breaking news, local crime stories, accidents, celebrity antics and athletics contests. In 1998, the *Economist* declared, 'In this information age, the newspapers which used to be full of politics and economics are thick with stars and sport.'

For the world's photojournalists, its combat zones have steadily divided into two groups: those in which America and the other main global players are involved, that are accessible on the warring powers' strict (and self-interested) terms; and wars in the rest of the world, that are freely accessible (if dangerous) but which fall outside the scope of the world media's interest. Photographic work in the latter category is frequently unpublished except in the pages of photojournalism magazines such as *Ei8ht* or as the winners of contests such as World Press Photo. Documenting America's wars independently, meanwhile, becomes the game of only a daring few. Even when it is possible, mainstream publishing opportunities remain limited. Kenneth Jarecke worked under the restrictions set up by the US Department of Defense during the first Gulf War, and contributed images to the pool distributed to the

Proceso, 9 December 2001

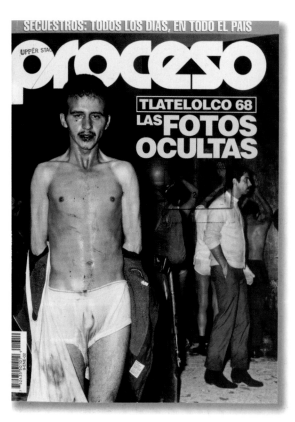

media during the war. But he remained in Iraq as a freelancer, and strayed into forbidden territory – coming across the charred remains of a vehicle holding Iraqi soldiers. American publishers would not touch the resulting photograph. It ran first in the *Observer* of London (and then only the conflict was over), becoming an icon of the desert war in America only much later.

A useful comment on the state of the publishing world today can be found in Walter Benjamin's observation (referring to the press of 1930s Berlin in his 1934 essay 'The Author as Producer') that the modern newspaper was a 'theatre of literary confusion', full of information on a limitless array of subjects, arranged with no particular order, organized by no principle other than one imposed by the reader. But for Benjamin this state of confusion also offered an opportunity: 'As writing gains in breadth what it loses in depth, the conventional distinction between author and public … begins to disappear. For the reader is at all times ready to become a writer.' Today his words offer an optimistic note. For example, the existence of independent satellite networks broadcasting over television and radio has made it possible for ordinary citizens in places like Peru, Argentina and Chile to challenge a press that was strictly censored. In however limited a way, the open skies of satellite communication make corruption and political censorship easier to expose, and protest harder to control and suppress. This climate benefits both the present and the historical record, and makes it possible to publish images that were once too dangerous to release, overturning years, even decades of censorship – for instance, with *Proceso*'s publication of previously suppressed photographs of the 1968 student riots in Mexico City (see left).

Technological change has been accompanied by new directions across photojournalism. When Benetton's Oliviero Toscani developed *Colors* magazine, he forged a radical, stylish update of the kind of photomontage once published by *Arbeiter Illustrierte Zeitung* capable of graphically relaying information about complex topics such as immigration, sexuality, consumerism and Aids. A host of new visual magazines are exploring the boundaries of reportage while in the mainstream press minimalist compositional approaches, reminiscent of Walker Evans, have resurfaced alongside new varieties of photographic virtuosity. Photographers like Susan Meiselas and Pedro Mayer have published websites that incorporate historical information, contemporary reportage and contributions from readers and viewers – in Mayer's case, developing the non-linear, autobiographical narratives that he explored on CD-ROM in the early 1990s (and which, ten years on, already seem technologically antique).

Without fanfare, photographers, publishers and audience alike have agreed to abandon sharp distinctions between art and journalism. The blur between personal expression and reportage also influences the formal characteristics of work today. Annie Leibovitz, for instance, makes overt references

to the style of the Dutch Masters in her group portrait of the Bush War Cabinet, commissioned by *Vanity Fair* in 2003 (see page 31). The distinctive compositions – and prints – made by photojournalists such as James Nachtwey and Stanley Greene have earned them exhibitions, books and a new following in the art world based on images originally produced while covering a story for publication. Other photographers trained in photojournalism have left the magazine entirely behind, to produce photographs specifically for the museum wall – notably Luc Delahaye with his 'History' series – that then find their way back into magazines in the context of reports about the artists' work and exhibitions. In a reversal of the trend, artists whose photographs regularly hang in museums and sell in galleries have recently turned to magazine reporting. When the *New York Times* sent artist Nan Goldin behind the scenes to follow the career of rising fashion model James King (see page 304), Goldin's trademark style, with its lurid colour and aggressive intimacy, gave a grim story glamour and suspense.

Perhaps most significant is the way in which digital photography and new channels for publication allow anyone with a camera to find an audience for his or her work. This 'democracy of photographs' was heralded as the subtitle of the exhibition, website and book *Here is New York* (2002), featuring contributions from both professionals and the masses of amateurs whose cameras recorded the events surrounding the 9/11 attack on the World Trade Center. In the spring of 2004, investigative reporters uncovered amateur digital images made in the prison of Abu Ghraib, outside Baghdad, and exposed the illegal torture of

Iraqi prisoners by the American military, in violation of the Geneva Conventions (first exposed in the pages of the *New Yorker* in 2004, see below). While photojournalists strive to distinguish their work from each other's, it has become a commonplace to see riveting news events illustrated by the guileless snaps of non-professionals.

The borderless media world, with its promiscuous appropriation of images, has forced journalists to re-examine the relationship between authors, publishers and readers. The publications of the future promise entirely new forms of communication – as different from our present magazines as *Vu* and the *Berliner Illustrirte Zeitung* were from their predecessors. In the 1930s, a great transformation in communication came about in part because rogue photographers like Erich Salomon used new cameras to make pictures that were inconceivable beforehand. In the era of the internet and the camera-phone, photographers and editors are inventing new means to reveal things as they are, and readers, photographers and publishers are forging new contracts.

The application of the term 'photojournalism' to camera-phone pictures of the 2004 tsunami will be questioned by some, but as published in magazines or on the internet, our criteria for its use here are met. We are forced to conclude either that photojournalism is alive and well and in the process of a dynamic reinvention. Or that something else is emerging from its history to take its place – and which has yet to be given a name.

New Yorker, 10 May 2004

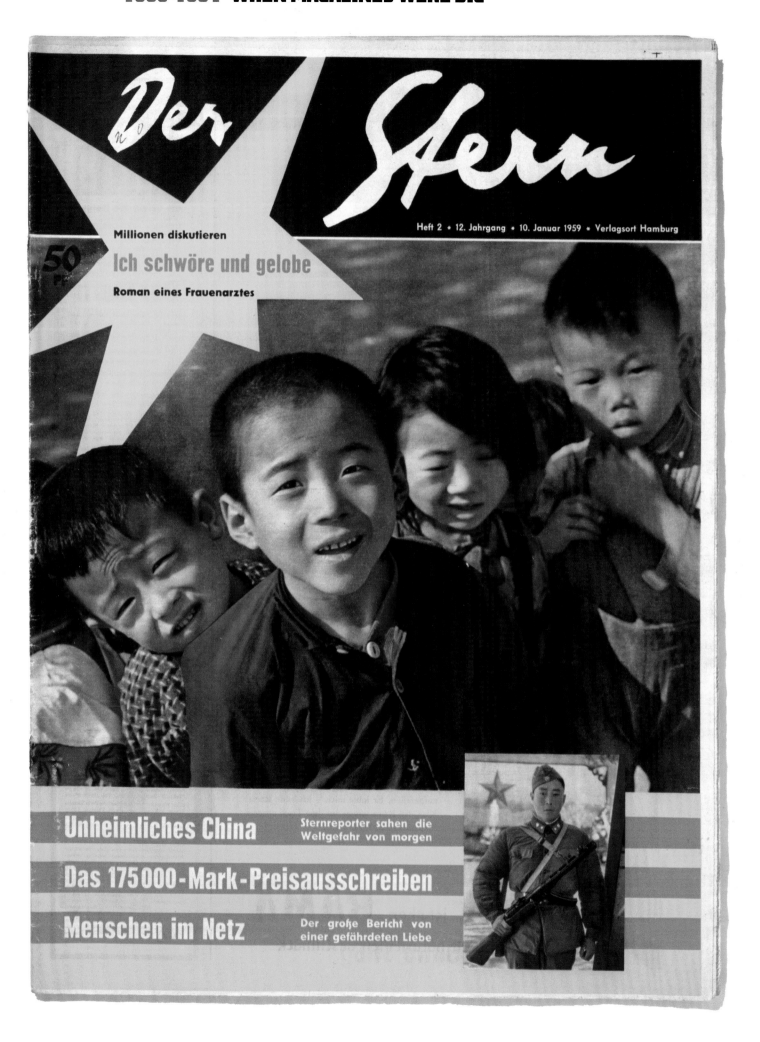

Der Stern

Heft 2 • 12. Jahrgang • 10. Januar 1959 • Verlagsort Hamburg

50 Pf

Millionen diskutieren

Ich schwöre und gelobe

Roman eines Frauenarztes

Unheimliches China Sternreporter sahen die Weltgefahr von morgen

Das 175 000-Mark-Preisausschreiben

Menschen im Netz Der große Bericht von einer gefährdeten Liebe

The magazines of the late 1950s are big in every way – with big pages, big pictures, big audiences, big photographers and big stories. Although the power of television grows constantly during the period – particularly in America – magazines that enter millions of homes around the world remain the most important source of visual information about the news of the day. As the postwar world is reshaped to new Cold War and post-colonial conditions – the Berlin wall is constructed and Pakistan separates from India – much remains for the photographer to discover and present for the first time in pictures. The world shrinks with sophisticated visual accounts of cultures – and conflicts – in the Soviet Union, China, Vietnam, South Africa, Cyprus, Japan, Algeria, Cuba and the Congo. Postwar austerity in Europe and America is steadily replaced by economic prosperity. Celebrities are in the front line of new consumer cultures and sell the most magazines – Grace Kelly weds Prince Rainier of Monaco, the good-looking Kennedy family enters the White House, and the genre of the 'paparazzi' is initiated in Italy. Photojournalism amplifies the celebrity charisma of Elvis, Fidel Castro and Pablo Picasso. As the Soviet Union pulls ahead in the battle for outer space, with Yuri Gagarin the first man to orbit the earth in 1961, Cold War tensions and alliances dominate the perspective of every nation's press. In late November 1963, the media momentum begins a decisive shift, as the coverage of the assassination of US President John F Kennedy brings a nation together to watch and mourn – on television.

MOGENS VON HAVEN
Competitor tumbles off his motorcycle during motorcross world championships. Volk Mølle racecourse, Randers, Denmark. World Press Photo of the Year 1955

YASUSHI NAGAO *Mainichi Shimbun*
Hibiya right-wing student assassinates Socialist Party Chairman Inejiro Asanuma during speech. Habiya Hall, Tokyo, Japan, 12 October 1960. World Press Photo of the Year 1960

HELMUTH PIRATH *Keystone Press*
German World War II prisoner released by the Soviet Union is reunited with his daughter. West Germany. World Press Photo of the Year 1956

DOUGLAS MARTIN *Associated Press*
Dorothy Counts, one of the first black students to enter the newly desegregated Harry Harding High School. Charlotte, North Carolina, USA, September 1957. World Press Photo of the Year 1957

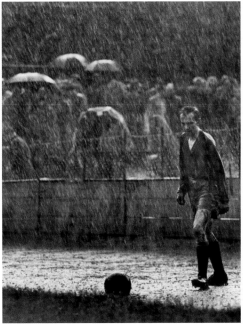

STANISLAV TEREBA *Večerni Praha*
National soccer championship between Prague and Bratislava. Prague, Czechoslovakia, September 1958. World Press Photo of the Year 1958

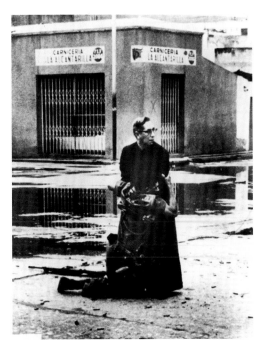

HÉCTOR RONDÓN LOVERA *Diario La República*
Priest Luis Padillo with soldier mortally wounded by a sniper during military rebellion. Puerto Cabello naval base, Venezuela, 4 June 1962. World Press Photo of the Year 1962

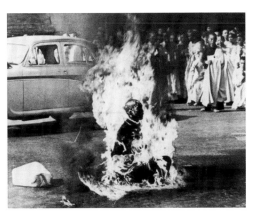

MALCOLM BROWNE *Associated Press*
Buddhist monk Thich Quang Duc sets himself ablaze in protest against alleged religious persecution by the South Vietnamese government. Saigon, South Vietnam, 11 June 1963. World Press Photo of the Year 1963

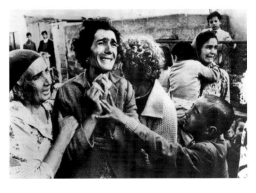

DON MCCULLIN *Observer, Quick, Life*
A Turkish woman mourns her dead husband, victim of the Greek-Turkish civil war. Ghaziveram, Cyprus, April 1964. World Press Photo of the Year 1964

To continue his series of sweeping profiles of countries in transition after World War II, Henri Cartier-Bresson reached Moscow in July 1954 after an eight-month wait for a visa – the first Western photographer to be granted access after Stalin's death the previous year. Independently produced, *Holiday* magazine considered giving an entire issue over to his pictures before *Paris Match* and *Life* magazine both bought the rights. In a sense, the story is simply that Cartier-Bresson went, and saw, and while he clearly bore some sense of responsibility toward the themes of interest to the magazine reader, his exploration of street-level Russia and the persistence of peasant culture in the modern state was a free-spirited engagement on his own artistic terms. He explained his goal as seeking to photograph 'human beings in the streets, in the shops, at work and at play, anywhere I could approach them without disturbing reality', and he used his inability to speak Russian as a shield, deflecting attention toward his official translator and away from his camera. The genius of Cartier-Bresson's work during this period lay not only in his images, but in his success at packaging his personalized vision so accessibly and intelligently for the photojournalism market. (29 January and 5 February 1955)

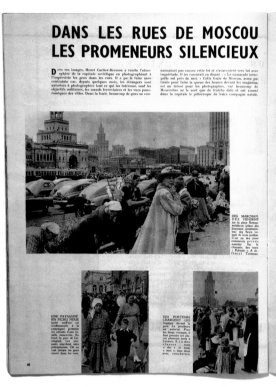

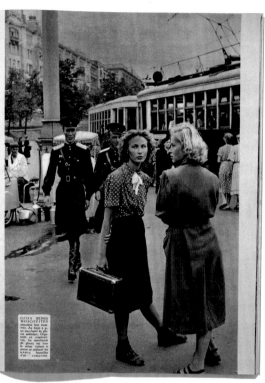

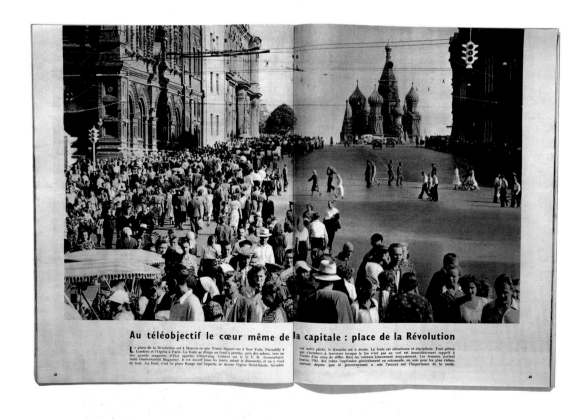

Le musée le plus couru : les couloirs du métro

Le temps est passé où l'U.R.S.S. prétendait ne rien devoir à la Russie d'autrefois. Elle a renoué avec beaucoup de ses traditions. La culture est hautement estimée. On trouve partout — surtout dans le métro qu'on visite comme un musée — des tableaux de style « chromo » soit sur des sujets historiques du passé, soit à la gloire du Travail ou de la Révolution. Les Russes, que l'impressionnisme n'a pas surpris, s'étonnent de la sévérité des Occidentaux à l'égard de leurs œuvres. « Comment, ont-ils demandé à Cartier-Bresson, vous aimez Tolstoï et vous n'appréciez pas notre peinture ? »

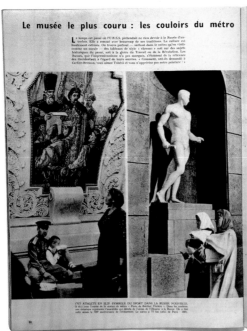

CET ATHLÈTE EN SLIP SYMBOLE DU SPORT DANS LA RUSSIE NOUVELLE, il est sous l'entrée de la statue du métro « Porte de Bolchoï Théâtre ». Dans les couloirs une sculpture représente l'assemblée au débuts de l'Union de l'Histoire à la Russie. On a fêté cette année le XX° anniversaire de l'événement. Le métro a 75 fois (celui de Paris : 100).

LA GALERIE TRETIAKOV, DU NOM DE DEUX FRÈRES QUI DONNÈRENT 2.500 tableaux à Moscou en 1892 est le temple de l'art officiel. Paradies et princes perfectionnels y viennent porter leurs fruits. Excellents écrivains musiciens et danseurs, les Russes entrent avec la Révolution, ses racines étés des peintres et des sculpteurs sans médiocres.

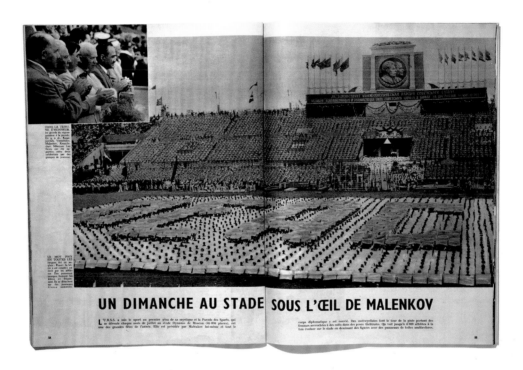

DANS LA TRIBUNE D'HONNEUR les grands du régime assistent à la parade. De g. à dr. : Boganovitch, Vorochilov, Malenkov, Krouchtchev, Mikoyan. Les fleurs sur ses appuyées, entre deux parties, celebrons par des groupes de jeunesse.

LE MOT PAIX EN TOUTES LES langues fleurit au stade. Pour : la lettre P est composée, à côté les tiret par les athlètes sur des affiches qui chaque tournant les lettre et forment bientôt en couleur. Ils le détachée sur des panneaux blancs successifs.

UN DIMANCHE AU STADE SOUS L'ŒIL DE MALENKOV

L'U.R.S.S. a mis le sport au premier plan de sa mystique et la Parade des Sports, qui se déroule chaque mois de juillet au stade Dynamo de Moscou (45.000 places), est une des grandes fêtes de l'année. Elle est présidée par Malenkov lui-même et tout le corps diplomatique y est convié. Des motocyclettes font le tour de la piste portant des femmes accrochées à des mâts dans des poses théâtrales. On voit jusqu'à 4.000 athlètes à la fois évoluer sur le stade en dessinant des figures avec des panneaux de toiles multicolores.

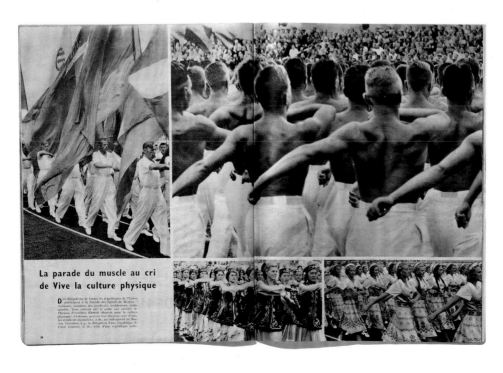

La parade du muscle au cri de Vive la culture physique

Des délégations de toutes les républiques de l'Union participent à la Parade des Sports de Moscou : militants, membres des syndicats, travailleurs, clubs sportifs. Tous entrent sur le stade aux accents de l'hymne écrivissien Baroch chantant pour la culture physique. Ci-dessus, portant leur drapeau aux plis, les syndicats ukrainiens, à dr., un club sportif de Moscou. Ci-contre, à g., la délégation d'une république de l'Asie centrale. À dr., celle d'une république balte.

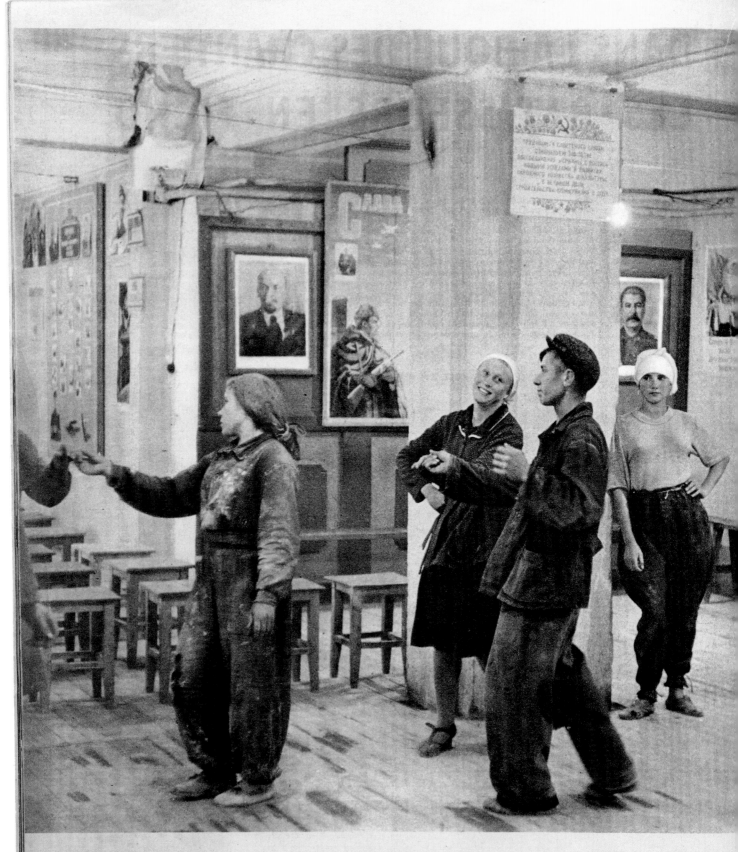

Hôtel Ukraine à l'heure de

Eⁿ visitant l'hôtel Ukraine en construction, Henri Cartier-Bresson a surpris les ouvriers et les ouvrières en train de danser au son de l'accordéon. La scène se passe dans le chan- tier pendant l'heure de repos au ce[r...] du club du bâtiment. A gauche, u[...] danse populaire. A droite, une da[...] occidentale. Le jazz est admis de n[...] veau. Dans les chantiers, les ouvri[...]

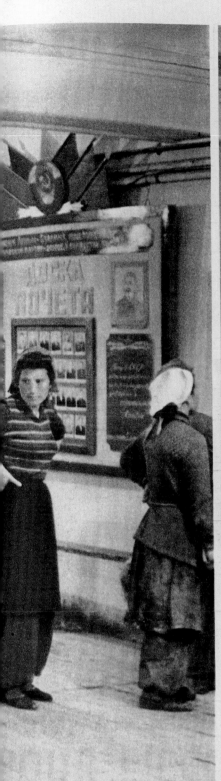
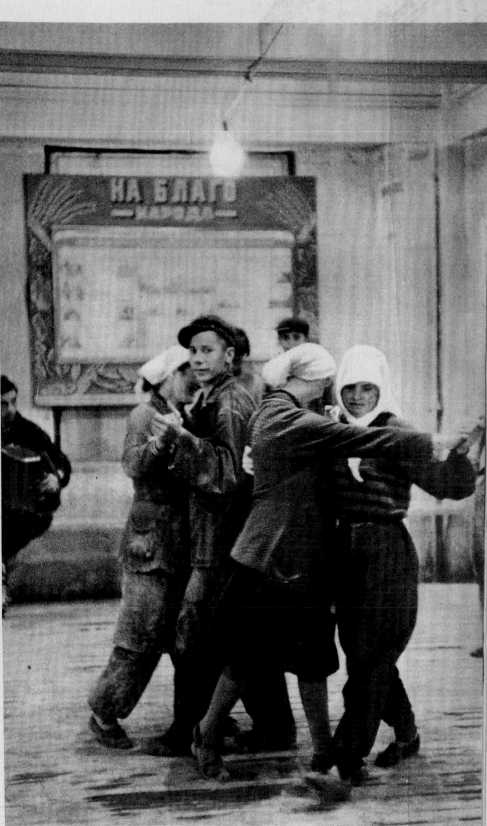

use : le fox-trot des ouvriers

ravaillent en équipes de jour et de
uit. Il est cependant difficile pour
a construction de suivre la cadence
e l'augmentation de la population
oscovite. Toutes les maisons ancien-

nes ne sont pas détruites. Celles qui
ont un intérêt artistique sont con-
servées. Si elles se trouvent dans la
zone à reconstruire, on les déplace
en les emmenant sur des rouleaux.

61

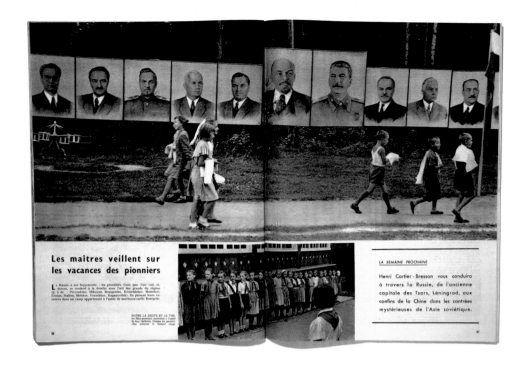

Les maîtres veillent sur les vacances des pionniers

La Russie a ses boys-scouts : les pionniers. Ceux que l'on voit ci-dessus, se rendent à la douche sous l'œil des grands du régime (g. à dr. : Pervoukhine, Mikoyan, Boulganine, Krouchtchev, Malenkov, Lénine, Staline, Molotov, Vorochilov, Kaganovitch). Ils passent leurs vacances dans un camp appartenant à l'usine de machines-outils Energetic.

ENTRE LA SIESTE ET LE THÉ, les filles-pionniers répondent à l'appel de leur chefette. Comme les garçons elles achèvent le foulard rouge.

LA SEMAINE PROCHAINE

Henri Cartier-Bresson vous conduira à travers la Russie, de l'ancienne capitale des Tsars, Léningrad, aux confins de la Chine dans les contrées mystérieuses de l'Asie soviétique.

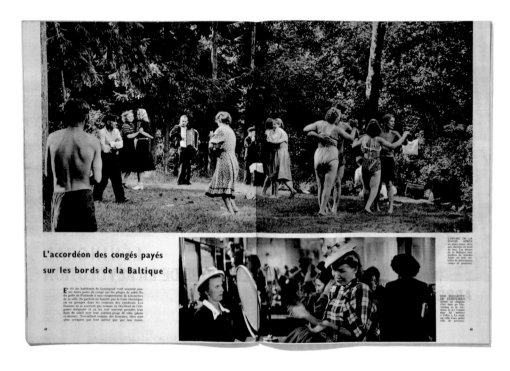

L'accordéon des congés payés sur les bords de la Baltique

Été les habitants de Léningrad vont souvent passer leurs jours de congé sur les plages de sable fin du golfe de Finlande à une cinquantaine de kilomètres de la ville. Ils partent en famille par le train électrique, ou en groupes dans les camions des syndicats. Les femmes ne se soucient pas comme en Occident de l'élégance balnéaire et on les voit souvent prendre leur bain de soleil avec leur soutien-gorge de ville (photo ci-dessous). Travaillant comme des hommes, elles sont plus occupées par leur métier que par leur toilette.

L'HEURE DE LA DANSE. APRÈS un pique-nique dans une clairière du bord de mer. Les plages de la Baltique sont bordées de grandes forêts où sont installés de pittoresques camps de pionniers.

UNE ÉLÉGANTE DE LÉNINGRAD choisit un chapeau d'été mais ce luxe reste encore réservé à une minorité de privilégiées.

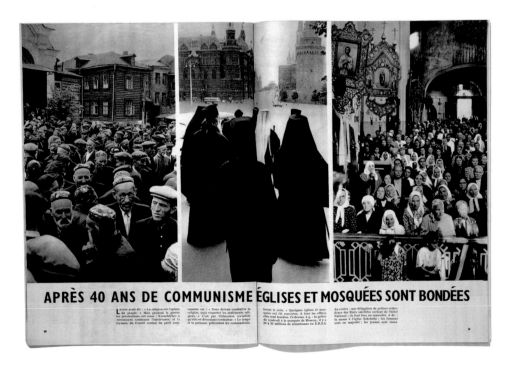

APRÈS 40 ANS DE COMMUNISME ÉGLISES ET MOSQUÉES SONT BONDÉES

Lénine avait dit : « La religion est l'opium du peuple ». Mais pendant la guerre les persécutions ont cessé : Krouchtchev a récemment combattu l'intolérance, et la formule du Comité central du parti communiste est : « Nous devons combattre la religion, mais respecter les sentiments religieux. C'est par l'éducation socialiste qu'elle se dissoudra comme un brouillard. « Le temps et la patience », prétendent les communistes.

fervent la foi. Quelques églises et mosquées ont été rouvertes. À tous les offices elles sont bondées. Ci-dessus, à g. : la prière du vendredi à la mosquée de Moscou. Il y a 20 à 35 millions de musulmans en U.R.S.S.

Au centre : une délégation de prêtres orthodoxes des États satellites sortant de l'hôtel National ; ils font face au nouvelle. À dr. : la messe à l'église Sokolniki ; les femmes sont en majorité ; les jeunes sont rares.

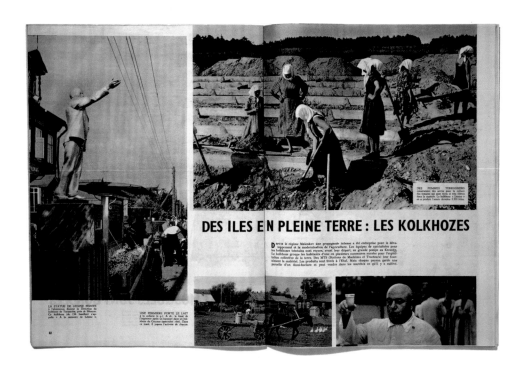

DES ILES EN PLEINE TERRE : LES KOLKHOZES

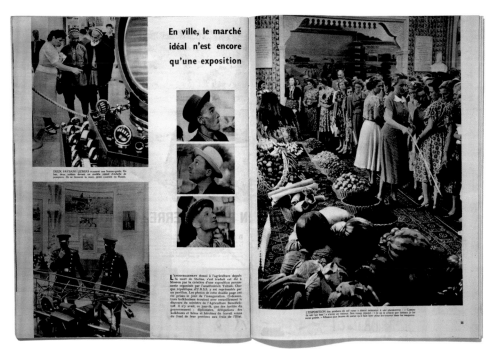

En ville, le marché idéal n'est encore qu'une exposition

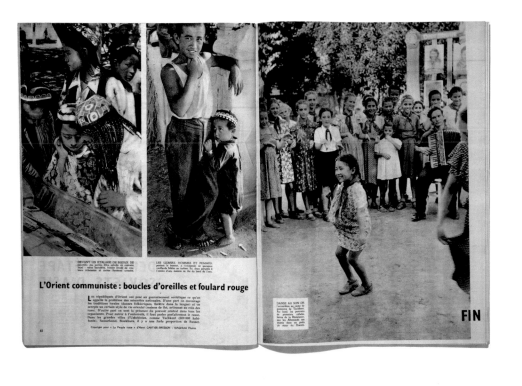

L'Orient communiste : boucles d'oreilles et foulard rouge

FIN

In 1945, Walker Evans became the first staff photographer for *Fortune*, where he remained until the early 1960s. Alongside routine assignments, he produced photo essays that recalled his work for the Farm Security Administration, on topics such as coalmining in Kentucky and the decline of small-town America. In 1948, with the new title of 'Special Photography Editor', Evans began to produce portfolios of photographs – about thirty in all – that aimed to 'take a long look at a subject, get into it and without shouting tell a lot about it'. One of the most successful was 'Beauties of the Common Tool' in which he photographed twelve ordinary objects using a technique he had employed to record African sculpture for the Museum of Modern Art, New York. For Evans, these tools embody an aesthetic that is both masculine and sensual, and his plain, descriptive images turn them into emblematic metaphors for human labour. In his own text he describes a hardware store display as 'a kind of offbeat museum show for the man who responds to good clear … design', by definition, full of 'elegance, candor and purity'. (July 1955)

Stahls chain-nose pliers (over actual size), from Eskilstuna, Sweden, $2.49

Beauties of the Common Tool

A portfolio by Walker Evans

Among low-priced, factory-produced goods, none is so appealing to the senses as the ordinary hand tool. Hence, a hardware store is a kind of offbeat museum show for the man who responds to good, clear "undesigned" forms. The Swedish steel pliers pictured above, with their somehow swanlike flow, and the objects on the following pages, in all their tough simplicity, illustrate this. Aside from their functions—though they are exclusively wedded to function— each of these tools lures the eye to follow its curves and angles, and invites the hand to test its balance.

Who would sully the lines of the tin-cutting shears on page 105 with a single added bend or whorl? Or clothe in any way the fine naked impression of heft and bite in the crescent wrench on page 107? To be sure, some design-happy manufacturers have tampered with certain tool classics; the beautiful plumb bob, which used to come naively and solemnly shaped like a child's top, now looks suspiciously like a toy space ship, and is no longer brassy. But not much can be done to spoil a crate opener, that nobly ferocious statement in black steel, as may be seen on page 104. In fact, almost all the basic small tools stand, aesthetically speaking, for elegance, candor, and purity.　　　　—W.E.

Baby Terrier crate opener, by Bridgeport Hardware Mfg. Corp., 69 cents

Tin snips, by J. Wiss & Sons Co., $1.85

Bricklayer's pointing trowel, by Marshalltown Trowel Co., $1.35

Open-end crescent wrench, German manufacture, 56 cents

One of the successful magazines published by flamboyant, conservative businessman Henry Luce, *Fortune* was about business and wealth, using lavish design, beautiful illustrations and solid reporting to lure a small, affluent group of readers – and the advertisers who wanted to reach them. Walker Evans gave work to documentary artists such as Ezra Stoller and Berenice Abbott to enhance the magazine's sophisticated appeal. In 1955, when the exclusive 'Congressional' train began express runs between New York and Washington DC, a subject he knew would appeal to *Fortune*'s readers, he assigned Robert Frank to photograph it. Frank's images depicted his powerful subjects and their setting without sympathy or condescension, creating an essay of subtle suspense. Simultaneously, Evans supported Frank's application to the Guggenheim Foundation for a grant 'to produce an authentic contemporary document' of American life, showing 'the things that are there, anywhere and everywhere – easily found, not easily selected and interpreted'. The grant and Frank's travels resulted in *The Americans*, published first in Paris in 1958 and in New York in 1959. (November 1955)

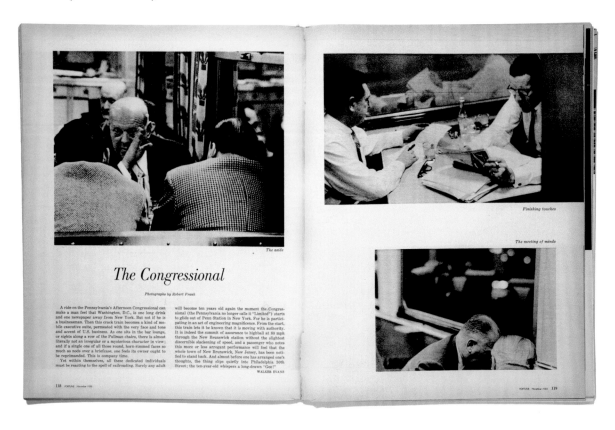

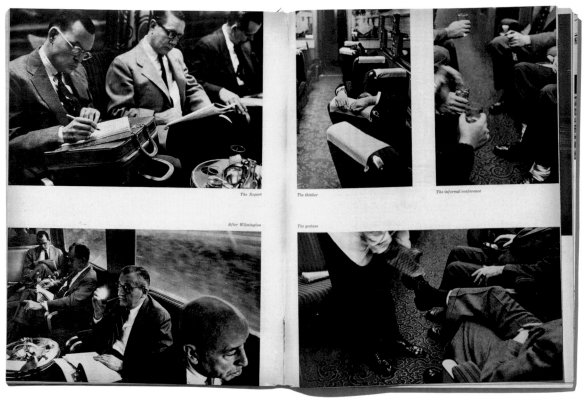

Shortly after David Douglas Duncan left the staff of *Life* magazine, *Collier's* published twelve pages of his colour photographs of Gaza. Using a few portraits and many landscape studies, Duncan represents military occupation with the same even gaze that he gives to timeless views of ocean and desert. At a time when the American press and public overwhelmingly favoured Israel, the report aroused a sharp response. Some readers welcomed the representation of Palestinian subject matter, while others complained that it amounted to pro-Arab or anti-Israeli propaganda. The magazine, first published as *Collier's Once a Week* in 1888, was one of the earliest American magazines to exploit the technology for reproducing photographs. Having established its reputation for promoting social reform issues early in the twentieth century, it reached the peak of its success during World War II – becoming for a moment *Life*'s liberal rival, when its contributing writers included Martha Gellhorn and Ernest Hemingway. However it did not survive the competition of television; in 1953 it started to publish fortnightly instead of weekly, and in 1957 it folded. (3 August 1956)

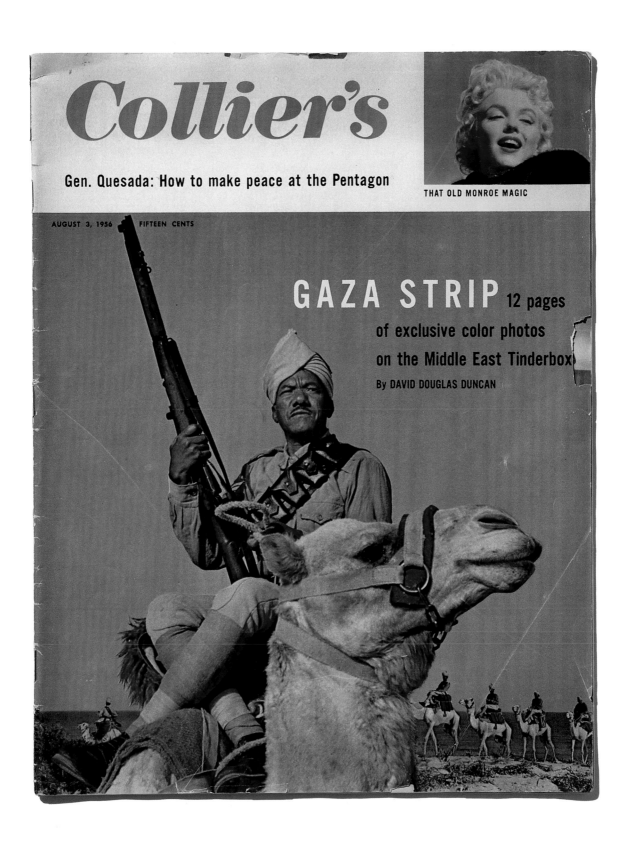

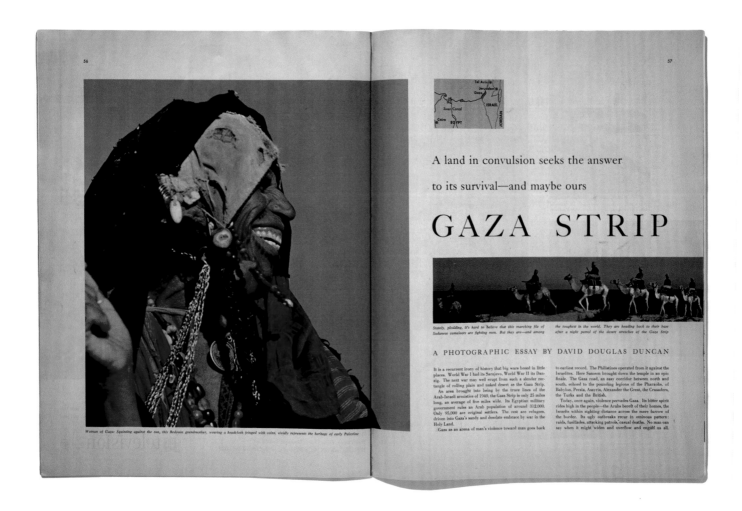

A land in convulsion seeks the answer

to its survival—and maybe ours

GAZA STRIP

Stately, plodding, it's hard to believe that this marching file of Sudanese cameleers are fighting men. But they are—and among the toughest in the world. They are heading back to their base after a night patrol of the desert stretches of the Gaza Strip

A PHOTOGRAPHIC ESSAY BY DAVID DOUGLAS DUNCAN

It is a recurrent irony of history that big wars breed in little places. World War I had its Sarajevo, World War II its Danzig. The next war may well erupt from such a slender rectangle of rolling plain and naked desert as the Gaza Strip.

An area brought into being by the truce lines of the Arab-Israeli armistice of 1949, the Gaza Strip is only 25 miles long, an average of five miles wide. Its Egyptian military government rules an Arab population of around 312,000. Only 95,000 are original settlers. The rest are refugees, driven into Gaza's sandy and desolate embrace by war in the Holy Land.

Gaza as an arena of man's violence toward man goes back to earliest record. The Philistines operated from it against the Israelites. Here Samson brought down the temple in an epic finale. The Gaza road, an easy corridor between north and south, echoed to the pounding legions of the Pharaohs, of Babylon, Persia, Assyria, Alexander the Great, the Crusaders, the Turks and the British.

Today, once again, violence pervades Gaza. Its bitter spirit rides high in the people—the Arabs bereft of their homes, the Israelis within sighting distance across the mere furrow of the border. Its ugly outbreaks recur in ominous pattern: raids, fusillades, attacking patrols, casual deaths. No man can say when it might widen and overflow and engulf us all.

Woman of Gaza: Squinting against the sun, this Bedouin grandmother, wearing a headcloth fringed with coins, vividly represents the heritage of early Palestine

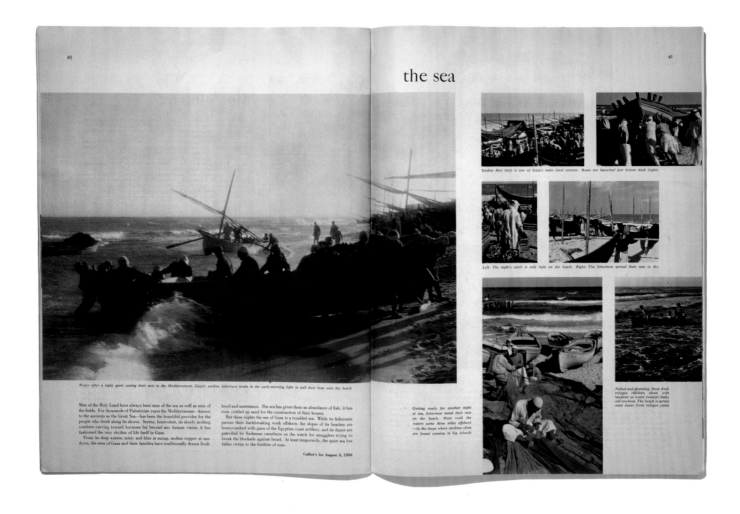

the sea

Weary after a night spent casting their nets in the Mediterranean, Gaza's sardine fishermen strain in the early-morning light to pull their boat onto the beach

Men of the Holy Land have always been men of the sea as well as men of the fields. For thousands of Palestinian years the Mediterranean—known to the ancients as the Great Sea—has been the bountiful provider for the people who dwell along its shores. Serene, benevolent, its slowly arching combers curving toward horizons far beyond any human vision, it has fashioned the very rhythm of life itself in Gaza.

From its deep waters, misty and blue at sunup, molten copper at sundown, the men of Gaza and their families have traditionally drawn livelihood and sustenance. The sea has given them an abundance of fish; it has even yielded up sand for the construction of their houses.

But these nights the sea of Gaza is a troubled sea. While its fishermen pursue their backbreaking work offshore, the slopes of its beaches are honeycombed with guns of the Egyptian coast artillery, and its dunes are patrolled by Sudanese cameleers on the watch for smugglers trying to break the blockade against Israel. At least temporarily, the quiet sea has fallen victim to the frailties of man.

Collier's for August 3, 1956

Sardine fleet (left) is one of Gaza's main food sources. Boats are launched just before dusk (right)

Left: The night's catch is sold right on the beach. Right: The fishermen spread their nets to dry

Getting ready for another night at sea, fishermen mend their nets on the beach. Most work the waters some three miles offshore—in the deeps where sardines often are found running in big schools

Naked and gleaming, these Arab refugee children shout with laughter as water swamps leaky old rowboat. The beach is across sand dunes from refugee camp

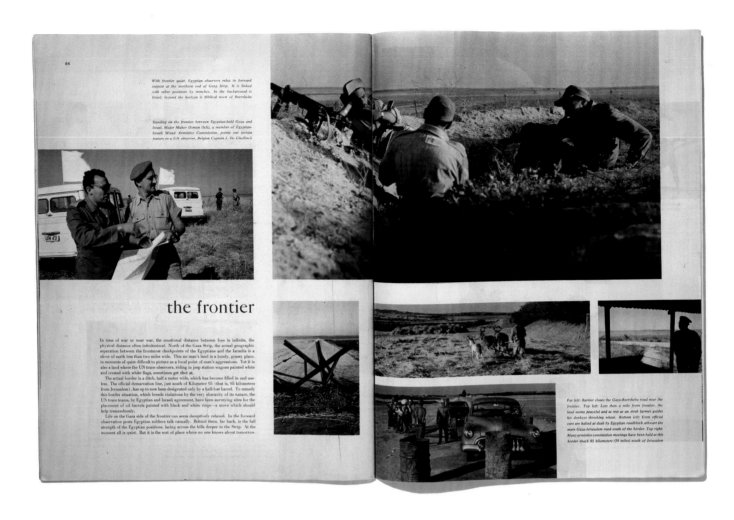

With frontier quiet, Egyptian observers relax in forward outpost at the northern end of Gaza Strip. It is linked with other positions by trenches. In the background is Israel; beyond the horizon is Biblical town of Beersheba

Standing on the frontier between Egyptian-held Gaza and Israel, Major Maher Osman (left), a member of Egyptian-Israeli Mixed Armistice Commission, points out terrain feature to a UN observer, Belgian Captain J. De Ghellinck

the frontier

In time of war or near war, the emotional distance between foes is infinite, the physical distance often infinitesimal. North of the Gaza Strip, the actual geographic separation between the frontmost checkpoints of the Egyptians and the Israelis is a sliver of earth less than two miles wide. This no man's land is a lonely, grassy place, in moments of quiet difficult to picture as a focal point of man's aggressions. Yet it is also a land where the UN truce observers, riding in jeep station wagons painted white and crested with white flags, sometimes get shot at.

The actual border is a ditch, half a meter wide, which has become filled in and useless. The official demarcation line, just south of Kilometer 95 (that is, 95 kilometers from Jerusalem), has up to now been designated only by a half-lost barrel. To remedy this border situation, which breeds violations by the very obscurity of its nature, the UN truce teams, by Egyptian and Israeli agreement, have been surveying sites for the placement of oil barrels painted with black and white rings—a move which should help tremendously.

Life on the Gaza side of the frontier can seem deceptively relaxed. In the forward observation posts Egyptian soldiers talk casually. Behind them, far back, is the full strength of the Egyptian positions, lacing across the hills deeper in the Strip. At the moment all is quiet. But it is the sort of place where no one knows about tomorrow.

Far left: Barrier closes the Gaza-Beersheba road near the frontier. Top left: Less than a mile from frontier, the land seems peaceful and at rest as an Arab farmer guides his donkeys threshing wheat. Bottom left: Even official cars are halted at dusk by Egyptian roadblock athwart the main Gaza-Jerusalem road south of the border. Top right: Many armistice commission meetings have been held at this border shack 95 kilometers (59 miles) south of Jerusalem

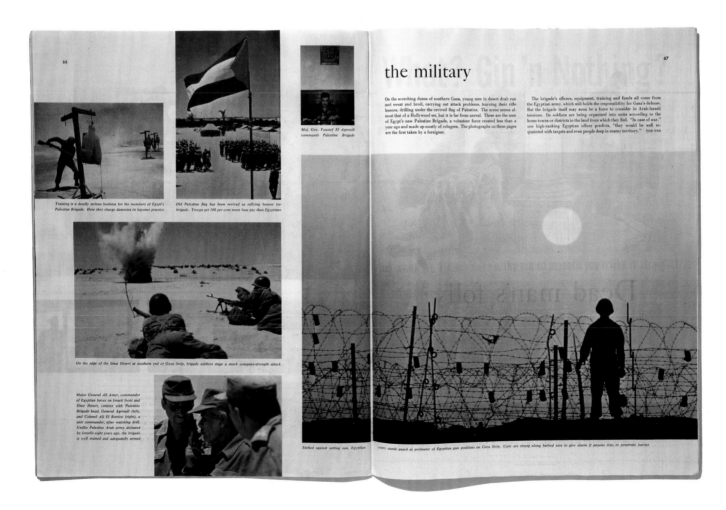

the military

On the scorching dunes of southern Gaza, young men in desert drab run and sweat and broil, carrying out attack problems, learning their rifle lessons, drilling under the revived flag of Palestine. The scene seems almost that of a Hollywood set, but it is far from unreal. These are the men of Egypt's new Palestine Brigade, a volunteer force created less than a year ago and made up mostly of refugees. The photographs on these pages are the first taken by a foreigner.

The brigade's officers, equipment, training and funds all come from the Egyptian army, which still holds the responsibility for Gaza's defense. But the brigade itself may soon be a force to consider in Arab-Israeli tensions. Its soldiers are being organized into units according to the home towns or districts in the land from which they fled. "In case of war," one high-ranking Egyptian officer predicts, "they would be well acquainted with targets and even people deep in enemy territory." THE END

Maj. Gen. Youssef El Agroudi commands Palestine Brigade

Training is a deadly serious business for the members of Egypt's Palestine Brigade. Here they charge dummies in bayonet practice

Old Palestine flag has been revived as rallying banner for brigade. Troops get 100 per cent more base pay than Egyptians

On the edge of the Sinai Desert at southern end of Gaza Strip, brigade soldiers stage a mock company-strength attack

Major General Ali Amer, commander of Egyptian forces on Israeli front and Sinai Desert, confers with Palestine Brigade head, General Agroudi (left), and Colonel Ali El Bareini (right), a unit commander, after watching drill. Unlike Palestine Arab army defeated by Israelis eight years ago, the brigade is well trained and adequately armed

Etched against setting sun, Egyptian sentry stands guard at perimeter of Egyptian gun positions on Gaza Strip. Cans are strung along barbed wire to give alarm if anyone tries to penetrate barrier

The headline reads: 'From inside the capital of the revolt our special correspondents risk their lives to bear witness to the Hungarian people's fight for freedom.' *Paris Match* took a partisan stand during the popular uprising that began on 24 October 1956 against Hungary's Communist government and its Soviet backers. Its spectacular feature went to press before Soviet tanks retook the city on 4 November and during the brief but exhilarating moment of victory while partisans remained in control of Budapest. The 'heroes' of the title were both the Hungarian rebels and *Paris Match*'s own team of writers and photographers, among whom was the magazine's own martyr – Jean-Pierre Pedrazzini, who was injured during street fighting and died in a Budapest hospital before *Match* published his pictures. A particularly striking ingredient of the story was the bought-in series of images made by *Life* magazine photographer John Sadovy on the first day of fighting, showing the shooting of seven young Hungarians believed to be collaborators. Their uniforms identified them as officers in the loathed Soviet police force, but several weeks later readers learned that they had in fact left the Soviet army and wanted to defect. (10 November 1956, with photographs by Melcher-Berretty, Franz Goezs, Erich Lessing, Paul Matthias, Jean-Pierre Pedrazzini, John Sadovy, Jean-François Tourtet and Vick Vance)

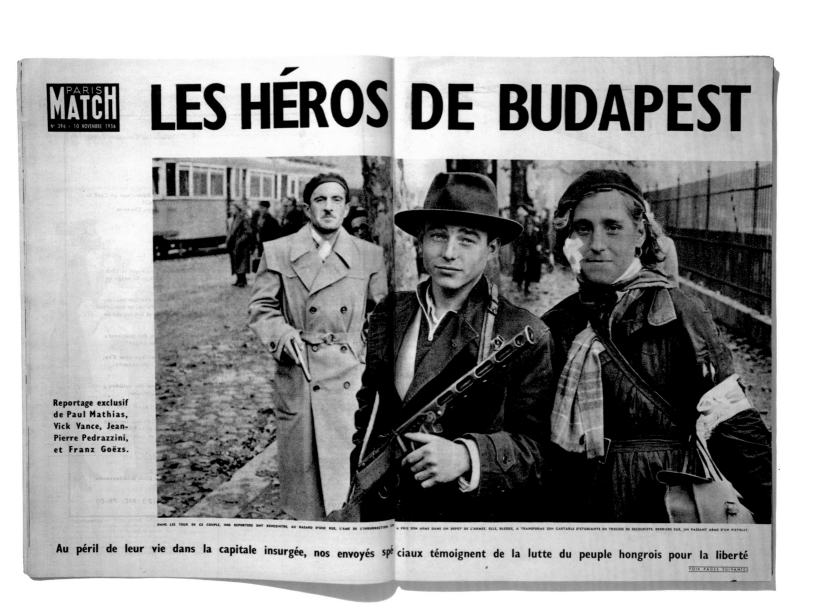

PARIS MATCH
N° 396 · 10 NOVEMBRE 1956

LES HÉROS DE BUDAPEST

Reportage exclusif
de Paul Mathias,
Vick Vance, Jean-
Pierre Pedrazzini,
et Franz Goëzs.

DANS LES YEUX DE CE COUPLE, NOS REPORTERS ONT RENCONTRE, AU HASARD D'UNE RUE, L'AME DE L'INSURRECTION [...] A PRIS SON ARME DANS UN DEPOT DE L'ARMÉE. ELLE, BLESSEE, A TRANSFORME SON CARTABLE D'ETUDIANTE EN TROUSSE DE SECOURISTE. DERRIERE EUX, UN PASSANT ARME D'UN PISTOLET.

Au péril de leur vie dans la capitale insurgée, nos envoyés spéciaux témoignent de la lutte du peuple hongrois pour la liberté

VOIR PAGES SUIVANTES

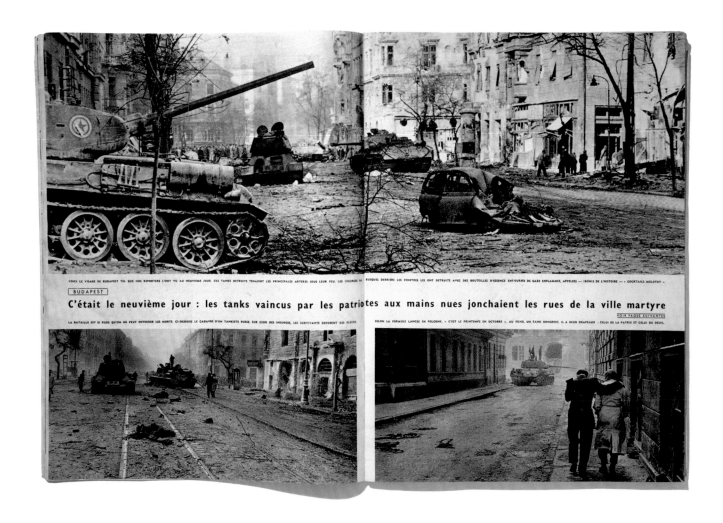

VOICI LE VISAGE DE BUDAPEST TEL QUE NOS REPORTERS L'ONT VU AU NEUVIÈME JOUR. CES TANKS DÉTRUITS TENAIENT LES PRINCIPALES ARTÈRES SOUS LEUR FEU. LES INSURGÉS SE ... BUSQUÉS DERRIÈRE LES FENÊTRES LES ONT DÉTRUITS AVEC DES BOUTEILLES D'ESSENCE ENTOURÉES DE GAZE ENFLAMMÉE, APPELÉES — IRONIE DE L'HISTOIRE — COCKTAILS MOLOTOV.

BUDAPEST

C'était le neuvième jour : les tanks vaincus par les patriotes aux mains nues jonchaient les rues de la ville martyre

VOIR PAGES SUIVANTES

LA BATAILLE EST SI RUDE QU'ON NE PEUT ENTERRER LES MORTS. CI-DESSOUS LE CADAVRE D'UN TANKISTE RUSSE. SUR CEUX DES INSURGÉS, LES SURVIVANTS DÉPOSENT DES FLEURS.

SELON LA FORMULE LANCÉE EN POLOGNE, « C'EST LE PRINTEMPS EN OCTOBRE ». AU FOND, UN TANK HONGROIS. IL A DEUX DRAPEAUX : CELUI DE LA PATRIE ET CELUI DU DEUIL.

BUDAPEST

A chaque coin de rue, à chaque seuil de porte et jusque dans les vitrines se dressent les soldats sans uniforme

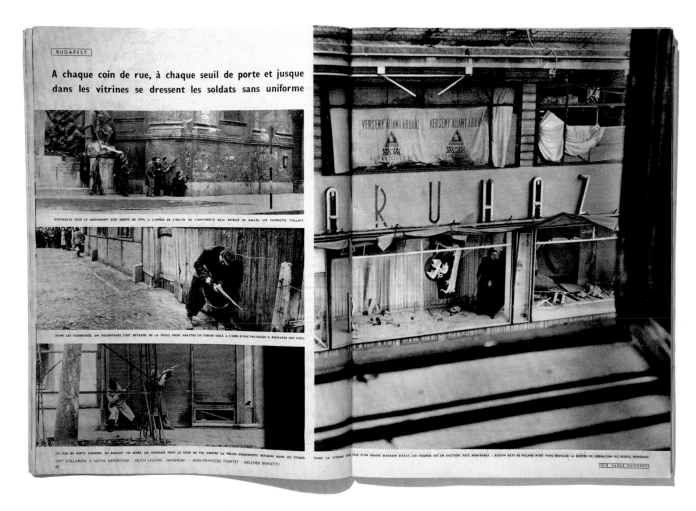

DISSIMULÉS SOUS LE MONUMENT AUX MORTS DE 1914, A L'ANGLE DE L'ÉGLISE DE L'UNIVERSITÉ DÉJÀ CRIBLÉE DE BALLES, LES PATRIOTES VEILLENT.

DANS LES FAUBOURGS, UN VOLONTAIRE S'EST DÉTACHÉ DE LA FOULE POUR ABATTRE UN TIREUR ISOLÉ. A L'ABRI D'UNE PALISSADE IL RECHARGE SON FUSIL.

ICI PAS DE PORTE COCHÈRE. EN RASANT LES MURS, LES INSURGÉS FONT LE COUP DE FEU CONTRE LA POLICE COMMUNISTE RÉFUGIÉE DANS LES ÉTAGES.

DANS LA VITRINE ÉVENTRÉE D'UN GRAND MAGASIN D'ÉTAT, UN INSURGÉ EST EN FACTION. FAIT ADMIRABLE : AUCUN ACTE DE PILLAGE N'EST VENU SOUILLER LA GUERRE DE LIBÉRATION DU PEUPLE HONGROIS.

ONT COLLABORÉ A NOTRE REPORTAGE : ERICH LESSING (MAGNUM) — JEAN-FRANÇOIS TOURTET — MELCHER BERRETTY

VOIR PAGES SUIVANTES

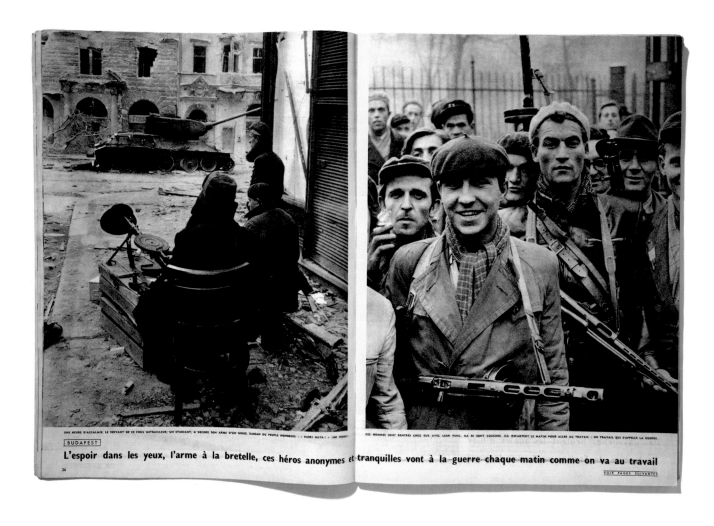

UNE HEURE D'ACCALMIE. LE SERVANT DE CE FUSIL MITRAILLEUR, UN ÉTUDIANT, A DÉCORÉ SON ARME D'UN GIBUS. SLOGAN DU PEUPLE HONGROIS: « RUSKI HAZA ! » (GO HOME!)

CES HOMMES SONT RENTRÉS CHEZ EUX AVEC LEUR FUSIL. ILS SE SONT COUCHÉS. ILS REPARTENT LE MATIN POUR ALLER AU TRAVAIL: UN TRAVAIL QUI S'APPELLE LA GUERRE.

L'espoir dans les yeux, l'arme à la bretelle, ces héros anonymes et tranquilles vont à la guerre chaque matin comme on va au travail

34

VOIR PAGES SUIVANTES

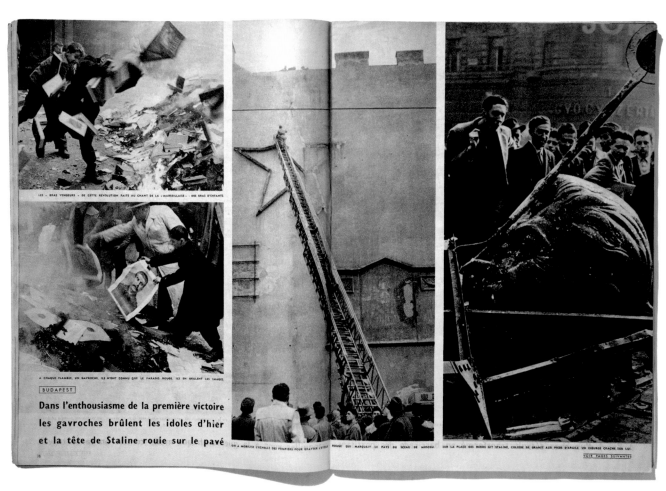

LES « BRAS VENGEURS » DE CETTE RÉVOLUTION FAITE AU CHANT DE LA « MARSEILLAISE »: DES BRAS D'ENFANTS

À CHAQUE FLAMBÉE, UN GAVROCHE. ILS N'ONT CONNU QUE LE PARADIS ROUGE. ILS EN BRÛLENT LES IMAGES.

Dans l'enthousiasme de la première victoire les gavroches brûlent les idoles d'hier et la tête de Staline roule sur le pavé

28

ON A MOBILISÉ L'ÉCHELLE DES POMPIERS POUR GRATTER L'ÉTOILE ROUGE QUI MARQUAIT LE PAYS DU SCEAU DE MOSCOU.

SUR LA PLACE DES HÉROS GÎT STALINE, COLOSSE DE GRANIT AUX PIEDS D'ARGILE. UN INSURGÉ CRACHE SUR LUI.

VOIR PAGES SUIVANTES

52

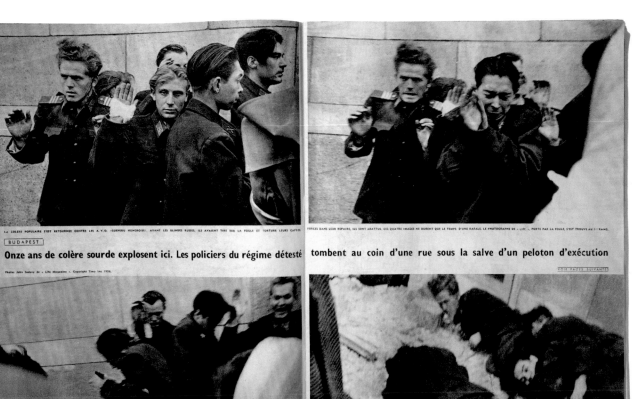

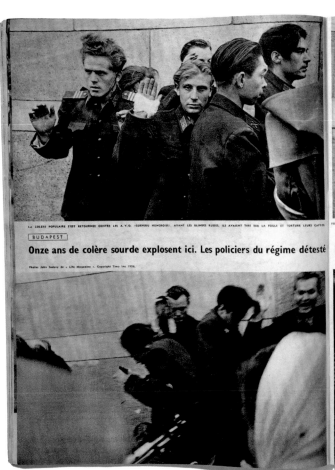

LA COLÈRE POPULAIRE S'EST RETOURNÉE CONTRE LES A.V.O. (GUÉPÉOU HONGROISE). AVANT LES BLINDÉS RUSSES, ILS AVAIENT TIRÉ SUR LA FOULE ET TORTURÉ LEURS CAPTIFS. FORCÉS DANS LEUR REPAIRE, ILS SONT ABATTUS. CES QUATRE IMAGES NE DURENT QUE LE TEMPS D'UNE RAFALE. LE PHOTOGRAPHE DE « LIFE », PORTÉ PAR LA FOULE, S'EST TROUVÉ AU 1er RANG.

Onze ans de colère sourde explosent ici. Les policiers du régime détesté tombent au coin d'une rue sous la salve d'un peloton d'exécution

Photos John Sadovy de « Life Magazine » - Copyright Time Inc 1956.

VOIR PAGES SUIVANTES

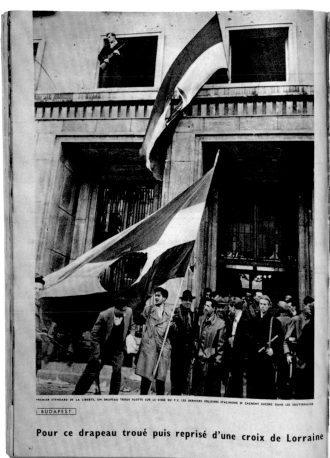

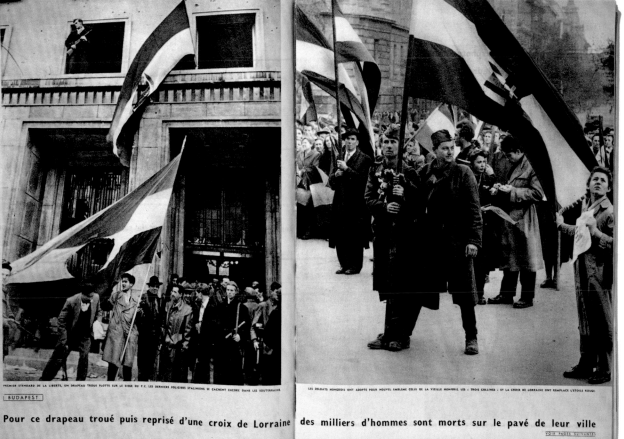

PREMIER ÉTENDARD DE LA LIBERTÉ, UN DRAPEAU TROUÉ FLOTTE SUR LE SIÈGE DU P.C. LES DERNIERS POLICIERS STALINIENS SE CACHENT ENCORE DANS LES SOUTERRAINS. LES SOLDATS HONGROIS ONT ADOPTÉ POUR NOUVEL EMBLÈME CELUI DE LA VIEILLE HONGRIE. LES « TROIS COLLINES » ET LA CROIX DE LORRAINE ONT REMPLACÉ L'ÉTOILE ROUGE.

Pour ce drapeau troué puis reprisé d'une croix de Lorraine des milliers d'hommes sont morts sur le pavé de leur ville

VOIR PAGES SUIVANTES

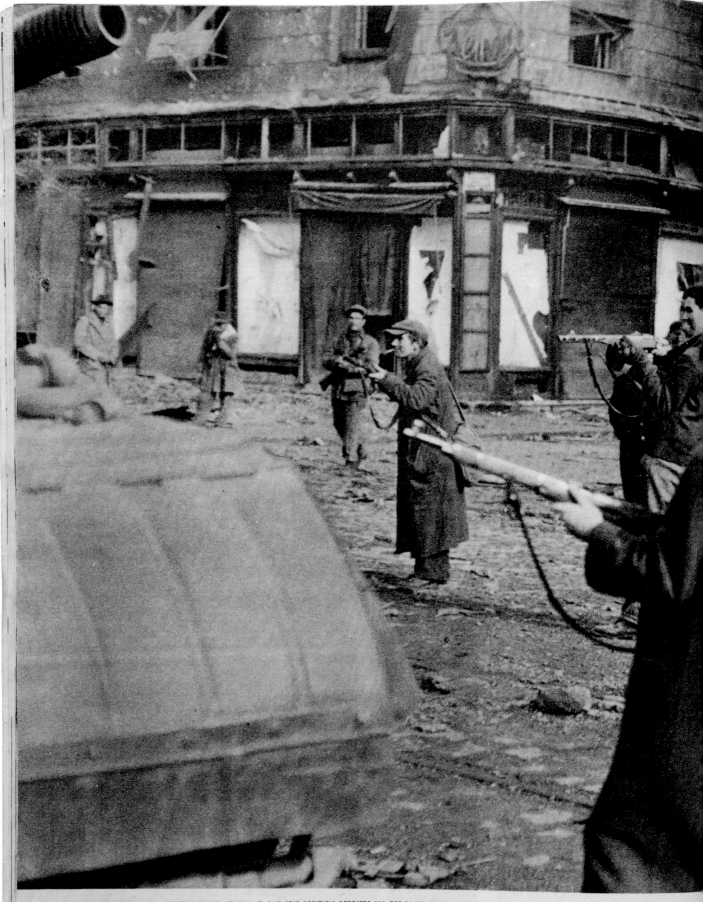

SUR L'AVENUE RAKOSI, LES INSURGES HOMMES ET FEMMES ONT PRIS POSITION DERRIERE UN DES 54 CHARS MIS HORS DE COMBAT. LES ENFANTS PLEURAIENT PARCE QU'IL N'Y AVAIT

A l'abri d'un char détruit transformé en barricade des partisan

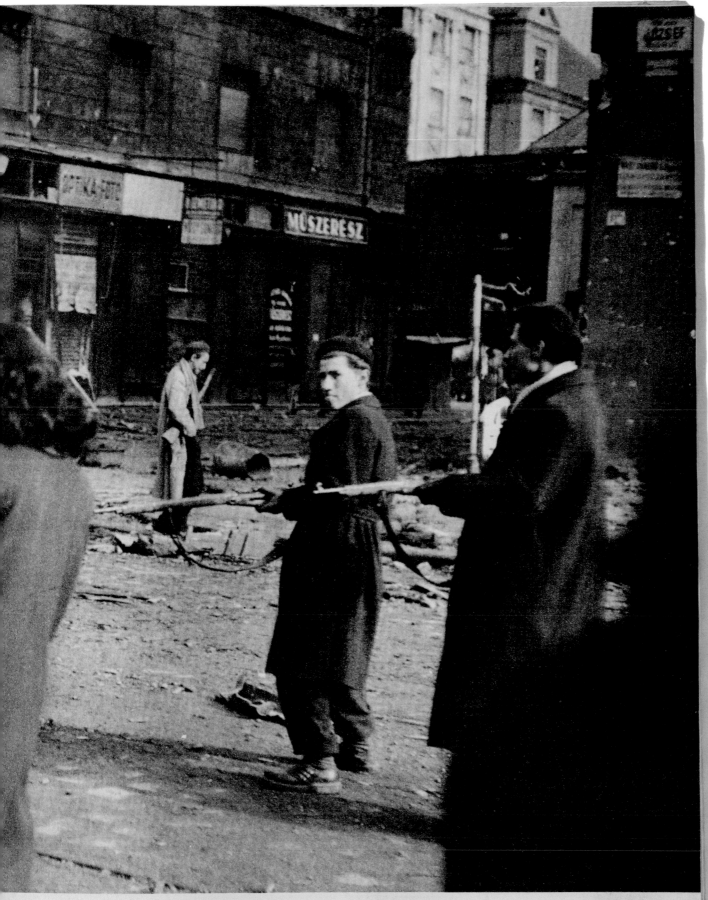

LS POUR EUX. MAIS ILS AVAIENT MIS AU POINT UNE TECHNIQUE : SAUTER SUR LE TANK PAR-DERRIERE, JETER UNE GRENADE A BOUT PORTANT ET SAUTER AVANT L'EXPLOSION.

rmés de fusils semblent composer le dernier tableau de l'insurrection

VOIR PAGES SUIVANTES

When Switzerland opened its borders to Hungarian refugees in 1956, Waldemar Dürst used his story on the subject for *Die Woche* (accompanied by his own text) to present a heartfelt essay on the plight of the refugee in the postwar world. He challenged readers (who might be tempted to celebrate Swiss generosity) by noting that the welcome given to just one thousand refugees was nothing more than a 'lonely gesture', rooting his invective in identification with those working toward a 'Free Hungary'. Though impoverished, his refugees appear conspicuously dignified, firmly positioned within a genre of humanistic representation. Dürst grew up in Switzerland, studying photography in Vevey under modernist Gertrude Fehr (who also influenced Bruno Barbey, Luc Chessex and Jean-Loup Sieff) before turning to photojournalism. He worked for *Die Woche* and other Swiss publications from 1952 until the early 1970s when, discouraged by the limited scope for his brand of concerned humanitarian approach within the illustrated press, he abandoned photography. (12 November 1956)

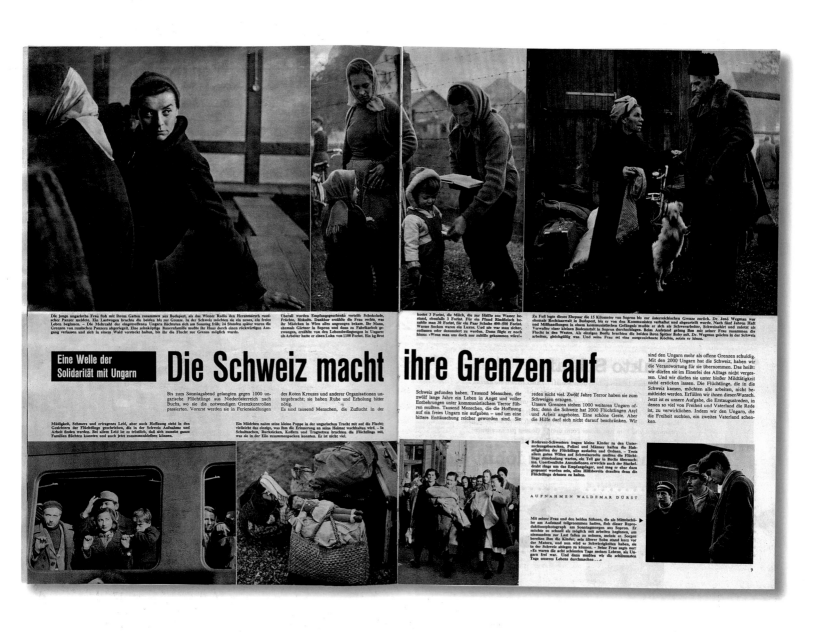

DIE WOCHE
NEUE SCHWEIZERISCHE ILLUSTRIERTE ZEITUNG

Die erste Suppe in der Schweiz löffelt ein ungarischer Vater seinem Töchterchen ein. Sie wurde den in Buchs eintreffenden Flüchtlingen serviert. Es ist an uns Schweizern, dafür zu sorgen, daß die eingereisten ungarischen Väter nicht lange auf Armensuppen angewiesen sind, sondern als vollwertige Glieder in unserer Wirtschaft das Brot für sich und ihre Familien verdienen können. (Zu Seiten 4 bis 9.) Aufnahme Waldemar Dürst

DIE WOCHE Olten / Zürich. 12. Nov. — 18. Nov. 1956
Verkaufspreis 50 Rp. Deutschland 70 Pfg.
Frankreich / Saar 60 frs. Italien 100 L. Österreich 3.20 Sch. **Nr. 47**

From the late 1940s until the late 1970s, Yuri Zhukov was one of the USSR's best-known and most admired journalists, and a regular interpreter of US politics and culture. In a paradox typical of the Cold War, he was also one of the best-known Soviet figures in the West, and whether in print or in casual conversation, his words were understood to express official government policy; in 1976, for instance, the *New York Times* referred to him as 'the Master's Voice of *Pravda*'. In 1957 Zhukov contributed this picture story to *Ogonyek*, showing New York City and especially Times Square, as the grim seat of capitalism – where nature was absent and time had no meaning. Advertisements were everywhere 'with letters that dance and change pitilessly, hypnotizing a man into giving up all his dollars'. Ironically, Zhukov's dark style echoes the work of his exact contemporary, Robert Frank, who was pursuing his own bleak (and equally un-American) vision of the continent at the same time. (January 1957)

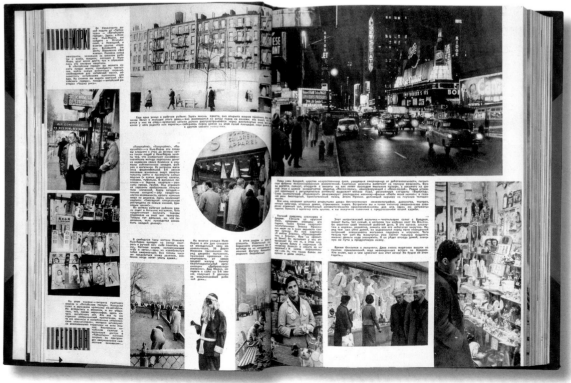

David Douglas Duncan met Pablo Picasso in the summer of 1956. The thirty-year-old war photographer dropped in unannounced at the door of the world's most famous painter, his only useful credential being the friendship of Robert Capa. From that moment until Picasso's death, Duncan served as Picasso's personal photographer. He copied paintings, took snapshots of Jacqueline and their two young children, and recorded the family at home in the South of France. Picasso even allowed Duncan the rare privilege of shooting in the studio while he worked. 'Picasso: à la maison' appeared in *Paris Match* the year after they met – a light-hearted, intimate essay showing Picasso alone with Jacqueline, dancing by himself, playing with Claude and Paloma in a studio stacked with his work. This story set the standard for nearly every subsequent article about the artist, and provided a model for stories about distinguished celebrities in old age. Before Picasso's death, Duncan shot more than 10,000 negatives. Together, painter and photographer established a durable modern myth: Picasso as the creative, potent, painter who would live forever, with a photographer as his most trusted friend. (12 April 1958)

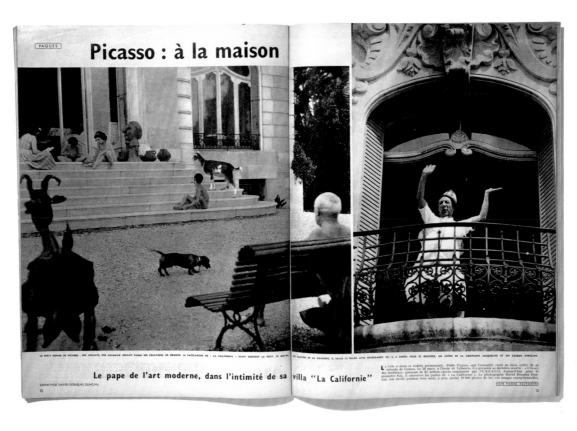

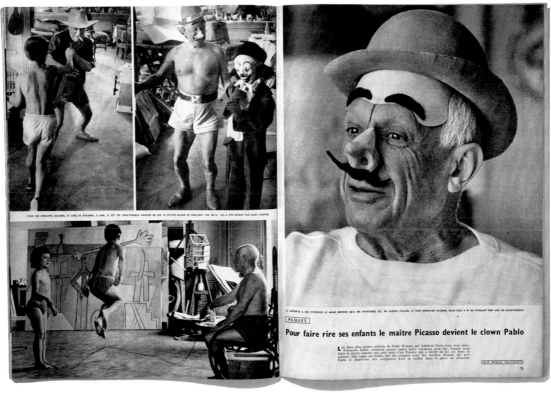

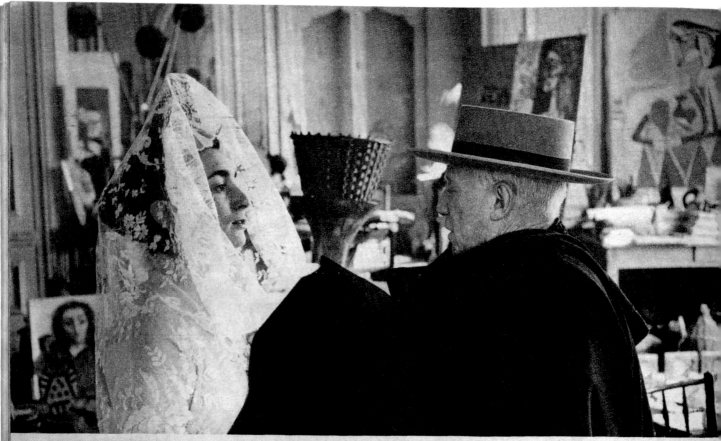

EN FEUTRE DE CORDOUE ET CAPE DE TORERO, IL TRANSFORME LA FEMME QU'IL AIME EN ANDALOUSE. IL GARDE LA NOSTALGIE DE L'ESPAGNE QU'IL N'A PLUS REVUE DEPUIS VINGT ANS

PAQUES

Toujours d'avant-garde à 77 ans, le peintre a un secret : sa joie de vivre

JACQUELINE veille à ce que rien ne rompe le calme de la maison quand Picasso est dans son atelier. Elle coupe la sonnerie du téléphone et ferme toutes les portes à clé. La seule loi impérative de cette vie bon enfant : ne toucher à rien. Les appartements privés sont un extravagant amas de meubles, de toiles, de dessins, de vêtements et d'objets souvenirs qu'il faut escalader pour pouvoir entrer.

DELAISSANT LA CHEVRE ET SA REPLIQUE EN BRONZE, ILS SE PROMENENT DANS LE PARC EN AMOUREUX. SES ETRANGES PANTALONS SONT COPIES SUR CEUX QUE PORTAIT COURBET

La gaieté est indispensable à son travail : souvent, dans son atelier, il improvise un pas de danse avant de se remettre à peindre.

Héctor García was an established photojournalist working in Mexico City when the railroad workers' strike led by Demetrio Vallejo (and known as the 'Vallejismo') brought the city to a standstill. Government troops used violent means to end the protests. Although *Excelsior*, the leading national daily, had encouraged García to cover the sequence of events, they declined to publish evidence of police or army brutality. García was determined to find a way to make his pictures public and set up his own newspaper, *Ojo* – in Spanish, 'eye' – as a means of distributing the work. The first print run of 4,500 copies sold out early on the day it first went on sale, but a reprint was prevented; the press on which it had been printed was smashed by the authorities within hours. García has since remained one of the leading figures in Mexican photojournalism. In a recent interview, he explained his view that photojournalism can only flourish where the photographer is fully engaged with his subject; when 'the photographer breathes the action, and seeks the collision of human life [with] human history'. (October 1958)

UNA QUIJOTADA ESTUDIANTIL CONMUEVE AL PAIS

Dar Servicio Gratis

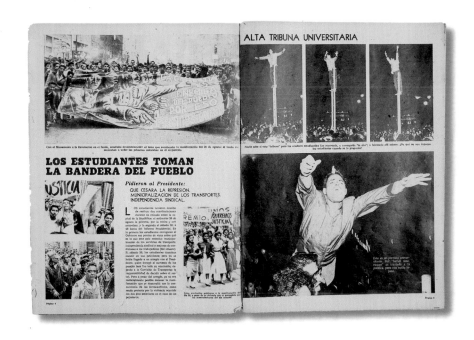

LOS ESTUDIANTES TOMAN LA BANDERA DEL PUEBLO

Pidieron al Presidente:
QUE CESARA LA REPRESION.
MUNICIPALIZACION DE LOS TRANSPORTES.
INDEPENDENCIA SINDICAL.

ALTA TRIBUNA UNIVERSITARIA

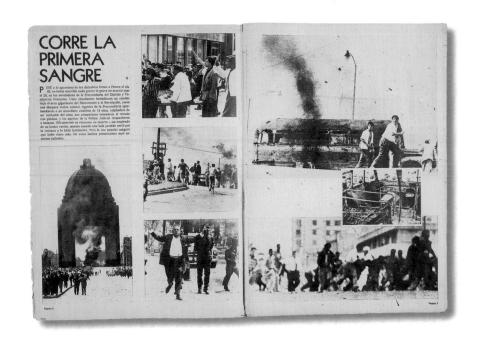

CORRE LA PRIMERA SANGRE

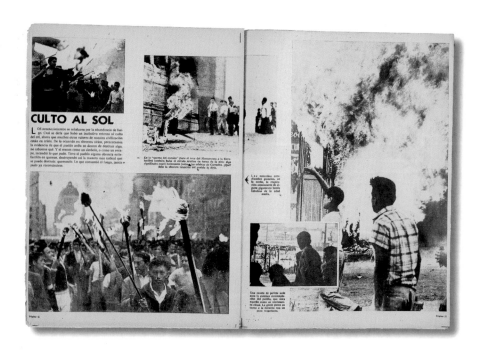

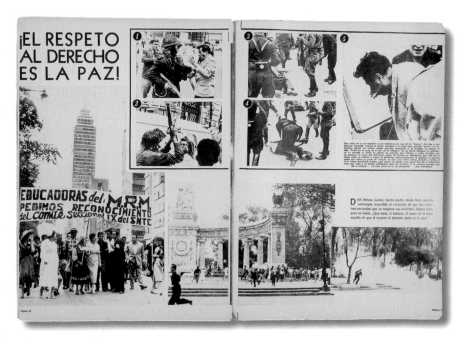

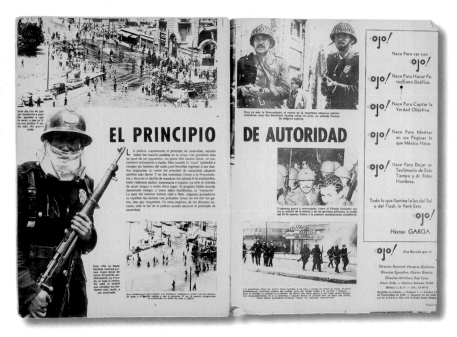

'Nothing will stop us, even if it means overturning tables and waiters … Even if the police intervene or we chase the subject all night long, we won't let go. We'll fight with flashguns!' This is how photographer Tazio Secchiaroli described the mission of the paparazzi in an interview in 1958. After World War II and the end of dictatorship and censorship, a taste for scandal developed in the Italian press, with a growing number of photographers aggressively patrolling the streets of Rome – particularly the Via Veneto – looking for Hollywood stars and members of the international aristocracy. It was 'Mr Paparazzo' in Federico Fellini's 1960 film *La Dolce Vita* who lent his name to the practice, with many of the film's scenes inspired by the adventures of Secchiaroli and his peers. Its striptease scene was a recreation of Secchiaroli's photographs of Turkish socialite Aiché Nanà at a birthday party in the Rugantino restaurant in Rome. When published in *L'Espresso*, they triggered a scandal that led to the banning of the issue and a public outcry. Young aristocrats were seen in the pictures, offering visual proof of the decadence of society. 'What happened before me was indescribable in those days,' Secchiaroli commented years later, 'the most sinful, transgressive thing I had ever photographed.' (2 November 1958)

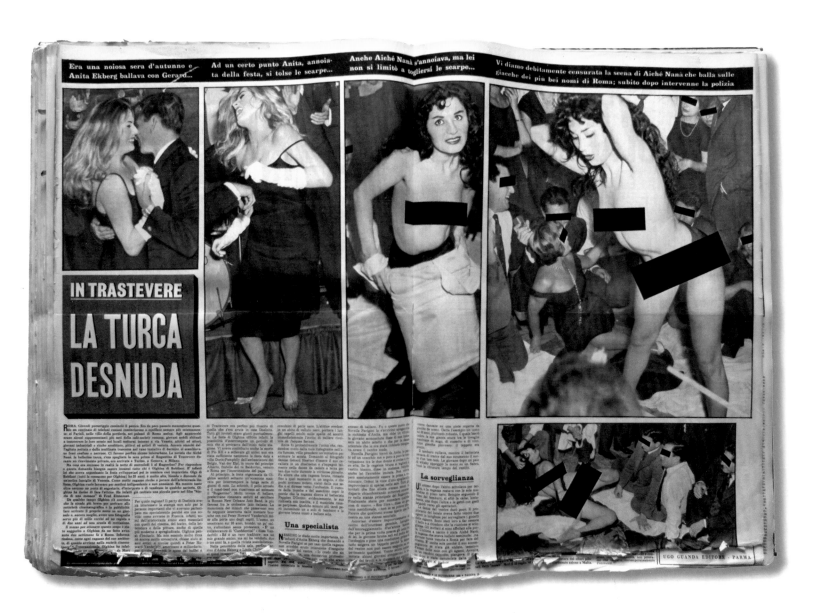

The Kuwait-based magazine *Al Arabi* was first published in 1958, aimed at a broad readership, with a wide selection of general interest features on subjects from culture and literature to science and politics. It was born with a clear agenda – to promote a common culture across the Arabic-speaking world and to support Arab independence movements throughout the Middle East and North Africa (at a point in time when Kuwait remained a British protectorate). The first issue opened with this photo feature about Algeria's National Liberation Army, the guerrilla army that from 1954 to 1962 fought against the French for the independence of Algeria. With text made up of revolutionary slogans, it proclaimed the heroic acts of the combatants in portraits and images of daily life and training. The photographs of women fighters – proud and unveiled – have become part of Algeria's national iconography, while the story testifies to a political era preoccupied with issues of national rather than religious identity. *Al Arabi* has published continuously since 1958, maintaining its mission to promote the advancement of Arab culture. (December 1958)

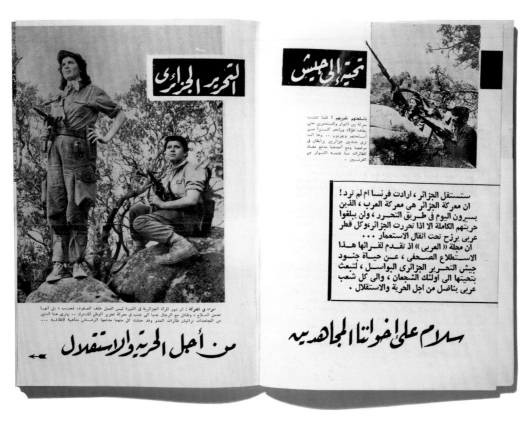

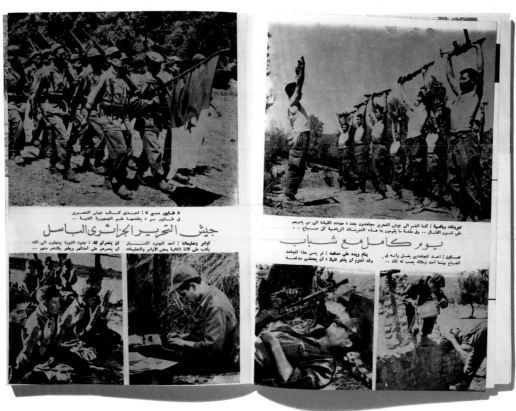

Rolf Gillhausen, a rising young photojournalist at *Stern*, initially proposed a story on the Trans-Siberian Railway as a vehicle to look at Russia under Communism. It resulted in his travelling over 12,000 km with writer Joachim Heldt, exploring China instead – what Heldt called 'Mao's great mysterious experiment into human history'. Published serially from late December 1958 until the following March, *Stern* gave more than 70 pages to the story. The photographs combine several familiar visual traditions; Gillhausen appropriates panoramas of happy workers and gleaming technology from Socialist Realism while drawing on the much older conventions of orientalism (in which all of Asia and the Middle East is seen as simultaneously alluring and inscrutable, different and dangerous). It set a new, high standard for postwar magazine layout, editing and design. Gillhausen remained central to the story of magazine photography in Germany thereafter; in 1965, he put down his camera to take over as *Stern*'s lead picture editor, becoming famous for his ruthless judgement and relentless energy; and from 1976 he served as a founding editor of the new *Geo* magazine. (12 December 1958 – 7 March 1959)

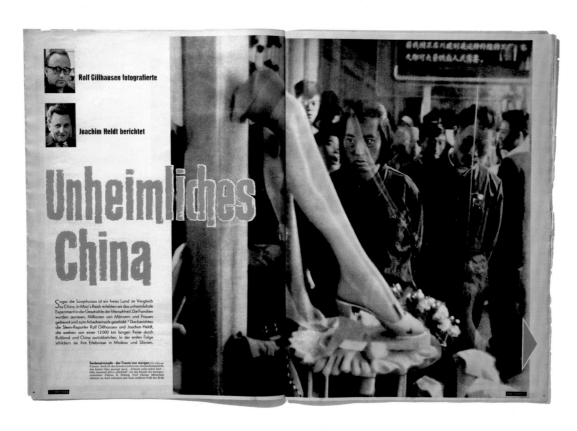

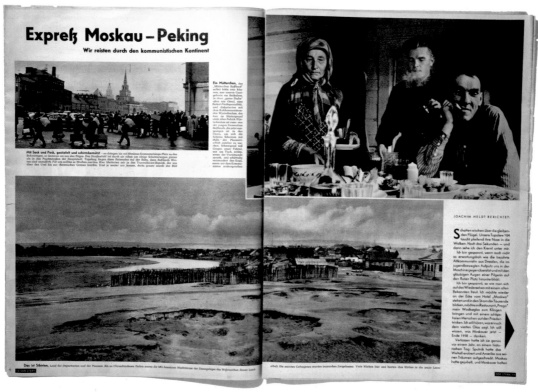

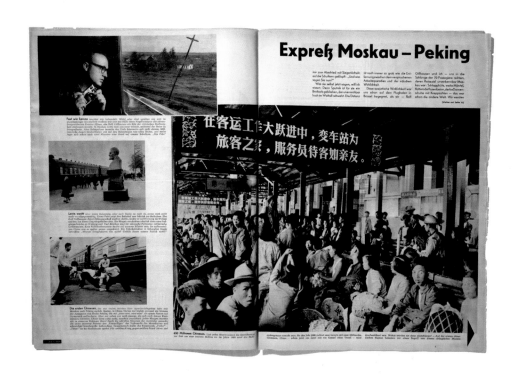

Expreß Moskau – Peking

任客运工作大跃进中，变车站为
旅客之家，服务员待客如亲友。

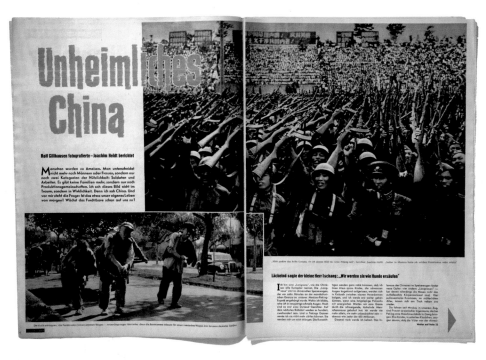

Unheimliches China

Rolf Gillhausen fotografierte – Joachim Heldt berichtet

Menschen wurden zu Ameisen. Man unterscheidet nicht mehr nach Männern oder Frauen, sondern nur nach zwei Kategorien der Nützlichkeit: Soldaten und Arbeiter. Es gibt keine Familien mehr, sondern nur noch Produktionsgemeinschaften. Ich sah dieses Bild nicht im Traum, sondern in Wirklichkeit. Denn ich sah China. Und vor mir steht die Frage: Ist das etwa unser eigenes Leben von morgen? Wächst das Furchtbare schon auf uns zu?

Lächelnd sagte der kleine Herr Tschang: „Wir werden sie wie Hunde ersäufen"

Weiter auf Seite 22

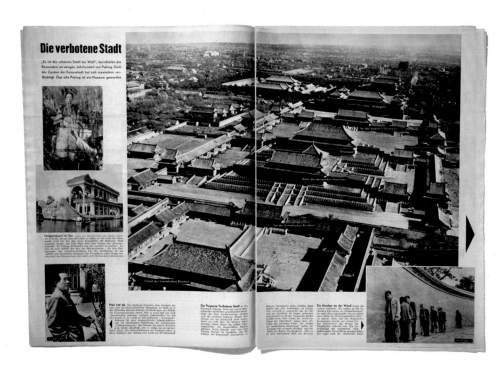

Die verbotene Stadt

„Es ist die schönste Stadt der Welt", berichteten die Reisenden im vorigen Jahrhundert von Peking. Doch der Zauber der Kaiserstadt hat sich inzwischen verflüchtigt. Das alte Peking ist ein Museum geworden

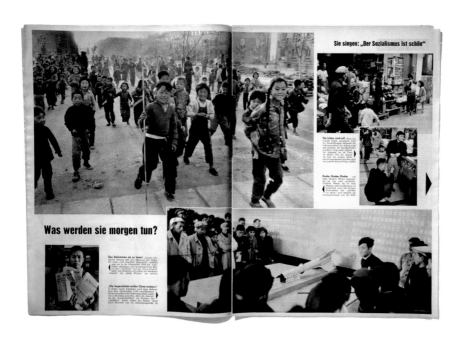

Sie singen: „Der Sozialismus ist schön"

Was werden sie morgen tun?

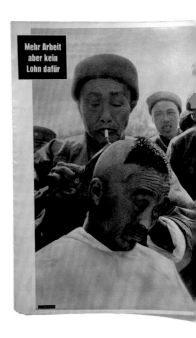

Mehr Arbeit
aber kein
Lohn dafür

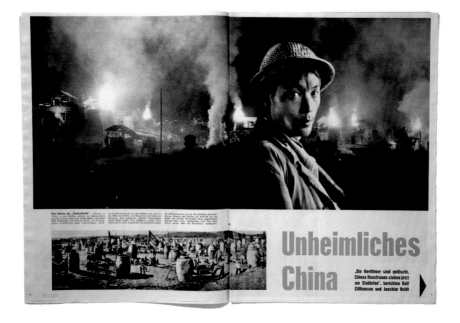

Unheimliches China

„Die Herdfeuer sind gelöscht. Chinas Hausfrauen stehen jetzt am Stahlofen", berichten Rolf Gillhausen und Joachim Heldt

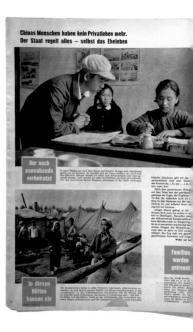

Chinas Menschen haben kein Privatleben mehr.
Der Staat regelt alles — selbst das Eheleben

Nur noch sonnabends verheiratet

In diesen Hütten hausen sie

Familien wurden getrennt

Unheimliches China

„Nur sonnabends sind sie noch verheiratet", berichten Rolf Gillhausen und Joachim Heldt von den Rotchinesen in den Volkskommunen

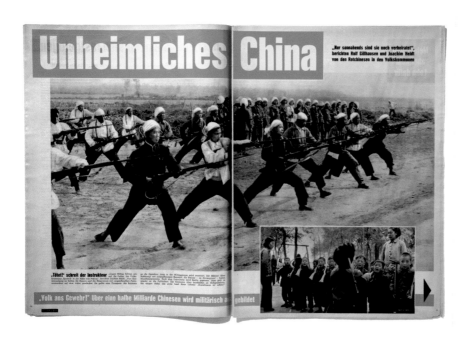

„Tötet!" schreit der Instrukteur

„Volk ans Gewehr!" Über eine halbe Milliarde Chinesen wird militärisch ausgebildet

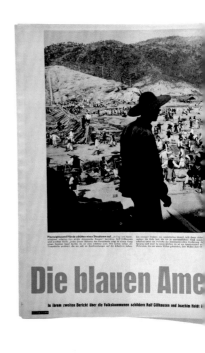

Die blauen Ame

In ihrem zweiten Bericht über die Volkskommunen schildern Rolf Gillhausen und Joachim Heldt

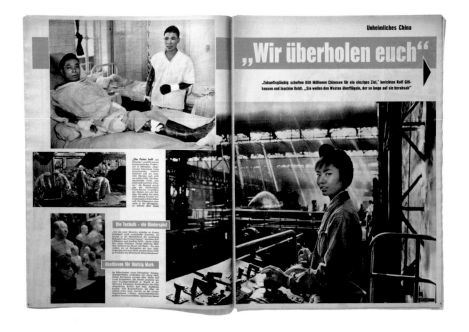

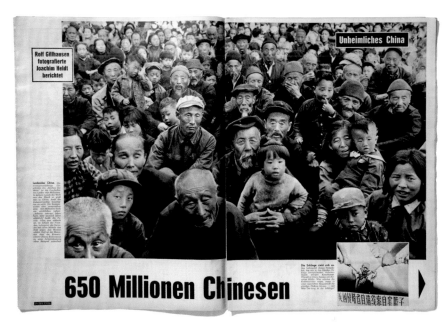

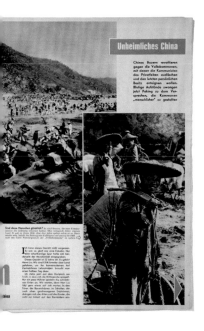

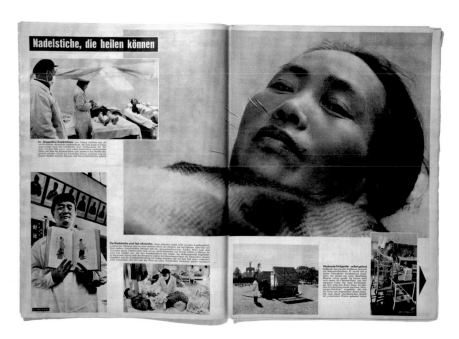

In 1958, *Life* magazine assigned Henri Cartier-Bresson to China as a new phase of its economic development began. He travelled 7,000 miles in four months, resulting in *Life*'s 18-page picture story in both colour and black and white – a rare glimpse at a struggling new nation. If Cartier-Bresson's colour journalism now comes as a surprise, it is because he later destroyed virtually all of his colour transparencies. The biggest problems he faced, as he later explained to *Life*, stemmed from the fact that his subjects found him highly exotic; wherever he went, he attracted crowds, making it hard to capture individuals without their being aware of him. Thanks to his sympathetic style, his images contradict the text that accompanies them: where the reporter describes China as a nation of faceless industrial workers, Cartier-Bresson's photographs show plenty of individuals; where the writer finds a harsh, manipulative social order, typically Cartier-Bresson shows satisfied people in orderly spaces. (5 January 1959)

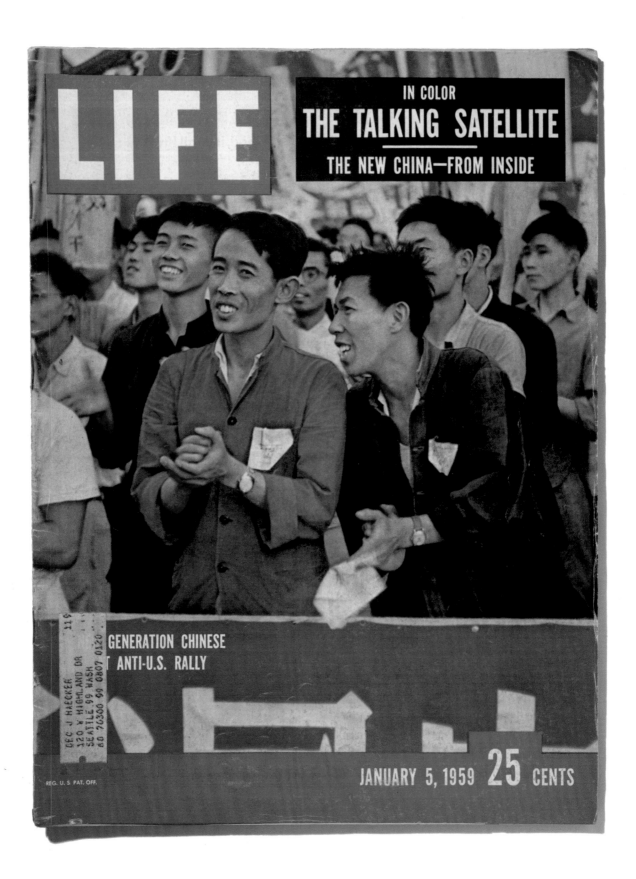

SWIFT CONSTRUCTION OF DAMS, WITH FANFARE AT THE FINISH

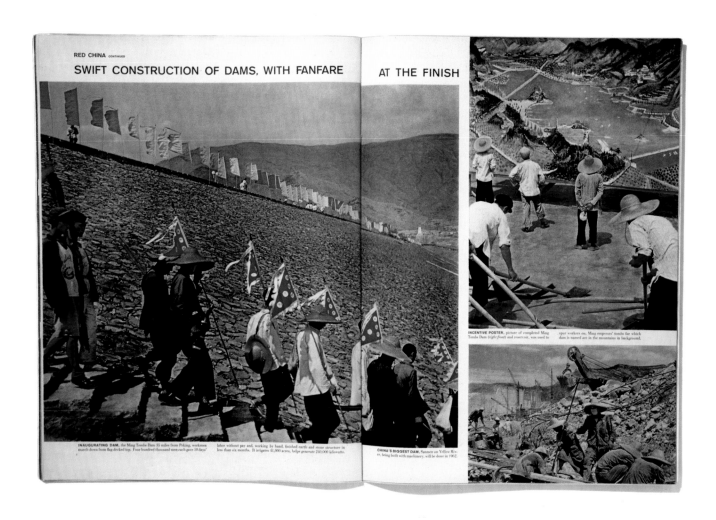

INAUGURATING DAM, the Ming Tombs Dam 35 miles from Peking, workmen march down from flag-decked top. Four hundred thousand men each gave 10 days' labor without par end, working by hand, finished earth and stone structure in less than six months. It irrigates 41,000 acres, helps generate 240,000 kilowatts.

INCENTIVE POSTER, picture of completed Ming Tombs Dam (right front) and reservoir, was used to spur workers on. Ming emperors' tombs for which dam is named are in the mountains in background.

CHINA'S BIGGEST DAM, Sanmen on Yellow River, being built with machinery, will be done in 1962.

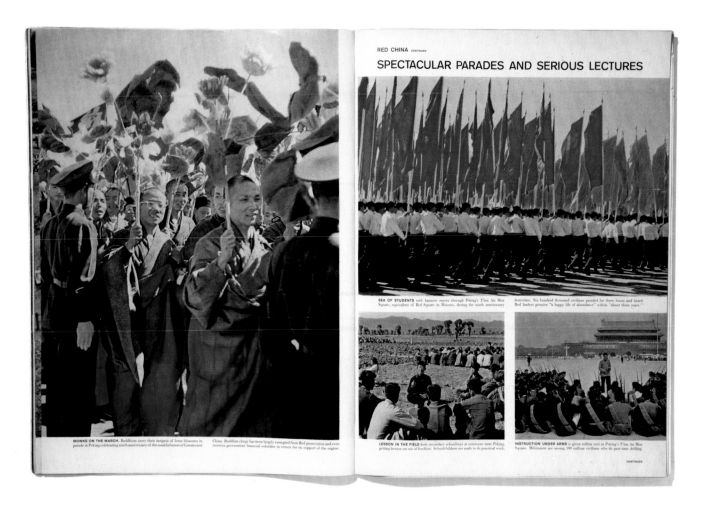

MONKS ON THE MARCH. Buddhists carry their insignia of lotus blossoms in parade in Peking celebrating ninth anniversary of the establishment of Communist China. Buddhist clergy has been largely exempted from Red persecution and even receives government financial subsidies in return for its support of the regime.

SPECTACULAR PARADES AND SERIOUS LECTURES

SEA OF STUDENTS with banners moves through Peking's T'ien An Men Square, equivalent of Red Square in Moscow, during the ninth anniversary festivities. Six hundred thousand civilians paraded for three hours and heard Red leaders promise "a happy life of abundance" within "about three years."

LESSON IN THE FIELD finds secondary schoolboys at commune near Peking, getting lecture on use of fertilizer. Schoolchildren are made to do practical work.

INSTRUCTION UNDER ARMS is given militia unit in Peking's T'ien An Men Square. Militiamen are among 100 million civilians who do part-time drilling.

CONTINUED

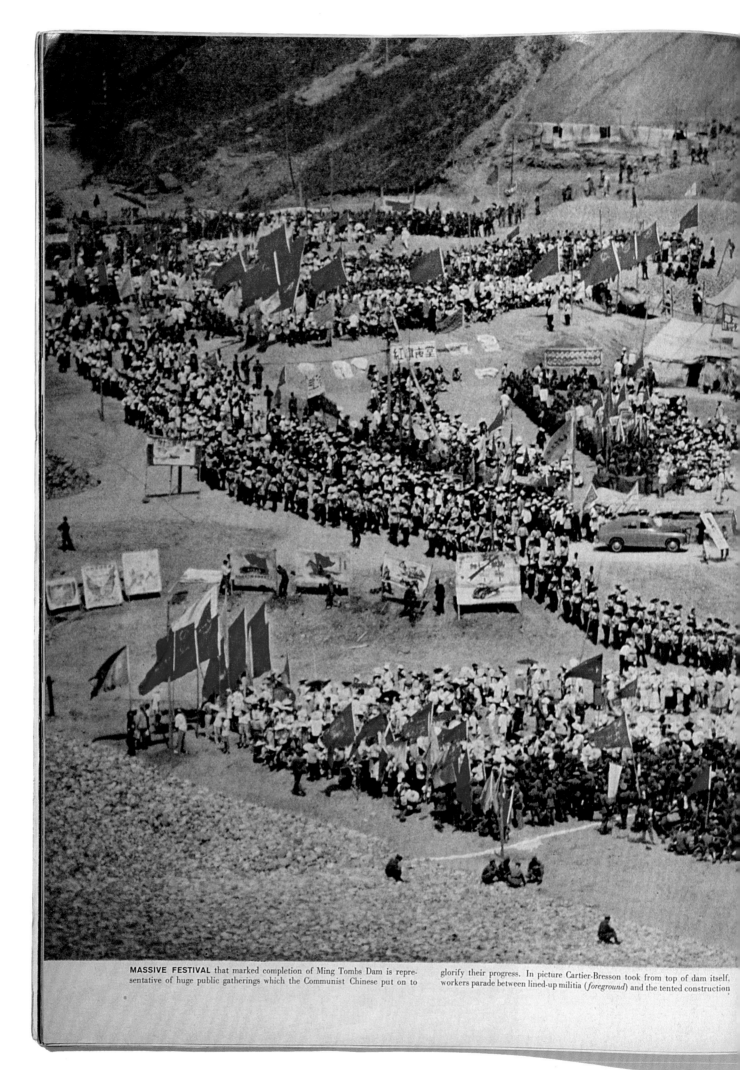

MASSIVE FESTIVAL that marked completion of Ming Tombs Dam is representative of huge public gatherings which the Communist Chinese put on to glorify their progress. In picture Cartier-Bresson took from top of dam itself, workers parade between lined-up militia (*foreground*) and the tented construction

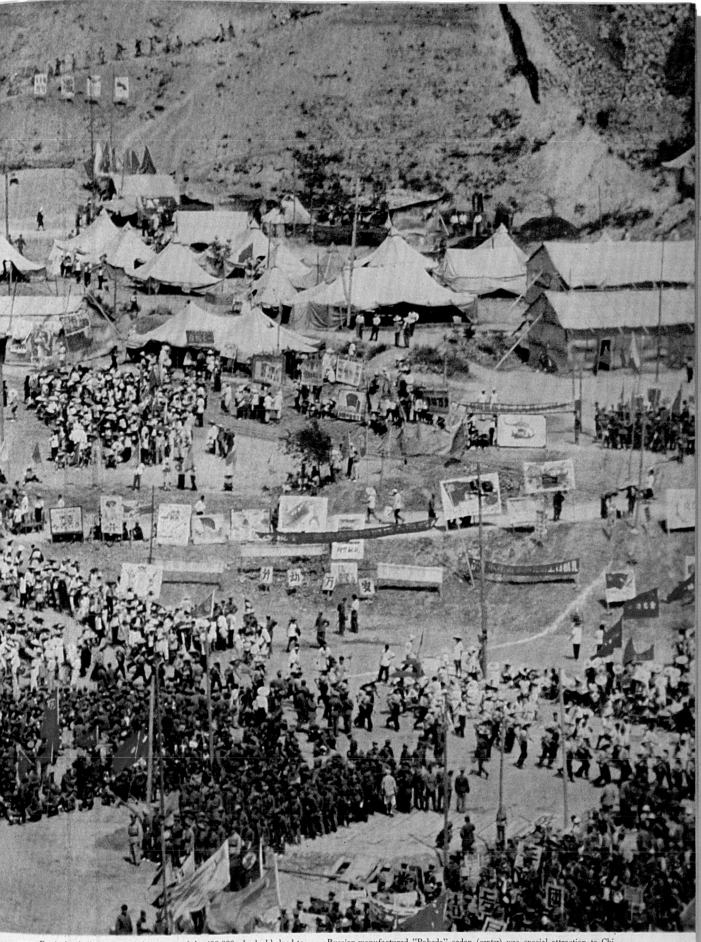

camp. Festival, which was attended by many of the 400,000 who had helped to build the dam, wound up with spirited folk dancing and group singing. Blue

Russian-manufactured "Pobeda" sedan (*center*) was special attraction to Chinese. They make a few cars but ordinary Chinese are not allowed to own them.

CONTINUED

Working for *Life* magazine in the late 1940s and early 1950s, Smith produced a series of photo essays that have become established landmarks of photojournalism. But in 1954 he resigned, convinced he would be able to produce his best work independently, without artistic compromise. He accepted a three-week assignment from former *Picture Post* editor Stefan Lorant to shoot illustrations for a book celebrating Pittsburgh's bicentennial, believing it presented an opportunity to make the masterpiece photo essay he felt he and the genre were capable of – a symphony in photographs that (as he told his brother) would 'influence journalism from now on'. He persisted with the project for four years, in poverty and with his life falling apart around him. It was first published over 38 pages of *Popular Photography*'s small-format 1959 annual, where its editor allowed Smith the scope to lay the work out exactly as he chose. By then, the story had become as much about his struggle with his own demons as it was about Pittsburgh – as Smith acknowledged in the title he gave it: 'Labyrinthian Walk' – and he deemed it a failure. It stands both as an epic experiment and as a moral fable for a generation of photojournalists. Smith redeemed himself, and contributed to the reinvention of the photojournalist as campaigner, with his triumphant 'Minamata' story in 1972. (December 1959)

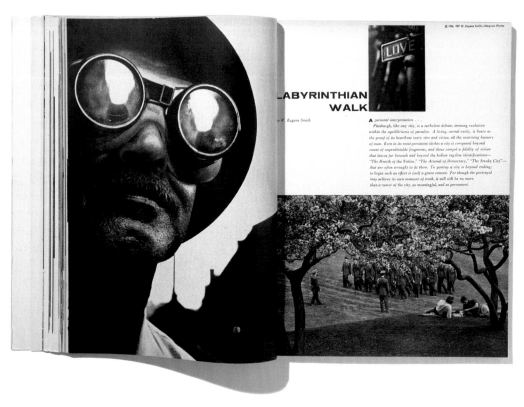

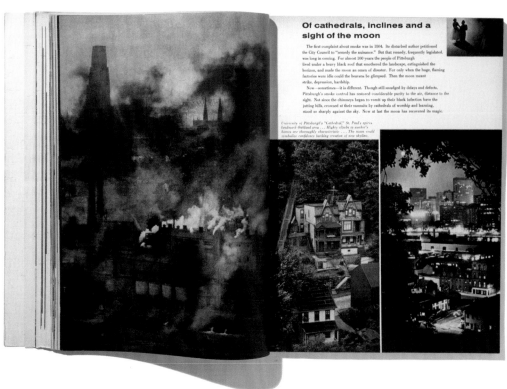

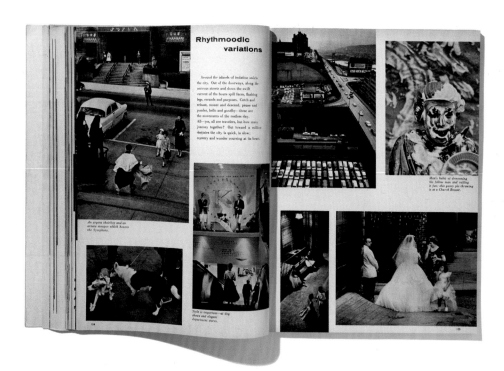

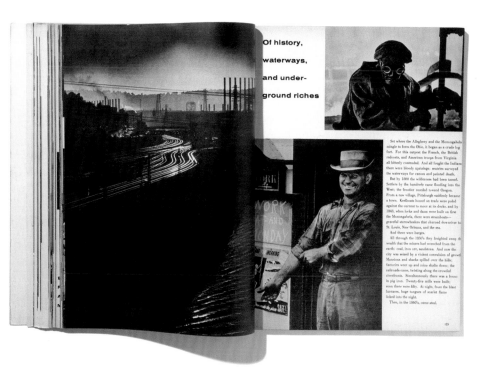

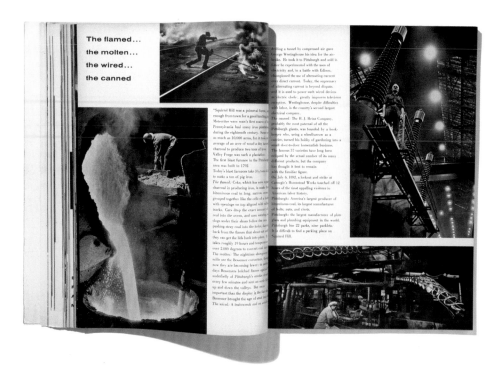

Through its signs, to know a city?

Romeo and Juliet approach each other, then swerve apart. Virgin Way vanishes before Oliver. And from the intersections such speeches can be conjured: *Orphan Basic Race Obey Judicial Breed Plow Forward Venture Divinity Blessing Abstract Refuge Superior Diamond Flush Freeland Rescue Liberty.*

In 1959 and 1960, Berlin-born Robert Lebeck spent twelve months in Africa, where he saw seventeen new nations declare independence from their former colonial rulers. His travels ended in Leopoldville, the capital of the Belgian Congo where King Baudoin was preparing to cede power to the newly elected President Joseph Kasavubu and Prime Minister Patrice Lumumba. The ceremonial parade was disrupted by dissident Joseph Kalonda; diving into the King's open car, Kalonda seized the King's sword and brandished it in front of the crowd (and Lebeck's camera) before military officers took control. The last in Lebeck's African essays for *Kristall*, it conveyed the facts of the skirmish as well as its allegorical implications: 'A harmless story. And a symbol. Just as Joseph Kalonda seized the sword, so have African men seized ruling power.' Lebeck is a key figure in the story of photojournalism in Germany, with a career that includes 30 years working for *Stern*. He was the also the co-founding editor-in-chief of *Geo* magazine. (Issue 16, 1960)

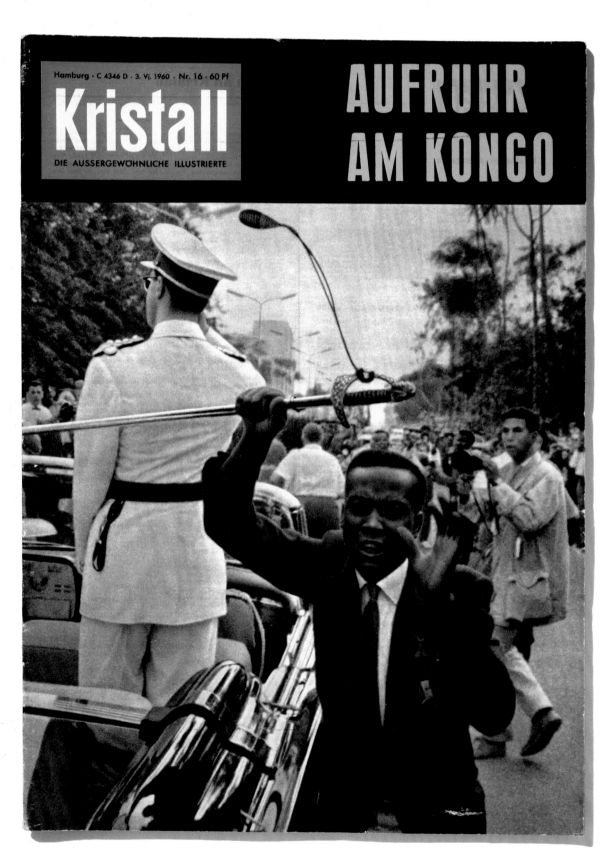

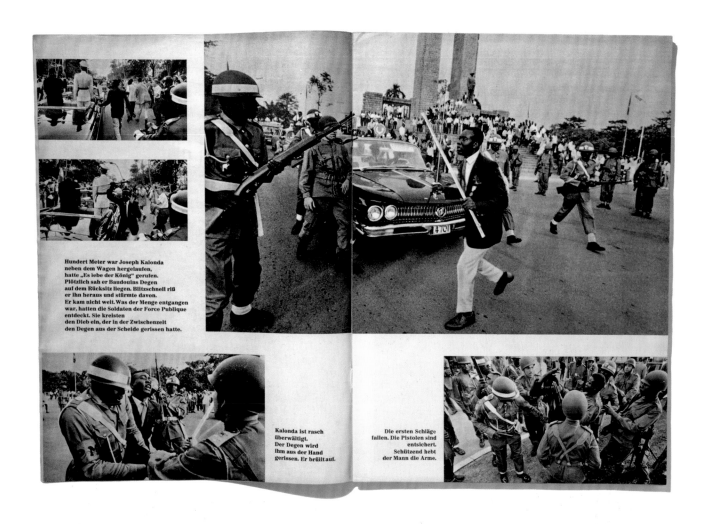

Hundert Meter war Joseph Kalonda
neben dem Wagen hergelaufen,
hatte „Es lebe der König" gerufen.
Plötzlich sah er Baudouins Degen
auf dem Rücksitz liegen. Blitzschnell riß
er ihn heraus und stürmte davon.
Er kam nicht weit. Was der Menge entgangen
war, hatten die Soldaten der Force Publique
entdeckt. Sie kreisten
den Dieb ein, der in der Zwischenzeit
den Degen aus der Scheide gerissen hatte.

Kalonda ist rasch
überwältigt.
Der Degen wird
ihm aus der Hand
gerissen. Er brüllt auf.

Die ersten Schläge
fallen. Die Pistolen sind
entsichert.
Schützend hebt
der Mann die Arme.

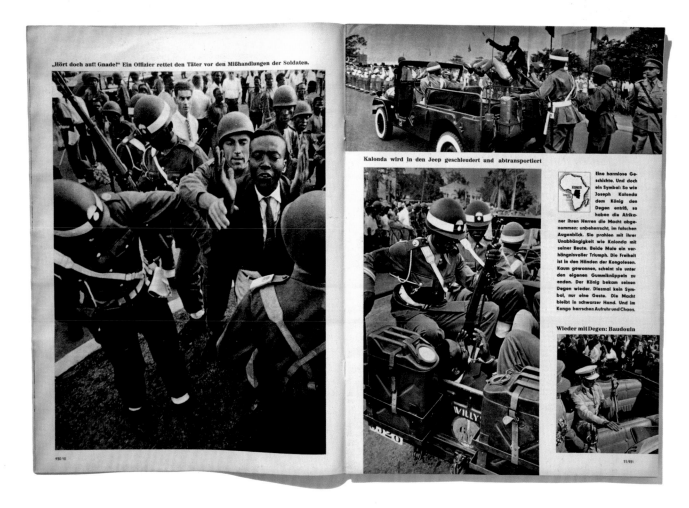

„Hört doch auf! Gnade!" Ein Offizier rettet den Täter vor den Mißhandlungen der Soldaten.

Kalonda wird in den Jeep geschleudert und abtransportiert

Eine harmlose Ge-
schichte. Und doch
ein Symbol: So wie
Joseph Kalonda
dem König den
Degen entriß, so
haben die Afrika-
ner ihren Herren die Macht abge-
nommen: unbeherrscht, im falschen
Augenblick. Sie prahlen mit ihrer
Unabhängigkeit wie Kalonda mit
seiner Beute. Beide Male ein ver-
hängnisvoller Triumph. Die Freiheit
ist in den Händen der Kongolesen.
Kaum gewonnen, scheint sie unter
den eigenen Gummiknüppeln zu
enden. Der König bekam seinen
Degen wieder. Diesmal kein Sym-
bol, nur eine Geste. Die Macht
bleibt in schwarzer Hand. Und im
Kongo herrschen Aufruhr und Chaos.

Wieder mit Degen: Baudouin

In 1961, in a debate published in *Asahi Camera*, Shomei Tomatsu, the influential leader of a generation of Japanese photographers, called for a new form of reportage: 'In order to prevent the hardening of photography's arteries,' he said, 'I believe we should drive off the evil spirits that haunt "photojournalism" and destroy the existing concepts carried by those words.' In the early 1960s, in the pages of the general interest magazine, *Chuo Koron* (meaning 'Central Review'), Tomatsu pioneered a raw new language for photography in Japan, rejecting the familiar descriptive terms of photography and filling the magazine's pages with wall-to-wall images, without text. In challenging and unexpected juxtapositions and sequences, he defied the traditional terms of descriptive photography, while dealing with the contrasts between traditional culture and the demands of a modern industrial economy, and the clash between Japanese society and the West. His values are exemplified in his essay about Iwakuni, the ancient city south of Osaka profoundly changed by the influence of the occupying Americans operating out of the local marine base. By 1965, Tomatsu had joined the art faculty of Tama University, and ceased to publish picture stories in the mainstream press. (April 1960)

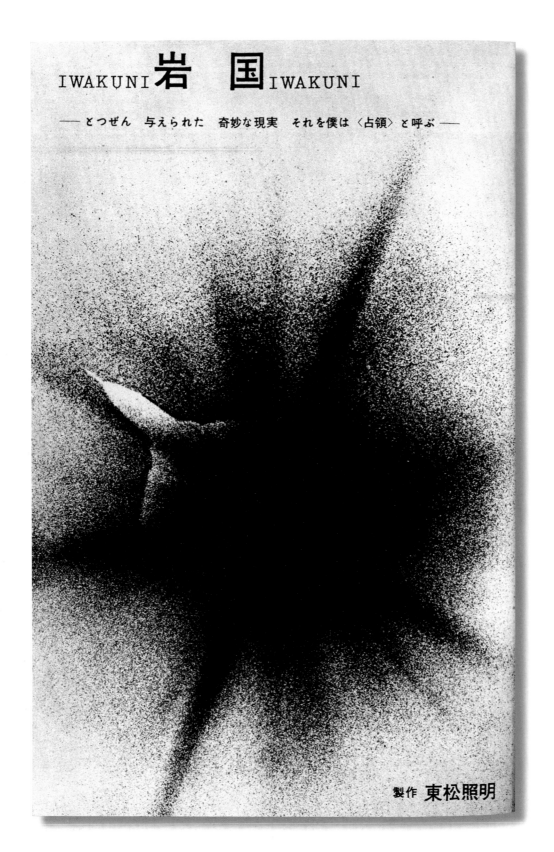

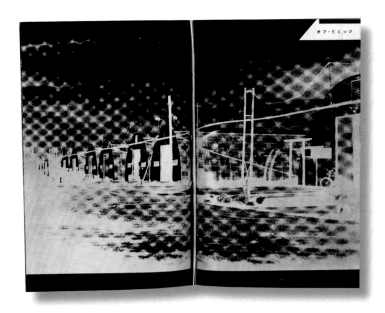

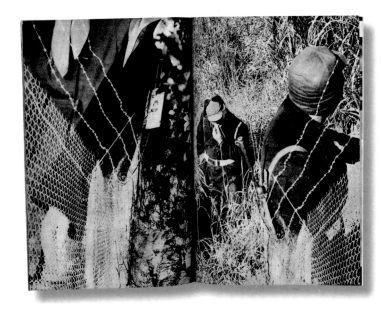

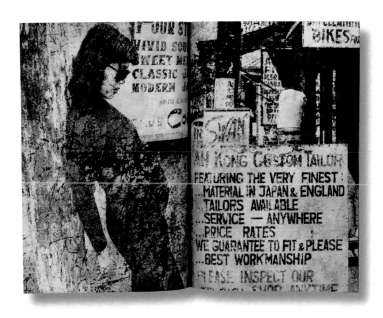

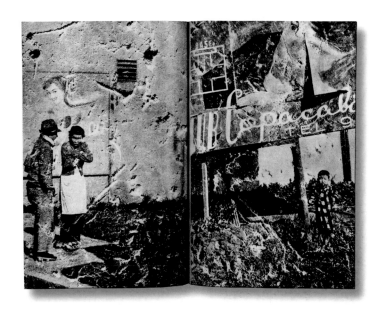

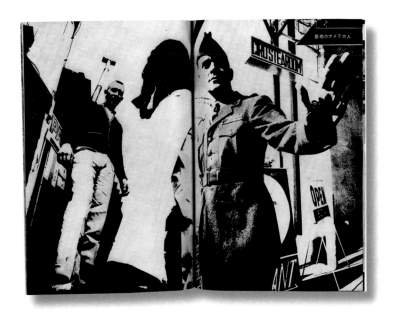

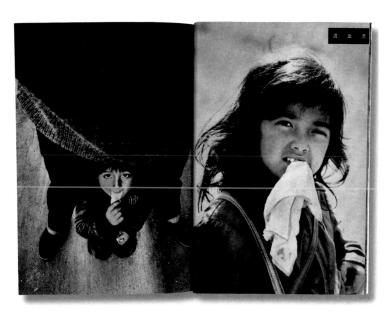

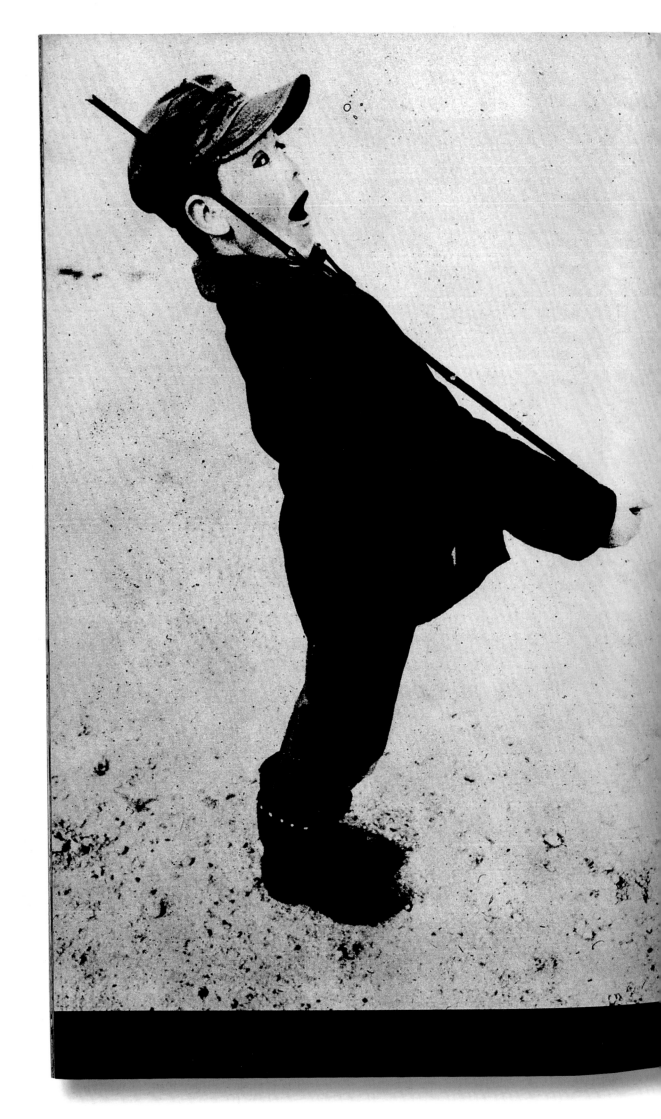

Peter Magubane began working at *Drum* as a driver in 1954 while he was in his twenties, with his first photographic assignment to cover the annual meeting of the as-yet un-banned African National Congress the following year. On 21 April 1960, Magubane covered a demonstration at the Sharpeville township that turned into the now-famous massacre. But editor Tom Hopkinson did not publish Magubane's work: 'He said "there are no close-ups, no photos here that will sell the magazine". I explained that I had been shocked. He said "Get the pictures first, then you get shocked." He was right!' Magubane recalls this story as the moment his career truly began. 'From that day I made up my mind that I shall think of my pictures first before anything. I no longer get shocked. I am a feelingless beast while taking photographs.' Weeks later, when Magubane covered the funeral of 35 Sharpeville martyrs, he produced a dark, vivid picture story – an early triumph as one of the key documentary witnesses of the Apartheid years. (May 1960)

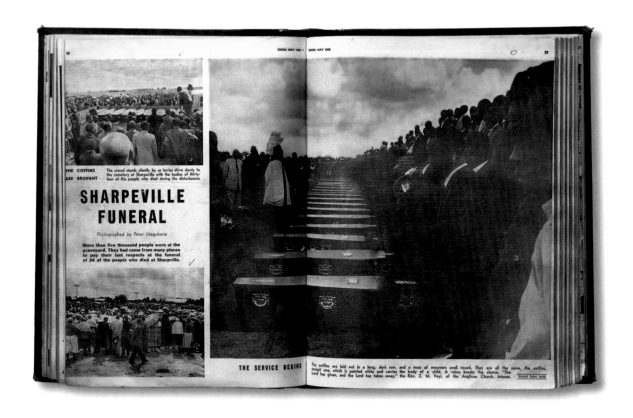

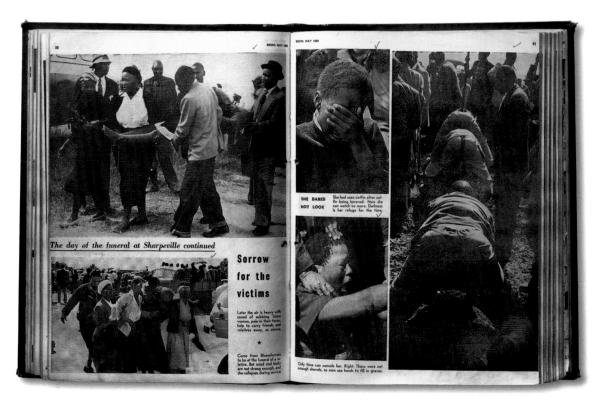

The first of many stories Diane Arbus shot for *Esquire* appeared in a special issue devoted to New York. Her contribution took the form of six portraits (with interviews) which challenged established standards of taste and style. Her images are blurred, uneven, flawed – utterly unlike a sharp newspaper shot, or a polished magazine illustration. She turns this affecting style on subjects invisible to *Esquire*'s urbane readers: Hezekiah Tramble, who performed daily as the 'Jungle Creep' in a Times Square sideshow; a shirtless one-eyed Bowery bum named Walter L Gregory; and midget entertainer Andrew Ratoucheff, who impersonated Marilyn Monroe and Maurice Chevalier. Her story includes other unconventional subjects: pretty blonde Dagmar Patino sitting with a balding man in a tuxedo, and genteel Flora Knapp Dickinson standing alone in her apartment (in the text she tells us about her distinguished ancestors). The final image shows us the bare feet of a nameless corpse found in the city morgue. They are all part of a New York City that only Arbus could reveal, and the series opened a wide new territory for photography, beyond the familiar definition of journalism. (July 1960)

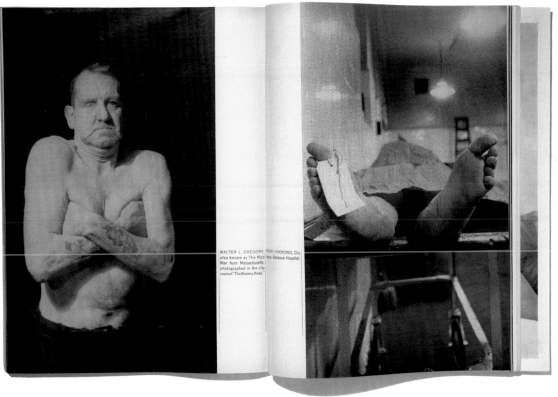

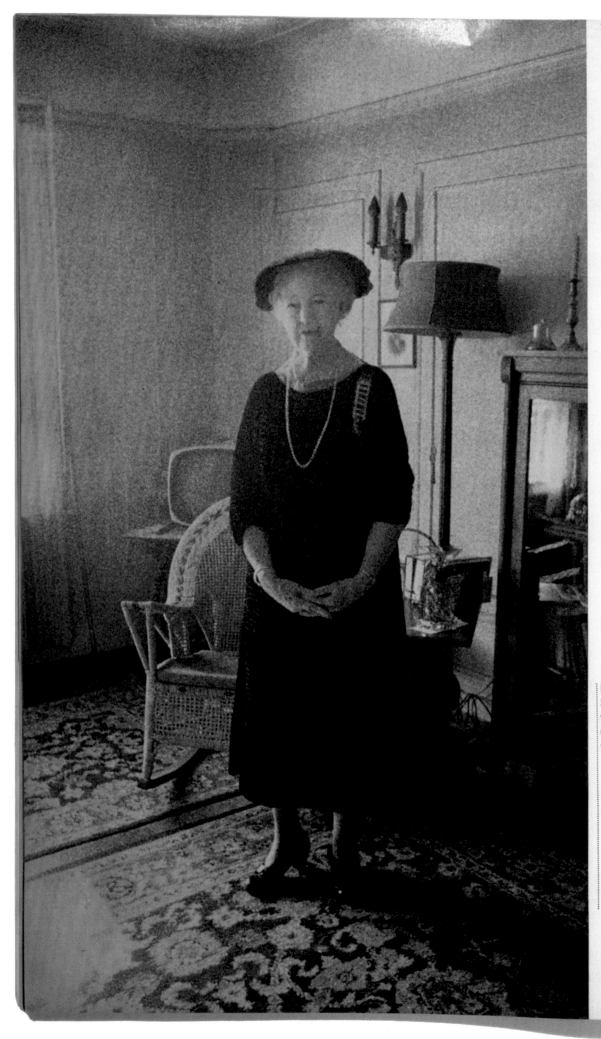

FLORA KNAPP DICKINSON, Honorary Regent of the Washington Heights Chapter of the Daughters of the American Revolution

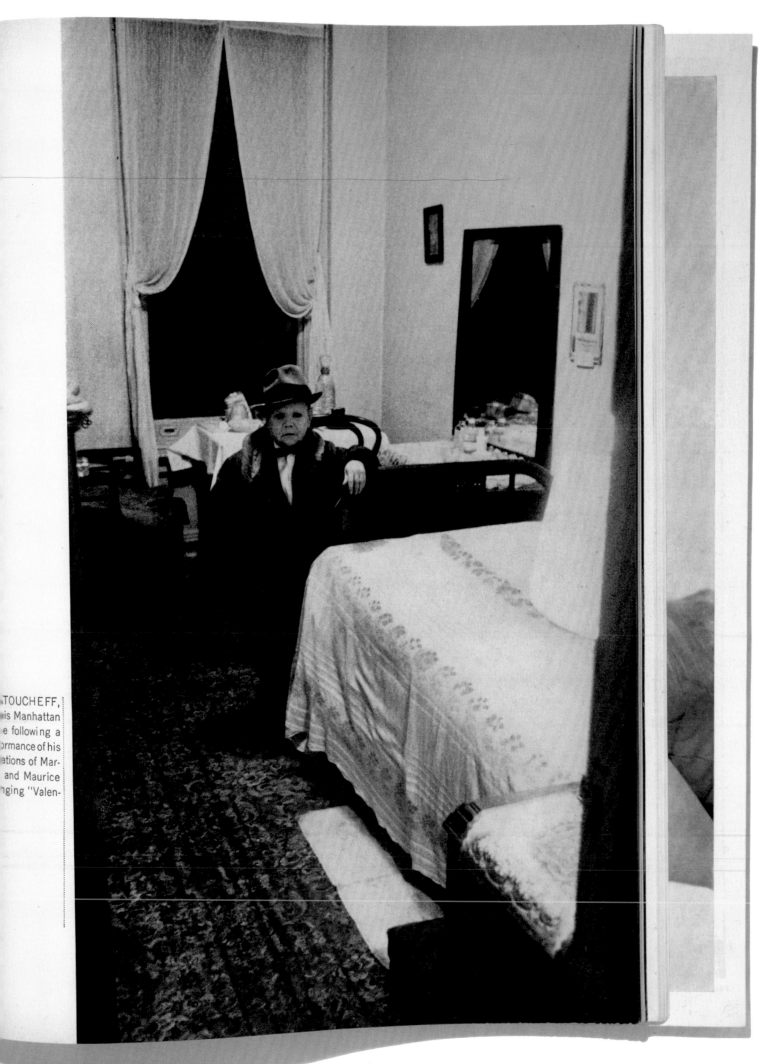

TOUCHEFF,
his Manhattan
e following a
ormance of his
ations of Mar-
and Maurice
nging "Valen-

Kishore Parekh's weekly front page photo reports for the *Hindustan Times*, usually accompanied by his own text, made him a treasured local celebrity and hero throughout the 1960s. Alongside his contemporary Sunil Janah working for the *Illustrated Weekly of India*, Parekh's photo essays set a national standard both for their exquisite form and for their ability to communicate clear, forceful statements about everyday life. With stories like 'Floods and Tears along the Cauvery', 'Tibetan Refugees', 'Coalminers of Asansol' and 'A Day with Police at Naxalbari', Parekh established a frank, emotional connection between his subjects and his readers, without drifting into sentimental formulae – a notable achievement given the hackneyed conventions that often governed representation of the impoverished of India. Parekh came to photojournalism while unable to find work in his chosen field, cinematography, and as the result of a chance meeting with powerful industrialist and owner of the *Hindustan Times*, G D Birla. Birla saw his potential as a popular storyteller, and he was rewarded by Parekh's central role in raising the national profile of the paper. Parekh's career was cut short, in 1970, when he died in an accident in the Himalayas. (30 May 1961)

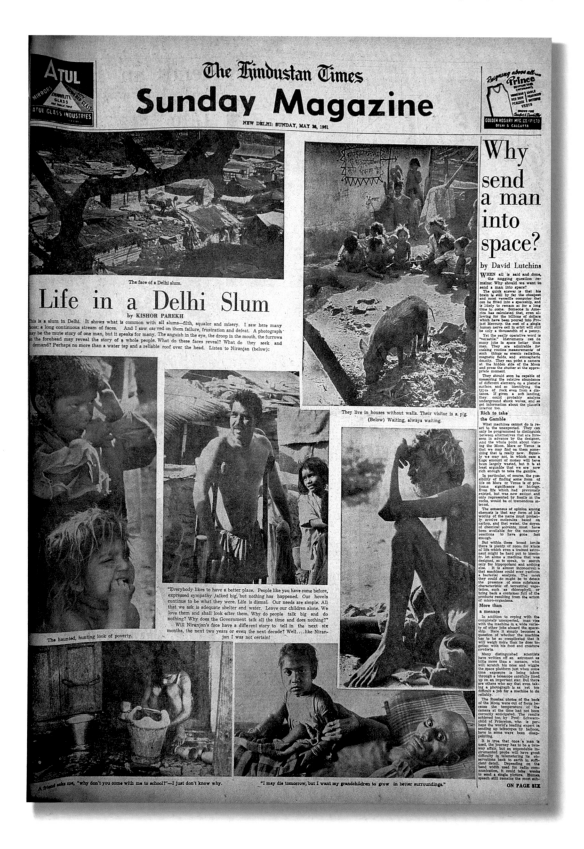

One of the best-remembered *Life* stories of the 1960s was its presentation of Gordon Parks' and reporter José Gallo's trip to a squatters' *favela* outside Rio – part of a larger political report showing Latin America's 'teeming poor' as 'a ripe field for Castroist and Communist political exploitation'. Parks put the focus on José and Nair Da Silva and their eight children, especially twelve-year-old Flavio, the eldest, who cared for his siblings while their parents scavenged for food. Flavio was sick, with his progressive asthma almost certain to end his life in a few years. Inspired by *Life*'s urgent rhetoric and Parks' emotional images, the magazine's readers rallied to assist Flavio and his family. Within a month, their contributions helped the Da Silvas leave the *favela*, and Parks brought Flavio to a renowned asthma clinic in Denver. Today historians cite Flavio's story as an example of photography's power to inspire action and change a life. But even at the time, *Life* cautioned its readers against this conclusion; after all, the editors explained, 'Flavio is just one in a numberless multitude', all of whom need help. (16 June 1961)

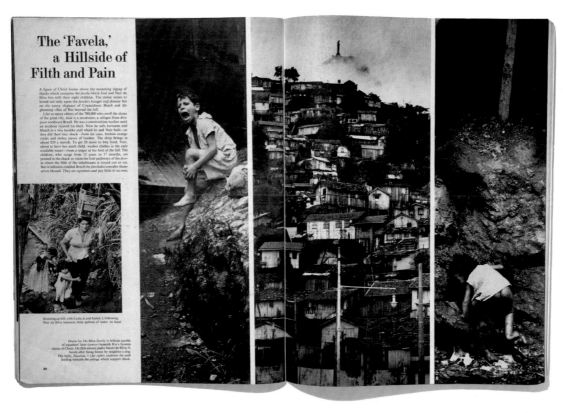

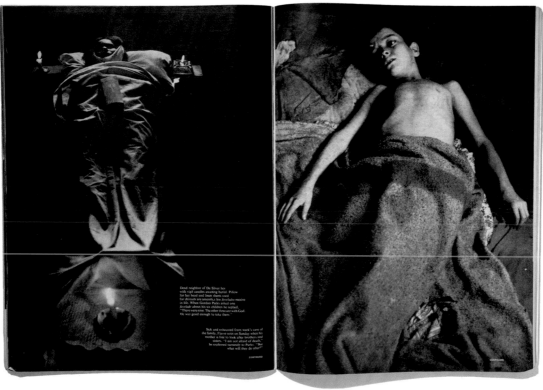

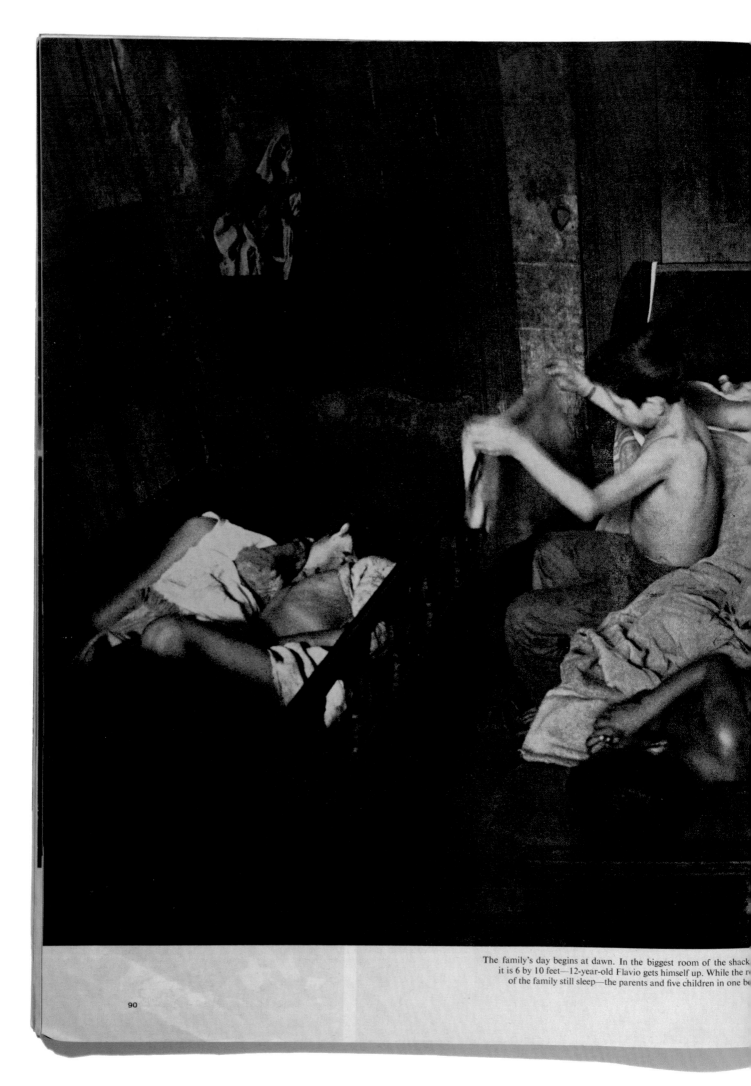

The family's day begins at dawn. In the biggest room of the shack
it is 6 by 10 feet—12-year-old Flavio gets himself up. While the rest
of the family still sleep—the parents and five children in one bed

90

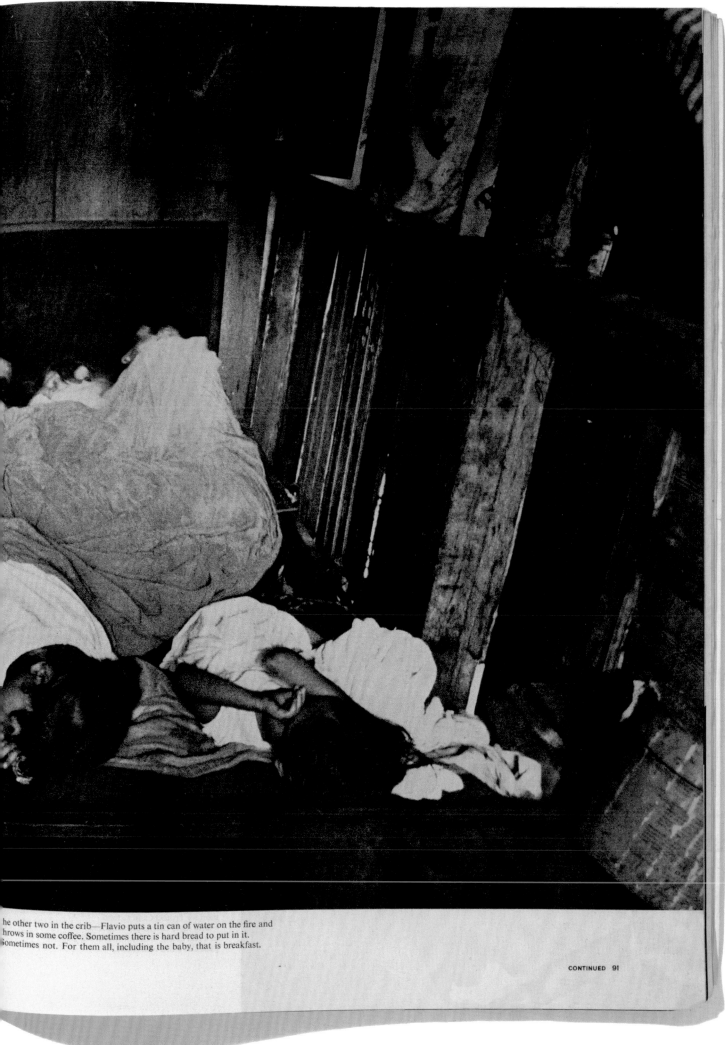

the other two in the crib—Flavio puts a tin can of water on the fire and throws in some coffee. Sometimes there is hard bread to put in it. Sometimes not. For them all, including the baby, that is breakfast.

CONTINUED 91

Although its approach may now seem familiar and obvious, on its publication 'Monsoon' was widely seen as a milestone in the poetic use of colour within photojournalism. Developed and shot by New Zealander Brian Brake over nine months, it calls on a visual inventory of the Western myth of South Asia – crouching women in saris surrounded by children, a sea of pilgrims under black umbrellas, a weeping woman waist-deep in the river at Benares – to create an exotic experience of Indian colour, simultaneously didactic and impressionistic. Brake drew on the ground-breaking imagery of Ernst Haas, one of colour photography's earlier pioneers and a colleague at Magnum Photos, while combining it with the careful construction of concept and storyline, in the tradition of *Life* magazine and W Eugene Smith. Every element was considered to achieve the right effect, from the identification of subjects through to the sequencing of images on the page. (The famous 'monsoon girl' picture was constructed in a studio with model Aparna Sen, a fourteen-year-old actress who went on to become a major Indian film star.) The story was a great success for Brake, whose sequence of images was run as he intended in major magazines worldwide, including *Life*, *Epoca*, *Queen* and *Paris Match*. (23 September 1961)

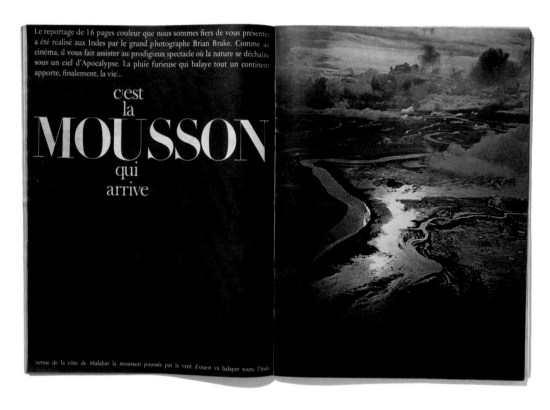

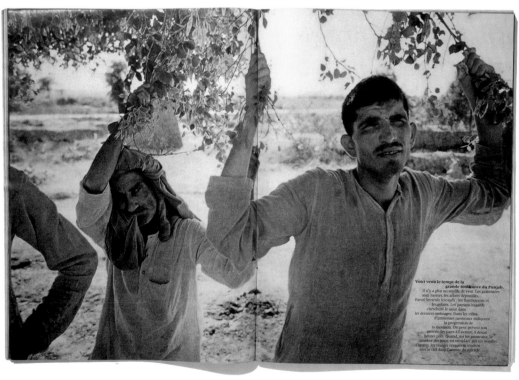

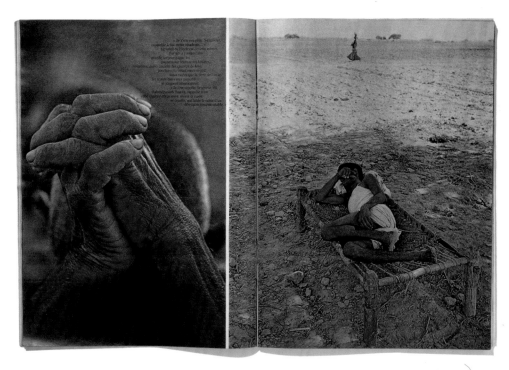

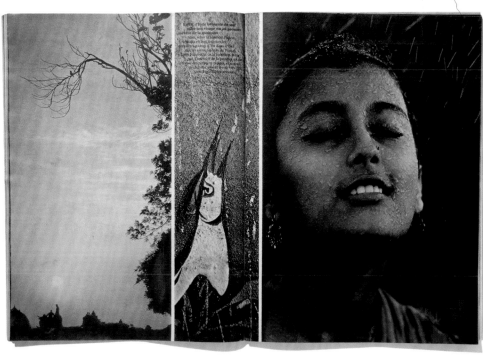

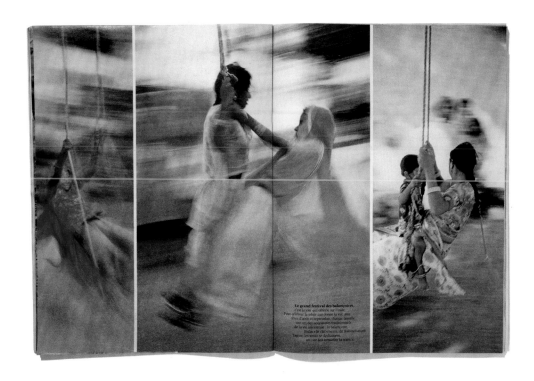

Le grand festival des balançoires.

Dickey Chapelle became a foreign correspondent during World War II in order to accompany her husband, a Navy pilot and photojournalist. She covered the Marines in Iwo Jima and Okinawa and later used her connections to reach the front lines in Korea and Lebanon. From the mid-1950s, Chapelle also officially gathered military intelligence, which gave her unusual access to military sites and required her co-operation with the US Defense Department's censors. Naive, ambitious and patriotic, Chapelle readily agreed. She arrived in Southeast Asia early in 1961 on assignment for *Reader's Digest*, one of a tiny handful of Western reporters covering an obscure civil war. Chapelle became increasingly unable to reconcile official policy with 'what my own eyes have taught me'. In 1962, she objected loudly when censors cut pictures of combat-ready armed Marines from her story for *National Geographic*. 'I am alive to make this protest only because of such readiness,' she answered, 'I cannot accept any effort to bury these facts.' The story ran as she wrote it. Chapelle's life ended on 21 November 1965, in Chu Lai, Vietnam, where she became the first American woman reporter to die in action. (November 1962)

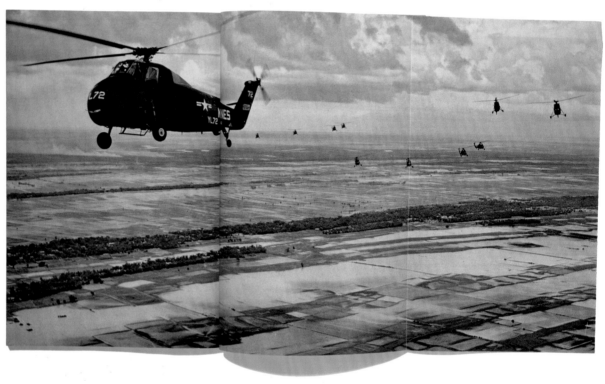

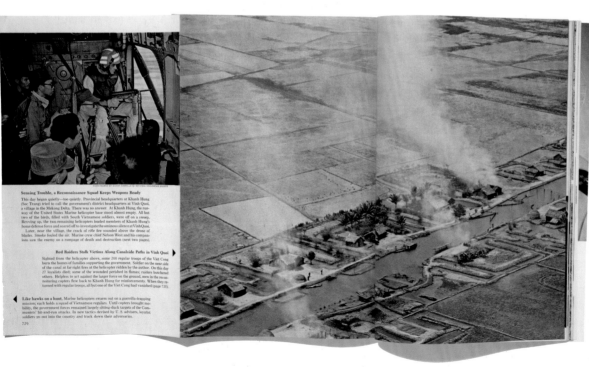

Sensing Trouble, a Reconnaissance Squad Keeps Weapons Ready
This day began quietly—too quietly. Provincial headquarters at Khanh Hung (Soc Trang) tried to call the government's district headquarters at Vinh Quoi, a village in the Mekong Delta. There was no answer. At Khanh Hung, the runway of the United States Marine helicopter base stood almost empty. All but two of the birds, filled with South Vietnamese soldiers, were off on a sweep. Revving up, the two remaining helicopters loaded members of Khanh Hung's home defense force and soared off to investigate the ominous silence at Vinh Quoi. Later, near the village, the crack of rifle fire sounded above the drone of blades. Smoke fouled the air. Marine crew chief Nelson West and his companions saw the enemy on a rampage of death and destruction (next two pages).

▶ **Red Raiders Stalk Victims Along Canalside Paths in Vinh Quoi**
Sighted from the helicopter above, some 200 regular troops of the Viet Cong burn the homes of families supporting the government. Soldier on the near side of the canal at far right fires at the helicopter ridden by the author. On this day 27 loyalists died; some of the wounded perished in flames; raiders butchered others. Helpless to act against the larger force on the ground, men in the reconnoitering copters flew back to Khanh Hung for reinforcements. When they returned with regular troops, all but one of the Viet Cong had vanished (page 733).

◀ **Like hawks on a hunt**, Marine helicopters swarm out on a guerrilla-trapping mission; each holds a squad of Vietnamese regulars. Until copters brought mobility, the government forces remained largely sitting-duck targets of the Communists' hit-and-run attacks. In new tactics devised by U.S. advisers, loyalist soldiers go out into the country and track down their adversaries.
729

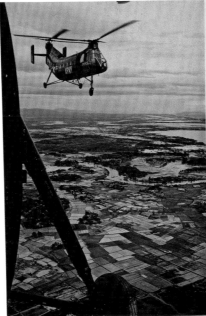

Helicopter War
in South Viet Nam

Article and photographs by DICKEY CHAPELLE

INSIDE THE HELICOPTER that morning I felt the heat of tension as soon as we were off the ground.

In newspapers back home the reports always seemed so cool and somehow detached from life: "Troops of the army of South Viet Nam were airlifted aboard U. S. helicopters today into combat against Red guerrillas."

To borrow confidence, I reminded myself that the men around me were professionals: an American Marine helicopter team—two pilots and crew chief—and a squad of veteran South Vietnamese infantrymen (page 725). I shifted my gaze from the men and stared out through the helicopter's square loading hatch, a gaping hole in the right wall of the fuselage. The sunlit rice fields of Ba Xuyen Province seemed to sink beneath us as the formation of 16 helicopters cast dragonfly reflections on the standing water below.

Oddly, the utter serenity of the mirrorlike water increased my tension. It brought home a banality that was nevertheless bedrock truth—it was too nice a day to die. Or to kill. Or to manhunt.

But that was what the men were here for, and I was going along to photograph them and write their story.

723

Work horses of war, United States Army helicopters fly above rice fields near the South China Sea. They epitomize the "wholly different kind of force" —in the words of President John F. Kennedy—needed to meet the challenge of "war by guerrillas, subversives, insurgents, assassins, war by ambush instead of by combat."

The author, knee-deep in muck, risks her life on a patrol with the army of the Sea Swallows (pages 736-7). Dickey Chapelle won the wings above her jacket pockets for parachute jumps with United States and Vietnamese forces. She began her career as a war correspondent on Iwo Jima during World War II. The Overseas Press Club recently gave her its highest honor, the George Polk Memorial Award, for her reports on fighting in South Viet Nam.

American team: Army adviser (right) and Marine flyer stride between flags of South Viet Nam and the United States in Quan Long, capital of An Xuyen Province. Adviser helps train government troops; helicopter pilot delivers them to battlefields.

Red tide threatens to engulf South Viet Nam, a nation about the size of Florida.

The bright view through the hatch was not a color movie, the sound did not come over a TV speaker, the mission to which we were committed would not end in time for the commercial. Ten days before, half of the helicopters on a mission like this one had been hit by rifle fire. The aircraft I rode in still bore the scars of guerrilla bullets.

This was the real front of the Free World, where the people of South Viet Nam with United States help were fighting Communists led from North Viet Nam.*

In the decade following World War II, nationalist and Communist forces, united in a common purpose, fought for and won their independence after years of French rule.† Of the four new nations that emerged—Laos, *(Continued on page 733)*

*See "South Viet Nam Fights the Red Tide," by Peter T. White, NATIONAL GEOGRAPHIC, October, 1961.

†These years of violence may be traced in previous GEOGRAPHIC articles: "Strife-Torn Indochina," by W. Robert Moore, October, 1950, and "Indochina Faces the Dragon," by George W. Long, September, 1952.

724

Veteran Airborne Fighters Grow Tense Before an Assault

Riding a helicopter with this squad of Vietnamese regulars, the author shared their fear of the unknown. They face shadowlike enemies—guerrillas of the Viet Cong army—who dress like farmers and fade into a crowd or drift like mist into the jungle. Dickey Chapelle followed the squad leader (center) on a house-to-house search of Ap My Thanh. The troops captured three prisoners.

Overrun by the Communists, Vinh Quoi's fortifications and houses blazed, the banners of flame bright against the sky. The crack of rifles told us the Reds were still in the village and were now shooting at us (pages 730-31).

The crew chief shouted "Yeah!" to a Vietnamese gunner with a Browning automatic rifle; the gunner began firing back. The authoritative cannon-cracker noise of the bursts from his weapon was much louder than the engine or the shots from the ground. I didn't realize the Marine was firing too, till the jerking muzzle of his gun slid into my view.

As soon as the two ceased firing, I grabbed a headset from a hook on the compartment wall. Captain Moreau's blared words in the earphones were: "See them go! I bet I can count two hundred right now!"

Headlong Chase Across Rice Fields Nets a Fleeing Red Guerrilla

Roaring a battle cry, the squad and its bareheaded adviser, Capt. Richard A. Jones, fan out over the stubble. Vietnamese rangers welcome the American because, says the author, "they recognize Jones as a superb soldier." Jones moves fast despite the heavy radio equipment on his back.

Prisoner precedes his captors (opposite, lower) to a waiting helicopter. He carried Communist propaganda and papers revealing him as a guerrilla chief.

Blindfolded with his own flag, the captive rides to headquarters in Can Tho for interrogation by intelligence officers.

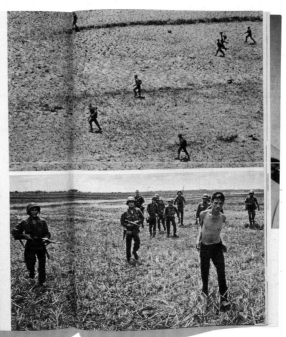

746

Raúl Corrales is best known today for his lyrical photographs of the Cuban Revolution – 'La Caballería' and 'The Dream'. He also made important photographic stories about everyday life in Cuba, first in 1959 for the short-lived *Revolución*, and then for *Cuba*, which began publication in 1961, modelled on *Ogonyek* and *Life*. In its early years, *Cuba* reflected the heartfelt exuberance of the Revolution while also publishing more predictable propaganda stories about Fidel Castro and his good works and celebrations of the picturesque Cuban landscape. In stories such as 'El Hombre, su mochila, su fusil', Corrales took on the more difficult task of developing a new kind of iconography, adequate to the representation of life in Cuba after the Revolution. Drawing on references to the Mexican Revolution fifty years earlier, his matter-of-fact depiction of Cuba's farmer-soldiers made no secret of his admiration for these subjects, yet rendered them too explicitly to invite sentimental clichés. Corrales's career began in 1944; he worked for newspapers, magazines and briefly for advertising before becoming Castro's official photographer in 1959. (September 1963)

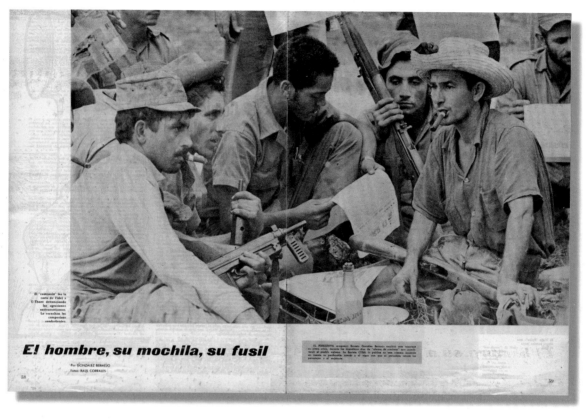

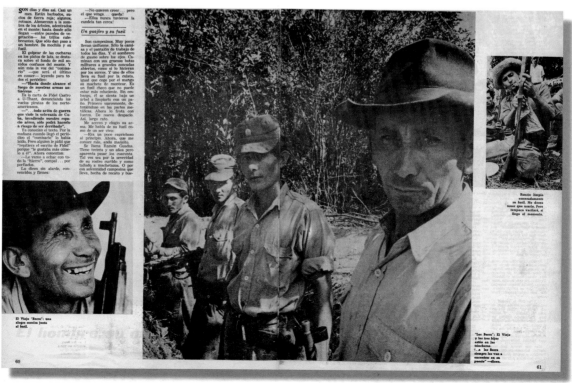

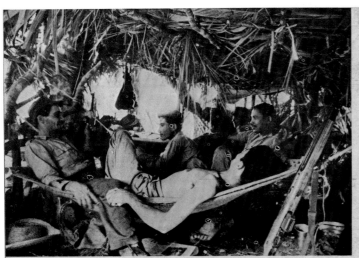

Es bueno sentarse allí a escuchar la charla de los campesinos combatientes. En la espera forzosa. Larga y forzosa.

na educación natural, que le hace guardar una distancia amistosa con su interlocutor. Dice:

—Hoy compañero, las condiciones han variado... demasiado... quién me iba a decir que yo iba a tener mi casa de mampostería, luz eléctrica, ducha, escuela pa' mis hijos... todo gratis... y encima mi buen centenar de pesos al mes.

Ramón trabaja en una Granja del Pueblo de la zona. Su mujer se llama Silvia. Y tiene dos hijos de ocho y diez años: Nancy y Ramón Hipólito. Es una familia muy unida: "todos somos uno pa' todo." Que se siente segura, con una vida propia. Pero antes...

—... le diré la verdad... muchas veces en mi casa lo que había pa' comer era un poco de harina... y nada más. En tiempo muerto yo tenía que caminar dos leguas y media, ida y vuelta, todos los días, pa' ganarme dos pesos. Y mi mujer tuvo que hacer mucho lavado pago pa' que el hambre fuera menos.

Más que rencor hay una sombra dolorosa en los ojos hundidos y negros de Ramón. Y una repentina y firme resolución:

—Los yanquis quieren volvernos a eso. Nosotros (habla despacio, masticando las palabras), le digo con sinceridad, no lo permitiremos.

Lo prueba esta movilización. Que ha sido "una salvajada."

—¿Por qué se creen que apoyamos la Revolución? Si la Revolución no solucionara nuestros problemas ¿para qué la querríamos?

Ramón vuelve a su silencio. Vuelve a su expresión concentrada y resuelta. Moja su trapo en el líquido de una botella y reanuda la limpieza de su fusil. Con cariño. Suavemente.

—Ojalá que no haya que usarlo. Pero si vienen, van a tener que matarnos a todos. Hasta a las mujeres y los niñitos. Vivos, no lo permitiremos, créame, no lo permitiremos.

Los "Borra"

El viejo y los tres hijos están en las trincheras. Son de apellido Yerea. Pero en el campamento nadie los conoce sino como "los Borra." Por tostados y bajitos.

El viejo "tiene" cincuenta años. Bajo el ala negra de su sombrero "de ciudad" aparece su rostro simpático de ojos abiertos y redondos. Cuando no se entrecierran con picardía. Antes que diga una de "las suyas."

—¡Hijos? Tengo nueve... diez... se me perdió la cuenta.

—Somos nueve, viejo —dice Julián, de 23 años.

—No, es que yo pensaba tener otro y ya lo había anotao.

Reímos con ganas, Heriberto —otro "Borra", que acaba de cumplir 22 años en las trincheras ("el año pasado me pasó igual") y que cumplirá los 23 "donde la Revolución lo disponga", dice:

—Usted tiene que conocer al viejo este. Medio rengo y con reuma, nos cansa a nosotros.

El viejo sonríe con satisfacción.

—Uno no podrá mucho, pero lo que puede, lo hace.

Y mirando a los hijos:

—Y le gusta estar cerca... qué sé yo...

El que tiene "más historia" de la familia es Bárbaro, de 17 años. Porque Bárbaro, "con otro compañero" capturó a Tom Dike, un bandido que asoló una región "torturando campesinos" y "matando gente aquí mismo."

—Lo encontram en un cayo e'caña —dice Bárbaro. Le vaciamo un peine, le dimo candela a la caña y lo cogimo.

Pero no es el único. Julián ha sido movilizado seis veces. Y siempre tuvo "confrontas."

—Tuvimos buena suerte, cada vez que salimo, nos topamo con los bandidos.

Con la madre, Isabel Martínez, de 39 años, quedaron en la Granja del Pueblo donde todos trabajan, el resto de "los Borra." Uno de quince años "que es joven comunista," un pionero de trece y otro varón "que no es pionero porque tiene ocho meses." Las demás "son tres hembras que están en las Federadas."

—Se ve que'l viejo tuvo las noches ocupadas —dice un combatiente.

—Las noches... y algunas mediodías, m'hijo.

Vuelven las risas. Los "Borra," el rostro medio aindiado, se parecen mucho. Y ahora que ríen todos, muestran sus dientes cuadrados y fuertes, hechos con el mismo molde.

—Usted tendría que ver cómo el viejo toca el bongó y los timbales —dice Heriberto—, lástima que no los trajo a las trincheras.

—No importa m'hijo, acá vamo'a tener "música" pronto...

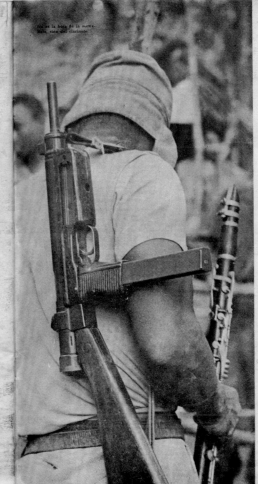

No es la hora de la metralleta, sino del clarinete.

Porque los "Borra" son de la opinión de que "los yanquis se tiran" y "como se tiran, quedan."

—A los "Borra" los van a encontrar en su puesto —dice el viejo súbitamente serio—, los "Borra" siempre van a estar en su puesto. Nosotros ya dijimos: si alguno de la familia se vira contra la Revolución, eso corre de cuenta nuestra nomás.

En las hamacas

No hace mucho calor en el monte. Sin embargo, se está mejor aquí, en la "barraca." Una construcción abierta hecha con seis troncos fuertes y un techo de guano, que chorrea a los costados. La hicieron los mismos combatientes. Ellos han oído que los yanquis necesitan dos compañías cuando están en combate. "Una pa'pelear" y otra que "les prepara todas las cositas." Pero "nosotros no somos soldados pagos... somos trabajadores y no necesitamos que nadie nos haga nada."

Sí, se está muy bien en la "barraca." Sobre las hamacas de yute, también de fabricación casera. Oyendo la charla de los campesinos combatientes. En la espera forzosa. Larga y forzosa.

Lázaro, que tiene 16 años y lleva el pantalón azul de los jóvenes comunistas, ocupa una hamaca junto a la mía. Lo veo hojear una revista. Encuentra la fotografía de un niño víctima de la droga Talidomida. Me dice:

—Después dicen que son demócratas y cristianos. Mira p'eso. Un chiquito sin brazos y sin piernas. ¡Mal rayo los parta!

Nadie comenta lo que dijo Lázaro. Pero seguro que todos pensamos en eso. Mientras fumamos y dejamos correr la mirada por el techo bajo de guano de donde cuelgan mochilas con los platos de lata atravesados en las cubrerras. Y algunas metralletas.

Atrás mío hablan dos combatientes.

—En cuanto los amigos de aquí cerca nos dejen tranquilos, quiero meterme a estudiar.

—Hace falta gente que estudie.

—Yo me iba a ir el año pasado pa'La Habana, becado. Pero no sabía bastante. En cuanto me supere un poquito y vengan por la Granja a recoger pa'estudiar, me voy pa'llá.

—Está bueno eso.

Otra vez el silencio. Sólo el chistido de los pájaros del monte, y el guano, agitado por la brisa, golpeando contra los troncos.

Un combatiente que lee el diario encuentra una foto de Mikoyan y el Che Guevara.

62 63

—El Ché luce diez años más nuevo que en la Sierra —dice.

—La vida es muy dura en el monte. Allá estaba flaco ¡cantidad!

Martín quiere que le alcancen el diario. Para ver "cómo está el Ché" y por Mikoyan, al que conoció en la Unión Soviética. Porque Martín Gómez estudió un año mecánica agrícola en la URSS. Durante la emergencia será el responsable de la planta eléctrica del hospital de campaña, cercano al campamento. Alguien le pregunta cómo encontró "aquéllo." Responde con entusiasmo:

—¡Muchacho! haría falta que Fidel nos mandara aún otros diez años pa'llá.

Martín es fuerte, lleno de bríos. Tiene un amplio tórax que le estira la camisa y parece estar a punto de hacerle saltar los botones. Quiere contar lo que vio en los campos soviéticos. Donde "el campesino que no tiene un automóvil, tiene una motocicleta." Y "las papas se plantan con máquina y se recogen con máquina: las chiquiticas pa'un lado y las grandes pa'otro."

Las cabezas empiezan a emerger del fondo de las hamacas. Lázaro deja su revista. Algunos combatientes se levantan y forman rueda. Martín sigue explicando. Dice que "cada campesino puede tener, de él, desde una vaca hasta cinco, desde un pato hasta cincuenta, desde una gallina hasta cincuenta."

—¿Y palomas? —pregunta uno.

—Pues, palomas... como allá quieren decir la paz... puedes tener todas las que quieras.

Martín recuerda que los soviéticos "todos los años, el primero de enero, hacen una gran fiesta, porque es un año que están más cerca del comunismo" y que "están muy orgullosos de tener un país fuerte y rico."

—Todos los países socialistas son ricos —apunta Martín.

—Oye, ¿y Cuba también? —pregunta un combatiente.

—Bueno, nosotros no tenemos riquezas todavía... pero somos ricos porque tenemos libertad.

Llama desde afuera un oficial. Hay que levantarse a cavar trincheras. Todos lo hacen rápidamente y sin comentarios. Pero un campesino combatiente, al salir, protesta:

—¡Cuándo se acabará esto! A mí me gusta cavar la tierra... pero pa'plantar frijoles.

El parque de los Combatientes

El jeep tiene que detenerse. Hacia el camino se adelanta un arbusto con un fusil. Es la posta. Las ramas le brotan del cuello de la camisa, del cinturón, de las botas. Un rostro barbudo emerge entre las hojas. Los ojos brillan y desconfían. Pregunta:

—¿A dónde van ustedes?

—Hasta el Estado Mayor.

¿Se precisa el pase, compañero?

—Y... (dice el combatiente levantando el fusil) un poquito.

Lee el pase lentamente, con esmero, moviendo los labios. Baja el arma. Sonríe y dice:

—Adelante, compañeros.

Vamos al Estado Mayor de la División. Con nosotros vuelve el "comisario." Me explica que aunque su denominación oficial es la de Instructor Revolucionario, los combatientes gustan llamarle así, "comisario." Como "en España y en la Unión Soviética." Aunque conocen la diferencia. "En la Unión Soviética —me explica— muchos oficiales eran zaristas y los comisarios tenían que imponérseles muchas veces. Nosotros no. Todos nuestros oficiales son revolucionarios y nuestra misión es otra. Ser un ejemplo de sacrificio y valentía para la tropa. Y asesorarla políticamente."

Llegamos. Un arco de troncos nos recibe con una leyenda. "Apoyamos los Cinco Puntos de Fidel" —dice un letrero en letras rústicas. Estamos en "la Jefatura." Una verdadera "ciudad" dentro de la manigua. Con "calles" bordeadas de barandas de palos finos y distintos "edificios" de tronco y guano que componen la comandancia. Cada uno con su letrero indicativo.

Llegamos hasta el centro de la "ciudad." Una baranda circular de troncos rodea unos cuantos árboles altos y delgados. En todo el perímetro hay bancos, también de troncos. Es el "Parque de los Combatientes." Y a esa hora (en la tarde) entra en funciones la orquesta de la tropa. Colocan los atriles entre los árboles. Tumbadoras, güiro, flauta, gangarria, tambor, saxofón y clarinete, ya están listos. Empieza la "pachanga."

Primero son rumbas y congas. Después canciones dedicadas al enemigo. Todos cantan: "Estamos atrincherados aquí a dónde quiera — si los yanquis vienen — seguro que quedan."

Después otra rumba de ritmo descalabrante. La baila un negro: Noel Fernández, obrero de pico y pala. Salta, se contonea. Hace reír a todos cuando —sin perder el ritmo del baile— imita la lucha con un "marine" a quien termina enterrando con grotescos taconazos.

Al apagarse los aplausos alguien grita:

—Oye, vamos a cerrar con "La Internacional."

La orquesta se prepara. Los rostros abandonan las sonrisas. Se hace silencio. Ahora cantan:

"Arriba los pobres del mundo..."

Son ochenta o cien combatientes que forman un anillo en torno a la plaza.

"...de pie los esclavos sin pan."

Las duras manos campesinas entrelazadas. Los cuerpos acompañándose con la música. Finalizan:

"...y se alcen los pueblos con valor..."

Las voces roncas, desafinadas, llenas de fervor:

"...con LA INTERNACIONAL."

—¡Viva Cuba libre!

—¡Viva!

Todos aplauden. Son hombres barbudos, sucios de tierra roja, algunos rotosos. Como ellos hay centenares de miles en toda la Isla. Es el pueblo de Cuba en armas.

Forma un ejército que cuenta con la técnica, el armamento y la organización de un ejército moderno. Pero por su espíritu sigue siendo guerrillero. Un ejército barbudo y socialista.

Como ayer, no importa la fuerza material del enemigo. Importa la justicia y la limpieza de una causa. Por eso Fidel está otra vez "alzado" y Cuba entera es una Sierra Maestra. Que canta "La Internacional."

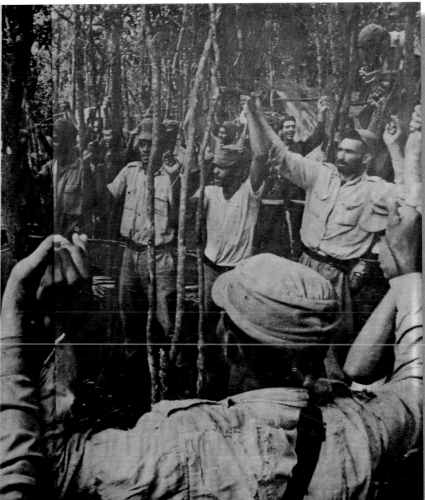

Las manos de los campesinos combatientes se unen y sus voces se juntan. Cantan, como Cuba entera, "La Internacional."

64

L'Europeo, launched in November 1945, was the first weekly magazine to be aimed at Italy's new postwar class of professionals and intellectuals, rapidly establishing itself as a critical voice in a rapidly changing society. In around 2,000 stories produced for *L'Europeo* over 30 years, its staff photographer Gianfranco Moroldo documented the reconstruction of Italy and its social conflicts, while bearing witness to earthquakes, homicides and wars in Vietnam, Egypt, Sierra Leone and Ethiopia. The Vaiont Dam, one of the highest in the world, was completed in 1961 but after heavy rains in 1963, landslides into the Vaiont reservoir caused the stored water to spill over the dam, sweeping away the villages in the valley and causing the deaths of 2,000 people. Moroldo's photographic account of the survivors, caught in the desolate landscape where their villages had stood, deeply touched a country that was struggling with rapid modernization. Moroldo's focus on the survivors was characteristic of his approach: 'There is nothing interesting in showing a man lying dead on the floor,' he once said, 'It's the drama of the man alive that interests me.' (20 October 1963)

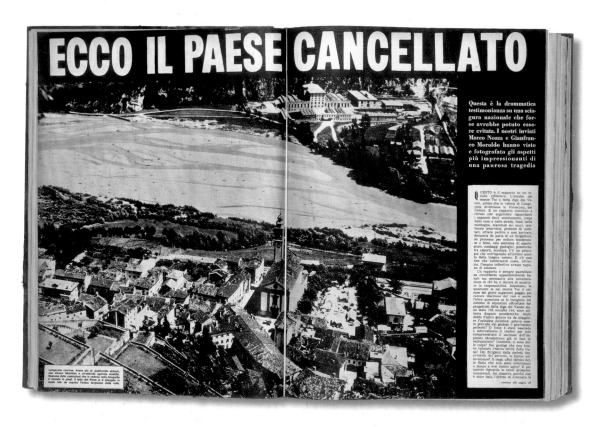

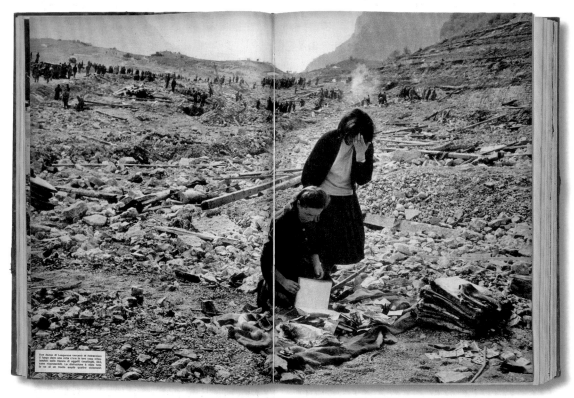

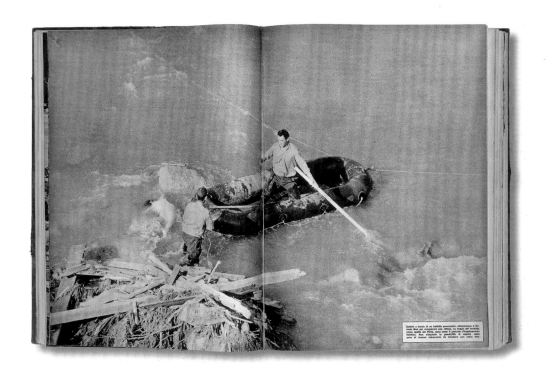

Soldati a bordo di un battello pneumatico attraversano il torrente Màel per recuperare una vittima. La acqua del torrente, come quella del Piave, sono vette il pericolo d'ingoiamento torrentoso. Non allacciate le possibilità di vivere vicine zone di terreno miracolato da intrattiene con salve vive

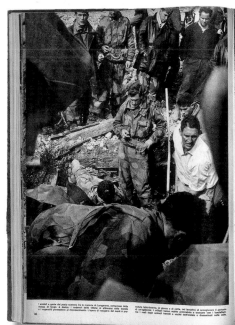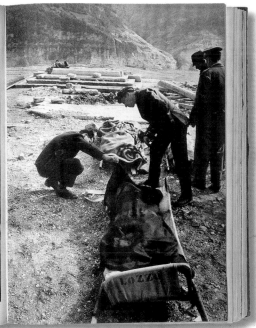

I soldati a gente del posto scavano tra le macerie di Longarone, compresse dalla massa di fango. A destra: i soccorsi delle vittime al attinsisi nelle barelle e i superstiti provenienti al rincondimenti. L'opera di recupero dei morti è proseguita febbrilmente, di giorno e di notte, nel tentativo di scongiurare il pericolo di un'epidemia. I militari hanno subito provveduto a bruciare con i lanciafiamme i resti degli animali bestuti e vecchie dell'sondata e disseminati nella valle.

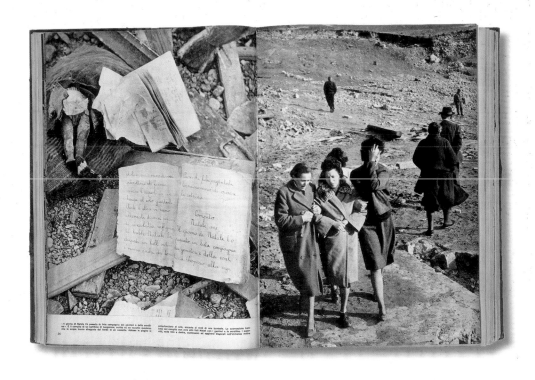

« Il giorno di Natale l'è passato in lieta compagnia di genitori e della sorella... ». È l'estratto di un bambino di Longarone, scritto su un vecchio quaderno che le acque hanno strappato dal bordo di un cassetto. Adesso le pagine si sfacciendano al sole, mezza ai resti di una bambola. La scinticlante bambino del compito non era altro lett Màel con i genitori e la sorellina. I superstiti, nella foto a destra, continuano ad ragionare disposti nell'immenso rovina

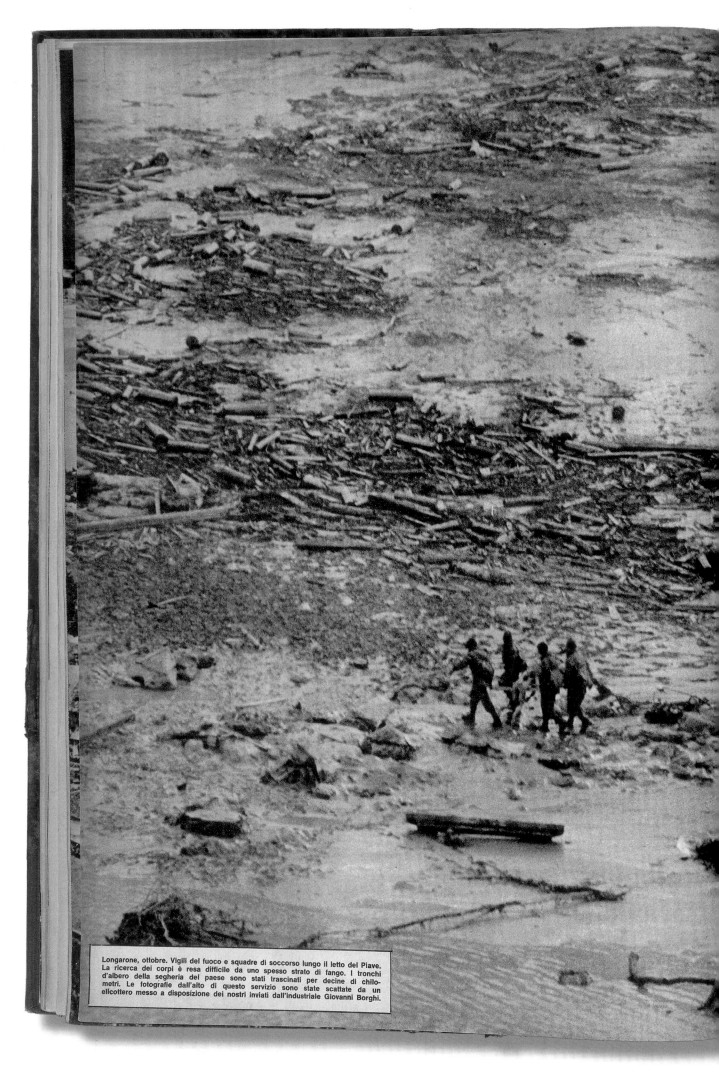

Longarone, ottobre. Vigili del fuoco e squadre di soccorso lungo il letto del Piave. La ricerca dei corpi è resa difficile da uno spesso strato di fango. I tronchi d'albero della segheria del paese sono stati trascinati per decine di chilometri. Le fotografie dall'alto di questo servizio sono state scattate da un elicottero messo a disposizione dei nostri inviati dall'industriale Giovanni Borghi.

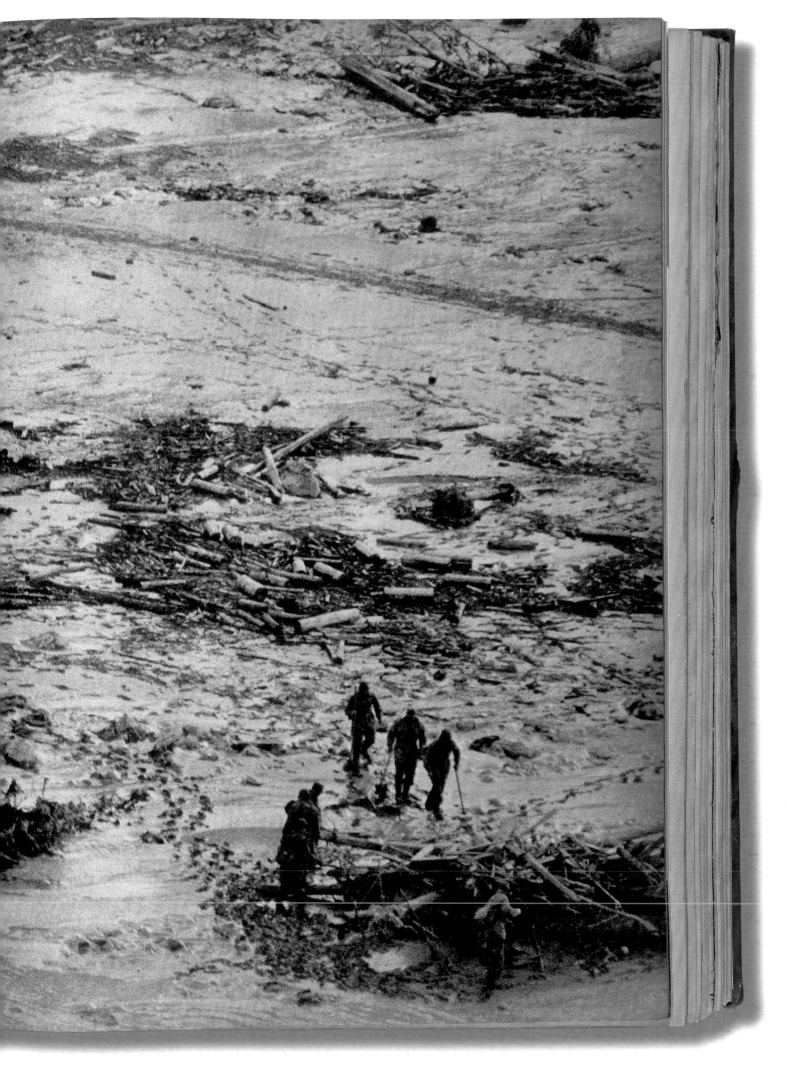

Pope Paul VI's visit to the Holy Land in January 1964 was a historic event for the Catholic Church. Including visits to Jordan, Israel and Syria, it was the first pilgrimage that a pope had made to the Holy Land and it carried powerful religious and political significance – especially so because he included the territories occupied by Israel in his itinerary. Subject to media and public scrutiny throughout, the pilgrimage inaugurated a new strategic model for papal evangelism, developed further by Pope Paul's successor, John Paul II. The Italian weekly magazine *Epoca* – founded in 1950 and inspired by the American magazines *Look* and *Life* – sent a team of its ten best journalists and photographers to create a special issue on location. Covered as a strictly chronological narrative, the three-day visit was presented moment by moment, from the incoming flight of the Pope's airplane onward. Its style was simple and direct yet highly polished, and it made utterly compelling viewing among an audience of Catholics who, as yet, had limited access to television. (12 January 1964, with photographs by Mario de Biasi, Giorgio Lotti, Walter Mori and Sergio del Grande)

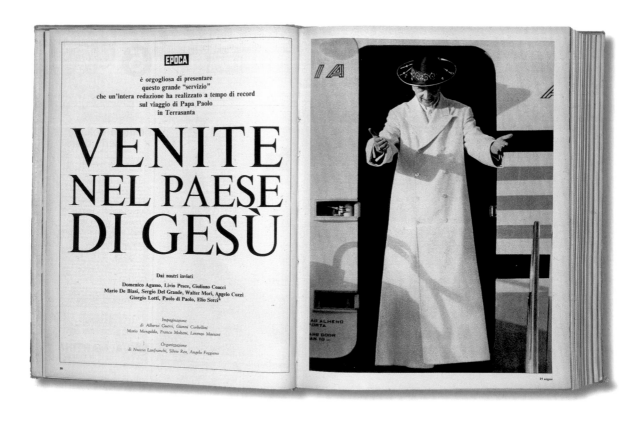

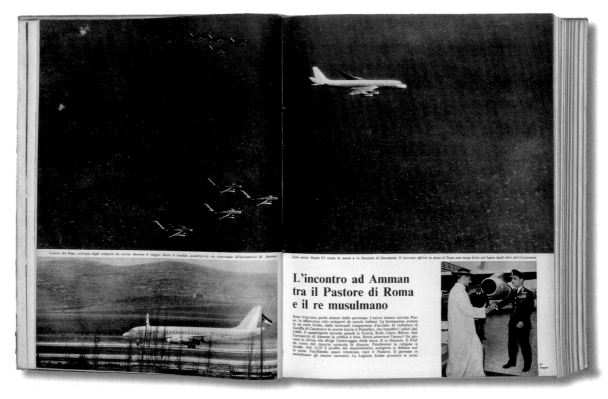

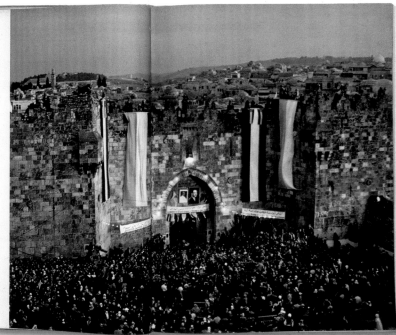

Alla porta di Damasco la folla impazzita travolge il Pellegrino

L'auto del Papa giunge alla porta di Damasco, l'ingresso della vecchia Gerusalemme. È il luogo che, duemila anni fa, partì un altro Paolo, quasi per annunciare che lo attendeva sulla via di Damasco. Sceso dalla vettura, il Pontefice avanza poi in mezzo al tumulto di una folla impazzita. Il suo viso è di un pallore allucinante; ora i suoi occhi si radunano una luce di amore. Le prime del la Legione Araba, cariche di mitragliatrici, fendono la calca patema. E un momento terribile. Il corteo del Papa, per un istante, deve aversi travolto. I suoi accompagnatori sono travolti dall'uncina o degli arabi vocianti, il Pontefice viene quasi soltevato da cinque militari. Il calcia dei mitra dei soldati sbatte il volto del Vicario di Cristo. Ma in quell'attimo, davanti alla porta di Damasco, sullo sfondo della città santa, le labbra di Paolo VI, spinto, prese per i gomiti, travolto nella stretta, mormorano una preghiera esultante. Il suo sguardo offerto una grande direto che non è terrena. A dieci metri dal Pontefice, un gruppo di fedeli intona l'inno dei pellegrini *Laudo Jerusalem Dominum*. Attorno, i soldati agitano palme e fucili.

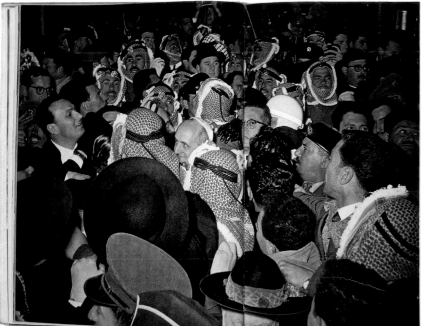

Corre un grido nella calca: il Papa sta male! Ma lui, smarrito, sorride ancora

Lungo le Stazioni della *Via Crucis* la tensa discesa tumultuosa: un'onda che nessuno più può arginare. Alla Quinta Stazione, quella della seconda caduta e del Cireneo, l'incalzare della folla è angoscioso. In mezzo ai muri umidi filtrano odori di agpri gennere. Il volto del Papa, palliodissimo, emerge a tratti fra le masse della roccia, variopinte dei copricapi arabi. Dai lineamenti scavati traspare la sofferenza. Il freddo, l'acrea, la pena brûcia fanno stremato il Pellegrino. Qualcuno grida: «Il Papa sta male!». Ma dalla calca affiora il suo sorriso, che rassicura, che incute fiducia, una luce di bontà che vince il timore. Per riprendersi, il Papa sosta in una cappella alla Sesta Stazione. Ha ritrovato la Patesidina di Gesù, ha avvertito l'angoscia della Croce: avvolto nell'esultante grido della folla, immerso nella turba degli strucusucosi, circondato da soldati urlanti.

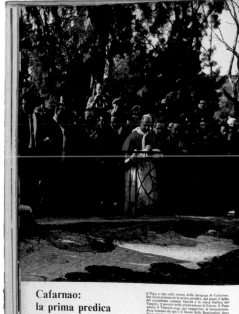

Cafarnao: la prima predica

Il Papa è qui sulle rovine della sinagoga di Cafarnao. Qui Gesù pronunciò la prima predica, qui guarì il figlio del centurione romano. Questa è la nuova Galilea del Vangelo. Il Pontefice erge, poi impartisce la benedizione. Poco lontano da qui è il Monte delle Beatitudini, dove Gesù rivolse alla turba il *Discorso della Montagna*.

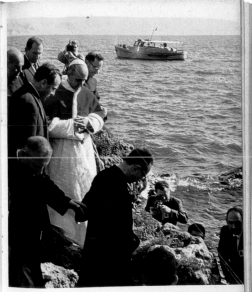

Tiberiade: il lago di Pietro

È uno splendido mezzogiorno di sole. Il lago di Tiberiade, il «mare di Galilea», risplende in una luce cristallina. All'orizzonte, si profila la linea delle colline della roccia, emerge in trasognata, traccia un segno di croce: davanti al lago, duemila anni fa, si avvoltata la barca di Pietro. La folla acconosciuta e prega.

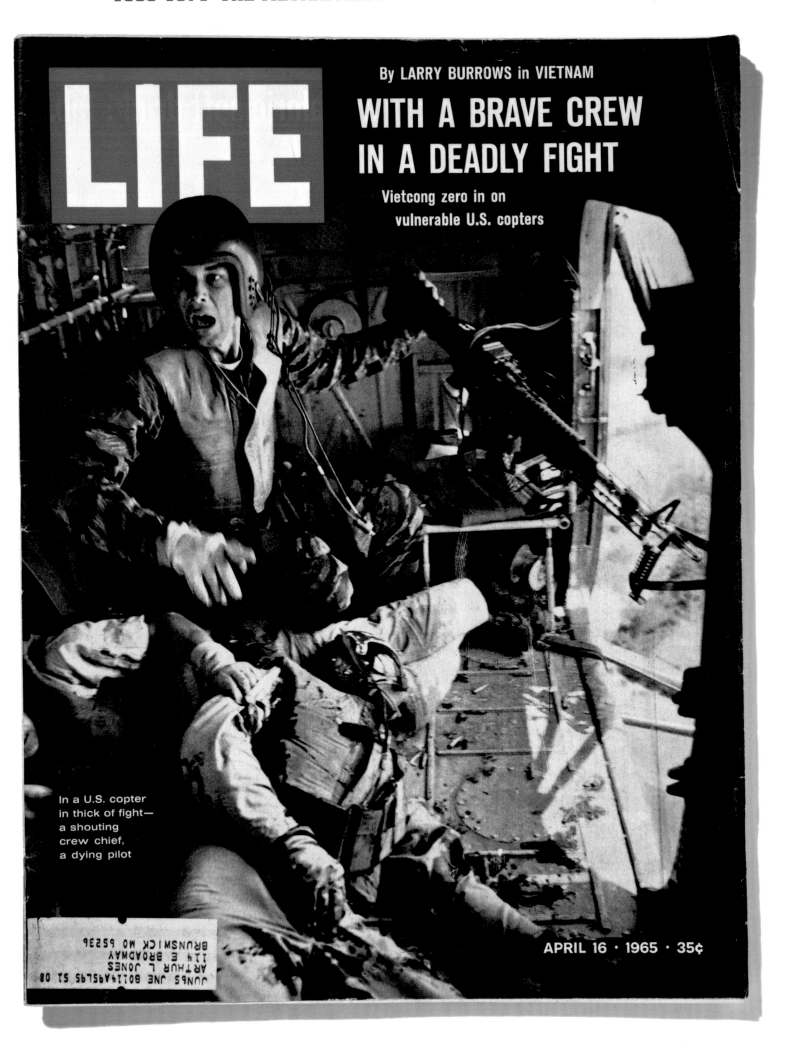

LIFE

By LARRY BURROWS in VIETNAM

WITH A BRAVE CREW IN A DEADLY FIGHT

Vietcong zero in on
vulnerable U.S. copters

In a U.S. copter
in thick of fight—
a shouting
crew chief,
a dying pilot

APRIL 16 · 1965 · 35¢

1965-1974 THE VIETNAM ERA

It's hard to imagine that one ten-year period could have generated so many of the century's historic headlines. Men walk on the moon, rock and roll music becomes the defining voice of a generation and Mohammed Ali becomes sport's greatest star. War in the Middle East comes and goes in a week. In Mexico City, Paris, Prague, Tokyo and Washington DC, demonstrations protesting government policies threaten a global revolution and are quelled with violence. Martin Luther King is assassinated while championing black America's fight for civil rights. Global terrorism erupts in the cause of nationalism and ideology. Over the changing visions and beliefs of the period, the violent debacle of the Vietnam War casts its shadow, polarizing and mobilizing public opinion. It motivates a generation of photographers, making campaigners of them as well as witnesses. The war prompts many of the iconic achievements of photojournalism, with photographs of its brutality provoking the passions of the era, but the times also see the end of the great American behemoth, *Life* magazine, which closes in 1972. The global headquarters of photojournalism moves to Paris, while Europe's colour magazines become its cutting edge – *Paris Match* in Paris, *Stern* in Hamburg and the *Sunday Times* magazine in London. Photojournalists establish their reputation for independence of thought and action, in a new environment for journalism, working mainly as freelancers through Paris-based agencies. Driven by missions they define themselves, and beginning to publish their work on their own terms in books, photojournalism begins to outgrow the press that gave it birth.

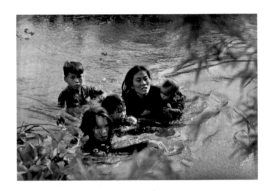

KYOICHI SAWADA *United Press International*
Mother and children wade across river to escape US bombing. Loc Thuong, Binh Dinh, South Vietnam, September 1965. World Press Photo of the Year 1965

HANNS-JÖRG ANDERS **Stern**
A young Catholic during clash with British troops. Derry, Northern Ireland, May 1969. World Press Photo of the Year 1969

WOLFGANG PETER GELLER
Shoot-out between police and bank-robbers. Saarbrücken, West Germany, 29 December 1971. World Press Photo of the Year 1971

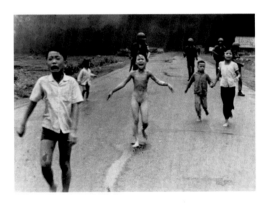

HUYNH CONG UT *Associated Press*
Phan Thi Kim Phuc (centre) flees with other children after South Vietnamese planes mistakenly dropped napalm on South Vietnamese troops and civilians. Trangbang, South Vietnam, 8 June 1972. World Press Photo of the Year 1972

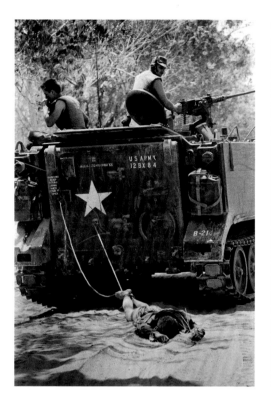

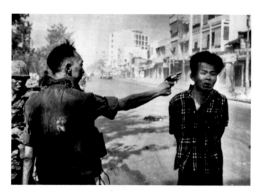

EDDIE ADAMS *Associated Press*
South Vietnam national police chief Nguyen Ngoc Loan executes a suspected Viet Cong member. Saigon, South Vietnam, 1 February 1968. World Press Photo of the Year 1968

KYOICHI SAWADA *United Press International*
American troops drag the body of a Viet Cong soldier to be buried. Tan Binh, South Vietnam, 24 February 1966. World Press Photo of the Year 1966

CO RENTMEESTER *Life*
US tank commander. South Vietnam, May 1967. World Press Photo of the Year 1967

ANON. *New York Times*
Democratically elected President Salvador Allende during military coup, at Moneda presidential palace. Santiago, Chile, 11 September 1973. World Press Photo of the Year 1973

OVIE CARTER *Chicago Tribune*
Drought victim. Kao, Niger, July 1974. World Press Photo of the Year 1974

Bill Eppridge might well be considered the quintessential professional photojournalist of the postwar American illustrated press. Sports, war, 'human interest', Hollywood and all manner of breaking news were efficiently and graphically documented by Eppridge as a staff photographer for *Life*. He adeptly photographed the Beatles on their first arrival in the United States in 1963, and in 1968 made the most widely seen images of the slain body of Robert F Kennedy. After the demise of *Life* he continued for Time Life Inc, working for magazines including *Fortune*, *Sports Illustrated*, *People* and *Time*. 'We are animals in a world no one knows', with its second instalment, 'Panic in Needle Park', is probably his best-known essay – though typical neither for Eppridge nor for *Life*. Illustrating a darker side of suburban America, the story follows the daily activities of an attractive, white, middle-class, New York couple who are heroin addicts, forced by their habit to turn to robbery and prostitution. With their moody drama, the pictures stylistically evoke a *film noir* approach. The story made a big impression on its American audience, the first to present the use of illegal drugs in the mainstream press. It remains among the best-remembered photo essays published by *Life*. (26 February 1965)

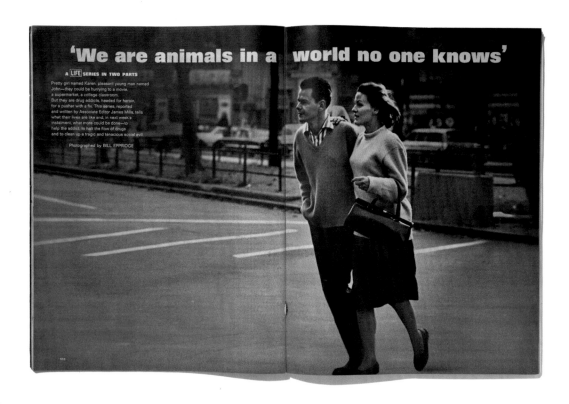

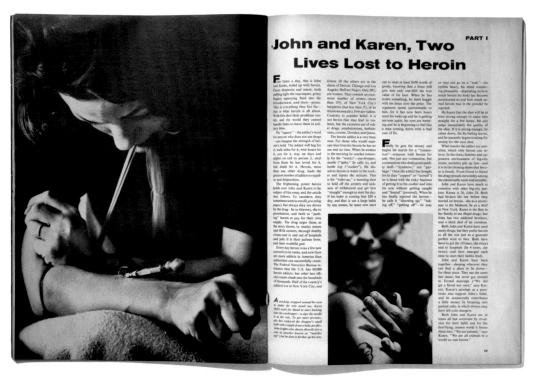

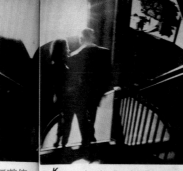

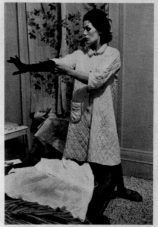

To get money, Karen prostitutes and pushes, John loots cabs

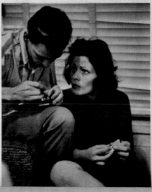

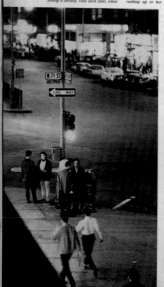

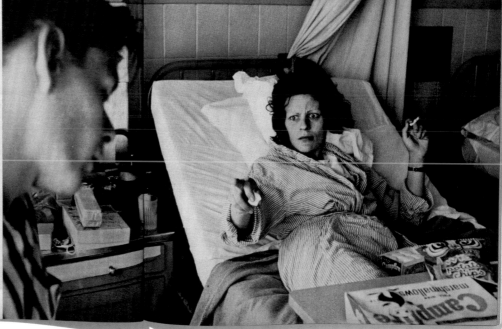

Keeping a furtive eye out for detectives, Karen passes a pusher $5 for a bag of heroin. Sometimes, like most junkies, she earns money for heroin by selling it herself. One such time, when a pusher gave her a small supply of unusually pure heroin on consignment, she went quickly into business on a corner (below). Soon junkies were rushing up to her to arrange buys.

Almost all female addicts support their habit by prostitution, and Karen is no exception. After a $10 "trick" with a "John" (customer) in a hotel, she leads him down back stairs (above, right), then stands lookout while John rifles cabs (below). Asked how many cabs he has "boosted," John said, "How many are in New York? I guess I make more off them than the owners."

Karen, once a show girl in a New York nightclub, grows nostalgic after a heroin shot (right) and begins to model clothes stolen from a friend's wife. Earlier she sat with John (below, right) while he tried to fix a radio taken from a cab. He gets many radios from taxis, and once turned up $500 hidden under a seat—but was himself robbed of half of it by other junkies.

He visits her in a hospital: 'Stop nodding, they'll throw me out'

Leaving for a hospital, Karen kisses a customer goodby, while John looks away. Her body had built up such a high tolerance to heroin that she was having trouble getting enough to hold off withdrawal symptoms. She knew that after a couple of weeks away from the drug in a hospital, she would be able to start her habit afresh—getting a stronger "high" from a smaller dose.

To win admittance to the hospital, Karen pretends to be in great pain from heroin withdrawal, while a nurse fills out forms. After a few questions and a quick search for drugs in her belongings, the hospital finally let her in.

Visiting Karen in the hospital, Johnny showed up high on heroin and spent most of his time there nodding (above). Afraid that he would get her in trouble with the nurses, Karen yelled at him to stand up straight (right). "You're stoned, buddy! Stop that nodding before they throw me out!" He grumbled that he was not nodding, just awfully sleepy from not having had a place to lie down for three days. On several later visits John brought her heroin and the needle and eyedropper needed to inject it. Why was she using stuff if she was there to kick the habit? "I just felt like getting high like any other human being would. I was bored. I'd been lying there in that hospital for a week, and when you're kicking and they're giving you methadone [a drug hospitals use to withdraw addicts from heroin] you just feel so normal."

72

Top spread

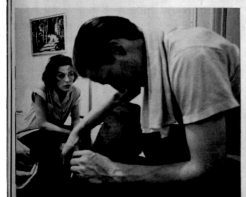

The cops search them—and John gets locked up

A few days after she left the hospital, Karen stood with John on a street corner, unaware that they were closely watched by two narcotics detectives (one is behind the mailbox in the top picture at left). The detectives had heard that John and Karen were selling drugs and, for an hour, stayed near enough to watch what they were up to. Then when another addict walked up, brushed against them and kept on going, the detectives assumed that drugs had been passed, and moved in. One questioned Karen (center picture) while the other searched John's pockets and cuffs. Karen broke into tears (bottom). "Whenever the cops come around," she explained later, "I right away start crying and yelling, especially if I've got stuff on me. Usually they don't want too much to do with a screaming, hysterical broad, so they lay off." John tries never to have any drugs on him. When he is pushing heroin, he usually follows the general practice and hides the bags between the pages of a phone book in a public booth, or under a trash can or behind a radiator in a hotel hallway. Then he simply takes the customer's money and tells him where to look.

Jailed for disorderly conduct, John stares through the bars, then sits on his bunk yawning and holding his stomach as he goes through withdrawal. A policeman arrested him when he balked at moving off a corner where he and other junkies were loitering. He was locked up for 18 days. John admits that often during withdrawal the nervous anxiety is far worse than the physical discomfort. "When I'm kicking in jail," he says, "I just gotta have someone to talk to. Once I was lyin' there kicking and this other guy was in the bunk over me and he was sleepin' and sleepin'—like a baby. I shoved hard on the bottom of his bunk and threw him clean out onto the floor. Man, he was scared, his eyes was wide open. And I said to him, 'Okay, man, now talk!'"

Bottom spread

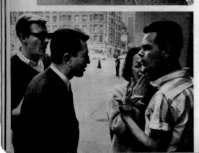

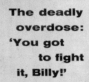 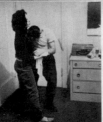 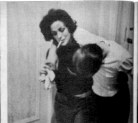 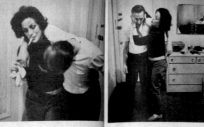

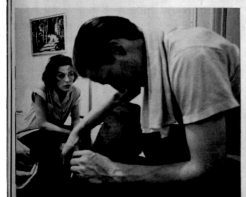

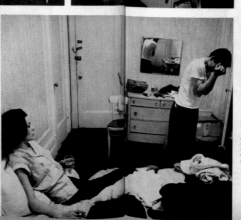

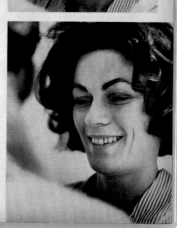

The deadly overdose: 'You got to fight it, Billy!'

One of the junky's natural enemies is the overdose, the "OD"—a shot that unexpectedly contains more heroin than his body can survive. In these pictures, taken while Johnny was in jail, Karen works to save the life of a young addict named Billy. Her expressions (right) mirror the danger, hope and final victory of her two-hour struggle. Billy collapsed in a hotel room after swallowing five Doriden tablets and then mainlining a shot of heroin. Though he is nearly unconscious, Karen holds him on his feet and keeps him walking.

Open your eyes, Billy. Try to wake up. You took too much stuff, Billy. Don't go to sleep—you might not wake up. You got to fight it, Billy. Do you hear me, Billy? You got to fight it, Billy! Billy?" Exhausted and hot from walking him around the room, Karen has dumped him into a chair and removed her sweater. Then, afraid that if he sits down too long he will slip into a fatal coma, she walks him some more. Finally, she sits him down in a chair again and shouts into his ear. He begins to come around. "That Doriden is something," she explains. "It makes you feel like you were almost clean, almost like you'd never had any heroin before. And then you take the heroin and, man, it really sends you."

Still only half-conscious, Billy sits with a cigaret in his hand and a wet towel thrown over his neck. Now that he can walk by himself, Karen—who herself has had a shot of heroin—rests on the bed with a glass of water. Billy begins to mumble, finally gets out a complete sentence: "Man, that was a good bag." He was lucky it wasn't better. Almost every day in New York City an addict dies of an overdose, some sold intentionally by pushers who think the addict has been "stealing" shots" contain no heroin at all, but rat poison. Addicts call this type of hotshot a "ten-cent pistol" because the poison costs a dime but is as effective as a gun. Junkies may be quite informal about disposing of OD'd friends. Karen once heard a strange sound ("it was like shhhhh, shhhhh") outside her hotel room. When she looked she saw two junkies dragging a body down the hall.

John out of jail: 'Don't play with my brains!'

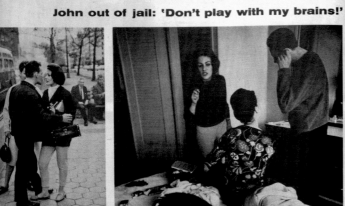

Meeting Karen his first day out of jail (above), John bawls her out for not writing. Later in a hotel (below) he gets affectionate, his drug-free days in jail having restored desires dulled by heroin.

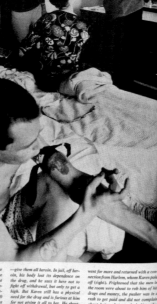

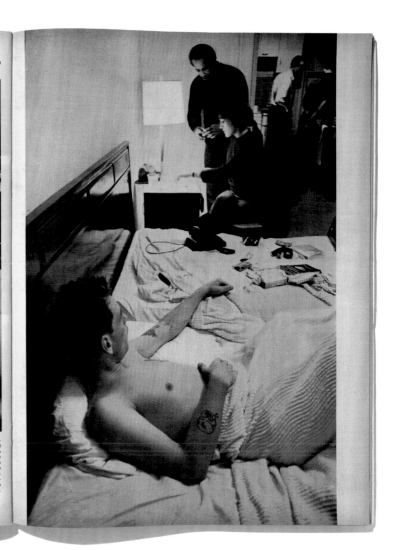

Go ahead and shoot it all up! You're a pig junky, just like you always were and always will be!" Karen screams at John as he takes a shot (above) minutes after his release from jail. Before he was arrested he had hidden 30 bags of heroin in a hotel hallway. Just after meeting Karen, he retrieved his stash, collected some friends and went to another hotel to "turn everyone on"—give them all heroin. In jail, off heroin, his body lost its dependence on the drug, and he uses it here not to fight off withdrawal, but only to get a high. But Karen still has a physical need for the drug and is furious at him for not giving it all to her. He shouted back at her, "Don't bug me, Karen! Don't play with my brains!" All 30 bags were gone by that night. A friend *went for more and returned with a connection from Harlem, whom Karen paid off (right). Frightened that the men in the room were about to rob him of his drugs and money, the pusher was in a rush to get paid and did not complain about being photographed. Nevertheless, since his identification might encourage him to retaliate against John and Karen, his face has been retouched.*

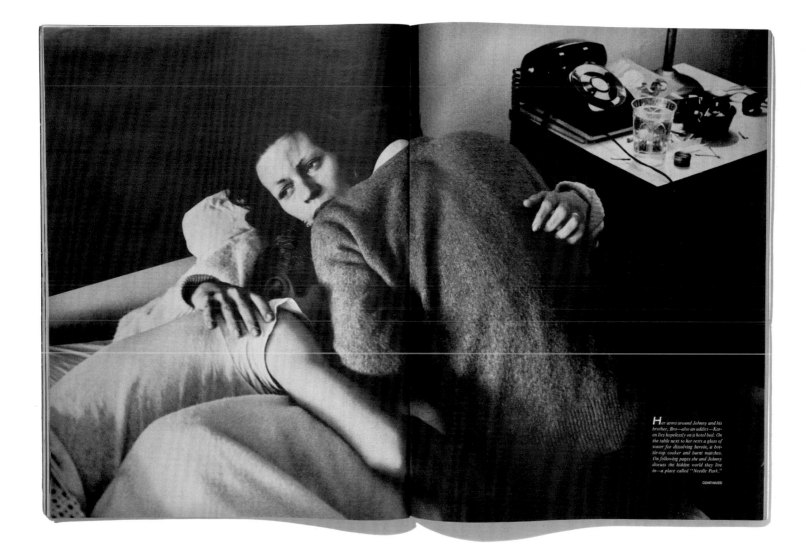

Her arms around Johnny and his brother, Bro—also an addict—Karen lies hopelessly on a hotel bed. On the table next to her rests a glass of water for dissolving heroin, a bottle-top cooker and burnt matches. On following pages she and Johnny discuss the hidden world they live in—a place called "Needle Park."

CONTINUED

The three photographers who made the most important essays about the Vietnam War – Don McCullin, Philip Jones Griffiths and Larry Burrows – were all British, but only Burrows worked for the American press. He began his career at sixteen, as a technician in *Life*'s London darkroom, and was already a senior photographer in 1962 when the first American military 'advisers' arrived in South Vietnam. According to Burrows' colleague, journalist David Halberstam, 'Vietnam what was what he had long been waiting for … He was drawn to it by both its elemental humanity and its parallel cruelty and violence, and by the fact that it lent itself so well to what he wanted to do – the magazine photo spread.' He was a consummate reporter and storyteller as well as image-maker. An advocate for the individual soldier and the victims of war rather than for any political point of view, he was perfect for *Life*; while his stories were full of emotion and gritty detail, they did not question the justice of the war itself. Burrows lost his life in Vietnam, in a helicopter crash in 1971. (16 April 1965)

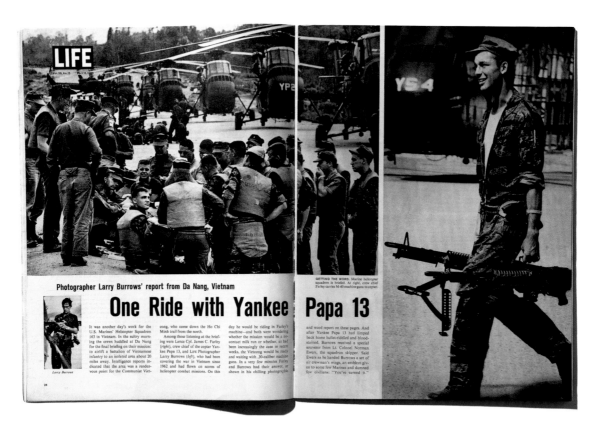

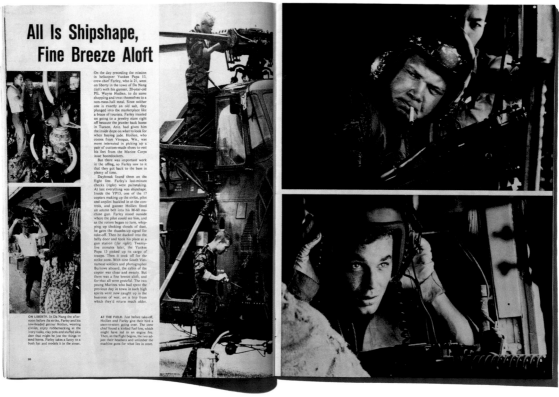

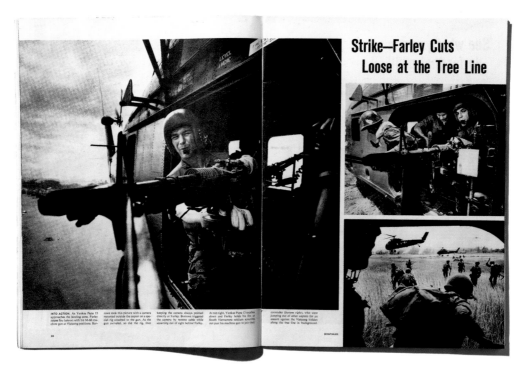

Strike—Farley Cuts Loose at the Tree Line

INTO ACTION. As Yankee Papa 13 approaches the landing zone, Farley opens fire (above) with his M-60 machine gun at Vietcong positions. Burrows took this picture with a camera mounted outside the copter on a special rig attached to the gun. As the gun swiveled, so did the rig, thus keeping the camera always pointed directly at Farley. Burrows triggered the camera by remote cable while squatting out of sight behind Farley.

At top right, Yankee Papa 13 circles down and Farley holds his fire as South Vietnamese soldiers scramble out past his machine gun to join their comrades (bottom right), who were jumping out of other copters for an assault against the Vietcong hidden along the tree line in background.

CONTINUED

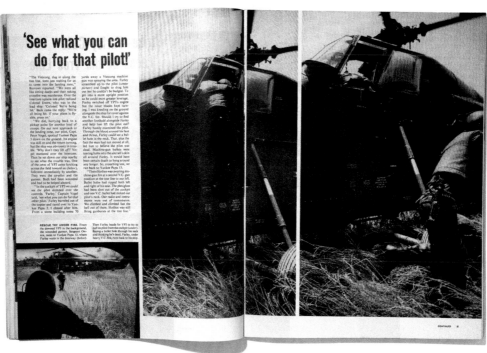

'See what you can do for that pilot!'

"The Vietcong, dug in along the tree line, were just waiting for us to come into the landing zone," Burrows reported. "We were all like sitting ducks and their raking crossfire was murderous. Over the intercom system one pilot radioed Colonel Ewers, who was in the lead ship: 'Colonel! We're being hit.' Back came the reply: 'We're all being hit. If your plane is flyable, press on.'

"We did, hurrying back to a pickup point for another load of troops. On our next approach to the landing zone, our pilot, Capt. Peter Vogel, spotted Yankee Papa 3 down on the ground. Its engine was still on and the rotors turning, but the ship was obviously in trouble. 'Why don't they lift off?' Vogel muttered over the intercom. Then he set down our ship nearby to see what the trouble was. One of the crew of YP3 came lurching across the field toward us (below), followed immediately by another. They were the co-pilot and the gunner. Both had been wounded and had to be helped aboard.

"In the cockpit of YP3 we could see the pilot slumped over the controls. 'Farley,' Captain Vogel said, 'see what you can do for that other pilot.' Farley hurried out of the copter and raced over to Yankee Papa 3. I closed after him. From a stone building some 70 yards away a Vietcong machine gun was spraying the area. Farley scrambled up to the pilot (center picture) and fought to drag him out but he couldn't budge him. To get into a more upright position so he could exert greater leverage, Farley switched off YP3's engine but the rotor blades kept turning. I was kneeling on the ground alongside the ship for cover against the V.C. fire. Should I try to find another foothold alongside Farley and help him lift the pilot out? Farley hastily examined the pilot. Through the blood around his face and throat, Farley could see a bullet hole in the neck. That, plus the fact the man had not moved at all, led him to believe the pilot was dead. Machine-gun bullets were tearing holes into the aircraft's skin all around Farley. It would have been certain death to hang around any longer. So, crouching low, we ran back to Yankee Papa 13.

"There Hollien was pouring machine-gun fire at a second V.C. gun position at the tree line to our left. Bullet holes had ripped both left and right of his seat. The plexiglass had been shot out of the cockpit and one V.C. bullet had ricked our pilot's neck. Our radio and instruments were out of commission. We climbed and climbed but the hell out of there. Hollien was still firing gunbursts at the tree line."

RESCUE TRY UNDER FIRE. From the downed YP3 in the background, the wounded gunner, Sergeant Owens, races to Yankee Papa 13, where Farley waits in the doorway (below).

Then Farley heads for YP3 to try to pull its pilot from the cockpit (center). Braving a bullet hole through his neck and thinking he's dead, Farley, under heavy V.C. fire, runs back to his ship.

CONTINUED

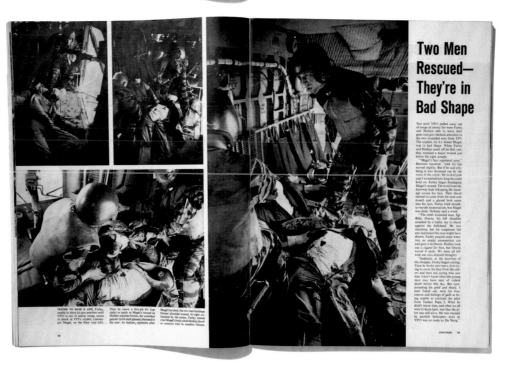

Two Men Rescued— They're in Bad Shape

Not until YP13 pulled away out of range of enemy fire were Farley and Hollien able to leave their guns and give medical attention to the two wounded men from YP3. The copilot, 1st Lt. James Magel, was in bad shape. When Farley and Hollien eased off his flak vest, they exposed a major wound just below his right armpit.

"Magel's face registered pain," Burrows reported, "and his lips moved slightly. But if he said anything it was drowned out by the noise of the copter. He looked pale and I wondered how long he could hold on. Farley began bandaging Magel's wound. The wind from the doorway kept whipping the bandage across his face. Then blood started to come from his nose and mouth and a glazed look came into his eyes. Farley tried mouth-to-mouth resuscitation, but Magel was dead. Nobody said a word.

"The other wounded man, Sgt. Billie Owens, his left shoulder assailed by a bullet, lay in shock against the bulkhead. He was watching, his sun sunglasses hid any expression his eyes might have shown. Farley poured some water into an empty ammunition can and gave it to Owens. Hollien took out a cigarette for him, but Owens waved it aside. We were all left with our own dismal thoughts.

"Suddenly, at the doorway of the chopper, Farley began cursing. Then he broke into tears, first crying to cover his face from the others and then not caring who saw this. I don't know what this young man may have seen of violent death before this day. But corresponding his grief and shock, I later found out, were his frustration and feelings of guilt at being unable to extricate the pilot from Yankee Papa 3. What he didn't know then, and what we all were to learn later, was that the pilot was still alive. He was rescued by another helicopter—even as YP3 was en route to Da Nang.

TRYING TO SAVE A LIFE. Farley, unable to leave his gun position until YP13 is out of enemy range, comes in shock at YP3's copilot, Lieutenant Magel, on the floor (top left).

Then he opens a first-aid kit (top right) to apply to Magel's wound as Hollien watches Owens, the wounded gunner (with dark glasses) slumped in the rear. At bottom, represents after Magel has died, the two men bandaged Owens' shoulder wound. At right, exhausted by the strain, Farley stands over Magel's body while Hollien tried to comfort or console Owens.

CONTINUED

THE WAY BACK. With 11 bullet holes in its skin and its radio knocked out, Yankee Papa 13 heads for Da Nang. Now, during the 20-minute flight, there is nothing more to be done. Magel lies dead on the floor and the wounded gunner Owens, his shoulder patched up, slumps against Hoilien. Farley (*right*), sags in exhaustion and fights back the tears.

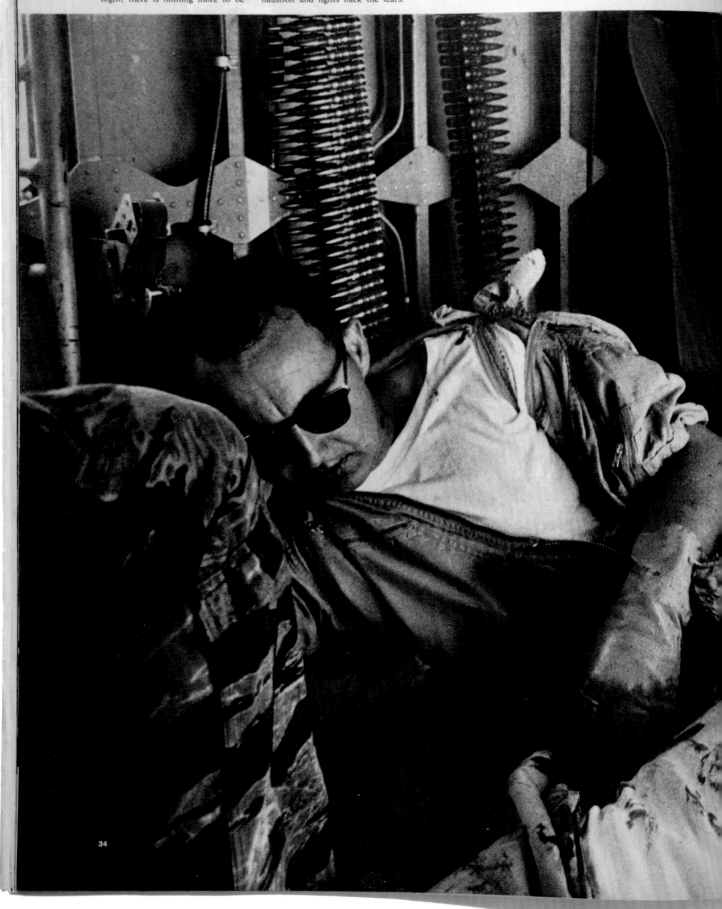

34

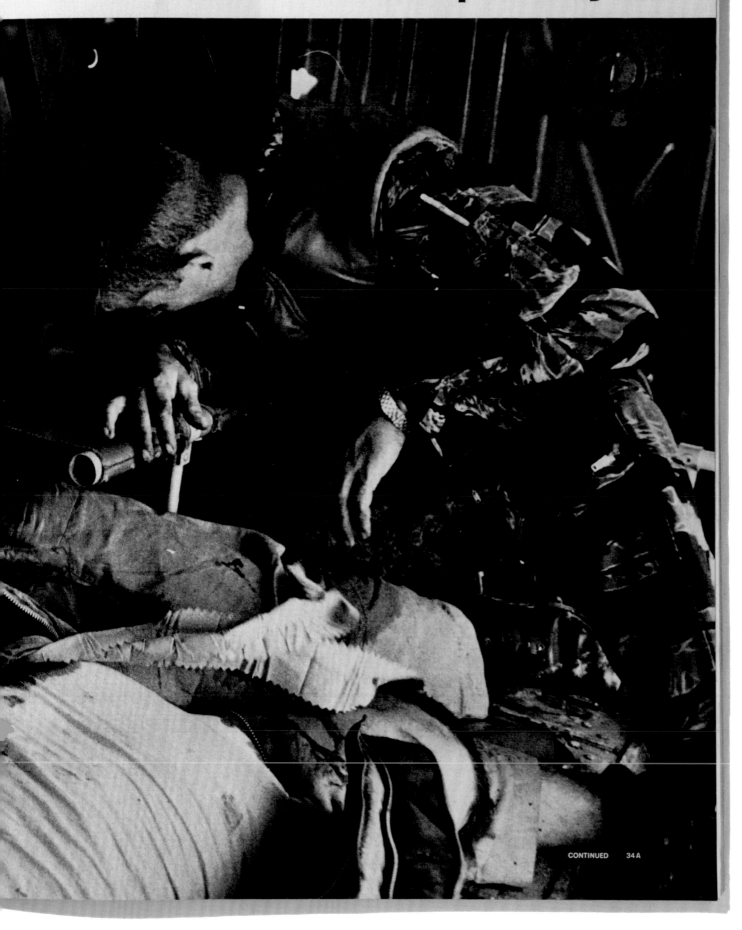

CONTINUED 34 A

The Civil Rights movement in the United States reached a turning point on Sunday, 7 March 1965, when television and newspapers covered a bloody battle between the Alabama police, armed with clubs, whips, and tear gas, and 600 mostly black civil rights demonstrators led by Martin Luther King. Thanks to the cameras, King's campaign – until then seen as a Southern phenomenon and problem – began to receive wide support across America. With the momentum raised, a crowd of over 3,200 left Selma on 21 March demanding equal voting rights, swelling to 25,000 by the time they reached Montgomery. When James Karales and writer Christopher Wren covered the story for *Look*, they faced a perennial magazine reporter's problem – they could not cover this urgent story as breaking news, because the magazine's slow production time meant that it would not reach the news-stands until the middle of May. In seeking an angle, they chose to focus on the growing strength of support for King among white clergy, many of whom participated in the march. Among the ten images the magazine ran, one became Karales's most famous – the endless column of peaceful marchers carrying American flags along an open highway – and an optimistic metaphor in the fight for social justice. (18 May 1965)

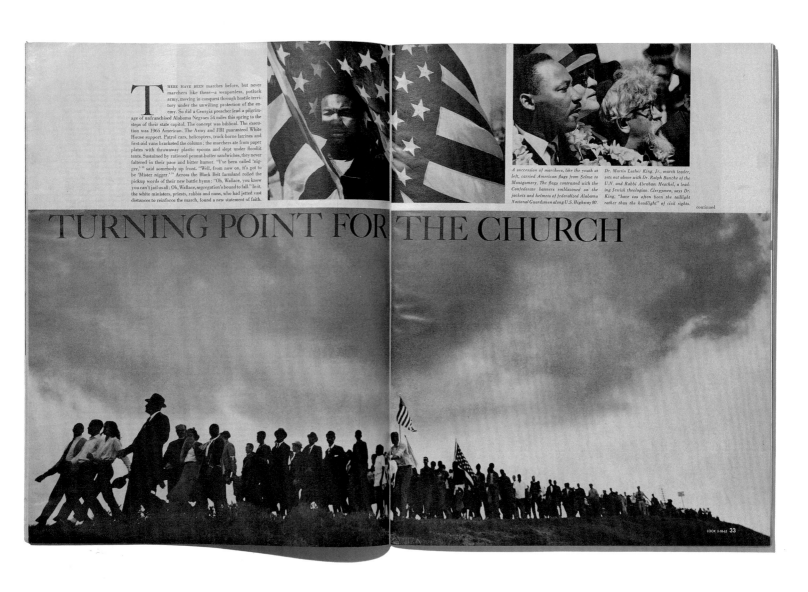

THERE HAVE BEEN marches before, but never marchers like these—a weaponless, potluck army, moving in conquest through hostile territory under the unwilling protection of the enemy. So did a Georgia preacher lead a pilgrimage of unfranchised Alabama Negroes 54 miles this spring to the steps of their state capitol. The concept was biblical. The execution was 1965 American. The Army and FBI guaranteed White House support. Patrol cars, helicopters, truck-borne latrines and first-aid vans bracketed the column; the marchers ate from paper plates with throwaway plastic spoons and slept under floodlit tents. Sustained by rationed peanut-butter sandwiches, they never faltered in their pace and bitter humor. "I've been called 'nigger,'" said somebody up front. "Well, from now on, it's got to be 'Mister nigger.'" Across the Black Belt farmland rolled the pickup words of their new battle hymn: "Oh, Wallace, you know you can't jail us all; Oh, Wallace, segregation's bound to fall." In it, the white ministers, priests, rabbis and nuns, who had jetted vast distances to reinforce the march, found a new statement of faith.

A succession of marchers, like the youth at left, carried American flags from Selma to Montgomery. The flags contrasted with the Confederate banners emblazoned on the jackets and helmets of federalized Alabama National Guardsmen along U.S. Highway 80.

Dr. Martin Luther King, Jr., march leader, sets out above with Dr. Ralph Bunche of the U.N. and Rabbi Abraham Heschel, a leading Jewish theologian. Clergymen, says Dr. King, "have too often been the taillight rather than the headlight" of civil rights.

continued

TURNING POINT FOR THE CHURCH

LOOK 5-18-65 **33**

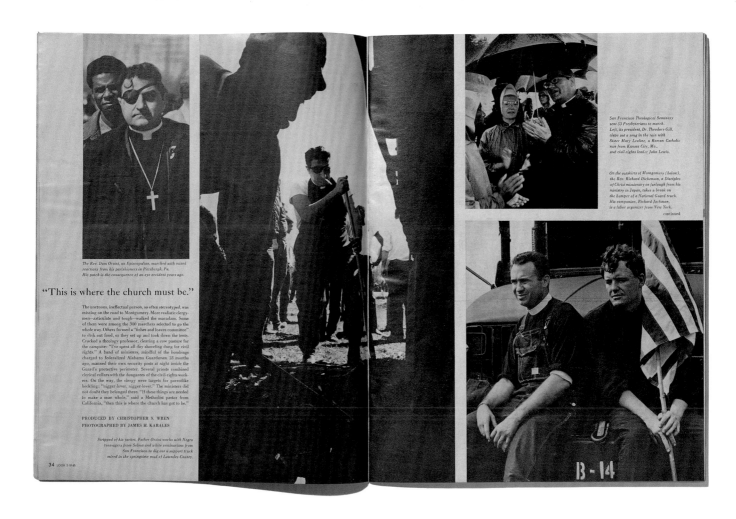

The Rev. Dom Orsini, an Episcopalian, marched with mixed reactions from his parishioners in Pittsburgh, Pa. His patch is the consequence of an eye accident years ago.

San Francisco Theological Seminary sent 53 Presbyterians to march. Left, its president, Dr. Theodore Gill, claps out a song in the rain with Sister Mary Leoline, a Roman Catholic nun from Kansas City, Mo., and civil-rights leader John Lewis.

On the outskirts of Montgomery (below), the Rev. Richard Dickenson, a Disciples of Christ missionary on furlough from his ministry in Japan, takes a break on the bumper of a National Guard truck. His companion, Richard Jackman, is a labor organizer from New York.

continued

"This is where the church must be."

The unctuous, ineffectual parson, so often stereotyped, was missing on the road to Montgomery. More realistic clergymen—articulate and tough—walked the macadam. Some of them were among the 300 marchers selected to go the whole way. Others formed a "fishes and loaves committee" to dish out food, or they set up and took down the tents. Cracked a theology professor, clearing a cow pasture for the campsite: "I've spent all day shoveling dung for civil rights." A band of ministers, mindful of the bombings charged to federalized Alabama Guardsmen 18 months ago, manned their own security posts at night inside the Guard's protective perimeter. Several priests combined clerical collars with the dungarees of the civil-rights workers. On the way, the clergy were targets for parrotlike heckling: "nigger-lover, nigger-lover." The ministers did not doubt they belonged there. "If these things are needed to make a man whole," said a Methodist pastor from California, "then this is where the church has got to be."

PRODUCED BY CHRISTOPHER S. WREN
PHOTOGRAPHED BY JAMES H. KARALES

Stripped of his jacket, Father Orsini works with Negro teenagers from Selma and white seminarians from San Francisco to dig out a support truck mired in the springtime mud of Lowndes County.

34 LOOK 5-18-65

B-14

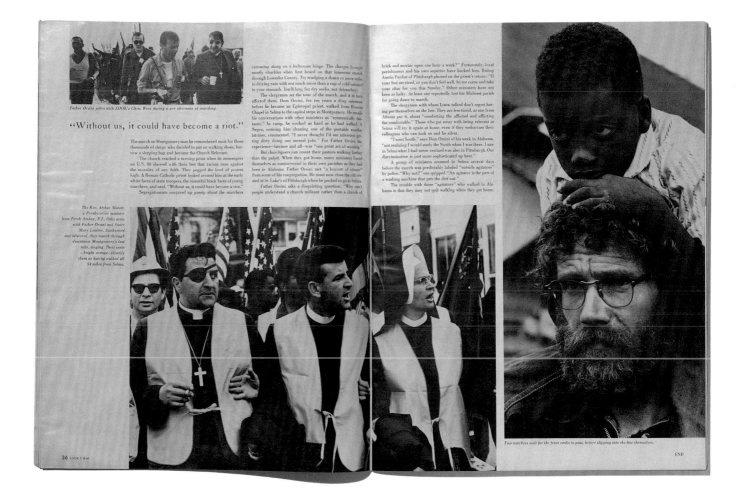

Father Orsini jokes with LOOK's Chris Wren during a wet afternoon of marching.

"Without us, it could have become a riot."

The march on Montgomery may be remembered most for those thousands of clergy who decided to put on walking shoes, borrow a sleeping bag and become the Church Belcrant.

The church reached a turning point when its messengers on U.S. 80 showed with their feet that racism runs against the morality of any faith. They pegged the level of protest high. A Roman Catholic priest looked around him at the surly white faces of state troopers, the resentful black faces of young marchers, and said, "Without us, it could have become a riot."

Segregationists conjured up gossip about the marchers carousing along on a lecherous binge. The charges brought mostly chuckles when first heard on that lonesome stretch through Lowndes County. Try trudging a dozen or more miles in driving rain with not much more than a cup of cold oatmeal in your stomach. You'll long for dry socks, not debauchery.

The clergymen set the tone of the march, and it in turn affected them. Dom Orsini, for ten years a drug salesman before he became an Episcopal priest, walked from Browns Chapel in Selma to the capitol steps in Montgomery. He recalls his conversations with other ministers as "ecumenically fantastic." In camp, he worked as hard as he had walked. A Negro, noticing him cleaning one of the portable wooden latrines, commented, "I never thought I'd see ministers getting dirty doing our menial jobs." For Father Orsini, the experience—latrines and all—was "one great act of worship."

But churchgoers can resent their pastors walking farther than the pulpit. When they got home, many ministers found themselves as controversial in their own parishes as they had been in Alabama. Father Orsini met "a boycott of silence" from some of his congregation. He must now close the rift created at St. Luke's of Pittsburgh when he packed to go to Selma.

Father Orsini asks a disquieting question: "Why can't people understand a church militant rather than a church of

brick and mortar open one hour a week?" Fortunately, loyal parishioners and his smart superior have backed him. Bishop Austin Pardue of Pittsburgh phoned on the priest's return: "If your feet are tired, or you don't feel well, let me come and take your altar for you this Sunday." Other ministers have not been as lucky. At least one reportedly lost his Midwest parish for going down to march.

The clergymen with whom Look talked don't regret having put themselves on the line. They are less timid, as one from Atlanta put it, about "comforting the afflicted and afflicting the comfortable." Those who got away with being relevant in Selma will try it again at home, even if they embarrass their colleagues who can look on and be silent.

"I went South," says Dom Orsini of his week in Alabama, "not realizing I would study the North when I was there. I saw in Selma what I had never realized was also in Pittsburgh. Our discrimination is just more sophisticated up here."

A group of ministers arrested in Selma several days before the march was predictably labeled "outside agitators" by police. "Why not?" one quipped. "An agitator is the part of a washing machine that gets the dirt out."

The trouble with those "agitators" who walked in Alabama is that they may not quit walking when they get home.

The Rev. Arthur Matott, a Presbyterian minister from Perth Amboy, N.J., links arms with Father Orsini and Sister Mary Leoline. Sunburned and blistered, they march through downtown Montgomery's last mile, singing. Their vests —bright orange—identify them as having walked all 54 miles from Selma.

Two watchers wait for the front ranks to pass, before slipping into the line themselves.

36 LOOK 5-18-65

END

119

The second World Heavyweight Championship match between boxers Mohammed Ali and Sonny Liston was an important moment in the history of boxing and in Ali's career. Ali won his first title in 1964, when he was still known as Cassius Clay, and had since converted to Islam, arousing some scepticism from the mostly white sports establishment. In a fight no-one believed Ali could win, he landed three punches. Liston fell on his back, and it was over in sixty seconds. The crowd yelled 'Fake!' Ali, anxious to prove his victory was real, broke regulations and stood over Liston shouting 'Get up and fight, sucker!' *Sports Illustrated* called it 'the fight you never saw' – though magazine readers got several pages of pictures, including spectacular photographs by Neil Leifer and a cover by George Silk. With this fight Ali secured his title and his new name – which he announced shortly afterwards. It made a hero out of Leifer too – with typical modesty, Leifer later claimed how Ali 'made every single person who got close to him a hero' – helping him consolidate a reputation for reliably catching the critical moment in a career in news and sports that lasted over 40 years.
(7 June 1965)

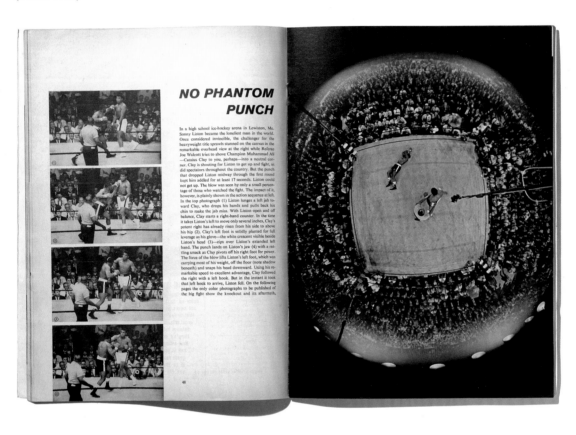

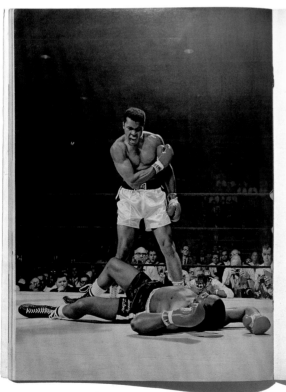

Sports Illustrated

VEECK: Part 4

JUNE 7, 1965 35 CENTS

THE FIGHT YOU DIDN'T SEE

Science writer Stephen Jay Gould called Fritz Goro 'the most influential photographer that science journalism (and science in general) has ever known'. Born Fritz Goreau in Germany at the turn of the century, he trained at the Bauhaus and worked for magazines in Munich and Paris before coming to America in 1936. There, along with other German refugees, he joined the Black Star agency and, in 1945, the staff of *Life* magazine. For the next forty years, Goro's images introduced *Life* and other magazines' readers to spectacular innovations in the fields of physics, biology, and chemistry. He visualized the DNA molecule and was the first to make still photographs of blood circulating in living animals. His essays addressed the processes of cancer and popularized molecular science. He modestly described his mission as making 'the truth so attractive that people will look and learn at once'. For many of his readers in the 1960s, the story was a revelation. (10 September 1965)

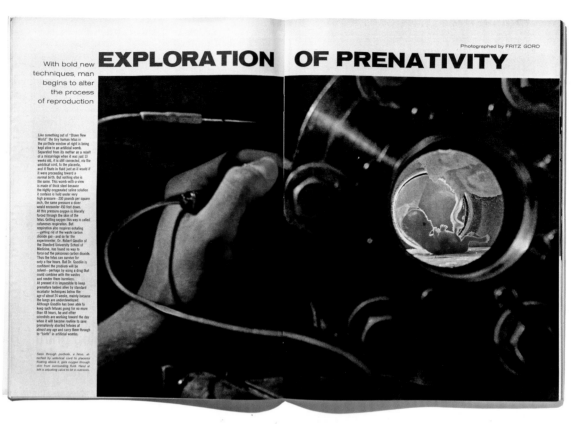

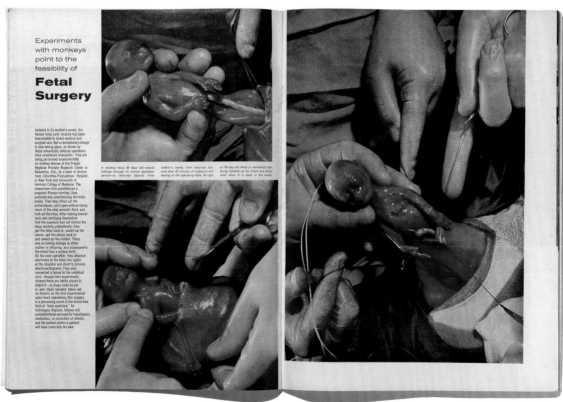

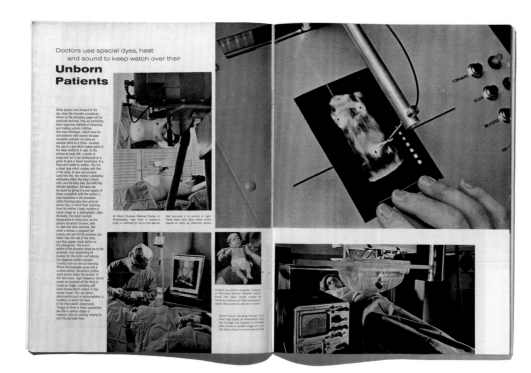

Doctors use special dyes, heat
and sound to keep watch over their

Unborn
Patients

While doctors look forward to the day when the dramatic procedures shown on the preceding pages will be practiced routinely, they are perfecting other ingenious methods of observing and treating unborn children.

One new technique—which must be administered with caution because excessive radiation can have an adverse effect on a fetus—involves the use of a dye which makes parts of the fetus visible to X-rays. In the picture at lower left, a doctor is using such an X-ray photograph as a guide to give a blood transfusion to a fetus still inside its mother. She has a blood type which clashes with that of her baby; in rare and extreme cases like this, the mother's protective antibodies attack the baby's blood cells, and the baby dies. But with this delicate operation, the baby can be saved by giving it a new supply of blood compatible with the mother's.

Less hazardous is the procedure called thermography (two pictures across top), in which heat radiating from the mother's body registers a visual image on a photographic plate. Normally, the body's surface temperature is fairly even, so the picture too would be even, with no light and dark contrasts. But when a woman is pregnant her breasts and part of the abdomen are hotter than the rest of the body, and thus appear much lighter on the photograph. The actual outline of the placenta shows up in the abdomen, then pinpointing its location for the doctor and helping him diagnose certain prenatal troubles such as internal bleeding. Where thermography gives only a surface outline, ultrasonics (below, right) probes below the surface. In this technique, high-frequency sound waves are bounced off the fetus to create an image—including soft, inner tissues which routine X-rays cannot reveal. This can detect abnormalities such as hydrocephalus, a condition in which the head of the fetus swells dangerously. Through all three of these approaches are still in various stages of research, they are already helping to cure ills and save lives.

At Albert Einstein Medical Center in Philadelphia, heat from a woman's body is reflected by mirror into device

that converts it to picture at right. These black dots show metal circles placed on body as reference points.

Using X-ray picture as guide, a doctor at Winnipeg General Hospital injects blood into fetus inside mother to reverse condition for fatal heartbeat it caused. Baby (above) was born normal.

Sound waves traveling through fluid-filled bag (right), at Hahnemann Medical College and Hospital in Philadelphia produce a graphic image of a mental baby's head on screen beside bed.

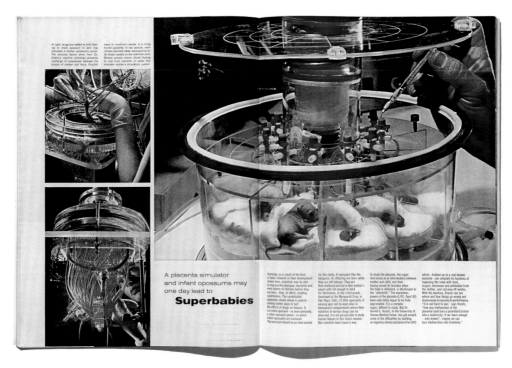

A placenta simulator
and infant opossums may
one day lead to

Superbabies

At right, drugs are added to milk flowing to infant opossum in tank that simulates a mother opossum's pouch. The pictures below show how Dr. Krantz's machine simulates placental exchange of substances between the bloods of mother and fetus. Purplish mass in machine's center is a living human placenta. In top picture, technicians connect tubes representing fetal blood vessels to the umbilical cord. Bottom picture shows blood flowing to and from placenta in tubes that simulate mother's circulatory system.

Someday, as a result of the kind of basic research in fetal development shown here, scientists may be able to improve the physique, mentality and even talents of children before they are born—thus, in effect, creating superbabies. The complicated apparatus shown above is used to develop better ways to test the effects of drugs on fetuses. It is a robot opossum—or more precisely, a robot opossum pouch—in which infant opossums are nurtured. The opossum should be an ideal animal for this study. A marsupial like the kangaroo, its offspring are born while they are still fetuses. They are then sheltered and fed in their mother's pouch until old enough to fend for themselves. In the robot pouch, developed at the Marquardt Corp. in Van Nuys, Calif., 12 little opossums of varying ages can be kept alive in transparent compartments where their reactions to various drugs can be observed. It is not yet possible to study human fetuses in this direct manner. But scientists have found a way

to study the placenta, the organ that serves as an intermediary between mother and child, and then, having severed its function when the baby is delivered, is discharged as the "afterbirth." The marvelous powers of the placenta (LIFE, April 30) have only lately begun to be truly appreciated. It is a complex organ, difficult to study. But Dr. Kermit E. Krantz, of the University of Kansas Medical Center, has got around some of the difficulties by building an ingenious device (pictures at far left)

which—hooked up to a real human placenta—can simulate its functions of supplying the fetus with food, oxygen, hormones and antibodies from the mother, and carrying off wastes. With his machine, Krantz can see where and how things go wrong and devise ways to improve its performance. "It is not hard to see," says Krantz, "how any malfunction of the placenta could turn a potential Einstein into a mediocrity. If we learn enough—who knows?—maybe we can turn mediocrities into Einsteins."

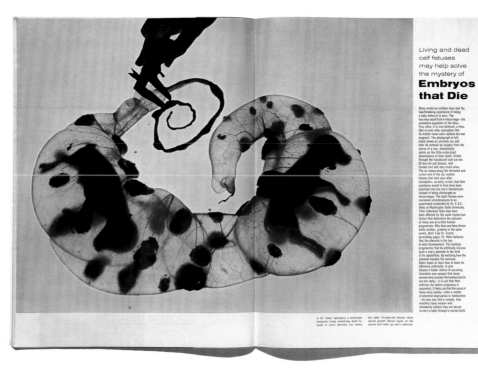

Living and dead
calf fetuses
may help solve
the mystery of

Embryos
that Die

Many would-be mothers have had the heartbreaking experience of losing a baby before it is born. The loss may result from a miscarriage—the premature expulsion of the fetus. Very often, it is now believed, a fetus dies so soon after conception that its mother never even realizes she was pregnant. The photograph at left, which shows an amniotic sac just after its removal by surgery from the uterus of a cow, dramatically points up the little-understood phenomenon of fetal death. Visible through the translucent wall are ten 90-day-old calf fetuses, well formed and still very much alive. The six lumps along the shriveled and curled end of the sac contain fetuses that died soon after conception—so early, in fact, that their substance would in time have been absorbed into the cow's bloodstream instead of being discharged as miscarriages. The eight fetuses were conceived simultaneously in an experiment conducted by Dr. E.S.E. Hafez at Washington State University. Their individual fates may have been affected by the same mysterious factors that determine the outcome of many one-at-a-time human pregnancies. Why does one fetus thrive while another, growing in the same womb, dies? Like Dr. Krantz (preceding page), Dr. Hafez believes that the placenta is the key to fetal development. The multiple pregnancies that he artificially induces push a cow's placenta to the limit of its capabilities. By watching how the placenta handles the overload, Hafez hopes to learn how to boost its efficiency artificially, to give fetuses a better chance of surviving. Scientists now suspect that many women who consider themselves sterile are not really—it is just that their embryos die before pregnancy is suspected. If Hafez can find the cause of these very early deaths—often a matter of placental deprivation or malfunction—he may also find a remedy, thus enabling many women who mistakenly believe they are barren to carry a baby through a normal birth.

In Dr. Hafez' laboratory a technician measures lumps containing dead fetuses in cow's amniotic sac where

two other 13-week-old fetuses show normal growth. Brown spots on the uterine wall make up cow's placenta.

The quest for more effective means of
Birth Control

Hardly any problem alarms scientists more than the world's population explosion. They spend a lot of time and energy devising more effective birth-control methods. The most popular contraceptive in the U.S. is the famous pill which prevents the ovaries from releasing eggs. It was developed at the Worcester Foundation for Experimental Biology where further research (left) is in progress. Researchers elsewhere hope soon to perfect a once-a-month injection to replace the pill-a-day. Meanwhile most existing contraceptives, including the pill, are too expensive for most of the world's people. As an interim measure, more and more people are using the so-called intra-uterine devices (IUDs). These are simply odd-shaped pieces of metal or plastic—some tied with bits of thread—that resemble free-form pieces of costume jewelry. They are inserted into the uterus by doctors and simply left there. No one is sure how they work—but they do.

At left two cow ovaries under glass (upper right) are kept alive by apparatus that simulates heart-lung functions to study how they react to radioactively tagged hormones. Below are intra-uterine birth-control devices.

It was while a student of forestry at Berkeley, in San Francisco, that Chilean Sergio Larrain first took up a camera. He travelled in Europe before choosing to live in isolation, not far from Valparaíso, where he read poetry and philosophy and produced photographs on excursions into Chile's harbour city. Although he went on to freelance for a while for Brazil's *O Cruzeiro* magazine, there is nothing conventionally professional about his approach. Larrain has described receiving his images in a 'state of grace … the grace that appears when one is free like a child in his first discovered reality'. His work recalls the 'magic realism' of his Latin American contemporaries – writers Gabriel García Márquez, Mario Vargas Llosa, and Pablo Neruda; the latter became Larrain's close friend and collaborator in his ongoing photography of Valparaíso. First seen in the Swiss cultural magazine *Du*, a regular publisher of extended photo essays that satisfied the criteria of both art and reportage, his pictures demonstrate a wholly original vision in which dream and association are as important as facts or reality. Before the end of the 1960s Larrain gave up photography, retreating again – this time into the Chilean mountains – to devote himself to the study of Eastern culture and mysticism. (February 1966)

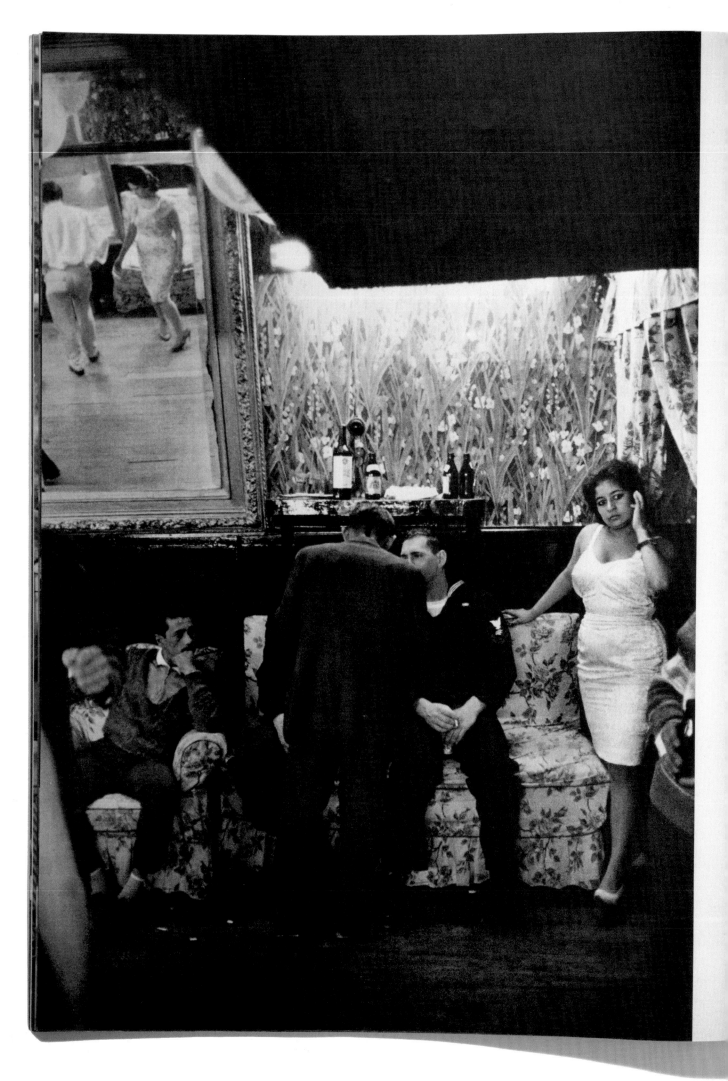

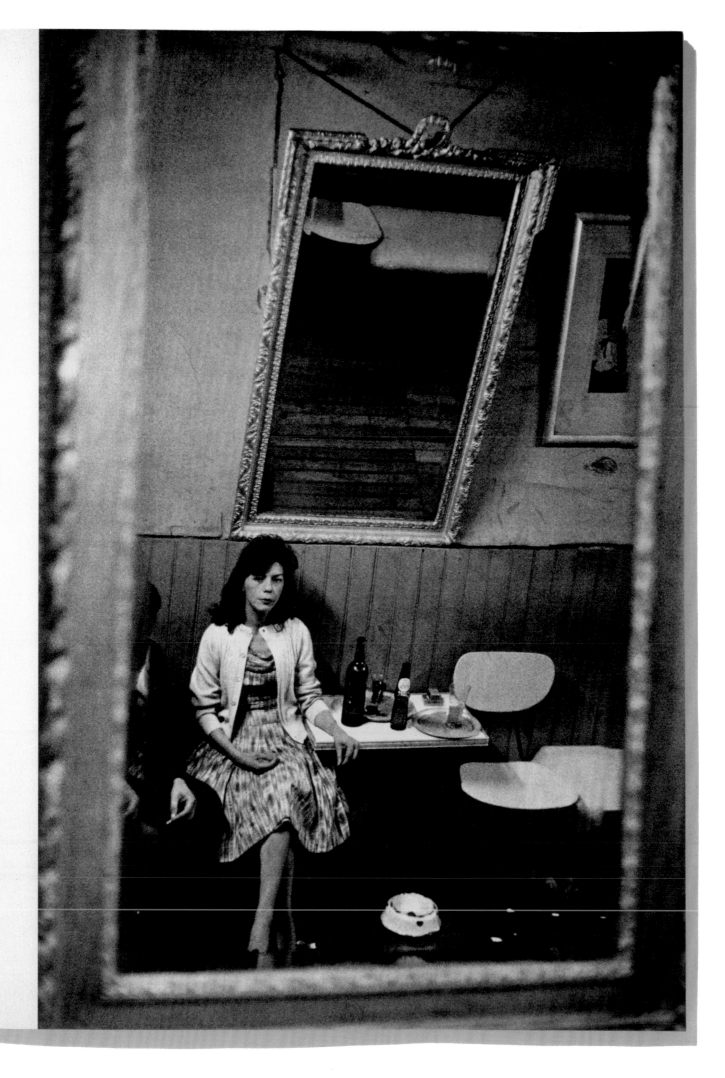

Swedish photographer Lennart Nilsson worked as a photojournalist reporting for *Picture Post*, *Life* and the Swedish magazine *Se* before becoming a pioneer in the photography of events inside – rather than outside – the human body. It was in the late 1940s on an assignment at Sabbatsbergs Hospital in Stockholm, that he first photographed human embryos, stored in glass jars. Several years later he showed the pictures to *Life* magazine, who published them and encouraged him to pursue the idea. He explored the use of microscopes and, in the 1960s, ultra-slim endoscopes that allowed him to get closer to his subjects and to photograph inside the body. He started recording the human embryo at each stage of its development, taking four years to complete a comprehensive account of the creation of a human being. First published in *Life* magazine, his ground-breaking story, as pictorial as it was scientific, created an immediate sensation. Adding a profound new ingredient to the iconography of human life, it reached vast audiences in magazines throughout the world, including in the Brazilian magazine *Realidade*. (April 1966)

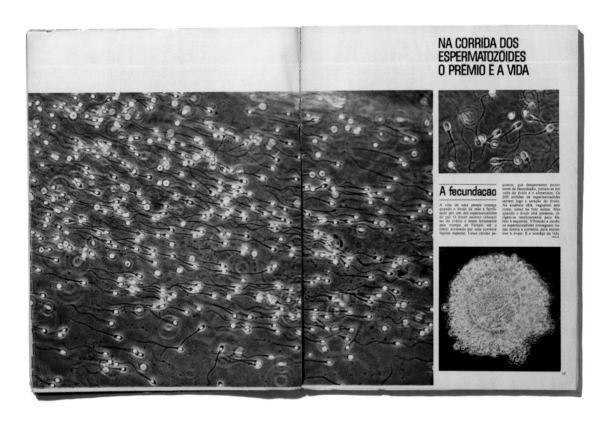

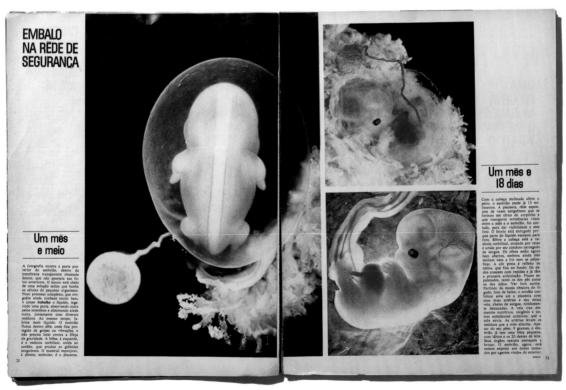

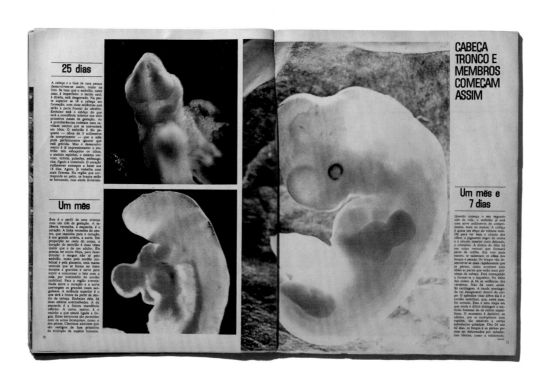

25 dias

A cabeça e a face de uma pessoa desenvolvem-se assim, como na foto. Se bem que o embrião, neste caso, é imperfeito: o tecido azul, à direita, está desgarrado. Na parte superior se vê a cabeça em formação, com duas saliências que serão a parte frontal do cérebro. Embaixo está o esboço do que será a mandíbula inferior nos dois primeiros meses de gestação. As protuberâncias rodeiam uma cavidade central que se converte em bôca. O embrião é tão pequeno — cêrca de 3 milímetros de comprimento — que a mãe pode perfeitamente ignorar que está grávida. Mas o desenvolvimento é impressionante: o embrião tem esboçados os olhos, a medula espinhal, o sistema nervoso, tiróide, pulmões, estômago, rins, fígado e intestinos. O coração rudimentar começou a bater aos 18 dias. Agora, já trabalha com mais firmeza. Na região que corresponde ao pélo, os braços estão se formando, mas ainda invisíveis.

Um mês

Este é o perfil de uma criança com um mês de gestação. A saliência vermelha, à esquerda, é o coração. A linha vermelha do centro, que caminha para o coração, é sua grande artéria, a aorta. Em proporção ao resto do corpo, o coração do embrião é duas vêzes maior que o de um adulto. Ele precisa ser muito fôrça, para fazer circular o sangue tão só pelo embrião, como pela placenta, uma massa carnuda que se forma no útero durante a gravidez e serve para o comunicar o feto com a mãe, por intermédio do cordão umbilical. Para a região avermelhada entre o coração e a aorta convergem os grandes vasos sangüíneos. A saliência superior é o que será a frente da parte de dentro da cabeça. Embaixo dela, há duas esferas avermelhadas. A da esquerda é a futura mandíbula inferior. A outra, menor, é o ossinho a que estará ligada a língua. Estas estruturas são parecidas com as arcos bronquiais, como o dos peixes. Cientistas admitem que são vestígios de fase primitiva da evolução da espécie humana.

CABEÇA TRONCO E MEMBROS COMEÇAM ASSIM

Um mês e 7 dias

Quando começa o seu segundo mês de vida, o embrião já está com nove milímetros de comprimento, mais ou menos. A cabeça é quase um têrço do volume total. Dá para ver bem o círculo dos olhos: o pigmento negro da retina e o círculo interior mais delicado, o cristalino. À direita do ôlho há em relêvo um outro vertical parte da orelha. Em tom mais escuro, se salientam os dois braços e pernas. Os braços vão desenvolver-se mais rapidamente que as pernas, como acontece com tôdas as partes que estão mais próximas da cabeça. Está começando a formar-se o esqueleto. Na frente das costas já há as saliências das vértebras. Não há osso ainda. Só cartilagens. A cauda pontiaguda vai desaparecer dentro do corpo. O apêndice visto além está é o cordão umbilical, que, neste caso, foi cortado. Esta é uma etapa em que ainda é difícil distinguir o embrião humano do de outros mamíferos. O momento é decisivo: as células, que se multiplicam com rapidez, são sensíveis a certas substâncias químicas. Dos 24 aos 42 dias, os braços e as pernas podem ser deformados por anomalias tóxicas, como a talidomida.

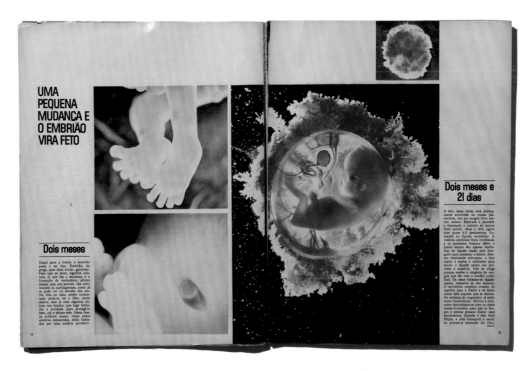

UMA PEQUENA MUDANÇA E O EMBRIÃO VIRA FETO

Dois meses

Daqui para a frente, o embrião passa a ser feto. Embrião, do grego, quer dizer brotar, germinar. Feto vem do latim, significa criatura. O que faz a mudança é a formação de verdadeiras células ósseas, que, aos poucos, vão substituindo as cartilaginosas, como já se pode ver no desalhe dos pés. No feto ao lado, muito aumentado, podê-se ver o ôlho, ainda aberto, mas já uma câmara escura em seu bordo, que logo fechar-se-á e cavidade, para protegê-lo bebê, até o sétimo mês. Nessa fase, os orifícios nasais, vistos como sombras amarelados, estão fechados por uma matéria protetora.

Dois meses e 21 dias

O feto, nessa idade, está praticamente envolvido na massa placentária, rica em sangue (foto menor, acima). Separada a placenta e iluminado o interior do âmnio (foto maior), vê-se o feto, agora com 4,5 centímetros, flutuando no líquido amniótico. A vesícula umbilical flutua mutilada e os pontinhos brancos sôbre o fundo escuro são apenas borbulhas do líquido usado pelo fotógrafo para sustentar o âmnio. Mesmo totalmente submerso, o feto aspira e expira o suficiente para mover o líquido salino nos pulmões e expelí-lo. Não se afoga porque recebe o oxigênio do sangue que flue viva o cordão umbilical. Os ossos formam-se rapidamente, inclusive os das costelas. O invólucro corporal cresceu da espinha para a frente e se fecha como uma jaqueta que se abotoa. Os sistemas do organismo já estão todos funcionando. Nervos e músculos entrelaçam-se em seu crescimento-formados, para que os braços e pernas possam iniciar seus movimentos. Quando o feto tiver fôrça, a mãe começará a sentir os primeiros pontapés do filho.

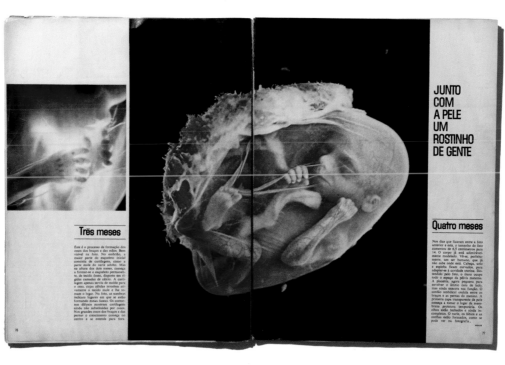

JUNTO COM A PELE UM ROSTINHO DE GENTE

Três meses

Este é o processo de formação dos ossos dos braços e das mãos. Bem visível, na foto. No embrião, a maior parte do esqueleto inicial consiste de cartilagem, como a parte mole do nariz adulto. Mas na altura dos três meses, começa a formar-se o esqueleto permanente, de tecido ósseo, disposto em cinco camadas de cálcio. A cartilagem apenas serve de molde para o osso, cujos pêlos trondem atravessam o tecido mole e fixe no mesmo o lugar. Na foto, as sombras mais difusas mostram cartilagens ainda não substituídas por ossos. Nos grandes dos braços e das pernas o osso e começa a formar-se pelo centro e se estende para fora.

Quatro meses

Nos dias que ficaram entre a foto anterior e esta, o tamanho do feto aumentou de 6,5 centímetros para 14. O corpo já está admirávelmente modelado. Vê-se, perfeitamente, um ser humano, que já não cabe com o de outra. Cabeça, onto é espinha ficam curvados. Pro adapta-se à cavidade interna do útero. Dentro dêle o feto ocupa todo o espaço de pélvis interno. A placenta, agora pequena para envolver o âmnio caiu de lado, mas ainda conecta sua função. O cordão umbilical ondula entre os braços e as pernas da menina. A primeira capa transparente da pele começa a tomar o lugar da membrana protetora temporária. Os olhos estão fechados e está completos. O nariz, os lábios e as orelhas estão formados, como se pode ver na fotografia.

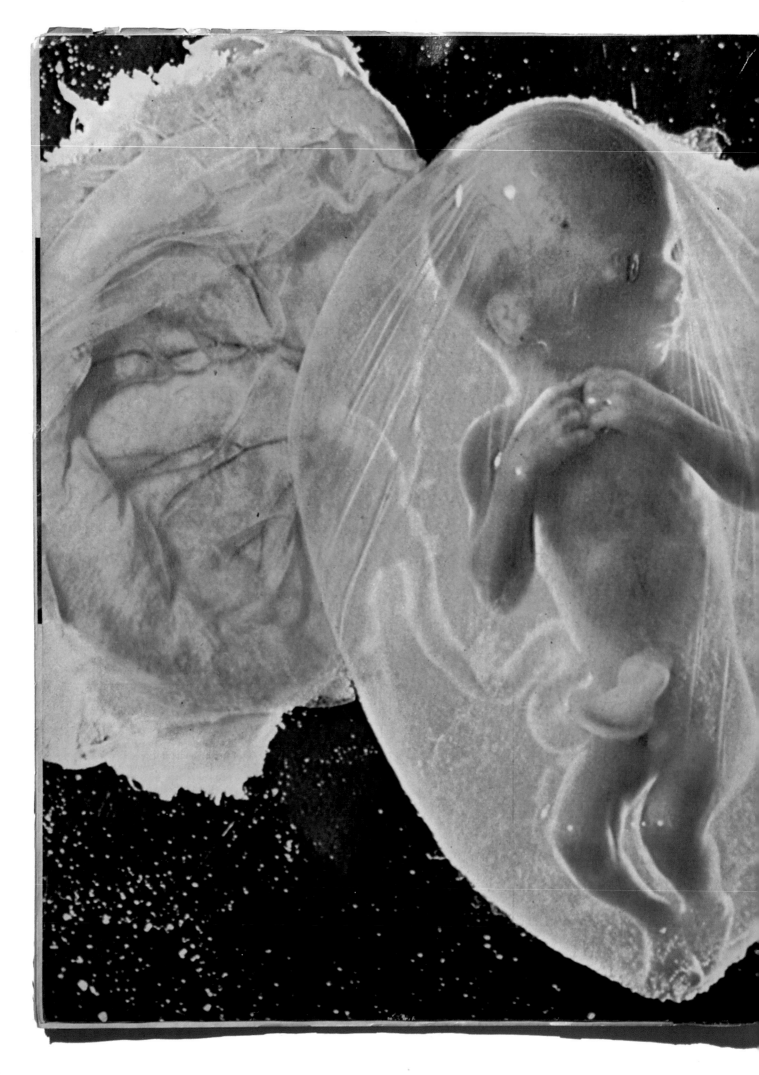

DEDO NA BÔCA PARA APRENDER A VIVER

Quatro meses e meio

O menino, com menos de 5 meses, já põe o dedo na bôca. É exercício, que o prepara para alimentar-se espontâneamente logo que nasça. Sua pele é tão delicada e transparente, que a rêde de vasos sanguíneos parece estar na superfície. Por ser delicada, a pele é vulnerável ao contato das unhas. Elas crescem ràpidamente e podem até causar pequenos arranhões antes do nascimento. Às vêzes, uma das primeiras tarefas ?a enfermeira que assiste no parto é cortar as unhas já bem compridas do bebê, para que não se machuque. Aos quatro meses e meio, o feto é vigoroso e ativo. Faz freqüentes flexões. Pode fechar o punho, dar socos e pontapés. Consegue até fazer os movimentos do chôro. Tem as cordas vocais mas não pode emitir som, porque não existe ar. Está com 16 centímetros. Ainda vive submerso, mas, enquanto cresce, vai tomando conta de todo o âmnio e deixa cada vez menos espaço para o líquido. O que sobra é levado pelo sangue, através do cordão umbilical e da placenta, ao organismo da mãe, para ser eliminado. Dez semanas depois, o desenvolvimento do feto está pràticamente concluído. Algumas crianças nascem prematuramente nessa época. Porém, o resto do tempo em que o feto permanece no útero lhe dá mais fôrças e lhe permite receber da mãe importante imunidade contra várias doenças, nos primeiros meses de vida.

SEGUE

79

Although there were dozens of photographers in Dallas along the route of the presidential motorcade, the most famous images of John F Kennedy's assassination come from a Super-8 film shot by businessman Abraham Zapruder. In a previously unprecedented act of 'chequebook journalism', *Life* reporter Richard Stolley secured the original film and all rights from Zapruder. Fragments of the film appeared in *Life*'s memorial issue on Kennedy, although it was printed in small, black and white strips, conveying little information. Its memorable publication came three years later, when *Life* covered the release of the Warren Commission report that officially reviewed all the evidence (including Zapruder's film) and confirmed that Lee Harvey Oswald was the assassin. This time, *Life* printed the film fragments in colour, greatly enlarged and presented frame by frame in the manner of forensic evidence (albeit with the most gruesome frames edited out). *Life* chroniclers have cited publication of the Zapruder film as proof that even moving pictures can find their most significant release in the form of still images on the printed page, although live coverage of the Kennedy funeral marked the moment when television replaced newspapers and magazines as the main source of breaking news.
(25 November 1966)

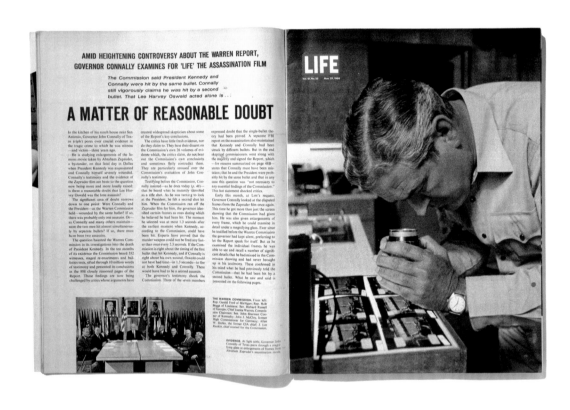

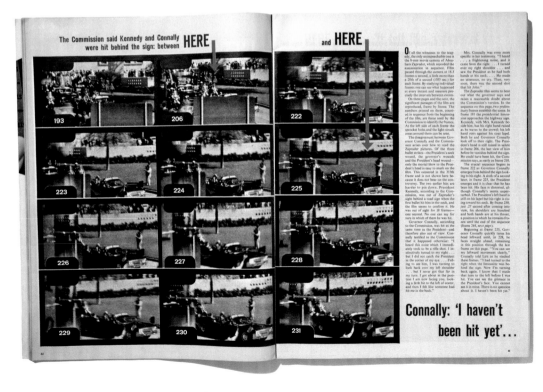

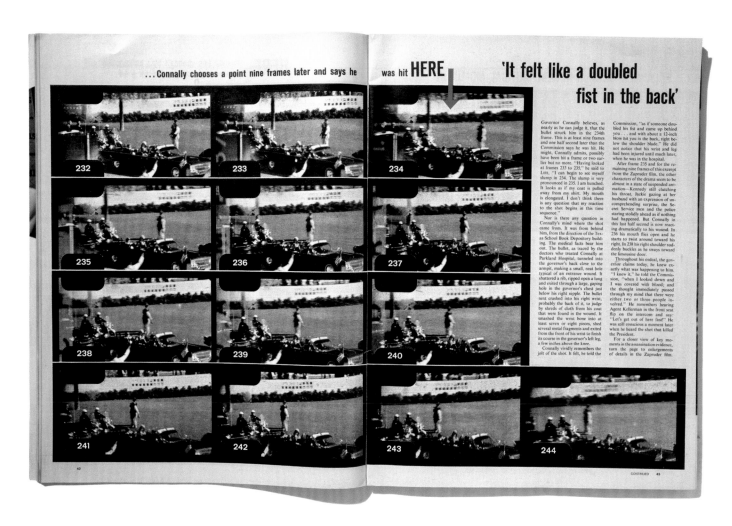

...Connally chooses a point nine frames later and says he was hit **HERE**

'It felt like a doubled fist in the back'

232 233 234

235 236 237

238 239 240

241 242 243 244

Governor Connally believes, as nearly as he can judge it, that the bullet struck him in the 234th frame. This is at least nine frames and one half second later than the Commission says he was hit. He might, Connally admits, possibly have been hit a frame or two earlier but no more. "Having looked at frames 233 to 235," he said to Life, "I can begin to see myself slump in 234. The slump is very pronounced in 235. I am hunched. It looks as if my coat is pulled away from my shirt. My mouth is elongated. I don't think there is any question that my reaction to the shot begins in this time sequence."

Nor is there any question in Connally's mind where the shot came from. It was from behind him, from the direction of the Texas School Book Depository building. The medical facts bear him out. The bullet, as traced by the doctors who treated Connally at Parkland Hospital, tunneled into the governor's back close to the armpit, making a small, neat hole typical of an entrance wound. It shattered a rib, ripped open a lung and exited through a large, gaping hole in the governor's chest just below his right nipple. The bullet next crashed into his right wrist, probably the back of it, to judge by shreds of cloth from his coat that were found in the wound. It smashed the wrist bone into at least seven or eight pieces, shed several metal fragments and exited from the front of his wrist to finish its course in the governor's left leg, a few inches above the knee.

Connally vividly remembers the jolt of the shot. It felt, he told the Commission, "as if someone doubled his fist and came up behind you . . . and with about a 12-inch blow hit you in the back, right below the shoulder blade." He did not notice that his wrist and leg had been injured until much later, when he was in the hospital.

After frame 235 and for the remaining nine frames of this excerpt from the Zapruder film, the other characters of the drama seem to be almost in a state of suspended animation—Kennedy still clutching his throat, Jackie gazing at her husband with an expression of uncomprehending surprise, the Secret Service men and the police staring stolidly ahead as if nothing had happened. But Connally in this last half second is now reacting dramatically to his wound. In 236 his mouth flies open and he starts to twist around toward his right. In 238 his right shoulder suddenly buckles as he sways toward the limousine door.

Throughout his ordeal, the governor claims today, he knew exactly what was happening to him. "I knew it," he told the Commission, "when I looked down and I was covered with blood; and the thought immediately passed through my mind that there were either two or three people involved." He remembers hearing Agent Kellerman in the front seat flip on the intercom and say "Let's get out of here fast!" He was still conscious a moment later when he heard the shot that killed the President.

For a closer view of key moments in the assassination evidence, turn the page to enlargements of details in the Zapruder film.

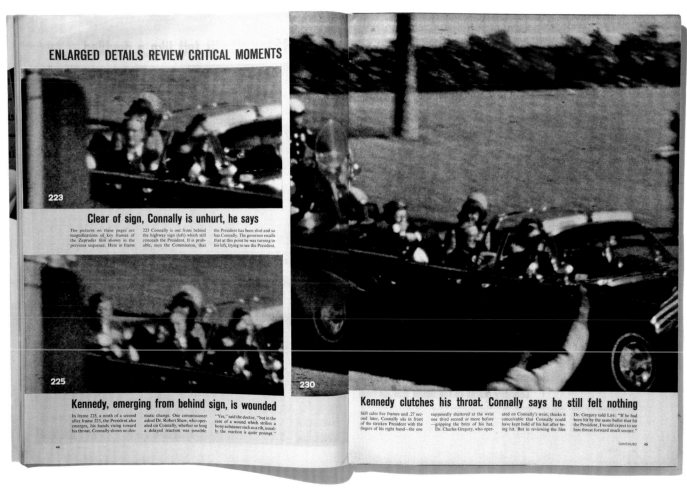

ENLARGED DETAILS REVIEW CRITICAL MOMENTS

223

Clear of sign, Connally is unhurt, he says

The pictures on these pages are magnifications of key frames of the Zapruder film shown in the previous sequence. Here in frame 223 Connally is out from behind the highway sign (left) which still conceals the President. It is probable, says the Commission, that the President has been shot and so has Connally. The governor recalls that at this point he was turning to his left, trying to see the President.

225

Kennedy, emerging from behind sign, is wounded

In frame 225, a ninth of a second after frame 223, the President also emerges, his hands rising toward his throat. Connally shows no dramatic change. One commissioner asked Dr. Robert Shaw, who operated on Connally, whether so long a delayed reaction was possible. "Yes," said the doctor, "but in the case of a wound which strikes a bony substance such as a rib, usually the reaction is quite prompt."

230

Kennedy clutches his throat. Connally says he still felt nothing

Still calm five frames and .27 second later, Connally sits in front of the stricken President with the fingers of his right hand—the one supposedly shattered at the wrist one third second or more before —gripping the brim of his hat. Dr. Charles Gregory, who operated on Connally's wrist, thinks it conceivable that Connally could have kept hold of his hat after being hit. But in reviewing the film Dr. Gregory told Life: "If he had been hit by the same bullet that hit the President, I would expect to see him throat forward much sooner."

236

Connally reacts to the bullet that hit him

In this enlarged detail of frame 236, Connally is now reacting to the bullet. This is one ninth of a second later than frame 234, which Connally marks as the moment he was hit. It is two thirds of a second since Kennedy began responding to his neck wound, and this raises an important question: is it likely that Connally would have had a delayed reaction to the hit while Kennedy's reaction was almost instantaneous?

In frame 236 Connally's mouth has flown open; his right shoulder sags. But he still appears to be holding on to his hat with his right hand, which is now to his right and level with the top of the car door.

In frame 242, one third of a sec-

242

is shoulder buckles, he starts to slump

l later, Connally is caving in. right shoulder has slumped matically. The change can be n best by noting the red patch ind him which was identified as a bunch of red roses lying on the seat next to Mrs. Kennedy. In 236 the roses are only barely visible behind Connally's right shoulder. In 242 much more of the roses can be seen, showing that Connally's shoulder has been jerked downward and perhaps also forward by the impact of the bullet. His head has snapped around to the right and his mouth seems to be framing a cry, perhaps the exclamation that his wife heard him utter soon after he was hit: "My God! They are going to kill us all!"

CONTINUED **47**

Having served in the design and graphics department of *Drum* magazine in the late 1950s, Ernest Cole spent six years freelancing for the South African press, pursuing his idea of documenting Apartheid. The *Sunday Times* publication of his essay was not only a triumph of photojournalism but a triumph of subversion against the regime he depicted. The South African state was mindful of the need to censor its portrayal abroad as a segregated society. Photography was monitored and restricted and, categorized as 'African', Cole was denied a passport. When questioned about his activities, he disguised his true intent under the cover of documenting black youth crime. He later exploited the contradictions of the Race Classification Board to have himself officially reclassified as 'Coloured' – allowing him both greater freedom of movement within the state and the opportunity, for the first time, to travel abroad. Having outmanoeuvred the authorities, and with the support of Magnum Photos, he left *Drum* magazine and brought his work to Europe and America. A year after the *Sunday Times* ran 'How it Feels to be Black in South Africa', he published his classic book *House of Bondage* (1967). (27 November 1966)

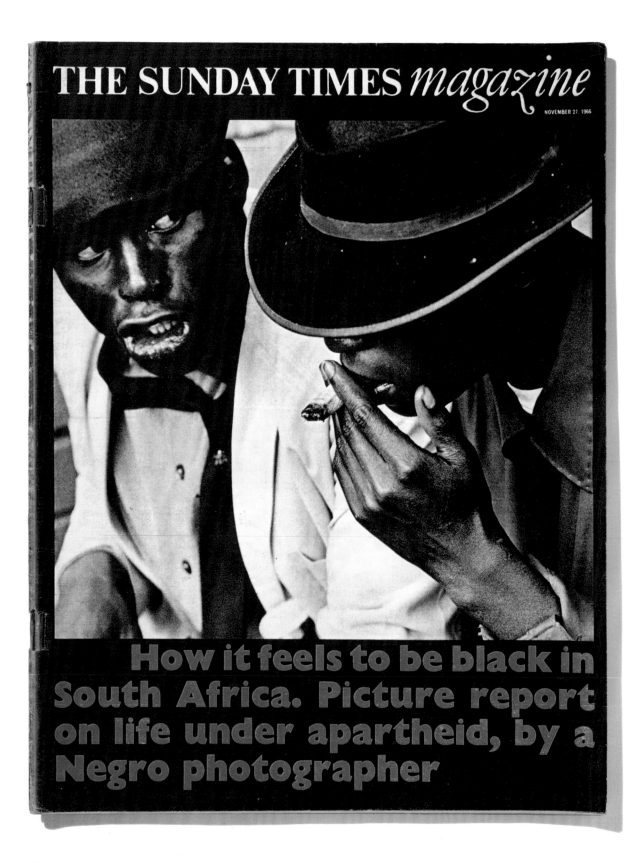

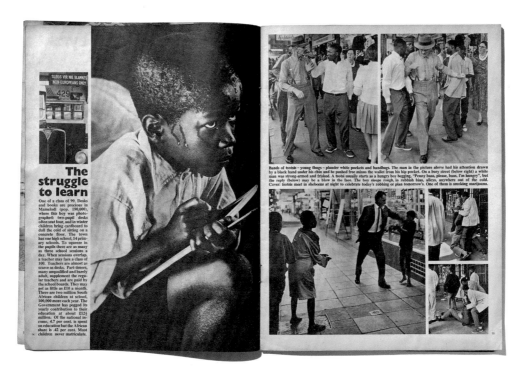

The struggle to learn

One of a class of 99. Desks and books are precious in Mamelodi (pop. 190,000), where this boy was photographed: two-pupil desks often seat four, and in winter children bring cardboard to dull the cold of sitting on a concrete floor. The town has one high school, 14 primary schools. To squeeze in the pupils there are as many as three school sessions a day. When sessions overlap, a teacher may face a class of 100. Teachers are almost as scarce as desks. Part-timers, many unqualified and barely adult, supplement the regular teachers and are paid by the school boards. They may get as little as £10 a month. There are two million South African children at school, 100,000 more each year. The Government has pegged its yearly contribution to their education at about £12½ million. Of the national income, 4.7 per cent is spent on education but the African share is .42 per cent. Most children never matriculate.

Bands of tsotsis – young thugs – plunder white pockets and handbags. The man in the picture above had his attention drawn by a black hand under his chin and he pushed free minus the wallet from his hip pocket. On a busy street (below right) a white man was strong-armed and frisked. A tsotsi usually starts as a hungry boy begging. "Penny baas, please, baas, I'm hungry", but the reply (below) may be a blow in the face. The boy sleeps rough, in rubbish bins, alleys, anywhere out of the cold. Cover: tsotsis meet in shebeens at night to celebrate today's robbing or plan tomorrow's. One of them is smoking marijuana.

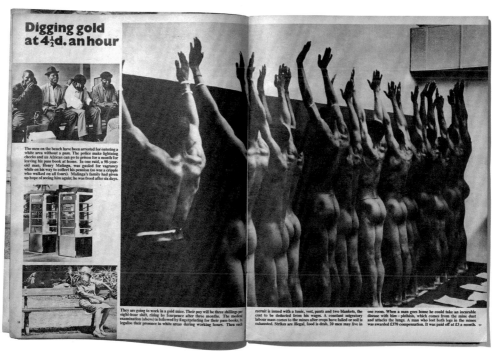

Digging gold at 4½d. an hour

The men on the bench have been arrested for entering a white area without a pass. The police make lightning checks and an African can go to prison for a month for leaving his pass book at home. In one raid, a 90-year-old man, Henry Malinga, was gaoled for vagrancy while on his way to collect his pension (so was a cripple who walked on all fours). Malinga's family had given up hope of seeing him again; he was freed after six days.

They are going to work in a gold mine. Their pay will be three shillings per eight-hour shift, rising by fourpence after three months. The medical examination (above) is followed by fingerprinting for their pass-books, to legalise their presence in white areas during working hours. Then each recruit is issued with a tunic, vest, pants and two blankets, the cost to be deducted from his wages. A constant migratory labour mass comes to the mines after crops have failed or soil is exhausted. Strikes are illegal, food is drab, 20 men may live in one room. When a man goes home he could take an incurable disease with him – phthisis, which comes from the mine dust and attacks the lungs. A man who lost both legs in the mines was awarded £370 compensation. It was paid off at £3 a month.

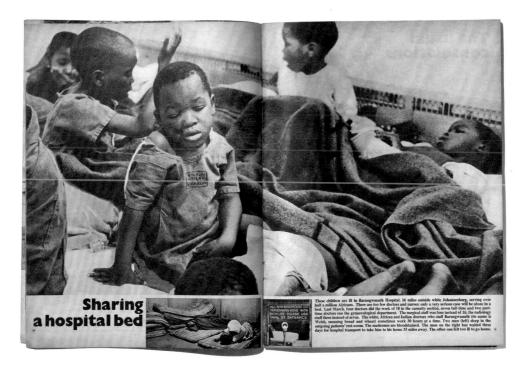

Sharing a hospital bed

These children are ill in Barangwanath Hospital, 16 miles outside white Johannesburg, serving over half a million Africans. There are too few doctors and nurses: only a very serious case will be alone in a bed. Last March, four doctors did the work of 18 in the casualty section, seven full-time and two part-time doctors ran the gynaecological department. The surgical staff was four instead of 16, the radiology staff three instead of seven. The white, African and Indian doctors who staff Barangwanath (its name is Welsh, meaning bread and wheat) sometimes work 30 hours at a time. Two men (left) sleep in the outgoing patients' rest-room. The mattresses are bloodstained. The man on the right has waited three days for hospital transport to take him to his home 35 miles away. The other one felt too ill to go home.

Mikhail Savin, like Yevgeni Khaldei and Dmitri Baltermans, is best known outside the former USSR as a war photographer, but Soviet readers first knew his work from the charged Socialist Realist pages of *USSR in Construction*. After the war, Savin joined the team of *Ogonyek* magazine. *Pravda* (the official newspaper of the Communist Party) started *Ogonyek* in 1923, and for the rest of the twentieth century it was the most popular illustrated magazine in the Soviet Union, a combination of *Time*, *Life*, *Holiday* and *Ladies Home Journal*, with regular historical features, a literary department and a crossword puzzle. As the magazine's leading colour photographer, Savin's work appeared frequently in the magazine's signature colour section where it occasionally featured as a stand-alone picture essay. The ingredients of his story on the Soviet Army in the Arctic echo the utopian forms of his earlier work while reflecting the responsibilities of a senior Soviet photojournalist at the height of the Cold War. His representation of brave, attractive, young Soviets set alongside gleaming military technology, reproduced in spectacular colour-saturated compositions, hover just short of kitsch. (21 March 1967)

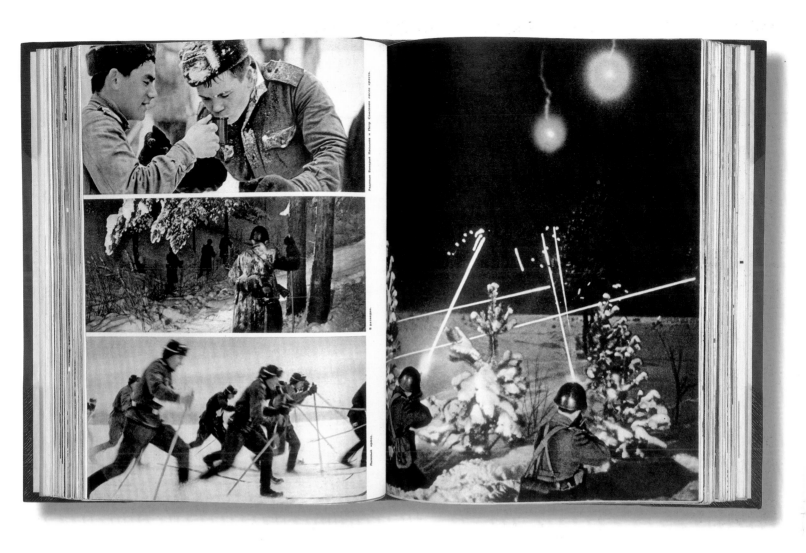

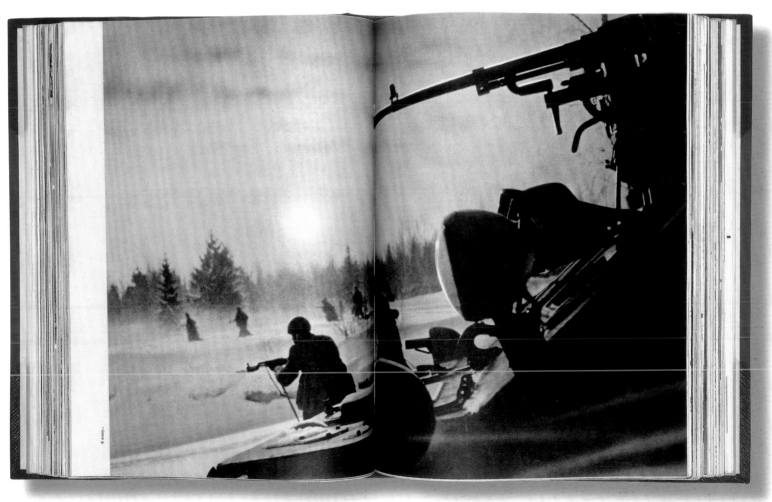

Cuban photographer Roberto Salas spent several weeks in Vietnam in the spring of 1967 to produce a report on the US war against the socialist government of a small, rural country much like his own. Salas worked on several separate essays, on subjects including the ruins of Vietnamese civilization that he found in the North, the peasant army in the South with whom he travelled through the jungle, and life in Hanoi. Salas's reportage, although obviously sympathetic to any struggle against the USA, differs in many ways from the images made by photographers working for North Vietnam. He employed the style of classic photo reportage, with a strong individual point of view that sets his photographs apart from those made purely for propaganda. Salas, son of the celebrated photographer Osvaldo Salas, was born in New York City, returning to Cuba among a small group of photographers sanctioned by the Cuban government and working principally for its leading newspaper, *Revolución*. He describes the period 1959-68 as the 'golden age of Cuban journalism'. (June 1967)

NUMERO ESPECIAL
DEDICADO A
VIETNAM HEROICO

EL SUR: *Jungla de Fusiles*
EL MUNDO: *Cortar la Mano*
EL NORTE: *Las Ruinas Victoriosas*
• BURCHETT • SARTRE • PIC
Norberto Fuentes • Jesús Martí

un reportaje de nuestro enviado especial a Vietnam del Norte ROBERTO SALAS

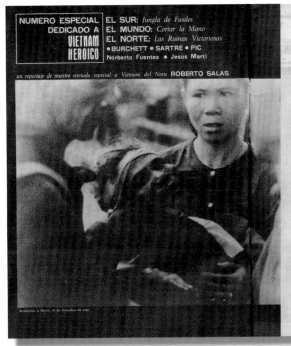

Bombardeo a Hanói, 15 de diciembre de 1966

EL SUR: JUNGLA DE FUSILES

Por JESUS MARTI

LOS HALCONES DESPLUMADOS

A FINES de este año, los efectivos norteamericanos en Vietnam del Sur deben alcanzar un total de 600 mil hombres, según las noticias que se filtran del Pentágono.

Las estimados fueron hechas en base a los informes, sugerencias y peticiones formuladas durante su reciente visita a Estados Unidos por el jefe de las tropas norteamericanas en Vietnam del Sur, general William Westmoreland.

Si en 1962 Estados Unidos mantenía en Vietnam del Sur sólo 13 mil hombres como "asesores" del ejército saigonés, en mayo de 1967, sus tropas pasaban de los 450 mil soldados.

Ese aumento está en relación directa con el fracaso de los planes puestos en práctica para "pacificar" al Sur de Vietnam y hacer uso de su territorio como base militar-económica de gran importancia en la zona del sudeste asiático.

Cuando John F. Kennedy se hizo cargo de la Presidencia de Estados Unidos ordenó una revisión de la estrategia político-militar seguida hasta entonces por el binomio Eisenhower-Foster Dulles, basada en las "represalias masivas", en la milbeo— y diplomacia "al borde de la guerra", en lo político.

Asesores de Kennedy como Maxwell Taylor, Walt Rostow y otros elaboraron nuevas teorías, que no renunciaban sin embargo al papel de gendarme internacional asumido por Estados Unidos.

Surge así la estrategia de tres tipos de guerra en las que eventualmente se vería envuelta Estados Unidos: Guerra Especial, Guerra Local, Guerra General o Nuclear.

Vietnam del Sur se convirtió en un "laboratorio de la Guerra Especial", en la cual el peso mayor de las actividades descansaba sobre un ejército nativo, dirigido, armado y entrenado por "asesores" norteamericanos.

De ese laboratorio debían salir fórmulas para enfrentar "casos de policía" similares en otras partes del mundo.

Los planes fueron frustrados por el Frente Nacional de Liberación, que partiendo de pequeños destacamentos guerrilleros estructuró en tres escalas las Fuerzas Armadas de Liberación: destacamentos locales, fuerzas regionales y fuerzas regulares.

Con una estrategia flexible y tácticas adaptadas a cada situación específica, las FAL hicieron de la Guerra Especial su propia guerra. Los combates tenían lugar no donde las tropas saigonesas y sus "asesores" norteamericanos planeaban, sino donde —y al nivel— que las FAL querían desarrollar.

Paralelamente a su estrategia militar se desarrolló una estrategia política encaminada a destruir —hasta sus bases— el régimen instalado en Saigón.

A fines de 1964 estaba claro que política y militarmente la Guerra Especial había fracasado. Los sucesivos golpes de estado de los generales saigoneses evidenciaban lo político, una situación de descomposición y desmoralización que se hacía clara en el campo de batalla.

En marzo de 1965, con el desembarco de unidades de "marines" en la base de Da Nang, Estados Unidos cambió su estrategia en Vietnam del Sur e inicia la Guerra Local con la participación obrera y principal de las tropas norteamericanas y las unidades saigonesas como auxiliares.

Con el envío de nuevas fuerzas, en número cada vez mayor, la Guerra Local tenía su "bautismo de fuego" en la primera contraofensiva de temporada de seco (octubre de 1965-marzo de 1966).

Los hechos demostraron que la "contraofensiva", en la práctica, no era otra cosa más que una ofensiva con fines defensivos: desbloquear bases y ciudades, abrir algunas comunicaciones, inyectar moral a las tropas saigonesas y estimular a las norteamericanas.

Fundamentado en las mismas bases de la "Guerra Especial", la nueva estrategia fracasó en su primer intento. Al respecto, los estrategas norteamericanos sólo pudieron apelar al "hemos debido de perder" para justificar sus descalabros.

La segunda contraofensiva de temporada de seca que acaba de terminar en marzo de este año, corrió igual y hasta peor suerte, ya que mientras las tropas norteamericanas se empeñaban principalmente por desbloquear a Saigón, las FAL, desarrollando la iniciativa, se hicieron casi del total control de las cinco provincias más septentrionales.

¿Hasta dónde llegará ahora esta guerra? Recientemente, el secretario general de Naciones Unidas, U Thant, advirtió que "estamos en los umbrales de la tercera guerra mundial".

La señal de alerta del Secretario General de la ONU fue —al menos para consumo público— desestimada en Estados Unidos al asegurar algunos dirigentes norteamericanos que la situación no era tan dramática.

Los envíos de nuevas tropas y más modernos medios de combate no cesan. Al contrario, van en aumento, mientras Johnson, McNamara, Rusk y los "halcones" de la estrategia político-militar norteamericana dan paso cada vez más graves en el camino de la guerra. Un ejemplo: la invasión, en mayo, de la zona desmilitarizada.

CUBA-9

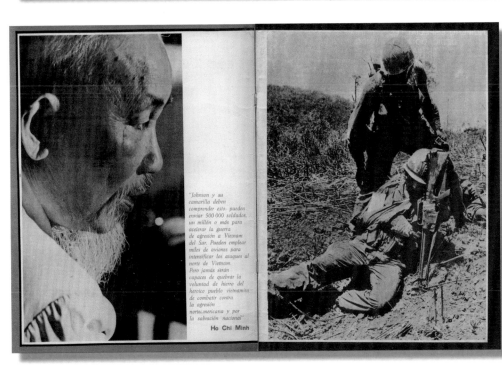

"Johnson y su camarilla deben comprender esto: pueden enviar 500 000 soldados, un millón o más para acelerar la guerra de agresión a Vietnam del Sur. Pueden emplear miles de aviones para intensificar los ataques al norte de Vietnam. Pero jamás serán capaces de quebrar la voluntad de hierro del heroico pueblo vietnamita de combatir contra la agresión norteamericana y por la salvación nacional"

Ho Chi Minh

LA GARRA

Lucharemos por la libertad en Vietnam y tras el escudo de nuestra determinación podrá seguirse escuchando la libre expresión del género humano

LYNDON B. JOHNSON
Conferencia de Prensa

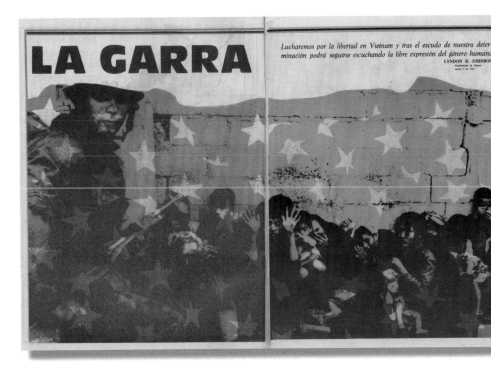

In 1956 Ed van der Elsken, the *enfant terrible* of Dutch photography, won immediate praise for his first book, *Love on the Left Bank*, a frank semi-fictional picture narrative about Bohemian life in postwar Paris. It led to the prolific production of many further books, always of street photographs (celebrations of the personalities he met on the street rather than campaign documents) and characterized by the energy of his layouts and ideas. After five years working as a film-maker, he returned to photography in 1967, shooting regular travel features for *Avenue* magazine. Van der Elsken's story on Cuba – one of his earliest for *Avenue* – demonstrates the approach for which he is best known: a depiction of street style, shot with a rhythm and pace learned from *cinema vérité*, with magazine pages used like a movie storyboard combining close-ups, panoramas, and candid asides to create a narrative that keeps the reader involved, on edge and constantly surprised. (December 1967)

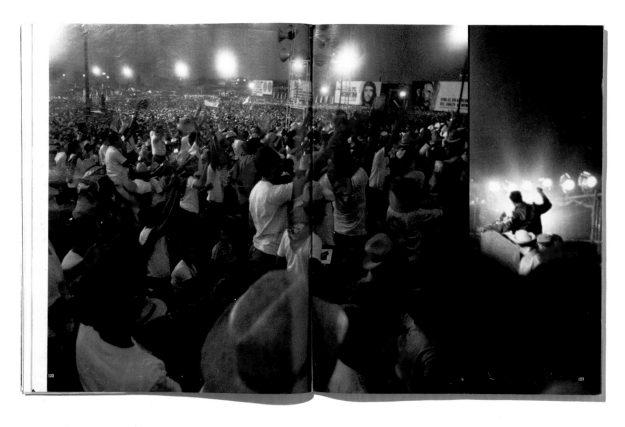

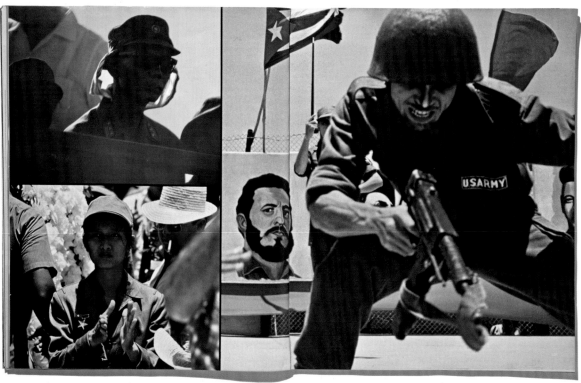

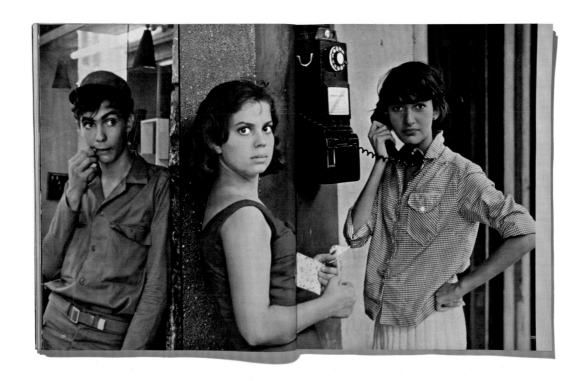

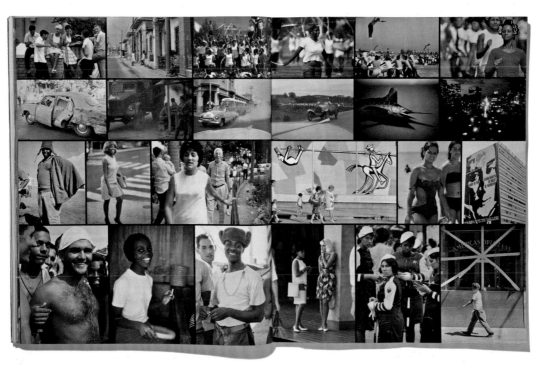

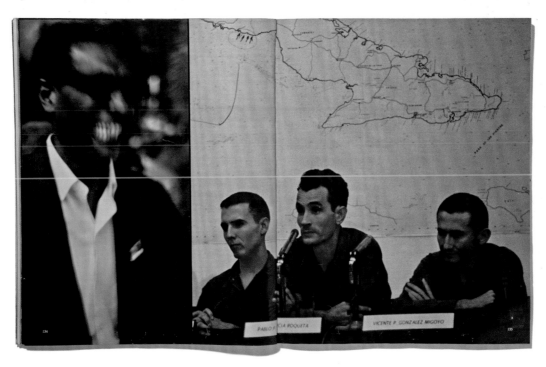

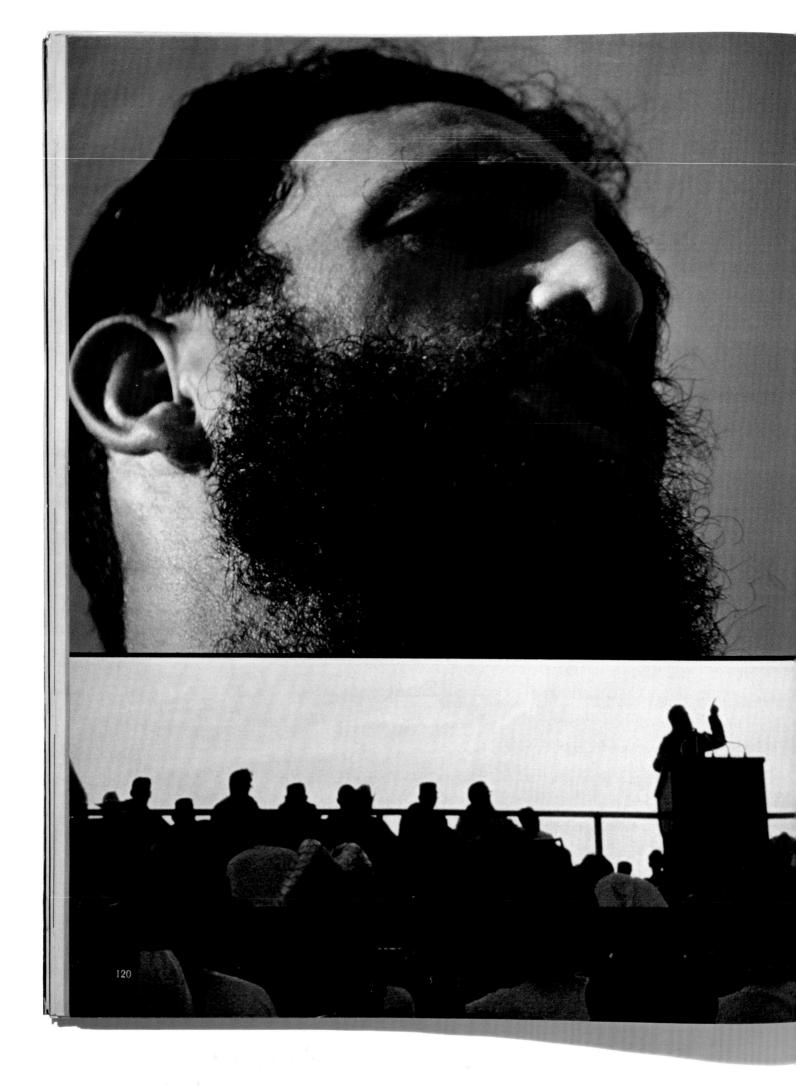

120

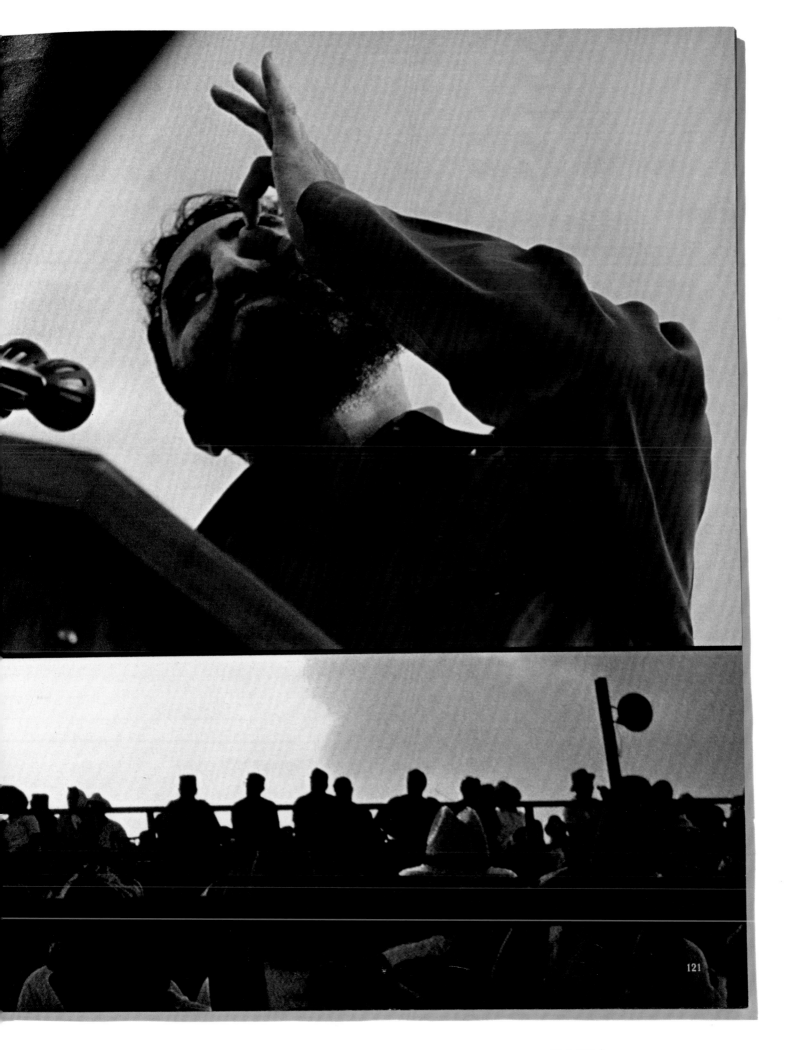

121

In 1967, the Beatles commissioned five portrait posters from Richard Avedon, placing reproduction rights with three magazines that reached three distinct markets: *Look* magazine in the United States, the *Daily Express* in the UK and *Stern* in Germany. Although it is hardly remarkable to see a group of rock stars exert control over their public image, this was a moment when mass culture and the counterculture united in promotion of a single, multi-national image. Significantly, the Beatles chose to distribute these universally appealing pictures through the pages of the general interest press who in turn understood exactly how they could be used to boost their own publicity, prestige and sales. When the Beatles chose a high profile fashion photographer and portraitist, they left behind the visual language of fanzine. For his part, Avedon used the assignment as an opportunity to appropriate a colourful pop style, that infused countercultural fashion, graphics and music journalism. The resulting psychedelic portraits are eloquent artefacts of 1960s exuberance – a perfect blend of celebrity portraiture, rock-journalism, publicity and pop art. (9 January 1968)

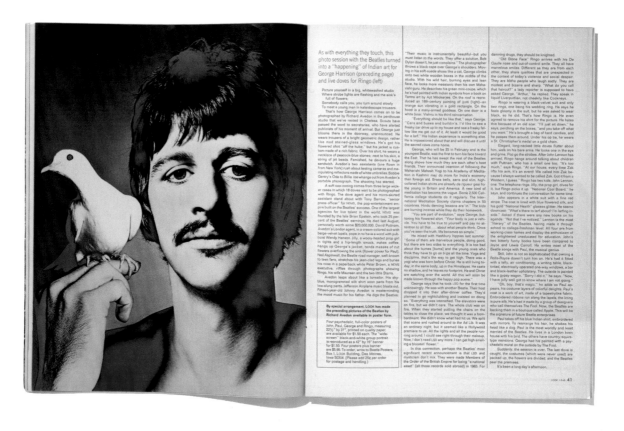

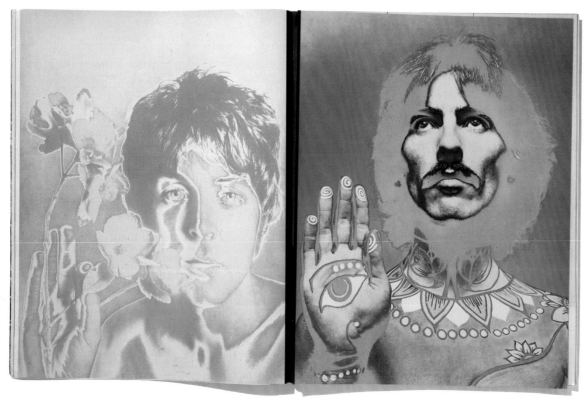

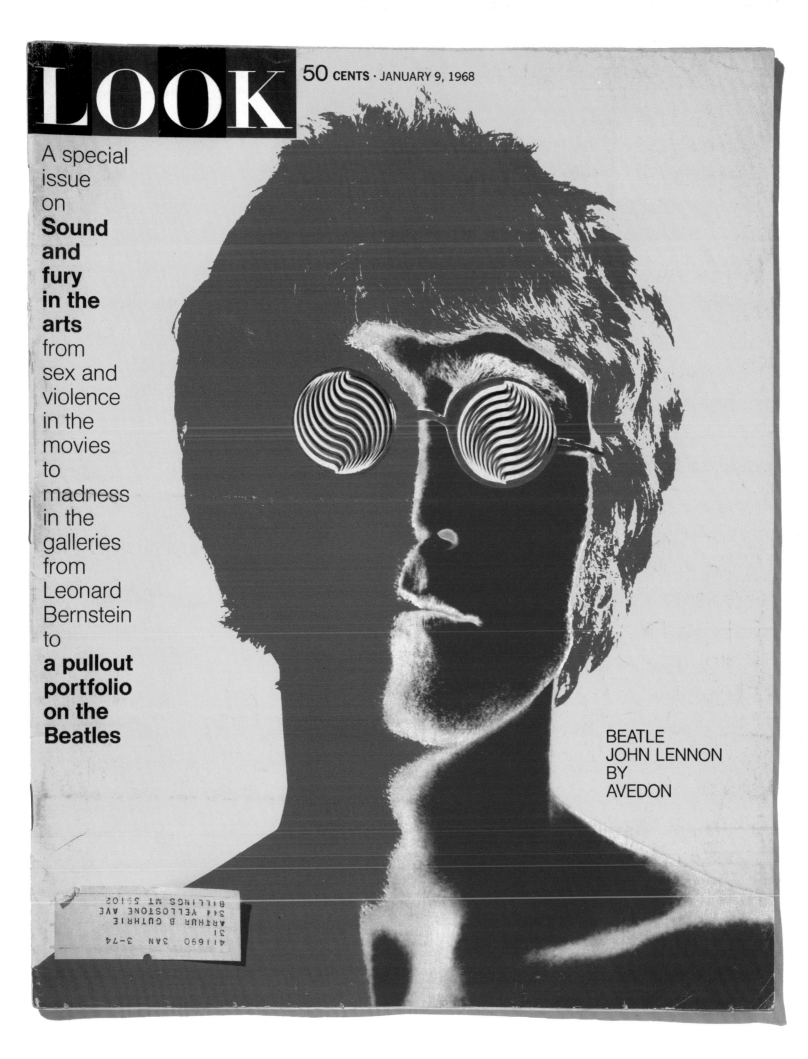

LOOK

50 CENTS · JANUARY 9, 1968

A special
issue
on
**Sound
and
fury
in the
arts**
from
sex and
violence
in the
movies
to
madness
in the
galleries
from
Leonard
Bernstein
to
**a pullout
portfolio
on the
Beatles**

BEATLE
JOHN LENNON
BY
AVEDON

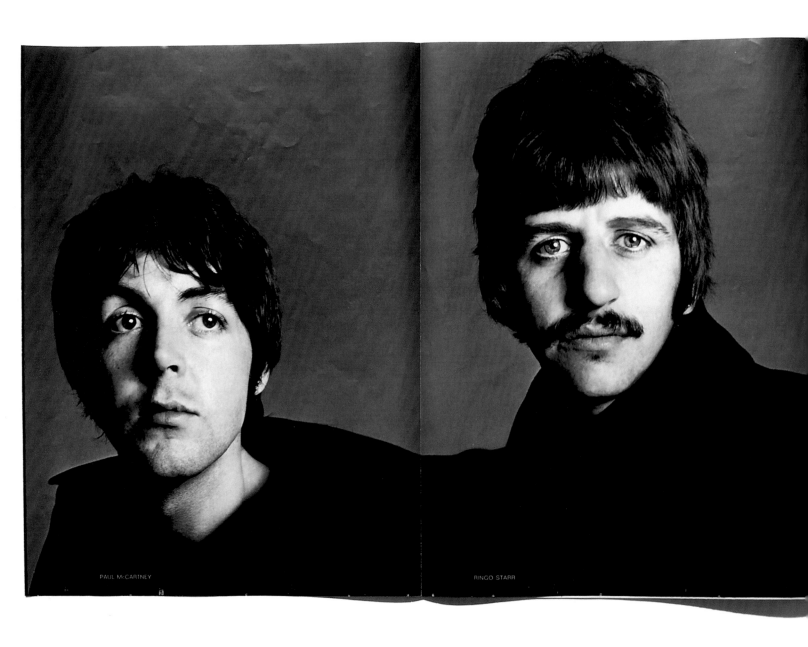

PAUL McCARTNEY

RINGO STARR

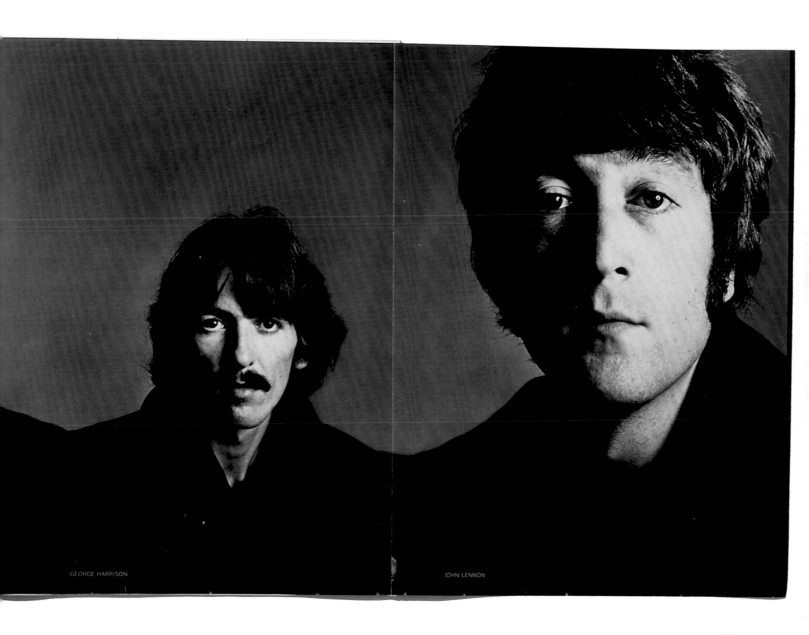

GEORGE HARRISON

JOHN LENNON

When Irving Penn could not convince *Vogue* to let him shoot a story on Californian counterculture, he took the idea to *Look* magazine, who eventually published the story in their special issue devoted to the 1960s. Penn went to San Francisco for several weeks, where he and *Look*'s West Coast editor sought the right subjects for a series of portraits. Many sitters were suspicious of a mainstream photographer working for a national magazine – the Hell's Angels only agreed after careful negotiations conducted over several meetings. Penn selected his sitters in part because of their commitment to change everyday society by any means available – whether through music, art or fashion, or by otherwise redefining traditional norms of work and family. Members of 'Big Brother and the Holding Company' explained: 'Nothing's separate – job, rehearsal, living, the way we dress … To us it's just a lifestyle, a total thing.' These sitters could not foresee the profitable celebrity culture that their music and lifestyle would help create, but Penn clearly understood the glamour. (9 January 1968)

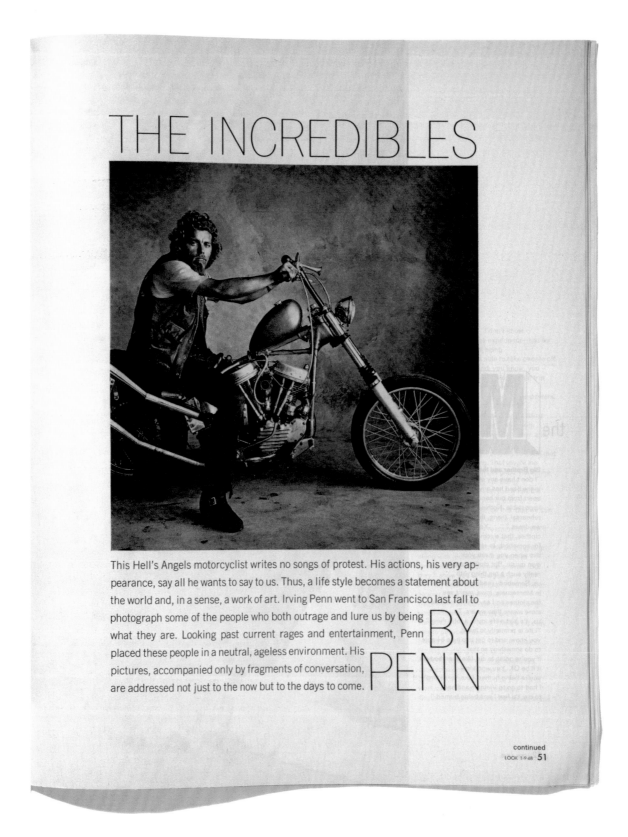

THE INCREDIBLES

This Hell's Angels motorcyclist writes no songs of protest. His actions, his very appearance, say all he wants to say to us. Thus, a life style becomes a statement about the world and, in a sense, a work of art. Irving Penn went to San Francisco last fall to photograph some of the people who both outrage and lure us by being what they are. Looking past current rages and entertainment, Penn placed these people in a neutral, ageless environment. His pictures, accompanied only by fragments of conversation, are addressed not just to the now but to the days to come.

BY PENN

continued
LOOK 1-9-68 51

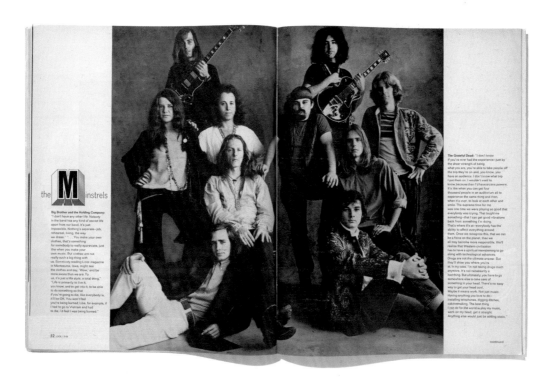

the Minstrels

Big Brother and the Holding Company: "I don't have any other life. Nobody in the band has any kind of secret life apart from our band. It's just impossible. Nothing's separate—job, rehearsal, living, the way we dress." ... "You make your own clothes, that's something for somebody to really appreciate, just like when you make your own music. But clothes are not really such a big thing with us. Somebody reading *Look* magazine in Montezuma, Iowa, might see the clothes and say, 'Wow,' and be more aware than we are. To us, it's just a life style, a total thing." "Life is primarily to live it, you know, and to get into it, to be able to do something so that if you're going to die, like everybody is, it'll be OK. You won't feel you're being burned. Like, for example, if I had to go to Vietnam and had to die, I'd feel I was being burned."

The Grateful Dead: "I don't know if you've ever had the experience—just by the sheer strength of being what you are, you're able to take people off the trip they're on and, you know, you have an audience. I don't know what trip I got them on. I wouldn't want to know, because then I'd have arcane powers. It's like when you can get four thousand people in an auditorium all to experience the same thing and then, when it's over, to look at each other and smile. The supreme time for me was one time we were playing so good that everybody was crying. That taught me something—that I can get good vibrations back from something I'm doing. That's where it's at—everybody has the ability to affect everything around them. Once we recognize this, that we can be a force on the planet, then we all may become more responsible. We'll realize that Western civilization has to have a spiritual reawakening to go along with technological advances. Drugs are not the ultimate answer. But they'll show you where you're at. In my case, I'm not taking drugs much anymore. It's not necessarily a bad thing. But ultimately, you have to go somewhere else to take care of something in your head. There's no easy way to get your head cool. Maybe it means work. Not just music. Having anything you love to do—installing telephones, digging ditches, cabinetmaking. The best thing I can do for the world is play my music, work on my head, get it straight. Anything else would just be adding static."

continued

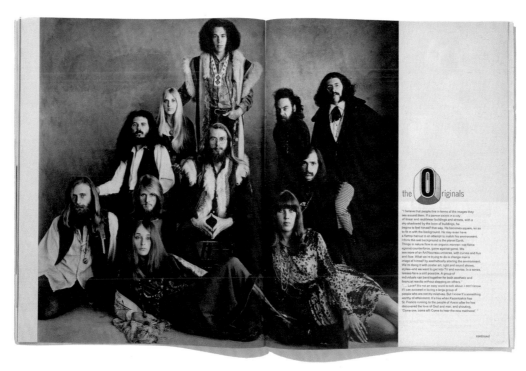

the Originals

"I believe that people live in terms of the images they see around them. If a person exists in a city of linear and rectilinear buildings and streets, with a sky shadowed by the loom of buildings, he begins to feel himself that way. He becomes square, so as to fit in with the background. He may even have a flattop haircut in an attempt to match his environment. I think the real background is the planet Earth. Things in nature flow in an organic manner—we frame against counterforce, game against game. We see more of an Art Nouveau universe, with curves and flux and flow. What we're trying to do is change man's image of himself by aesthetically altering the environment. We're doing it with poster art, light and sound shows, styles—and we want to get into TV and movies. In a sense, release form is still possible. A group of individuals can band together for both aesthetic and financial results without stepping on others."

"... Love? It's not an easy word to talk about. I don't know if I can succeed in loving a large group of people who are not my relatives. But I know it's something worthy of attainment. It's like when Kazantzakis has St. Francis running to the people of Assisi after he has discovered the love of God and man, and shouting, 'Come one, come all! Come to hear the new madness!'"

continued

the Families

"What I'm really interested in now is, I have a son. That's all I'm working for now. I wish I knew just how to raise him. I can't say complete freedom. You have to decide what's right and wrong. Of course, I do a lot of wrong things myself." "We're not in that giant crowd of people they call hippies. We were doing these things—a lot of us were—before all this publicity came along, and I think we'll keep on doing them. Any art I do is something I feel right at the moment. Even dressing this way is an art. When you're walking down the street like this, you don't have to have an exhibit of your paintings, or even say anything. Unfortunately, most people see only what they want to see. I feel we're clean and good and all those things the Boy Scouts are. We just get our enjoyment other ways. We like different kinds of music and different kinds of art. We don't have enough money, but if we had more money, we'd really be outrageous." "It's really far out when you find you can do anything you want with your life. It would seem strange to me to pay an insurance company so that maybe later you'd get paid." "Yeah, those people out there are really insane. They spend half their life with paper work. And then they say, 'Vote. Vote for what? If Reagan runs for President, he'll win, I'll vote for him. It'll bring it all down quicker. When enough people get fed up with this civilization, this trip is going to fall. But I'm not hassling, not fighting it. I feel good. I've let my hair down."

PRODUCED BY GEORGE B. LEONARD AND JOHN LUCE

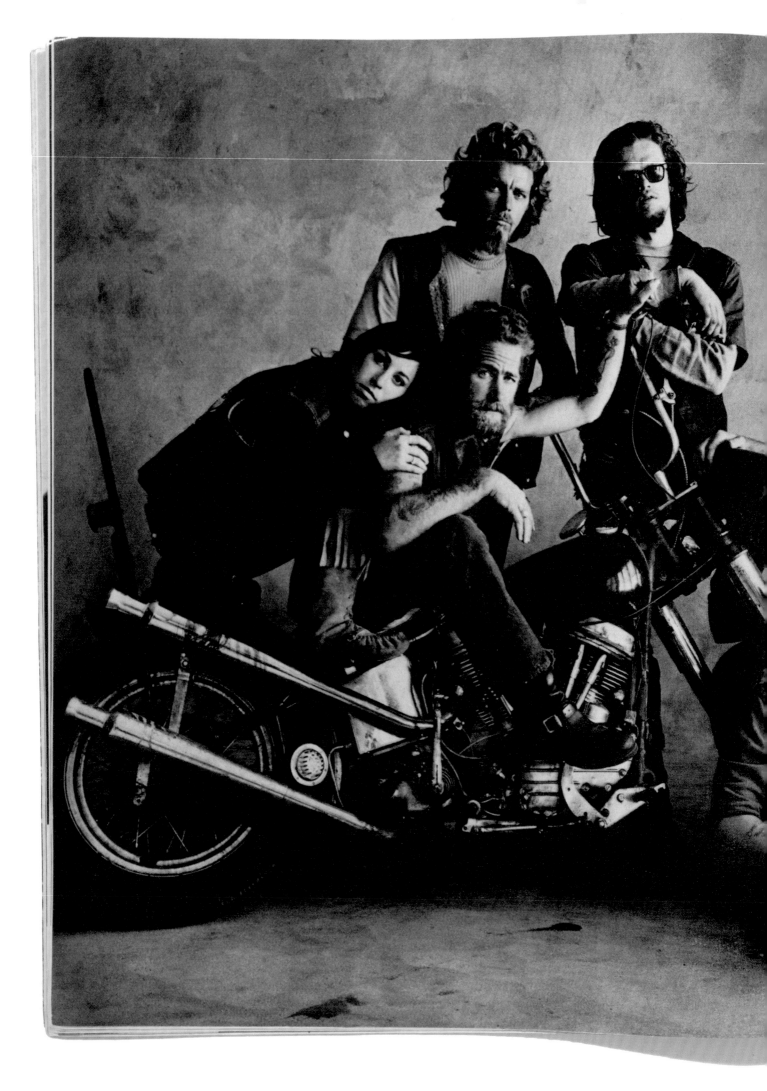

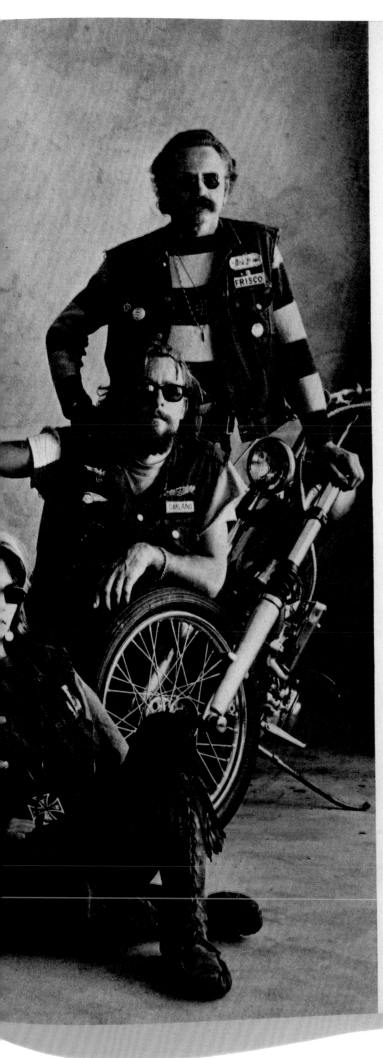

the utrageous

"There's only one thing that really means anything to me and that's the Hell's Angels patch I wear. I can get me anything else—a new bike, a new old lady or money—but I can't get me another patch."
"We've had a few deaths this year, but otherwise, it's been a good year. By that I mean we haven't had much police harassment." ". . . . It's like being brothers. Like, every man in the club's your brother." "Power. That's what it feels like when we ride in. On a three-day weekend, we might have one-fifty, two-hundred bikes out on a run. People all get excited when they see us coming, and— I don't know—it's beautiful." ". . . You know what it is, it's a mind-blower. They come around with movie cameras. It's really beautiful." "If somebody messed up one of our brothers, it would be complete retaliation. An eye for an eye." ". . . My brothers—that's my whole life. My brothers. It's all I've got."

continued

Don McCullin provided both text and images for this story about the US counter-offensive against the Imperial city of Hue, captured by the North Vietnamese during the Tet Offensive. This was his second assignment in Vietnam and McCullin welcomed the chance to join the Fifth Marine corps, charged with taking the city's picturesque old city. Its age and beauty reminded him of Jerusalem when he covered the Six Day War, an assignment that then made him feel that he 'would like to do war photography every day of the week'. A 24-hour battle was expected but it took 11 days to retake the Citadel. McCullin's photographs are dramatically harrowing in their depiction of the battlefield, and almost painfully intimate when showing the soldiers' dedication to each other. The story also conveyed the emerging disillusionment with the war that McCullin felt himself and that he saw in the soldiers. Things had changed since his assignment two years previously: 'Then they were confident about the war and felt sure they had a right to be there. Now they have doubts.' (24 March 1968)

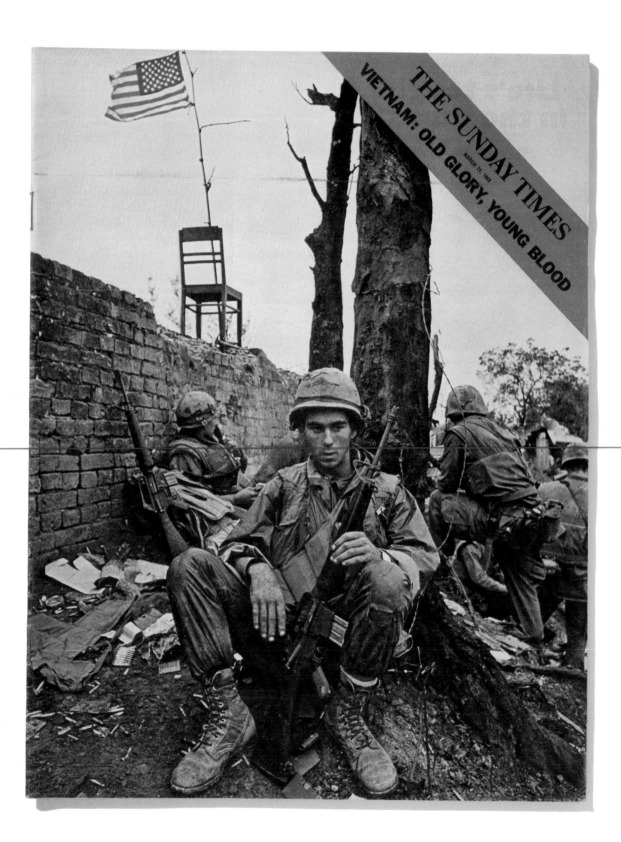

THIS IS HOW IT IS

Photographs and commentary by Donald McCullin

This is Donald McCullin's photographic report on a bunch of young American Marines engaged in a bloody confrontation with the Viet Cong. His own words describe what is happening in his pictures:

"This big Negro was doing what they call hand-to-hand fighting. Both sides were dug in and lobbing grenades at each other. Unfortunately on this occasion the Marines were short of grenades. We were trying to advance along the earthwork top of the Citadel wall of Hué and the grenades were being passed up the line of dug-in men one at a time. Naturally there had to be a pause in supply at some stage. When this happened the Viet Cong popped up and hurled a grenade. I'd just taken this picture before it happened . . . the grenade landed short but it wounded the GI in the hand.

"I spent 11 days with the Americans fighting their way into the Citadel. What worried me about this whole battle was the fact that there were so few mature soldiers with the Marine platoons. The captain back at the command post was only 24 and the average age of the platoons going out to storm the Viet Cong positions was only 20. There seemed a great need among the young men for leadership.

"The most impressive thing was the accuracy of the American shelling. Their ships out at sea were hitting the streets right in front of our positions. And shells from an army base 16 miles away were landing 200 yards ahead of us.

"Something I found very moving was the way the Negroes and the Whites have developed this uncanny kind of relationship while they're fighting together. They cook each other's food and drink out of each other's canteens. It's strange. A kind of love. It's not that the Whites go out of their way to be nice to the Negroes – rather the other way round. I got the feeling it was a kind of protectiveness on the part of the Negroes. I think it's something to do with the fact that for the first time they find themselves in a situation where they're all equal and they're accepted.

"The general attitude of the ordinary American soldier in Vietnam has changed a lot since I was with them two years ago. Then they were confident about the war and felt sure they had a right to be there. Now they have their doubts."

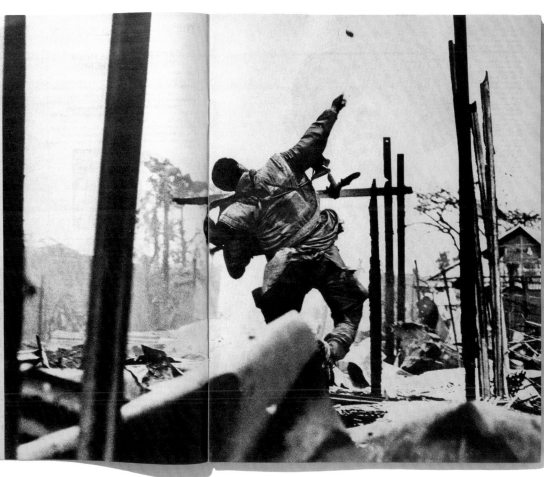

"This is Eric Henshall, a Scottish boy who emigrated to America in 1959. His U.S. citizenship came through last year – he was drafted this year. He's only in his early twenties, but he got to look a lot older inside the Citadel. Those binoculars are given to him because he's a sniper working ahead of the platoons.

"The old man with the blindfold was being questioned because he was suspected of giving our movements away to the Viet Cong. But the old boy was very nervous. He might have just got caught in the middle. After all, if Hampstead Garden Suburb was being shelled there'd always be someone who'd go back to see if his property was all right"

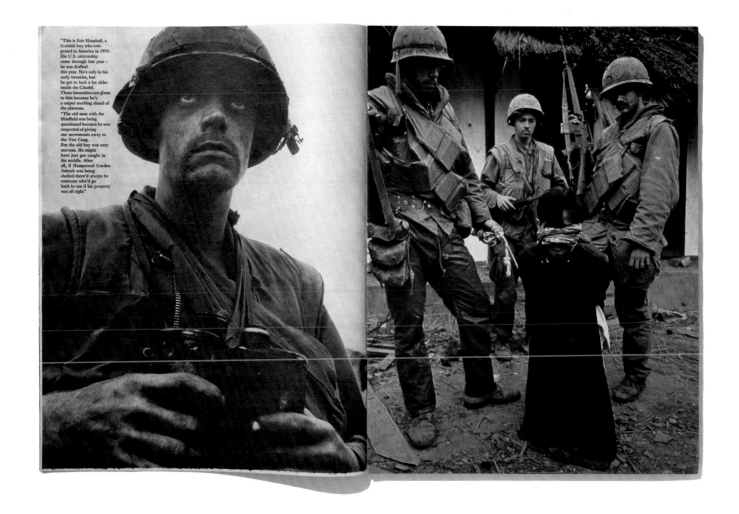

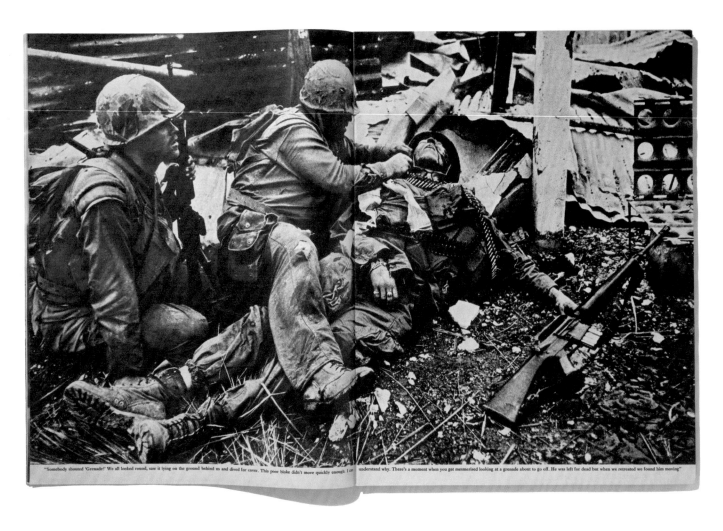

"Somebody shouted 'Grenade!' We all looked round, saw it lying on the ground behind us and dived for cover. This poor bloke didn't move quickly enough. I can't understand why. There's a moment when you get mesmerised looking at a grenade about to go off. He was left for dead but when we retreated we found him moving"

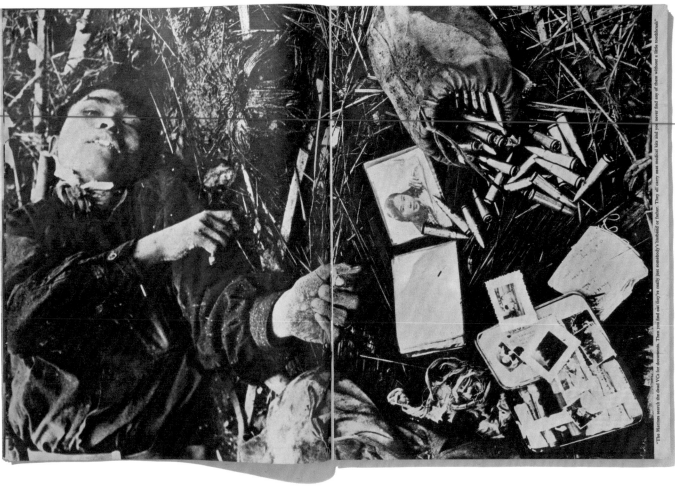

"The Marines search the dead VCs for documents. Then you find out they're really just somebody's husband or father. They all carry neat medical kits and you never find any of them without a little toothbrush"

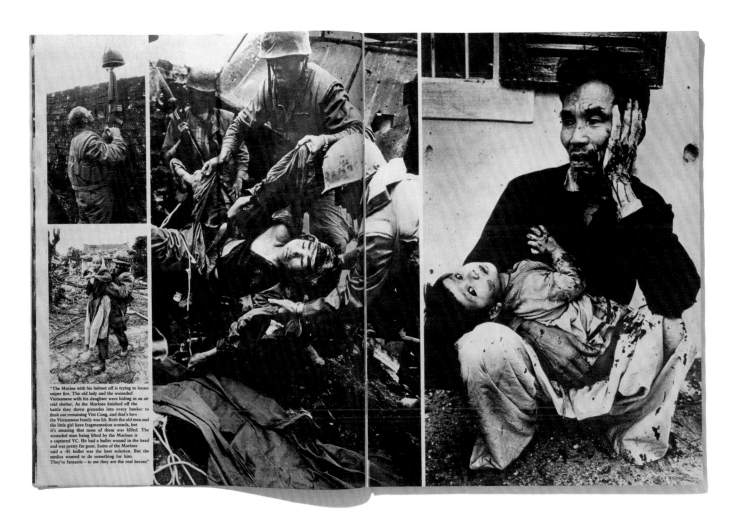

"The Marine with his helmet off is trying to locate sniper fire. The old lady and the wounded Vietnamese with his daughter were hiding in an air raid shelter. As the Marines finished off the battle they threw grenades into every bunker to flush out remaining Viet Cong, and that's how the Vietnamese family was hit. Both the old man and the little girl have fragmentation wounds, but it's amazing that none of them was killed. The wounded man being lifted by the Marines is a captured VC. He had a bullet wound in the head and was pretty far gone. Some of the Marines said a .45 bullet was the best solution. But the medics wanted to do something for him. They're fantastic – to me they are the real heroes"

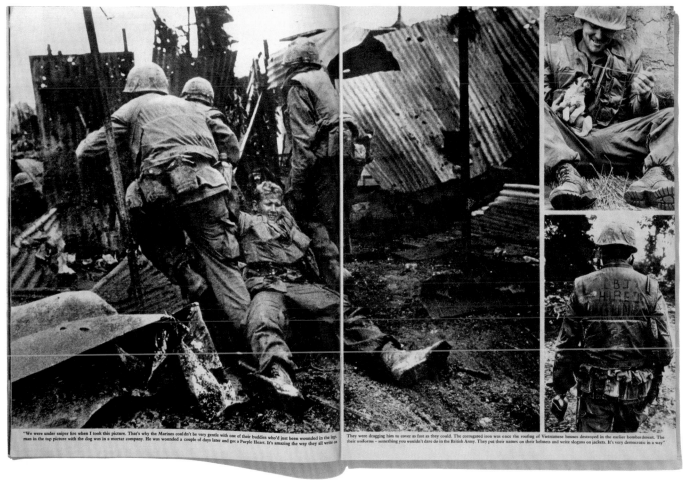

"We were under sniper fire when I took this picture. That's why the Marines couldn't be very gentle with one of their buddies who'd just been wounded in the legs. man in the top picture with the dog was in a mortar company. He was wounded a couple of days later and got a Purple Heart. It's amazing the way they all write on

They were dragging him to cover as fast as they could. The corrugated iron was once the roofing of Vietnamese houses destroyed in the earlier bombardment. The their uniforms – something you wouldn't dare do in the British Army. They put their names on their helmets and write slogans on jackets. It's very democratic in a way"

In 1966, with the aid of the first grant given for photography by the National Endowment for the Arts, Bruce Davidson began a two year project to photograph the residents of East 100th Street in Spanish Harlem, New York. Prompted by glimpses of street life on this notorious city block that Davidson saw through the window of the elevated train he regularly took from Grand Central Station, he said 'It was at the same time as we as we were sending men to the moon. I felt we were losing our focus; that we had to go into inner space not outer space: the inner space in the centre of our broken-down cities, in order to recover our humanity. I wanted to get inside and to explore it.' Shunning the photographic language usually applied at the time to stories about poverty, Davidson used a 4x5 view camera mounted on a tripod, making direct, non-judgemental portraits with the participation of his subjects. In the wake of the riots that erupted in American cities during the 1960s, his intimate view of America's black underclass was widely published.
(21 April 1968)

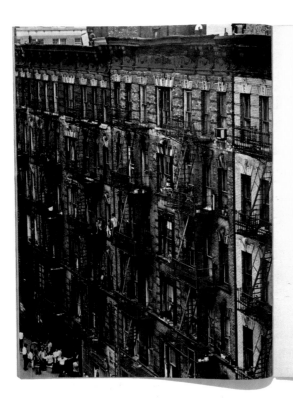

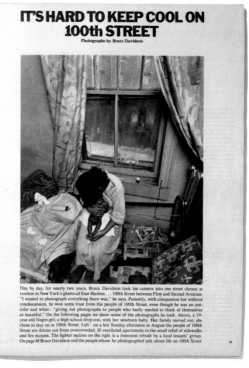

IT'S HARD TO KEEP COOL ON 100th STREET

Photographs by Bruce Davidson

Day by day, for nearly two years, Bruce Davidson took his camera into one street chosen at random in New York's ghetto of East Harlem . . . 100th Street between First and Second Avenues. "I wanted to photograph everything there was," he says. Patiently, with compassion but without condescension, he won some trust from the people of 100th Street, even though he was an outsider and white: "giving out photographs to people who badly needed to think of themselves as beautiful." On the following pages we show some of the photographs he took. Above, a 19-year-old Negro girl, a high school drop-out, with her newborn baby. Her family moved out, she chose to stay on in 100th Street. Left: on a hot Sunday afternoon in August the people of 100th Street are driven out from overcrowded, ill-ventilated apartments to the small relief of sidewalks and fire escapes. The lighter section on the right is a tenement rebuilt by a local tenants' group. On page 48 Bruce Davidson and the people whom he photographed talk about life on 100th Street

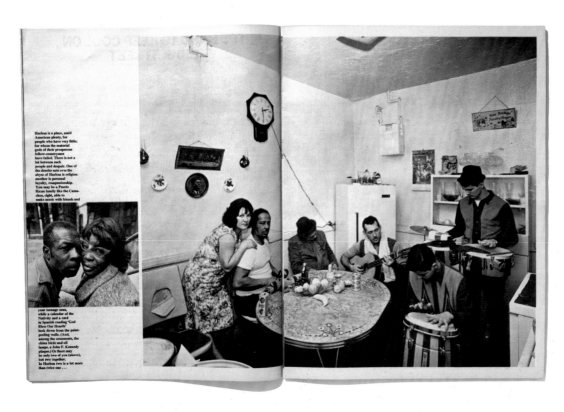

Harlem is a place, amid America's plenty, for people who have very little; for whom the material gods of their prosperous fellow-countrymen have failed. There is not a lot between each people and despair. One of the slender nets over the abyss of Harlem is religion: another is personal loyalty, companionship. You may be a Puerto Rican family like the Caméchos, right, able to make music with friends and your teenage sons, while a calendar of the Nativity and a card in Spanish reading 'God Bless Our Hearth' look down from the paint-peeling walls. (And, among the ornaments, the china birds and oil lamps, a John F. Kennedy plaque.) Or there may be only two of you (above), but two together. In Harlem two is a lot more than twice one . . .

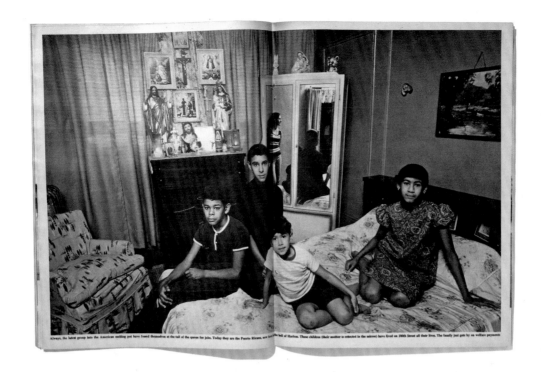

Always, the latest group into the American melting pot have found themselves at the tail of the queue for jobs. Today they are the Puerto Ricans, now in the belt of Harlem. These children (their mother is reflected in the mirror) have lived on 100th Street all their lives. The family just gets by on welfare payments

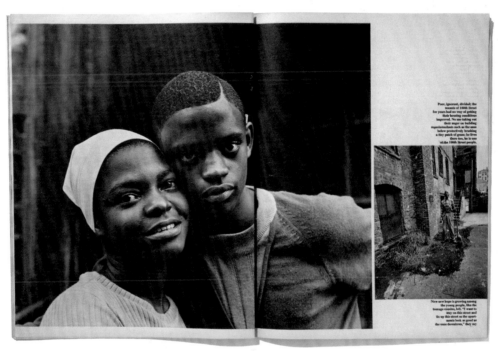

Poor, ignorant, divided; the tenants of 100th Street for years had no way of getting their housing conditions improved. No one taking out their anger on building superintendents such as the ones below protectively brushing a tiny patch of grass; he lives there too, he is one of the 100th Street people.

New new hope is growing among the young people, like the teenage cousins, left. "I want to stay on this street and fix up this street so the apartments look as good as the ones downtown," they say

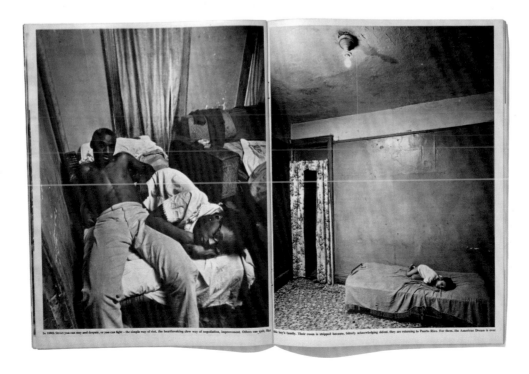

In 100th Street you can stay and despair, or you can fight — the simple way of riot, the heartbreaking slow way of negotiation, improvement. Others can quit, like this boy's family. Their room is stripped because, bitterly acknowledging defeat, they are returning to Puerto Rico. For them, the American Dream is over

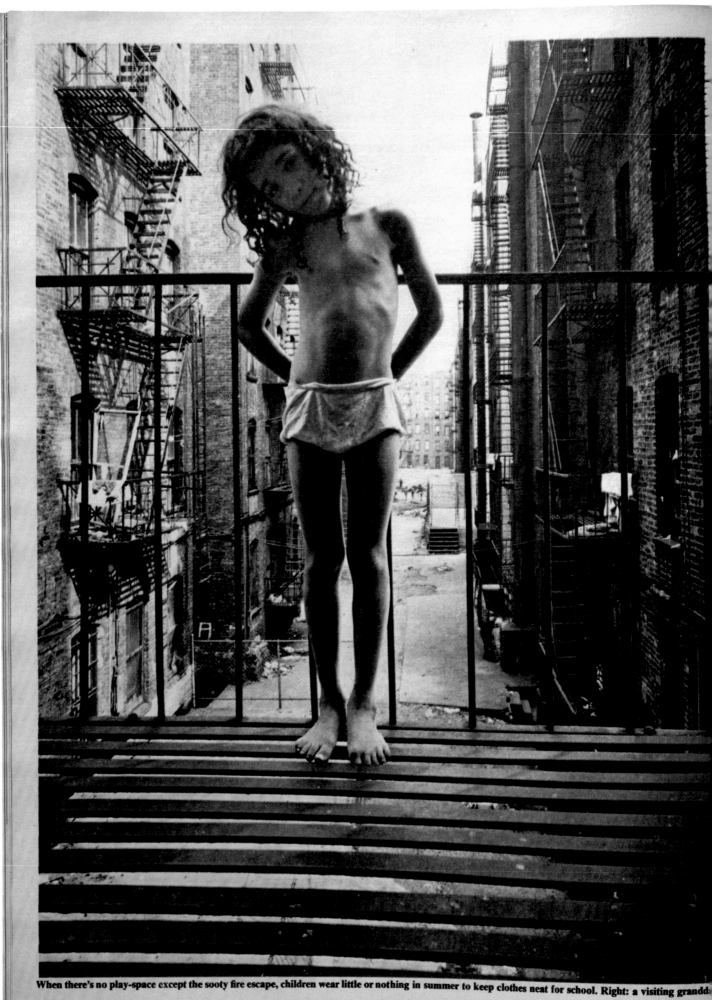

When there's no play-space except the sooty fire escape, children wear little or nothing in summer to keep clothes neat for school. Right: a visiting granddau...

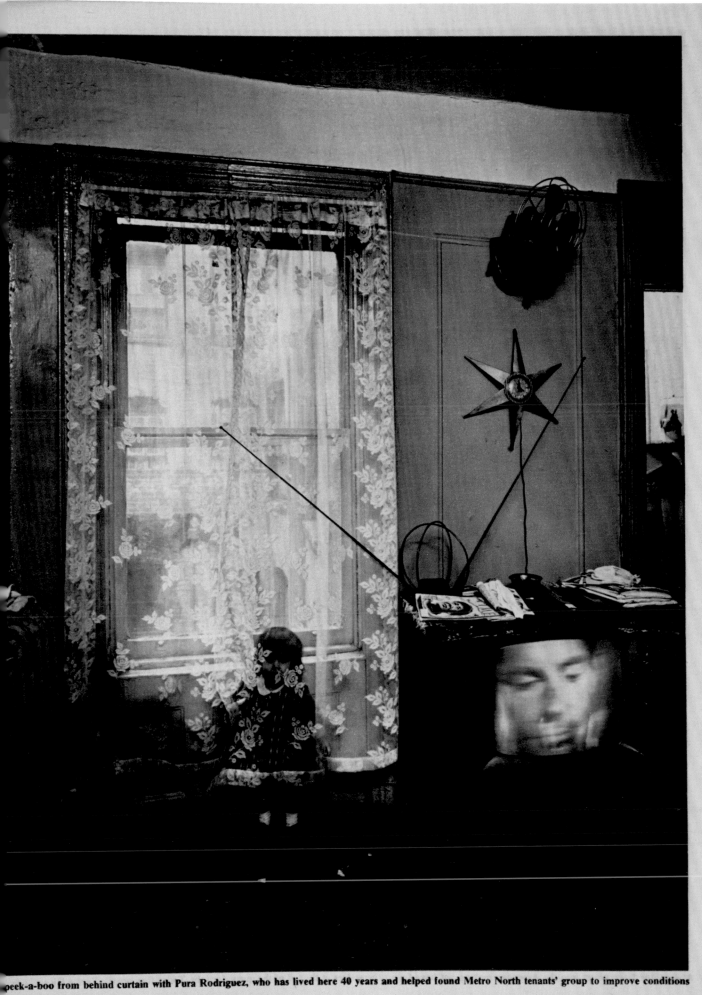

peek-a-boo from behind curtain with Pura Rodriguez, who has lived here 40 years and helped found Metro North tenants' group to improve conditions

The Christian Ibo people's war of independence against the Nigerian state had been going on for nearly a year, and 200,000 combatants had already died before this first photojournalistic account of it was published. Gilles Caron's black and white photographs documented life with the rebel army without sentiment; for example, we see soldiers ordered to pass by their own wounded colleagues because there is no time to care for them. Meanwhile Floris de Bonneville provided brutal colour shots of the aftermath of battle: the magazine's opening shot shows a body burning, with a double-page spread showing a road strewn with cars wrecked by a mortar blast. Together, the images brought readers close to the action but without arousing their sympathy. Eventually Nigeria found a more effective way to fight the rebellious Ibos, by inducing famine conditions inside Biafra; at this point the press filled with images of starving civilians, many of them children, which attracted international humanitarian assistance. But the Ibos' political mission had failed, and in 1970 Nigeria reabsorbed the rogue nation. (4 May 1968)

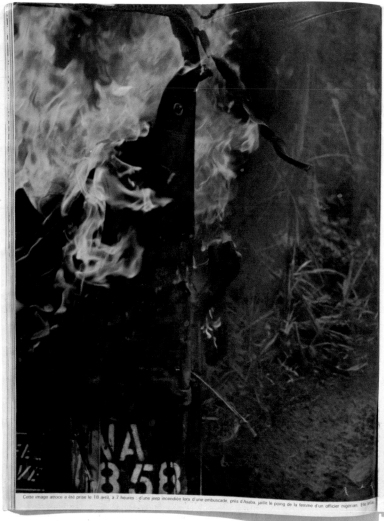

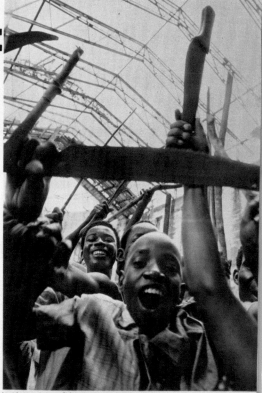

BIAFRA: LA GUERRE IGNORÉE

Deux journalistes français ramènent les premières images de l'offensive du Biafra révolté contre le Nigeria. C'est le témoignage d'un conflit sans merci qui a déjà fait plus de 200 000 morts.

Depuis onze mois, entre le Nigeria (45 millions d'habitants, pour la plupart musulmans) et la province sécessionniste du Biafra (14 millions de chrétiens), une guerre sans prisonniers et sans pitié se poursuit presque ignorée du monde entier. Déjà, de juin 1967 à janvier 1968, 200 000 civils biafrais ont été tués par l'aviation nigérianne, tandis que l'armée du gouvernement central occupait les villes de Calabar, Onitsha et Enugu, elle-même, la capitale des « rebelles ». Cependant, luttant à un contre cinq, mal équipés d'armes hétéroclites, l'armée biafraise commandée par un géant catholique et barbu, le colonel Ojukwu, est passée à la contre-attaque à la fin de janvier. Et là, des journalistes étaient présents : deux Français de vingt-sept ans, le photographe Gilles Caron et Floris de Bonneville. Pour « Paris-Match », ils ont ramené les premières photos parvenues en Europe de l'hallucinante offensive des guérilleros du Biafra. En deux mois et demi d'embuscades, suivie d'une marche en territoire ennemi vers la ville d'Asaba, ceux-ci ont mis hors de combat 18 000 soldats nigérians et fait passer la victoire dans le camp des combattants sans uniforme.

Le cri de victoire des jeunes Biafrais : sous les poutrelles de la cathédrale inachevée d'Owerri, ils fêtent la prise d'Asaba.

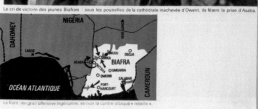

Au cœur de l'Afrique occidentale : Nigeria et Biafra. Le front : en gris l'offensive nigérianne, en noir la contre attaque « rebelle ».

Cette image atroce a été prise le 18 avril, à 7 heures : d'une jeep incendiée lors d'une embuscade, près d'Asaba, jaillit le poing de la femme d'un officier nigérian. Elle grille.

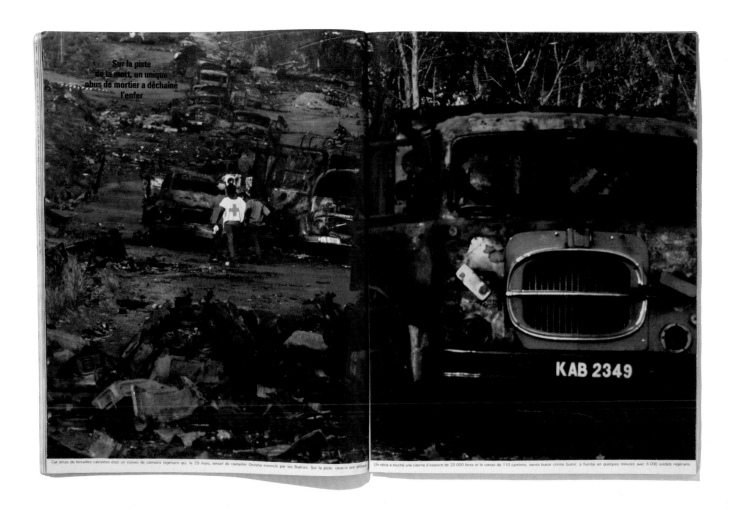

Sur la piste
de la mort, un unique
obus de mortier a déchaîné
l'enfer

KAB 2349

Cet amas de ferrailles calcinées était un convoi de camions nigérians qui, le 29 mars, tentait de ravitailler Onitsha encerclé par les Biafrais. Sur la piste, ceux-ci ont attaqué.

Un obus a touché une citerne d'essence de 20 000 litres et le convoi de 110 camions, serrés butoir contre butoir, a flambé en quelques minutes avec 6 000 soldats nigérians.

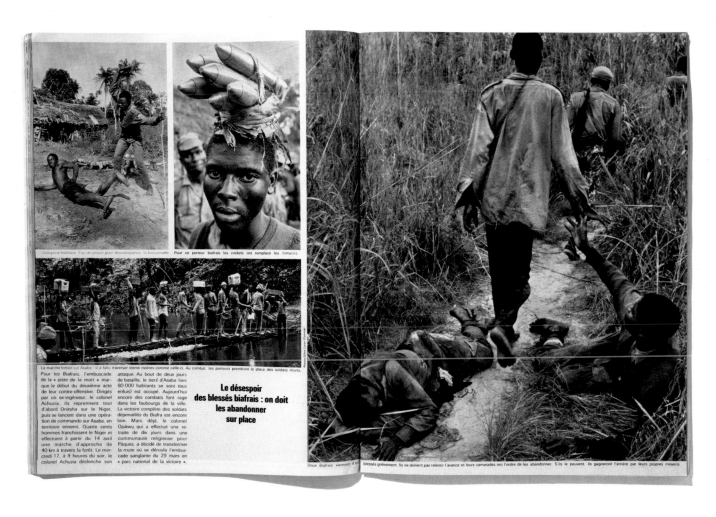

Discipline biafraise. Pas de procès pour désobéissance, la bastonnade.

Pour ce porteur biafrais les rockets ont remplacé les bananes.

La marche forcée sur Asaba : il a fallu traverser trente rivières comme celle-ci. Au combat, les porteurs prendront la place des soldats morts.

Pour les Biafrais, l'embuscade de la « piste de la mort » marque le début du deuxième acte de leur contre-offensive. Dirigés par un ex-ingénieur, le colonel Achuzia, ils reprennent tout d'abord Onitsha sur le Niger, puis se lancent dans une opération de commando sur Asaba, en territoire ennemi. Quatre cents hommes franchissent le Niger et effectuent à partir du 14 avril une marche d'approche de 40 km à travers la forêt. Le mercredi 17, à 9 heures du soir, le colonel Achuzia déclenche son attaque. Au bout de deux jours de bataille, le tiers d'Asaba (ses 80 000 habitants se sont tous enfuis) est occupé. Aujourd'hui encore des combats font rage dans les faubourgs de la ville. La victoire complète des soldats dépenaillés du Biafra est encore loin. Mais, déjà, le colonel Ojukwu, qui a effectué une retraite de dix jours dans une communauté religieuse pour Pâques, a décidé de transformer la route où se déroula l'embuscade sanglante du 29 mars en « parc national de la victoire ».

**Le désespoir
des blessés biafrais : on doit
les abandonner
sur place**

Deux Biafrais viennent d'être blessés grièvement. Ils ne doivent pas ralentir l'avance et leurs camarades ont l'ordre de les abandonner. S'ils le peuvent, ils gagneront l'arrière par leurs propres moyens.

In the issue of May 18, *Paris Match* devoted a special report to the widespread insurrection that flared in the streets around the Sorbonne in the days between 6 and 11 May 1968. Photographs by a dozen reporters include an hour-by-hour photographic account of the battle between students and police that took place over the night of 10 May, climaxing with Gilles Caron's now famous image of a lone student in flight from a policeman. The accompanying essay by Jean Maquet seems now to have missed the mark. For him these events were not part of 'a crisis of society around the world', merely a dramatic student gesture against rampant materialism. He could not know that within days the revolutionary spirit of the students would capture the country, with over ten million workers on strike for better wages and working conditions. As a result of subsequent events, these records of the intense excitement and suspense that filled the streets of Paris in the early days of May 1968 became iconic references for a new generation come of age. (18 May 1968, including photographs by Claude Azoulay, Gilles Caron and Patrice Habans)

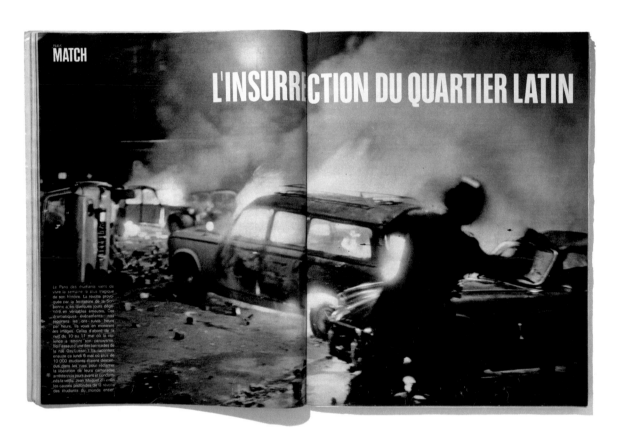

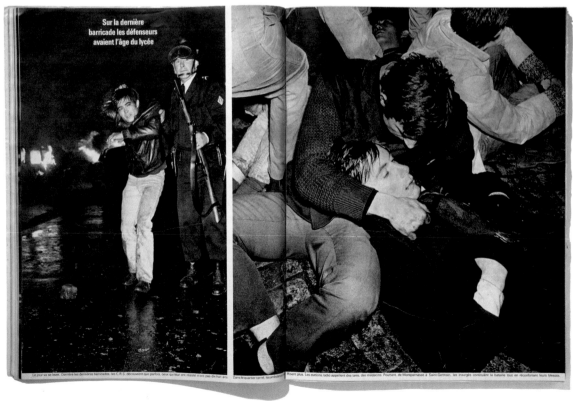

Les étudiants
veulent s'ouvrir le chemin
de la Sorbonne

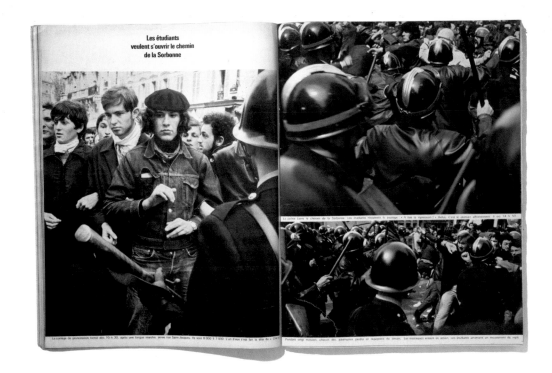

Le cortège de protestation formé dès 10 h 30, après une longue marche, prise rue Saint-Jacques. Ils sont 6 000 à 7 000. L'un d'eux crie que le titre du « C'est le premier affrontement. Il est 14 h 50.

Pendant vingt minutes, chacun des adversaires perdra et regagnera du terrain. Les matraques entrent en action. Les étudiants amorcent un mouvement de repli.

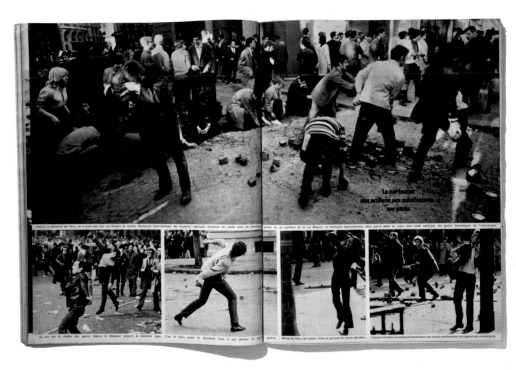

La rue fournit
une artillerie aux manifestants
ses pavés

Depuis la libération de Paris, on n'avait pas revu ces images de révolte. Boulevard Saint-Germain, les étudiants regroupés arrachent les pavés pour la bataille police. Ici, au carrefour de la rue Mignon, ils retrouvent spontanément, alors que le défilé du matin était resté pacifique, les gestes dramatiques de l'insurrection.

Ils ont fait la chaîne des pavés, depuis le dépaveur jusqu'à la première ligne. C'est ici le vacur prise du désordre mais il est devenu un guerre. Même les filles s'en mêlent. Elles ne sont pas les moins décidées. Ceux qui sont venus en vacances ce traquent pour une simple manifestation se jugeaient sous contrainte.

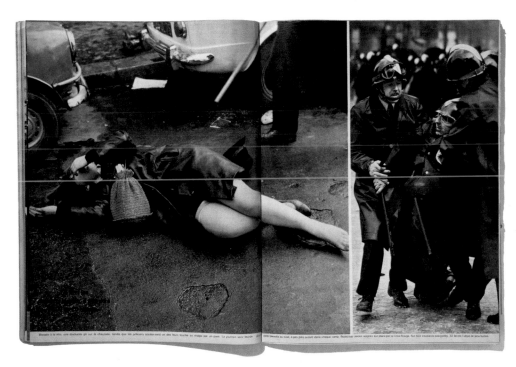

Blessée à la tête, une étudiante git sur la chaussée, tandis que les préfecture soutien sont un des leurs touché au visage par un pavé. La journée sera meurdre. 8000 blessés au total, à peu près autant dans chaque camp. Beaucoup seront soignés sur place par la Croix-Rouge. Sur 422 étudiants interpellés, 32 seront l'objet de poursuites.

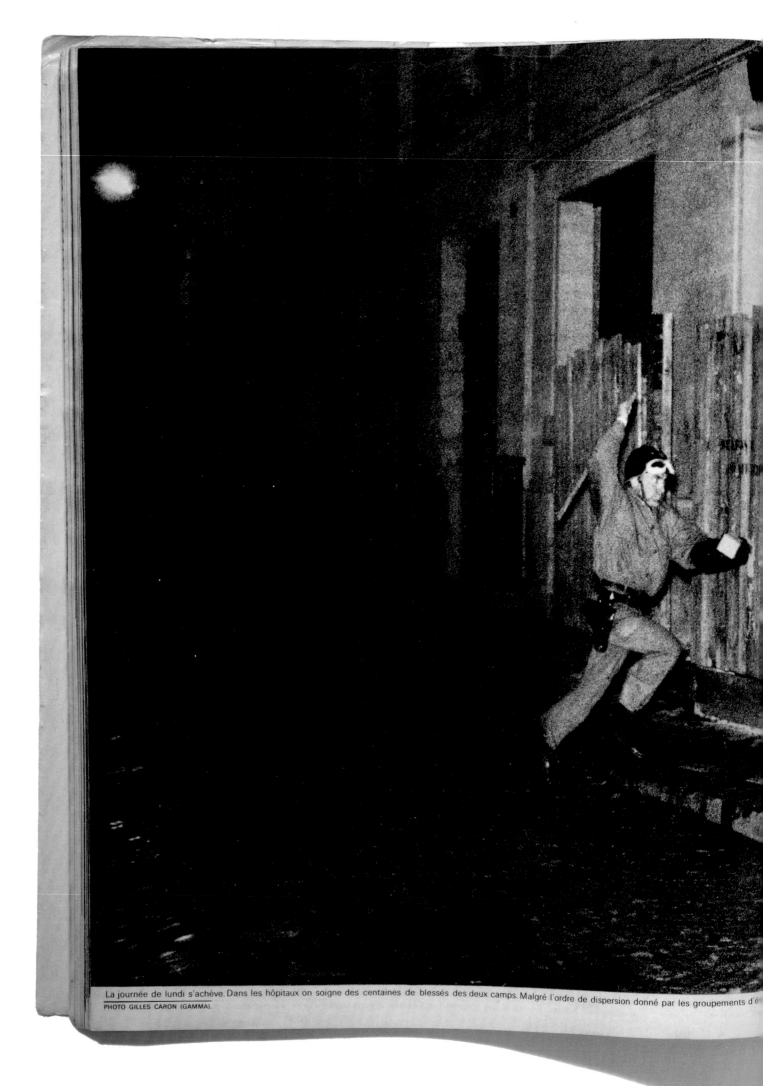

La journée de lundi s'achève. Dans les hôpitaux on soigne des centaines de blessés des deux camps. Malgré l'ordre de dispersion donné par les groupements d'é
PHOTO GILLES CARON (GAMMA).

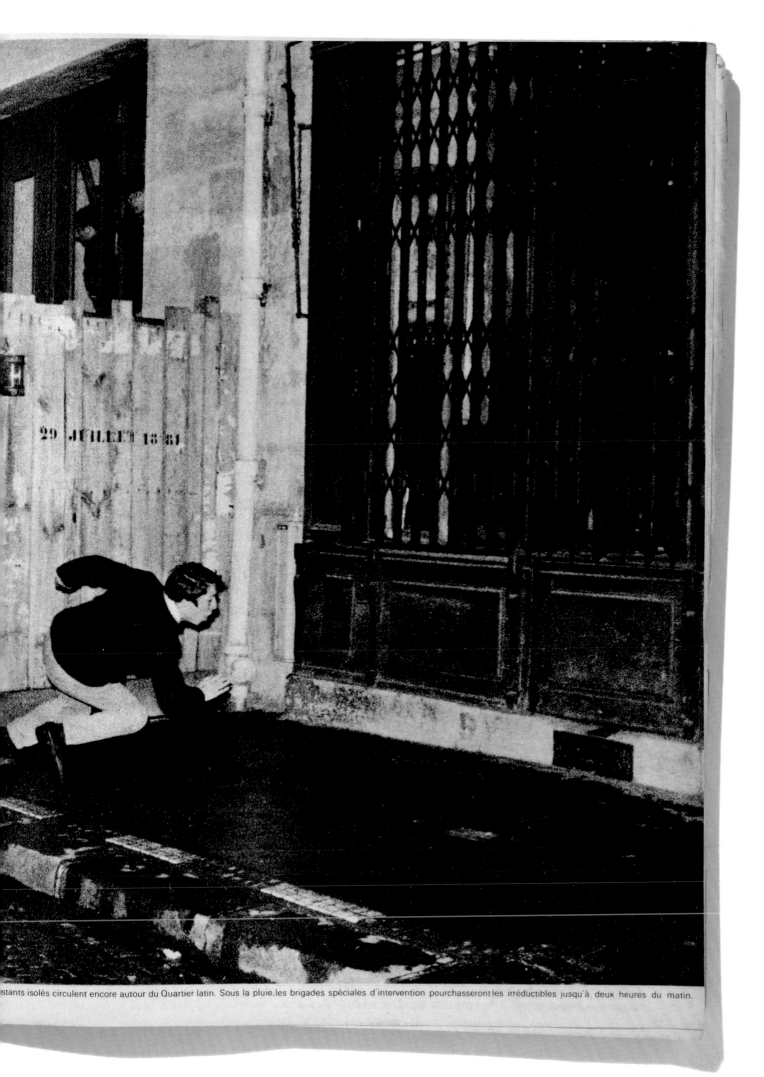

29 JUILLET 13 61

stants isolés circulent encore autour du Quartier latin. Sous la pluie,les brigades spéciales d'intervention pourchasseront les irréductibles jusqu'à deux heures du matin.

In its short life, the Brazilian magazine *Realidade* achieved the status of myth in publishing history. The magazine started in 1966 with a progressive social and political agenda, but closed after five years during a time of widespread cultural censorship introduced by Brazil's military rulers. Claudia Andujar, a Swiss photographer who emigrated to Brazil in 1955, worked for *Realidade* throughout the years it published. Her photo stories, notable for an aesthetic that was ahead of its time, pushed at the moral boundaries of conservative public opinion; when *Realidade* published her story on the lives of prostitutes in São Paulo, it was considered 'immoral', and her sympathetic treatment of her subject 'insulting'. The issue of the magazine that featured another Andujar story, about midwives and showing the birth of a child for the first time in the Brazilian press, was found offensive and immediately withdrawn from circulation under censorship rules. She continued working on controversial issues after *Realidade* closed, Her photographs of the Yanomami Indians, in whose interests she campaigned, also challenged conservative taboos of Brazilian society; in this case, her efforts were rewarded, in 1992, with the creation of the Yanomami Park reserve. (July 1968)

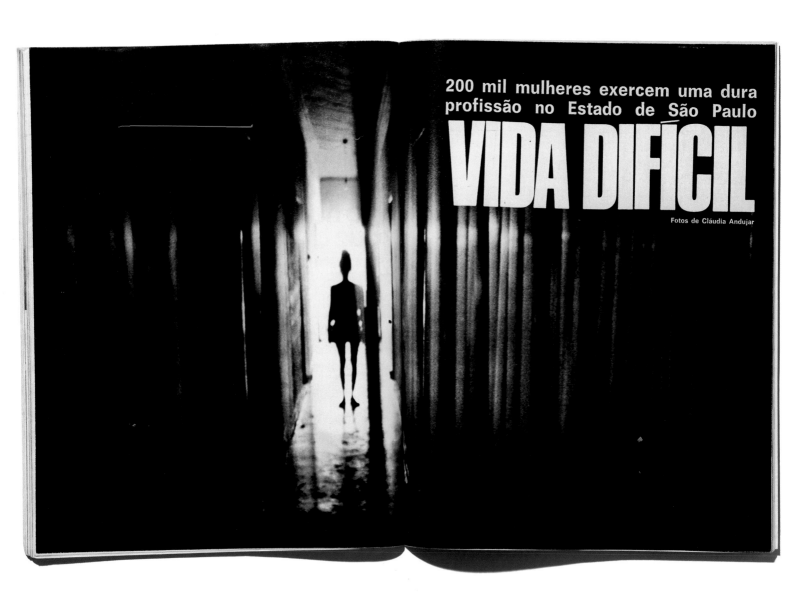

CLAUDIA ANDUJAR PROSTITUTION IN SÃO PAULO REALIDADE

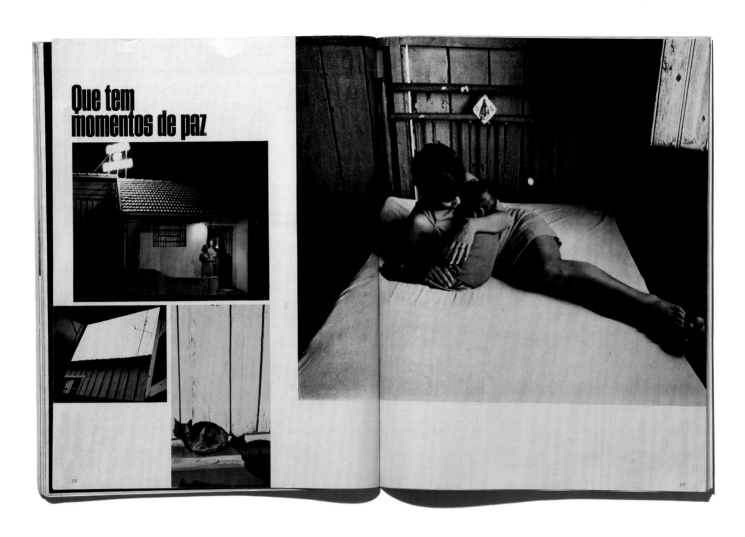

Que tem
momentos de paz

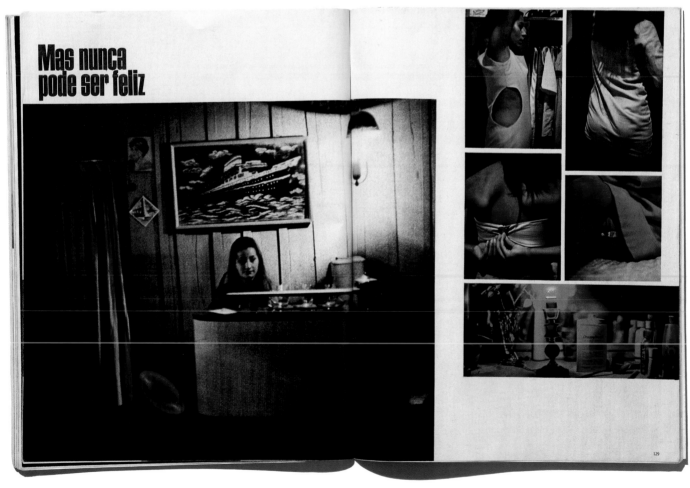

Mas nunca
pode ser feliz

By 1967 America was committing 200,000 troops to Vietnam in an escalating and increasingly bloody war. Welsh-born photographer Philip Jones Griffiths, whose Celtic background predisposed him to empathy with the underdog, discovered Vietnam to be a 'goldfish bowl where the values of the American and the Vietnamese can be observed, studied and because of their contrasting nature, more easily appraised'. He went further than other photographers of Vietnam in his explicit critique of American involvement and its subjugation of the Vietnamese, and as a result faced difficulties getting his photographs published; the London *Daily Telegraph* magazine went where few American magazines were prepared to go in presenting his photographs of Saigon following the Tet Offensive. He supported his photographic vigil with income earned from a scoop – pictures of Jackie Kennedy on holiday in neighbouring Cambodia in 1967 – and finally published his complete essay on the war in his book *Vietnam Inc* in 1971. While other photographers' work was used to serve anti-war arguments, Griffiths' invective documentary account established a new model for the anti-war photographer-campaigner. (2 August 1968)

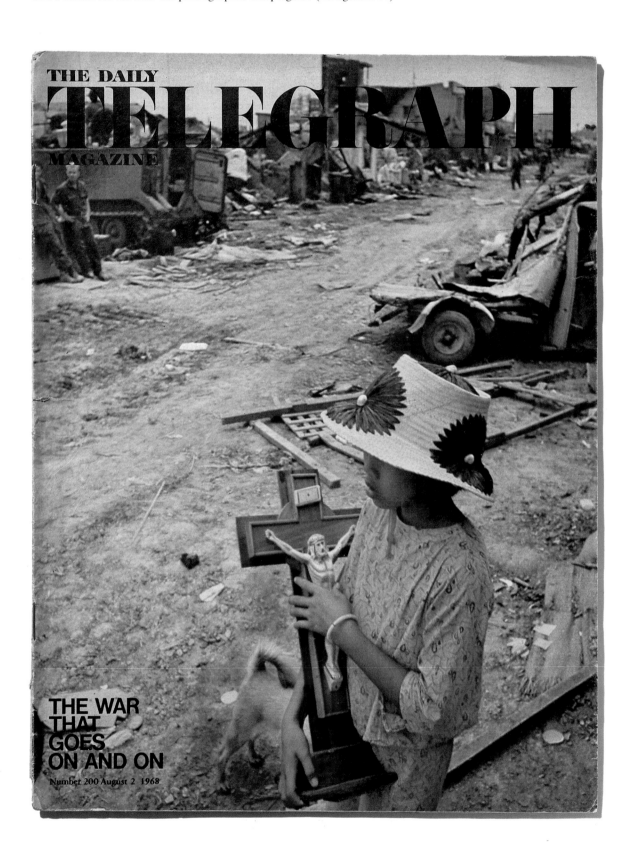

THE DAILY
TELEGRAPH
MAGAZINE

THE WAR
THAT
GOES
ON AND ON
Number 200 August 2 1968

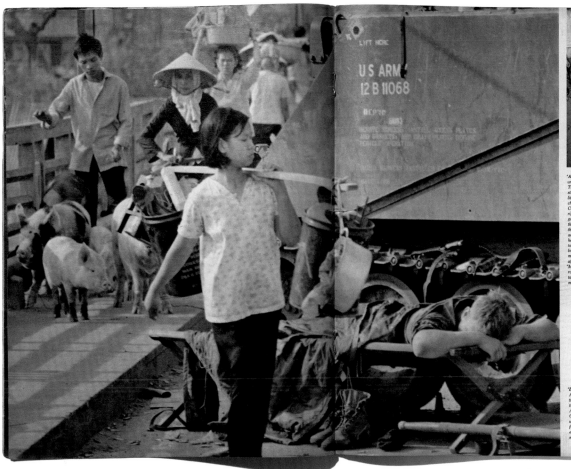

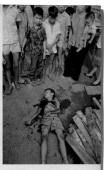

'ABOVE IS THE BOY I found after the unexplained explosion on the "safe side" of Trung Hung Dao (page 12). The spectators standing around him, mainly children, showed little interest. The Vietnamese are Confucian by character if not always by religion, and as Confucianism is the embodiment of the "I'm all right Jack" mentality the fact that it is not a good idea to allow a young boy to lie bleeding in the street seemed to occur to none of them. On the way to the sound of the explosion I came across a mother, covered in blood and carrying her two wounded children, trying to flag down a taxi to get them to hospital. She had to wait a long time before she found a driver who didn't mind having to clean bloodstains off the seats afterwards.

'Many civilians are being killed by Viet Cong rocket bombardments of Saigon. This latest tactic is designed to destroy any faith the people may still have in their government'

'LOOT which appeals most strongly to the ARVIN are the small portable items such as transistor radios; the American troops, due to their superior carrying power in the form of Armoured Personnel Carriers, prefer TV sets. One more sensitive soldier said to me: "What's wrong with these people! Don't they have any feelings? We've been killing them and destroying everything they own and they just carry on as if nothing's happened!"'

15

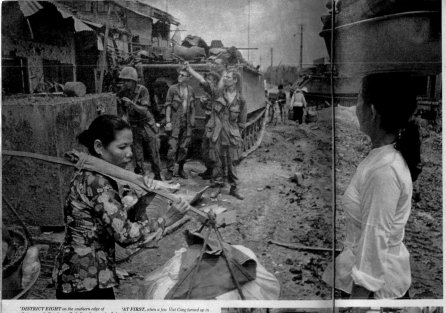

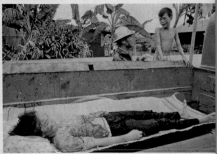

'DISTRICT EIGHT on the southern edge of Saigon was built to house Catholic refugees who fled from North Vietnam when the country was partitioned in 1954. District Eight was the showplace where visiting American senators were shown what could be done. It was the product of the Americans' best efforts in Vietnam, but it was soon destroyed when a handful of Viet Cong moved in. The Americans – untrained in house-to-house fighting – resorted to a "scorched-earth" policy. Artillery fire, 750lb bombs, napalm and rocket bombardment reduced large areas of District Eight to rubble. For every dead Viet Cong, I estimated that five civilians died, 60 were wounded and 200 made homeless. In the photograph above, people have returned to recover their possessions while one of a group of American soldiers gets some target practice shooting at a cat on the roof of a house. His weapon is not a standard issue revolver; many soldiers in Vietnam buy, or bring with them, their own "personal" weapons'

'AT FIRST, when a few Viet Cong turned up in their midst, the people of Saigon didn't realise the Americans would call in jets with bombs and napalm. But they soon learned to evacuate the area as quickly as possible, taking their possessions with them – for they had also learnt that anything left behind would be looted by the South Vietnamese or American soldiers. Many civilians are killed while trying to rescue their possessions when the helicopter gunships come; a few are just too old to run. In my experience, the pattern was always the same: a few Viet Cong would enter a block and fire at the local police, who then called in the ARVIN (Army of the Republic of Vietnam). The ARVIN would tell the people to leave, then start looting. Much gunfire would be heard – mostly ARVIN shooting the locks off shop doors (they didn't even mind me photographing them doing this!) and the American ARVIN adviser would declare that "heavy contact" had been established with the Viet Cong. The ARVIN would be told to pull back and the helicopter gunships, artillery and air-strikes would be brought to bear on the alleged Viet Cong positions'

'MOST OF THE SAIGONESE live in crude hovels built over water, or more correctly, huge cess-pools (top). American officials point out that the burning of these hovels during fighting provides the opportunity for rebuilding better homes, but this has never happened after fires in the past and is unlikely to happen now. The Saigon Fire Department is supplied with the finest American equipment – huge fire engines which are unfortunately unable to penetrate large areas of Saigon because the streets are too narrow. As the men trying to save their house in this picture surely know, what was needed was a fire boat'

'A 12-YEAR-OLD BOY refuses to leave his 15-year-old sister who was killed by "friendly" rocket fire near Cholon, a few miles south-west of Saigon. Her body is being taken away by the Saigon Fire Department disposal team. The ARVIN had been searching the area for some Viet Cong snipers when U.S. 9th Division troops on the other side of the river received some sniper fire from the area of the nearby Saigon slaughterhouse. They called for an air-strike without consulting the ARVIN adviser. When I arrived he was desperately trying to contact the helicopters by radio to get them to stop. He said some of the ARVIN had only just got out in time and a lot of civilians hadn't. One English-speaking Vietnamese, overcome with anger and frustration, screamed at me: "Why Americans crazy! Only fear VC. Americans bring helicopters destroy everything." By this time most of the area was in flames. As one GI put it: "They're pretty angry with us in Cholon today." According to one 9th Division Captain, the intention is to burn to the ground all the areas where the Viet Cong might be, as this is "the most economical way from the point of saving American lives"'

16
17

173

...THE TALKS GO ON...

A personal report in words and photographs by Philip Jones Griffiths

As peace negotiations drag on, the war in Vietnam continues – a war that has moved from the countryside into the towns and cities. The civilians of Saigon now live daily with the full horror of warfare and for the foreign correspondents all the action is only a ten-minute taxi ride away.

One Sunday morning while I was based in Saigon, something exploded – no one was quite sure what – on the "safe side" of Trang Hung Dao, the main street leading to Cholon. At the site of the blast I found a boy, bleeding from wounds, surrounded by a crowd of slightly bored onlookers. When the boy had eventually been taken away, a woman from the adjacent house produced a hose and with a stoicism bred during a lifetime of violence hosed away the pool of blood. She spoke a little English (she had probably worked in a bar). She couldn't understand why I was interested in knowing what had caused the explosion and who had been hurt. She made it clear that it was of no concern to her and certainly nothing to be surprised at. Her one regret was that the boy had been hit in front of her house which, she felt, rather made her responsible for washing away the blood.

Many of the Saigonese have been lured to the city from their villages by an American mixture of force and "planned seduction". The Americans promised: "Move to the cities, be loyal supporters of the government of Vietnam and you will be protected and safe from the war." The photographs on the following pages give some idea of how safe the Saigon civilians really are – from the Viet Cong and from their defenders

The seven-day Apollo VIII mission over Christmas 1968 was the first manned orbit of the moon and provided, for the first time, high resolution colour photographs of the earth as a singular orb viewed from space. Although the image of the earth from space has since become an indelible icon of global consciousness, picturing it was literally an afterthought on the part of Bill Anders, the astronaut in charge of the mission's photography. What was of interest to NASA were the images that mapped the far side of the lunar surface while it was lit by the sun: vertical and oblique overlapping photographs shot on black and white film (providing a higher degree of resolution and image clarity than colour) that would enable scientists to chart the geology of the moon and identify potential future landing sites. In the build-up to the mission, rumours of the Soviet Union's readiness to launch its own manned lunar orbit persisted. For the readers of *Life* magazine the story yielded welcome evidence of American dominance in the race for space, and anticipated the excitement of the moon landing to come. (20 January 1969)

Man at the Moon

It was mankind's farthest stride in the history of exploration. Almost a quarter-million miles from the planet earth, Astronauts Frank Borman, James Lovell and William Anders took this photograph of the cratered surface of the moon and the glowing half-orb of earth hanging in the void of space 240,000 miles away, as they came over the horizon in their first orbit of the moon. The sunset terminator, separating day and the shadow of night, bisects Africa. The visible area of the moon's surface is about 700 miles across and 480 miles to the horizon.

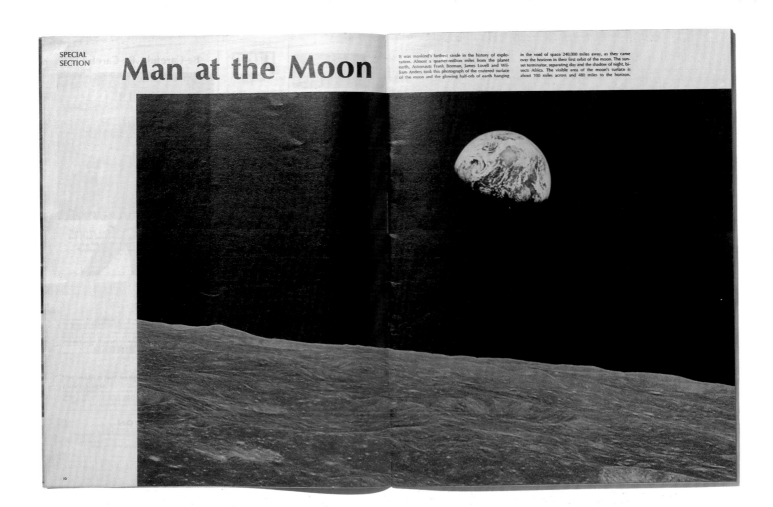

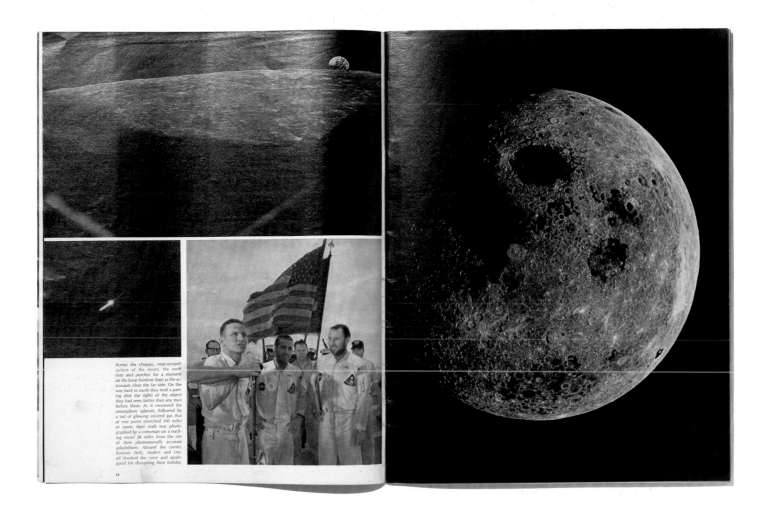

Across the choppy, near-oceanic surface of the moon, the earth rises and perches for a moment on the lunar horizon (top) as the astronauts clear the far side. On the way back to earth they took a parting shot (far right) of the object they had seen better than any men before them. As it reentered the atmosphere (above), followed by a tail of glowing ionized gas that at one point stretched 100 miles or more, their craft was photographed by a crewman on a tracking vessel 28 miles from the site of their phenomenally accurate splashdown. Aboard the carrier, Borman (left), Anders and Lovell thanked the crew and apologized for disrupting their holiday.

Daido Moriyama was one of a group of leading photography innovators who gathered around the magazine *Provoke*, published in Tokyo by photographer and writer Takuma Nakahira and the art critic Koji Taki. Following photographer Shomei Tomatsu's call for a radical new language of photojournalism, *Provoke* sought new ways to describe and respond to a society in upheaval in the late 1960s. Moriyama's contribution to *Provoke*'s third and final issue was a series of photographs of shelves of Japanese and Western consumer goods. Spontaneous and deliberately artless, they were both conceptually articulate (Moriyama identified the influence of photographs by Weegee and William Klein, and the writing of Jack Kerouac) and uncompromisingly raw. In an interview he explained: 'For me, photography is not about an attempt to create a two-dimensional work of art, but by taking photo after photo, I come closer to truth and reality at the very intersection of the fragmentary nature of the world and my own personal sense of time.' *Provoke*'s disruptive approach to conventional rules took it way beyond accessibility to most consumers of photojournalism, but it influenced a generation of photographers in Japan and, later, the vocabulary of photojournalism in the West. (August 1969)

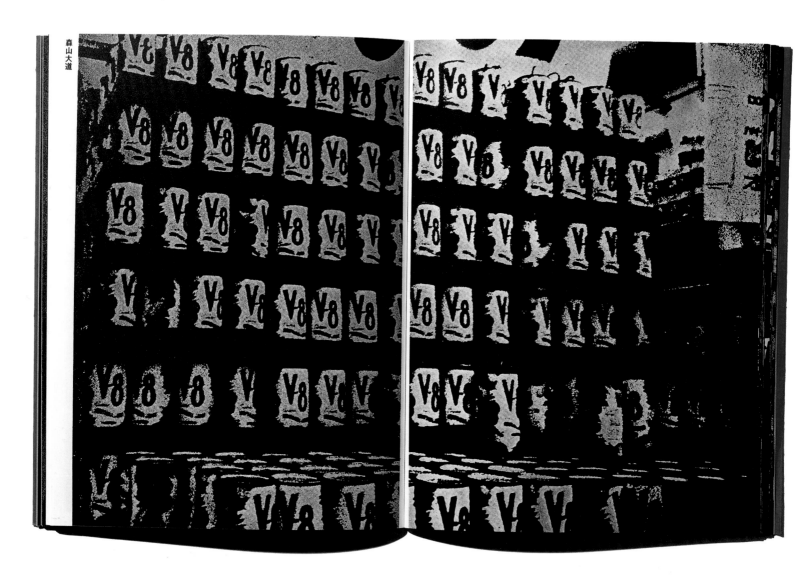

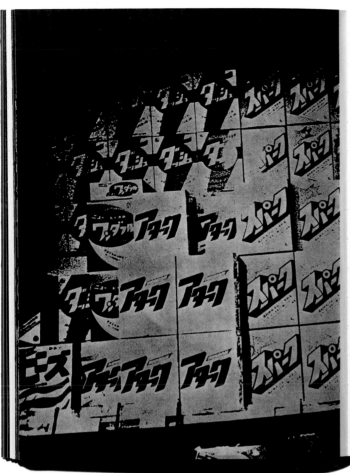

In June, 1969, *Life* magazine devoted its cover and 11 pages to 242 photographs of American soldiers who died in Vietnam between 28 May and 3 June 1969. Aside from an opening paragraph and a short concluding essay, the story was comprised entirely of portraits provided by families and mainly showing their subjects in uniform. *Life*'s register was the solution to a problem: how to illustrate and illuminate the extent of the war's American casualties – at that point running to a total of 36,000. There was a precedent in July 1943, when *Life* had honoured 13,000 soldiers who died in the first 18 months of World War II by printing their names and addresses on pages bordered with dark stars; but in this case standing each reader face to face with those who had died transformed an abstraction into an unforgettable experience. According to *Life* editor Loudon Wainwright, this was 'possibly the first time the magazine dropped its life-long posture as the earnest, cheerful broker of the high-mindedness and good intentions of the American establishment' to side with 'the growing mass of dissidents'. The essay established an approach that others would follow, for instance when the *New York Times* recognized the victims of the 9/11 attack on the World Trade Center with the publication of domestic portraits and short biographical essays. (27 June 1969)

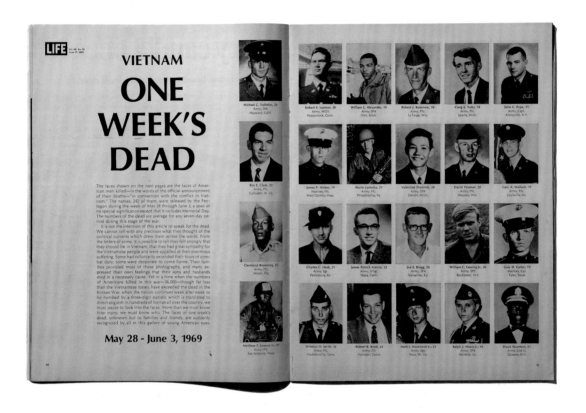

Brainchild of art director Willy Fleckhaus and named after one of the first brands of jeans sold in Germany, *Twen* was first published in Cologne in 1959. It combined clean design grids with Alexey Brodovich's emotional style in an innovative new attitude to magazine layout. With its progressive politics – the magazine promoted sexual liberation, anti-racism, multiculturalism and the legalization of homosexuality – *Twen* inspired the German beat generation. It used photography as an art form, rather than as illustration, introducing international photographers like Irving Penn, William Klein, Bruce Davidson and Guy Bourdin to the German public while launching the careers of several young photographers, most notably the Cologne-based American, Will McBride. Initially with black and white photographs of his friends having fun, drinking whisky and listening to jazz music in Berlin, and later with sophisticated colour stories from exotic locations, McBride's work was the product of collaboration with his art director – Fleckhaus sometimes drew sketches of possible compositions for him. When Fleckhaus came back from the United States with a copy of *Siddhartha* by Hermann Hesse, he asked McBride to go to India and shoot a story inspired by the novel. The result was this essay about coming of age and the journey toward spiritual and sensual enlightenment. (July, August and September, 1969)

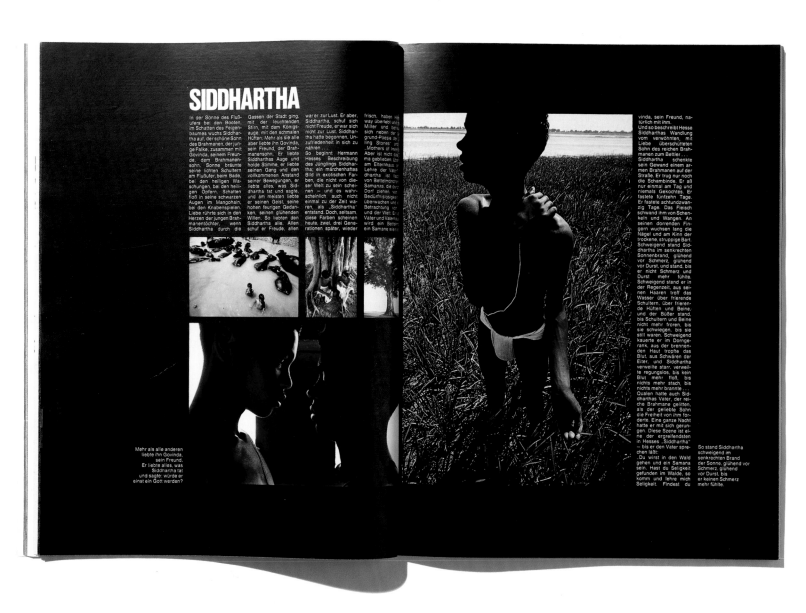

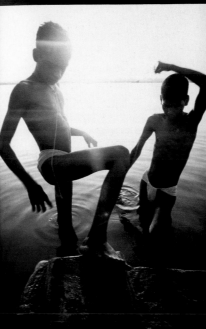

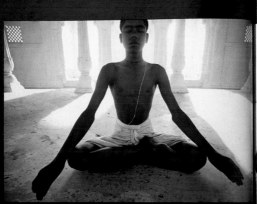

Lange schon übte sich Siddhartha in der Kunst der Betrachtung, im Dienst der Versenkung. Aber die Seele war nicht ruhig, das Herz ungestillt.

mane sah, daß Siddhartha in den Knien leise zitterte. In Siddharthas Gesicht sah er kein Zittern, fernhin blickten die Augen. Da erkannte der Vater, daß Siddhartha schon jetzt nicht mehr bei ihm weile, daß er ihn jetzt schon verlassen habe. Als Siddhartha auf erstarrten Beinen die noch stille Stadt verließ, erhob sich bei der letzten Hütte ein Schatten, der dort gekauert war, und schloß sich dem Pilgernden an – Govinda. Vergessen war die sorgenlose, hoffnungsvolle Zeit, die Siddhartha im reichen Hause seines Vaters verbracht hatte – eine Zeit aber auch, die erfüllt war von den Zweifeln darüber, ob unter dem Dach des Vaterhauses der Weg zur Selbstverwirklichung gefunden werden könnte Was

Wunder, daß Hesses „Siddhartha" empfindsame Saiten in der suchenden Generation von heute anrührt! Versetzen wir uns deshalb noch einmal, bevor wir Siddharthas Weg durch die selbstauferlegte Askese begleiten, zurück in die umsorgte Welt seines Vaterhauses, die ihn – vor allem Umsorgtsein zum Trotz – so aufwühlend mit Unruhe erfüllt wurde. Lange schon übte sich Siddhartha in der Kunst der Betrachtung, im Dienst der Versenkung. Aber Siddhartha, hatte begonnen, Unzufriedenheit in sich zu nähren. Er hatte begonnen zu fühlen, daß die Liebe seines Vaters und die Liebe seiner Mutter, und auch die Liebe seines Freundes, Govindas, nicht immer und für alle Zeit ihn beglük-

ken, ihn stillen, ihn sättigen, ihm genügen werde. Er hatte begonnen zu ahnen, daß sein ehrwürdiger Vater und seine anderen Lehrer, daß die weisen Brahmanen ihm von ihrer Weisheit das meiste und beste schon mitgeteilt, daß sie ihre Fülle schon in sein wartendes Gefäß gegossen hätten, und das Gefäß war nicht voll, der Geist war nicht begnügt, die Seele war nicht ruhig, das Herz nicht gestillt. Die Waschungen waren gut, aber sie waren Wasser, sie wuschen nicht Sünde ab, sie heilten nicht Geistesdurst, sie lösten nicht Herzensangst. Vortrefflich waren die Opfer und die Anrufung der Götter – aber war dies alles? Gaben die Opfer Glück? Und wie war das mit den Göttern? Waren nicht

die Götter Gestaltungen, erschaffen wie ich und du, der Zeit untertan, vergänglich? War es also gut, war es ein sinnvolles und höchstes Tun, den Göttern zu opfern? Wem anders zu opfern? Gab es einen anderen Weg, den zu suchen sich lohnte? Ach, und niemand zeigte diesen Weg, niemand wußte ihn, nicht der Vater, nicht die Lehrer und Weisen, nicht die heiligen Opfergesänge!

Alles wußten sie, die Brahmanen und ihre heiligen Bücher, sie wußten sich gekümmert, und um mehr als alles hatten sie sich gekümmert. Viele ehrwürdige Brahmanen kannte Siddhartha, seinen Vater, vor allen, den Reinen, den Gelehrten, den höchst Ehrwürdigen. Zu be-

man zu eigen haben! Alles andere war Suchen, war Umweg, war Verirrung. So waren Siddharthas Gedanken, dies war sein Durst, dies sein Leiden ...

Als Hermann Hesse, knapp dreißigjährig, Indien zum ersten Mal bereiste, war er von der religiösen Durchdringung des täglichen Lebens sehr stark beeindruckt. In dem Tagebuch seiner Reise, „Aus Indien", das 1913 erschien, vermerkte er: „Schön und nachdenklich war es auch, alle diese Menschen bei ihren religiösen Übungen zu sehen, Hindu, Mohammedaner und Buddhisten. Sie haben alle, vom reichen städtischen Häuserbesitzer bis zum geringsten Kuli und Paria herab, Religion. Ihre Religion ist minderwertig, verdorben, veräußerlicht, verroht, aber sie ist mächtig und allgegenwärtig wie Sonne und Luft, sie ist Lebensstrom und magische Atmosphäre und sie ist das einzige, um was wir diese armen und unterworfenen Völker ernstlich beneiden dürfen. Was wir Nordeuropäer in unserer intellektualistischen und individualistischen Kultur nur selten, etwa beim Anhören einer Bachmusik, empfinden dürfen, das selbstvergessene Gefühl der Zugehörigkeit zu einer idellen Gemeinschaft und des Kräfteschöpfens aus unversieglich magischer Quelle, das hat der Buddhist in der kahlen Vorhalle seines Tempels jeden Tag." Davon muß man wissen, davon und von dem tiefen Eindruck, den die Alltagsreligiosität der Inder auf ihn machte. Dann wird die seelische Landschaft, in der sich Siddharthas Zweifel bekämpften, transparent. Auch aber die Generationen hinweg, sind nicht die Auseinandersetzungen um Kirche

wundern war sein ter, still und leise sein Gehaben, rein Leben, weise sein feine und adelig danken wohnten in ner Stirn – er ... lebte er denn in ... keit, hatte er Fried war er nicht auch ein Suchender ein stender? Mußte er immer und immer an heiligen Que ein Durstender, m ... am Opfer, an den chern, an der Wis Stunde abwaschen den Tag um Rein sich bemühen, Tag von neuem finden, den Urqu eigenen ich, ...

Die Waschungen waren gut, aber sie waren nur Wasser, sie wuschen nicht Sünde ab, sie lösten nicht, so fühlte Siddhartha, die Angst.

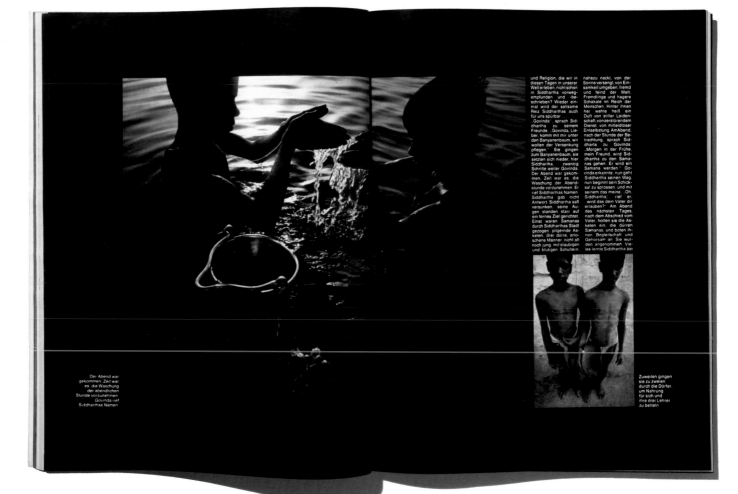

Der Abend war gekommen, Zeit war es, die Waschung der abendlichen Stunde vorzunehmen. Govinda rief Siddharthas Namen

mane sah, daß Siddhartha

und Religion, die wir in diesen Tagen in unserer Welt erleben, nicht schon in Siddhartha vorweggenommen und beschrieben? Wieder einmal wird der seltsame Reiz Siddharthas auch für uns spürbar „Govinda", sprach Siddhartha zu seinem Freunde, „Govinda, Lieber, komm mit mir unter den Banyanenbaum, wir wollen der Versenkung pflegen." Sie gingen zum Banyanenbaum, sie setzten sich nieder, hier Siddhartha, zwanzig Schritte weiter Govinda. Der Abend war gekommen. Zeit war es, die Waschung der Abendstunde vorzunehmen. Er rief Siddharthas Namen Siddhartha gab nicht Antwort. Siddhartha saß versunken, seine Augen standen starr auf ein fernes Ziel gerichtet. Einst waren Samanas durch Siddharthas Stadt gezogen, pilgernde Asketen, drei dürre, erloschene Manner nicht all noch jung, mit staubigen und blutigen Schultern.

nahezu nackt, von der Sonne versengt; von Einsamkeit umgeben, fremd und feind der Welt, Fremdlinge und hagere Schakale im Reich der Menschen. Hinter ihnen her wehte heiß ein Duft von stiller Leidenschaft, vonzerstörendem Dienst, von mitleidloser Entselbstung. Am Abend, nach der Stunde der Betrachtung, sprach Siddharta zu Govinda: „Morgen in der Frühe, mein Freund, wird Siddhartha zu den Samanas gehen. Er wird ein Samana werden." Govinda erkannte nun geht Siddhartha seinen Weg, nun beginnt sein Schicksal zu sprossen, und mit seinem das meine. „Oh, Siddhartha", rief er, „wird das der Vater dir erlauben?" Am Abend des nächsten Tages, nach dem Abschied vom Vater, holten sie die Asketen ein, die dürren Samanas und boten ihnen Begleitschaft und Gehorsam an Sie wurden angenommen. Vieles lernte Siddhartha bei

Zuweilen gingen sie zu zweien durch die Dörfer, um Nahrung für sich und ihre drei Lehrer zu betteln

Siddhartha liebt

„Vor der Stadt, bei
einem schön
umzäunten Haine,
begegnete Siddhartha,
dem Wandernden,
ein kleiner Troß von
Dienern und
Dienerinnen.
Inmitten in einer
geschmückten Sänfte,
von Vieren
getragen, saß
eine Frau, die Herrin.
Siddhartha sah,
wie schön sie war.
Tief verneigte er sich,
und sich
wieder aufrichtend,
blickte er in das helle,
holde Gesicht,
atmete einen Hauch
von Duft,
den er nicht kannte.
Lächelnd
nickte die Frau einen
Augenblick . . ."
Die Zweifel hatten
Siddhartha
vom bisherigen Weg
abgehen lassen;
das ungewisse
Versprechen im Blick
der schönen Frau
wies ihm den neuen
Weg. Kamala,
die reiche Kurtisane,
die Priesterin
der sinnlichen Liebe,
soll ihm
nun Freundin und
Lehrerin sein . . .
Er sucht der schönen
Kamala Haus.
Geld hat er nicht, aber
sie belohnt
ihn für ein Gedicht . .
„Sie zog ihn mit

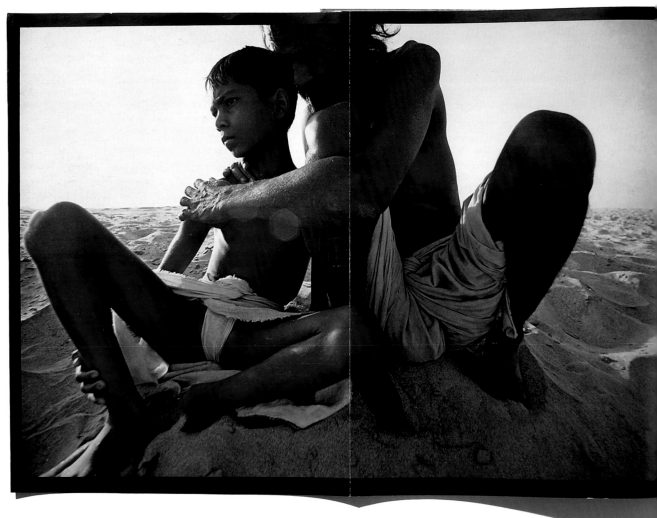

Traum vom Lebens-
le: „Leer werden,
rst, leer von Wunsch,
aum, leer von Freud
Von sich selbst weg-
ht mehr Ich sein, ent-
zens Ruhe zu finden,
steten Denken dem
en stehen . . ." (Her-
e, Siddhartha, Frank-
eite 19.)

m Traum der Bürde-
und Freiheit, auf
räumt vor Jahrzehn-
ssin, nach Indien ge-
us Amerika! Müdes
odischer Geistigkeit
t hinaus. Jetzt geht
r um Jahre nach.
orgen denken, fühlen
gt ihm die Übersee-
auffällige Haus. Mor-
kommen die herz-
üße von Hermann
New York, aus Bever-
s' der Hippieprovinz
bury in der Bundes-
! Das alles hätten Sie
us Frankfurt haben

Siddharthas, der „im
Sonnenbrand, glü-
hmerz, glühend vor
, bis er nicht Schmerz
mehr fühlte" (Hesse,
, Frankfurt 1967,
o LSD-Traum des
lfs (,,Genüßreicher
, du lachst dich ka-
Hesse, Der Steppen-
Seite 159) — ihr habt
en flüchtender,
ger junger Menschen
icht über ihre Wirk-

lichkeit nachzudenken, als sie
sich mit Hitler transformierten
in Mord und Krieg; und ihr wer-
det eine neue Generation ver-
führen.
O Traum vom hohen geheimnis-
vollen Sinn alles Lebens, bei ko-
kelndem Gartenfeuer im Tessin
ausgedacht von diesem bis ge-
stern so unbeschreiblich toten
Dichter Hermann Hesse — aber
einmal war er ihm nahe, dem
Traum, dem Dichter, am Ort
seines Träumens, im Tessin, in
Montagnola. Wenn ich aus
einem der kreisrunden Fenster
schaute, die mit ihrem unteren
Rand fast den roten Ziegelboden
des Mansardenraumes berühr-
ten, fiel mein Blick hinunter auf
einen verwilderten Garten, klein
und eng, zwischen Mauern ge-
zwängt, einem Steilhang in Ter-
rassen abgewonnen.
In der Mitte des Raumes stand
ein sehr großes, sehr wackeliges
Bett aus Eisen. Dort liebten wir
uns, S. und ich. Durch die run-
den Fenster sahen wir unten die
Lichterketten der Bucht von
Lugano, die sich emporschwin-
gend in den Lampenreihen fort-
setzten längs der Bergbahntras-
sen auf den uns nahen Monte
Salvatore, den uns ferneren
Monte Bré. Und es war die letzte
und höchste Lampe, vielleicht
schon die erste, am niedrigsten
stehende Stern.
Kerzenlicht und Mondlicht. Ich
las S. aus „Klingsors Zauber-
garten" vor, und die Bäume, die
Blumen, die modrigen Laub-
höhlen, die Jasmindüfte, die
Schnecken, die auf feuchtem

Tuffstein glänzende Spurbänder
zogen, das tropfende Wasser
unter den Zypressen: das war
das Urbild von Hesses Zauber-
garten.
Und nun war es auch der unsere
doppelt: der Garten in seiner
Wirklichkeit und der Garten im
Buch. Der wirkliche gehörte
zu Montagnolas seltsamstem,
schönstem, seit einem Jahrhun-
dert vor sich hinträumenden,
Träume gebärenden Haus, der
Casa Camuzzi. Da wohnte Hes-
se, da wohnte, malte und starb
Purrmann. Und da wohnten wir
ein paar Wochen lang in der
weitläufigen Mansarde und be-
nützten den Ort, den Dichter,
seine Welt, seine Bücher als
Aphrodisiaka. Er saß damals
schon in seinem neuen Garten
mit Pinsel und Block unter
einem immer verwegen schief
stehenden Schirm; ich versuchte
auf der Turmplattform der Ca-
sa das zu malen. Dann las Sie
vor:
„Ja", gab ich zu, „es ist mir seit
Jahren nicht so gut gegangen.
Das kommt alles von dir, Her-
mine."
„Oh, nicht von deiner schönen
Maria?"
„Nein. Auch die hast du mir
geschenkt. Sie ist wunderbar."
„Sie ist die Geliebte, die
du brauchtest, Steppenwolf.
Hübsch, jung, guter Laune, in
der Liebe sehr klug und nicht
jeden Tag zu haben. Wenn
du sie nicht mehr mit anderen
teilen müßtest, wenn sie bei dir
nicht immer bloß ein flüchtiger
Gast wäre, ginge es nicht so gut.
Ja, auch das mußte ich zugeben."

(H. H., Steppenwolf, S. 124).
S. war „Hermine", und meine
„schöne Maria" war in Mün-
chen, nicht immer zu haben, und
deshalb einverstanden, daß wir
nach Montagnola gefahren wa-
ren. Die Parallelen waren gege-
ben. Wir tauchten durch lila-
farbene Tage und schwarzblaue
Sternnächte immer tiefer in die
Hesse'sche Pappwelt ein, stellten
uns in sein bengalisches Licht,
möblierten unsere Phantasie
mit seinen Panoptikumfiguren,
den Brahmanensohn dort, den
Rocker Harry Haller hier, den
Steppenwolf.
Wir lachten dabei über uns, wa-
ren voll der Ironie und tanzten
gleichsam auf einem doppelten
Boden unseres Bewußtseins über
Hesses schreckliche Ernsthaftig-
keit hinweg. Wir trieben Miß-
brauch und Schabernack mit
ihm und liebten uns. Bis eines
Tages das kleine Mädchen der
Posthalterin kam und mich von
der Terrasse weg ans öffentliche
Telefon rief, wo ich „Marias"
Stimme hörte und sie mir sagte,
Hitler habe gestern seine erste
Gewalttätigkeit gegen jüdische
Ärzte und Anwälte durchge-
führt. Sie verließe das Land.
„Maria" war Jüdin.
Da fiel Siddharthas Hütte kra-
chend in sich zusammen, und 24
Stunden später waren wir wie-
der in München. Es war der
Frühling des Jahres 1933. Der
Dichter und Seher von Mon-
tagnola saß noch 30 Jahre auf
seinem Tessiner Hügel. Und
jetzt, was für ein Spaß, hat Ame-
rika den Mann aus Montagnola
(Lesen Sie weiter auf Seite 154)

(Lesen Sie weiter auf Seite 154)

Über drei Folgen
hat twen nun das
Leben des Brahma-
nen-Sohnes
Siddhartha, so wie
es der deutsche
Dichter und Nobel-
preisträger
Hermann Hesse in
seinem Roman
schilderte, in Farben
aufgeblättert. Die
plötzliche Liebe
zu Hermann Hesse,
die in Amerika
aufgeflammt ist und
sich in Buchauf-

lagen äußert, die in
die Hunderttausende
gehen, und die
ihre Wellen zurück
zu uns schlägt,
kann nicht bestrit-
ten werden.
Streiten jedoch kann
man darüber, ob
Hesses Dichtung
nun wirklich so

verehrungswürdig ist.
Der Schriftsteller
und Journalist
Alexander Parlach
kennt die Welt,
in der Hermann
Hesse lebte und dich-
tete, aus eigener
Betrachtung: Als
junger Mann wohnte
er einmal einen
Sommer lang
in Hermann Hesses
früherem Haus in
Montagnola.

SS
NN
MANN
SE
N?

Photography had a negligible role in the early days of the race for space – for instance, the astronaut John Glenn bought a 35mm drugstore camera to make the only in-flight record of the Mercury mission in 1962. However the public relations potential of photography became central to the Apollo programme. Astronauts were trained and equipped to use video, film cameras and 70mm Hasselblads. The first moon landing on 20 July 1969 was a televisual event broadcast live to an attentive world. Magazines had to wait a further two weeks for the return and processing of their material. *Life* was first off the mark with a cover and 12-page spread, opening with a sequence of film frames before offering readers the triumph of still photography: carefully composed, richly detailed and iconic images of the astronauts, leaving the imprint of their boots, saluting the American flag, collecting samples and conducting geological experiments. (8 August 1969)

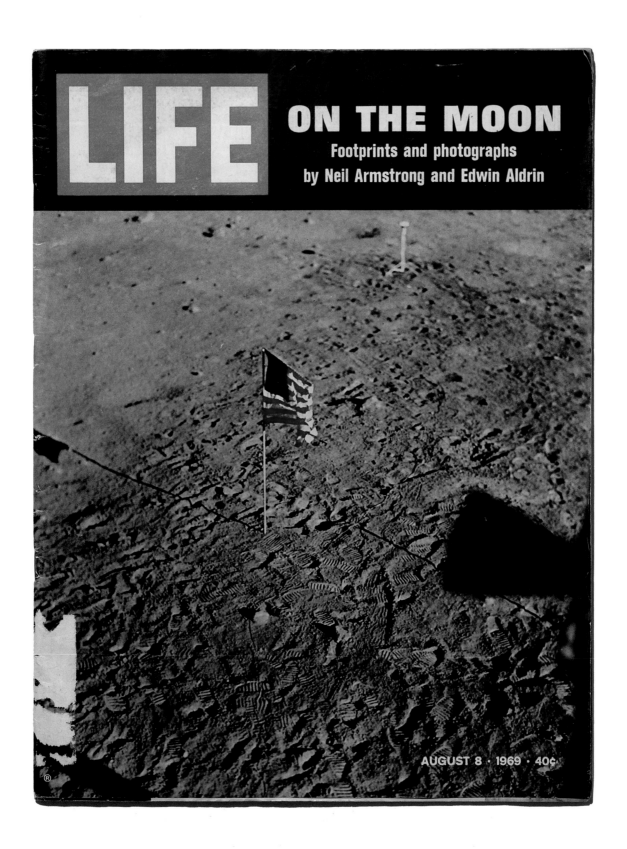

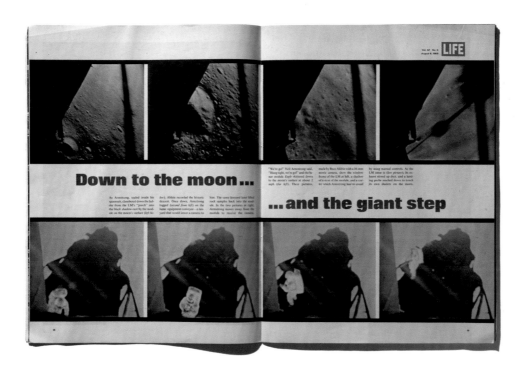

Down to the moon...

...and the giant step

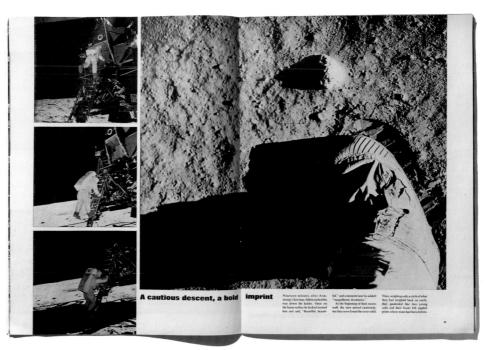

A cautious descent, a bold imprint

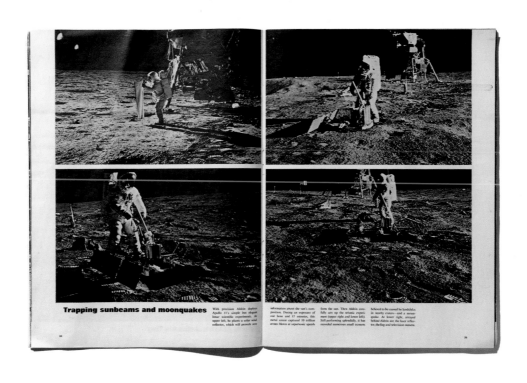

Trapping sunbeams and moonquakes

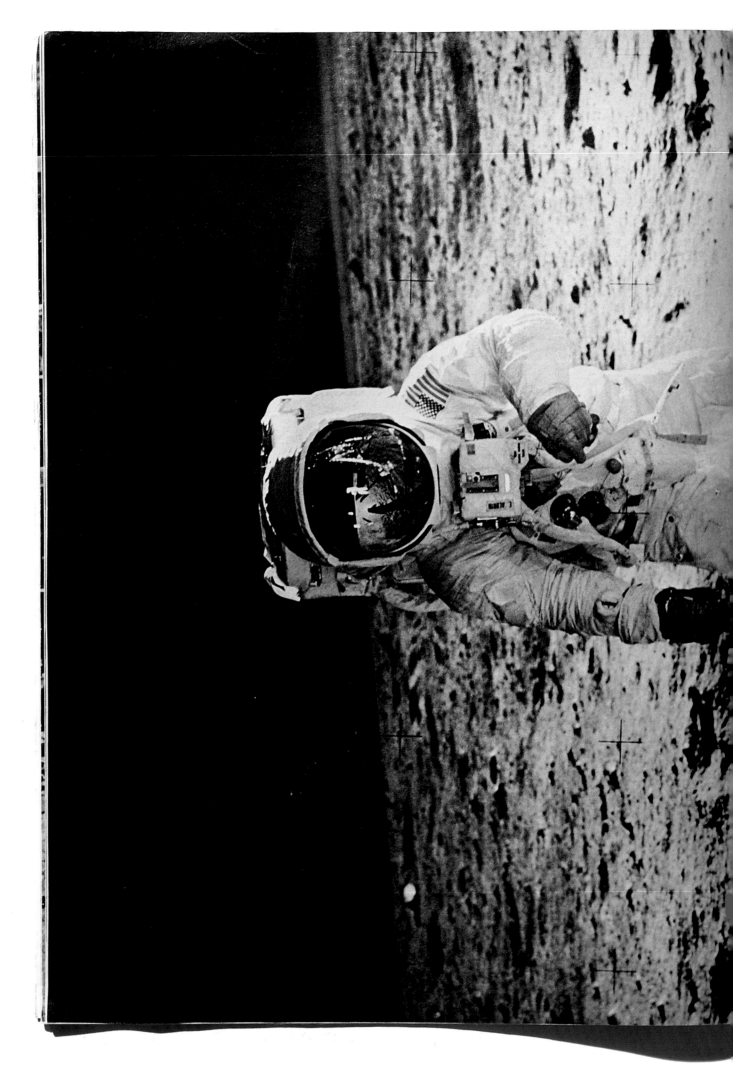

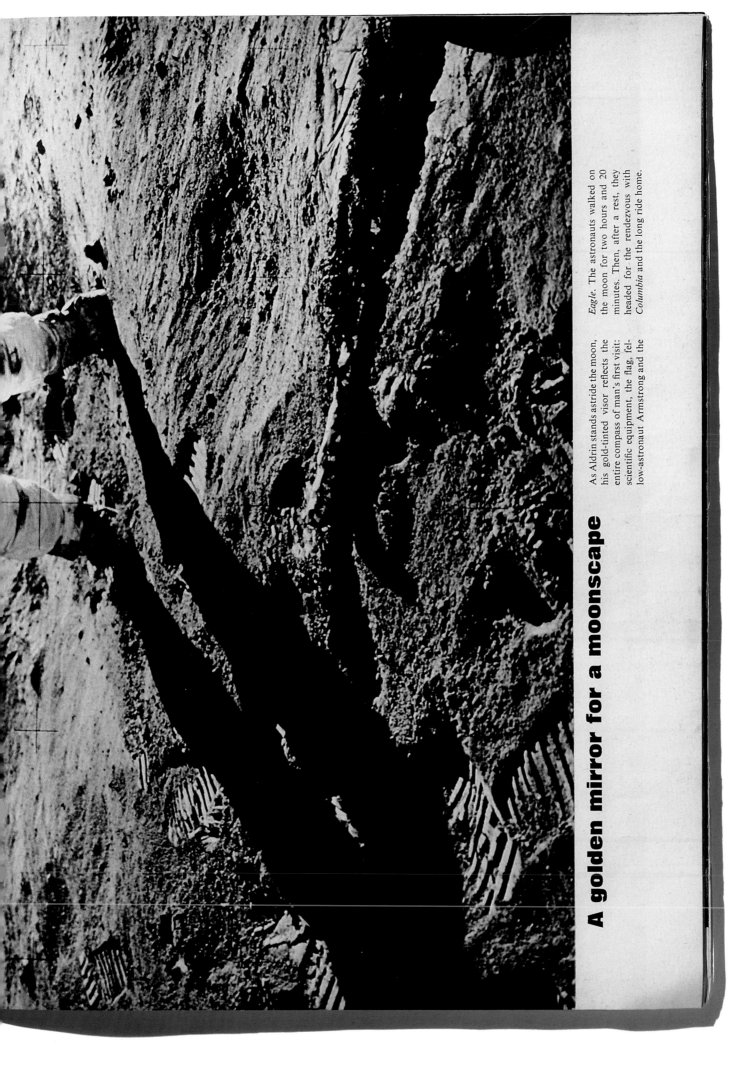

A golden mirror for a moonscape

As Aldrin stands astride the moon, his gold-tinted visor reflects the entire compass of man's first visit: scientific equipment, the flag, fellow-astronaut Armstrong and the *Eagle*. The astronauts walked on the moon for two hours and 20 minutes. Then, after a rest, they headed for the rendezvous with *Columbia* and the long ride home.

My Lai was a village in Vietnam where the massacre of around 500 Vietnamese civilians by American troops in 1968 was recorded by army photographer Ron Haeberle. He was about to finish his tour of duty, having seen little action, when he volunteered for a mission that promised to be 'hot'. He recorded events on three cameras – one loaded with black and white film which he turned in to the Army, and two loaded with colour which he kept for himself. For a year, Haeberle showed his photographs to civic groups in his native Cleveland, but faced disbelief – 'They caused no commotion … Nobody believed it. They said Americans wouldn't do this.' Internal reports of the massacre forced an Army investigation in the summer of 1969, and a commanding officer, Lt William Calley, was accused of murder. But the full story only reached the public through the work of freelance journalist Seymour Hersh in the *Washington Post* and the London *Times*. After the story broke, Haeberle found an audience, initially in the *Cleveland Plain Dealer*. Its subsequent publication in *Life* created a storm that helped turn American opinion decisively against the war. (5 December 1969)

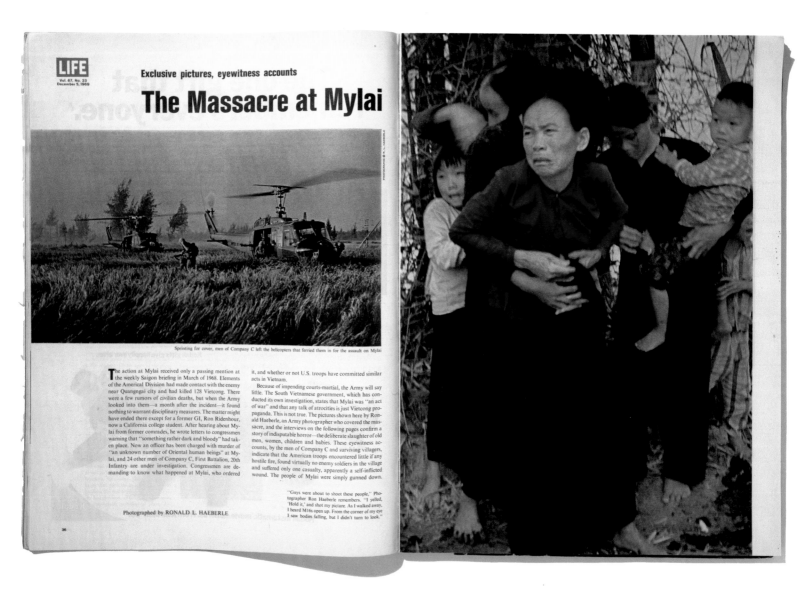

'The order was to destroy Mylai and everything in it'

These photographs and the first detailed eyewitness account of Mylai were brought to light by Joseph Eszterhas, a reporter for the Cleveland Plain Dealer. He helped prepare the following article, based on his own interviews with Photographer Ron Haeberle and reports from LIFE Correspondents Dale Wittner, John Saar, Tom Flaherty and Reg Bragonier and Stringers Kent Demaret and Jane Estes.

On the day before their mission the men of Company C met for a briefing after supper. The company commander, Captain Ernest Medina, read the official prepared orders for the assault against Mylai and spoke for about 45 minutes, mostly about the procedures of movement. At least two other companies would also participate. They, like Company C, were elements of Task Force Barker, named for its commander, Lt. Colonel Frank Barker, who was to die in action three months later. But only Company C would actually enter the cluster of huts known as Mylai 4.

"Captain Medina told us that this village was heavily fortified," recalls one of his squad leaders, Sgt. Charles West. "He said it was considered extremely dangerous and he wanted us to be on our toes at all times. He told us there was supposed to be a part of the 98th NVA Regiment and the 48th VC Battalion there. From the intelligence that higher levels had received, he said, this village consisted only of North Vietnamese army, Vietcong, and VC families. He said the order was to destroy Mylai and everything in it."

Captain Medina was a stocky, crew-cut, hard-nosed disciplinarian whom his men called "Mad Dog Medina." Men respected him: to Charles West he was one of "the best officers I've known." Most of them had served under Medina since the company had formed the previous year in Hawaii as C Company, First Battalion, 20th Infantry, 11th Light Infantry Brigade.

"As far as I'm concerned, Charlie Company was the best company to ever serve in Vietnam," says West. "Charlie Company was a company, not just a hundred and some men they call a company. We operated together or not at all. We cared about each and every individual and each and every individual's problems. This is the way that we were taught by Captain Medina to feel toward each other. We were like brothers."

Mylai 4 was one of nine hamlets, each designated by a number, which were clustered near the village of Songmy, a name sometimes used also for the hamlets. The men of Company C called the area "Pinkville" because it was colored rose on their military maps and because these fertile coastal plains long had been known as Vietcong territory. Pinkville was only seven miles northeast of the provincial capital of Quangngai, where, during the Tet offensive only a month before, Vietcong and North Vietnamese troops had boldly occupied portions of the city. Soon Company C would use the name Pinkville not only for the entire area but for the single hamlet Mylai 4.

Company C had seen its first real combat in

the previous weeks, all of it around Pinkville. A couple of weeks before, sniper fire from across the river had killed one man. His buddies believed the fire had come from Mylai 4. Two weeks before, enemy land mines had killed five men and wounded 22. Several days before, in a hamlet near Mylai 4, a booby trap made from an unexploded artillery shell had killed one of the GIs' favorite squad leaders, Sgt. George Cox.

"I was his assistant squad leader," recalls Charles West. "On the way back to camp I was crying. Everybody was deeply hurt, right up to Captain Medina. Guys were going around kicking sandbags and saying, 'Those dirty dogs, those dirty bastards.'"

At the briefing, says West, "Captain Medina told us we might get a chance to revenge the deaths of our fellow GIs." Afterward the men held a memorial service for George Cox, but the ritual of mourning was more like a pep rally for the forthcoming action.

"Captain Medina didn't give an order to go in and kill women or children," says West. "Nobody told us about handling civilians, because at the time I don't think any of us were aware of the fact that we'd run into civilians. I think what we heard put fear into a lot of our hearts. We thought we'd run into heavy resistance. He was telling us that here was the enemy, the enemy that had been killing our partners. This was going to be our first real live battle, and we had made up our minds we were going to go in and with whatever means possible wipe them out."

Shortly after sunrise on March 16, 1968, a bright, clear, warm day, the helicopters began lifting approximately 80 men of Company C from the base camp at Landing Zone Dottie and delivering them 11 kilometers away in the paddies west of Mylai 4.

Army Photographer Sgt. Ron Haeberle and SP5 Jay Roberts, both of the 31st Public Information Detachment, came in on the second helicopter lift. Haeberle, who had been drafted out of college, had only a week left on his tour in Vietnam. Neither man had seen much action. They had volunteered for this operation because the word was out that it would be "a hot one." The squad the two were assigned to was getting its orders by walkie-talkie from Captain Medina. Haeberle was carrying three cameras—one for the Army, two of his own. (He turned in his black-and-white film to the Army. The Army took no action at that time but apparently intends to use the film as evidence in the court-martial proceedings.) Roberts, a college student who had volunteered for the draft, took pad and pencil. Their
CONTINUED

Haeberle found the bodies above on a road leading from the village. "Most were women and babies. It looked as if they tried to get away."

"When these two boys were shot at," says Haeberle, "the older one fell on the little one, as if to protect him. Then the guys finished them off."

"This man was old and trembling so that he could hardly walk. He looked like he wanted to cry. When I left him I heard two rifle shots."

'You don't call them civilians—to us they were VC'

CONTINUED

mission was to prepare news releases and a report for the brigade newspaper.

"We landed about 9 or 9:30 in a field of elephant grass," says Varnado Simpson, then a 19-year-old assistant platoon leader from Jackson, Miss. Gunships and grenade launchers. It was clear and very warm and it got warmer. "Our landing zone was the outskirts of town, on the left flank. There were about 25 of us and we went directly into the village. There wasn't any enemy fire. We'd come up on a hoo'ch, we'd search it to see if there was someone in it. If there was no one in it, we'd burn it down. We found people in some, and we took some back to the intelligence people for questioning. Some ran, we tried to tell them not to run. There were about 15. Some stopped. About five or six were killed."

Haeberle and Roberts moved through the rice fields toward a hill in back of the village area. Haeberle was with 10 or 15 GIs when he saw a cow and heard shots at the same time. The shooting was straight ahead. A GI shot a cow and then others kept pumping bullets into the cow until the cow finally fell.

"Off to the right," says Haeberle, "a wom-

an's form, a head, appeared from some brush. All the other GIs started firing at her, aiming at her, firing at her over and over again. She had slumped over into one of those things that stick out of the rice paddies so that her head was a propped-up target. There was no attempt to question her or anything. They just kept shooting at her. You could see the bones flying in the air chip by chip. Jay and I, we just shook our heads."

"There were a whole lot of Vietnamese people that I especially liked," recalls Sgt. Charles West of his year in Vietnam. "Most of them were at this orphanage I used to visit frequently after I came off field duty. I'd go down there and the people would try to teach me more of the Vietnamese language and they would explain a lot of customs that I wanted to know something about."

Charles West led his squad of 13 men through the rice paddies and heard the sound of gunfire. They were coming down a sharply winding trail and were keeping a close watch for booby traps. They turned a curve in the trail and there, 25 feet ahead of them, were six Vietnamese, some with baskets, coming toward them. "These people were running into us," he says, "away from us, running every

which way. It's hard to distinguish a mama-san from a papa-san when everybody has on black pajamas." He and his squad opened fire with their M16s. Then he and his men kept going down the road toward the sound of the gunfire in the village.

"I had said in my heart already," says West, "and I said in my mind that I would not let Vietnam beat me. I had two accomplishments to make. The first was to serve my government and to accomplish my mission while I was in Vietnam. My second accomplishment was to get back home."

"There was a little boy walking toward us in a daze," says Haeberle. "He'd been shot in the arm and leg. He wasn't crying or making any noise." Haeberle knelt down to photograph the boy. A GI knelt down next to him. The GI fired three shots into the child. The first shot knocked him back, the second shot lifted him into the air. The third shot put him down and the body fluids came out. The GI just simply got up and walked away. It was a stroboscopic effect. We were so close to him it was blurred."

"The people who ordered it probably didn't think it would look so bad," says Sgt. Michael

A. Bernhardt, who asserts he refused to take part in the killings.

As he entered the village, Bernhardt recalls, a plane was circling above, warning the people in Vietnamese to leave. "Leaflets were dropped ahead of time, but that doesn't work with the Vietnamese people. They have very few possessions. The village we went into was a permanent-type village. It had hard walls, tile roofs, hard floors and furniture. The people really had no place to go. The village is about all they have. So they stay and take whatever comes.

"It was point-blank murder. Only a few of us refused. I just told them the hell with this, I'm not doing it. I didn't think this was a lawful order."

"To us they were no civilians," says Varnado Simpson. "They were VC sympathizers. You don't call them civilians. To us they were VC. They showed no ways or means that they wasn't. You don't have any alternatives. You got to do something. If they were VC and got away, then they could turn around and kill you. You're risking your life doing that work. And if someone kills you, those people
CONTINUED

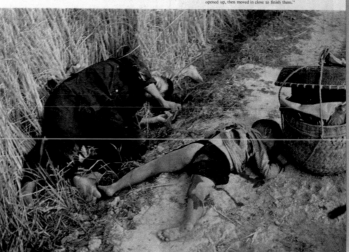

Haeberle remembers that the body in front of a burning house (above) kept twitching and that one GI commented, "He's got ghosts in him."

Intent on destroying everything that might be of use to the Vietcong, a soldier (below) stokes a fire with the baskets used to dry rice and roots.

"This man and two little boys popped up from nowhere," says Haeberle. "The GIs I was with opened up, then moved in close to finish them."

On the Sunday before Christmas, in an edition loaded with advertisements for cognac, port and gift boxes of cigarettes, the *Sunday Times* magazine underscored its reputation for uncompromising photojournalism by offering as its lead story a portfolio of 12 photographs about the escalating conflict in Northern Ireland. Don McCullin had first visited Northern Ireland in 1969 and had been making frequent trips to the Catholic Bogside district of Derry throughout 1971. With typical obstinate courage he worked the streets amongst the armed British troops and the dissenting young Catholic men as they fought increasingly violent pitched battles; he was hit in the back and temporarily blinded by CS gas while working on the story. McCullin's direct and perfectly crafted photographic vision was complemented by its treatment in the magazine. Under the overall editorship of Harold Evans, the magazine's approach to photography was handled by art director Michael Rand and designer David King; their respect for photographs and photographers, along with the magazine's fearless approach to difficult subject matter, led to the freshest and most powerful magazine layouts of the period. (19 December 1971)

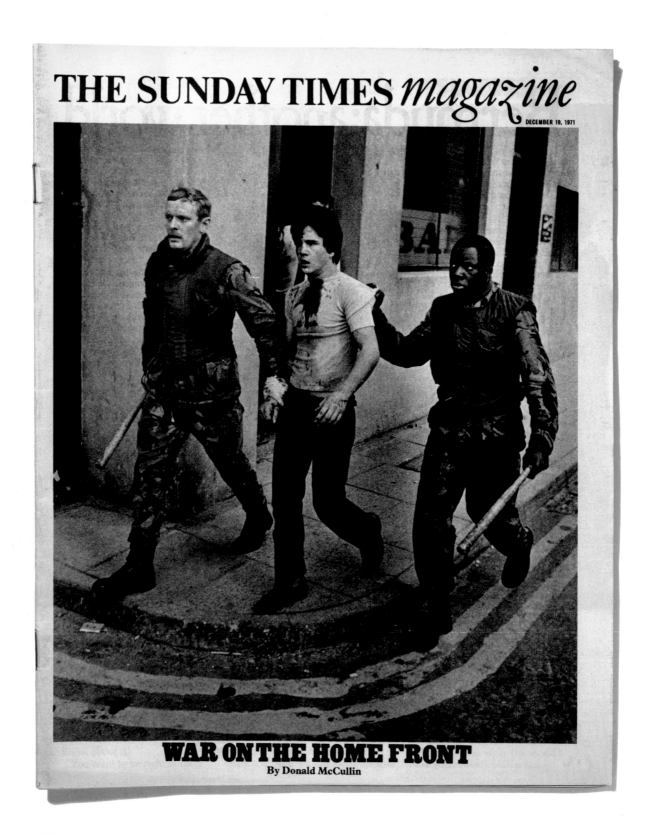

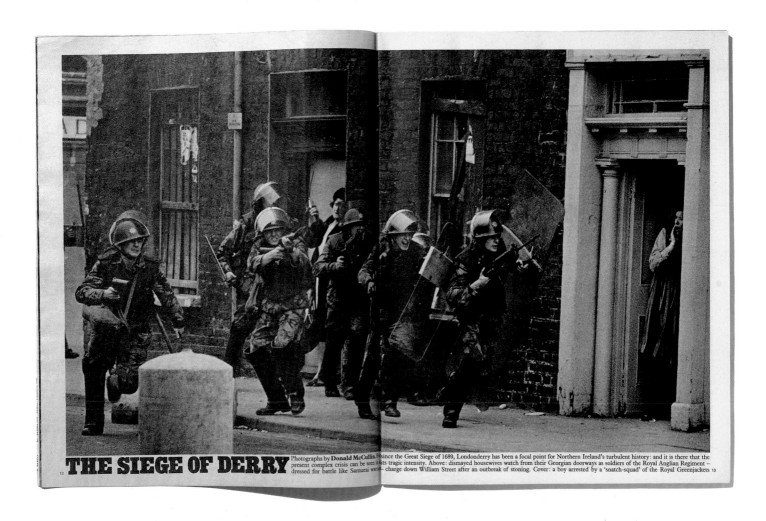

THE SIEGE OF DERRY

Photographs by **Donald McCullin**. Since the Great Siege of 1689, Londonderry has been a focal point for Northern Ireland's turbulent history: and it is there that the present complex crisis can be seen in its tragic intensity. Above: dismayed housewives watch from their Georgian doorways as soldiers of the Royal Anglian Regiment – dressed for battle like Samurai warriors – charge down William Street after an outbreak of stoning. Cover: a boy arrested by a 'snatch-squad' of the Royal Greenjackets

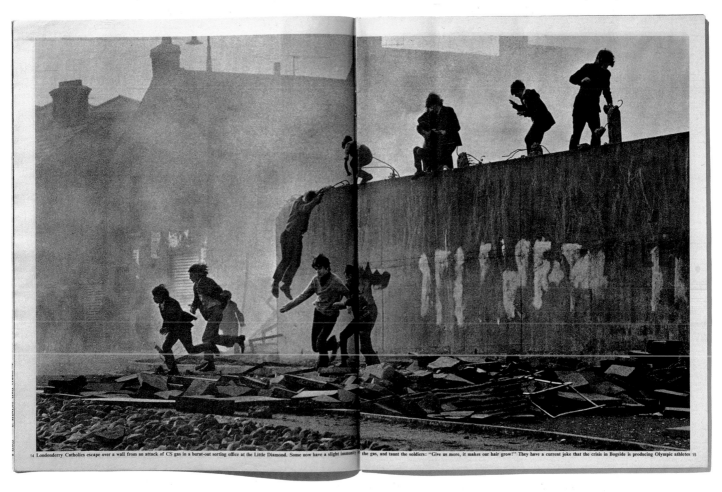

14 Londonderry Catholics escape over a wall from an attack of CS gas in a burnt-out sorting office at the Little Diamond. Some now have a slight immunity to the gas, and taunt the soldiers: "Give us more, it makes our hair grow!" They have a current joke that the crisis in Bogside is producing Olympic athletes 15

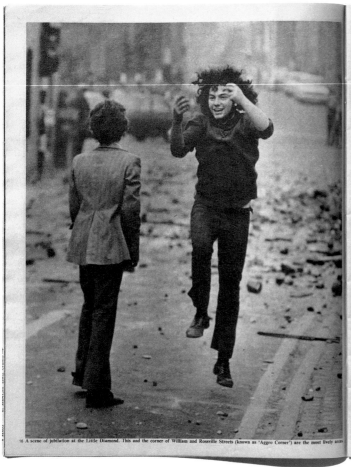

16 A scene of jubilation at the Little Diamond. This and the corner of William and Rossville Streets (known as 'Aggro Corner') are the most lively areas

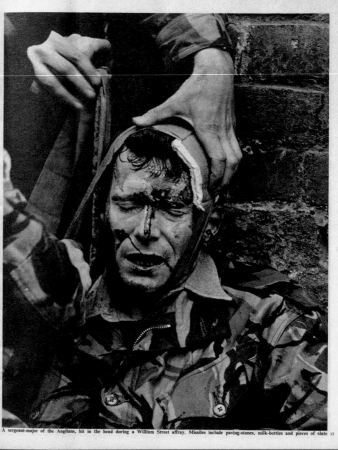

A sergeant-major of the Anglians, hit in the head during a William Street affray. Missiles include paving-stones, milk-bottles and pieces of slate 17

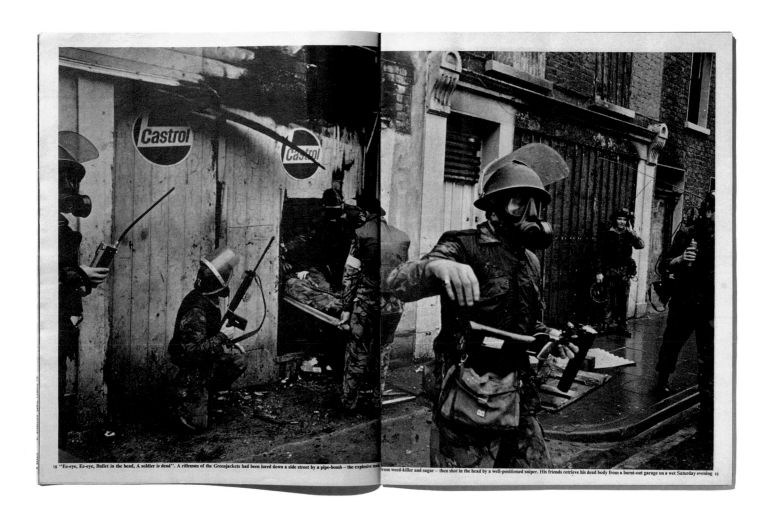

18 "Ee-eye, Ee-eye, Bullet in the head, A soldier is dead". A rifleman of the Greenjackets had been lured down a side street by a pipe-bomb – the explosive made from weed-killer and sugar – then shot in the head by a well-positioned sniper. His friends retrieve his dead body from a burnt-out garage on a wet Saturday evening 19

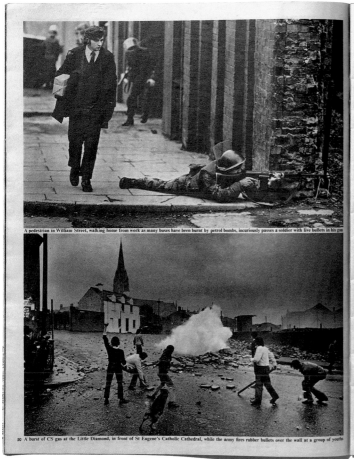

A pedestrian in William Street, walking home from work as many buses have been burnt by petrol bombs, incuriously passes a soldier with live bullets in his gun

A burst of CS gas at the Little Diamond, in front of St Eugene's Catholic Cathedral, while the army fires rubber bullets over the wall at a group of youths 20

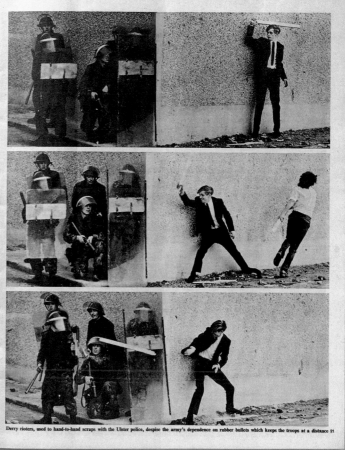

Derry rioters, used to hand-to-hand scraps with the Ulster police, despise the army's dependence on rubber bullets which keeps the troops at a distance 21

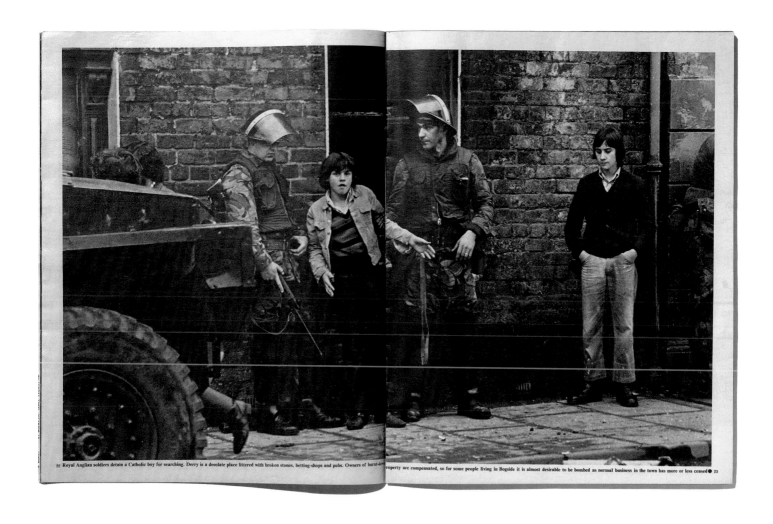

22 Royal Anglian soldiers detain a Catholic boy for searching. Derry is a desolate place littered with broken stones, betting-shops and pubs. Owners of burnt-down property are compensated, so for some people living in Bogside it is almost desirable to be bombed as normal business in the town has more or less ceased ● 23

In the summer of 1972 the Olympics made a historic return to Germany. On 5 September, eight Palestinians – under the name 'Black September' – invaded the Olympic Village, killing two Israeli athletes and taking nine others hostage. They demanded the release of 234 Palestinians being held in Israeli jails. The crisis received widespread media attention, including many hours of live television broadcast. Eighteen hours later, a botched rescue effort resulted in the deaths of all the Israelis, a German officer and five of the terrorists. Within a week, *Paris Match* published a clear and suspenseful 16-page account of the crisis. An hour-by-hour narrative brought readers close to the action by means of eerie telephoto shots of the fedayeen, detailed accounts of clandestine negotiations, and graphic images of the attempted German rescue as it went wrong. The report reflected the skill of *Paris Match* reporters and the enormous access to information that the magazine could command. It also showed how a magazine could still deliver an account of a major news event capable of successfully competing with round the clock television news. (16 September 1972, including photographs by Michel Sola and Robert Boulay)

Des silhouettes de série noire prêtes à tuer ou à mourir

La sentinelle seule a le visage découvert. L'arme au pied, une grenade passée à la ceinture, elle est postée devant l'entrée du pavillon israélien.

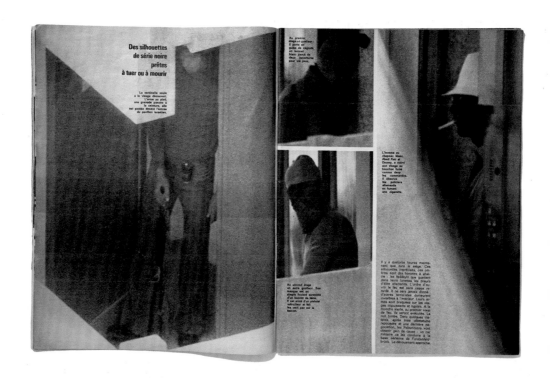

Au premier étage un guetteur à perte en guise de cagoule le bonnet blanc percé de deux ouvertures pour les yeux.

L'homme au chapeau blanc, Abed Kair al Drawy, a ôté son visage au bouchon fumé par les commandos. Il observe les policiers allemands en fumant une cigarette.

Au second étage : un autre guetteur. Son masque est un simple foulard surmonté d'un bonnet de laine. Il est armé d'un pistolet mitrailleur et fait feu cent par le balcon.

Il y a distante heures maintenant que dure le siège. Ces silhouettes imprécises, ces ombres sont des hommes à abattre : les feddayin que portent dans leurs lunettes les tireurs d'élite allemands. L'ordre d'ouvrir le feu est sans cesse retardé. Il ne sera jamais donné d'abattre terroristes demeurent invisibles à l'intérieur. Leurs armes sont braquées sur les otages impuissants et ligotés. À la moindre alerte, au premier coup de feu, ils seront exécutés. La nuit tombe. Dans quelques instants, après trois ultimatums repoussés et une dernière négociation, les Palestiniens vont obtenir gain de cause : un car militaire va les conduire à la base aérienne de Fürstenfeldbrück. Le dénouement approche.

La police allemande croit trouver une alliée dans la nuit qui tombe

Rien ne bouge maintenant dans le village olympique. Le silence est écrasant. L'avant-dernier acte du drame va se jouer. À vingt-trois minutes. Un minibus Volkswagen bleu sombre vient se ranger devant le pavillon israélien. Les feddayin refusant la voiture qu'ils jugent trop étroite : ils ne pourtant s'y défendre. Un car militaire arrive ensuite. Le chauffeur, dans son affolement, fauche un arbuste au passage. Un Palestinien inspecte minutieusement le véhicule. Puis les neuf otages, reliés au dos, sont embarqués sous la menace des pistolets mitrailleurs. Le car se dirige vers un terrain dégagé, à l'ouest du village olympique, où trois hélicoptères attendent, rotors tournant. Il est 22 h 21. Sur l'aéroport de Fürstenfeldbrück, le piège est prêt à se refermer sur les terroristes.

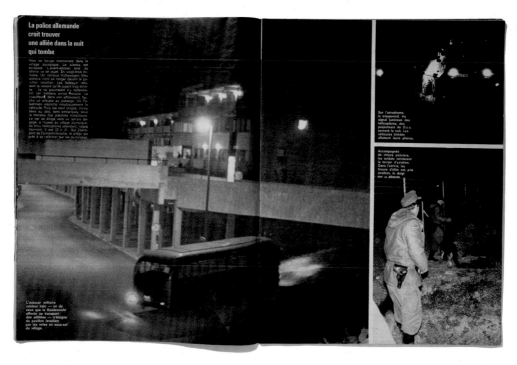

Sur l'aérodrome, le traquenard. Au signal lumineux des hélicoptères, des projecteurs de D.c.a. percent la nuit. Les véhicules blindés allument leurs phares.

Accompagnés de chiens policiers, les soldats ceinturent le terrain d'aviation. Dans l'ombre, les tireurs d'élite ont pris position, le doigt sur la détente.

L'autocar militaire couleur kaki — un de ceux que la Bundeswehr affecte au transport des athlètes — s'éloigne du pavillon israélien par une voie en sous-sol du village.

L'aube se lève sur les morts inutiles et le rêve olympique bafoué

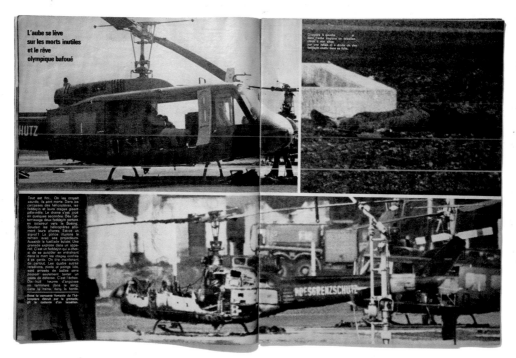

Tout est fini... On les croyait sauvés, ils sont morts. Dans les carcasses des hélicoptères, les feddayin et leurs otages gisent pêle-mêle. Le drame s'est joué en quelques secondes. Dès l'atterrissage deux feddayin partent en éclaireur vers le Boeing. Soudain les hélicoptères allument leurs phares. Est-ce un signal? La police illumine le terrain avec ses projecteurs. Aussitôt la fusillade éclate. Une grenade explose dans un appareil. C'est un feddayin qui a choisi de se suicider en entraînant dans la mort les otages confiés à sa garde. On tira maintenant de partout. Les quatre autres israéliens, pieds et poings liés, ne peuvent seulement tenter un geste de défense. C'est l'échec. Dix-huit heures d'angoisse se terminent dans le sang, dans la haine, dans la horde.

Sous la carcasse fumante de l'hélicoptère détruit par la grenade, gît le cadavre d'un israélien.

Chapitre à gauche : dans l'aube tragique un israélien, criblé à son siège sur une rafale et à droite un des feddayin abattu dans sa fuite.

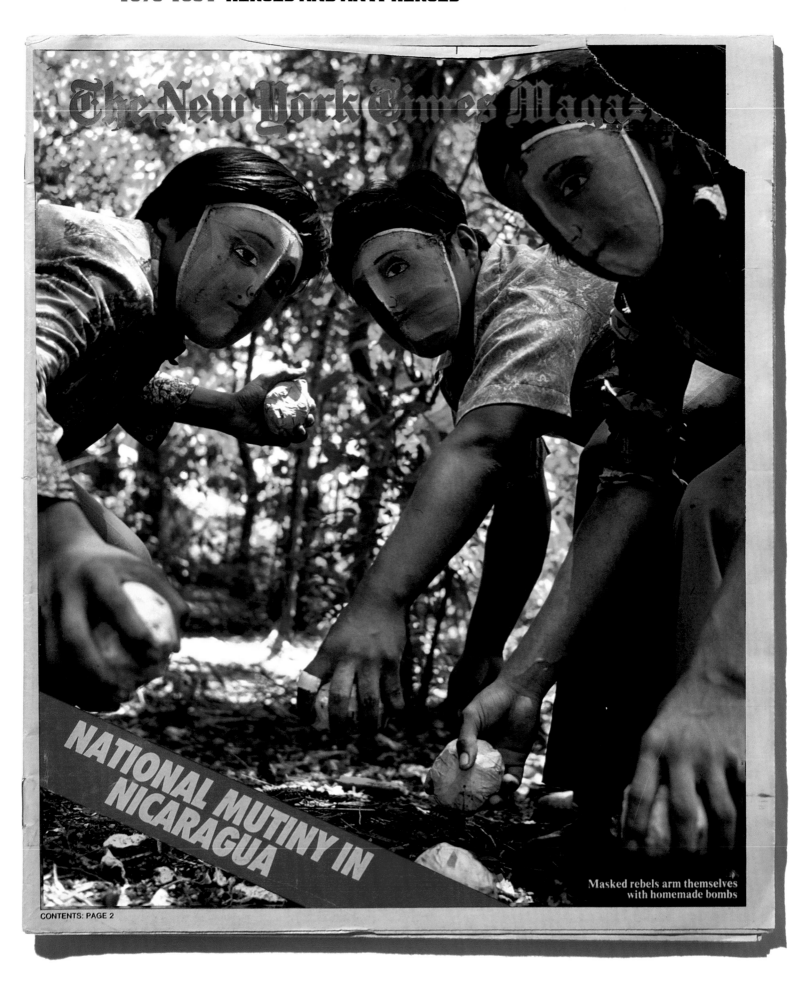

The New York Times Magazine

NATIONAL MUTINY IN NICARAGUA

Masked rebels arm themselves
with homemade bombs

By the middle of the 1970s, the Cold War shows signs of ending – symbolized by the link up of Apollo and Soyuz spacecraft in orbit in 1975 – and its familiar storylines begin to fragment. The swift spread of American commodities and culture – Nike, McDonald's, Coca-Cola, MTV and the unifying brands of rock music – feeds the idea of the global village but global inequalities grow. A new front line between the rich 'north' and the poor 'south' begins to emerge that for photojournalists will replace the intense urgency of the Vietnam War. Meanwhile, old-world dictators and popular new heroes star in a myriad of plotlines. The dockworkers in Gdansk, Poland, mobilize world support in their campaign for democracy. War in Lebanon descends into a web of complexity that defies the best of journalists to explain. Franco dies, and Spain welcomes a new democracy and a free press. In Nicaragua, the Sandinistas oust dictator Somoza, as Central American conflicts pit grassroots rebels against US-backed military forces. The Ayatollah Khomeini establishes a religious state in Iran and Queen Elizabeth II celebrates her jubilee to the punk soundtrack of the Sex Pistols. The Viking probe sends back the first pictures of Mars, and the mysterious deathly illness affecting mainly gay men is named as Aids. As audiences for magazines break up into niche markets and photojournalism seems momentarily diminished, new directions in visual reporting take hold between the cracks.

STANLEY FORMAN *Boston Herald*
A woman and a girl are hurled off a collapsing fire escape in an apartment house fire. The woman was killed but the child survived, her fall cushioned by the woman's body. Boston, USA, 22 July 1975. World Press Photo of the Year 1975

MICHAEL WELLS
Starving boy and missionary. Karamoja district, Uganda, April 1980. World Press Photo of the Year 1980

MANUEL PÉREZ BARRIOPEDRO *Agencia EFE*
Lt. Col. Antonio Tejero Molina and members of the Guardia Civil and the military police hold the Spanish parliament hostage. Madrid, Spain, 23 February 1981. World Press Photo of the Year 1981

DAVID BURNETT *Contact Press Images*
A Cambodian woman cradles her child while waiting for food to be distributed. Sa Keo refugee camp, Thailand, November 1979. World Press Photo of the Year 1979

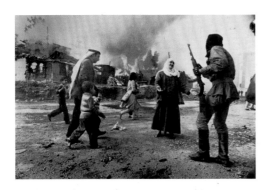

FRANÇOISE DEMULDER *Gamma*
Palestinian refugees in the district La Quarantaine.
Beirut, Lebanon, January 1976. World Press Photo of the
Year 1976

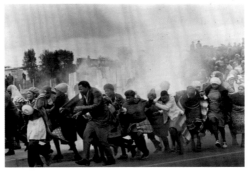

LESLIE HAMMOND *Argus*
The police tear-gas inhabitants of Modderdam squatter
camp outside Cape Town protesting against the
demolition of their homes. Modderdam, Western Cape,
South Africa, August 1977. World Press Photo of the
Year 1977

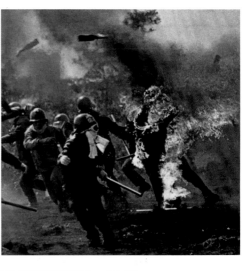

SADAYUKI MIKAMI *Associated Press*
Protest against the construction of Narita Airport. Tokyo,
Japan, March 1978. World Press Photo of the Year 1978

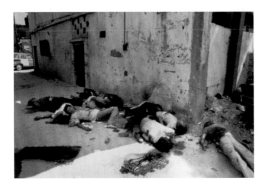

ROBIN MOYER *Black Star/Time*
Aftermath of massacre of Palestinians by Christian
Phalangists in the Sabra and Shatila refugee camps.
Beirut, Lebanon, 18 September 1982. World Press Photo
of the Year 1982

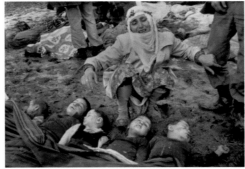

MUSTAFA BOZDEMIR *Hürriyet Gazetesi*
Kezban Özer finds her five children buried alive after a
devastating earthquake. Koyunoren, Turkey, 30 October
1983. World Press Photo of the Year 1983

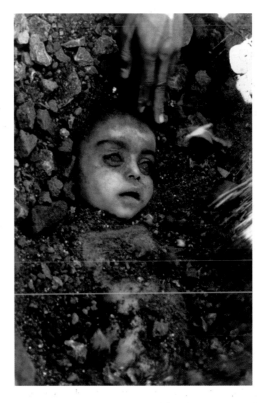

PABLO BARTHOLOMEW *Gamma*
Child killed by the poisonous gas leak in the Union
Carbide chemical plant disaster. Bhopal, India,
December 1984. World Press Photo of the Year 1984

The influential left-wing monthly journal *Sekai* – literally 'the World' – was launched in 1946, dedicated to building 'peace and social justice' and 'freedom and equality' in postwar Japan. Dominated by political analysis and argument, each issue began with a 16- to 24-page photo essay printed in gravure that in most cases profiled a city or a country in the region – part of a programme to promote 'harmony and solidarity with the peoples of East Asia'. *Sekai*'s photo essay contributors included Shisei Kuwabara, Shinzo Hanabusa and Hiroji Kubota, with Kubota producing over 40 essays for the magazine between 1967 and 1980 on topics such as China, Burma and Okinawa under American occupation. It was as *Sekai* correspondent that Kubota became the first freelance Japanese photographer allowed to visit North Korea in 1978, and he produced four stories on Thailand during a period when the Kingdom feared a Communist takeover. His gentle, respectful reportage style was a reaction to the suffering he witnessed as a child in Japan during World War II, and proved a useful vehicle for *Sekai* to foster mutual understanding between its audience and the nations Kubota photographed. (September 1976)

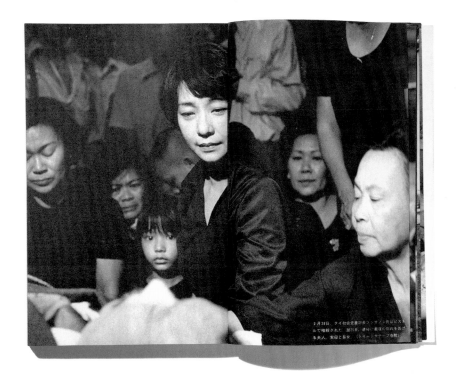

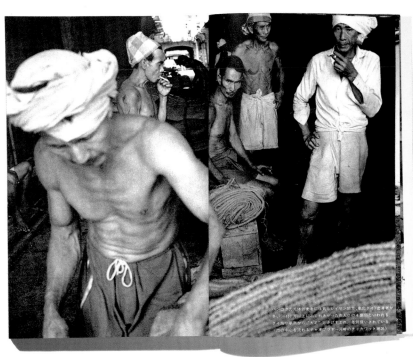

2月28日、タイ社会党書記長フンサノン氏はピストルで暗殺された。翌29日、遺体に最後の別れを告げる夫人、実母と長女。（トリートサテープ寺院）

バンコクの荷役労働者には貧しいイサン地方（東北タイ）出身者が多い。100万以上にふくれあがった市内人口の4割といわれるタイ族や華僑から"大足"とさげすまれ、差別扱いされている。（市の中心を流れるチャオプラヤー河畔のチャカワット地区）

バングラバー通りには100軒程の銃砲店がならぶ。警察の簡単な許可書があれば誰でも火器が手に入る。すぐ近くには射撃場も用意されている。（ウラチャ銃砲店前）

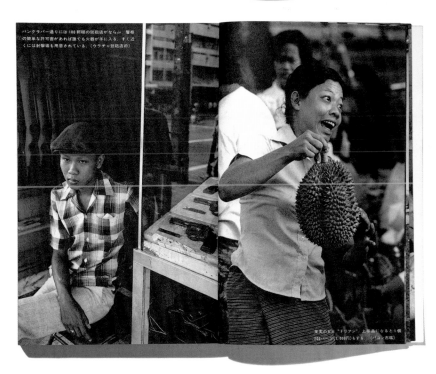

果実の女王"ドリアン"上等品になると1個200バーツ（1,000円）もする。（パコン市場）

In 1976, while celebrations of America's Bicentennial stirred patriotic emotions and shut out painful memories of Watergate, Nixon and Vietnam, *Rolling Stone* hired Richard Avedon to portray the political landscape in the lead up to the 'bicentennial Presidential election'. Avedon shaped the assignment according to his own style and convictions. He felt that 'the real story was not simply the candidates, but a broad group of men and women – some of whom we have never heard of before – who constitute the political leadership of America'. The project included more than 70 portraits made with an 8x10 view camera, each figure standing against a plain white background and run throughout the entire issue of the magazine. The only text takes the form of the sitter's official entry in the biographical encyclopedia *Who's Who*. Adopting an approach neutrally dedicated to facts alone, this essay was Avedon's response to 'new journalism' – the highly personal reporting style closely associated with *Rolling Stone*. The project was an important landmark in Avedon's own career, as he moved from fashion and advertising photography to journalism and art. (21 October 1976)

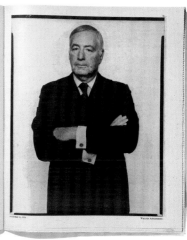
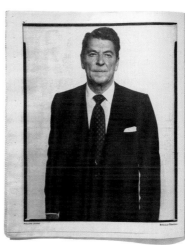
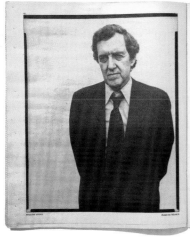
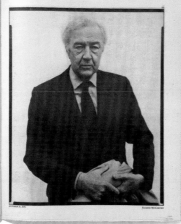

205

Susan Meiselas came to Nicaragua early in 1978, not as a war photographer entering a war zone, but as a young documentary photographer looking for a subject, pursuing her curiosity in the growing opposition to the country's military dictatorship. She was prompted to go by the murder – apparently by members of Nicaragua's National Guard – of Pedro Joaquín Chamorro, the opposition leader and journalist publisher of Nicaragua's *La Prensa*. His death also proved a decisive event in uniting opposition to the regime, stirring the beginnings of a revolution. Without media interest in her pictures, Meiselas recorded the rise of the Sandinistas while getting to know 'the rhythm of Nicaragua's history'. When the *New York Times* magazine sent a writer to describe the emerging revolution, it 'picked up' Meiselas's unpublished photographs for a cover story that turned her gripping portraits of masked insurgents into icons of the revolution. This story also propelled her from obscurity to the front line of international photojournalism, presenting her with opportunities to photograph other conflicts. She preferred to stay in Nicaragua, developing an independent practice, financially supported by 'guarantees' towards her work rather than assignments. (30 July 1978)

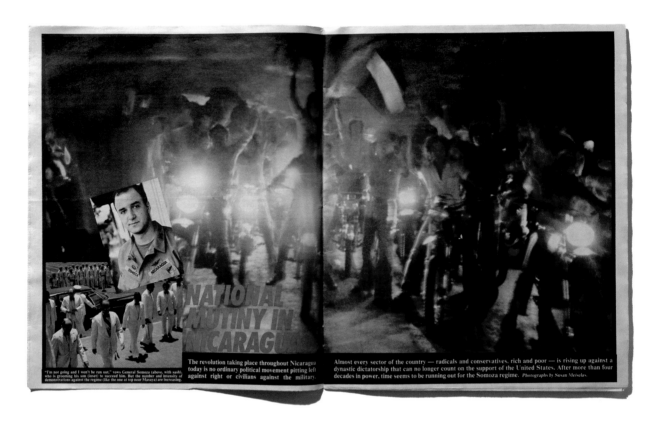

NATIONAL MUTINY IN NICARAGUA

"I'm not going and I won't be run out," vows General Somoza (above, with sash), who is grooming his son (inset) to succeed him. But the number and intensity of demonstrations against the regime (like the one at top near Masaya) are increasing.

The revolution taking place throughout Nicaragua today is no ordinary political movement pitting left against right or civilians against the military.

Almost every sector of the country — radicals and conservatives, rich and poor — is rising up against a dynastic dictatorship that can no longer count on the support of the United States. After more than four decades in power, time seems to be running out for the Somoza regime. *Photographs by Susan Meiselas.*

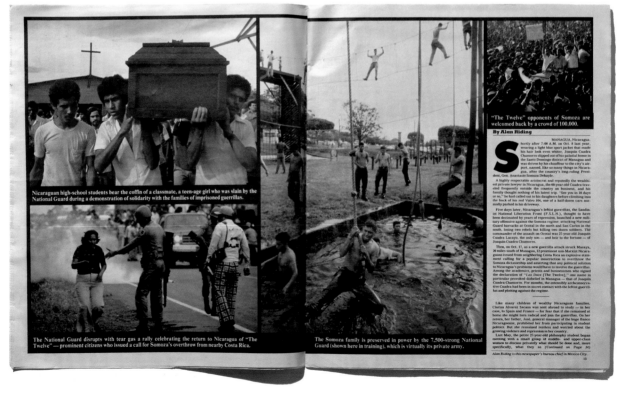

Nicaraguan high-school students bear the coffin of a classmate, a teen-age girl who was slain by the National Guard during a demonstration of solidarity with the families of imprisoned guerrillas.

The National Guard disrupts with tear gas a rally celebrating the return to Nicaragua of "The Twelve" — prominent citizens who issued a call for Somoza's overthrow from nearby Costa Rica.

The Somoza family is preserved in power by the 7,500-strong National Guard (shown here in training), which is virtually its private army.

"The Twelve" opponents of Somoza are welcomed back by a crowd of 100,000.

By Alan Riding

MANAGUA, Nicaragua.

Shortly after 7:00 A.M. on Oct. 8 last year, wearing a light blue sport jacket that made his hair look even whiter, Joaquín Cuadra Chamorro slipped out of his palatial home in the Santo Domingo district of Managua and was driven by his chauffeur to the city's airport, named, like so many things in Nicaragua, after the country's long-ruling President, Gen. Anastasio Somoza Debayle.

A highly respectable aristocrat and reputedly the wealthiest private lawyer in Nicaragua, the 60-year-old Cuadra traveled frequently outside the country on business, and his family thought nothing of his latest trip. "See you in 10 days or so," he had called out to his daughters before climbing into the back of his red Volvo 164, one of a half-dozen cars normally parked in his driveway.

Five days later, Nicaragua's leftist guerrillas, the Sandinist National Liberation Front (F.S.L.N.), thought to have been decimated by years of repression, launched a new military offensive against the Somoza regime, attacking National Guard barracks at Ocotal in the north and San Carlos in the south, losing two rebels but killing two dozen soldiers. The commander of the assault on Ocotal was 27-year-old Joaquín Cuadra Lacayo, the only son — and heir to the fortune — of Joaquín Cuadra Chamorro.

Then, on Oct. 17, as a new guerrilla attack struck Masaya, 20 miles south of Managua, 12 prominent non-Marxist Nicaraguans issued from neighboring Costa Rica an explosive statement calling for a popular insurrection to overthrow the Somoza dictatorship and asserting that any political solution to Nicaragua's problems would have to involve the guerrillas. Among the academics, priests and businessmen who signed the declaration of "Los Doce [The Twelve]," one name in particular provoked disbelief in Managua — that of Joaquín Cuadra Chamorro. For months, the ostensibly archconservative Cuadra had been in secret contact with the leftist guerrillas and plotting against the regime.

Like many children of wealthy Nicaraguan families, Clarisa Alvarez Sacasa was sent abroad to study — in her case, to Spain and France — for four that if she remained at home she might turn radical and join the guerrillas. On her return, her father, José, general manager of the huge Banco Nicaraguense, prohibited her from participating in student politics. But she remained restless and worried about the growing violence and repression in her country.

Last May, the petite 27-year-old philosophy student began meeting with a small group of middle- and upper-class women to discuss privately what should be done and, more specifically, what they as (Continued on Page 34)

Alan Riding is this newspaper's bureau chief in Mexico City.

Café Lehmitz was located near the Reeperbahn in Hamburg, Germany. Open around the clock, it was frequented by a colourful group of social outsiders, including sailors, cab drivers, prostitutes, pimps, poets and small-time criminals. 'The people at the Café Lehmitz had a presence and a sincerity that I myself lacked,' said Swedish photographer Anders Petersen, who first came across the café in the late 1960s and over the next three years spent much of his time there taking pictures of its customers. 'It was okay to be desperate, to be tender, to sit all alone or share the company of others. There was a great warmth and tolerance in this destitute setting.' A student and follower of the seminal Swedish photographer Christer Strömholm, Petersen borrowed from his teacher's stark black and white style while adopting his participatory approach to observation. Like Strömholm, who spent years with the transsexuals of Place Blanche in Paris for one of his best-known series of pictures, Petersen became a part of the Bohemian life of Lehmitz community himself. The pictures published by *Stern* show the intimacy he shared with his subjects, while never exposing them to ridicule or giving the impression of voyeurism. (11 November 1979)

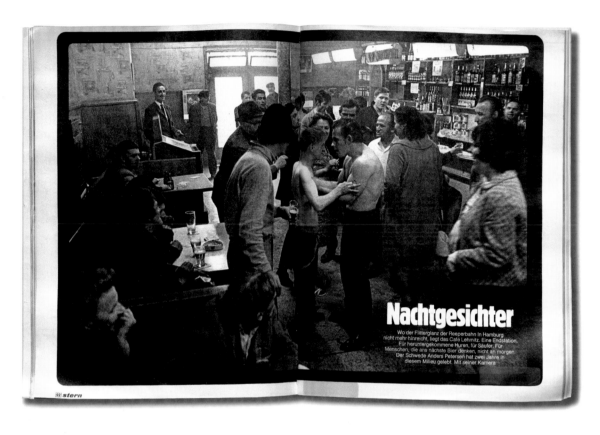

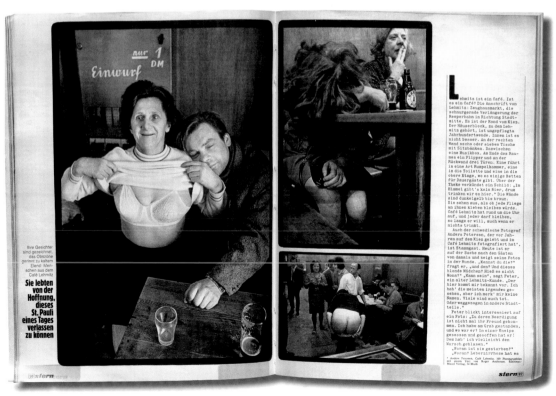

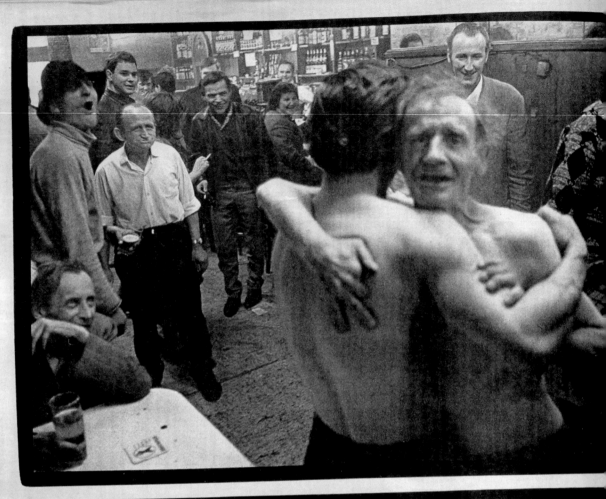

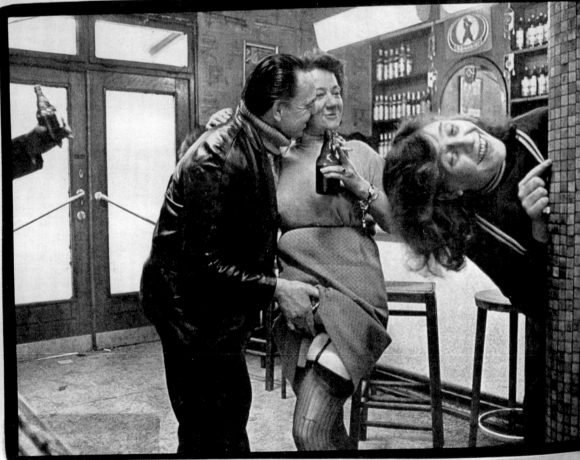

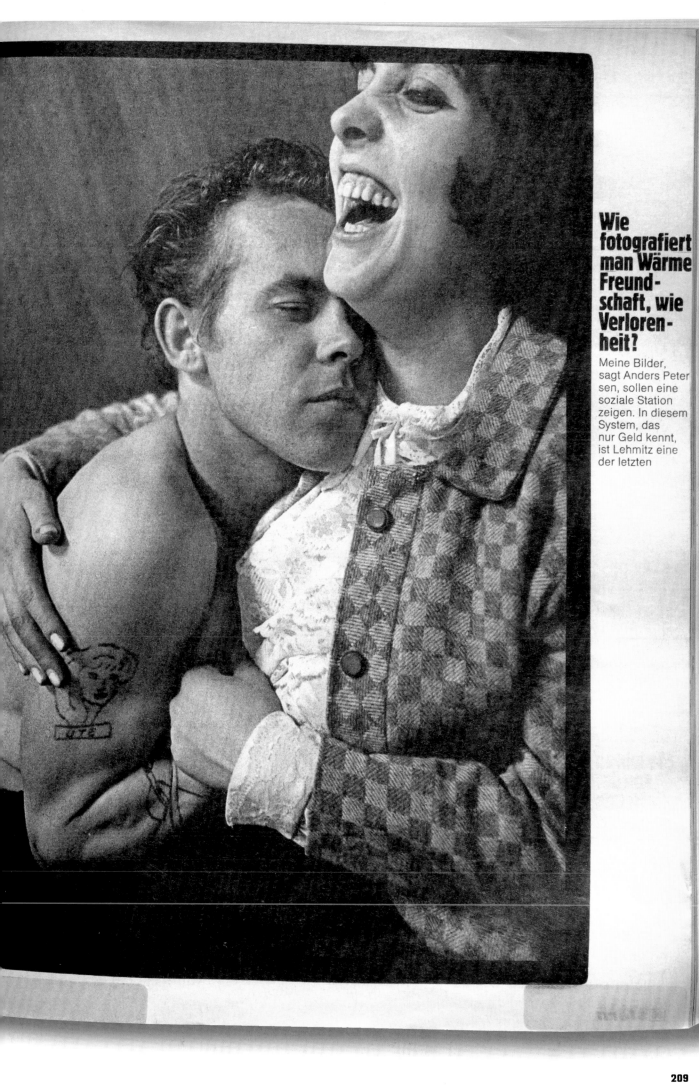

Wie fotografiert man Wärme Freundschaft, wie Verlorenheit?

Meine Bilder, sagt Anders Petersen, sollen eine soziale Station zeigen. In diesem System, das nur Geld kennt, ist Lehmitz eine der letzten

Helmut Newton once said that while other photographers recorded what they saw, he photographed what he had *once seen*. His life's work was a sustained autobiographical essay about his perceptions of the world, particularly the mores and codes of 'Old Europe', reflecting on scenes from his past overlaid with contemporary erotic narratives, and usually shot for the editorial pages of fashion magazines. Newton was born in Berlin in 1920, escaping the Nazi persecution of the Jews in 1938. When he returned on assignment for *Vogue*'s German edition, the idea was to record the places of his childhood as he remembered them. In some he found items from his past and used them as props, such as the furniture of a lakeside restaurant he used to frequent. In each location, he worked at the edge of available light, creating an appropriately melancholic mood. The models, meanwhile, were an intrusion of the modern world, set in contrast to the Berlin of the past. While Newton could never be described as a photojournalist, his substantial contribution to magazine photography was as a narrative storyteller, absorbed by the question of how to represent reality. (November 1979)

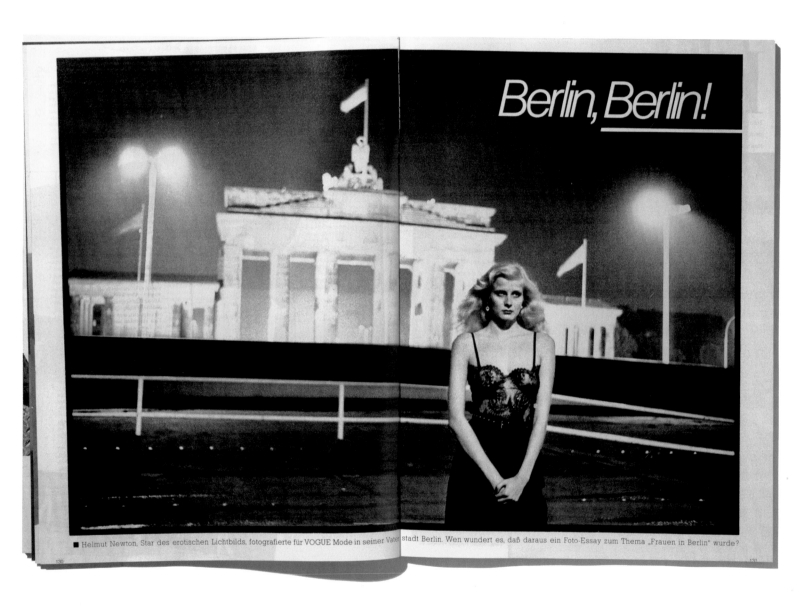

■ Helmut Newton, Star des erotischen Lichtbilds, fotografierte für VOGUE Mode in seiner Vaterstadt Berlin. Wen wundert es, daß daraus ein Foto-Essay zum Thema „Frauen in Berlin" wurde?

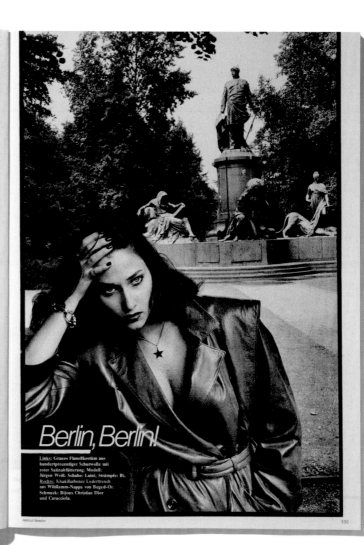

Berlin, Berlin!

■ Newtons Genie: Es besteht vor allem auch darin, „Tiefenwirkungen" zu erzielen. „Meine Bilder reflektieren nur das, was ich um mich herum sehe", sagt er. Und vergißt hinzuzufügen, daß diese „Wirklichkeit" seine Erfindung ist. Der überlebensgroße Generalstabschef Helmuth von Moltke wird von den attraktiven Beinen eines kleinen engelsblonden Wesens zum Statisten degradiert. Und welche Chance hatte Bismarcks Gloria gegen den Flintenweib-Charme jener finster blickenden Ninotschka (rechts)?

Links: Graues Flanellkostüm aus hundertprozentiger Schurwolle mit roter Satinabfütterung. Modell: Jürgen Weiß. Schuhe: Luini; Strümpfe: Bi. Rechts: Khakifarbener Ledertrench aus Wildlamm-Nappa von Beged-Or. Schmuck: Bijoux Christian Dior und Caracciola.

134 135

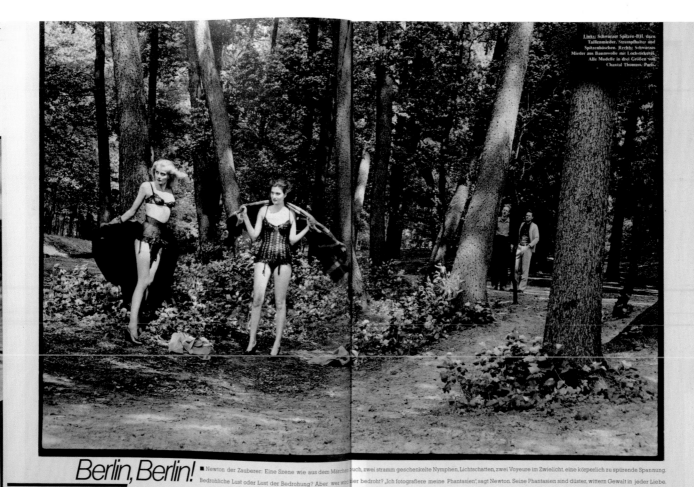

Links: Schwarzer Spitzen-BH. dazu Taillenmieder, Strumpfhalter und Spitzenhöschen. Rechts: Schwarzes Mieder aus Baumwolle mit Lochstickerei. Alle Modelle in drei Größen von Chantal Thomass, Paris.

Berlin, Berlin!

■ Newton der Zauberer: Eine Szene wie aus dem Märchenbuch, zwei stramm geschenkelte Nymphen, Lichtschatten, zwei Voyeure im Zwielicht, eine körperlich zu spürende Spannung. Bedrohliche Lust oder Lust der Bedrohung? Aber wer wird hier bedroht? „Ich fotografiere meine Phantasien", sagt Newton. Seine Phantasien sind düster, wittern Gewalt in jeder Liebe.

136 137

Photographers Letizia Battaglia and Franco Zecchin joined the staff of Palermo's leftist newspaper, *L'Ora*, in 1974 where their most important work for the paper was in documenting the evidence of the ongoing police, judicial and political war against the Mafia. By 1981, one Mafia murder was taking place every three days. On 6 January 1980, Piersanti Mattarella, President of the Sicilian region, was shot in his car by the Mafia after speaking out publicly about the involvement of establishment politicians in organized crime. Battaglia and Zecchin arrived at the crime scene minutes after the shooting when the politician was still alive and while his wife, who was in the car with him, desperately clung to his body. They followed the story from the rush to hospital, through anxious waiting, until the announcement of his death. Talking about her work during the period, Battaglia said: 'I felt it was my responsibility, as a Sicilian, to fight. It is not acceptable for one evil part of the society to decide the future for all.' She organized large public exhibitions devoted to exposing Mafia activity and invited other photographers to participate. Most declined. She subsequently set up a school for photographers, a gallery and a publishing house – becoming herself a symbol of the war against the Mafia system.
(7 January 1980)

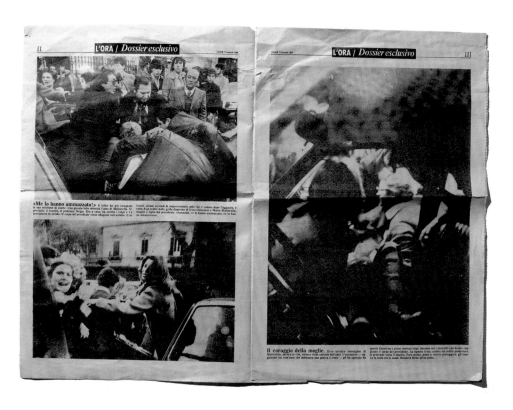

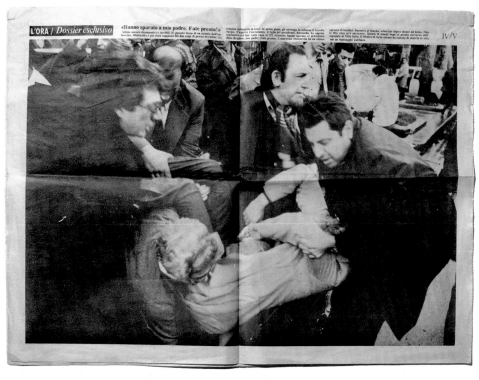

L'ORA

Dossier esclusivo

Le foto dell'assassinio di Mattarella

E' ancora vivo! Ore 13: Piersanti Mattarella è ancora vivo. Con questa drammatica immagine s'apre il dossier fotografico, esclusivo dell'agguato al presidente della Regione siciliana. I fotoreporters Letizia Battaglia e Franco Zecchin si trovano in via Libertà pochi attimi dopo la fuga del killer. Hanno sentito, da lontano, i colpi di pistola. E colgono con l'obiettivo il volto sofferente ma composto di Mattarella mentre familiari e passanti lo soccorrono. *Fotoservizio esclusivo L'ORA - Letizia Battaglia e Franco Zecchin*

Gilles Peress began a five-week visit to Iran shortly after the Revolution. He went during the hostage crisis, with Iranian militants holding 179 Americans, while much of the US media described Iran's revolutionaries as mad fanatics and only represented the scene at the Embassy. Peress, always untrusting of the media, wanted to see for himself. Employing what he describes as his 'strategy of drift', looking for the visual and historical 'patterns that emerge from reality', he explored the rhythms of Iran's city streets. In a blend of journalistic enquiry and subjective observation, he recorded both spectacular scenes and minute details, in what the *New York Times* called a 'jarring array of images'. At one level this was an appropriate journalistic response to the confusion of Iran at the time, but this was also Peress's disruptive antidote to the safe formulae and simplistic narrative tidiness of conventional journalism. His photographs challenged the viewer to engage with the issues of history but at the same time, to distrust the storyteller's objectivity. Peress's book *Telex Iran*, published four years later, had a profound impact on the practice of documentary photography thereafter. (15 June 1980)

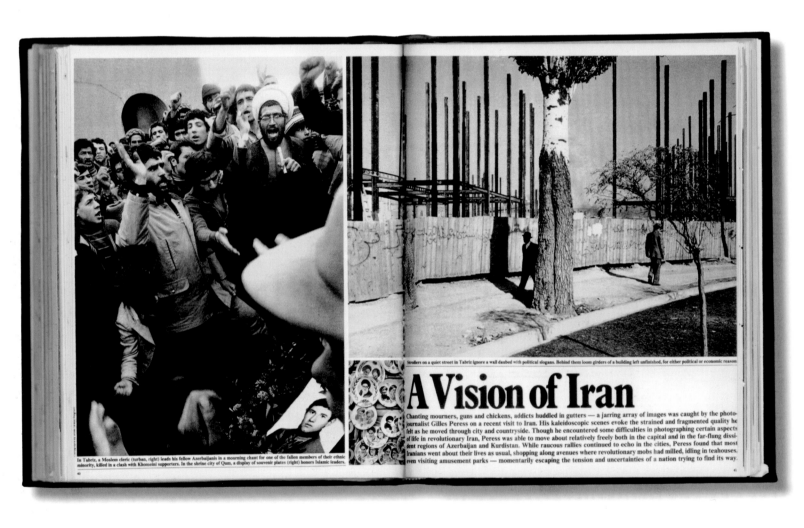

Strollers on a quiet street in Tabriz ignore a wall daubed with political slogans. Behind them loom girders of a building left unfinished, for either political or economic reason.

A Vision of Iran

Chanting mourners, guns and chickens, addicts huddled in gutters — a jarring array of images was caught by the photo-journalist Gilles Peress on a recent visit to Iran. His kaleidoscopic scenes evoke the strained and fragmented quality he felt as he moved through city and countryside. Though he encountered some difficulties in photographing certain aspects of life in revolutionary Iran, Peress was able to move about relatively freely both in the capital and in the far-flung dissident regions of Azerbaijan and Kurdistan. While raucous rallies continued to echo in the cities, Peress found that most Iranians went about their lives as usual, shopping along avenues where revolutionary mobs had milled, idling in teahouses, even visiting amusement parks — momentarily escaping the tension and uncertainties of a nation trying to find its way.

In Tabriz, a Moslem cleric (turban, right) leads his fellow Azerbaijanis in a mourning chant for one of the fallen members of their ethnic minority, killed in a clash with Khomeini supporters. In the shrine city of Qum, a display of souvenir plates (right) honors Islamic leaders.

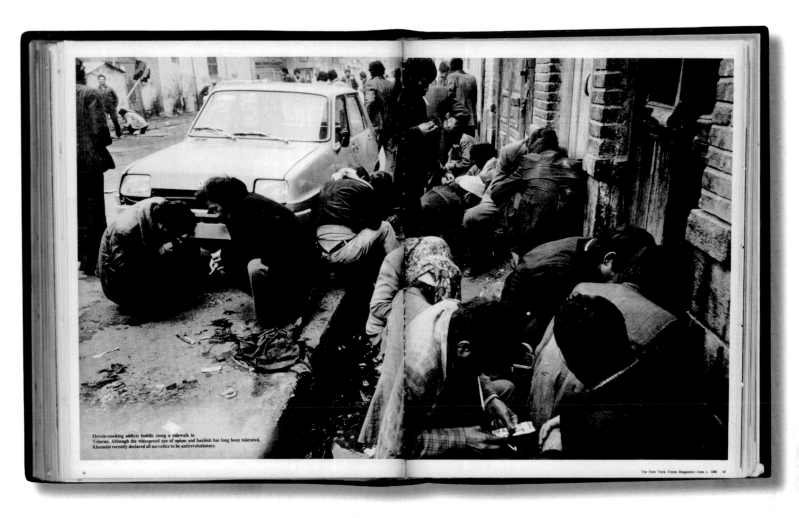

Heroin-smoking addicts huddle along a sidewalk in Teheran. Although the widespread use of opium and hashish has long been tolerated, Khomeini recently declared all narcotics to be antirevolutionary.

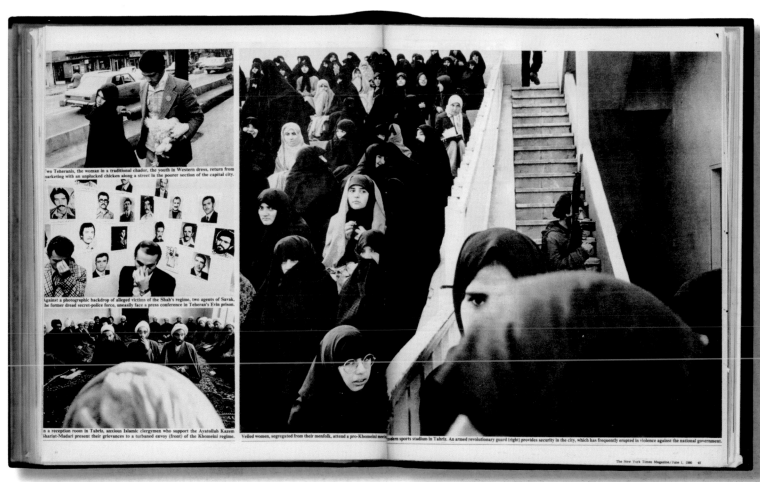

Two Teheranis, the woman in a traditional chador, the youth in Western dress, return from marketing with an unplucked chicken along a street in the poorer section of the capital city.

Against a photographic backdrop of alleged victims of the Shah's regime, two agents of Savak, the former dread secret-police force, uneasily face a press conference in Teheran's Evin prison.

In a reception room in Tabriz, anxious Islamic clergymen who support the Ayatollah Kazem Shariat-Madari present their grievances to a turbaned envoy (front) of the Khomeini regime.

Veiled women, segregated from their menfolk, attend a pro-Khomeini meeting in a modern sports stadium in Tabriz. An armed revolutionary guard (right) provides security in the city, which has frequently erupted in violence against the national government.

In 1980, Alain Bizos accompanied Jan, a young labour leader representing his factory, over two weeks of negotiations between the shipyard workers and the Polish government. The story published by *Actuel* takes the form of images arranged in sequence with conversational captions, in the style of a scrapbook or diary. We see the strike unfold from Jan's point of view, feeling the claustrophobia of strike headquarters, and enduring the tedium of waiting for news. The meeting with Lech Walesa, a hero to Jan, is a climactic moment in this choppy, episodic account when Walesa's charisma shines through. Bizos creates a particular feeling of authenticity with his snapshot style, at once awkward and spontaneous, and with his use of colour ironically emphasizing the harsh characteristics of ordinary environments. There is no suggestion of an objective summary of events here. On a subject where there are many competing points of view, it is the personal account that becomes the most reliable. (October 1980)

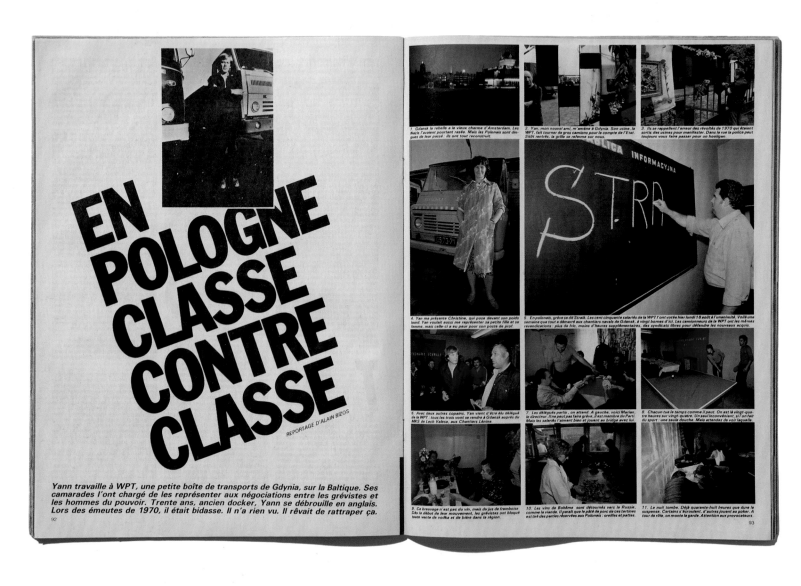

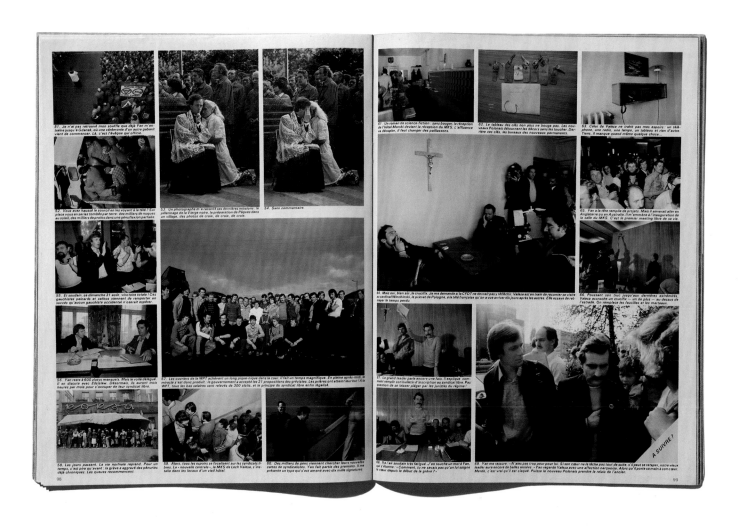

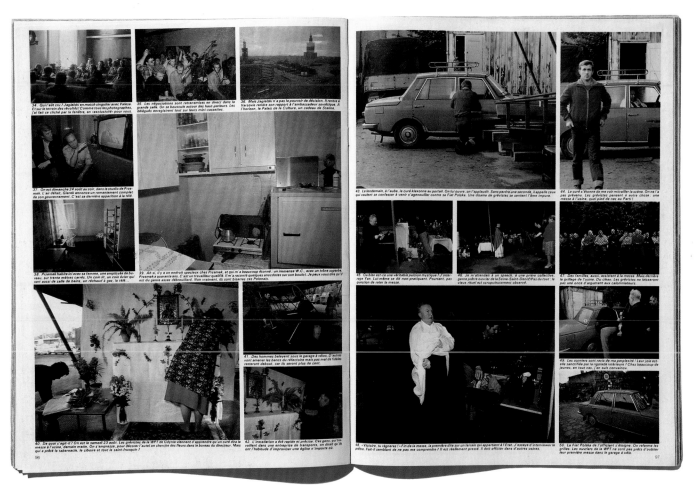

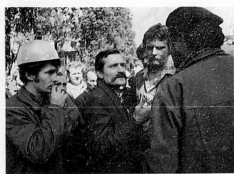

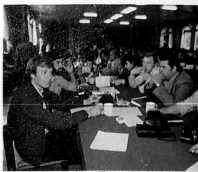

12. Le lendemain, je retrouve Yan et son camarade Zdzis-law parmi les familles de grévistes qui attendent devant l'énorme portail des Chantiers Navals Lénine.

13. « Viens voir notre grand leader ! » dit Yan avec une pointe d'ironie. Voici donc l'incroyable moustachu qui fit tomber Gomulka en 1970 : Lech Valesa.

14. Dans la salle de conférence des Chantiers Lénine Zdzislaw et Przemek ont mis un carton devant eux : « prise WPT de Gdynia. » Pour eux, même cela est ne

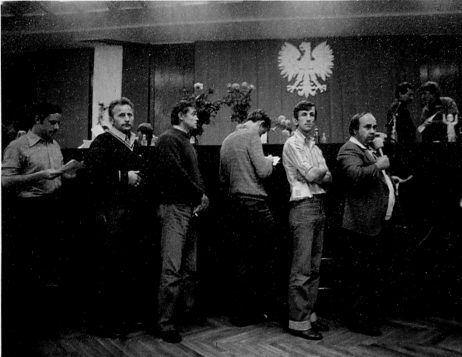

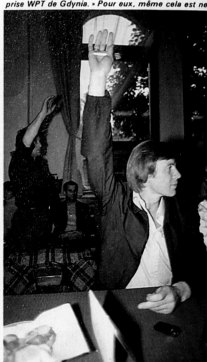

15. Les délégués viennent se présenter au micro en une queue ininterrompue : toutes les heures de nouvelles entreprises se mettent en grève. Au train où ça va, Yan et ses deux potes vont bientôt faire figure d'anciens. Ils en rient. Mais on s'inquiète : le téléphone ne marche plus. Gdansk est coupée du reste du monde.

16. « Nous ne négocierons pas sans téléphone », anno les grévistes. « Ni sans radios : envoyez-nous des ters ! » Lentement le pouvoir a cédé sur ces revendica

17. J'ai discuté avec ces types : leurs têtes fonctionnent aussi bien que les mains du bricolo qui a fait la maquette. Ils craignent les Russes et la faiblesse de Gierek.

18. Vladimir Illitch Lenine détourne son regard courroucé du petit groupe des dix-huit qui mènent la danse autour de Lech Valesa depuis le début.

19. Une danse réglée : depuis combien de temps la gr préparait-elle ? Dès que l'assemblée générale des dé grévistes se termine, vers 21 heures, hop, on nettoie

20. Les délégués, eux, foncent dans leurs usines pour tout raconter. Przemeck a pris des photos. Sitôt rentré à Gdynia, ses pellicules sont développées.

21. C'est fait. Les ouvriers se ruent sur les photos. A quoi diable peut bien ressembler une assemblée libre de délégués ouvriers ? J'ai du mal à m'y faire : c'est leur première grève.

22. La nuit tombe sur Gdynia, au bord de la Baltique autre longue veille commence. Je les bluffe un peu France, nous avons une grève par jour ! » Ils en restoe

94

23. Voici la fameuse et uni-
que douche de l'entreprise
WPT.

24. Mais ici en Pologne, malgré un sens de la combine as-
sez développé, la plupart des ouvriers n'ont pas de douche
chez eux. Ça reste un luxe.

25. Bref, après s'être lavés sous l'engin que vous venez d'a-
percevoir, les camionneurs s'installent pour la nuit, chacun
dans son coin. Celui-ci dans la cabine de son poids lourd.

es deux-là à l'arrière d'un autre camion sous une
. On est en août et pourtant ça caille dans la région.

27. Un quatrième a installé son lit au pied d'un établi.
Comme ça au moins on ne volera pas d'outils. Mais pendant
la grève, l'honnêteté est de rigueur.

28. Un mec dort sur un matelas prêté par l'hôpital voisin.

Voici l'homme qui raconte les histoires les plus drôles.
amarades l'ont baptisé Le Poulet. A votre avis, passe-t-
llement ses nuits entre les dents d'une pelleteuse ?

30. Un dernier dormeur et je m'arrête. Le bureau est un peu trop court pour lui. Pourtant il va s'endormir béatement comme
un enfant. Et sans une goutte de vodka ! Comment font-ils pour rester si calmes, quand chacun se demande si les chars russes
ne vont pas débouler d'un instant à l'autre ?

e lendemain, le gouvernement s'obstine mollement
son refus de négocier. De retour à Gdansk parmi les dé-
s du MKS, Yan s'écroule de fatigue.

32. Les ouvriers grimpent
aux fenêtres pour regarder
leurs délégués.

ET PUIS
BRUSQUEMENT
L'ORAGE DU SOIR :
LE GOUVERNEMENT
CRAQUE. GIEREK
ACCEPTE DE
NEGOCIER. MIEUX, IL
RENONCE A CE QUE
LES NEGOCIATIONS
AIENT LIEU A
VARSOVIE. UN
MEMBRE EMINENT
DU PARTI DOIT SE
RENDRE DEMAIN A
GDANSK POUR
ENTENDRE LES
DOLEANCES DES
GREVISTES.

33. Le voici, l'éminent communiste. Il s'appelle Jagielski.
Toutes les télévisions du monde ont filmé sa figure lugubre
quand il débarque à Gdansk.

95

Eugene Richards had trouble finding anyone willing to publish his photographic essay on Dorothea Lynch's three-year battle with breast cancer. Magazines turned it down as too gruesome, and as a subject of little interest to their readers. Their response masked the real problem; even as late as 1981, strong social taboos prevented the exposure of cancer, and its treatment, to public scrutiny. Breast cancer was the most forbidden topic of all – at the time of her diagnosis, Lynch had no idea what a mastectomy would look like. But *American Photographer* gave the story 14 pages and a bold layout, adding a 'backstory' about Richards himself. Dorothea Lynch was Richards' longtime companion – they later married – and his record of her treatment and recovery was in part a document of his response to and coming to terms with her illness. This story was among the first frank depictions of surgery and chemotherapy. Lynch survived another two years, and in 1986 Richards published the full story of her illness as a book, *Exploding into Life*, that became a landmark of a new kind of autobiographical photojournalism. (June 1981)

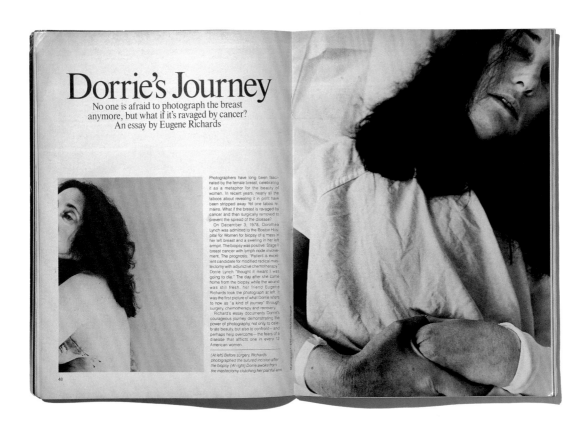

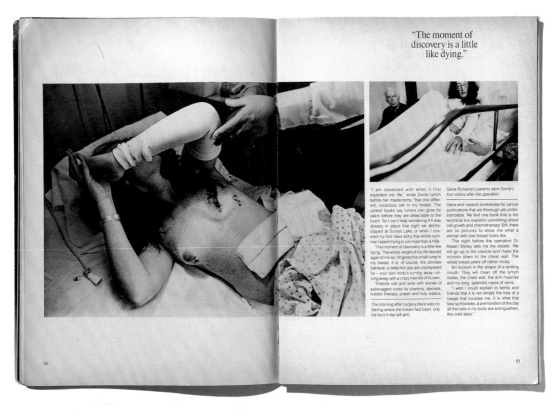

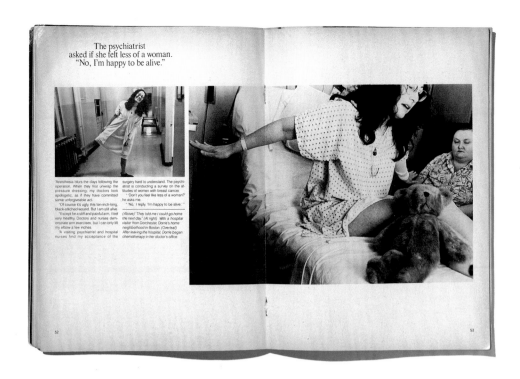

The psychiatrist asked if she felt less of a woman. "No, I'm happy to be alive."

"Anesthesia blurs the days following the operation. When they first unwrap the pressure dressing, my doctors look apologetic, as if they have committed some unforgiveable act.

"Of course it's ugly, this ten-inch-long, black-stitched wound. But I am still alive.

"Except for a stiff and painful arm, I feel very healthy. Doctors and nurses demonstrate arm exercises, but I can only lift my elbow a few inches.

"A visiting psychiatrist and hospital nurses find my acceptance of the surgery hard to understand. The psychiatrist is conducting a survey on the attitudes of women with breast cancer.

"'Don't you feel like less of a woman?' he asks me.

"'No,' I reply, 'I'm happy to be alive.'"

(Above) They told me I could go home the next day. (At right) With a hospital visitor from Dorchester, Dorrie's home neighborhood in Boston. (Overleaf) After leaving the hospital, Dorrie began chemotherapy in her doctor's office.

52 53

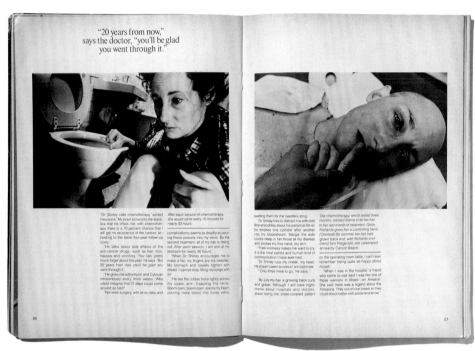

"20 years from now," says the doctor, "you'll be glad you went through it."

"Dr. Shirley calls chemotherapy 'added insurance.' My brain locks onto the statistics that he offers me: with chemotherapy, there is a 70 percent chance that I will get no recurrence of the cancer, according to the latest four-year follow-up study.

"He talks about side effects of the anti-cancer drugs, such as hair loss, nausea and vomiting. 'You can pretty much forget about this year,' he says. 'But 20 years from now you'll be glad you went through it.'

"He gives me adriamycin and Cytoxan intravenously every three weeks. Who could imagine that 21 days could come around so fast?

"Not even surgery, with all its risks and complications, seems as deadly as pouring these poisons into my veins. By the second treatment, all of my hair is falling out. After each session, I am sick at my stomach for nearly 30 hours.

"When Dr. Shirley encourages me to make a fist, my fingers are ice needles. My stomach and bowels tighten with dread. I cannot stop filling my lungs with air.

"He ties the rubber hose tightly across my upper arm, trapping the veins. Boom-bam, boom-bam, slams my heart, pouring more blood into those veins, swelling them for the needle's sting.

"Dr. Shirley tries to distract me with odd little anecdotes about his personal life as he empties one cylinder after another into my bloodstream. Margie the aide clucks deep in her throat at my distress and strokes my free hand, my arm.

"Their kindness makes me want to cry. It is the most painful and human kind of communication I have ever had.

"Dr. Shirley rubs my cheek, my head. He doesn't seem to notice I am bald now.

"'Only three more to go,' he says."

After each session of chemotherapy, she would vomit every 15 minutes for nearly 30 hours.

By July my hair is growing back curly and grayer. Although I still have nightmares about hospitals and doctors, about being the sheet-covered patient

The chemotherapy which lasted three months, robbed Dorrie of all her hair in her last month of treatment. Dorrie Richards gives her a comforting hand. (Overleaf) By summer her hair had grown back and, with Richards and friend Tom Fitzgerald, she celebrated at nearby Carson Beach.

on the operating room table, I can't ever remember being quite so happy about myself.

"When I was in the hospital, a friend who came to visit said I was like one of those warriors in Brazil—an Amazon. She said there was a legend about the Amazons. They cut off one breast so they could shoot better with a bow and arrow."

56 57

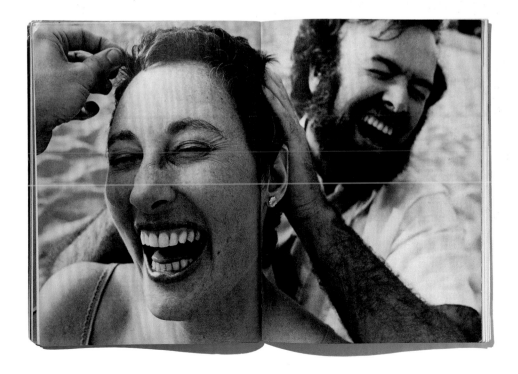

Mary Ellen Mark first saw Bombay's notorious Falkland Road, with its prostitutes in cages, on her first trip to India, in 1968. After several attempts to take photographs there – 'the women threw garbage and water and pinched me' – she returned ten years later with an assignment from *Geo*'s American edition. Her initial approach was simply to wait; Mark spent days sitting in cafés, pacing the streets – arousing much curiosity – before finally being invited by a madam into her brothel-room for tea. That meeting began a friendship, and Mark was soon able to photograph freely. The resulting photo essay contains many familiar elements of 'orientalist' fantasy, with the fact of its colour – it was *Geo*'s editors who wanted the story in colour – breaking with traditional documentary representations of this kind of subject. The story brings readers close to a way of life that is alternately fascinating, repulsive, sensual and disarmingly affectionate. When Mark returned home, *Geo* considered the pictures too raw and disturbing for its American audience, and declined to publish. The same was not true for Germany, where the story was avidly picked up by *Stern*. (9 September 1981)

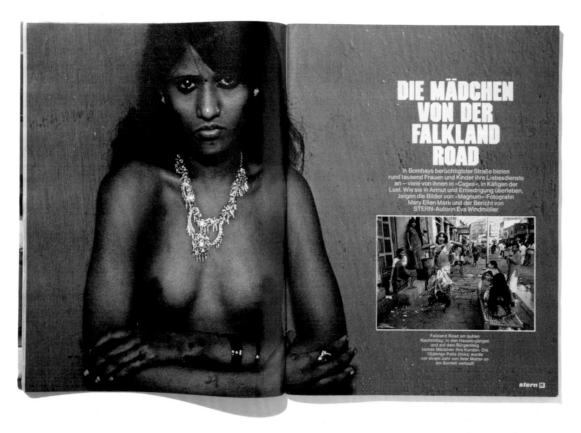

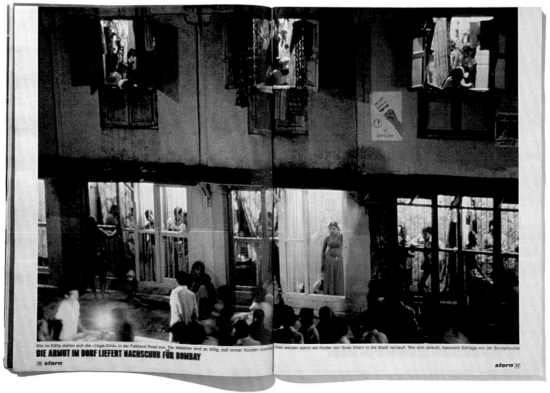

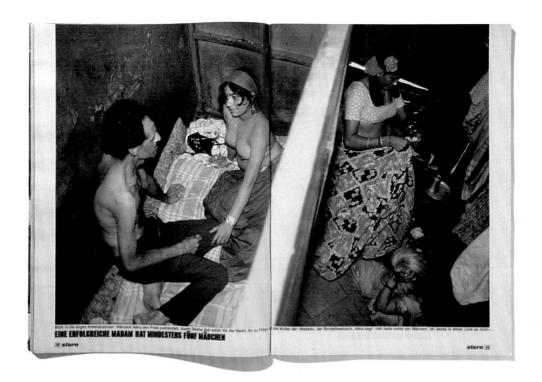

Blick in die engen Arbeitskabinen: Während Asha den Preis aushandelt, macht Rekha sich schön für die Nacht. Ihr zu Füßen die Mutter der »Madam«, der Bordellbesitzerin. Asha sagt: »Ich halte nichts von Männern. Ich denke in erster Linie an mich.«

EINE ERFOLGREICHE MADAM HAT MINDESTENS FÜNF MÄDCHEN

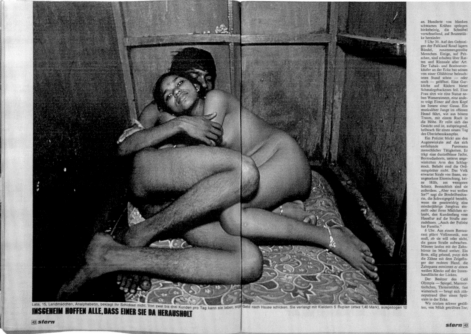

Lata, 15, Landmädchen, Analphabetin, beklagt ihr Schicksal nicht. Von zwei bis drei Kunden pro Tag kann sie leben, Geld nach Hause schicken. Sie verlangt mit Kleidern 5 Rupien (etwa 1,40 Mark), ausgezogen 1/2

INSGEHEIM HOFFEN ALLE, DASS EINER SIE DA HERAUSHOLT

an. Hunderte von blanken schwarzen Krähen springen hierkeibeinig, die Schnäbel verschnellend, auf Beuteltücke hiernieder.

5 Uhr 30: Auf den Gehsteigen der Falkland Road lagern Bündel, zusammengerollte Menschen. Einige, auf Pritschen, sind schräg über Rauch- und Kinnale aller Art. Der Tabak- und Bonbonverkäufer an der Ecke hat seinen von einer Glühbirne beleuchteten Stand schon — oder noch — geöffnet. Eine Garküche auf Rädern bietet Schmalzgebackenes feil. Eine Frau sitzt wie eine Statue neben Wassereimern, eine andere trägt Einer auf dem Kopf im Innern einer Gasse. Ein muskulöser Junge im offenen Hemd führt, wie aus bösem Traum, mit einem Ruck in die Höhe. Er reibt sich das Gesicht und ist, aufspringend, hellwach für einen neuen Tag des Überlebenskampfes.

Ein Polizist blickt aus den Augenwinkeln auf das sich entfaltende Panorama menschlicher Tätigkeiten. Er trägt eine dunkelblaue Jacke, Bermudashorts, unteren angewinkelten Arm den Schlagstock. Beliebt sind die Ordnungshüter nicht. Das Volk erwartet Strafe von ihnen, angestraftes Eintreffischung, keine Hilfe. Bestechlich sind sie außerdem. »Aber was wollen Sie?« sagt die Bordellbesitzerin, die Schweigegeld bezahlt, wenn sie gesetzwidrig eine minderjährige Jungfrau einstellt oder ihren Mädchen erlaubt, den Kundenfang vom Haustür auf die Straße auszudehnen. »Auch der Polizist hat Familie.«

6 Uhr: Aus einem Restaurant plärrt Vollautomsik, nun muß, ob sie will oder nicht, die ganze Straße aufwachen. Männer laufen mit der Zahnbürste im Mund umher. Sie Beta, eilig gehend, putzt sich die Zähne mit dem Zeigefinger der rechten Hand, die Zahnpasta entnimmt er einem weißen Klecks auf der Innenhandfläche der Linken.

Der Besitzer des Café Olympia — Spiegel, Marmortischchen, Thonerstühle, fast wienerisch — berugt sich aufreputierend über einen Spülstein in der Ecke.

Wir trinken schwer gelößten, von Milch gelbbraun To

der Mann hinter der Theke füllt Strohkartoffeln aus einer Blechdose in zwei Bootbongles. Zwei Mädchen setzen sich auf die Wandbank. Der eine fällt in rollender Bewegung, das Kinn auf die Brust. Sie ist lustig und süßlich, vielleicht 17. Ihre Freundin, rundes Gesicht, braune, schnell schillernde Augen, ignoriert uns. Ihr zur Seite der Breyfreund nach Zuhälter, das lohnt nicht hier auf der unteren Straße des „Red Light District" von Bombay. Sie hat auf sie gewartet. Nun ist er auf sie wütend und es, weil sie es schafft. Sie später das, boxt ihn in die Seite, gießt ihm den heißen Tee auf die Unterwäsche. Als wir eine Viertelstunde später noch einmal vorbeikommen, schläft er an seiner Schulter.

Unser indischer Dolmetscher Rajesh Joshi, ein junger Dokumentarfilm-Kameramann, sieht die Falkland Road weder sentikal/heroisch noch moralisch. Für ihn ist sie eine der vielen Möglichkeiten, im Chaos zu überleben. Er bezeichnet, lächelnd, die Lage in Indien als hoffnungslos. Er sagt: „Auch bei uns kommt das Thema Weltende durch Nuklearkrieg gelegentlich auf — wir lachen darüber. Obschon, vielleicht wäre eine Atomexplosion die Lösung unseres Bevölkerungsproblems."

Drei Kinos gibt es in der Straße, Tag und Nacht stehen sie Schlange davor. Der Eintritt kostet 5 Rupien (1,40 Mark), so viel wie ein Bordellbesuch. Das Bordell bietet Frucht vor Wirklichkeit für Minuten. Das Kino für Stunden.

10 Uhr vormittags. Wir sagen hallo in einem der besseren Häuser. Es liegt in der Foras Road, einer Seitengasse, in der wir uns durch Kinder, Tiere, Pritschenschläfer und Gruppen von Neugierigen den Weg zu Lalita bahnen. Lalita ist eine gewichtige Frau um die 40, das Urbild der Madam (sprich Mädöm), die alles gut unter Kontrolle hat.

Wie sie drei ihrer auf ihrem mit Seidenschirm ausgelegten Himmelbett, Ohrgehängchen, Hals-, Arm-, Fußgelenke und Zehen mit Goldschmuck für gut und gern 4500 Mark behängt, hat man den Ein-

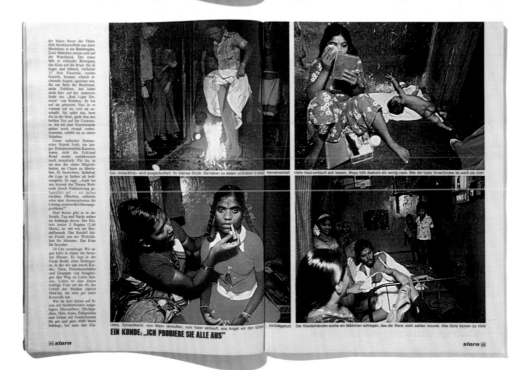

Der »böse Blick« wird ausgelacht. Ihr kleines Glück: Sie haben zu essen und leben in einer Gemeinschaft. Helle Haut verkauft sich besser. Meya hilft deshalb ein wenig nach. Wer der Vater ihres Kindes ist, weiß sie nicht

Lisha, Epileptikerin, vom Mann verstoßen, vom Vater verkauft, aus Angst vor den Göttern zurückgeholt. Der Kleiderhändler wollte ein Mädchen schlagen, das die Ware nicht zahlen konnte. Alle Girls kamen zu Hilfe

EIN KUNDE: „ICH PROBIERE SIE ALLE AUS"

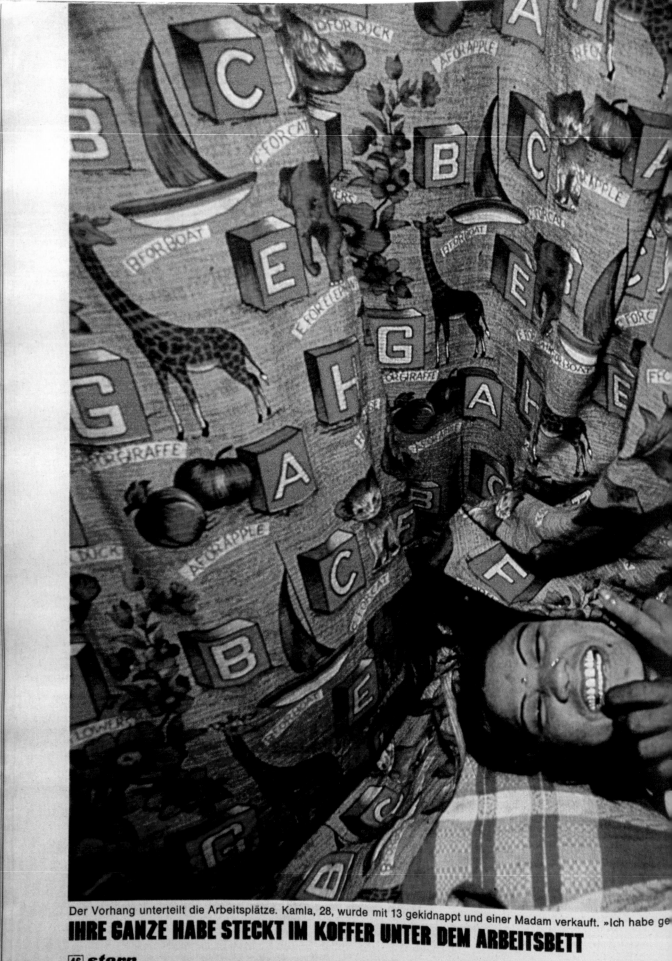

Der Vorhang unterteilt die Arbeitsplätze. Kamla, 28, wurde mit 13 gekidnappt und einer Madam verkauft. »Ich habe ge

IHRE GANZE HABE STECKT IM KOFFER UNTER DEM ARBEITSBETT

nt, aber dann mußte ich Make-up auflegen und anfangen.« Sie hat jetzt einen Freund

druck, daß der Laden läuft. Lalita liebt die hingelagerte Körperhaltung auf Decken und Kissen. Sich nicht bewegen zu müssen bei der Hitze ist nicht nur angenehm. Es gehört auch zu ihrem Status, andere für sich springen zu lassen.

Für Lalita springen zwölf Mädchen. Lalita ist — wie jede gute Madam — herrisch und zugleich mütterlich. Die Mädchen fühlen sich abwechselnd als Sklavin und als Tochter. Die Fotografin Mary Ellen Mark war Zeuge, wie eine 13jährige von einer anderen indischen Madam geschlagen wurde, weil sie von einem Betrunkenen zu wenig Geld genommen hatte. In der Nacht umarmte sie ihre Herrin, massierte ihr den Rükken.

„Wenn ich ein Mädchen schlage", hat jene Herrin gesagt, „muß es fünf Minuten später wieder bei der Arbeit sein. Mit fröhlichem Gesicht."

Zwölf Mädchen zu haben ist viel. Die Norm liegt zwischen drei und zehn, fünf gilt als guter Durchschnitt. Lalitas Mädchen stehen kichernd an der Wand aufgereiht, laufen für Wasser, Tee, Curryreis und Betelspuckschale nach hinten. Die Jüngste mag 15, die Älteste 22 sein, viele wissen ihr Alter selber nicht. Schreiben und lesen kann keine von ihnen (Analphabeten-Rate in Indien: 65 Prozent der Bevölkerung).

Lalitas Mädchen sind die teuersten in dieser armen Gegend. 25 Rupien (7 Mark) kostet hier der Bordellbesuch, 150 Rupien eine ganze Nacht, 300 Rupien das Mieten eines Girls außer Haus. „Manche Kunden", sagt Lalita, „wollen ein Girl nicht für Sex, sondern zum Reden oder fürs Kinogehen. Das kostet 30 Rupien. Aber ich lasse sie nie alleine gehen. Ich schicke immer einen Aufpasser mit."

Lalita läßt ein Tablett mit scharfem Curry bringen und rollt ihn mit flinken Fingern in dünne Brotfladen, aus denen die Soße tropft. Sie schiebt uns die Fladen, da gibt es keine Widerrede, in den Mund. Sie schmecken ausgezeichnet.

20 Kunden hat Lalita täglich, macht 500 Rupien, mindestens. Ein Arbeiter im

Raymond Depardon's career maps the spectrum of photojournalism, from his beginnings as a teenage paparazzo, to becoming a leading international news photographer (and founder of the agency Gamma), to his success as a documentary artist and film-maker. His New York diaries mark a significant break between two phases of his career. Feeling confined by the treadmill of photojournalism within Gamma, he moved to Magnum in 1978. As he sought a new direction, he went to New York for the summer of 1981, as a place to think – as a non-English speaker, he compared the experience to that of being a recluse in the desert. He had the support of a bold assignment, to file his daily observations to *Libération*. Behind the published musings on the street life of the city, in pictures and words, was a soul-searching reflection on his professional role and identity. New York made him see things differently, and it was there that his future path became clear: he would make a film about the Sahara desert and to go back to his parents' farm in France. The desert and the farm became the two major themes of the next 25 years of his work. (8, 9 & 27 July, 5 & 8 August, 1981)

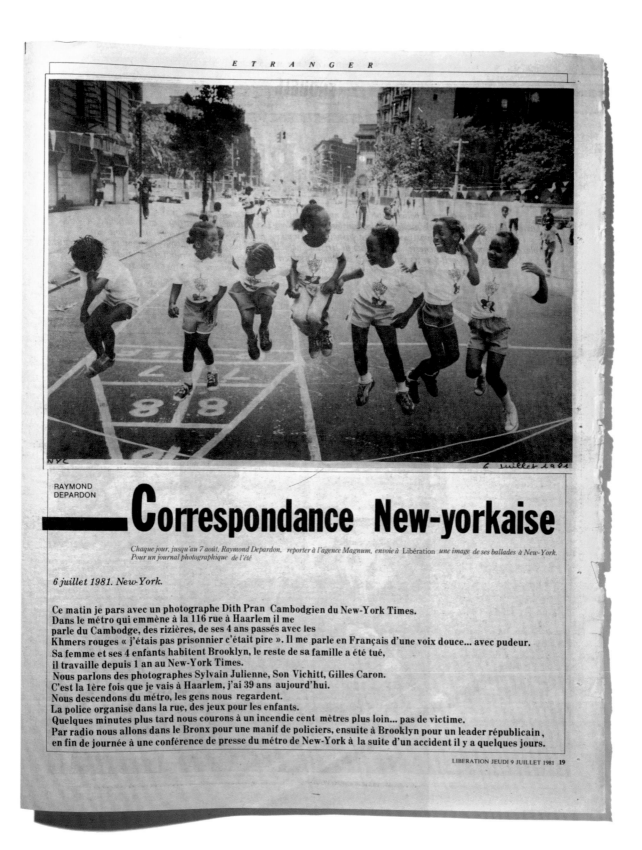

ETRANGER

RAYMOND
DEPARDON

Correspondance New-yorkaise

Chaque jour, jusqu'au 7 août, Raymond Depardon, reporter à l'agence Magnum, envoie à Libération une image de ses ballades à New-York. Pour un journal photographique de l'été

6 juillet 1981. New-York.

Ce matin je pars avec un photographe Dith Pran Cambodgien du New-York Times.
Dans le métro qui emmène à la 116 rue à Haarlem il me
parle du Cambodge, des rizières, de ses 4 ans passés avec les
Khmers rouges « j'étais pas prisonnier c'était pire ». Il me parle en Français d'une voix douce... avec pudeur.
Sa femme et ses 4 enfants habitent Brooklyn, le reste de sa famille a été tué,
il travaille depuis 1 an au New-York Times.
Nous parlons des photographes Sylvain Julienne, Son Vichitt, Gilles Caron.
C'est la 1ère fois que je vais à Haarlem, j'ai 39 ans aujourd'hui.
Nous descendons du métro, les gens nous regardent.
La police organise dans la rue, des jeux pour les enfants.
Quelques minutes plus tard nous courons à un incendie cent mètres plus loin... pas de victime.
Par radio nous allons dans le Bronx pour une manif de policiers, ensuite à Brooklyn pour un leader républicain,
en fin de journée à une conférence de presse du métro de New-York à la suite d'un accident il y a quelques jours.

LIBERATION JEUDI 9 JUILLET 1981 **19**

RAYMOND DEPARDON — Correspondance New-yorkaise

Chaque jour, jusqu'au 7 août, Raymond Depardon, reporter à l'agence Magnum, envoie à Libération une image de ses ballades à New-York. Pour un journal photographique de l'été

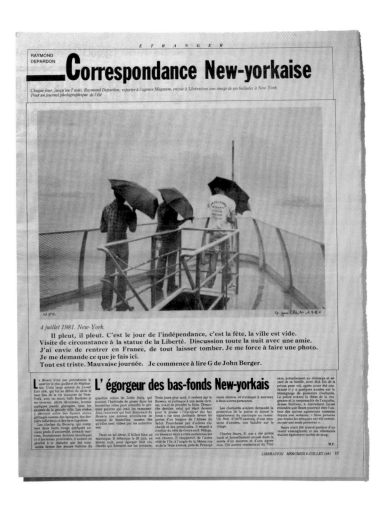

4 juillet 1981. New-York.

Il pleut, il pleut. C'est le jour de l'indépendance, c'est la fête, la ville est vide.
Visite de circonstance à la statue de la Liberté. Discussion toute la nuit avec une amie.
J'ai envie de rentrer en France, de tout laisser tomber. Je me force à faire une photo.
Je me demande ce que je fais ici.
Tout est triste. Mauvaise journée. Je commence à lire G de John Berger.

L' égorgeur des bas-fonds New-yorkais

RAYMOND DEPARDON — Correspondance new-yorkaise

Chaque jour, jusqu'au 7 août, Raymond Depardon, reporter à l'agence Magnum, envoie à Libération une image de ses balades à New York. Pour un journal photographique de l'été

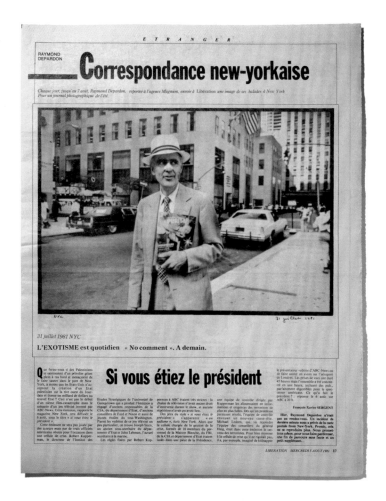

31 juillet 1981 NYC

L'EXOTISME est quotidien « No comment ». A demain.

Si vous étiez le président

François-Xavier SERGENT

RAYMOND DEPARDON — Correspondance new-yorkaise

Chaque jour, jusqu'au 7 août, Raymond Depardon, reporter à l'agence Magnum, envoie à Libération une image de ses balades à New York. Pour un journal photographique de l'été

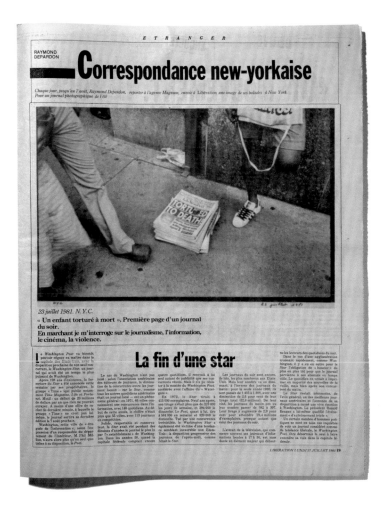

23 juillet 1981. N.Y.C.

« Un enfant torturé à mort ». Première page d'un journal du soir.
En marchant je m'interroge sur le journalisme, l'information, le cinéma, la violence.

La fin d'une star

RAYMOND DEPARDON — Correspondance new-yorkaise

Chaque jour, jusqu'au 7 août, Raymond Depardon, reporter à l'agence Magnum, envoie à Libération une image de ses balades à New York. Pour un journal photographique de l'été

4 Août 1981 N.Y.C. Wall Street: une mine d'or pour les photographes, ici il n'y a pas de vacances !
Je lis dans le New-York Times que la police vient de créer une nouvelle brigade pour la répression de la drogue dans les parcs, les endroits publics, y compris les quartiers d'affaires

Le cousin d'Amérique du monstre du Loch Ness

A.F.P.

Throughout the summer of 1983, Bruce Weber travelled across America with a collapsible tent studio and a crew to photograph around 250 athletes preparing to compete in the upcoming XXIII Summer Olympic games in Los Angeles, for a 90-page portfolio in *Interview*. Weber compared the journey to a rock tour, full of long delays but with moments of great exhilaration. He saw his subjects as beautiful misfits, made different from the rest of us by their talent and drive. He shot them in a style that deliberately recalled the Olympians of 1936 as photographed by Leni Riefenstahl, although perhaps most 1984 viewers would have been more reminded of Weber's advertising photographs for Calvin Klein that dominated public spaces at the time. His advertising, fashion and celebrity portraiture balanced the influence of the prewar avant-garde with a sensual feel-good hedonism. This perfectly matched the iconoclasm of Warhol's *Interview* magazine, which defined a new journalistic territory with its mixing of celebrity gossip, social satire and acute documentary reporting. (January/February 1984)

Carl Lewis
Track & Field

by Carolyn Farb

At 21, Carl Lewis may be the greatest track athlete of all time. A master of the long jump, with a personal best of 28'9", Carl is the only man to have approached Bob Beamon's still unbroken 1968 record of 29'2½". Actually, Carl has cleared over 30', but the jump was disqualified over a much-disputed marginal foot fault.

A phenomenal sprinter, Carl Lewis speeds through 100 meters in 9.96 seconds and covered that distance faster than anyone in history in the final leg of the 4x100 meter relay at last year's Helsinki games. Videotapes show his time to have been an amazing 8.9 seconds.

Carl is also heading towards a record in the 200-meter dash. At the 1983 T.A.C. (The Athletics Congress) meet, the exuberant runner, anticipating his victory, threw his arms up in the air, pulling back slightly as he broke the tape at the finish line. His elation cost him a world record by 1/100th of a second.

A patriotic, born-again Christian, Carl is only one of a family of outstanding athletes, including his younger sister, Carol, the United States women's long jump champion.

Carolyn Farb spoke with Lewis in the library of her Texas home, later continuing the conversation at the University of Houston track where "the best American athlete since Jesse Owens" trains.

CAROLYN FARB: You and Mary Decker are strangely compared to one another.
CARL LEWIS: I think that Mary and I are linked together because we're somewhat unique. I am somehow in a position of following a hero in Jesse Owens and Mary Decker is something of a darling.

CF: How do you train?
CL: I train quite differently, I guess, because I spend two hours a day on it, eleven months a year. I train as a sprinter and a long jumper, so it is a very intricate but very interesting type of workout schedule. I usually work two days a week on my sprinting and two days a week on my jumping. I reserve Fridays for whichever one I didn't do as well in that week.

CF: How do you know when you do well? Is it when your coach says so or is it something you feel?
CL: It's something I feel, basically, because I think when a person does well at anything he tries, he feels a personal satisfaction. They realize they really worked hard for it and it's something they can recognize.

CF: Is there a special way you mentally prepare yourself for a race?
CL: I might be a little more low-key than most. I've never been the kind of person who has had to sit down and ponder the situation to psych myself up. I just feel a confidence in competition that comes from training well and having a good idea of what I'm doing. I have a sense of confidence because I've worked hard and I have a peace of mind and ease about competition so I don't have any secrets or do anything special.

CF: Do you look at your body as if it were a finely tuned machine? Do you have a little mental check-out that you do?
CL: I do in competition. Mainly because regardless of how finely tuned you are and how hard you work and how well you train, you're still going to make mistakes. You have to mentally check yourself and make sure you go over a list of things you must be ready to do—make sure you keep an idea of all the areas you want to stay involved in. That way you can keep the body as finely tuned as possible.

CF: Who encouraged you?

CL: I guess the encouragement came from my parents. They started a sports program in the town where I'm from in New Jersey, and they gave me the opportunity to start in track and field. My sister Carol and I got into the program as the years went by. It wasn't a situation where they pushed. I think they were a little reluctant to get us involved mainly because they were afraid of pushing.

CF: They didn't want you to be disappointed, perhaps.
CL: Exactly. They maybe held us back a little at the beginning, but Carol and I kept pushing and pushing and they just opened up things and let us get involved.

CF: They're both coaches, aren't they?
CL: Yes, they're coaches at rival high schools now. I remember one particular year when a meet was going on and it was very, very close. It came down to two events with my father's team leading by one point, and it just started to pour out of nowhere. They had to postpone the rest of the meet until the following Thursday. We were sitting in the house with my parents as rival coaches. There were no dinners cooked.

CF: How do you spend your free time, or don't you have any?
CL: I don't have a lot and I'm involved in Radio/Television at the University of Houston, so school takes up a lot of my time as well as some of the sports activities I mentioned earlier. Then just doing little tidbits here and there—I advertise for Xerox of Japan and BMW of America so that keeps me very busy and little things I do—speaking engagements and interviews like this one today—and I'm involved with muscular dystrophy...millions of things.

CF: Do you speak before many different groups?
CL: Yes. I've spoken before all types of groups and banquets and I'm also involved in Christian organizations.

CF: Do you have a lot of fan worship?
CL: I do and I think one thing is that I come from a typical situation. I was in sports at a very young age. Most people say that if you start at six or seven you burn out and your parents push you too hard. I was in that type of program and I went from nowhere to where I am right now. Until high school I was a small athlete, scrawny and a late bloomer. By being that way, I was able to see both sides of the coin. My sister was somewhat different. She was always out in the front, always won, always the best. I was totally the opposite. I think I was rather typical in that respect, and that's how people can relate to me—I always let my personality show.

CF: Your coaches speak very highly of you and say you're very easy to know and you'd be good at anything you did. Coach Doolittle described you as an "artist"—how do you react to that comment?
CL: Of course, I take it as a compliment because anyone who is respected must have a tremendous amount of confidence to do anything active as well as a lot of discipline and a lot of concentration. So I respect them very much—I've been here four years training under them and always gotten along very well with them. To hear the comments that they've made is very encouraging.

CF: What is the difference between a sprinter and a long distance runner?
CL: One difference, of course, is stamina—sprinters are just not born with the stamina. There are different types of muscle fibers in the body called "fast twitch" and "slow twitch." Fast twitch are sprint type of fibers where you get strength, quickness: football players, track and basketball athletes, have them. Slow twitch are distance runners, swimmers in most cases, and others areas that require long distance and endurance type of training. That's one difference. It also takes different types of minds. Distance runners work hard in one aspect—they work harder hours because they go out and do distance runs and a track workout which is very tough. Sprinters come out and have a short workout, which is very tough as well, because it's very fast but it's difficult. I think the main difference is they're born with different types of muscle fibers.

CF: Is there something spiritual that makes you project?
CL: Yes, I think so. I am a very strong Christian, number one, and I think that one thing has helped me. I've only been a born again Christian three years, and it has given me peace of mind. Now I know that everything I do to the best of my ability is all I can do. The Lord has given me a talent in the area of track and field as well as other areas, and there's always improvement regardless of how old or young you are. As long as you let your personality show and try your best to improve and realize that the Lord is our main Being, giving us the strength to do it, I feel a lot more confident in my competition.

CF: Your sister, Carol, is an outstanding athlete. Is she a long jumper? Has she ever placed in 100-meter hurdling?
CL: Carol mainly dabbles with the hurdles just to have something else to do. She hasn't competed in any major hurdle competitions, but in the long jump, of course, she's been the national champion and was third in the World Championships, so she's really excelled. When there's nothing else to do, she may hurdle. When she competes for the University, she runs a conference meet, in the hurdles, but she doesn't like them that much. She just likes something to do and it is an event closely related to the long jump.

CF: Did she make the Olympic team?
CL: She made the Olympic team in 1980—she was the youngest member at 16.

CF: I understand you have other interests—that you collect crystal and silver.
CL: Yes. I've been to Europe eight times and the idea of crystal always intrigued me. Three years ago I went with my agent; he has always collected crystal and fine wines, so one year we went out looking at crystal. It was interesting to see the ideas in crystal glass, so from that point on I started getting different pieces and reading up on it and learning about the different ideas. I graduated into silver and it's been an interesting hobby because I get to go to Europe so frequently. I've had a good time.

CF: When you come home it's like your refuge from the world.
CL: Exactly.

CF: How do you handle pressure at your level of competition?
CL: I guess it all goes back to confidence. I go into a competition and since I have a clear idea of competing at a certain level and in a certain area, then I'm going to be at the top of the ball game with the best people. Since I've been number one I go as hard as anyone else.

CF: To make sure you keep your goals or meet even higher ones?
CL: Yes. Two years ago I was number one in the world, and if I had run the exact same times, I would probably have been third or fourth in the 100 meters and second in the long jump. People are coming as fast as I'm going, so I have to be a little bit faster. It's like a cycle. The person who gets to the top must keep improving and when they get to a point or an age where they can't improve anymore, then they step down and someone else comes up from behind. It always works that way.

CF: It works both ways and you have to protect yourself in a certain way. The N.C.A.A. rule does not permit funding but now isn't it legal to receive funding in a trust through The Athletics Congress?
CL: That's correct. The N.C.A.A. rule prohibits strongly and strictly an athlete making any type of money, so an athlete like myself, let's say I was on a scholarship, would be getting x number of dollars in scholarship money. Let's say I stay in the dorms. My room and board and tuition are paid for and I get $20 a month to live on. That's what a typical full-scholarship athlete gets. If I were to decide I wanted to go out and get a part-time job—say my season is during the spring and I wanted a part-time job and a friend would give me a job to work September, October, November and December for the off season—well that's not allowed under the N.C.A.A. rules because they say you're earning money under the University so you're not allowed to make any money yourself. The Athletics Congress is the governing body of track and field, controlling the N.C.A.A., and they allow advertising and basically anything a professional can do—even prize money at certain track meets now. But it has to go into a trust fund.

CF: So T.A.C. is more directly related to the running community?
CL: Yes, the running community in amateur athletics. The N.C.A.A. does not allow you to make any money outside of the tuition, room and board and $20 a month the university pays you. That's why there's so many problems with collegiate athletes. Like in football they have a system where the N.F.L. cannot intrude into the collegiate system. But now the players are saying, "How can we live for four years on a simple scholarship?" Track and field athletes did not have that problem before because track and field were not making any money. Now that they're getting attention and starting to make money there's a problem. So athletes are starting to leave universities and run amateur. Once they're where they could be world class, they may leave track and field and join basketball. They're starting to become younger and younger, and now football is going to start so the N.C.A.A. is going to have to change their rules or they'll lose too many athletes.

CF: I was going to ask you about the recent steroid controversy.
CL: I think the philosophy I have is that, when I was young, I was exposed to steroids, that is I'd heard about them. When I was out of high school I heard that they were testing for steroids and I said, "What is this?" The coach told me that, in my event, it didn't make much of a difference. They might make you stronger or a little bit faster, but the person who is doing things correctly is going to beat a person on drugs who is doing it incorrectly. If you make mistakes, you might be a little bit stronger, but you're going to make mistakes anyway. I don't necessarily believe in them because I don't think they help that much. But, as I stated before, if someone decides to take steroids or any drug, that is their responsibility. I don't think it's right or good but....

CF: You're not sitting in judgement.
CL: Exactly. Anyone can do what they want to do. Who am I to judge?

86

Bob Roggy

Track & Field

Greg Foster

Linda Karecki

Jane Frederick

Track & Field

Andre Phillips

Greg Louganis
Diving

by Scott Cohen

In international diving competition, there are only two events: three-meter springboard and ten-meter platform. There are 21 dives in a meet, representing six diving directions: front, back, reverse, inward, twister and arm stand (ten-meter platform only). Nine judges rate a dive on a scale of one to ten. The two highest and lowest scores are thrown out, the remaining five added together, multiplied by three and then multiplied by the dive's degree of difficulty, which ranges from 1.0 to 3.5. The product is the score of the dive.

World championship diver Greg Louganis, who at 23 has already won the championship a half-dozen times, balances on the edge of the ten-meter platform, approximately 33 feet above the pool, about to perform the tricky reverse three-and-a-half. The degree of difficulty is 3.4. Later he'll do the same dive on the three-meter springboard, where the degree of difficulty is the maximum 3.5, about as difficult as a dive gets.

GREG LOUGANIS: The reverse three-and-a-half is a dive where you start off going forward, but you're spinning backwards towards the platform, not towards the sky. I count myself off: one, two, three, go. I jump, reach back towards the tower, bring my legs up as quick as I can and come around until I see water. Then I throw my head back again and do another tumblesault, then another. I'll see water, water, water and then I kick. The difference between a dive on the ten-meter platform and the three-meter springboard is the springboard, which is exactly what it says it is. It goes up and down and you use that to elevate yourself into the air. My approach on the springboard consists of five steps and a hurdle. Your balance has to be just right, but it's not going to be right every time. It's going to vary from pool to pool and from competition to competition. That's why no competition is ever the same. You're not going to hit the mark every time, but you're going to try and hit it. The board is a factor. The board goes up and down, but your weight's going to be different and you have to compensate for it. That's why you practice. The platform is more consistent. You're ten meters above the water, you're on a solid concrete structure and that thing's not going to move. You make your adjustments, but they're not going to be as great as on your springboard.

SCOTT COHEN: *Do you still hear the board vibrating after you leave it and go into your dive?*

GL: When I go into my hurdle, I'll push off with my left leg, my right leg up, to try to get the board moving. Then I hear the board beat twice against the fulcrum. Then I'm landing back on the board, to be able to push off into the air and get my dive. I know, by listening to the board, whether I'm going to be in or out of time with the board, so I can compensate accordingly. I don't hear the board after I'm in the air, because after I'm in the air there's nothing more I can do. I'm committed.

SC: *Does it feel better to hit the water head or feet first?*

GL: Your legs are stronger than your arms, so it's probably easier to come in feet first. It's easier on your body. What happens when you go into the water is you create a bubble at the point of impact and the way to get in, without any splashes, is to drop into that bubble before it closes up.

SC: *What does the pool look like from ten meters up?*

GL: When you're standing ten meters, or approximately 33 feet above the water, you don't see 33 feet, you see 50 feet, because the pool is about 17 feet deep and you see the bottom of the pool and not the surface of the water. When you first get up there, it's pretty terrifying because you're seeing 50 feet above where you may be going.

SC: *Are you afraid of heights?*

GL: Not as long as I have water underneath me. I wouldn't like to be on a scaffold, working in construction or anything. I'm not real phobic about it, but I am uneasy. You look off a cliff or a tall building, you really have to catch yourself from jumping. Have you ever experienced that, when you're looking off a cliff, you really have to hold yourself back, that you have this great desire to jump?

SC: *I'm so afraid that I'm going to jump that I want to jump just to get it over with.*

What is the view you see from up there?

GL: In Caracas, you see all these cardboard houses. Not cardboard, but comparable with cardboard. Mission Viejo is well-landscaped. You've got grass and it's real hilly, with trees in the distance.

SC: *Do you have to be in shape just to climb up the ladder?*

GL: It takes a lot out of you just to climb up. After you're up there you want to rest awhile before diving. Sometimes there will be up to five divers on the platform.

SC: *You talk to each other?*

GL: You talk about your next dive, what you want to accomplish. Basically you're talking shop.

SC: *Do you use the same 21 dives over and over again?*

GL: I have a set group of dives that I do. There's been quite a number of dives that have been added into the rule book as of last year, so I'm doing some of the new dives, too.

SC: *You don't create new dives?*

GL: No. It's a safety factor in our sport that new dives are put on probation for usually one year, to make sure the dive can be done safely.

SC: *Doesn't that rule inhibit your creativity?*

GL: No.

SC: *You just perfect the dives already there?*

GL: Yes.

SC: *Have you ever dived off the cliffs at Acapulco?*

GL: No. Quite honestly, I think it's pretty stupid. I'd never get up there. It's not very safe, number one, and why take your life in your own hands when you don't know what's down there? They have different standards of diving. It is more spectacular. What I want to bring to diving is more grace.

SC: *Are you a good dancer?*

GL: Yeah. I've studied jazz, tap and ballet.

SC: *Do tall, thin divers with long legs score more points?*

GL: That varies with the judges. I like a long, sleek line, like Jennifer Chandler or Michelle Mitchel. Michelle's short, but she has a real sleek line. Dave Burgering's a real pretty diver. A longer line will definitely accentuate your graceful features. If you have them. I like to think I have them, but I don't know if I do.

SC: *Do you prefer the three-meter springboard or the ten-meter platform?*

GL: Three-meter is more of a challenge. It's not more difficult, but the ten-meter's a lot more exciting, simply because of the height.

SC: *Do you find your spot on the diving board with your eyes or toes?*

GL: You know exactly where it is, without looking, because you take off from that same spot every time.

SC: *Can your feet tell by the feel of the board what spot you're in?*

GL: They don't have to. Boards are usually the same length. The surface isn't necessarily always the same, it's just a non-skid surface. When you're competing at a pool you're familiar with, of course, you're going to feel more at ease. You're going to be used to the board. When you go to a competition at another pool, you're not used to the boards, and you have to get used to them—each one is different. It's just not the feeling in your feet that is different, it's your body bouncing on the board. It's not just the feet doing the work.

SC: *When you get a good spring and come off the board, isn't it anticlimactic to come down?*

GL: That all depends upon whether you hit the dive or not. I like to keep my feet on the ground. □

66

Kurt Wienants - *Swimming*

64

Paige Zemina - *Swimming*

65

Peruvian photographer Vera Lentz photographed Peru's internal conflict – between the Shining Path, other revolutionary groups and the government's counter-insurgency forces – from the early 1980s, seeking to document some of the rarely reported civilian atrocities. Her photographs-as-evidence are examples of a particularly brave campaigning journalism; working as a photojournalist here was intrinsically dangerous, with those enquiring into government-sponsored atrocities regularly joining the lists of the murdered or missing. Her story, published anonymously and modestly in the German magazine *Konkret*, investigates a massacre that took place in Soccos, in the Ayacucho region of the Andes, showing the excavation of the mass grave of 34 members of an Indian family gunned down during a wedding celebration. Eleven members of the Civil Guard were later convicted of their murder. With the end of the civil war, Lentz became a leader within the Movement for Truth and Reconciliation; a Commission was established in 2002, after which these photographs were finally exhibited and published within Peru. (3 March 1984)

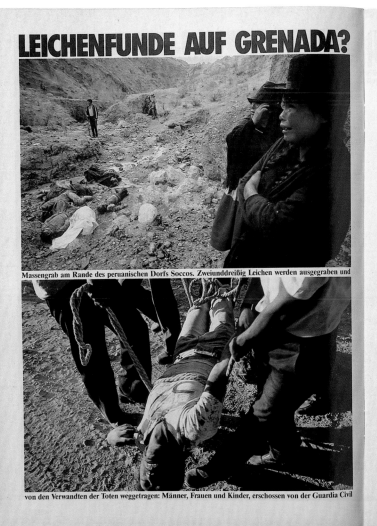

LEICHENFUNDE AUF GRENADA?

Massengrab am Rande des peruanischen Dorfs Soccos. Zweiunddreißig Leichen werden ausgegraben und

von den Verwandten der Toten weggetragen: Männer, Frauen und Kinder, erschossen von der Guardia Civil

Erinnern Sie sich an die ersten Meldungen nach dem Überfall auf Grenada, die US-Marines hätten Massengräber entdeckt? Es ist bis heute unbekannt, wer diese Lüge in die Welt gesetzt hat. Warum sie geboren und von amerikanischen Journalisten für wahr gehalten werden konnte, erklären diese Bilder. Sie stammen aus einem jener Staaten Lateinamerikas, mit deren Regierung die USA einverstanden sind: Peru.

Am Abend des 13. November feierte eine indianische Familie in dem peruanischen Dorf Soccos ein Yaycupacu, eine Verlobungsfeier. Plötzlich erschien eine Gruppe Sinchis, Polizisten der Guardia Civil. Am Tag zuvor hatten die Polizisten den Indios ein Rind gestohlen und es geschlachtet. Nun luden sie bei den Bestohlenen zum Feiern ein.

Als die unfreiwilligen Gastgeber es wagten, über den Viehdiebstahl zu sprechen, war die Feier zu Ende. Mit vorgehaltenem Gewehr trieben die Polizisten die Gäste aus dem Haus. Männer, Frauen und Kinder. Zunächst gings zum Hauptquartier der Polizei auf dem Dorfplatz. Dort wurden den Männern und Frauen Handfesseln angelegt. Dann wurden sie vors Dorf getrieben. Für einige Zeit wurden Männer und Frauen getrennt. Was in dieser Zeit mit den Frauen geschah, ist unbekannt. Schließlich trieb die Polizei wieder alle zusammen, zweiunddreißig Menschen.

Sechs Tage später, am 19. November, erschien ein Untersuchungsrichter am Ort der Tat. Es dauerte fünf Stunden, bis alle zweiunddreißig Leichen ausgegraben waren. Alle waren zuerst erschossen und dann zugeschüttet worden.

Die erste Leiche, die gefunden wurde, war die einer jungen Frau mit ihrem sechs Monate alten Kind, das sie auf dem Rücken getragen hatte. Die Ärzte begannen mit der Autopsie, Verwandte der Toten trugen die Leichen in Tüchern ins Dorf. Eine der letzten Toten, die gefunden wurden, war eine schwangere Frau im achten Monat. Die Kugel, die die Mutter tötete, hatte auch den Foetus getroffen. Es wäre ein Mädchen geworden. Requiescat in pace americana. ■

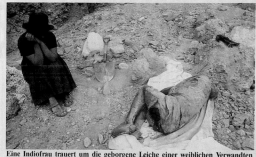

Eine Indiofrau trauert um die geborgene Leiche einer weiblichen Verwandten

Ärzte mit einem acht Monate alten Foetus, der im Mutterleib erschossen wurde

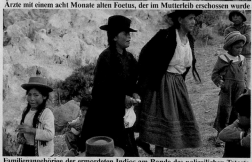

Familienangehörige der ermordeten Indios am Rande des polizeilichen Tatorts

Raghu Rai began work as a photojournalist in the mid-1960s on the staff of the New Delhi paper the *Statesman*, and established his reputation as India's foremost current affairs photographer in the following decade. It was while director of photography at *India Today*, the leading news weekly published in English and Hindi, that it fell to Rai to address the massive explosion at the Union Carbide chemical plant in Bhopal on the night of 3 December 1984. He arrived in the city at daylight on the following morning, before the enormity of the disaster had become clear. Lethal toxic gas had filled the city, killing 3,800 people immediately, with thousands more permanently injured. Rai witnessed the chaos of the first response to tragedy, with hospitals crammed with sick and dying, and rescue workers grimly searching the rubble and gathering the dead for burial and cremation. His methodical coverage balanced heartbreaking details with panoramas conveying the scale of the disaster which *India Today* ran throughout the magazine between its text commentaries and analysis. Rai's photographs have become the documents of record, and tools in the ongoing campaign for compensation for Bhopal's victims. (31 December 1984)

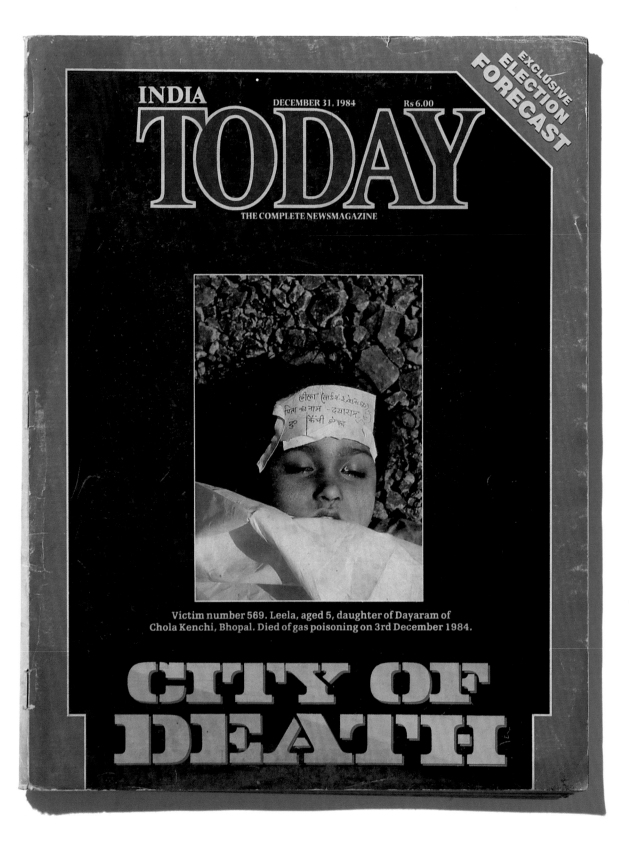

BHOPAL

CITY OF DEATH

SAYED KHAN, resident of a one-room tenement in Bhopal's Jayaprakash Nagar, had come home from a film show at 12:30 that night. "I'd just got into bed," he recalled, "when my eyes started to hurt, as if someone had flung chillies into a fire." He went out to investigate but his irritation got worse, and the last thing he remembers of his family, before he fled, frightened out of his wits, towards new Bhopal is all of them coughing, sputtering and vomiting.

ZAHEER AHMAD, whose compact jhuggi is just across the road from the Union Carbide factory on Bhopal's outskirts, was on duty as a watchman at the military recruitment centre. When he returned shortly after 6:00, his home stood unlocked, and inside lay the bodies of his wife and two sons, 13 and 9. Only a daughter, Shabnambee, 8, and his eldest son, Raeez, 16, survived.

M.L. GARG, retired brigadier and general manager of the paper factory, Straw Products Ltd, was asleep that night when the telephone rang at 1:15 a.m. It was the factory calling to say four people had fainted. "We are suffocating, sir," the voice said. Just then, Garg recalls, his eyes began to water and he himself felt suffocated. The windows of his home were open and he soon saw a "yellowish gas" waft in. "I then realised it was a very serious matter," he said, and ordered his factory closed and evacuated.

SHEZAD KHAN, a tanker driver aged 30, too was asleep with his wife and four young daughters in Jayaprakash Nagar which also borders the factory. *"Main jaga aur ankhon mein ek dam jalan mahsoos hui, jaise ki koi nazar utaar raha ho,"* he said. (He awoke, his eyes smarting, as if someone had flung chillies into a fire to ward off the evil eye.) In blind panic, Shezad fled from his room. He can't explain why, but he jumped onto the first passing vehicle and was deposited some 40 kms away at Kurawal. It was the last time he saw his family alive.

RAM SEWAK PIASI was luckier because he works in Bijawar near Khajuraho. The news of the gas leak from the Union Carbide plant alarmed him because he knew his brother and his family lived in Chola Kenchi next to the factory. Catching the first train to the state capital, Ram Sewak reached his brother's home 48 hours after everyone had fled from it. It took him five days to find his sister-in-law and niece in Hamidia Hospital. And he didn't learn of the fate of his brother and two nephews until the authorities pasted pictures of the unidentified dead all over the city.

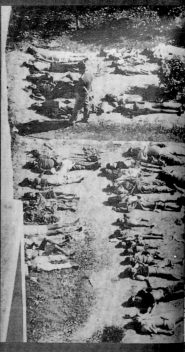
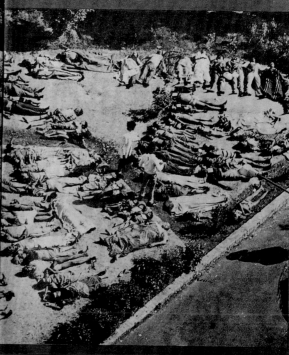

ASHOK CHADHA

RAGHU RAI

A caring hand brushes dirt from the unseeing eyes of a baby being buried

Bureau of Investigation (CBI) wanted to take a sample of MIC from tank 610 for its investigations all that it was able to get was vapour.

It wasn't just Union Carbide where systems had broken down. No administration could possibly have coped with what was happening that night. At least 1,00,000 people living in the vicinity of the factory had fled their homes. Bhopal's rudimentary public transport, even when it was pressed into service, was in no shape to cope. Said Garg: "I didn't see any official help coming that night with the exception of the army." The popular anger was fuelled by news that many ministers and officials had fled town with their families in government vehicles. Said Puri: "The anger is understandable, but the police did press into service whatever vans and trucks were available, and took people out of Bhopal. But don't forget, at that point we ourselves didn't know the nature of the gas leak."

While it is true that the magnitude of the tragedy was awesome, it nevertheless exposed the state government machinery: its centralisation, lack of initiative and collapse under stress. This was particularly evident in the first few days of the disaster. True, individuals within the administration worked themselves to their physical limits but all was on a piece-meal basis with no overall planning. The first coordination meeting of secretaries and heads of departments was called only on the night of December 4, more than 40 hours later.

Initially, the doctors didn't know quite what to do. It was a mad rush to simply keep track of what was happening and administer first aid, and dispose of the dead who were brought in increasing numbers from early that night, as one doctor recalls. Common complaints included irritation in the eyes, nausea and vomiting, chest pains, difficulty in breathing. When patients in their tens of thousands started streaming into Bhopal's hospitals one doctor said, "We are dealing with something that is quite unknown." There was no precedent. All that is known is that MIC destroys the lung tissue leading to pulmo-

nary oedema, or an accumulation of fluids. The victim, in effect, drowns. Dr. N.R. Bhandari, superintendent of the Hamidia Medical College and Hospital, said that if lung tissue was destroyed, death occurred in a matter of minutes. But others died of subsequent complications including anoxia, or insufficient oxygen to the blood, and cardiac arrest brought upon by the weakening of the pulmonary system.

Doctors were able to treat other symptoms—difficulty in breathing and

Bleeding and fatigued by sorrow and pain, an old victim suffers alone

burning eyes—using bronchodilators, steroids and eye medicines.

There was no shortage of medicines, says Nagoo, because there were enough eye medicines stocked under the national programme to combat blindness. But there was a shortage of oxygen—some cylinders came from the Bharat Heavy Electricals Ltd unit and some was brought from Delhi in a pressurised AN 32 of the air force. There was a terrible shortage of hospital beds: some 50,000 patients passed through Bhopal's seven hospitals.

Hamidia Medical College and Hospital pitched scores of tents to accommodate the 2,500 patients who clamoured for its 750 beds. Jayaprakash Hospital's 125 beds were unequal to the task of treating a total of 12,000 patients who passed through its doors for treatment.

And, there was a shortage of doctors. Nagoo estimates that in addition to Bhopal's 350-400 doctors and 150 interns, at least another 250 doctors came to the city from other parts of the state and country. Toxicologists and experts were

sent by the World Health Organisation while the Centre despatched a high powered team led by Dr S. R. Saxena of Safdarjang Hospital. Saxena said that two irritants appeared to have been at work. "The reaction to one came within a couple of hours and to the other after a passage of 48 to 72 hours," he said. This could be medical evidence of the existence of phosgene in the MIC vapours but Saxena wouldn't comment. But INDIA TODAY has learnt that MIC is stored to a purity of 99.5 per cent and that upto 0.1 per cent of phosgene, which was used in World War I to annihilate tens of thousands of soldiers, is permitted as an impur-

235

DIE ZEITSCHRIFT DER KULTUR

Heft Nr. 11
November 1992

du

Burma 1992.
Eine Reportage

The twentieth century seems to come to an early close with the fall of the Berlin Wall, the end of Apartheid, and the handshake of Yitzhak Rabin and Yasser Arafat on the White House lawn. As the Soviet Union dissolves, a new and better post-Cold War order is proclaimed. New democracies arising out of the embers of Communism give cause for optimism, but are short-lived as the world descends rapidly into new wars and revived ethnic conflicts. Chinese students launch a democratic revolution on live television – and are shot down. Croatia's war of independence against the Yugoslav state signals the start of ten years of brutal conflict in the Balkans. An American-led assault on Iraq following Saddam Hussein's invasion of Kuwait demonstrates a new generation of technological weaponry and a new style of media war. Mass ethnic violence erupts in Rwanda, exposing as hollow the slogan that the world would 'never again' allow genocide to take place while it watched. A colossal famine ravages Africa's Sahel. The turning of world events seems to offer photojournalists a myriad of storylines, with more magazines filling more pages with more stories than ever. But the media's focus is moving steadily away from uncomfortable subjects, into the cosy retreat of celebrity chat. Along with rapid technological change, shrinking magazine budgets and the beginning of consolidations and closures in the industry, photojournalists face a new order of their own. But Sebastião Salgado becomes photojournalism's first global star, offering his peers a new model for engagement.

FRANK FOURNIER *Contact Press Images*
Twelve-year-old Omayra Sanchez trapped in the debris caused by the eruption of Nevado del Ruíz volcano. After sixty hours she eventually lost consciousness and died of a heart attack. Armero, Colombia, 16 November 1985. World Press Photo of the Year 1985

CHARLIE COLE *Newsweek*
Demonstrator confronts a line of People's Liberation Army tanks during Tiananmen Square demonstrations for democratic reform. Beijing, China, 4 June 1989. World Press Photo of the Year 1989

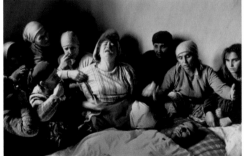

GEORGES MERILLON *Gamma*
Family and neighbours mourn the death of Elshani Nashim (27), killed during an Albanian nationalist protest against the Yugoslav government's decision to abolish the autonomy of Kosovo. Nogovac, Kosovo, 28 January 1990. World Press Photo of the Year 1990

DAVID TURNLEY *Black Star/Detroit Free Press*
US Sergeant Ken Kozakiewicz mourns the death of fellow soldier Andy Alaniz, a victim of friendly fire on the final day of fighting in the Gulf War. Iraq, February 1991. World Press Photo of the Year 1991

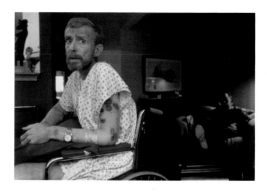

ALON REININGER *Contact Press Images*
Ken Meeks' skin is marked with lesions caused by Aids-related Kaposi's Sarcoma. San Francisco, USA, September 1986. World Press Photo of the Year 1986

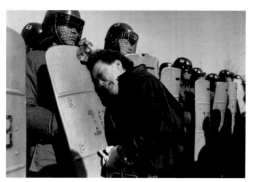

ANTHONY SUAU *Black Star*
A mother pleads with the riot police after her son is arrested at a demonstration accusing the government of fraud in the presidential election. Kuro, South Korea, 18 December 1987. World Press Photo of the Year 1987

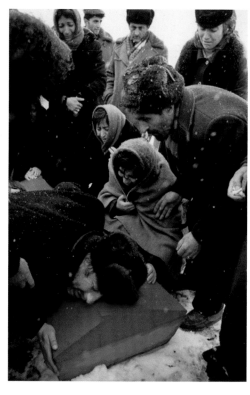

DAVID TURNLEY *Black Star/Detroit Free Press*
Boris Abgarzian grieves for his 17-year-old son, victim of the Armenian earthquake. Leninakan, USSR, December 1988. World Press Photo of the Year 1988

JAMES NACHTWEY *Magnum Photos/Libération*
Mother lifts up the body of her child, a famine victim, to bring it to the grave. Bardera, Somalia, November 1992. World Press Photo of the Year 1992

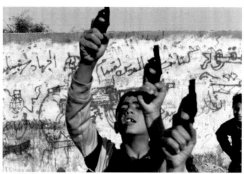

LARRY TOWELL *Magnum Photos*
Gaza City, Palestinian Territories, March 1993. Palestinian boys raise their toy guns in a defiant gesture. World Press Photo of the Year 1993

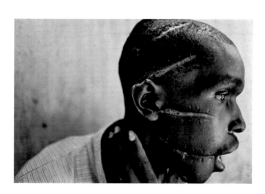

JAMES NACHTWEY *Magnum Photos/Time*
Hutu man mutilated by the Hutu 'Interahamwe' militia, who suspected him of sympathizing with the Tutsi rebels. Rwanda, June 1994. World Press Photo of the Year 1994

Sebastião Salgado first came to the Sahel in 1984 to make photographs for Médecins Sans Frontières (who were bringing world attention to the refugee crisis in the Horn of Africa), and for *Libération*. Over 2.5 million refugees had left homes in Chad, Ethiopia, Mali, southern Sudan and northern Somalia in order to escape the combined effects of drought and local unrest, and in the course of Salgado's coverage, the situation worsened into a severe famine. Already a highly regarded current affairs photographer, it was with this project that Salgado found a new ambition in his work and developed his signature style – what Christian Caujolle, then *Libération*'s picture editor, has called 'epic … almost biblical' in its employment of majestic compositions to convey great human suffering. Salgado's emblematic images were suited to *Libération*; although rough newsprint could not easily render minute detail, the tabloid format and the newspaper's graphic sophistication gave them power and authority. His work aroused controversy – some critics argued that his gorgeous aesthetic was inappropriate for the subject matter, inducing passive admiration in his viewers rather than enlightenment or action. Popular response has been quite different – the images drew large, enthusiastic audiences wherever they appeared. (24 January, 16 April & 21 August 1985)

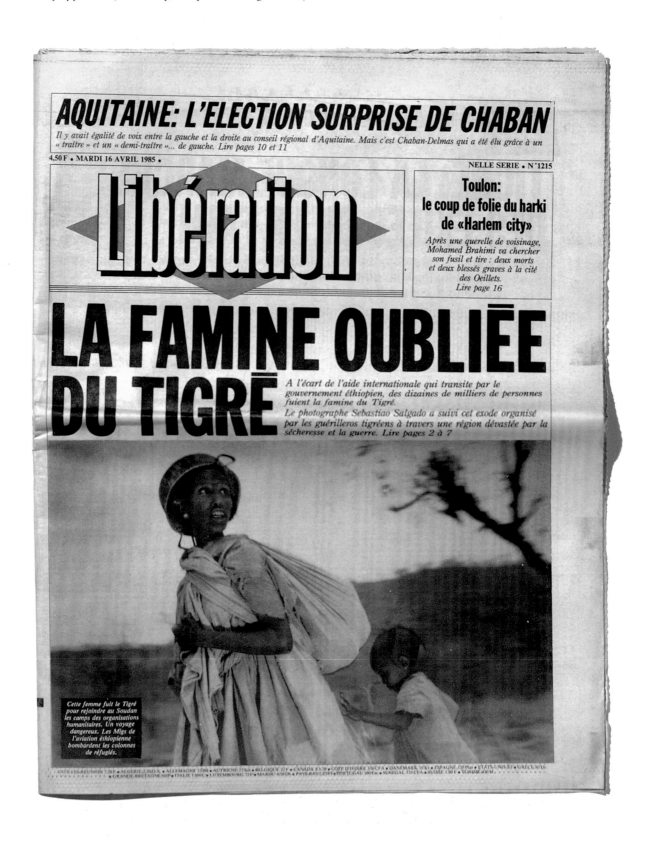

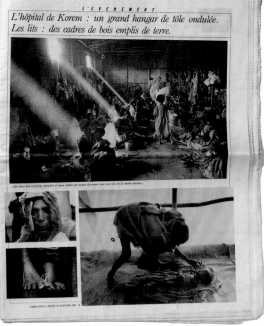
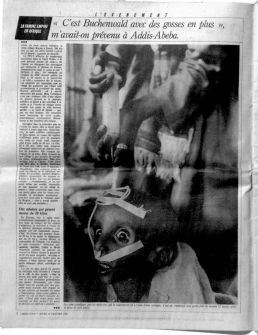

LA FAMINE EMPIRE EN AFRIQUE

« C'est Buchenwald avec des gosses en plus », m'avait-on prévenu à Addis-Abeba.

L'hôpital de Korem : un grand hangar de tôle ondulée. Les lits : des cadres de bois emplis de terre.

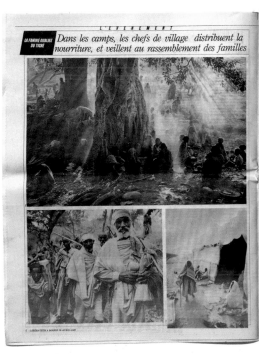
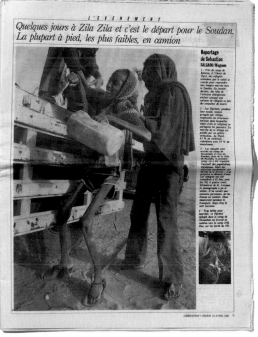

LA FAMINE OUBLIEE DU TIGRE

Dans les camps, les chefs de village distribuent la nourriture, et veillent au rassemblement des familles

Quelques jours à Zila Zila et c'est le départ pour le Soudan. La plupart à pied, les plus faibles, en camion

Reportage de Sebastiao SALGADO/Magnum

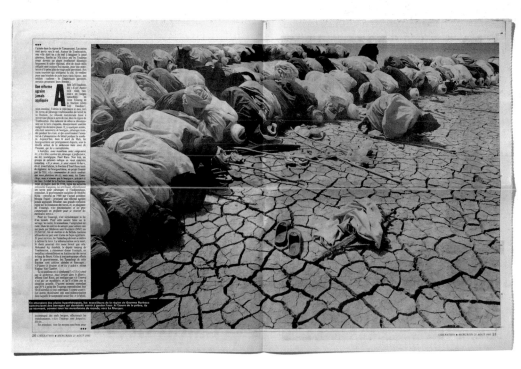

Five years after the start of the Iran Iraq War, *Libération* commissioned a photo essay from Iranian Paris-based photographers Reza and Manoocher Deghati. (The brothers' dissident activities inside Iran led them to work under their first names only.) Rather than engage with the geopolitics of the region, their reportage looks at events from the viewpoint of the individual soldiers and their families. This is war reporting from a distinctly contemporary perspective – the photographers have not flown in to cover the action as detached voyeurs but understand the language and culture of the area and are engaged with its issues on personal terms. At a time when the West viewed the Iranian religious revolution with deep suspicion, and treated the whole inaccessible region as an oriental mystery, *Libération*'s approach was both brave and practical. Twenty years later, in 2001, Reza and Manoocher established Aina, a photo agency and school in Kabul to train Afghan photojournalists to tell their own stories, to give 'local actors access to new technologies [and to promote] the emergence of independent media … where democracy is still fragile'. (14 February 1985)

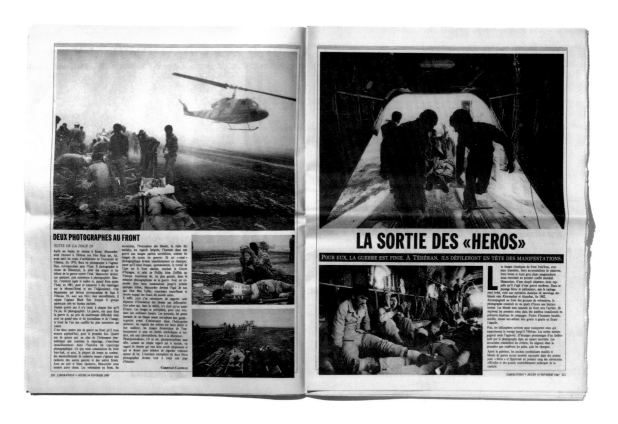

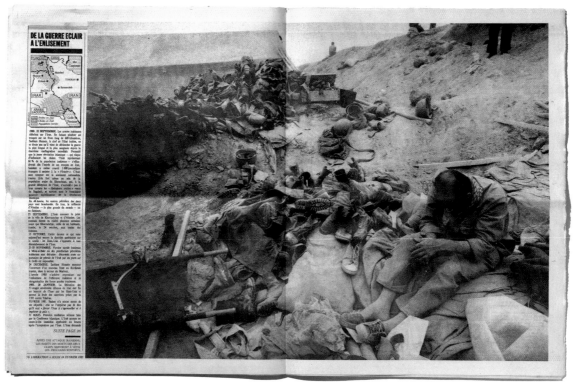

Much is made of the fact that Brazilian-born Sebastião Salgado trained and worked as an economist before becoming a photographer in 1973. And with good reason: his survey of 'Workers' around the world – of which 'Serra Pelada' was the first instalment – is dramatic visual evidence of a global economy dependent on cheap raw materials and cheap labour. His depiction of the open cast strip mining of Bald Mountain, in the heart of the Amazon, offered access to a complex story about local and national politics, ecological damage, world bullion markets, debt repayment and the relations of freelance prospectors to the large mining companies. The photographs seared into the public imagination, inviting comparisons with Hieronymus Bosch's and Dante's visions of hell, and the story's publication around the world (first in the *Sunday Times* magazine) made Salgado the era's first global star of photojournalism, helping to renew public interest in photojournalism generally. Also, the manner in which he developed and marketed the 'Workers' project thereafter, with each instalment a chapter within his broader story and the whole made available within multi-chapter magazine contracts, offered independent photojournalists a new model of practice that was widely imitated. (24 May 1987)

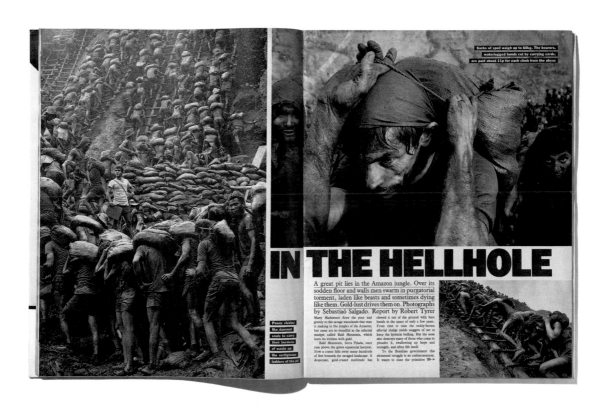

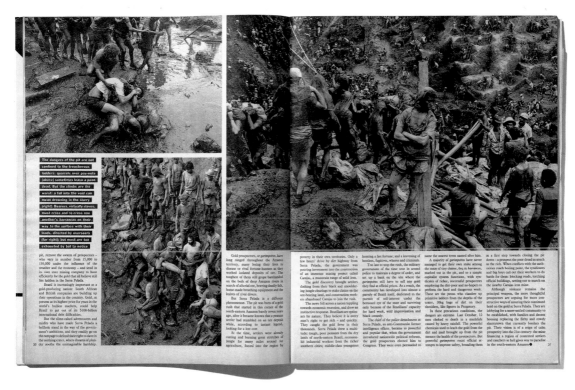

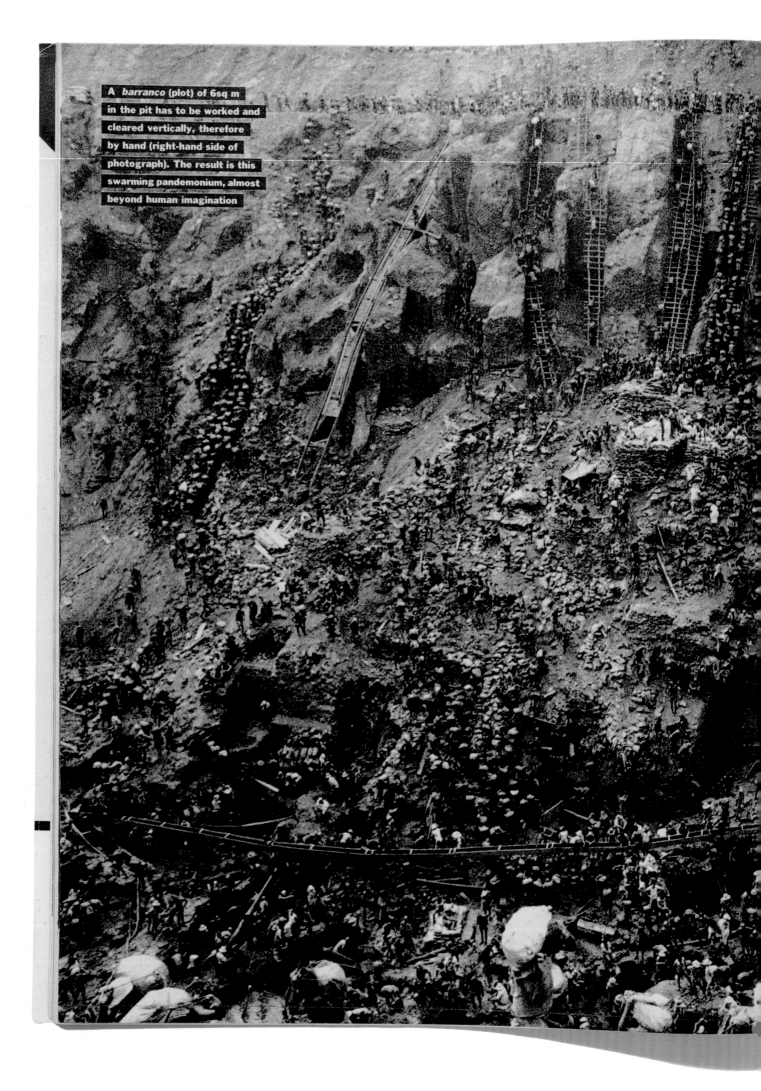

A *barranco* (plot) of 6sq m in the pit has to be worked and cleared vertically, therefore by hand (right-hand side of photograph). The result is this swarming pandemonium, almost beyond human imagination

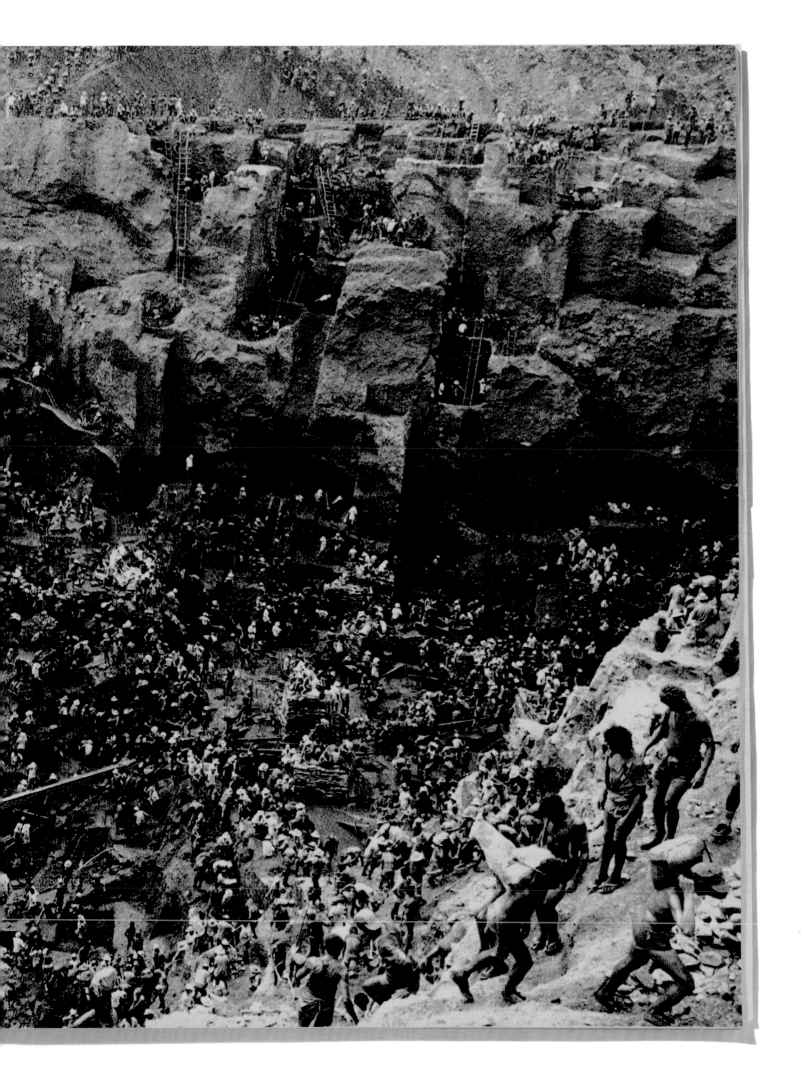

In the 1980s, American photojournalists found new supporters in the Sunday supplements published by regional newspapers such as the *Philadelphia Inquirer*, *Boston Globe*, *Denver Post* and *Detroit Free Press*. In 1987, the *Philadelphia Inquirer* backed Donna Ferrato to shoot an investigative essay on the almost invisible phenomenon of domestic violence against women and children, a subject she had first encountered a few years earlier while working on a story about 'swinging' suburban life. Its publication propelled Ferrato's work as journalist and activist and as publicist for the movement to recognize and stop domestic violence. Her career became a model for a style of political journalism that combined advocacy, agitation and public art. Ferrato's photographs are distinguished by their unusual ability to reveal sexual transgression without appearing to compromise the dignity or privacy of its victims, and they continue to occupy a disturbing space that hovers between voyeurism and rage. While the subject certainly continues to be current, Ferrato's own relationship to this material has grown – her book *Living with the Enemy* (1992) has achieved a place in the overlapping canons of feminist art and documentary practice. (26 July 1987)

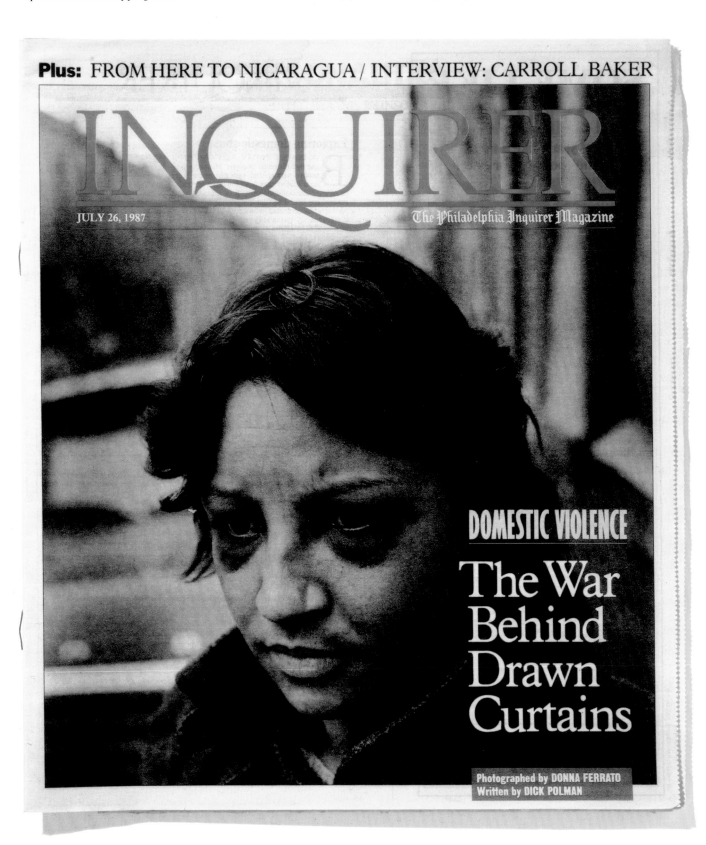

Plus: FROM HERE TO NICARAGUA / INTERVIEW: CARROLL BAKER

INQUIRER

JULY 26, 1987 The Philadelphia Inquirer Magazine

DOMESTIC VIOLENCE

The War Behind Drawn Curtains

Photographed by **DONNA FERRATO**
Written by **DICK POLMAN**

DOMESTIC VIOLENCE

PART ONE

One year in the trenches, one year working on domestic abuse cases, is enough to burn her out. It gets to the point where she watches people on the street and wonders which of the men are beating their women.

By the time summer arrives, Hillary Hochman is glad she's leaving the city district attorney's office and going off to law school. She is starting to think of Philadelphia as "the city of wife-beaters." She knows the label isn't fair — the assaults occur everywhere every day, among all races and classes, afflicting an estimated two million women nationwide — but it gets to the point where she can't ride her bike without seeing evidence of the war being waged behind drawn curtains.

Text continued on Page 19

Photographed by DONNA FERRATO
Written by DICK POLMAN

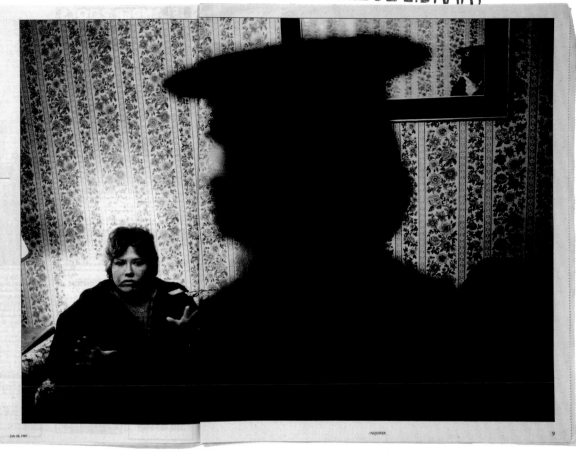

DOMESTIC VIOLENCE

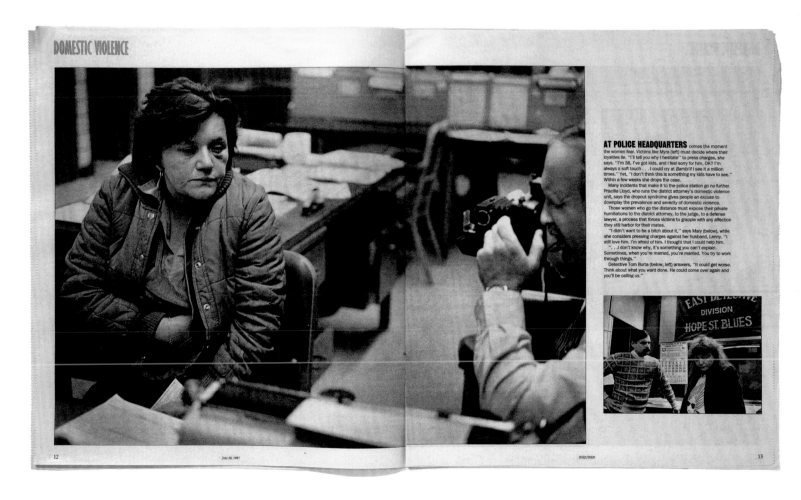

AT POLICE HEADQUARTERS comes the moment the women fear. Victims like Myra (left) must decide where their loyalties lie. "I'll tell you why I hesitate" to press charges, she says. "I'm 38, I've got kids, and I feel sorry for him, OK? I'm always a soft touch . . . I could cry at *Bambi* if I see it a million times." Yet, "I don't think this is something my kids have to see." Within a few weeks she drops the case.

Many incidents that make it to the police station go no further. Priscilla Lloyd, who runs the district attorney's domestic violence unit, says the dropout syndrome gives people an excuse to downplay the prevalence and severity of domestic violence.

Those women who go the distance must expose their private humiliations to the district attorney, to the judge, to a defense lawyer, a process that forces victims to grapple with any affection they still harbor for their mates.

"I didn't want to be a bitch about it," says Mary (below), while she considers pressing charges against her husband, Lenny. "I still love him. I'm afraid of him. I thought that I could help him. " . . .I don't know why, it's something you can't explain. Sometimes, when you're married, you're married. You try to work through things."

Detective Tom Burta (below, left) answers, "It could get worse. Think about what you want done. He could come over again and you'll be calling us."

247

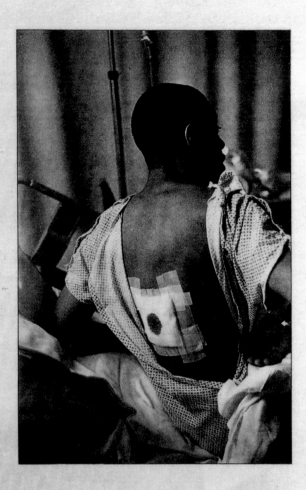

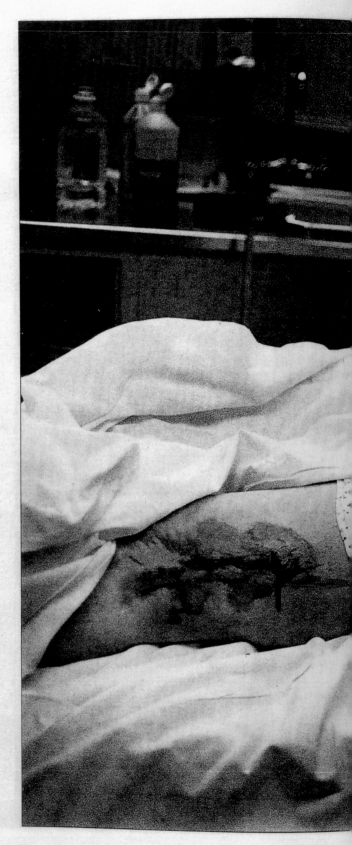

NINETY-FIVE PERCENT of abuse victims, it is believed, are women; Jesse (above) is an exception. But the urge to rationalize the violence is universal. At Temple University Hospital, Jesse tells of being stabbed by his girlfriend after they argued over a roll of film, then says, ''She's still on my mind a little, as far as love goes. Love is blind. I don't think she really meant it.''

At Episcopal Hospital late one night, Martha talks about the stab wound in her leg. Echoing Jesse, she explains why she won't have her boyfriend arrested: ''He didn't mean it. It's hard [to press charges] when you love somebody, it is . . . Put it this way, love is blind.''

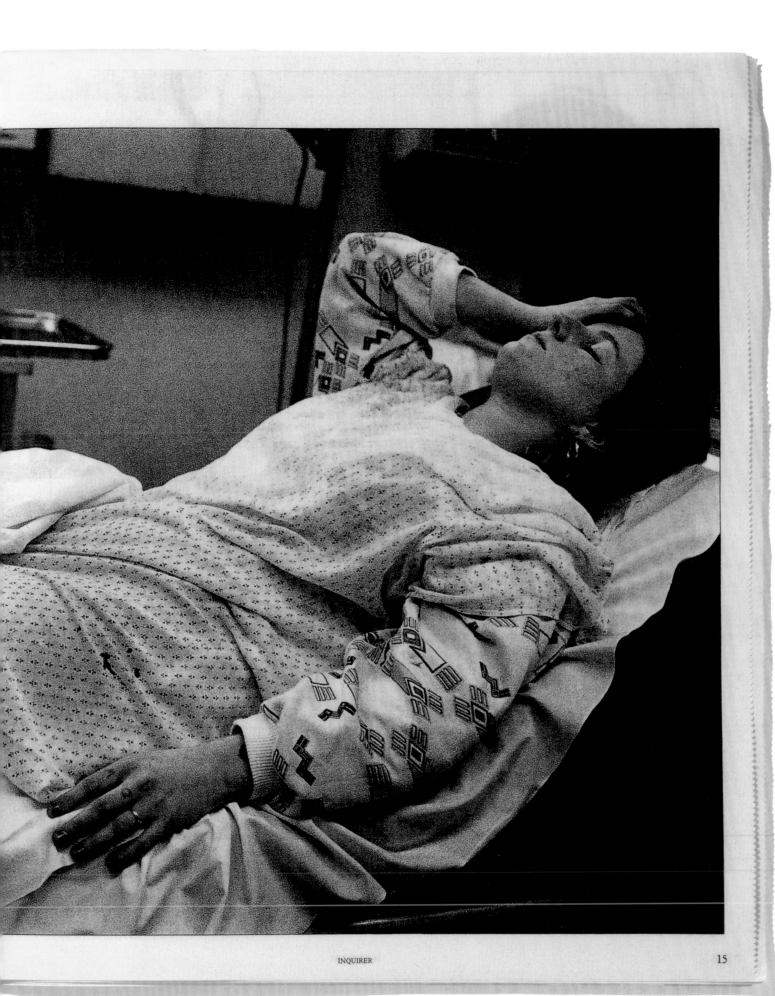

'Stammheim' is the name of the Stuttgart prison that housed the most prominent members of the 1970s German terrorists, the Red Army Faction, while on trial. The 7th floor where the prisoners were held was billed as the most secure prison section in the world, but this did not prevent guns being smuggled in to them by their lawyers – guns that on the night of 17 October 1977 contributed to the suicides of the Faction's leaders, Andreas Baader and Gudrun Ensslin. When young photographer Bernd Hoff was making a profile of the city ten years later for *Tempo* magazine, he found himself allowed access to the notorious 7th floor while the section was empty and being refurbished. The pictures he made of the banal details of Baader's and Ensslin's cells, with their direct flash and saturated colours, were a journalistic coup. They were also an early example of an emerging magazine photography aesthetic that would overturn the familiar ingredients of reportage. *Tempo*, Germany's youth-oriented lifestyle magazine, also carried classic reportage stories, but became known for its opinionated, post-modern approach; for instance, it was among the first in Germany to embrace the photography of Martin Parr. (October 1987)

STAMMHEIM
10 JAHRE DEUTSCHER HERBST

DER SIEBTE STOCK, FRISCH GEBOHNERT. Hinter einer der Türen sitzt Christian Klar, der Nachfolger Baaders. Er ist der einzige Gefangene im Hochsicherheitstrakt. Videokameras registrieren jede seiner Bewegungen.

WÄCHTER VOR DEM TOR ZUM GEFÄNGNISHOF. Sie erinnern sich nur ungern an die Zeiten, als Andreas Baader den siebten Stock regierte. Er behandelte die Beamten wie den letzten Dreck, Gudrun Ensslin beschimpfte die Wärterinnen als „alte Fotzen".

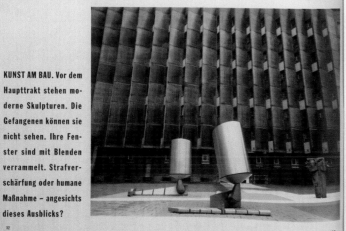

KUNST AM BAU. Vor dem Haupttrakt stehen moderne Skulpturen. Die Gefangenen können sie nicht sehen. Ihre Fenster sind mit Blenden verrammelt. Strafverschärfung oder humane Maßnahme – angesichts dieses Ausblicks?

DIE BESUCHERZELLE. Eine dicke Panzerglasscheibe trennt die Gefangenen von ihren Anwälten und Angehörigen. Kein Händeschütteln, kein Kuß, keine Berührung. Trotzdem gelang es RAF-Helfern, ein ganzes Waffenarsenal in die Zellen zu schmuggeln.

32

33

STAMMHEIM
10 JAHRE DEUTSCHER HERBST

BLITZBLANKE SICHERHEIT. Die Toiletten in den Zellen wurden aus einer neuartigen Aluminiumlegierung angefertigt. Sämtliche Sanitäreinrichtungen sind aus einem Guß, es gibt keine Fugen, keine Nischen, keine Winkel. Nichts, wo die Gefangenen Messer, Radios oder Drogen verstecken könnten.

34

Alon Reininger began to address the mysterious cancer killing gay men in America in 1981, with a story on the Veterans Hospital in New York, before the disease was named 'Aids'. Among the first photojournalists to address the subject, he sensed a story of enormous consequence and he decided to stay with it despite formidable obstacles. At the outset, in so far as the mainstream media recognized Aids as a problem at all, it was seen as a concern only to gay men in metropolitan centres. Indifference was succeeded by public and media hysteria, with the disease branded a 'gay plague' and with gay men and people with Aids subject to widespread prejudice and discrimination. Reininger struggled to find people with Aids willing to be photographed, and struggled to find magazines to take the pictures seriously when he did. As shock and bewilderment in the gay community turned into anger toward government and media, photojournalists were charged with pursuing sensational images of people dying of Aids rather than life-affirming images of people fighting it. It was 18 months after Reininger made his iconic image of Ken Meeks that the resurrected *Life* magazine first published a serious essay of the work. (January 1988)

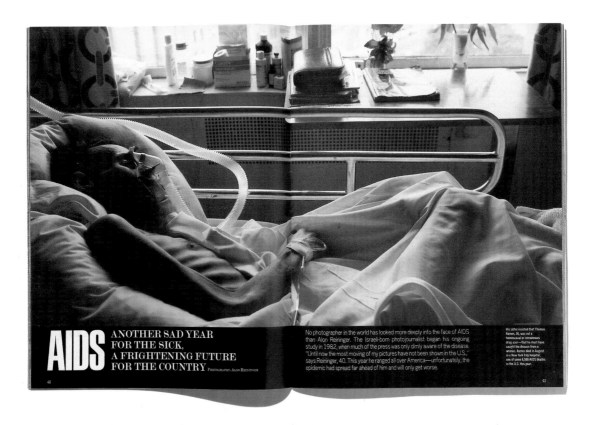

AIDS ANOTHER SAD YEAR FOR THE SICK, A FRIGHTENING FUTURE FOR THE COUNTRY PHOTOGRAPHY: ALON REININGER

No photographer in the world has looked more deeply into the face of AIDS than Alon Reininger. The Israeli-born photojournalist began his ongoing study in 1982, when much of the press was only dimly aware of the disease. "Until now the most moving of my pictures have not been shown in the U.S.," says Reininger, 40. This year he ranged all over America—unfortunately, the epidemic had spread far ahead of him and will only get worse.

His sister insisted that Thomas Ramos, 30, was not a homosexual or intravenous drug user—that he must have caught the disease from a woman. Ramos died in August in a New York City hospital, one of some 6,500 AIDS deaths in the U.S. this year.

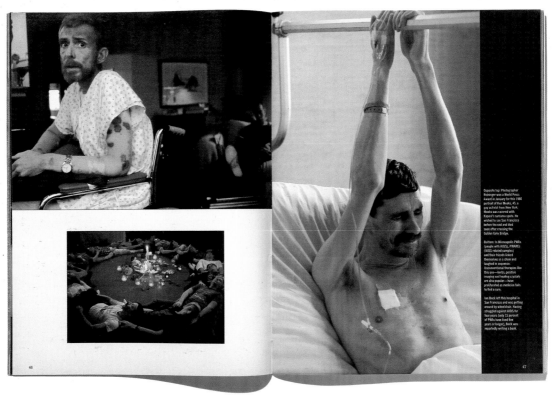

Opposite top: Photographer Reininger won a World Press Award in January for this 1986 portrait of Ken Meeks, 45, a gay activist from New York. Meeks was covered with Kaposi's sarcoma spots. He wished to see San Francisco before the end and died soon after crossing the Golden Gate Bridge.

Bottom: In Minneapolis PWAs (people with AIDS), PWARCs (AIDS-related complex) and their friends linked themselves in a chain and laughed in sequence. Unconventional therapies like this pose—herbs, positive imaging and healing crystals are also popular—have proliferated as medicine fails to find a cure.

Ian Beck left this hospital in San Francisco and was getting around by wheelchair. Having struggled against AIDS for four years (only 15 percent of PWAs have lived five years or longer), Beck was reportedly writing a book.

Lialia Kuznetsova began her social portrait of the Roma in Russia in the late 1970s. When her project began, the gypsies were a much-maligned group, living in poverty on the steppes – marginal inhabitants of a remote corner of a vast continent. Her earliest images document migrant bands who lived and travelled under conditions that had barely changed since the nineteenth century. Kuznetsova recognized the metaphoric power of this culture; her camera shows how this primitive existence also granted them remarkable freedom within the boundaries of a powerful totalitarian state. Over the next 15 years, Kuznetsova continued to document gypsy settlements as they became more permanent. She followed gypsy families into Odessa as they began to take up conventional employment. By the late 1980s, when *Ogonyek* published Kuznetsova's 'Gypsy Style', her photographs had already changed meaning; the humanistic documents of a rogue culture had become a safe romantic eulogy to an authentic folk culture in decline. (30 July 1988)

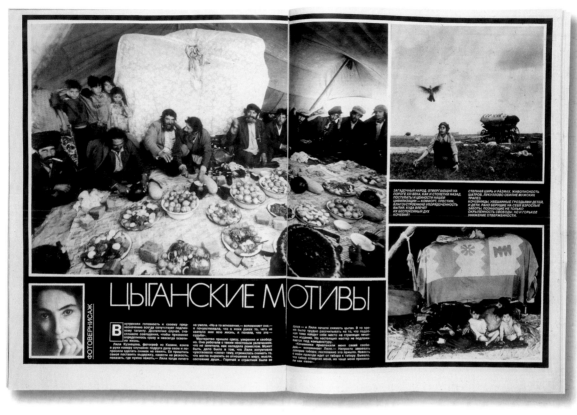

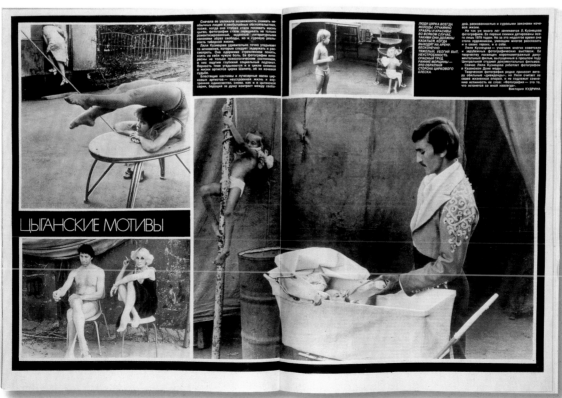

While many photographers develop a lasting affinity for a particular subject, French-born Eric Valli went a stage further, making the Nepalese/Tibetan Dolpo-pa culture both the subject of his work and the centre of his life. The former cabinet-maker met his future wife travelling in the region and settled there, raising a family and immersing himself in the local language and culture. His access to the remote master honey hunters of central Nepal, who dangle on rope ladders over 120-metre cliffs to harvest the thick slabs of honeycomb from *Apris laboriosa* (the world's largest honeybee), results from his deep local knowledge. The worldwide audience for the story, first seen in *National Geographic* and published widely thereafter, was amazed by the technical virtuosity of both the honey hunters and of Valli himself. The popular epitome of the romantic adventurer, explorer and storyteller, Valli worked closely with *National Geographic* on many further photo stories and documentary films – until 2001 when, frustrated with the limitations of being able to 'grab things' but not to 'recreate the emotion I witnessed or felt', he combined fiction with his documentary approach in a feature film based on his experience of trekking with Dolpo-pa yak caravans through the Himalayas. (November 1989)

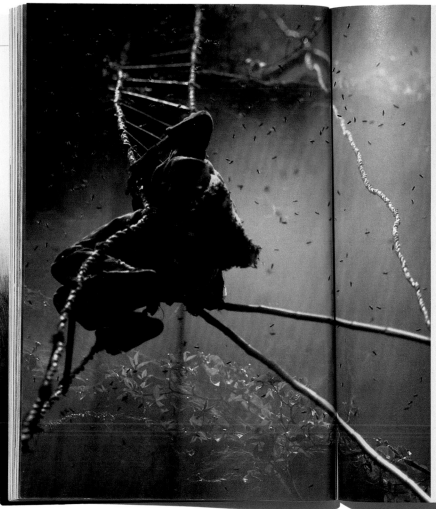

BEFORE HE STARTS down the ladder, Mani Lal takes a small pouch of rice from his waistband. As he sprinkles grains in the air, he recites the different names of Pholo, god of the forest. "I must not cut the comb when the god is not pleased," he says. "I must always pray first."

The Gurungs practice a mixture of Hinduism, Buddhism, and animism. That morning Mani Lal had sacrificed a chicken to Pholo, searching for omens in the animal's lungs.

Mani Lal's father, Barta, taught him the sacred mantras. But Barta's belief had not been strong. As he descended the ladder one day, the bees attacked him by the thousands, and he was blinded by a sting. "He did not make the offerings with a good heart," Mani Lal explains.

Now Mani Lal turns his attention inward. His eyes, normally alert to the slightest movement, lose their sharpness. Without a word, he starts down the swaying ladder like a spider on a frail strand of web. The slightest error of judgment would mean death (left).

Mani Lal stops beneath an overhang to face a nest nearly as large as he is. Its surface ripples with a thick, black layer of bees. Two of the honey hunters, Krishna and Akam (above), have climbed a third of the way up the cliff to secure the ladder. Clinging to the rock, they pull the rope against the cliff to bring Mani Lal closer to the comb.

Meanwhile a fire has been set at the base of the cliff to disorient the bees with smoke and encourage them to leave the nest. But the wind is blowing the smoke away. Gesturing toward the top of the cliff, Mani Lal issues a silent order. Within minutes a flaming bundle of leaves is lowered, and Mani Lal pushes it under the bees with a bamboo pole. Now panic runs over the living surface of the nest as the bees furiously depart in the smoke. Nothing distracts Mani Lal however. The golden comb has been unveiled.

A husband and wife team, ERIC VALLI and DIANE SUMMERS live in Kathmandu, Nepal. Their book on the honey hunters will be published this month by Harry N. Abrams in New York, by Thames & Hudson in London, and by Nathan in Paris.

665

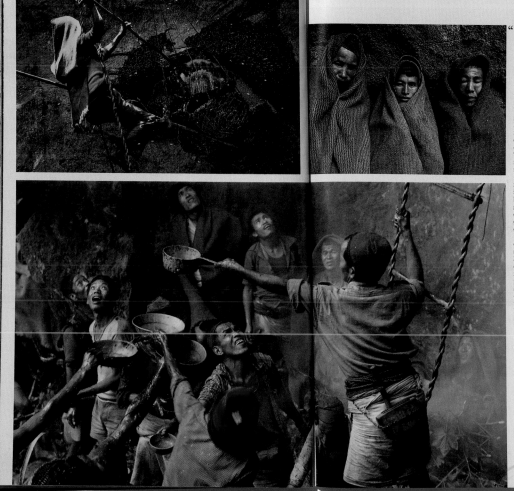

"IT'S RAINING honey," shout villagers gathered at the base of the cliff. Faces upturned, they thrust out pots and pans to catch the sticky liquid as it runs freely from the comb.

These eager bystanders do not belong to Mani Lal's group, but they are welcome at the cliff nevertheless because they have helped in the past to pay the government's annual tax on honey hunting. When income from a harvest is slim, the hunters collect the equivalent of six cents from many villagers. These persons then have the right to a taste of honey at the next harvest.

By the time Mani Lal finishes filling the first basket, it's brimming with 15 liters of honeycomb. As it reaches the ground, villagers swoop upon it, dipping in bowls and breaking off small chunks of comb to chew. It is a honey feast.

Later Mani Lal examines the color of the honey and pours a small amount into the palm of his hand to see if it tingles. If it does, it may not be safe to eat, for the bees are known to visit plants that produce toxic substances. Occasionally a villager consumes the honey before it is tested and collapses on the way home, unable to walk for hours, suffering from cold sweats, vomiting, and impaired vision.

With only capes to shield them, the honey hunters take their share of punishment from the bees. Plucking stingers from his arms with a pair of tweezers later that evening, Mani Lal laughs at the swollen faces of Akam, Amarjang, and Men Bahadur (above right).

"I am old; my flesh is dry and no longer swells," he says. "But the flesh of young men is soft and blows up with the bites of the bees."

669

In 1987 *Corriere della Sera*, Italy's bestselling newspaper, launched a supplement called *Sette*, conceived as a visual magazine of extended photo essays. Its editor Paolo Pietroni (also founder of the innovative *Max* and *Specchio* magazines) and photo editor Giovanna Calvenzi chose to fill the magazine with double-page spreads, with only short texts and prominent profiles of the contributing photographers, renewing a tradition of popular photojournalism in danger of being lost. Patrick Zachmann was commissioned by *Sette* (as part of an international co-production) to cover the peaceful protest of Chinese demonstrators in Beijing, mainly students who had occupied Tiananmen Square for seven weeks and were refusing to move until their demands for democratic reform were met. The filmic sequence, characteristic of Zachmann's work, depicts the expectations, hopes and determination of the young Chinese before the protest's unexpected, bloody repression. *Sette* came out after television had covered the dramatic denouement; but rather than pull the story, it ran as a beautiful and touching testimony of the demonstrators' hopes, all the more dramatic for the knowledge that many of them died. (June 1989)

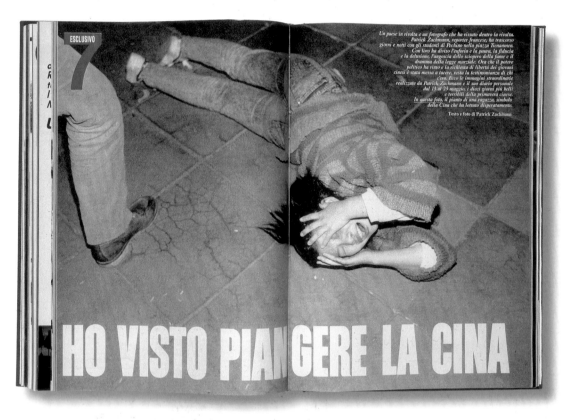

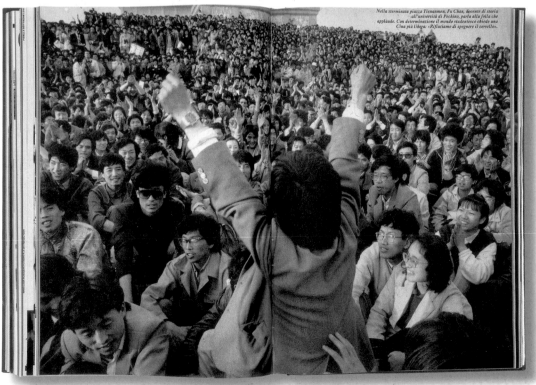

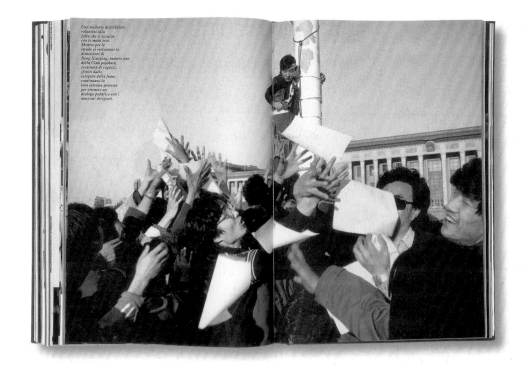

Uno studente distribuisce
volantini alla
folla che si accalca
con le mani tese.
Mentre per le
strade si reclamano le
dimissioni di
Deng Xiaoping, numero uno
della Cina popolare,
continua di ragazzi,
sfiniti dallo
sciopero della fame,
continuano la
loro estrema protesta
per ottenere un
dialogo pubblico con i
massimi dirigenti.

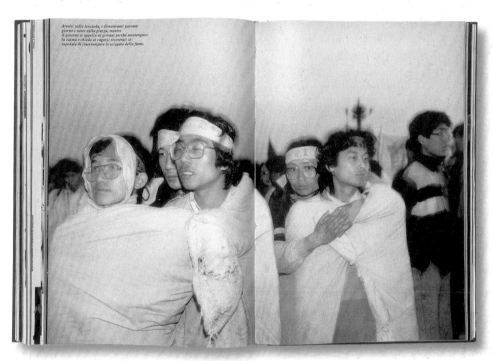

Avvolti nelle lenzuola, i dimostranti passano
giorno e notte nella piazza, mentre
il governo si appella ai giovani perché mantengano
la calma e chiede ai ragazzi ricoverati in
ospedale di interrompere lo sciopero della fame.

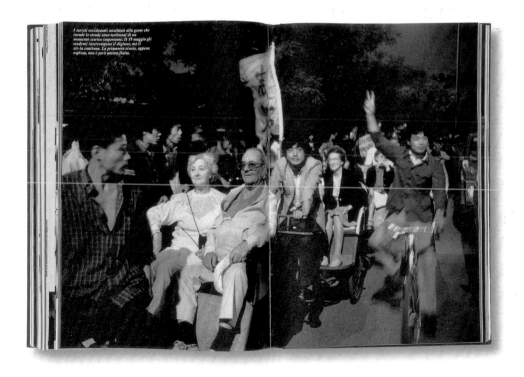

I turisti occidentali mischiati alla gente che
invade le strade sono testimoni di un
momento storico importante. Il 19 maggio gli
studenti interrompono il digiuno, ma il
sit-in continua. La primavera cinese, appena
esplosa, non è però ancora finita.

Paris Match acknowledged the fall of the Berlin Wall with a special issue run two weeks after a spontaneous popular demonstration began its symbolic destruction. It was essentially a 50-page history of the Wall as seen by the magazine, from its construction in August 1961 to its fall. This retrospective view represented a strategic choice on the part of the editors, who had to find a good and interesting way to cover a story that had already entranced television viewers in real time, and was far from over. By leaning on history, they were able to put together a souvenir picture narrative that would not become obsolete with the next political upheaval that took place. The special issue staked out a particular territory for photojournalism – not the first line of pictorial coverage (long ceded to television), but extended historical accounts in visual form. It demonstrates how a well-produced reflection on contemporary events could be critical to popular understanding of a major story. It also proved how photojournalism remained an essential resource – the most valuable tool for the presentation of the history of our own time. (23 November 1989, including photographs by Patrice Habans, Yevgeni Khaldei and Vladimir Sichov)

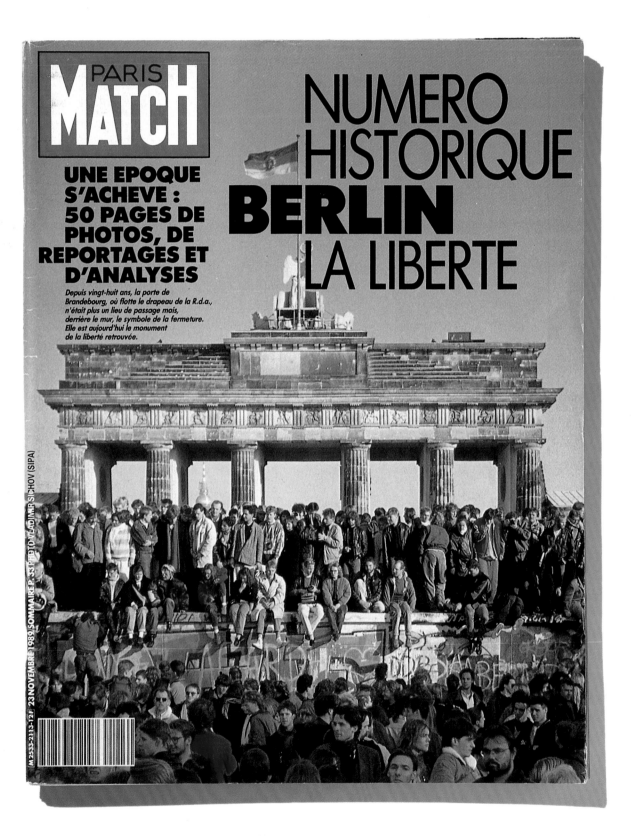

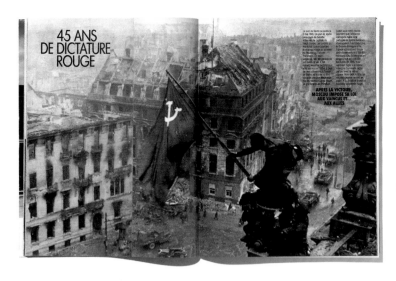

45 ANS DE DICTATURE ROUGE

APRES LA VICTOIRE, MOSCOU IMPOSE SA LOI AUX VAINCUS ET AUX ALLIES

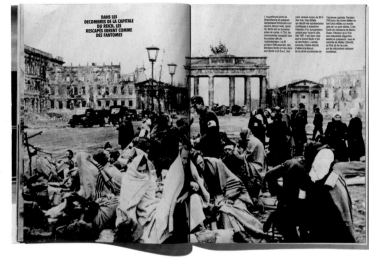

DANS LES DECOMBRES DE LA CAPITALE DU REICH, LES RESCAPES ERRENT COMME DES FANTOMES

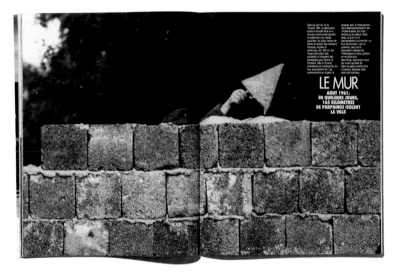

LE MUR

AOUT 1961: EN QUELQUES JOURS, 165 KILOMETRES DE PARPAINGS ISOLENT LA VILLE

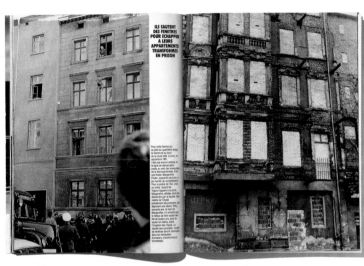

ILS SAUTENT DES FENETRES POUR ECHAPPER A LEURS APPARTEMENTS TRANSFORMES EN PRISON

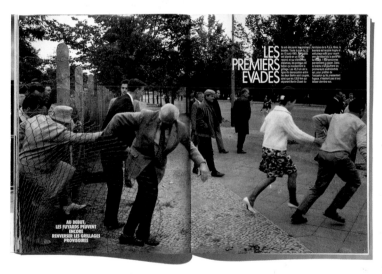

LES PREMIERS EVADES

AU DEBUT, LES FUYARDS PEUVENT ENCORE RENVERSER LES GRILLAGES PROVISOIRES

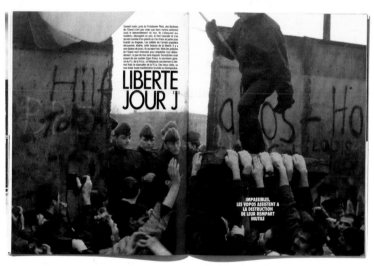

LIBERTE JOUR J

IMPASSIBLES, LES VOPOS ASSISTENT A LA DESTRUCTION DE LEUR REMPART INUTILE

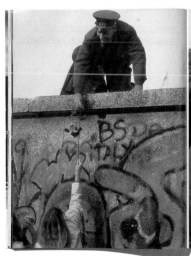
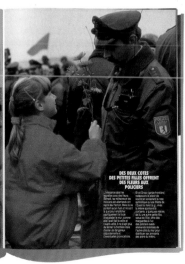

DES DEUX COTES DES PETITES FILLES OFFRENT DES FLEURS AUX POLICIERS

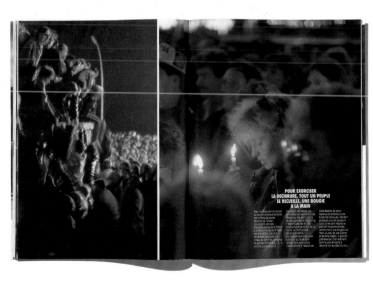

POUR EXORCISER LA DECHIRURE, TOUT UN PEUPLE SE RECUEILLE, UNE BOUGIE A LA MAIN

Through the 1970s, the expected role of a photojournalist in relation to social upheaval was to show it as it happened. But by the late 1980s, with television and the wire agencies now dominating the supply of hard news, many established photo essayists were removing themselves from the media frenzy, seeking to distinguish themselves instead with reflections on the consequences or legacy of historical events after the 'news' was over. The format of the 'think piece', with reflective text accompanying a photo essay, allowed photojournalists the scope to work as street photographers, with an obligation to general relevance but no obligation to particular events or personalities. This story model was particularly favoured at the *Independent* magazine, and was used by Colin Jacobson to support and publish the work of independent essayists like Mike Abrahams. Jacobson also expressed a clear taste for classic, lyrical photographs of daily life, usually in black and white, that became a defining feature of the magazine. (3 March 1990)

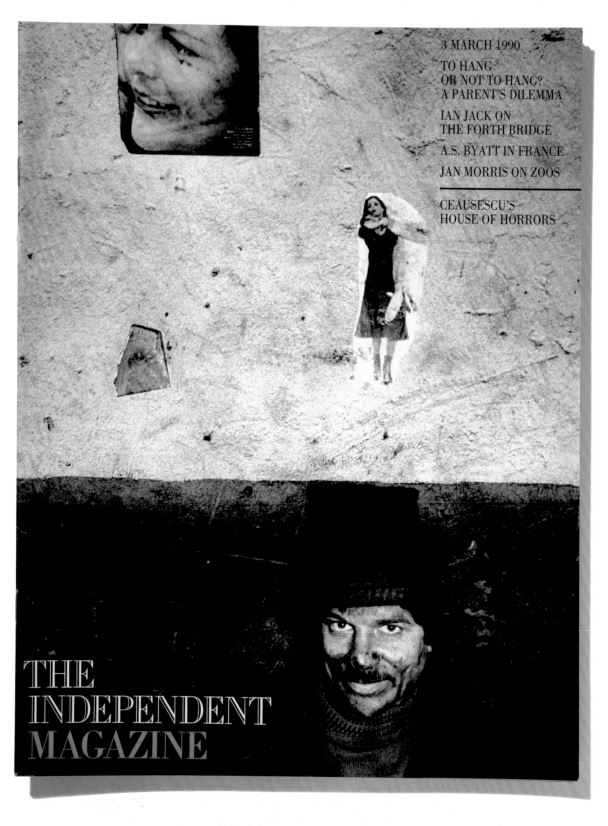

CEAUSESCU'S LEGACY

*Many evils of Romania's Communist regime survive to plague its successors.
Having no regard for human health or safety (but an overwhelming
regard for secrecy), President Ceausescu's government failed to control industrial
pollution, forced women to have children, and hid the handicapped away
in primitive hospitals. By MARK ALMOND. Photographs by MIKE ABRAHAMS*

Grevă la morga – "Strike in the mortuary." Everywhere in revolutionary Bucharest there are posters and graffiti proclaiming workers' unrest, but even by local standards this was an unusual announcement. What were the strikers' demands? "We want democracy in the mortuary." Not such an outlandish idea, since the Mina Minovici Medico-Legal Institute is no ordinary mortuary.

To begin with, it is big. Seven storeys high, the mortuary stretches a couple of hundred yards across one of the southern suburbs of the city. It is a new concrete building with touches of white pseudo-marble which give it an appropriately cold and sepulchral atmosphere. Like so many other prestige projects initiated by the Ceausescus, the mortuary is unfinished.

Inside the shell, dissecting chambers remain unfurnished; unconnected wires peer out of the wall; even bodies lie higgledy-piggledy on the floor of one room. (There was a strike on, after all.)

Nicolae and Elena Ceausescu liked to centralise everything: political power, economic planning, even death. Elena had overall control of public health and science. What could seem more natural to her than to bring together every aspect of death in one place? The Mina Minovici Institute is not just a clearing house for corpses, but is also the only centre in Romania for the study of the causes of death.

In the late 19th century Romania was in the vanguard of thanatology. The brothers Minovici made quite a family concern out of it. (Nicolae Minovici even died as the

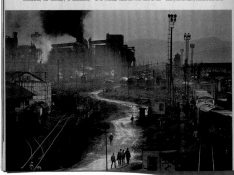

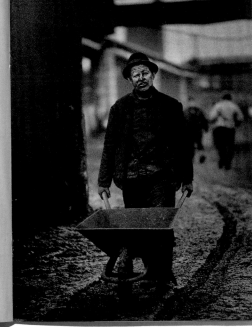

Right: A worker at the Carbosin blacking factory at Copsa Mica in Transylvania

Below: The whole town of Copsa Mica is covered with a blanket of black dust pumped out by the Carbosin factory, but the real danger lies in lead waste from the nearby lead and zinc works

result of researching the effects of hanging on himself.) In 1892, the original institute was established in the heart of old Bucharest. It became a leading centre for forensic science as well as post-mortem analysis. The old building fell victim to Ceausescu's bulldozers, which obliterated so much of the city centre to make way for the (unfinished) Palace of the People and Boulevard of the Victory of Socialism. The sentimental scientists and morticians working there were only able to rescue a few fragments of the old structure's decorations, which had to be kept hidden until after the revolution. Elena Ceausescu, however, gave them a new building and a new director, Vladimir Beleş, whose continuation in office was the cause of the strike.

Employees throughout Romania have risen up against the petty tyrants and political appointees imposed on them from above. In Ceausescu's Romania, telling one's superiors what they wanted to hear was a key virtue, as was the keeping of secrets. Not only were foreigners to be kept in ignorance about the real state of the economy and social conditions inside the country, but the regime was even more determined to hide the facts from its subjects. The mania for secrecy extended not least to the causes of death in Romania. The job of the director of the Mina Minovici Institute was to ensure that such information was only passed to the few approved recipients and kept from everyone else, including his employees.

The mortuary's deputy administrator, Gheorge Opreş, is an inexhaustible mine

of information about death in Romania, particularly unnatural deaths. Now he is free to reveal some of the facts about how people came to die in Ceausescu's Romania; it is easy to understand why the data and his wife were so anxious to keep the health statistics from public scrutiny. In 1989, he says in as matter-of-fact a way as possible, almost 800 people died as a result of chemical intoxication, mainly in industry, some in agriculture. He cannot say how many people survived industrial poisoning; only the dead are brought to the institute for post-mortems. One person died as a result of radioactive contamination: a man from Cernavoda, near the Black Sea, the site of Romania's fledgling nuclear joint-venture with Canada.

The staff of the institute do not need to

study the causes of death in industrial accidents to know that Ceausescu's government did not rate health and safety at work as a high priority. They themselves do not enjoy safe working conditions while engaged in post-mortem analysis. The dissecting chambers lack infra-red lamps which would kill off dangerous bacteria from the corpses. Even though the specialists have to work with agents known to cause cancer, they have to work without adequate protective clothing. Fifty days of exposure are compensated for by three days extra holiday.

The Mina Minovici Institute is typical of Ceausescu's Romania: an unfinished and unsafe operation obliged to operate at full capacity in order to fulfil some plan laid down from above. However, to go from the quiet marbled halls of the mortuary to the factories in a place like the little town of Copsa Mica in Transylvania is to travel into a superficially clean and safe world into an industrial nightmare, the sort of place which feeds the dissecting tables. Copsa Mica is synonymous with industrial pollution in Romania. Even small children will say "black, everything black" when its name is mentioned.

The cause of the town's reputation for filth is the Carbosin blacking factory, which pumps thousands of tons of waste into the atmosphere every year. The visitor can be forgiven for presuming that the black dust produced as a by-product of the Carbosin works is its only product. The black dust settles all over any alien object which stays in the valley for more than a few hours. At times it is almost like the coming of a biblical darkness.

Unpleasant and throat-drying though the waste from the Carbosin factory is, it is

not the real killer in Copsa Mica. Opposite the blacking factory stands a lead and zinc smelting works. Although only put up in the mid-Sixties at the start of Ceausescu's drive to industrialise Romania on the model of Stalin's Russia, working conditions inside the smelting works resemble something from a hundred years earlier. The plant was imported from Britain, but any protective clothing or respiratory equipment also brought in has long disappeared. Men carry lead-sludge in their bare hands to a small furnace.

According to Ovidiu Ilies, the economics director of the plant, the fumes coming off contain lead, zinc, cadmium, arsenic... The men do not even have glasses to protect them from the sparks and glare of the furnace. Elsewhere the only ventilation comes through open doors or holes in the walls and roof of the plant. In one place high up in the works, a couple of men are wearing useless masks because of the asbestos coming off the materials in the smelter, but the masks look like token gestures against the fumes. No one can remember when their filters were renewed. There is nothing they could do about it. Who could they have complained to?

About 4,000 people smelt lead and zinc; another 2,000 man the Carbosin works. They have a sanatorium at Avrig, south-east of Sibiu. It is an attractive building, once a country house, with a small park and artificial waterfall. In 1989 fewer from Copsa Mica, visited the sanatorium. The medical assistant, Liviu Gliga, took it for granted that a sooner or later every worker from the plant would spend the standard 15 days recuperating from lead or zinc poisoning. The younger workers, still growing, are

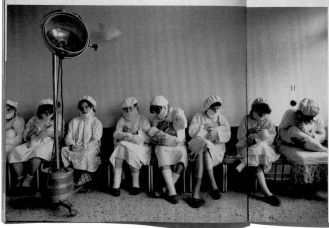

Left: Women waiting for abortions, which have only been legal since the December revolution, shown here at the Filantropica clinic with women recuperating from the operation

Below left: Mothers and babies in a Bucharest hospital. Women were encouraged to have children and so provide the new material for the new Romania dreamed of by the Ceausescus

Overleaf: Children waiting for a meal at Gradinari hospital for the handicapped near Bucharest. A staff of four nurses, a medical assistant, a cook and a washerwoman look after 96 children and 23 adults

more susceptible to the effects of working with lead. Some only last three months before developing symptoms of an overdose. The current record for working without having to visit the sanatorium is held by a man who had survived 14 years among the furnaces.

Conditions for the 101 inmates of the sanatorium were good, if a little crowded. The old regime had wanted them to recover and return to the factory floor to continue producing lead. Much of the lead the factory produced was destined to line the walls of Ceausescu's new palace in Bucharest, to protect him and the chosen few from a possible nuclear war or an accident at Cernavoda.

The degraded working conditions and the consequences for the health of the workers and local people in Copsa Mica are repeated all over Romania and throughout Eastern Europe. What made the Ceausescus' rule different from that in neighbouring Communist states was their

application of the drive for production at any cost and regardless of value whether it was increasing the output of factories or mothers. Just as their central planning of the economy left much to be desired, so the couple could think in only the crudest terms about demography. Numbers alone counted. Their greatness depended upon Romania having a population worthy to support the "genius of the Carpathians" and his "world-ranking scientist and engineer" wife. The paltry 22 million Romanians would have to be increased to 30 million by the end of the century. In fact, the increase has been only one million. Elena tried to boost the birth rate by command while living conditions steadily worsened. Her husband began his drive to pay off an enormous foreign debt (incurred by ill-conceived gigantic industrial projects) by exporting food, and anything else which came to hand, while every woman, married or not, was obliged to breed.

The consequences of the population

drive litter Romanian hospitals today; they are full of both unwanted and underweight children. And malnutrition is the key reason for the apparent epidemic of illegal abortions. Queues have now formed for the abortions previously banned for any woman with fewer than five children. Doctors work night shifts to deal with the demand, frequently performing abortions without proper anaesthetics. Still, it is better than the black-market methods of abortion widespread before the revolution, which often killed the mother. Only about five per cent of Bucharest women of childbearing age have a completely healthy uterus, which says much about the frequency of illegal abortions.

It is easy to understand why so many mothers preferred to risk their own lives than to have more children. When they gave birth, mothers frequently could not feed their babies. In any Romanian maternity ward, the doctors will say the same thing: the main cause of the problems of mother and child are social, not medical.

Malnourished mothers give birth to premature and underweight children. And malnutrition is the key reason for the apparent epidemic of Aids among Romania's infants.

The problem is not unique to Romania, though the scale of the disaster is more distressing there than elsewhere in the Soviet bloc. Last year in Astrakhan, there was a similar outbreak of Aids in a children's hospital and for the same reason because of the lack of mother's milk and the incapacity of collective agriculture to produce milk, let alone distribute it, the hospitals have taken over the task of providing thousands of newborn infants with essential nutrients. These are given intravenously. Scores of children receive the same injections each day with the same needle. In addition, blood transfusions are required on certain occasions. Someone forgot to plan for disposable syringes, so doctors have a stark choice: either inject with the same needle or deny a child

its only source of nutrition. Sterilisation equipment is often quaint, and in any case overworked doctors and nurses often do not have time to sterilise their instruments.

Horrified though they are by the outbreak of Aids, and guilty though they feel about it, doctors do not see it as the main danger to public health in Romania. To put it bluntly, none of its victims will live long enough to spread the infection. So far, although hundreds of infants are dying of the disease, only 13 cases have been identified among adults. But perhaps the prognosis that Aids is limited essentially to malnourished infants in hospital will prove over-optimistic. It is not only infants who suffer from the reuse of syringes. Vaccinations are generally performed with multiple re-use of the same needles. In addition, every GP in Romania had to fulfil a quota of blood donations, like any worker in a factory. Nicolae Ceausescu used to say, "everyone is free to fulfil the plan in his own way." Nobody

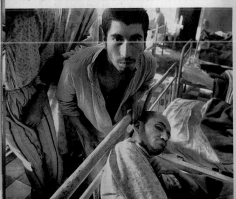

Left: Patients at Cula mental hospital outside Bucharest. It is common to see two to a bed

Below: Five children huddled together for warmth under a shared blanket at the Gradinari hospital. There was water on the ground outside, but the hospital had no heating or hot water

31

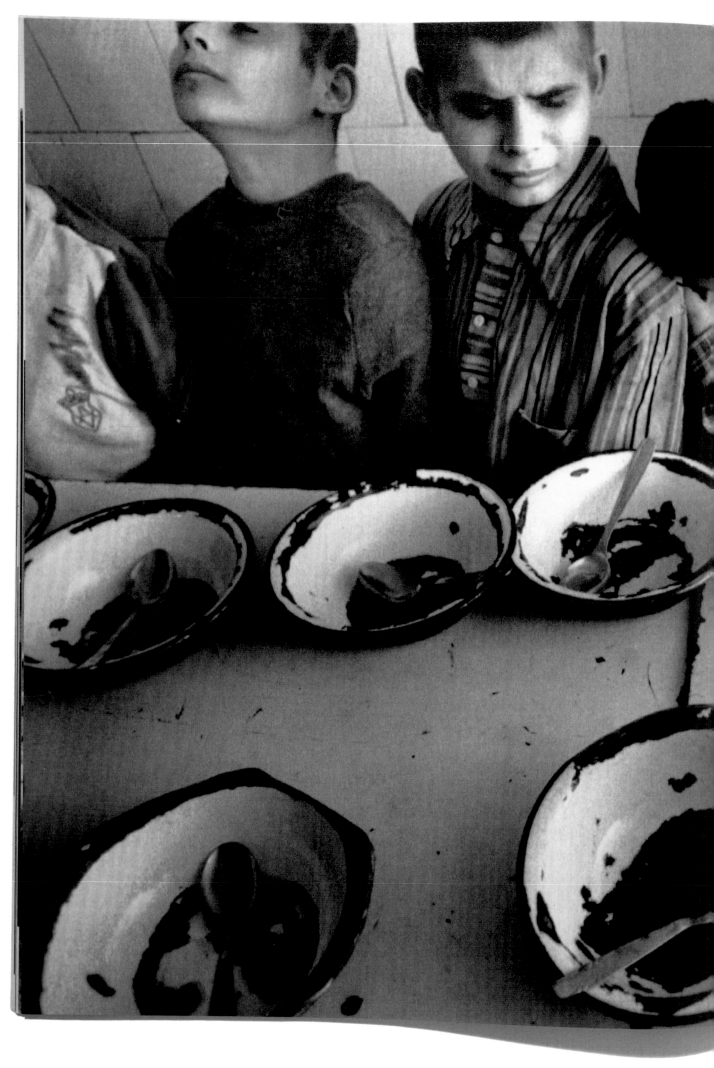

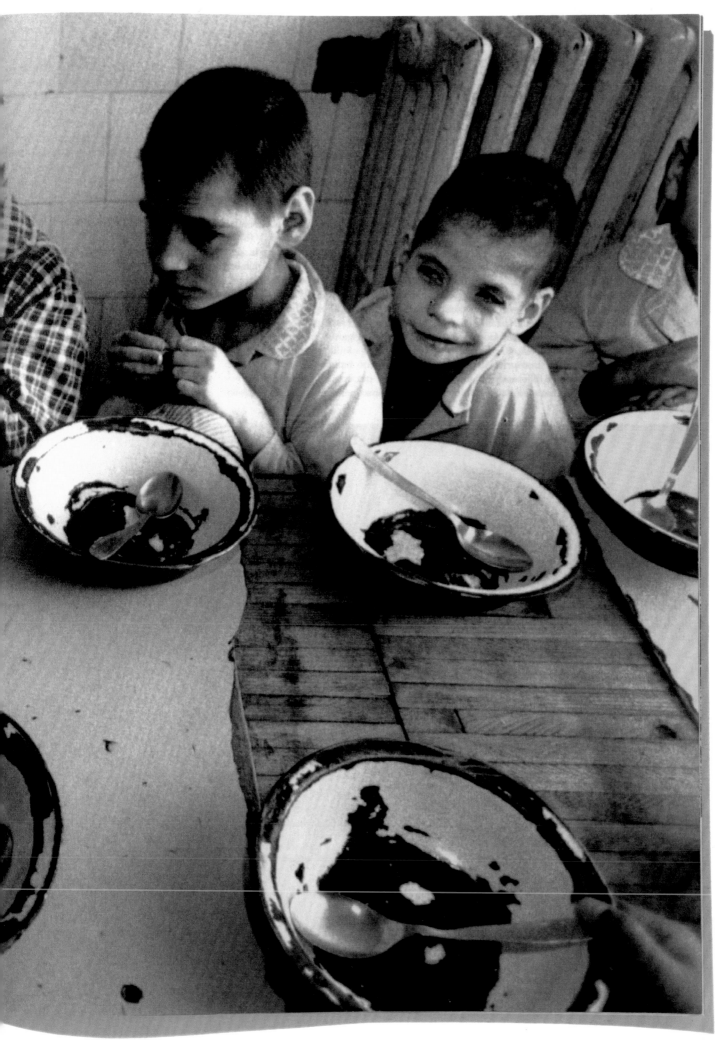

Czech-born Antonin Kratochvil emigrated to the West in the 1970s and spent many years working as a journeyman reporter and commercial photographer before establishing a reputation within photojournalism with his expressionistic study of East European landscapes wrecked by pollution. More than just a shocking story of industrial greed and governmental indifference, his work was welcomed by magazines as a visual metaphor for the consequences of life under Communism. These hellish views, made in Poland, Ukraine, East Germany and Czechoslovakia, are populated by bleak figures reminiscent of Dorothea Lange's documents of the American dust bowl. Kratochvil's graphic compositions and chiaroscuro palette earned him a place alongside Sebastião Salgado and James Nachtwey in a small group of high-profile photojournalists who, by the beginning of the 1990s, were achieving broad public recognition for their beautiful, emotion-laden images about forbidding subjects shot in black and white. One signal of Kratochvil's growing stature appears on the cover of the *New York Times* magazine – where the photographer's name has become part of the title of the story. (29 April 1990)

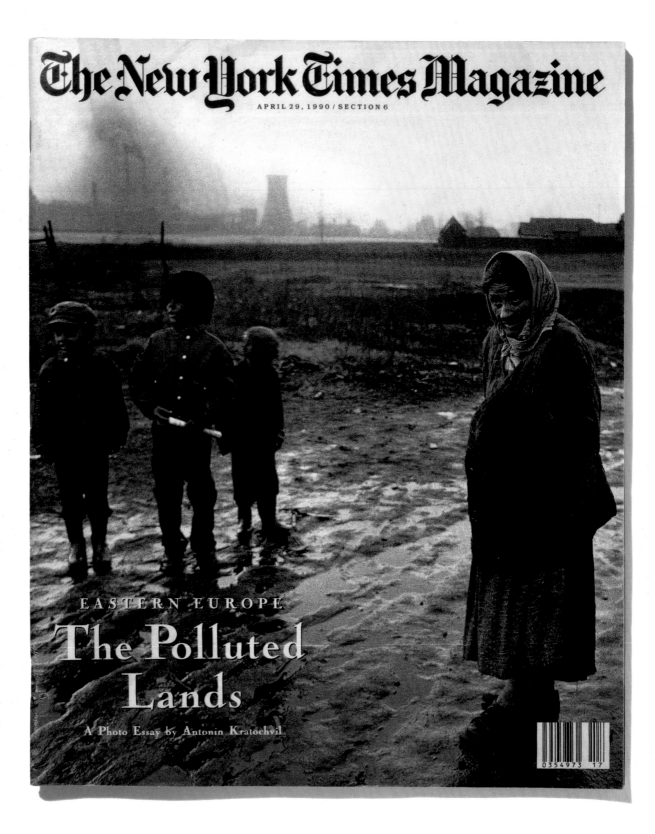

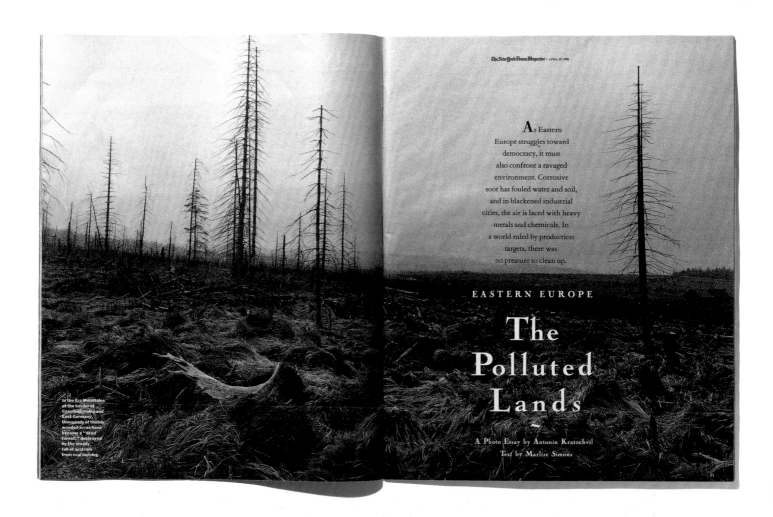

As Eastern
Europe struggles toward
democracy, it must
also confront a ravaged
environment. Corrosive
soot has fouled water and soil,
and in blackened industrial
cities, the air is laced with heavy
metals and chemicals. In
a world ruled by production
targets, there was
no pressure to clean up.

EASTERN EUROPE

The Polluted Lands

A Photo Essay by Antonin Kratochvil
Text by Marlise Simons

In the Erz Mountains at the border of Czechoslovakia and East Germany, thousands of thickly wooded acres have become a "dead forest," destroyed by the steady fall of acid rain from coal burning.

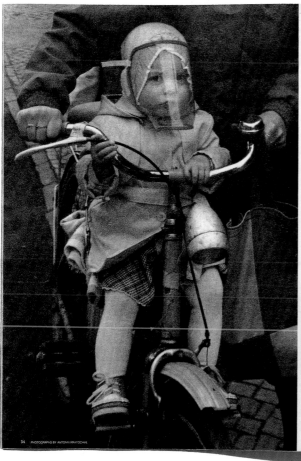

A child in Bitterfeld, East Germany, left, wears a mask for protection against the foul air.

In Katowice, Poland, young adults are dying of cancer, heart disease and emphysema at an alarming rate. Right: the grave of a woman who died of pollution-related illness.

In Copsa-Mica, Romania, below, the land that farmers tend is black from soot.

water in many regions. But the main trail of industrial devastation follows Central Europe's coal and steel belt, stretching from the south of East Germany, across northern Czechoslovakia to southern Poland. More than 15 million people live in this area. Here, close to 40 percent of the forests have been damaged by acid rain. And West Germany estimates that pollution in East Germany alone causes $18 billion worth of damage each year.

The pollution in Poland is widely acknowledged to be the worst. A persistent stinging smog — created by steel mills, power stations and chemical plants — hovers over the towns of Silesia, where men in their 30's and 40's are dying of cancer, heart disease and emphysema. Near Cracow, a sanitarium in a salt mine 650 feet below the polluted surface is a refuge for those with respiratory problems.

The new governments of Eastern Europe have created environmental departments, and they acknowledge that cleaning up will mean closing many outdated plants and tearing down neighborhoods steeped in lead and zinc dust. Environmentalists demand the rehabilitation of rivers sluggish with toxic waste and of land so acidic it can sustain no crops.

Some experts say an ecological Marshall Plan is needed. Western Europe, threatened by the toxic brew and dust flowing and blowing to its own doorstep, is offering aid. West Germany has approved about $500 million to clean up East Germany, and Sweden has pledged $45 million to help stem pollution in Poland.

Yet it will take more than money to bring life back to these sullen industrial towns, where even young people sound defeated and drink heavily. Some leave and others hope the political changes will bring a psychic lift.

"I don't know the way," says a Polish teen-ager in Katowice, "but we have to get over the I-don't-care disease." ■

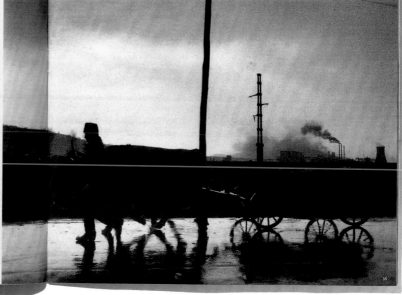

The title for this story comes from a Chinese proverb, 'Killing the chickens to scare the monkeys', referring here to the strategy of targeting the enemies of the Chinese government by making an example of the 'hooligans' and 'parasites' who supported them. According to Amnesty International, hundreds of 'chickens' (Chinese dissident sources put the number much higher) were killed in the months following the military crackdown at Tiananmen Square on 4 June 1989, in a blunt warning to all participants in the movement for greater democracy. The *Independent* magazine published these shocking photographs on the condition that neither the execution site nor the photographer – who made the images as part of a government record – would be identified. The story is unforgettable, yet it also demonstrates the contingent nature of photographic meaning. Although the photographs offer compelling evidence of a death by firing squad, without supporting recorded facts – the name of the photographer, the names of victims, details of where and when the depicted events took place – any certain conclusions must remain in doubt. (2 June 1990)

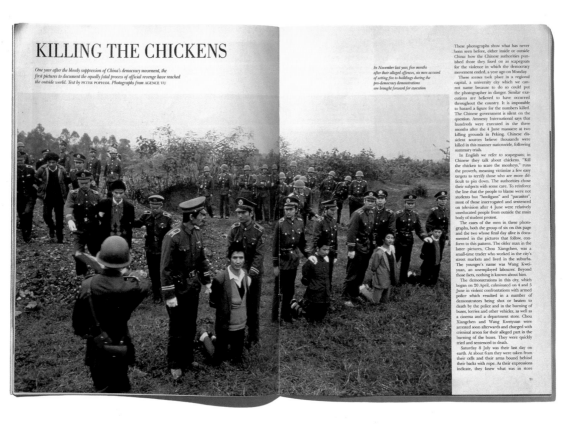

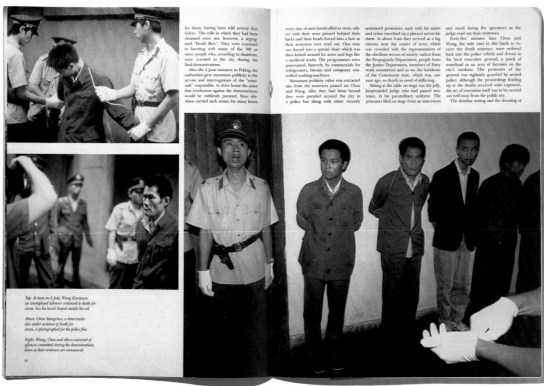

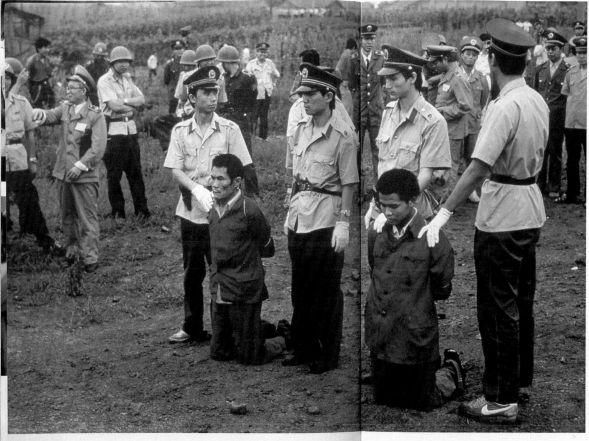

each man by a single soldier gives the impression that this was a furtive, hole-in-the-corner, death-squad type of execution, but this is wrong. Both the manner of killing and the nature of the location – a place well away from centres of population, fronted by a natural slope so that the earth absorbs the bullets – are standard in China. To Chinese eyes the Western-style firing-squad appears equally strange.

And although this was not a public spectacle, official witnesses were numerous, among them the judge himself, still apparently in excellent humour, and a film crew and photographer, documenting the event for police records.

Each prisoner was led by his executioner to a spot near the foot of the bare slope and required to kneel. The soldiers pressed the barrels of their rifles against the backs of the condemned men and then, when another soldier let his red flag drop, fired a single shot into the victim's heart. Both men fell forward. Chou died at once. Wang's executioner must have missed the mark, however, because Wang writhed on the ground as the blood gushed from his mouth. Another soldier stepped forward and kicked him to hasten the loss of blood and thus his death.

When Wang was finally still, both bodies were turned over and strips of paper bearing the legend "Executed for arson" and their names were placed next to them for the final official photograph. Afterwards the corpses were taken to the police crematorium. It is unknown what happened to the ashes. Even if the next-of-kin were informed, it is likely that they were too frightened to collect them.

Four months later, in November, the six men seen in the first photograph were executed in the same place for their alleged part in burning down buildings in the city. Once again it was the chickens who got it in the neck: all the condemned men were, like Chou and Wang, from the fringes of society, and therefore easily labelled "hooligans". None were students.

The mills of retribution grind exceedingly fine in China, and they have been steadily in motion ever since 4 June. No punishment was exacted in the city of Guangdong, for example, in the immediate aftermath of Tiananmen Square, but large-scale trials and numerous executions are said to have taken place there in the early months of this year. And while the chickens continue to be slaughtered, the monkeys have not got away scot-free.

Many hundreds of students are believed to have been sentenced to years in jail or in remote labour camps. But nothing is

Wang and Chou kneel at the execution ground.
The judge who sentenced them is
seen at far left, in peaked cap and spectacles

clear. China says that only about 6,000 activists were arrested in the wake of the 4 June crackdown, and claims that many of those have since been released. Amnesty International, on the other hand, has learned from "various sources" that the number of those arrested may run into the tens of thousands.

The organization has submitted to prime minister Li Peng, the man whose declaration of martial law led directly to the Tiananmen Square massacre, a list of 650 prisoners of conscience, with a demand to know whether they have been charged, tried or sentenced. Li Peng, not surprisingly, has yet to furnish a reply.

Even those who avoided imprisonment have been made to confess their wrongdoing. The ritualistic humiliation of writing self-criticisms, studying "important speeches" of Deng Xiaoping and so on, have been imposed on workers and students all over the country by local Party committees. Such punishments continued well into this year. For large numbers it was a question of going through the self-abasing motions while avoiding naming names or dates or doing anything which would allow the authorities to carry the purge further. And many Party cadres, whose job it was to impose such punishments, went along with such acts of discreet disobedience, it is said, displaying an unmistakable lack of zeal for their task.

None the less, the government can feel well pleased with its efforts: the embers of revolt have been very thoroughly smothered, and the country whose peaceful uprising heralded the onset of the year of revolutions remains stuck quite as firmly as before in the mud of stagnation and terror. The uncanny, sullen calm that descended like a fog after 4 June shows no sign of shifting. Everyone is waiting for someone to die. ●

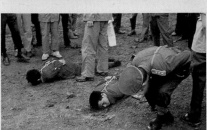

Below: The executioners, with a
single bullet each, prepare to shoot

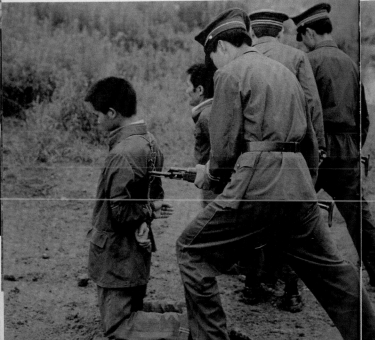

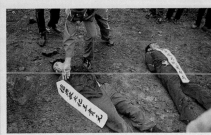

Top: After the shots, the two men slump forward

Centre: The bodies are checked for signs of life

Bottom: Labels indicating the dead men's
names and crimes are placed against the bodies
for the taking of final official photographs

The first Gulf War, waged on Iraq by a US-led coalition and authorized by the United Nations, began on 18 January 1991 and ended less than a month later. It was the first major war to engage US forces since Vietnam, and the first to be reported according to a strict new system devised by the US government to limit and control press access. The innocuous-sounding 'Department of Defense Pool' forced hundreds of reporters to rely on the work of a small group, and photographers who refused to follow the established rules worked on the margins of the war at their own risk – and this included the risk of conservative editors declining to publish images that questioned or implied criticism of the government. *Newsweek*'s first war reports appeared with mostly generic images, but reporters released new images that offered explicit information about the fighting, in time for their 11 March issue. Nearly a dozen photographers contributed to this dramatic war portfolio – including Ken Jarecke, whose damning image of the scorched face of an Iraqi soldier subsequently became an icon of the brutality of a war obscured behind the US government's public relations machinery. (11 March 1991, with photographs clockwise from top right: David Turnley, Sadayuki Mikami, Gary Kieffer, Charles Platiau, Mark Peters, Kenneth Jarecke and Philippe Wojazer)

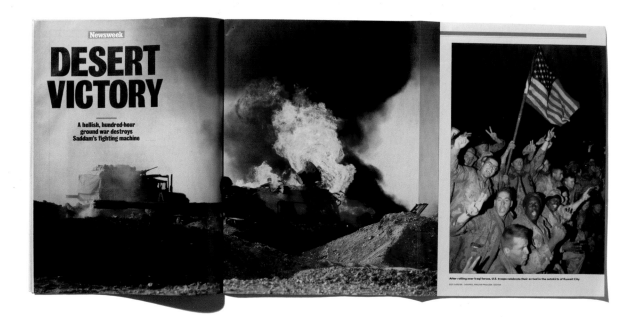

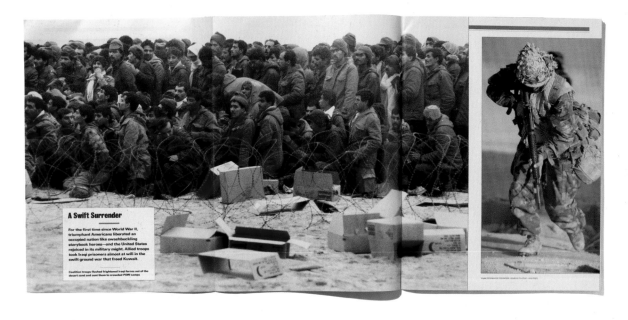

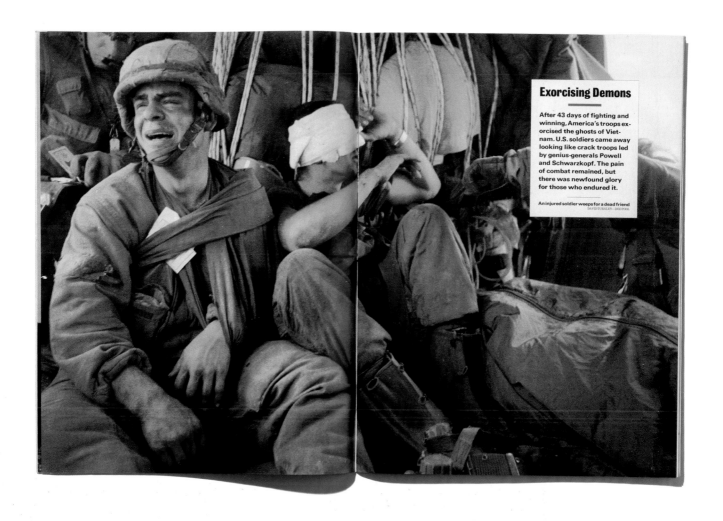

Exorcising Demons

After 43 days of fighting and winning, America's troops exorcised the ghosts of Vietnam. U.S. soldiers came away looking like crack troops led by genius-generals Powell and Schwarzkopf. The pain of combat remained, but there was newfound glory for those who endured it.

An injured soldier weeps for a dead friend
DAVID TURNLEY—DOD POOL

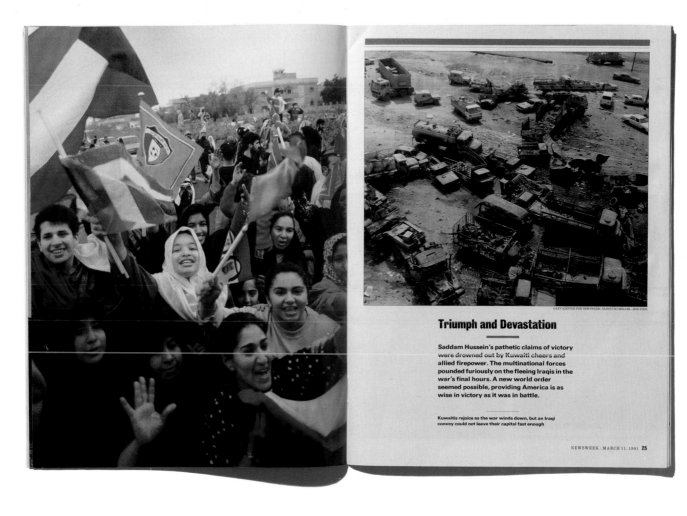

GARY KIEFFER FOR NEWSWEEK; SADAYUKI MIKAMI — DOD POOL

Triumph and Devastation

Saddam Hussein's pathetic claims of victory were drowned out by Kuwaiti cheers and allied firepower. The multinational forces pounded furiously on the fleeing Iraqis in the war's final hours. A new world order seemed possible, providing America is as wise in victory as it was in battle.

Kuwaitis rejoice as the war winds down, but an Iraqi convoy could not leave their capital fast enough

NEWSWEEK : MARCH 11, 1991 **25**

In 1991, geologists were able to predict the eruption of Mt Pinatubo, giving the Philippine government sufficient warning to prevent tragedy by evacuating 75,000 local residents in time. But there was no way to foresee that the eruption would coincide with a passing tropical storm, causing the explosion to cover the surrounding island of Luzon with a snowy volcanic ash that in some places reached a depth of 13 inches. Nature journalist Philippe Bourseiller arrived on Luzon in time to see the eruption take place, and to photograph the island under its ashy blanket. An expert in the photography of harsh settings such as the Sahara and Antarctica, Bourseiller had not photographed a volcanic eruption before. He called the experience 'a true thunderbolt' – a life-changing event that revealed to him the shape of his own emotional relationship to nature. The result was a sequence of surreal tableaux that also offered an eloquent allegory of disaster in the twentieth century; it is hard to look at these landscapes – intact, empty, covered with dust – without imagining that we see a picture of nuclear holocaust. (15 June 1991)

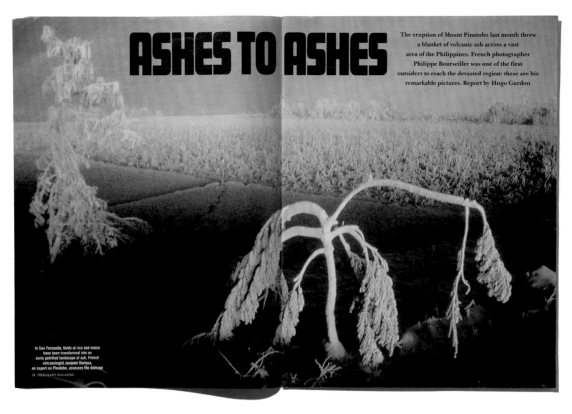

In San Fernando, fields of rice and maize have been transformed into an eerie petrified landscape of ash. French volcanologist Jacques Durieux, an expert on Pinatubo, assesses the damage

22 TELEGRAPH MAGAZINE

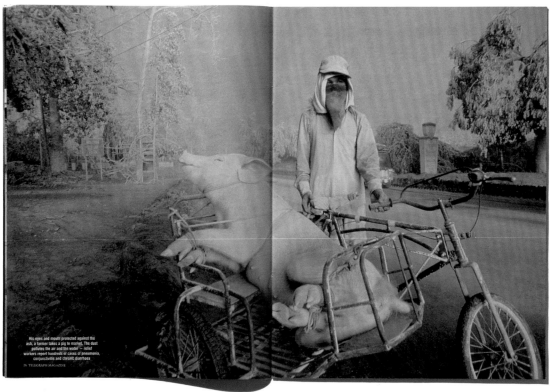

His eyes and mouth protected against the ash, a farmer takes a pig to market. The dust pollutes the air and the water – relief workers report hundreds of cases of pneumonia, conjunctivitis and chronic diarrhoea

26 TELEGRAPH MAGAZINE

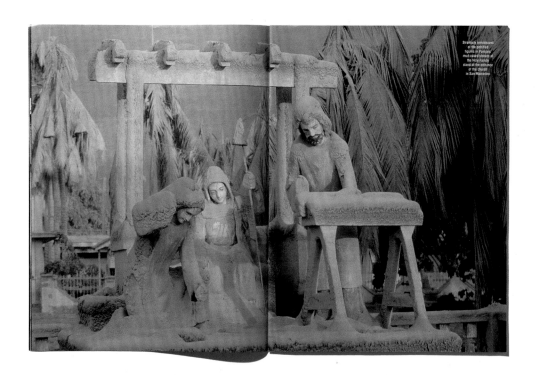

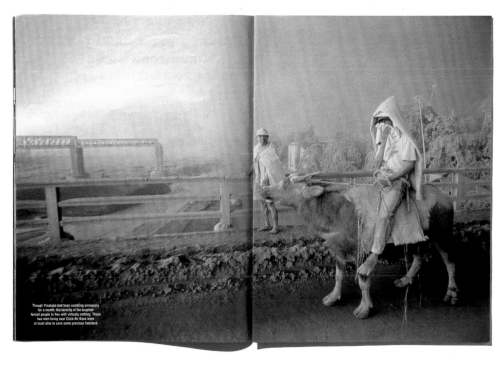

Though Pinatubo had been rumbling ominously for a month, the ferocity of the eruption forced people to flee with virtually nothing. These two men living near Clark Air Base were at least able to save some precious livestock

12, the day of the first explosion. Pinatubo had been grumbling for a month and vulcanologists warned of a major eruption, but the sky was still blue and the rice paddies still a brilliant green. Mothers walked their children across sunlit streets, and youths lounged in the shade. A dog, disturbed from its slumbers in the nave of a church, barked at a passer-by. A housewife was doing her washing at the kitchen window.

But at 8.45 people trooped what they were doing and gaped across the fields. Beyond the labourers and buffaloes and acacia trees, a grey-brown cloud rolled out of the Zambales mountains. A silent column of ash, steam and red-hot rock hundreds of yards wide shot 15 miles into the atmosphere in just three minutes.

It brushed aside high-level cirrus like cobwebs, which then hung in tatters under the dome of the mushroom cloud. For a while it mimicked the explosion at Hiroshima, then the wind came and blew it into the South China Sea.

Within half an hour, people returned to work. But scores of eruptions followed and the wind shifted again and again to ensure even-handed destruction. The big brothel-towns of Angeles and Olongapo (combined populations 680,000), built respectively around Clark base and the Subic Bay naval dockyard, are now forlorn.

Clark has been abandoned and its 16,000 airmen and dependents have flown home. The ransoms who are up shop by the perimeter fence, and the girls who worked the bars nearby, are ruined. No one needs them any more. Over in Olongapo the hotel rooms with mirrored ceilings are unused, or have collapsed under the weight of ash. A barman, disconsolately polishing glasses, said, 'I hope tomorrow's eruption is the last; Angeles is dying.' In fact, Angeles is already doomed. If ash grinds down jet engines in flight, what is the point of running an air base on the side of an active volcano?

The financial effects on the Philippines will be devastating. Between them, the bases pumped £500 million into the country's economy every year. With the loss of Clark, this figure will fall to £300 million. Four-fifths of the Filipinos living near the bases work directly or indirectly for the Americans. They are the second biggest employer in the country after the government.

Subic, as the linchpin of the US Navy's presence in the western Pacific, is going to be restored. But Clark — now obsolete because of the development of long-range bombers and carrier-borne jets — had become an optional luxury. For months Manila haggled with the Bush administration over new leases for Subic and Clark, demanding £530 million a year, while the US offered £225 million. With continually twisted logic, Philippine Foreign Secretary Raul Manglapus suggested that because the volcano had caused so much damage, the price of the bases might go up, not down.

The Philippine Institute of Volcanology and Seismology says Pinatubo could keep erupting for months, even years. It may have been awoken by an earthquake which jolted northern Luzon last year. Not long before Pinatubo blew, Mount Unzen in Japan exploded, and not long after, two more Philippine volcanoes — also part of the fiery necklace of volcanoes that circle the Pacific — began to rumble and wheeze. These are torrid times on the Pacific's Ring of Fire.

Now the worst of the eruptions is over, hunger is a greater worry. Above, in San Fernando a man searches among the sugar cane for food that is fit to eat. Right, the volcanic ash mixes with typhoon rains to form devastating mudslides. Near Clark Air Base, vast tracts of land have been engulfed

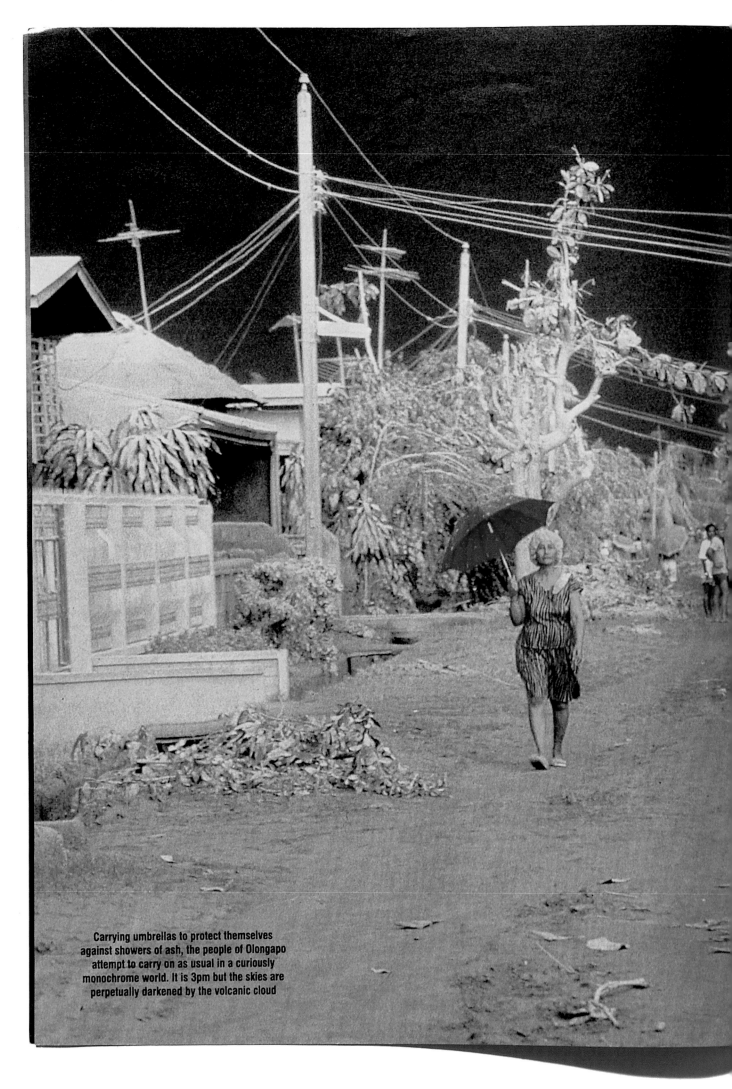

Carrying umbrellas to protect themselves against showers of ash, the people of Olongapo attempt to carry on as usual in a curiously monochrome world. It is 3pm but the skies are perpetually darkened by the volcanic cloud

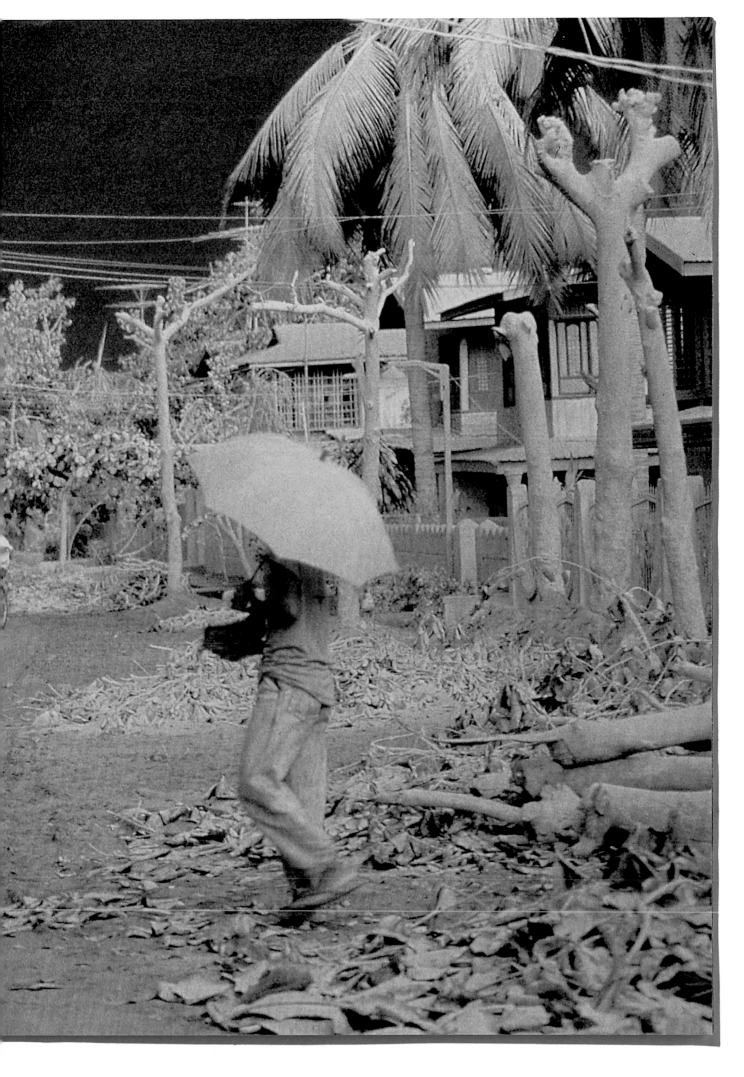

In 1989, photographer Hans-Jürgen Burkard started working for *Stern* magazine, the beginning of a collaboration that produced a series of distinctive photo essays over the following years. Comprising visually dramatic colour photographs lit with flash and run over consecutive full-bleed double-page spreads, his main subject was Russia during the collapse of the Soviet Union. His investigative talents and his unusual freedom of movement inside the country (Burkard was only the second foreign photographer to receive official accreditation in 1989) gave him wide access to subject matter not previously seen in the Western media. Stories on subjects including pollution in Siberia, the emergence of an extreme right wing and Moscow nightlife established Burkard as *Stern*'s dynamic monitor of the fast-changing Russian society. His investigation of the Russian Mafia, at that time little known, was the product of nearly a year's work following the RUOP, the division of the Ministry of Internal Affairs dedicated to combating organized crime – dangerous work during which he was often beaten up and his life threatened. His work became the epitome of *Stern*'s approach to photojournalism at the time: bright, serious and sensationally compelling. (28 November 1991)

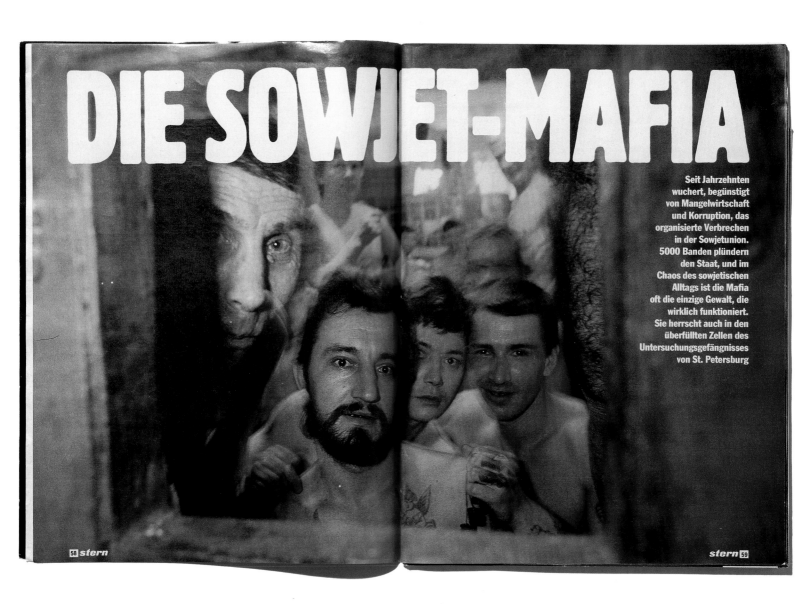

DIE SOWJET-MAFIA

Seit Jahrzehnten wuchert, begünstigt von Mangelwirtschaft und Korruption, das organisierte Verbrechen in der Sowjetunion. 5000 Banden plündern den Staat, und im Chaos des sowjetischen Alltags ist die Mafia oft die einzige Gewalt, die wirklich funktioniert. Sie herrscht auch in den überfüllten Zellen des Untersuchungsgefängnisses von St. Petersburg

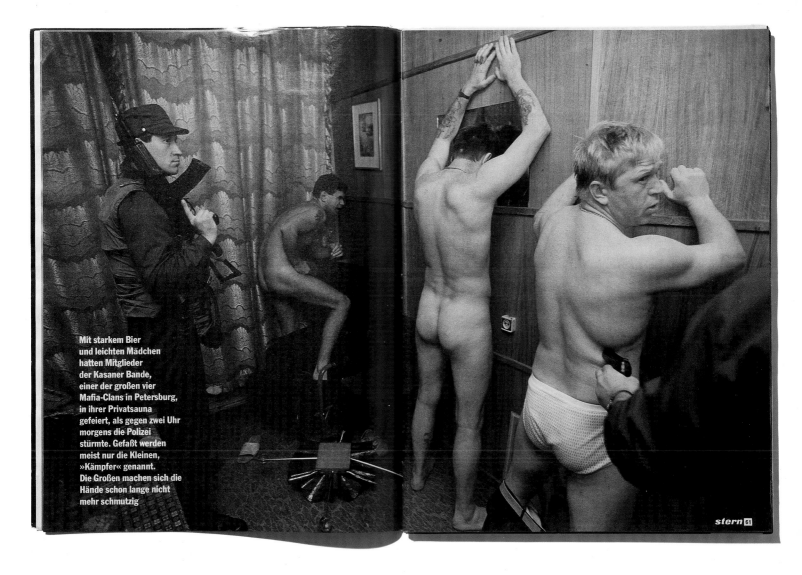

Mit starkem Bier
und leichten Mädchen
hatten Mitglieder
der Kasaner Bande,
einer der großen vier
Mafia-Clans in Petersburg,
in ihrer Privatsauna
gefeiert, als gegen zwei Uhr
morgens die Polizei
stürmte. Gefaßt werden
meist nur die Kleinen,
»Kämpfer« genannt.
Die Großen machen sich die
Hände schon lange nicht
mehr schmutzig

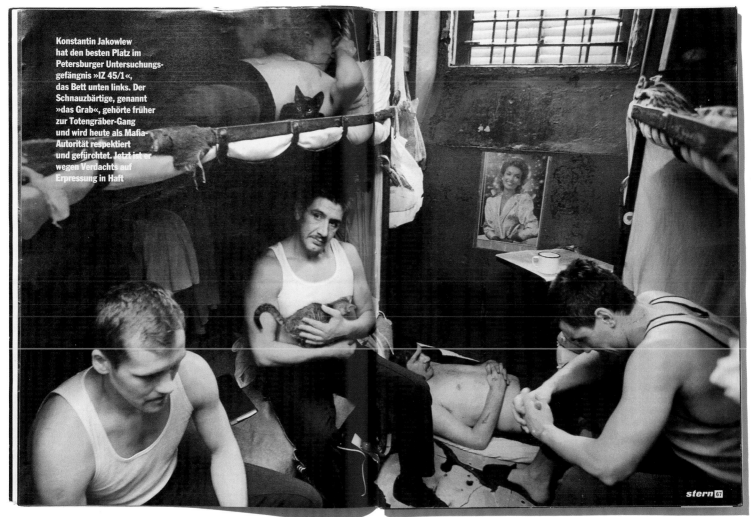

Konstantin Jakowlew
hat den besten Platz im
Petersburger Untersuchungs-
gefängnis »IZ 45/1«,
das Bett unten links. Der
Schnauzbärtige, genannt
»das Grab«, gehörte früher
zur Totengräber-Gang
und wird heute als Mafia-
Autorität respektiert
und gefürchtet. Jetzt ist er
wegen Verdachts auf
Erpressung in Haft

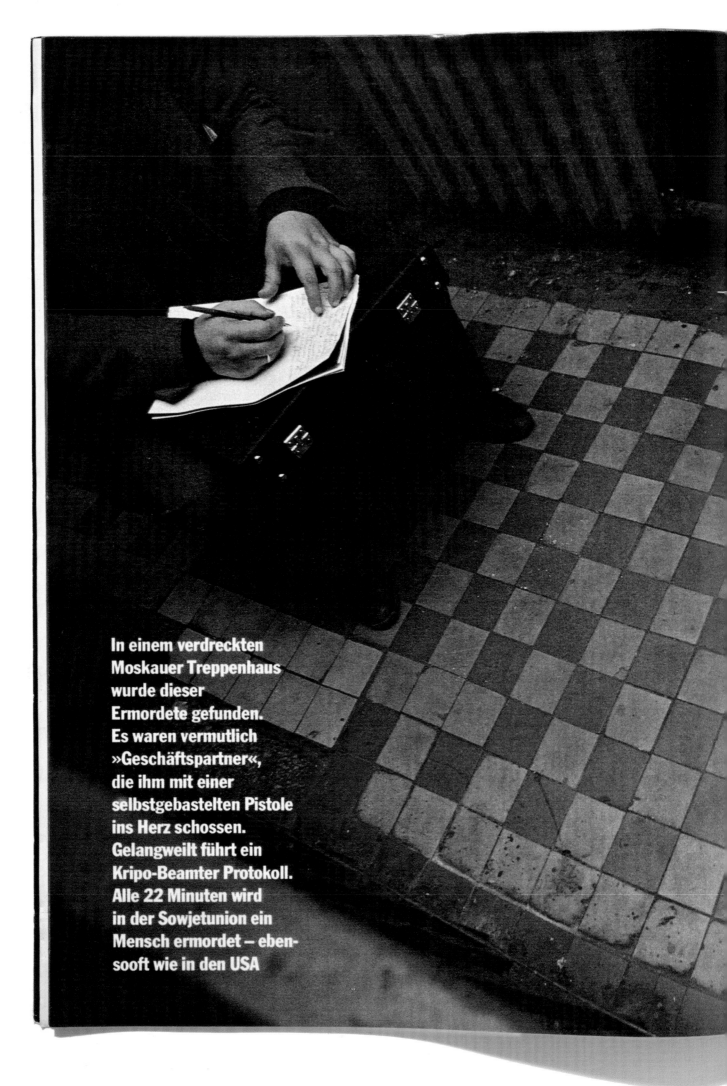

In einem verdreckten
Moskauer Treppenhaus
wurde dieser
Ermordete gefunden.
Es waren vermutlich
»Geschäftspartner«,
die ihm mit einer
selbstgebastelten Pistole
ins Herz schossen.
Gelangweilt führt ein
Kripo-Beamter Protokoll.
Alle 22 Minuten wird
in der Sowjetunion ein
Mensch ermordet – eben-
sooft wie in den USA

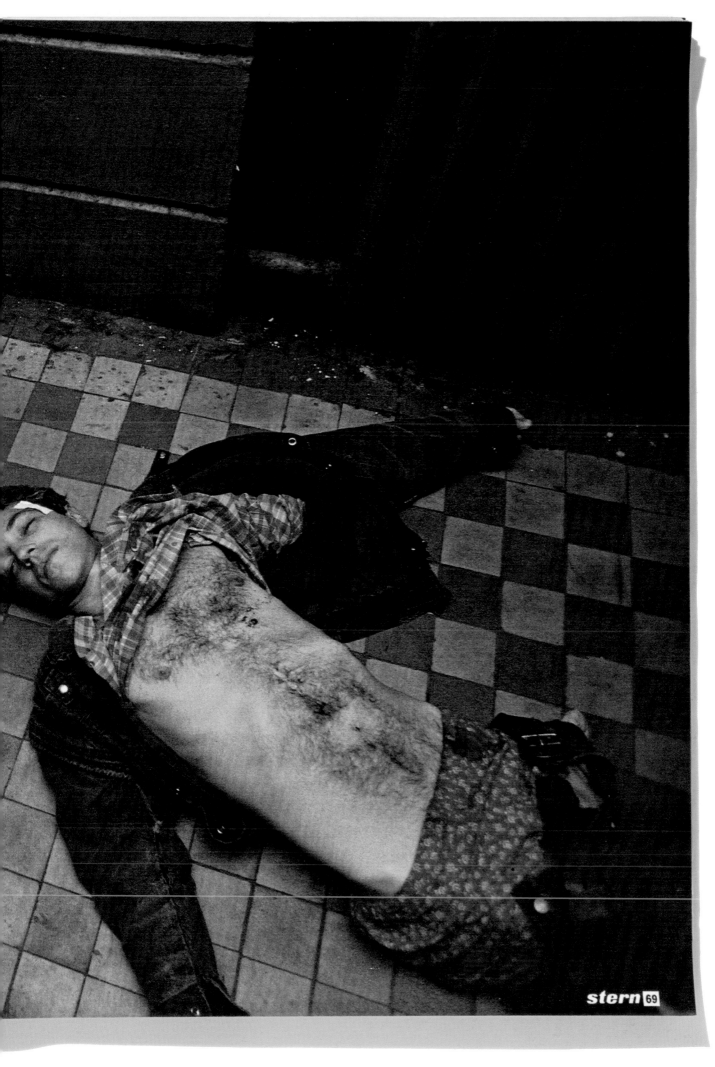

During the early 1990s Russia began to open up to international journalists working on daily life stories, although not without the help of expert local fixers (in Atwood's case, Stas, her street-wise young interpreter who helped to pull official strings). Once inside this women's prison in Perm, Siberia, she was able to win the trust of her subjects – both prisoners and warders – and documented it from their point of view. Curiosity was the initial spur for the story, but her surprise, shock and bewilderment at what she found gradually turned to a rage about the unjustified incarceration of women whose crimes were often responses to domestic violence and abuse. Atwood felt compelled to develop the project. Drawing on the model of Sebastião Salgado's 'Workers', with its instalments on related subjects, she produced essays on over forty women's prisons around the world that became chapters in an extended documentary essay, made over a ten-year period and involving extensive interviews with her subjects. (25 January 1992)

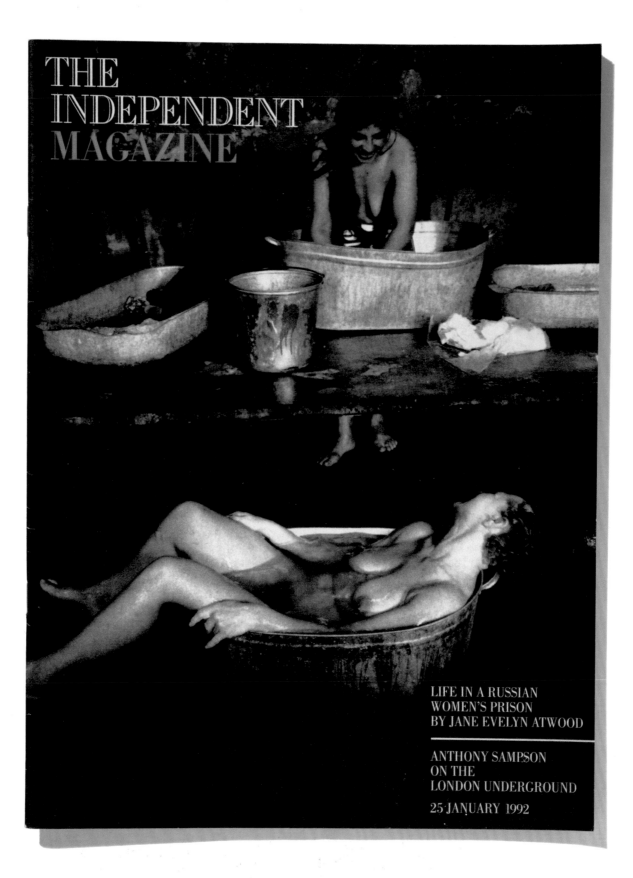

THE
INDEPENDENT
MAGAZINE

LIFE IN A RUSSIAN
WOMEN'S PRISON
BY JANE EVELYN ATWOOD

ANTHONY SAMPSON
ON THE
LONDON UNDERGROUND
25 JANUARY 1992

LOCKED UP

The American photographer JANE EVELYN ATWOOD spent a week at a typical women's prison in the former Soviet Union

Perm is an industrial Russian city of 1.5 million people at the foot of the Ural mountains. Twenty minutes outside the city, surrounded by a thick forest of tall pines, lies the Perm Penal Colony for Women. There are no signs to indicate what is inside. The muddy, pot-holed driveway and the low, red brick buildings, badly in need of repair, look more like a dilapidated farm than a women's prison. Anything from 400 to 1,200 women live here. Many of them have been incarcerated several times before.

The republics of the former Soviet Union hold 27,000 woman prisoners in 49 institutions. Under the presidency of Mikhail Gorbachev, reform was under way. Thousands of political and non-violent prisoners had been released; thousands more were benefiting from increased access to the outside world. Now, prisons and prisoners are in the hands of the republics. No one is certain how – or if – reform will progress.

I spent a week in Perm last year, before the break-up of the Soviet Union. There was evidence of reform, but the prison was in other ways primitive, as if lodged somewhere between *glasnost* and old-fashioned Soviet brutalism. Most of the prisoners were in for ordinary criminal offences, such as theft, but others were in for crimes which are being gradually abolished, such as infringement of the internal passport laws.

The prison population was at its lowest, but I was told it was not uncommon for 200 new prisoners to arrive at once. At first shy or suspicious, the women were surprisingly quick to accept my presence. A few did not allow me to photograph them at all, but others gave me access to all parts of their lives.

Unlike most prisons in the West, there are no cells at Perm. The women live in dormitories that house from 80 to 180, and

Right: A woman washing in a steam bath in the Perm Penal Colony for Women, Russia.

Below: Two inmates at Perm. The woman on the left has tuberculosis, which is rife in the prison.

Overleaf: These in solitary confinement can exercise in outdoor cages for half an hour a day.

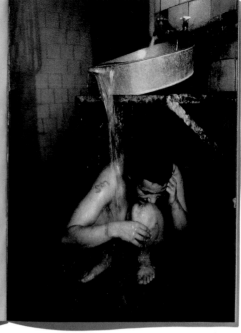

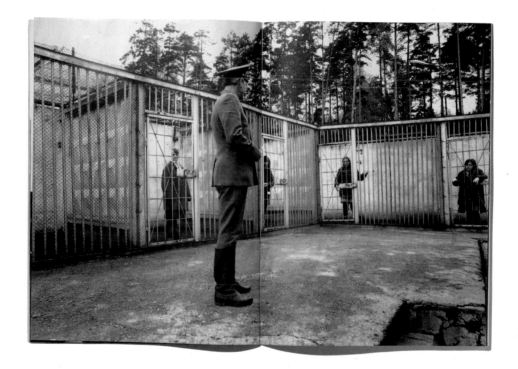

sleep in bunk beds. During my visit, the prisoners slept two to a bed, but three women share a mattress when necessary.

The guards spend most of their time in small offices at the end of each dormitory. Many had had other jobs but were unable to find work. One woman had been a biologist and another a lawyer. There is no privacy for the prisoners, and male guards freely enter the dormitories. Inmates often try to hide by hanging a sheet from the top bunk.

Food consists of a soupy slop with unidentifiable pieces floating in it. It is poured from metal buckets into metal bowls. Smoking is not permitted, but it is tolerated. Thirty minutes are allotted for meals, but the women eat in ten and use the rest of the time to smoke – in the toilets or the dormitory doorways.

The toilets are holes in the ground with three sides and no doors but, unlike in the West, they are located in a separate room from the sleeping area. Visits last two hours, and prisoners are also entitled to two three-day visits a year. These take place in small rooms off a long corridor, at the end of which is a kitchen where families can prepare meals. During this time, the prisoners live with their children, husbands, mothers and friends. After visits, the women are often obliged to submit to an internal body search by a prison gynaecologist.

Perm is a labour camp. The women spend eight hours a day in huge workshops, mostly at sewing machines. They make uniforms for the firemen of Russia. They cut gloves and large panels for the jackets out of heavy pieces of rubber. Many of the women have tuberculosis, but they are still required to work. When they go anywhere within the prison, inmates move in military formation, either lining up themselves or at the orders of the guards. They are required to wear uniforms – thick tights, knee-high heavy leather boots, short, fitted skirts, and shirts with their names embroidered on them or heavy, quilted jackets. They wear white headscarves indoors and thick shawls when they are outside. The headscarves represent prison to the women. They regard them as humiliating and some didn't want to be photographed in them.

A couple of times a week, the women are allowed to take a steam bath. Here they wash themselves and their clothes. The water is hot and there is plenty of it.

The solitary confinement cells are in an isolated building. Women can be held in them for as long as six months. The walls of the cells are crumbling and painted black instead of tea. They are allowed outside for exercise once a day, for half an hour, in cages where they are surveyed by a guard. One woman asked to be put in solitary confinement because she said that communal life was driving her crazy.

There is a nursery and maternity ward. A child was born an hour before my arrival one morning. Prisoners are allowed to keep their babies until they are 18 months old. There are about 30 babies in the nursery and the women can leave work or the dormitories to nurse them three times a day. The nursery is clean and the attendants wear white hospital gowns.

The guards are envious of the nursery; they say that their own babies, living outside the prison, are less fortunate. They say their babies are not as well fed and cared for. ●

Right: A prisoner in solitary confinement.

Below: A carpeted room at Perm in which prisoners and guards can sit in comfortable chairs and listen to music.

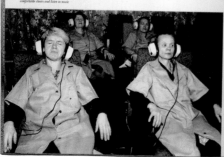

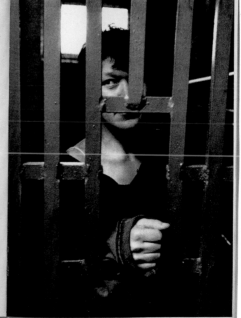

Since 1990, Swiss photographer Daniel Schwartz has produced complex documentary essays, infusing travel stories with political content. When he produced his essay about Burma, the country had just been taken over by its military and renamed the Union of Myanmar. All political parties were banned, and the country's elected leader, Aung San Suu Kyi, was placed under house arrest. Schwartz's essay conveys the sense of crisis without resorting to melodrama or cliché. Unlike many of his contemporary photo essayists (for whom strength of imagery takes priority over content) he employs economic analysis and an understanding of cultural history to drive his work – without giving up the chance to make beautiful images. Over the following years, Schwartz continued to work in Vietnam, Cambodia and Bangladesh. His resulting book, *Delta: the Perils, Profits and Politics of Water in South and Southeast Asia* (1997), marries the qualities of the artistic portfolio with the pointed analysis of a development report. (November 1992)

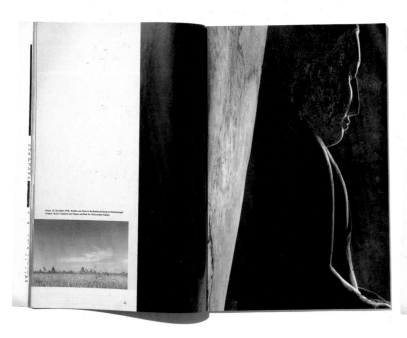

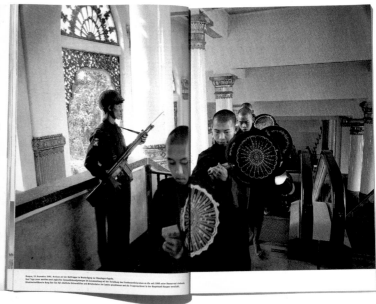

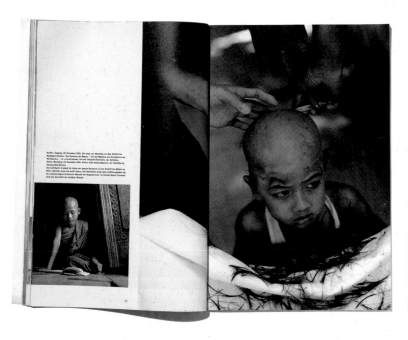

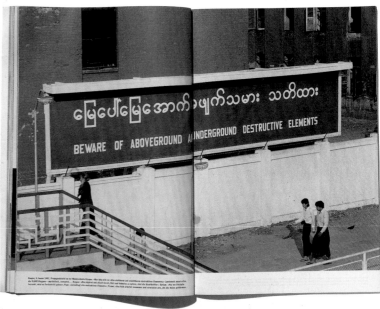

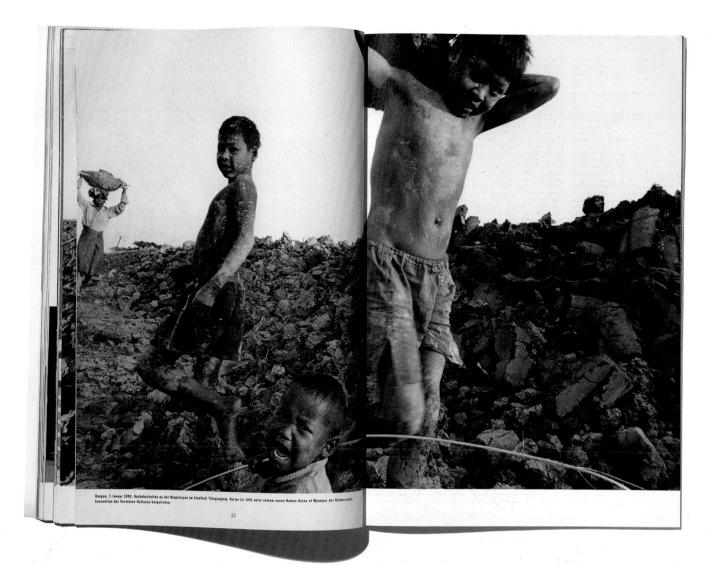

Rangun, 7. Januar 1992. Aushebarbeiten an der Ringstrasse im Stadtteil Thingangyun. Burma ist 1991 unter seinem neuen Namen Union of Myanmar der Kinderrechts-konvention der Vereinten Nationen beigetreten.

52

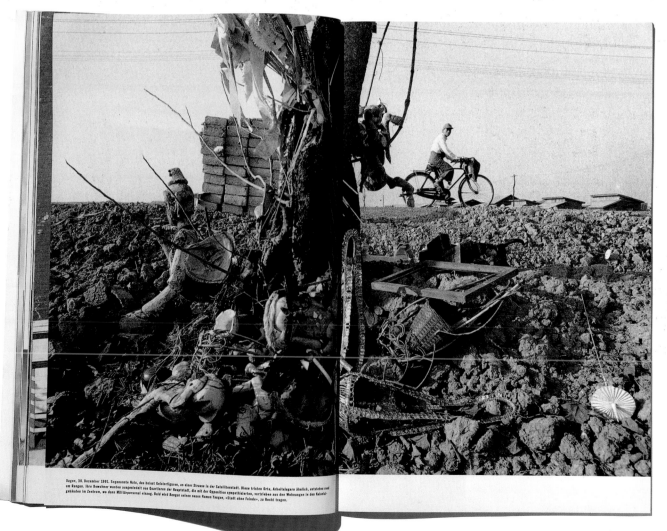

Dagon, 30. Dezember 1991. Sogenannte Nats, das heisst Geisterfiguren, an einer Strasse in der Satellitenstadt. Diese tristen Orte, Arbeitslagern ähnlich, entstehen rund um Rangun. Ihre Bewohner wurden ausgesiedelt aus Quartieren der Hauptstadt, die mit der Opposition sympathisierten, vertrieben aus den Wohnungen in den Kolonial-gebäuden im Zentrum, wo dann Militärpersonal einzog. Bald wird Rangun seinen neuen Namen Yangon, «Stadt ohne Feinde», zu Recht tragen.

In 2000 Wolfgang Tillmans became the first photographer to be awarded the Turner Prize for contemporary art, for installations that included large inkjet prints and pages of magazines attached to the wall with pins. From the outset, Tillmans broke conventional boundaries. Exhibiting photographs on gallery walls as well as on the pages of magazines, and blurring the lines between reportage and fashion, commercial and art photography, he contested the traditional hierarchy of artistic value coined in Walker Evans' ironic statement, 'This picture is art, it belongs in a museum. This picture is journalism, it belongs in a wastebasket.' Tillmans' influential early work involved photographing and designing iconoclastic visual reports on cultural events for *I-D*, the British youth lifestyle magazine, combining portraits, still lifes, and staged and reportage photographs. In a diary-like cataloguing of his preoccupations – boys, friends, clothes, politics – no one thing matters more than any other. He expresses equal pleasure in everything. (September 1992)

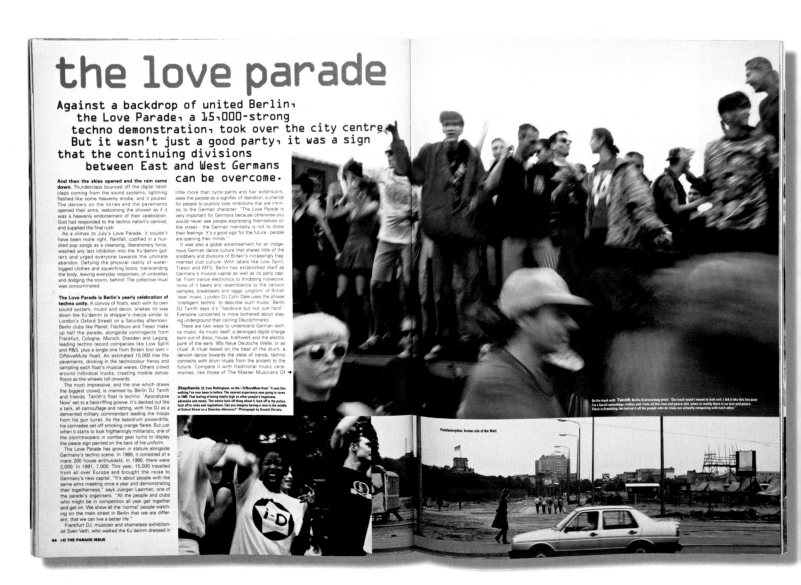

the love parade

Against a backdrop of united Berlin, the Love Parade, a 15,000-strong techno demonstration, took over the city centre. But it wasn't just a good party, it was a sign that the continuing divisions between East and West Germans can be overcome.

And then the skies opened and the rain came down. Thunderclaps bounced off the digital handclaps coming from the sound systems, lightning flashed like some heavenly strobe, and it poured. The dancers on the lorries and the pavements opened their arms, welcoming the shower as if it was a heavenly endorsement of their celebration. God had responded to the techno nation's carnival, and supplied the final rush.

As a climax to July's Love Parade, it couldn't have been more right. Rainfall, codified in a hundred pop songs as a cleansing, liberationary force, washed any last inhibition into the Ku'damm gutters and urged everyone towards the ultimate abandon. Defying the physical reality of waterlogged clothes and squelching boots, transcending the body, leaving everyday responses, of umbrellas and dodging the storm, behind. The collective ritual was consummated.

The Love Parade is Berlin's yearly celebration of techno unity. A convoy of floats, each with its own sound system, music and decor, snakes its way down the Ku'damm (a shopper's mecca similar to London's Oxford Street) on a Saturday afternoon. Berlin clubs like Planet, Fischbüro and Tresor make up half the parade, alongside contingents from Frankfurt, Cologne, Munich, Dresden and Leipzig, leading techno record companies like Low Spirit and R&S, plus a single one from Britain (our own i-D/NovaMute float). An estimated 15,000 line the pavements, drinking in the technicolour frenzy and sampling each float's musical wares. Others crowd around individual trucks, creating mobile dancefloors as the wheels roll onwards.

The most impressive, and the one which draws the biggest crowd, is manned by Berlin DJ Tanith and friends. Tanith's float is techno: 'Apocalypse Now' set to a hard-riffing groove. It's decked out like a tank, all camouflage and netting, with the DJ as a demented military commandant leading the troops from his gun turret. As the bassdrum powerdrills, his comrades set off smoking orange flares. But just when it starts to look frighteningly militaristic, one of the stormtroopers in combat gear turns to display the peace sign painted on the back of his uniform.

The Love Parade has grown in stature alongside Germany's techno scene. In 1989, it consisted of a mere 200 house enthusiasts. In 1990, there were 2,000. In 1991, 7,000. This year, 15,000 travelled from all over Europe and brought the noise to Germany's new capital. "It's about people with the same aims meeting once a year and demonstrating their togetherness," says Juergen Laarman, one of the parade's organisers. "All the people and clubs who might be in competition all year get together and get on. We show all the 'normal' people watching on the main street in Berlin that we are different, that we can live a better life."

Frankfurt DJ, musician and shameless exhibitionist Sven Vath, who walked the Ku'damm dressed in little more than cycle pants and hair extensions, sees the parade as a signifier of liberation, a chance for people to publicly lose inhibitions that are intrinsic to the German character: "The Love Parade is very important for Germans because otherwise you would never see people expressing themselves on the street - the German mentality is not to show their feelings. It's a good sign for the future - people are opening their minds."

It was also a global advertisement for an indigenous German dance culture that shares little of the snobbery and divisions of Britain's increasingly fragmented club culture. With labels like Low Spirit, Tresor and MFS, Berlin has established itself as Germany's musical capital as well as its party capital. From trance electronics to throbbing noisecore, none of it bears any resemblance to the cartoon samples, breakbeats and ragga 'junglism' of British 'rave' music. London DJ Colin Dale uses the phrase 'intelligent techno' to describe such music. Berlin DJ Tanith says it's "hardcore but not *just* hard". Everyone concerned is more bothered about staying underground than coining Deutschmarks.

There are two ways to understand German techno music. As music itself, a deranged digital charge born out of disco, house, Kraftwerk and the electropunk of the early '80s Neue Deutsche Welle, or as ritual. A ritual based on the beat of the drum, a dervish dance towards the state of trance, techno connects with drum rituals from the ancient to the future. Compare it with traditional music ceremonies, like those of The Master Musicians Of ➔

Stephanie, 23, from Nottingham, on the i-D/NovaMute float: "It was like nothing I've ever been to before. The nearest experience was going to raves in 1989. That feeling of being totally high on other people's happiness, adrenalin and music. The whole fuck-off thing about it, fuck off to the police, fuck off to rules and regulations. Can you imagine having a rave in the middle of Oxford Street on a Saturday afternoon?" Photograph by Donald Christie.

On the truck with **Tanith**, Berlin DJ/recording artist. "Our truck wasn't meant to look evil, I did it like this because I'm a fan of camouflage clothes and I hate all this love and peace shit, when in reality there is no love and peace. There is friendship, but behind it all the people who dj clubs are actually competing with each other."

Potsdamerplatz, former site of the Wall.

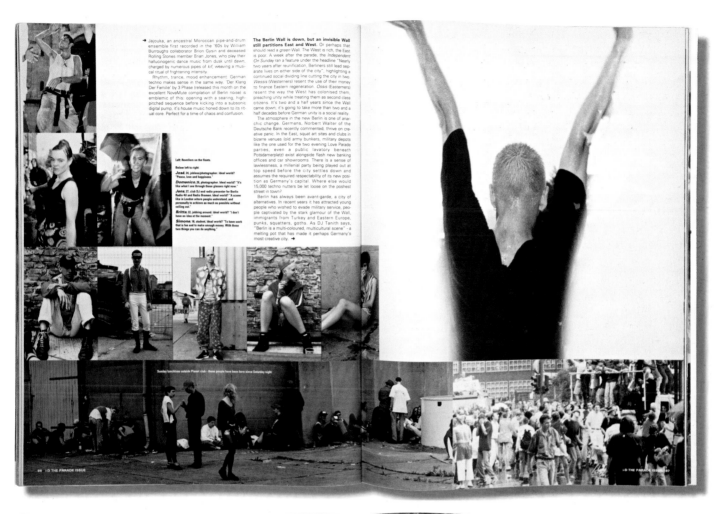

→ Jajouka, an ancestral Moroccan pipe-and-drum ensemble first recorded in the '60s by William Burroughs collaborator Brian Gysin and deceased Rolling Stones member Brian Jones, who play their hallucinogenic dance music from dusk until dawn, charged by numerous pipes of *kif*, weaving a musical ritual of frightening intensity

Rhythm, trance, mood enhancement. German techno makes sense in the same way. 'Der Klang Der Familie' by 3 Phase (released this month on the excellent NovaMute compilation of Berlin noise) is emblemic of this: opening with a searing, high-pitched sequence before kicking into a subsonic digital pump, it's house music honed down to its ritual core. Perfect for a time of chaos and confusion.

Left: Revellers on the floats.

Below left to right:

José, 24, jobless/photographer. Ideal world? "Peace, love and happiness."

Domenico, 26, photographer. Ideal world? "It's like what I see through these glasses right now."

Jens, 27, club DJ and radio presenter for Berlin Radio 4U and Radio Bremen. Ideal world? "A scene like in London where people understand, and personally to achieve as much as possible without selling out."

Britta, 22, jobbing around. Ideal world? "I don't have an idea of the moment."

Simona, 18, student. Ideal world? "To have work that is fun and to make enough money. With those two things you can do anything."

The Berlin Wall is down, but an invisible Wall still partitions East and West. Or perhaps that should read a green Wall. The West is rich, the East is poor. A week after the parade, the *Independent On Sunday* ran a feature under the headline "Nearly two years after reunification, Berliners still lead separate lives on either side of the city", highlighting a continued social dividing line cutting the city in two. *Wessis* (Westerners) resent the use of their money to finance Eastern regeneration. *Ossis* (Easterners) resent the way the West has colonised them, preaching unity while treating them as second class citizens. It's two and a half years since the Wall came down, it's going to take more than two and a half decades before German unity is a social reality.

The atmosphere in the new Berlin is one of anarchic change. Germans, Norbert Walter of the Deutsche Bank recently commented, thrive on creative panic. In the East, squat art sites and clubs in bizarre venues (old army bunkers, military depots like the one used for the two evening Love Parade parties, even a public lavatory beneath Potsdamerplatz) exist alongside flash new banking offices and car showrooms. There is a sense of lawlessness, a millenial party being played out at top speed before the city settles down and assumes the required respectability of its new position as Germany's capital. Where else would 15,000 techno nutters be let loose on the poshest street in town?

Berlin has always been avant-garde, a city of alternatives. In recent years it has attracted young people who wished to evade military service, people captivated by the stark glamour of the Wall, immigrants from Turkey and Eastern Europe, punks, squatters, goths. As DJ Tanith says, "Berlin is a multi-coloured, multicultural scene" - a melting pot that has made it perhaps Germany's most creative city. →

Sunday lunchtime outside Planet club - these people have been here since Saturday night

86 i-D THE PARADE ISSUE

i-D THE PARADE ISSUE 87

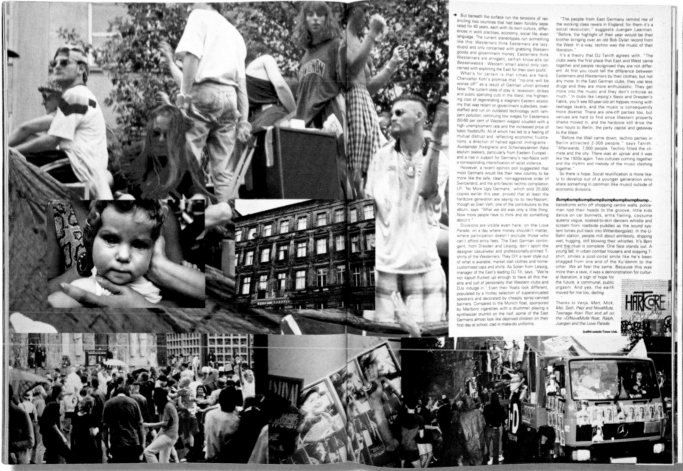

→ But beneath the surface run the tensions of reconciling two countries that had been forcibly separated for 40 years, each with its own culture, differences in work practices, economy, social life, even language. The current stereotypes run something like this: Westerners think Easterners are lazy, stupid and only concerned with grabbing Western goods and government money; Easterners think Westerners are arrogant, selfish know-alls (or *Besserwessis* - Western smart alecs) only concerned with exploiting the East for their own profit.

What's for certain is that times are hard. Chancellor Kohl's promise that "no-one will be worse off" as a result of German union proved false. The current state of play is recession, strikes and public spending cuts in the West, the frightening cost of regenerating a stagnant Eastern economy that was reliant on government subsidies, over-staffed and run on outdated technology with rampant pollution; continuing low wages for Easterners (50-60 per cent of Western wages) coupled with a high unemployment rate and the increased price of basic foodstuffs. All of which has led to a feeling of mutual distrust and, reflecting economic frustrations, a direction of hatred against immigrants - *Auslaender* (foreigners) and *Scheinasylanten* (fake asylum seekers, particularly from Eastern Europe) - and a rise in support for Germany's neo-Nazis and a corresponding intensification of racist violence.

However, a recent opinion poll suggested that most Germans would like their new country to be more like the safe, clean, non-aggressive order of Switzerland, and the anti-fascist compilation LP, 'No More Ugly Germans', which sold 20,000 copies earlier this year, proved that at least the hardcore generation are saying no to neo-Nazism; though as Sven Vath, one of the contributors to the album, says: "What we did was only a little thing. Now more people have to think and do something about it."

Divisions are visible even here, on the Love Parade, on a day where money shouldn't matter, where participation doesn't exclude those who can't afford entry fees. The East German contingent, from Dresden and Leipzig, don't sport the designer casualwear and professionally-printed T-shirts of the Westerners. They DIY a raver style out of what is available, market stall clothes and home-customised caps and shirts As Soren from Leipzig, manager of the East's leading DJ Till, says, "We're not kaputt (fucked up) enough to have all this theatre and cult of personality that Western clubs and DJs indulge in." Even their floats look different, populated by a motley selection of superannuated speakers and decorated by cheaply spray-canned banners. Compared to the Munich float, sponsored by Marlboro cigarettes with a drummer playing a synthesizer drumkit on the roof, some of the East Germans almost look like deprived children on their first day at school, clad in make-do uniforms.

"The people from East Germany remind me of the working class ravers in England; for them it's a social revolution," suggests Juergen Laarman. "Before, the highlight of their year would be their brother bringing over an old Bob Dylan record from the West. In a way, techno was the music of their liberation."

It's a theory that DJ Tanith agrees with. "The clubs were the first place that East and West came together and people recognised they are not different. At first you could tell the difference between Easterners and Westerners by their clothes, but not any more. In the East German clubs, they use less drugs and they are more enthusiastic. They get more into the music and they don't criticise as much." In clubs like Leipzig's Basis and Dresden's Fabrik, you'll see 50-year-old art hippies mixing with teenage ravers, and the music is consequently more diverse. There are one-off parties too, but venues are hard to find since Western property sharks moved in, and the hardcore still drive the two hours to Berlin, the party capital and gateway to the West.

"Before the Wall came down, techno parties in Berlin attracted 2-300 people," says Tanith. "Afterwards, 7,000 people. Techno fitted the climate and the city. There was an uproar and it was like the 1920s again. Two cultures coming together and the rhythm and melody of the music clashing together."

So there is hope. Social reunification is more likely to develop out of a younger generation who share something in common (like music) outside of economic divisions.

Bumpbumpbumpbumpbumpbumpbumpbump... bassdrums echo off shopping centre walls, policemen nod their heads to the groove, little kids dance on car bonnets, arms flailing, costume queens vogue, soaked-to-skin dancers whistle and scream from roadside puddles as the sound system lorries pull back into Wittenbergplatz. In the U-Bahn station, people mill about aimlessly, dripping wet, hugging, still blowing their whistles. It's 8pm and the ritual is complete. One face stands out. A young lad, in urban combat trousers and sopping T-shirt, smiles a post-coital smile like he's been shagged from one end of the Ku'damm to the other. We all feel the same. Because this was more than a rave, it was a demonstration for cultural liberation, a sign of hope for the future, a communal, public orgasm. And yes, the earth moved for me too, darling.

Thanks to Vanja, Matt, Mick, Mel, Seth, Pepi and NovaMute, Teenage Atari Riot and all on the i-D/NovaMute! float, Ralph, Juergen and the Love Parade.

Graffiti outside Tresor club.

Steve McCurry began photographing in Afghanistan in 1979, when he was smuggled into the country to report on mujahedeen resistance to Soviet forces. The resulting story began an affinity with the region – a relationship with its people and landscapes and an aptitude for navigating its social conventions. It also earned him a Robert Capa Gold Medal, launching his long relationship with *National Geographic*. In the spring of 1992, accompanied by writer Richard Mackenzie, McCurry returned for the first time since the departure of the Soviets to report on the Afghan recovery. While his earlier photographs are raw by comparison, by the time McCurry revisited he had perfected a craft that was at once old-fashioned, in the traditions of humanist reportage, while employing a heightened awareness of light and colour within a seductive, contemporary pictorialism. Always informative and relentlessly optimistic, his pictures have become a central ingredient of *National Geographic* from the early 1980s to the present – in forty major stories and some of its most memorable covers – as the magazine sought to outshine its rivals with the brilliance of its pictures. (October 1993)

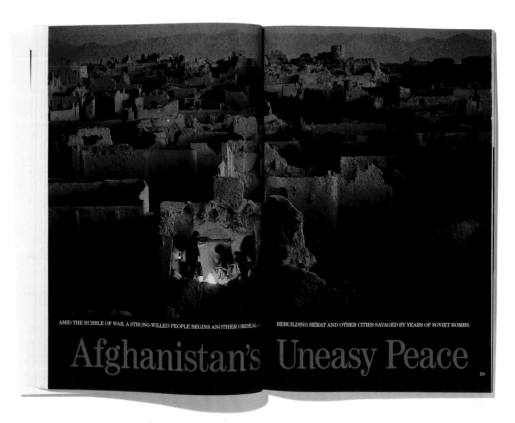

AMID THE RUBBLE OF WAR, A STRONG-WILLED PEOPLE BEGINS ANOTHER ORDEAL— REBUILDING HERAT AND OTHER CITIES SAVAGED BY YEARS OF SOVIET BOMBS.

Afghanistan's Uneasy Peace

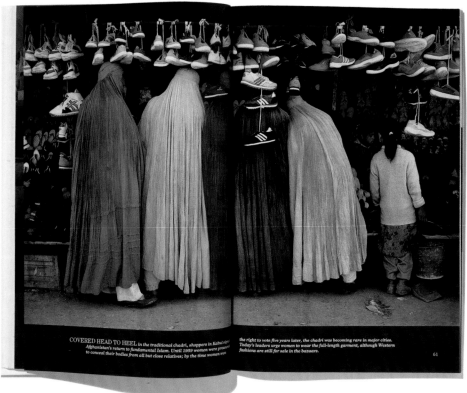

COVERED HEAD TO HEEL *in the traditional chadri, shoppers in Kabul signal Afghanistan's return to fundamental Islam. Until 1959 women were pressured to conceal their bodies from all but close relatives; by the time women won* the right to vote five years later, the chadri was becoming rare in major cities. Today's leaders urge women to wear the full-length garment, although Western fashions are still for sale in the bazaars.

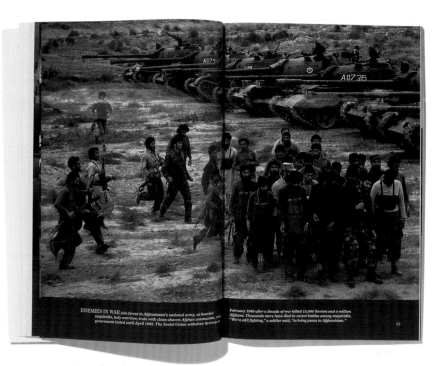

ENEMIES IN WAR join forces in Afghanistan's national army, as bearded mujahidin, holy warriors, train with clean-shaven Afghan communists, whose government lasted until April 1992. The Soviet Union withdrew its troops in February 1989 after a decade of war killed 15,000 Soviets and a million Afghans. Thousands more have died in recent battles among mujahidin. "We're still fighting," a soldier said, "to bring peace to Afghanistan."

63

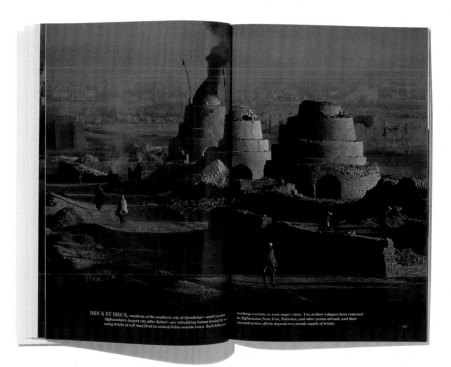

BRICK BY BRICK, residents of the southern city of Qandahar—until recently Afghanistan's largest city after Kabul—are rebuilding homes leveled by war, using bricks of soft mud fired in conical kilns outside town. Such kilns are working overtime in most major cities. Two million refugees have returned to Afghanistan from Iran, Pakistan, and other points abroad, and their reconstruction efforts depend on a steady supply of bricks.

69

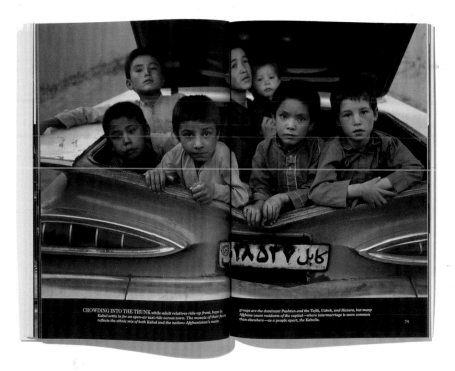

CROWDING INTO THE TRUNK while adult relatives ride up front, boys in Kabul settle in for an open-air taxi ride across town. The mosaic of their faces reflects the ethnic mix of both Kabul and the nation: Afghanistan's main groups are the dominant Pashtun and the Tajik, Uzbek, and Hazara, but many Afghans count residents of the capital—where intermarriage is more common than elsewhere—as a people apart, the Kabulis.

79

South African-born Gideon Mendel provides both text and photographs for this story, which was the first in his campaigning engagement with the Aids epidemic in Africa. It features the bleak Malaga Mission Hospital in southern Zimbabwe where two Swiss doctors and a dozen African nurses care for 118 patients. On a formal level, these images are complex, with emotional relationships taking physical form, as shapes and volumes intersect and overlap. Mendel also becomes part of the story, as a witness or, perhaps, as an intruder; his edit includes one image showing a man in his wife's arms at the moment of his death. Mendel wrestled with the decision: 'In that situation, seconds after the man had died, as the reality of the situation began to strike me, his family began to wail and break down. I put my camera down and stopped photographing. But the doctor looked at me calmly and said, "Come on man, do your job." In that context of medical crisis it was the constructive thing I knew how to do.' (27 November 1993)

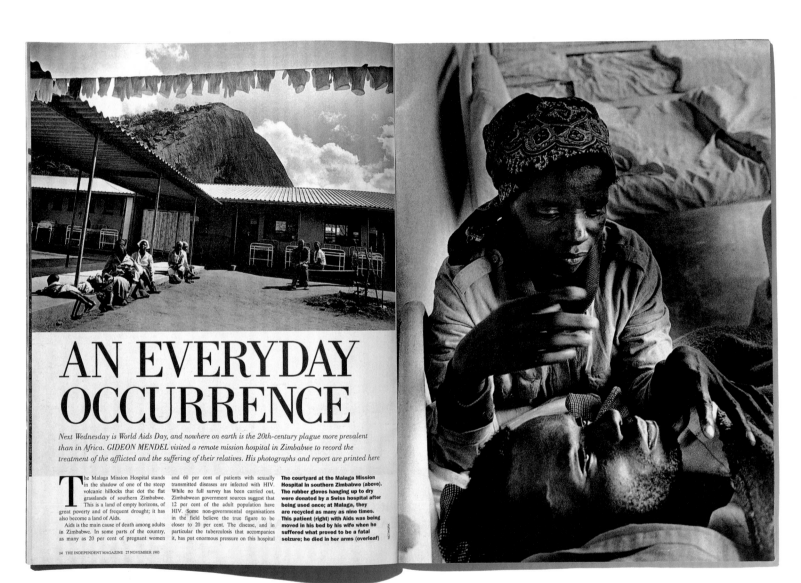

AN EVERYDAY OCCURRENCE

Next Wednesday is World Aids Day, and nowhere on earth is the 20th-century plague more prevalent than in Africa. GIDEON MENDEL visited a remote mission hospital in Zimbabwe to record the treatment of the afflicted and the suffering of their relatives. His photographs and report are printed here

The Malaga Mission Hospital stands in the shadow of one of the steep volcanic hillocks that dot the flat grasslands of southern Zimbabwe. This is a land of empty horizons, of great poverty and of frequent drought; it has also become a land of Aids.

Aids is the main cause of death among adults in Zimbabwe. In some parts of the country, as many as 20 per cent of pregnant women

and 60 per cent of patients with sexually transmitted diseases are infected with HIV. While no full survey has been carried out, Zimbabwean government sources suggest that 12 per cent of the adult population have HIV. Some non-governmental organisations in the field believe the true figure to be closer to 20 per cent. The disease, and in particular the tuberculosis that accompanies it, has put enormous pressure on this hospital

The courtyard at the Malaga Mission Hospital in southern Zimbabwe (above). The rubber gloves hanging up to dry were donated by a Swiss hospital after being used once; at Malaga, they are recycled as many as nine times. This patient (right) with Aids was being moved in his bed by his wife when he suffered what proved to be a fatal seizure; he died in her arms (overleaf)

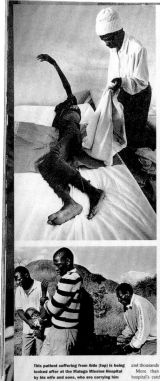

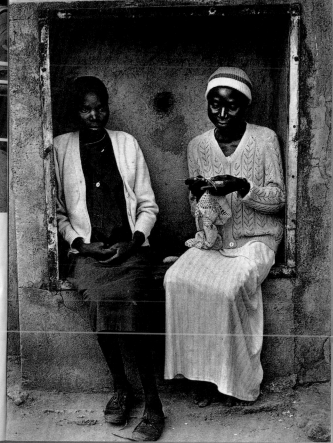

This patient suffering from Aids (top) is being looked after at the Malaga Mission Hospital by his wife and sons, who are carrying him (above) to visit a traditional healer in a clearing 200 yards from the hospital (right). Many patients in Africa use both Western and traditional medicine. The consultation cost the patient, who had been a government land-surveyor, 120 Zimbabwe dollars (about £12). Having inhaled smoke from a medicinal plant, he was possessed by the voice of his grandfather, who admonished the family for squandering cattle he had bequeathed them

and thousands like it across the continent.

More than 200,000 people live in the hospital's catchment area. Like most African hospitals, it is chronically overcrowded. There are 55 beds, but during the time I spent there it was caring for 118 patients, many of whom spend the daylight hours resting outside, where they can escape the congestion, while at night large numbers are obliged to sleep on the floor. The two Swiss doctors and 13 nurses, most of them Zimbabwean and including some sisters, both black and white, from the mission's convent nearby, also see about 50 outpatients

every day. Despite the large number of patients, the hospital is clean and hygienic.

As in many other hospitals around the country, well over half the patients here have Aids or HIV-related infections; every day, between five and 12 new cases are diagnosed on the basis of both typical symptoms and a positive HIV blood test (the standard of diagnosis in Zimbabwe is acknowledged by authorities on the disease to be high). As patients with Aids have low immunity to disease, the spread of tuberculosis has reached epidemic proportions.

When they are admitted to the hospital, most

patients bring members of their family with them to feed, clean and care for them. Small fires are lit in the hospital's dusty yard where the carers cook maize porridge and other food, both for themselves and to augment the patients' diet. At night, the wards of the hospital are crowded with the carers' sleeping bodies.

Many drugs which are used in the West to control the disease or delay its onset are beyond the means of simple hospitals such as this. When patients with Aids reach a point where nothing further can be done for them, they are discharged to be cared for at home by their

relatives, who are given instruction in how to cope by staff at the hospital.

In addition to being treated in the hospital, many patients with Aids also consult traditional healers, called *nyangas*. The hospital's doctors are aware of this and do not object: some of the healers are deeply versed in the properties of medicinal herbs and roots and, while they can no more cure Aids than Western doctors can, they may be able to exert a positive psychological influence and even, perhaps, relieve some of the symptoms.

In Zimbabwe, the taboo against talking about

sex means that open discussion of the Aids issue is still avoided by many people, while its causes – unsafe sexual activity, the widespread occurrence of sexually transmitted diseases and multiple sexual partners – remain largely unchecked. Attitudes are slowly changing: condoms are now being distributed, and there is growing awareness among young people of the value of using them. However, the dimensions of the problem are so vast that this is not nearly enough to halt the spread of the disease.

Rural society is being placed under great strain. The deaths of economically active men

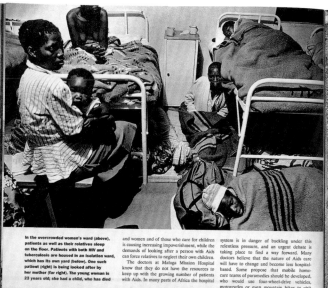

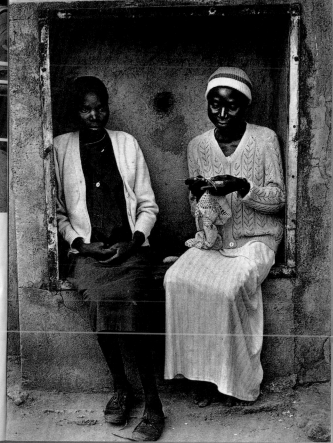

In the overcrowded women's ward (above), patients as well as their relatives sleep on the floor. Patients with both HIV and tuberculosis are housed in an isolation ward, which has its own yard (below). One such patient (right) is being looked after by her mother (far right). The young woman is 23 years old; she had a child, who has died

and women and of those who care for children is causing increasing impoverishment, while the demands of looking after a person with Aids can force relatives to neglect their own children.

The doctors at Malaga Mission Hospital know that they do not have the resources to keep up with the growing number of patients with Aids. In many parts of Africa the hospital

system is in danger of buckling under this relentless pressure, and an urgent debate is taking place to find a way forward. Many doctors believe that the nature of Aids care will have to change and become less hospital-based. Some propose that mobile home-care teams of paramedics should be developed, who would use four-wheel-drive vehicles, motorcycles or even mountain bikes to visit patients in their homes and teach the patients' relatives how to look after them. Others contend that this would be a misuse of the limited resources that are available.

On the last day of my stay at the hospital, I unwittingly photographed the death of a patient with Aids. I had begun to photograph the man as his wife started to lift him from the bed, to change his position. He then had a seizure; I carried on photographing, not realising until afterwards that he had died.

It has become one of the conventions of photojournalism that one can photograph illness and suffering, one can photograph bodies and funerals, but that photographing the moment of death is not allowed. Had I intruded on a sacred moment?

After much thought, I decided that these pictures, too, should be published. If the task I had set myself was to tell the story of Aids in Africa, I could not shy away from the cruel fact that Aids leads to death. I hope these images help to convey the tragedy caused by Aids. One death affects a family, a community, a society. This is a tragedy which is being repeated across Africa many times every day. ●

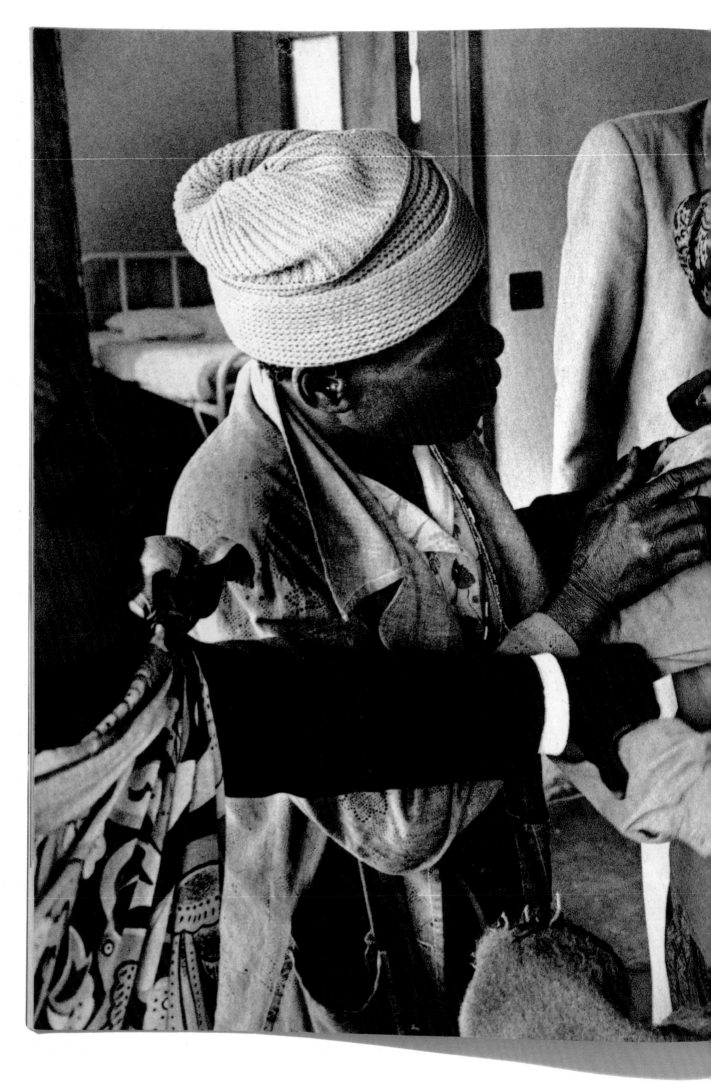

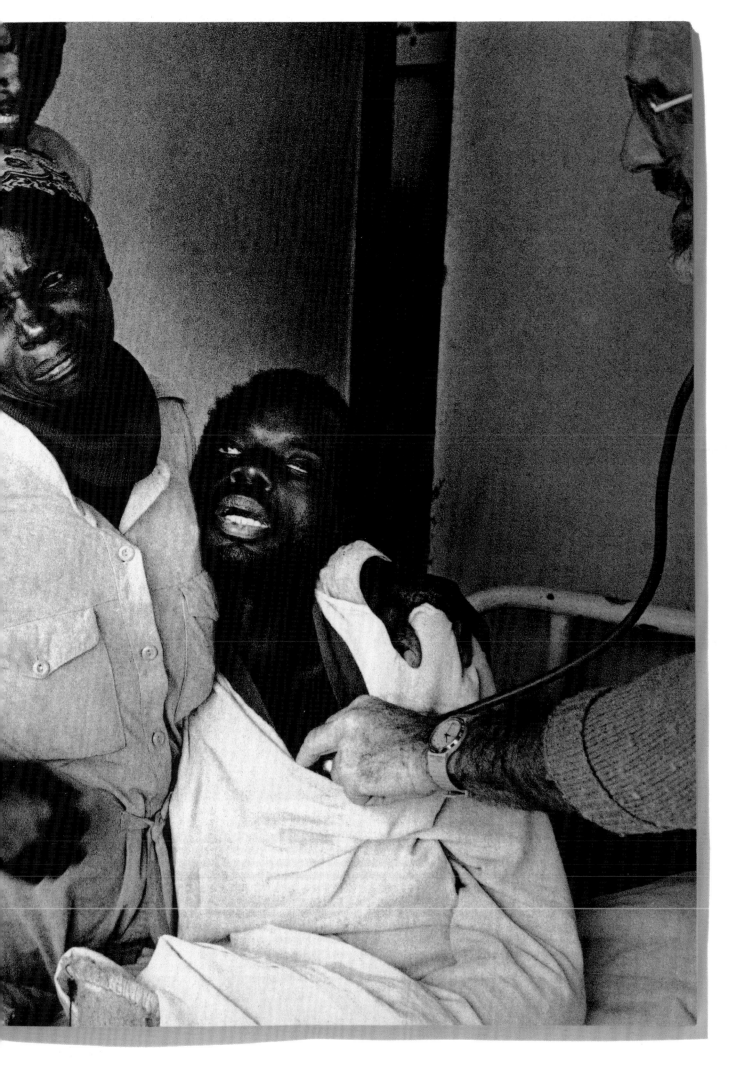

On Christmas Day 1979, *Twen*'s creator Willy Fleckhaus, and his protégé Hans-Georg Pospischil, conceived an idea for a colour supplement for the urbane readers of the *Frankfurter Allgemeine Zeitung* to satisfy the paper's need for a vehicle for colour advertising. It would not cover conventional current affairs stories, nor in fact 'stories' in the narrative sense at all, but would rely on extended photographic sequences that would be moody, often abstract or, to use Pospischil's term, 'mystical'. Carefully chosen photographers defined the sophisticated aesthetic style that the magazine could call its own – the exact opposite of the flamboyant, sensationalist *Stern*. Flash photography was banned. The cover would always feature photographs framed by a simple black background. Fleckhaus died before the first issue was published in 1980, but the magazine consistently maintained its strict criteria over the following 19 years with little variation. Alfred Seiland was one of the small group of favoured contributing photographers chosen by Pospischil. His essay on New England, with quiet airy landscapes captured in minimalist frames and rendered in muted colours, exemplifies the magazine's refined, contemplative approach. (30 December 1993)

Berge und Meer:
Die Staaten am nordwestlichen
Rand von Amerika bieten
beides, zur Freude
der Besucher, die in Newport
segeln oder den Mount
Washington per Dampfbahn
erklimmen

Sie setzte sich umständlich ihre Brille auf
und blätterte in einem dicken, zerfledderten Buch. Nur für eine Nacht, ja. Still
war es im Haus, beklemmend still. Die
Schiebefenster verschwanden hinter Lagen von
Rüschen, Mull und burgunderroten Stoffresten.
Aus braungrauem Teppichen stieg das Aroma
vieler langer Jahre. Staubduft, extra dry. Im
Licht der Schreibtischlampe schwebte die Decke
über den riesigen Schatten unserer Köpfe. Mit
aufreizender Gelassenheit arbeitete sie sich
durch ihre Lektüre. Sie ließ den Bleistift Seite um
Seite hinunterfahren, wog bedenklich das
Haupt und legte die Stirn in Falten. Vielleicht
hatte ich sie aus dem Bett geklingelt, vielleicht
müsste sie sich wachhalten. Deshalb Geduld. Zimmer Nummer fünf, entfuhr sie ihr plötzlich. Sie
zog eine Schublade auf und kramte nach einem
Schlüssel. Gehen Sie über den Hof, zu
ist die zweite Tür rechts. Frühstück gibt's zwischen sieben und neun. Have a good night.

WO DIE
PILGERVÄTER
MIT DER
MAYFLOWER
LANDETEN
Von Jordan Mejías
Fotos Alfred Seiland

19

Kürbisse und Kirchtürme:
Nördlich von New
York liegen Massachusetts und
New Hampshire, für
amerikanische Verhältnisse ganz
nah bei der Metropole,
und sind doch liebenswerte
Provinz.

Entlang den Umrissen des Nebengebäudes tastete ich mich an mannshohen
Hecken vorbei. Unter meinen Schritten
knirschte Kies. Der Schlüssel paßte
ins erste Schlüsselloch, das sich mir im Streichholzschein offenbarte. Ein winziges Zimmer.
Doch für das Bett war Platz genug. Und für den
Fernseher. In strähnigem Schwarzweiß hielt er
einen ganzen Kanal feil. Um so prächtiger funktionierte die Heizung. Ich drehte sie voll auf und
hatte nicht die Spur eines schlechten Gewissens.
Die Reise durch Neuengland, dachte ich mir,
muß nicht unbedingt in einer ofenlosen Blockhütte ihren Höhepunkt finden. Auch auf den
Spuren eines Ralph Waldo Emerson und seines
Schülers Henry David Thoreau braucht niemand ihrem naturentrückten Transzendentalismus unter freiem, nächtlichem Himmel zu testen.
Statt am Walden Pond in einem Schlafsack zu
kriechen, beschloß ich, noch einmal bei Henry
Thoreau selber über das ursprüngliche Landleben und seinen geliebten See nachzulesen.

NEW ENGLAND

21

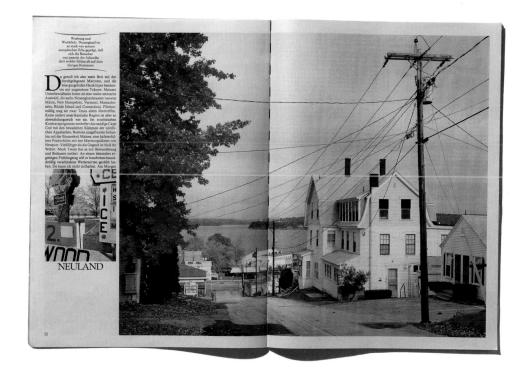

Werbung und
Weitblick: Neuengland ist
so stark von seinen
europäischen Erbe geprägt, daß
sich die Besucher
von jenseits des Atlantiks
dort wohler fühlen als auf dem
übrigen Kontinent

Da genoß ich also mein Bett mit der
durchgelegenen Matratze, und die
leise gurgelnden Heizkörper bescherten mir angenehme Träume. Meinem
Unterhaltungsdrang bot sie eine reiche seßnische
Auswahl, die sechs Neuenglandstaaten namens
Maine, New Hampshire, Vermont, Massachusetts, Rhode Island und Connecticut. Flächenmäßig mag sie zwei Texas allein übertreffen.
Keine andere amerikanische Region ist aber so
abwechslungsreich wie sie. Im touristischen
Kontrastprogramm wetteifert das sandige Cape
Cod mit den bewaldeten Kämmen der nördlichen Appalachen, Bostons ausgefranste Suburbia mit der Einsamkeit Maines, eine halbverfallene Fischerhütte mit den Marmorpalästen von
Newport. Vielfältiger als die Gegend ist bloß das
Wetter. Mark Twain hat es mit Bewunderung
und Bedauern notiert. An einem besonders ergiebigen Frühlingstag will er hundertunddreißig verschiedene Wettersorten gezählt haben. Da kann ich mithalten. Am Morgen

NEULAND

22

In his essay on Fès that appeared in *Du*, Bruno Barbey demonstrates his unmatched ability to make compositions of formal beauty and significance within the framework of thematic reportage. Born in Morocco, Barbey spent his youth in Paris and studied commercial photography in Switzerland, before covering war and conflict around the world during the 1960s, in the manner of the traditional photojournalist. But from the late 1970s, he began a steady retreat from the genre and into an ongoing personal essay on Morocco. Combining the timeless subject matter of Delacroix with the decorative colour of Matisse, this was more than an exercise in pursuing the 'pure pleasure of aestheticism' for Barbey. Informed by a knowledge of customs and popular superstitions, and by his own vivid childhood memories, his essay is an enquiry into Morocco's culture and his relationship to it – a puzzle defying resolution – as well as a personal celebration of its patterns, designs and structures. By the time of *Du*'s publication, his pictures of Morocco had evolved from their illustrative beginnings to a striking level of sensual power. (July/August 1994)

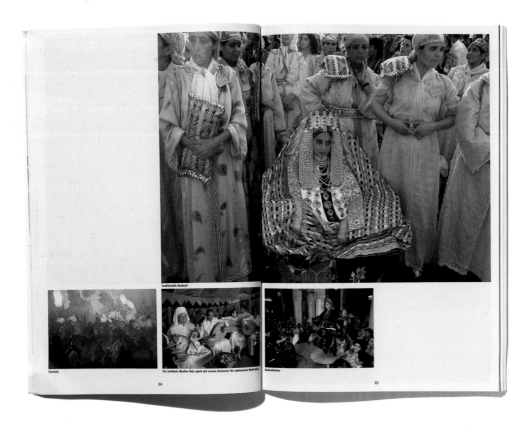

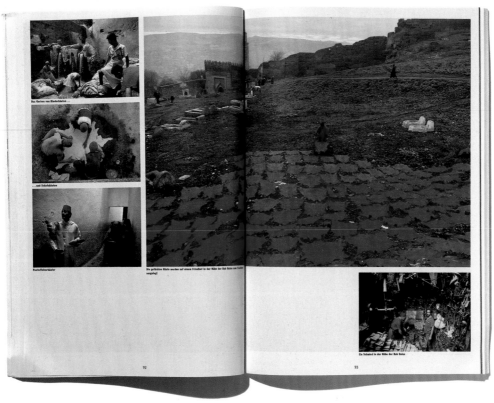

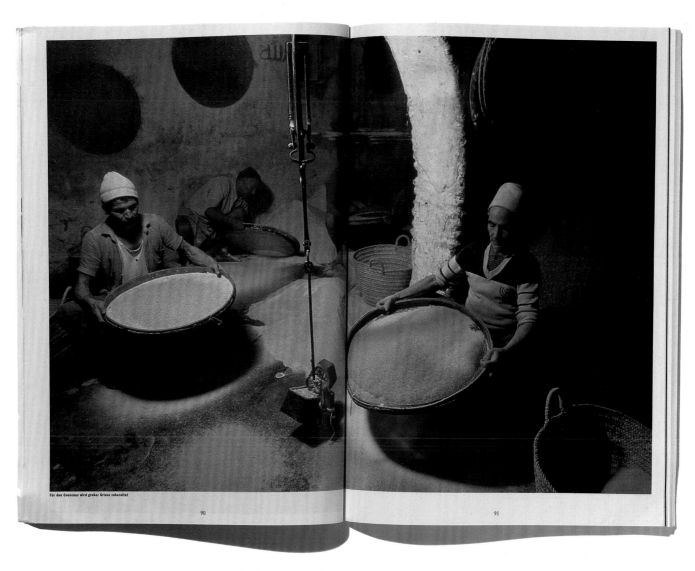

Für den Couscous wird grober Griess zubereitet

90

91

Der Hof (Riad) eines Wohnhauses in der Nähe des Gerberviertels

Der Innenhof der Moschee Qarawijin

Die Moschee, im 9. Jahrhundert von den Andalesiern errichtet, wurde zu Beginn des 13. Jahrhunderts von den Almohaden umgebaut

Rechte Seite: Tor im Innern des Königspalastes

96

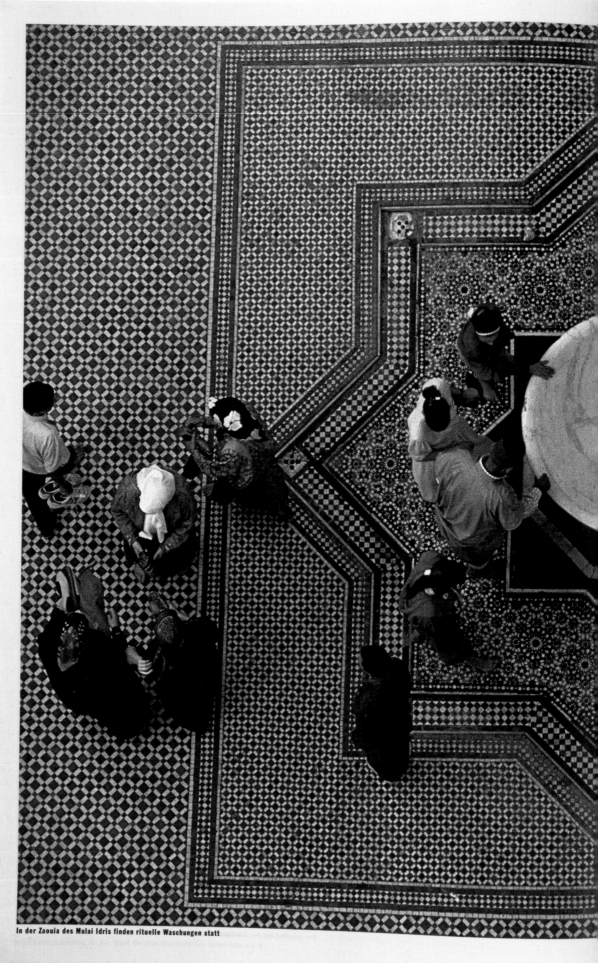

In der Zaouia des Mulai Idris finden rituelle Waschungen statt

100

294

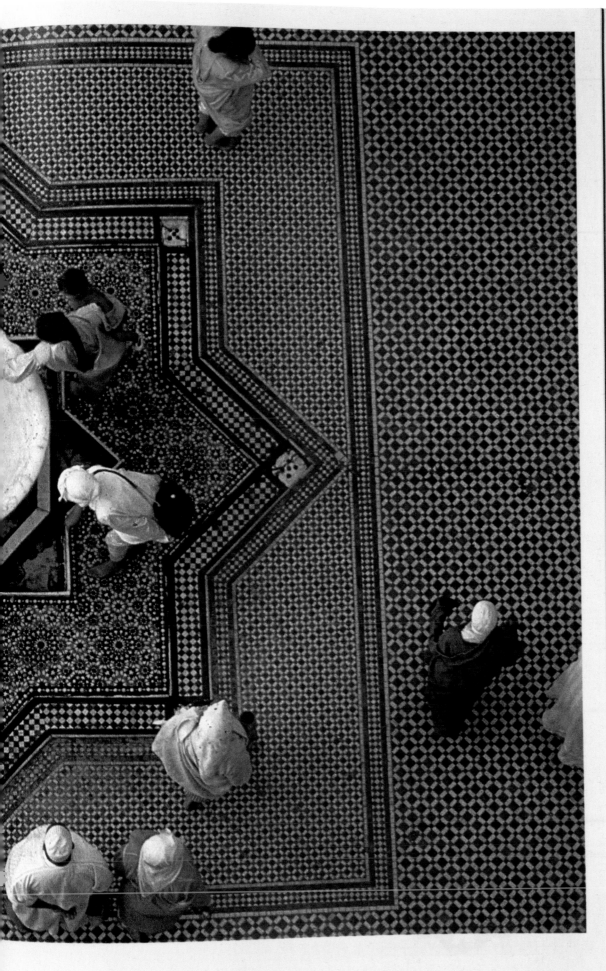

Süddeutsche Zeitung
ZIN

No. 20 — 14.5.2004

GUT GELAUFEN
Die Geschichte von Reinhold Messners Füßen

As the digital era gets into swing, with digital cameras reaching the consumer marketplace and the internet now a household tool, technological change continues at breakneck pace. The human genome is decoded and scientists clone a sheep. The world becomes more divided between spectacular wealth and extreme poverty, between and within nations, and China becomes a formidable economic force. Then, on 11 September 2001, Islamic terrorists mount an unparalleled attack on symbols of the political and military power of America and the global economic order, shifting history into a new dynamic. America's invasion of Iraq polarizes world opinion, while the Middle East descends into a renewed quagmire of violence. For photojournalism, there's plenty to address, but the environment has changed. Its cottage industry era has given way to consolidated global corporations, with photographers becoming content-providers low down on the supply chain. Princess Diana is killed in a car crash and photographers are blamed. The press tightens its belt, hard. Yet the public taste for photography grows more sophisticated and a booming market for photographic prints takes off. Photography moves from the fringe of the art world to its centre; the museum accommodates journalism and the magazine accommodates the artist. New opportunities are embraced by a group of brand-name reporter-artists, while accessible digital production and distribution tools – the camera-phone and the internet – challenge the authority of the professional photojournalist. Defining photo reports about American operations in Iraq and the Asian tsunami are by amateur photographers. Now everyone is watching.

LUCIAN PERKINS *Washington Post*
A bus on the road leading to Grozny during fighting between Chechen independence fighters and Russian troops. Chechnya, May 1995. World Press Photo of the Year 1995

CLAUS BJØRN LARSEN *Berlingske Tidende*
Wounded Kosovo-Albanian man walks the streets of Kukës, one of the largest gathering points for ethnic Albanian refugees fleeing violence in Kosovo. Albania, April 1999. World Press Photo of the Year 1999

LARA JO REGAN *Life*
Uncounted Americans: the mother of a Mexican immigrant family makes piñatas to support herself and her children. Texas, USA, 2000. World Press Photo of the Year 2000

ERIK REFNER *Berlingske Tidende*
The body of a one-year-old Afghan boy who died of dehydration is prepared for burial. Jalozai refugee camp, Pakistan, June 2001. World Press Photo of the Year 2001

FRANCESCO ZIZOLA *Agenzia Contrasto*
Landmine victims. Kuito, Angola, 1996. World Press Photo of the Year 1996

HOCINE *Agence France-Presse*
A woman cries outside the Zmirli Hospital, where the dead and wounded have been taken after a massacre in Bentalha. Algiers, Algeria, 23 September 1997. World Press Photo of the Year 1997

DAYNA SMITH *Washington Post*
At a funeral, relatives and friends comfort the widow of a Kosovo Liberation Army fighter shot dead the previous day while on patrol. Izbica, Kosovo, 6 November 1998. World Press Photo of the Year 1988

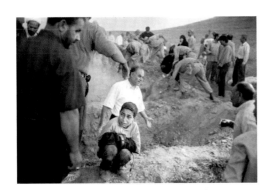

ERIC GRIGORIAN *Polaris Images*
Boy mourns at his father's graveside after earthquake. Qazvin Province, Iran, 23 June 2002. World Press Photo of the Year 2002

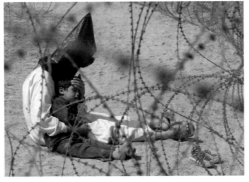

JEAN-MARC BOUJU *Associated Press*
Iraqi man comforts his son at a holding center for prisoners of war. An Najaf, Iraq, 31 March 2003. World Press Photo of the Year 2003

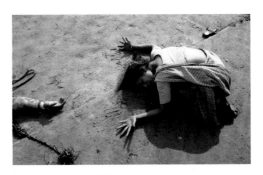

ARKO DATTA *Reuters*
Woman mourns relative killed in tsunami. Cuddalore, India, 28 December 2004. World Press Photo of the Year 2004

On January 15, 1995 the *Independent* magazine devoted a cover and a remarkable 20 pages to Paul Lowe's diary of Russia's assault on Grozny, following Chechen separatists' declaration of independence earlier in 1994. Lowe was one of only a handful of journalists in Grozny before the Russian tanks arrived, and the only independent photographer to stay through the Chechens' victory until the city finally fell – hence his coverage was uniquely comprehensive. Although the war subsequently dragged on and news media interest soon tired, news audiences at the time were riveted. Who were these Chechens? While Russia's spokesmen presented them as violent gangsters, Lowe painted a picture of a tribe of plucky Davids facing down a Russian Goliath. That the story ran so extensively was partly because the main events happened over Christmas (and in competition with the hijack of a French airliner), meaning the story stayed unusually fresh for a weekly supplement. The story proved Colin Jacobson's swansong: it was the last issue of the *Independent* magazine that he edited and seemed to signal the end of a photojournalistic era. (14 January 1995)

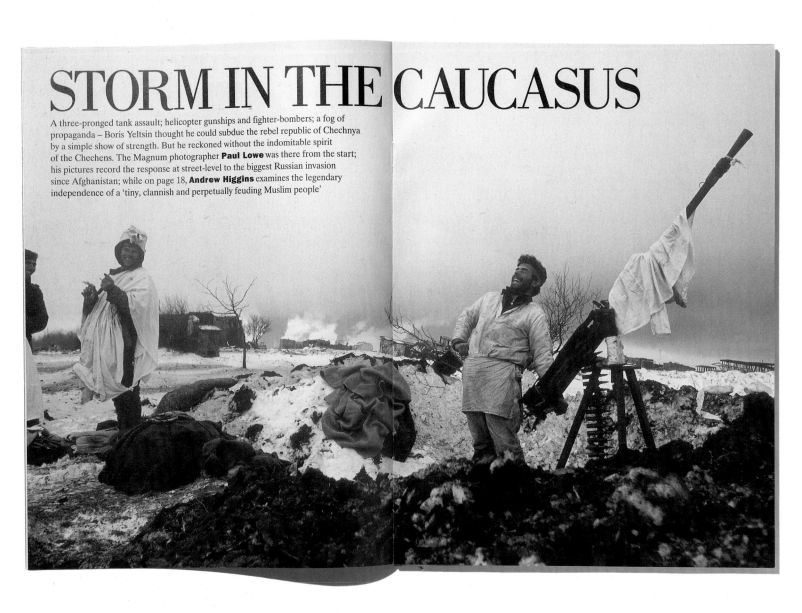

STORM IN THE CAUCASUS

A three-pronged tank assault; helicopter gunships and fighter-bombers; a fog of propaganda – Boris Yeltsin thought he could subdue the rebel republic of Chechnya by a simple show of strength. But he reckoned without the indomitable spirit of the Chechens. The Magnum photographer **Paul Lowe** was there from the start; his pictures record the response at street-level to the biggest Russian invasion since Afghanistan; while on page 18, **Andrew Higgins** examines the legendary independence of a 'tiny, clannish and perpetually feuding Muslim people'

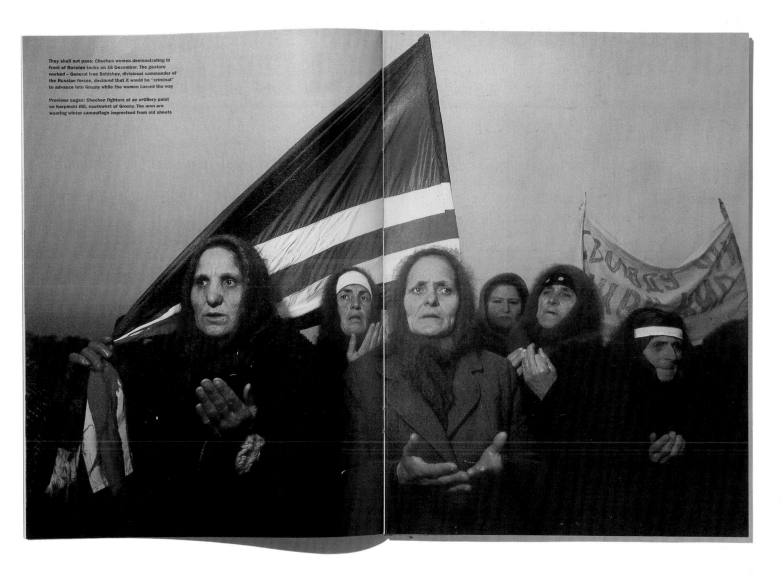

They shall not pass: Chechen women demonstrating in front of Russian tanks on 16 December. The gesture worked – General Ivan Babichev, divisional commander of the Russian forces, declared that it would be "criminal" to advance into Grozny while the women barred the way

Previous pages: Chechen fighters at an artillery point on Karpinski Hill, southwest of Grozny. The men are wearing winter camouflage improvised from old sheets

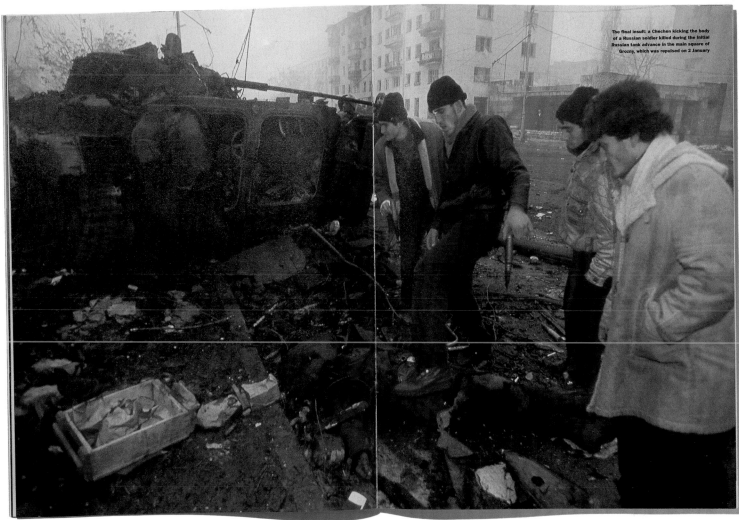

The final insult: a Chechen kicking the body of a Russian soldier killed during the initial Russian tank advance in the main square of Grozny, which was repulsed on 2 January

Cambodia's Khmer Rouge operated the secret prison S-21 at a former school in Phnom Penh, from 1975 to 1978, where those suspected of counter-revolutionary activity were photographed prior to their torture, forced confession and execution. Of the 14,200 political prisoners taken to S-21, only seven survived. Shortly after the fall of Pol Pot, the prison and its contents became a museum where, in March 1993, young American photographers Doug Niven and Chris Riley found the deteriorating negatives of the systematic prison records in a filing cabinet. They established the Photo Archive Group to clean, catalogue, print and present the approximately 6,000 photographs. First published in *Reportage* magazine, they have subsequently been widely published, exhibited and discussed. In February 1997, the Associated Press released an interview with Nhem Ein, revealing that he and five apprentices were the photographers responsible for the S-21 images. The true author, however, was the regime itself, and Nhem another of its victims. The work stands as a model for the rescue of other historically important photographs, and the potential for their sensational contemporary impact. (April 1995)

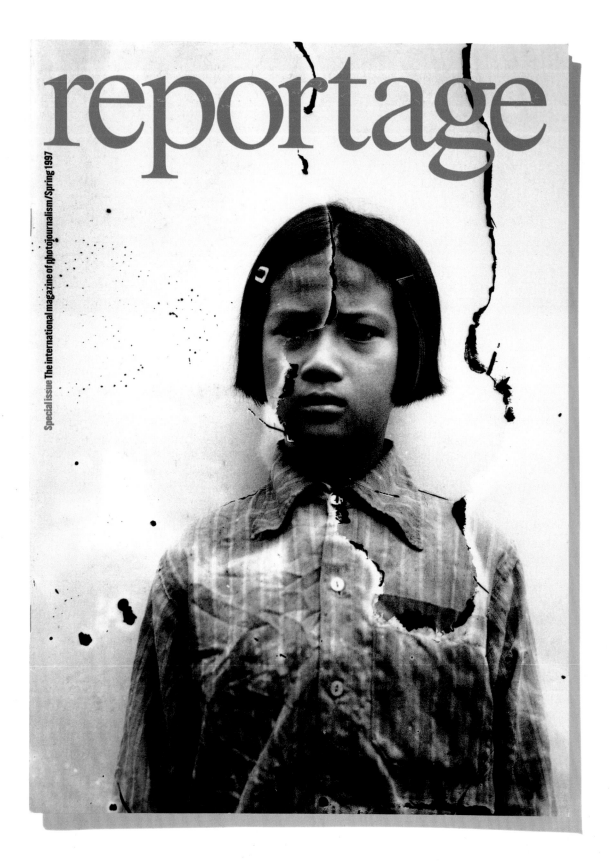

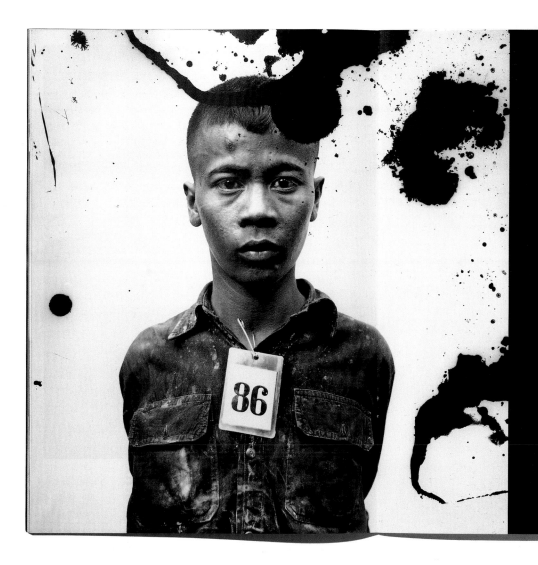

The sadness of S-21

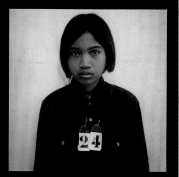

The catacomb-like heaps of bones exhumed from Cambodia's killing fields are a familiar, if grisly sight, but they are victims without faces. Less well-known are the prisoners of 'S-21' photographed by the Khmer Rouge

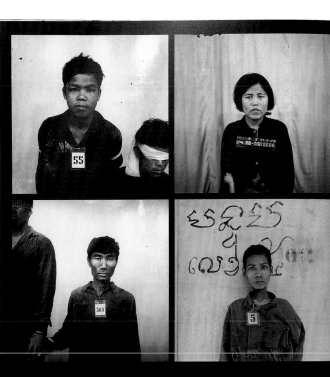

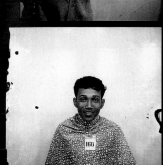

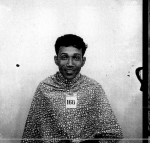

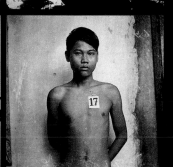

Until 16 April 1975, 'detention' at Tuol Sleng high school, like everywhere else in the world, simply meant being kept late in class. The very next day that changed for ever: 17 April was the birthday of a new millennium, a historical spasm so convulsive that its progenitors decreed an end to the old calendar.

This was Year Zero, when the revolutionary Khmer Rouge forces commanded by Pol Pot and his Paris-educated cadres overthrew 'bourgeois rule' and forced the citizens of Cambodia out of the cities to work in the fields. Under this crash-course scheme of Maoist re-education, detention at the high school at Tuol Sleng acquired an altogether more sinister and brutal aspect. The Khmer Rouge turned it into a prison, where those suspected of harbouring counter-revolutionary sentiments were interrogated, harassed, humiliated, forced into writing confessions and then, in any case, executed.

The Khmer Rouge's blunt renaming of the building 'S-21' was unintentionally eloquent, prefiguring the way in which the 14,000 Cambodians who passed through the school gates and died inside were themselves deprived of names, becoming numbers. The grim irony of their fate was that their killers – the self-styled enemies of bureaucracy – were themselves expert and meticulous bureaucrats, who kept not only a written record of each prisoner, including copies of confessions, but also a photograph of every one.

By the time the Vietnamese intervention of 1979 forced the former schoolteacher Pol Pot into exile, one million Cambodians – approximately one in seven of the population – had died of disease or starvation. Another 200,000 were killed as enemies of the state, many of them crudely dispatched by blows to the skull with agricultural implements. After Year Zero, ploughshares were turned into swords.

The Khmer Rouge followed the precedent of Stalin's and Mao's repressions, yet there was something still more demented paranoid about Pol Pot's depredations. For all that it was a grotesque charade, the Maoist ritual of rectification and self-criticism did at least allow for eventual rehabilitation; likewise, Stalin's show trials were grim parodies of judicial process but they were conducted in public and a death sentence was not automatic.

The confessions extracted in Tuol Sleng were for the Party's private satisfaction only; they provided no grounds for clemency. Only seven people are known to have survived the prison. When the Vietnamese finally overran Phnom Penh, they found the bodies of prisoners executed only hours earlier, their spilt blood not yet dried.

Following the chaotic retreat of Pol Pot's forces, a large part of the archive was looted and destroyed; and what remained was scattered, filthy and mildewed. Still, with the efforts of the US-based Photo Archive Group, some 6,000 negatives survived to be housed in archives when the former school was turned into a museum to commemorate the holocaust that Cambodia, now Kampuchea, had endured.

Recently, the photographer responsible for these haunting images was discovered in Kampuchea. Nhem Ein, now 37, joined the Khmer Rouge as a 10-year-old. He was sent to China for training and returned in May 1976 aged 16 to be chief photographer at Tuol Sleng. Interviewed in Phnom Penh by Robin McDowell of the Associated Press, Nhem Ein estimated that he took about 10,000 photographs at S-21 and recalled seeing face after face filled with fear and a deep sadness: "I knew that I was taking the pictures of innocent people, but I knew that if I said anything, I would be killed."

Nan Goldin's pictures dominate writer Jennifer Egan's cautionary account of the life of an international runway model – James, a pretty fifteen-year-old girl from Nebraska. James' friends, mother, agent and fellow models all profess enormous affection for her, yet seem indifferent to the bleak rewards that accompany a childhood devoted to meeting the needs of the fashion industry; James coughs constantly, lives on coffee and cigarettes, and has no permanent home, yet on her own terms she has 'made it'. Goldin may seem an unusual choice for this editorial assignment, given her established reputation as an independent artist. On the surface, her autobiographical approach, snapshot aesthetic and the art world context in which her work is usually seen set her distinctly apart from the world of photojournalism. Yet her subject matter – drag queens, heroin addiction, sado-masochism and fighting Aids – and her interest in storytelling mean she has much in common with the typical photojournalist. 'James' was not her first editorial assignment; an earlier fashion story starring Goldin's friends had been rejected by the designer who said she 'would never let junkies like that sell her clothes'. (2 February 1996)

In the fashion world of the 90's, teen-age models simulate an adulthood they've yet to experience for women who crave a youthful beauty they'll never achieve. Sweet 16 it's not.
By Jennifer Egan Photographs by Nan Goldin

James
is a girl

AN OCTOBER MORNING IN PARIS. JAMES KING, HER HAIR PULLED back into a ponytail, bounds from an elevator into the lobby of the Hôtel de la Trémoille, not far from the Arc de Triomphe, where she has been staying for the past week. "How do I look — what do you think?" she asks the 20-year-old Julia Samersova, who used to work at Company Management, the modeling agency that began representing James nearly two years ago, when she was still known as Jaime. (Company Management already represented Jaime Rizhar, a top model. "James" was already Jaime King's nickname.) Samersova is now James's best friend and occasional chaperone. Seated at a breakfast table squeezing lemons into a bottle of Evian, she looks up at James, who gestures nervously at her black pants and long-sleeved black shirt. "Do you think it's proper? Do you think it's fierce yet subtle?" ("Fierce" is the superlative du jour this fall among the fashion crowd.)

"Yes," Samersova says, nodding. "Yes."

She has enormous dark eyes and braces on her teeth, and will tell anyone who asks that her father is a Russian mobster. Motherly beyond her years, she has taken a break from her studies in fashion-business merchandising at the Fashion Institute of Technology in New York to accompany James to this fall's ready-to-wear shows in Europe, which began the first week in October in Milan.

"Banana Republic rocks, I'm sorry," James says.

It is the morning of the John Galliano show, one of the most anticipated of the collections being shown in Paris, and James has been cast in it — a triumph for any model, not to speak of one having her first season in Paris. James has just finished her third season in Milan (fall, spring, fall), but because of French law, any model under 16 is prohibited from appearing in the Paris collections. James turned 16 in April.

When James has finished her breakfast — tea, a small pain au chocolat and a chain of Marlboros — I walk with her and Samersova to the Théâtre des Champs-Élysées, where the Galliano show is to take place. Despite the balmy weather, Paris has been a mess — a general strike and the resulting gridlock have filled the air with a throat-scorching smog; the proliferation of terrorist bombs in subways and garbage cans has led to a heavy police presence on the streets. Yet the fashion world feels eerily removed from all this. At the backstage entrance to the Galliano show, the most pressing question is who will get in and who won't. Fashion shows used to be sedate affairs catering mostly to magazine editors and department-store buyers. Now that models have become icons, the shows have about them an air of exquisite urgency: they're cultural high-low events, like a Stones concert in the 1970's.

Though the show isn't scheduled to start until 6:30 P.M., models like

Jennifer Egan is the author of "The Invisible Circus," a novel, and "Emerald City," a collection of stories just published by Nan A. Talese-Doubleday. This is her first article for the Magazine. Nan Goldin is a New York-based photographer whose last assignment for the Magazine was on gang girls. She is having a retrospective at the Whitney Museum of American Art this fall.

James backstage at the Jean Colonna spring '96 show in Paris. She is no longer shy about getting dressed and undressed in front of strangers when she's working.

Moss for imperfect beauty that triumphed. Within minutes of the supermodels' arrival, the room is saturated with camera flashes and television crews, everyone tripping over wires and elbowing one another aside to get at those famously beautiful faces. The media runoff falls to the newer, lesser-known models, who are already inured to the giant cameras clocking their every move, often only inches from their faces.

By now, outside the theater, an impatient, well-heeled crowd surges against the waist-high metal barriers cordoning off the doors. Everyone is brandishing crumpled invitations and wailing the name of Galliano's gatekeeper, a young bespectacled Englishman named Mesh. "Mesh! Mesh!" He paces frantically before them, occasionally waving his arms and consulting with the security guards. Now and then, a shaken-looking fashion editor makes herself heard and a pried from the crush. "I'm so sorry!" Mesh murmurs in soothing tones while delivering her into the theater. "I had no idea you were there." Inside, resting is assigned in direct accordance with status, and Galliano has sharpened the hierarchy at this show by seating his most important guests right on the stage.

Eventually, the show opens to sound bites from the "Pulp Fiction" soundtrack. It's a convoluted spectacle, no simple runway viewing. Campbell saunters about the stage like a high priestess, several choirboys trotting in her wake; Shalom, barelegged in a tutu, pirouettes around the perimeter of the balcony. James appears in a white dress, her hair full of leaves. As the darts to and fro, following Galliano's wordless, pretentious script with complete sincerity, she brings to mind nothing so much as a girl starring in the school play.

James met Michael Flutie, founder and owner of the Company Management modeling agency, when she was 14. 'I wanted to go somewhere with my life and I wanted it now,' she recalls.

IN THE FASHION WORLD, MODELS ARE always "girls." Successful models are "big girls." Stars like Moss and Campbell and Evangelista are "huge girls." Diminutive though the term may sound for a 30-year-old like Evangelista, who has made millions during her career, "girl" captures the peculiar role played by a model of any age. Backstage at a show or at a shooting in a loft, "girl" suggests, as it is meant to, someone more beautiful and less complicated than a woman.

In recent years, America has become obsessed with "girls," and the fashion world has a theory about why: actresses have lost their glamour by turning into real people, and models have replaced them as the stars of our time. Certainly models are this decade's contribution to our already crowded celebrity pantheon. They are what rock stars were to the 70's and visual artists were to the 80's. The rise of models has less to do with the fashion industry, whose business has slumped since the 80's, than with the potent blend of cultural preoccupations they embody: youth, beauty and, perhaps most of all, media exposure. Models are perfectly suited to a culture obsessed with fame for its own sake. Appearing in the media is their job — their images are their stock in trade. They are famous for being famous.

In the fashion world, there is a feeling that models have changed. "Today, you're not looking for perfection anymore," says Michael Flutie, the owner of Company Management, one of several new modeling agencies that have been founded in New York in the last decade. What matters more than any particular look is a model's attitude, her ability to project an inner life for the camera: the inner life of someone whose surface fascinates us.

To "find a girl" is to discover a teen-ager with potential. The career arc of a model requires that she start young, and the preternatural beauty of very young girls (along with their quite genuine girlishness) makes them un-models of a sort. Even a face 21 years old doesn't look quite as fresh, and I've had models in their 20's admit that they're a few years older than they say, and tell me how hard it was to adjust to metabolic changes. For years now, and in international especially, Manhattan has teemed with schoolgirls, some as young as 12 or 13, who are building up their modeling portfolios during vacation. The ones with real potential almost always get magazine

work before they graduate high school. The paradox of the outcry over Calvin Klein's recent advertisements for his jeans is that most of his young models were shown to look their real ages.

But if models have always been young, they have not always been media celebrities, and nowadays, teen-agers like James must contend with a level of attention — and the pressures that come with it — that wasn't there in the early 80's, when I modeled briefly. The media presence is greater now, and the world has shrunk: a 16-year-old model might be offered jobs in Paris one week and Prague the next. She is part of a globalized industry.

To "make a girl" is to put her on the map. Flutie began making James two years ago. James is big today, and there are people in the fashion world who believe that she could be huge. She has long, straight blond hair and a heartbreaking face — sexy and sorrowful. She has an endearingly snaggletoothed smile and the luminous skin of a child. She is a slender girl and a voluptuous woman. She is growing up before our eyes, and she is growing up very, very fast.

ON THE DAY FLUTIE ARRIVES IN PARIS from Milan, company management holds a dinner for its models at Natacha, a restaurant popular this fall with the fashion crowd. (Fashion people tend to surround themselves with one another, wherever they are.) In a downstairs room bathed in gold light, the models and their guests sprawl around several tables and wait for Flutie. There's Jicky Schnee, a bleached-blonde whose modeling career took off when she had the good fortune to share an elevator one day with the fashion photographer Steven Meisel, whom she didn't recognize but whose dog she patted. There is Suzy Richards, from London, who recently cut off her long brown hair and bleached it white, and Lesli Holcrek, who recently cut off her long blond hair and dyed it blue-black (and, more recently, back to blond). The models share gossip from Milan — Evangelista looked fat, the runways were full of blondes, some models aren't coming to Paris because of the nuclear testing in Tahiti.

Joi Tyler, a black model, is having a miserable time in Paris. The designers are using few black models this season, and she has heard it's because Romeo Gigli used mostly black models in his spring '95 show and the line wasn't a commercial hit. Tyler turns to Andreas Radutoiu, a cinnamon-haired model with strong Eastern European features. "I never want to come back here," she says, almost close to tears.

Finally, James arrives with James and Samersova. James looks exhausted. Flutie, who has bleached-blond hair and eyebrows and is wearing black leather pants (as he almost always does), sits down near Radutoiu, looking pained. He has bad news: a mix-up has occurred between the organizers of the Comme des Garçons show and the French bureaucrats who issue work permits, and Radutoiu, a new model who is having her first season, has been canceled from her biggest show. "But I was just there for the rehearsal," Radutoiu says in a near whisper, "and they didn't say anything." She has a sweet, unpretentious air — once, having run out of moisturizer, she rubbed Maxola oil on her face for a couple of days. She has just turned 19, and spent her adolescence struggling with the rest of her Romanian family as they all settled in Chicago. She looks stunned.

James, who was canceled from the Comme des Garçons show for the same reason as Radutoiu, bellows from her end of the table: "They can [expletive]. I have more important shows to do!" (Later, I heard she was in tears when she first found out.) After venting his frustration with Comme des Garçons, Flutie sips red wine. Among his models, he tends to assume a half-listening stance, like a distracted father whose mind is still at the office. Radutoiu broods. Her book is full of tear sheets from magazines, but in her first year she'll probably earn less than $30,000, more than half of which will go to repay the agency (on top of a 20 percent commission) for money advanced to her for the many expenses she incurred in the development

MODEL LIFE

With her bundle of hair, James waits backstage at the spring '95 Ghost show in New York. It is a long and arduous day: five shows in about eight hours.

She has a look that's earned her runway jobs, magazine covers, tens of thousands of dollars and a shot at celebrity. All she's lost is her youth. **At 16, A Model's Life** **By Jennifer Egan** Photographs by Nan Goldin

Top row, left to right: James with her boyfriend, Kyle, in town from Omaha; looking Lolita-like at one Paris show, and royal at Karl Lagerfeld's.
Middle row: James and another model, Carolyn Murphy, at the Ghost show; in Paris at a fitting for Jean Colonna,
and with her mother, Nancy King, who came to her daughter's shows in New York. Bottom row: "Her body rocks in a big way" is how James's best friend
described her; James on a Jean Colonna set made to resemble a hotel room, and with Kyle at a pool hall in New York.

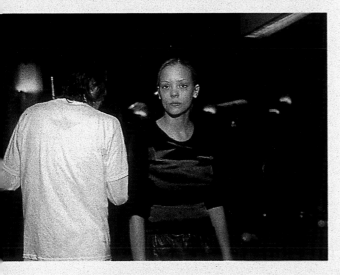

At Richard Tyler, one of **James's** biggest fall shows at Bryant Park, she wore three outfits that had in common transparency from the waist up, so that her breasts were fully visible.

process: haircuts, air fare, messenger fees, laser prints for her book, multiple copies of each magazine she appears in and even food. The model pays for everything, and it adds up. James, whose Corn Belt blond hair and blue eyes are more naturally the stuff of catalogues — a good source of income for models — will make an estimated $150,000 in this, her second year. But she, too, will have a commission and expenses to pay. The rest will go to her parents, who invest it and provide her with a weekly allowance.

Striking a balance among editorial, advertising and catalogue work is crucial to the success of any model who, like Radutoiu or James, is shooting for the top. Editorial work — that is, posing for the photographs that appear in the fashion pages of magazines — is low paying ($150 per day on average), but highly prestigious and a valuable source of tear sheets and exposure. Catalogues pay much better (day rates start at $750 and can go as high as $10,000 or more, for a star), but are useless in forwarding a career. To be perceived as a mere catalogue girl is to lose the hope of editorial work, without which a model has little chance at grasping for the real prizes of her business: campaigns, or seasonal advertising for designers, which can pay as much as $20,000 per day; and most desired of all, contracts, in which a model becomes a representative for a company's products or apparel lines (Moss for Calvin Klein, Claudia Schiffer for Revlon). A contract model may earn sums in the millions.

There is an upright piano at Natacha, and James begins fooling around on it. She has a charisma that draws others to her, and soon a group is gathered at the piano. Watching her, I find myself thinking of her description of her first meeting with Flutie, when she was 14: "Michael asked me a question. He's like, 'Why do you want to do this?' And I said, 'Because I want to be a star.' It didn't mean that I want to be famous. It didn't mean that I wanted everyone to know me, it just meant that I want to be a star to myself. That I wanted to be successful to myself, that I wanted to go somewhere with my life and I wanted it then, I wanted it now."

JAMES IS FROM OMAHA. "I GREW UP IN THE SUBURBS," SHE TELLS ME, "very normal family, like Mom, Dad, that kind of thing." She has an older sister and a younger brother. Her parents separated more than a year ago (something James never mentions), but the split is amicable and they still work together in Omaha, renting out mostly low-income apartments. "When I was 12 or 13," James says, "that's when I started looking at magazines, and I became literally obsessed with designers and models. Like, I would stay up till 3 o'clock in the morning slicing the best pictures out of Harper's Bazaar and Vogue and making collages and posting them up on my door, like the fiercest pictures that I saw, like of Gaultier and Galliano and whatever. I knew every model, I knew who Steven Meisel was."

In the minds of a great many young American girls, modeling has replaced Hollywood as the locus for fantasies of stardom. Kelly Stewart, a 14-year-old high-school freshman who has been with the Click agency for two years, says she became obsessed at age 8. A room plastered with pages from Vogue has become as emblematic of American girlhood as Barbie has, and the assiduous merchandising of models in books, magazines and cable-television shows is no doubt fueling this surge of interest.

"When I was in junior high, I had a lot of problems with people," James says. "I started getting my breasts earlier than everyone, I had my period

Stanley Greene began working in Chechnya in 1994, during the first war that the Chechen rebels launched against Moscow. The story became a personal mission, in which he clearly identifies with the Chechens against their 'mass murder' by Russian forces, and he continued to cover it long after the news media lost interest. He eventually made over twenty trips, financed by portrait and fashion photography, before ending his ongoing series in 2003. While working in the manner of a clandestine reporter (necessarily, given the difficulties of access), Greene's expressionistic, emotional style breaks from traditional documentary war coverage; at the same time his mysterious images of the bleak landscape aptly convey the opaque, complex and primitive ferocity of the Chechen-Russian conflict. 'You can't save the world,' he later told an interviewer, 'I'm not so naive to think that. But there are certain stories, certain issues, where you do your part, you make your statement. There are stories that get to you so deeply that you have to get them out – and this was mine.' (26 February 1996)

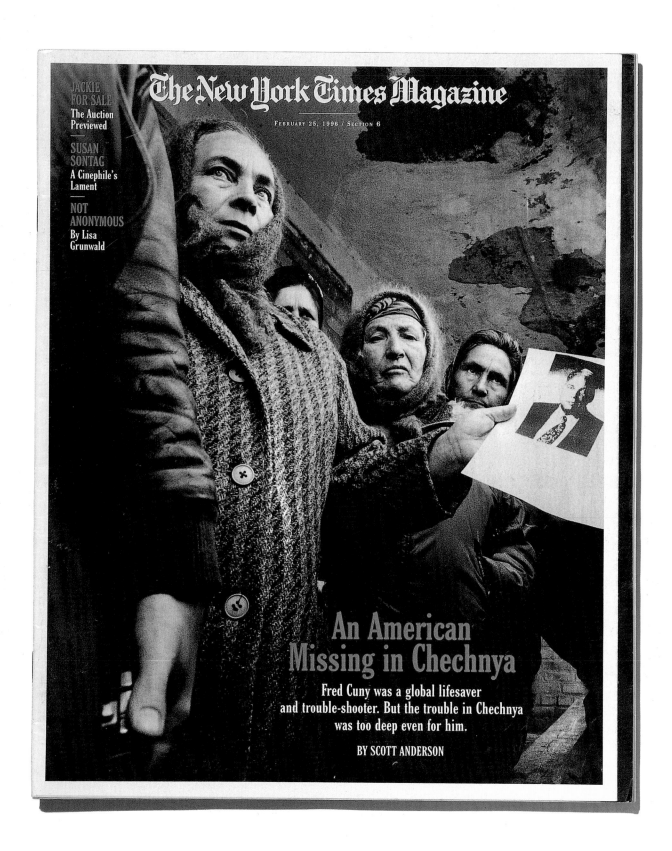

He had done
hero's work from
Biafra to Bosnia, but
he was tired
of building latrines
and flying in food.
He wanted to be
a peacemaker,
a deal broker, a
player. That
ambition probably
killed him.

What Happened to Fred Cuny?

ASA BASAYEV BELIEVES
she saw him. "I remem-
ber him because he was
very big and a little bit heavy,"
she said. We were standing on
the front steps of the burned-
out municipal building in Sa-
mashki, a small agricultural
town in war-battered western
Chechnya, and Basayev, an eld-
erly woman with piercing gray
eyes, was pointing toward the

By Scott Anderson
Photographs by Stanley Greene

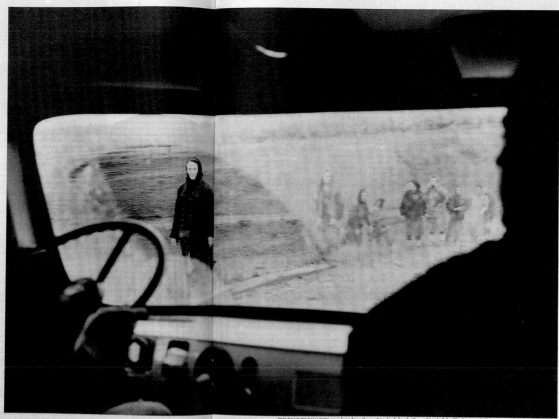

THE ROAD TO SAMASHKI *may have been the road to death for the "great friend of the Chechen people."*

THE CENTRAL MARKET *in Grozny, the city that is a battleground. A Chechen rebel here claimed to know what had happened to Cuny.*

consider ending the mission in the northern Caucasus or, at the
very least, to remove Cuny — whom they viewed as increasing-
ly and noisily partisan. At this critical juncture, Cuny arrived in
Moscow planning to enter a Chechnya that had grown ever-
more treacherous in the months since his first visit. At many of
the isolated army checkpoints, Russian units were operating
as little more than autonomous armed gangs, detaining,
robbing and sometimes murdering travelers at random. Mean-
while, a bunker mentality had set in among the Chechen

rebels, fueled by persistent reports that the Russians were
infiltrating their areas with spies and agents provocateurs. The
separatist rebels, or boyeviki, had begun to view any outsider
as a potential enemy.

Despite the fact that a dangerous place seemed to be growing
more so every day, the Soros administrators bowed to Cuny's
considerable powers of persuasion and agreed to extend, at least
temporarily, his projects in Chechnya and Ingushetia. But they
did suggest two precautions. Before leaving Moscow, Cuny was

advised to first meet with Sergei Kovalev, a highly respected
human rights activist who had recently returned from the
northern Caucasus and knew the current situation intimately.
And before considering any venture into Chechnya, Cuny
should wait in Ingushetia for the arrival of Slava Miklayev, the
Soros liaison who had been overseeing the foundation's projects
in the northern Caucasus and who was en route to Ingushetia
with a convoy of relief supplies.

Cuny did neither. Instead, after meeting with Ambassador

LOST IN CHECHNYA

Pickering and other officials in the American Embassy, he
boarded a flight from Moscow to Ingushetia on the morning
of March 30. The very next day he set out for western
Chechnya accompanied by the three Soros contract employe-
ees — the interpreter, Oleinik, and the two doctors, Sereda
and Makarov — who had been detained there 10 days earlier.
Eschewing the paved highways that cut across the Chechen
plains, the party took a grueling dirt road that led to the very
heart of the Chechen war.

It was not until mid-April, some 10 days after the driver
returned to Ingushetia alone, that concern over the
group's whereabouts escalated to alarm. Back in
Dallas the news rekindled an uncomfortable sense of
premonition in Damir Lulo. "As we drove away from
Fred's house that night," Lulo said, "my wife turned
to me and said, 'You know, I don't think we're going
to see Fred again.'"

SOON AFTER CUNY WAS REPORTED MISSING,
American officials in Moscow and Washington
took note of a disturbing trend: right-wing Russian
newspapers were carrying outlandish reports that Cuny was
alive and well — and working directly with the Chechen rebel
leader, Dzhokhar Dudayev, as a C.I.A.-sponsored adviser.
The sources of these reports, the State Department privately
concluded, were high officials in Russia's F.S.B., the domestic
branch of the old K.G.B. To officials in the United States this
clumsy disinformation campaign suggested that the Russians
had something to hide. Had they killed Cuny?

"Why come up with these absurd stories that Cuny is alive
and working with Dudayev?" one State Department official
asked. "About the only conclusion you can make is that these
F.S.B. guys are throwing all this out because they're trying to
cover up."

In Moscow in the fall, I met with the F.S.B. press attaché,
Maj. Gen. Aleksandr Mikhailov, at his office on Lubyanka
Square in the old K.G.B. headquarters. "Who was Fred Cuny?"
he asked rhetorically, seated behind his desk and smoking a
cigarette. "We had never even heard of Cuny until after he and
the others went missing. At that time, we were asked by the
American Government to help search for them, and we did so.
We had our people in the field look, we contacted all the army
commanders in the region, but we have never been able to say
definitively what happened — only that our forces were not
involved in any way."

And the stories in the newspapers?

"Are there no irresponsible journalists in your country who
make up stories?" he asked. "Well, we have journalists who do
the same. The F.S.B. has never told these stories." (Last month,
Mikhailov was stripped of his post after acting as spokesman for
the Russian Government's ever-changing account of the Che-
chen hostage-taking fiasco in the village of Pervomayskoye.)

The specter of high-level Russian involvement in the disap-
pearances added a whole new layer of intrigue to the hunt for
Cuny. Throughout the summer, a steady stream of current and
former American Government employees trekked to Chechnya
to assist in the search — C.I.A. agents, political affairs officers, a
retired defense-intelligence colonel, even two F.B.I. agents
briefly flown in from Washington. In Moscow, Ambassador
Pickering held regular status-report meetings on the investiga-
tion. To many Russians, particularly in the military and intelli-
gence spheres, the very ambition of this effort seemed to
confirm that Cuny was, in fact, an American agent. Others
believed that the Cuny search *Continued on page 68*

*Helping Kurds
in Iraq, 1991.*

By traveling
with a native
of Bamut,
Cuny and the
others had
managed to
enter Lower
Bamut, the
site of the
nuclear-missile
base. At that
point, their
fate may well
have been
sealed.

LEFT: STANLEY GREENE/VU, FOR THE NEW YORK TIMES. RIGHT: INTERTECT.

Colors was born in 1990 when Italian photographer Oliviero Toscani, then in charge of Benetton's advertising, invited American design guru Tibor Kalman to create, design and edit a new magazine. 'Tibor's dearest dream was to be the editor of *Life*,' wrote his wife Mira, 'He worshipped that magazine. He also greatly admired Neville Brody's visionary aesthetics for the *Face* and the global view of *National Geographic*.' The result of this mix of inspirations was an innovative anthropological magazine with a radical graphic approach that featured strong and often controversial journalism, using stock news photographs drawn from agency archives. Distributed internationally in several languages, each issue provocatively approached a different social subject – Aids, shopping, animals, food – combining the languages of photojournalism and advertising to offer insights into human nature. Its 'War' issue, produced after Kalman left the magazine, staged a typically rhetorical assault on the conduct of war: catalogue-style product shots and descriptions of weapons were paired with pictures of injuries caused by their use. Indirectly, *Colors* also assaulted the traditional formula of the photo story. (March 1996; photograph below right by Guenay Ulutunçok; top right by Christopher Morris)

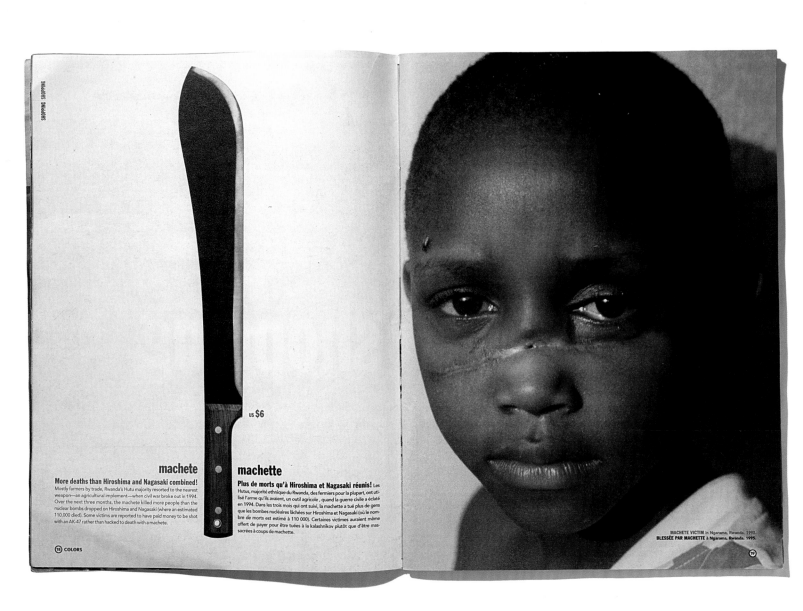

machete
More deaths than Hiroshima and Nagasaki combined!
Mostly farmers by trade, Rwanda's Hutu majority resorted to the nearest weapon—an agricultural implement—when civil war broke out in 1994. Over the next three months, the machete killed more people than the nuclear bombs dropped on Hiroshima and Nagasaki (where an estimated 110,000 died). Some victims are reported to have paid money to be shot with an AK-47 rather than hacked to death with a machete.

machette
Plus de morts qu'à Hiroshima et Nagasaki réunis! Les Hutus, majorité ethnique du Rwanda, des fermiers pour la plupart, ont utilisé l'arme qu'ils avaient, un outil agricole , quand la guerre civile a éclaté en 1994. Dans les trois mois qui ont suivi, la machette a tué plus de gens que les bombes nucléaires lâchées sur Hiroshima et Nagasaki (où le nombre de morts est estimé à 110 000). Certaines victimes auraient même offert de payer pour être tuées à la kalashnikov plutôt que d'être massacrées à coups de machette.

US $6

MACHETE VICTIM in Ngarama, Rwanda. 1995.
BLESSÉE PAR MACHETTE à Ngarama, Rwanda. 1995.

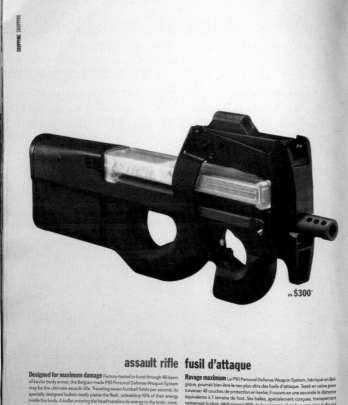

us $300*

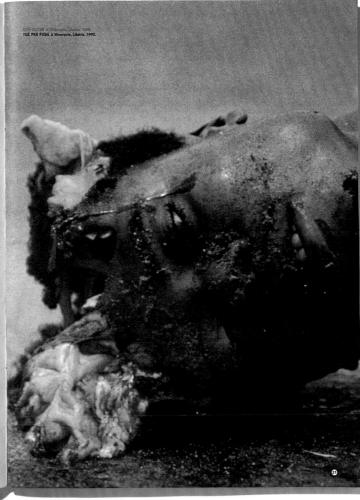

assault rifle fusil d'attaque

Designed for maximum damage Factory-tested to burst through 48 layers of kevlar body armor, the Belgian-made P90 Personal Defense Weapon System may be the ultimate assault rifle. Traveling seven football fields per second, its specially designed bullets neatly pierce the flesh, unleashing 90% of their energy inside the body. A bullet entering the head transfers its energy to the brain, creating an explosion that forces brain tissue through the sinuses and the seams of the cranium, actually tearing the skull bones apart (see right). Although the wound featured here was not inflicted by the P90 (not yet combat-tested), the manufacturer's brochure assures prospective buyers that the P90 has been "designed for maximum wound profile."

Ravage maximum Le P90 Personal Defense Weapon System, fabriqué en Belgique, pourrait bien être le nec plus ultra des fusils d'attaque. Testé en usine pour traverser 48 couches de protection en kevlar, il couvre en une seconde la distance équivalente à 7 terrains de foot. Ses balles, spécialement conçues, transpercent nettement la chair, déchargeant 90% de leur énergie dans le corps. Une balle qui pénètre dans la tête transfere son énergie au cerveau provoquant ainsi une explosion qui projette les tissus du cerveau par les sinus et les jointures du crâne, pulvérisant les os craniens (cf à droite). Bien que la blessure de la photo n'ait pas été infligée par un P90 (pas encore testé en combat), la brochure du fabricant assure aux clients potentiels que le P90 a été "conçu pour infliger une blessure maximale."

*ESTIMATED VALUE PRESUMÉE

20 COLORS

21

us $3 – $3,000

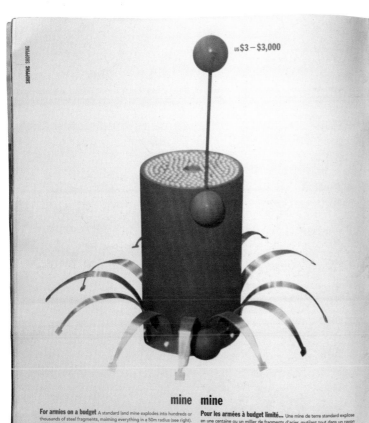

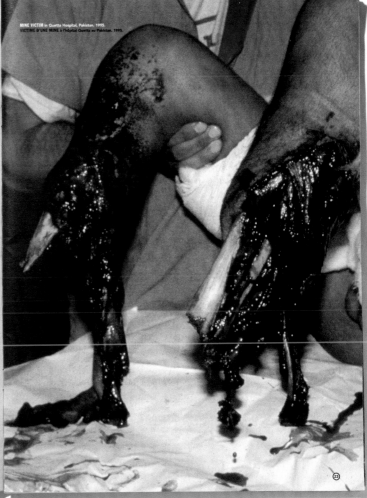

mine mine

For armies on a budget A standard land mine explodes into hundreds or thousands of steel fragments, maiming everything in a 50m radius (see right). Half of all mine victims die within minutes; another third lose limbs. And while advanced mines like the one above, designed to prevent airplanes from landing, can cost as much as US$3,000, standard land mines are extremely cost effective. Available from China for as little as US$3 apiece, they're ideal for developing countries, says mine manufacturer Li Chenge. And sales confirm it: Angola's 15 million mines outnumber the population, two to one. Most of the 110 million live land mines now scattered throughout 64 countries will lie in wait long after conflicts have ended, assuring maximum consumer value.

Pour les armées à budget limité... Une mine de terre standard explose en une centaine ou un millier de fragments d'acier, mutilant tout dans un rayon de 50m (cf à droite). La moitié de toutes les victimes des mines meurent dans les minutes qui suivent; un tiers est mutilé. Tandis que le prix des mines plus sophistiquées (cf en haut), conçues pour empêcher les avions d'atterrir, peut atteindre 3 000$US, les mines standard sont très économiques. On peut en trouver en Chine pour seulement 3$US pièce, c'est l'idéal pour les P.V.D d'après le fabricant de mines Li Chenge. Et les ventes le confirment: les 15 millions de mines de l'Angola dépassent le nombre d'habitants de moitié. La plupart des 110 millions de mines répandues dans 64 pays attendront longtemps après la fin des conflits, acquérant ainsi une valeur marchande maximale.

22 USING CURRENT METHODS, it will take 20,000 years to clear all the mines laid in Afghanistan. AVEC LES MÉTHODES ACTUELLES, il faudrait 20 000 ans pour déblayer toutes les mines d'Afghanistan.

23

'On the brink of the millennium, war has returned to Europe' was how *La Revista*, supplement to the Spanish daily newspaper *El Mundo*, introduced one of a series of stirring war albums by James Nachtwey. Featuring photographs from Bosnia (1993-4) and Chechnya (1995-6) originally commissioned for *Time* magazine, they were presented as a dark panorama of the state of Europe and the period in general rather than as a report on immediate events. This suits the ambition of Nachtwey's work. He has said that he learned most about the photography of war from the etchings of Spanish artist Francisco Goya, whose *Disasters of War* (1810-20) depicts scenes from Napoleon's war with Spain. Like Goya, Nachtwey's photographs are explicit representations of particular wars, but tend to be read in a more general way as a searing vision of humanity's capacity for brutality. Nachtwey cites the series in *La Revista* as one of his most satisfying magazine collaborations and he used a similar layout approach in his book *Inferno* (1999) as well as in many subsequent magazine essays. (4 March 1996)

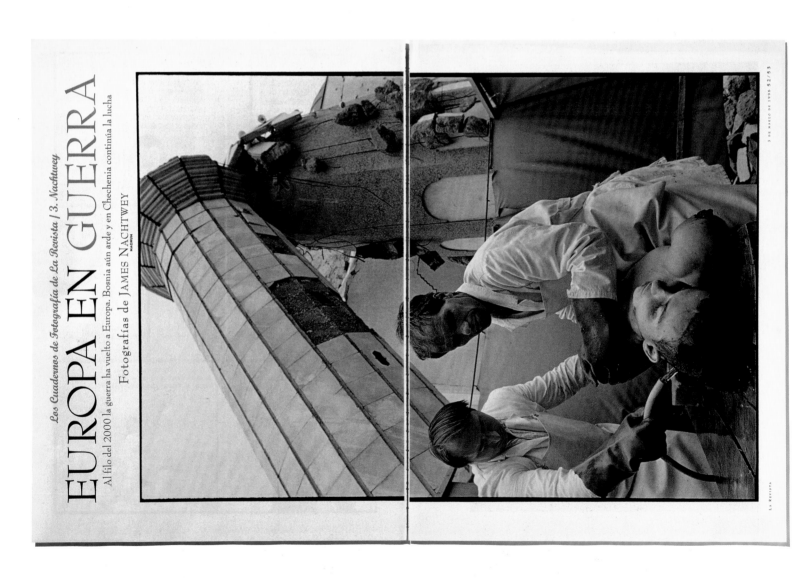

Los espacios libres de las ciudades bosnias, parques, campos de deportes... se convirtieron en improvisados cementerios, en sucesiones de tumbas y estelas funerarias.

Ancianos, niños, mujeres, civiles... toda la población bosnia ha sido objetivo. Unos, de las balas de los francotiradores, otros de las bombas artilleras, ellas, de las violaciones...

Rusia se ha ido enfangando cada vez más en una guerra lejana y costosa que está aumentando las dificultades para superar la permanente crisis en la que se halla sumida.

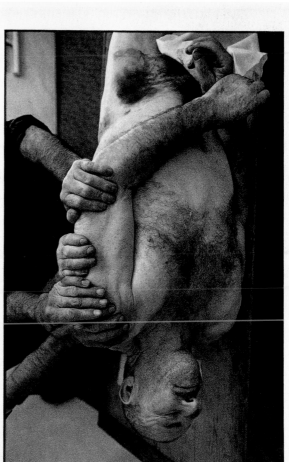

Al final, los conflictos se resumen en la suma de las cifras de muertos de cada bando: cientos de civiles o combatientes chechenos, cientos de civiles o soldados rusos.

El hacha de guerra europea estaba enterrada en Sarajevo. Después de los años de lucha la firma de la paz no ha conseguido cerrar las heridas abiertas entre los contendientes.

No había terminado el fuego en los Balcanes cuando comenzó a arder en el otro extremo de Europa, en el recóndito Cáucaso, donde combaten rusos y chechenos.

When *W* magazine commissioned English photographer Martin Parr to explore the kitsch culture of Florida's beaches, he had already established a quirky iconography of resort behaviour. Eighteen months before the assignment, he published his essay about global tourism – *Small World* (1995) – that was part comedy of manners, part withering satire of globalization. But by 1997, Parr was developing a darker photographic style, both more intrusively detailed and more abstract, using a ring flash camera – normally used for forensic close-ups within medical photography. The resulting essay, influenced in its tone and layout by recent Japanese photography, surprised an audience familiar with Parr's work. Although the general territory and some of the essay's ingredients were recognizably Parresque – the suburban front yards, the hats – there was much that was new. The things that fascinated Parr in Florida, such as the toy dogs, gaudy jewellery and sunburned human skin, went on to become central motifs in the next phase of his work. 'Sun Kitsch' is one of the magazine features Parr is proudest of, and shows him in the process of reinventing the language of the documentary essay. (January 1997)

As part of Mayor Rudolf Giuliani's project to revitalize Manhattan, making it attractive for tourism and corporate investment, he planned the transformation of the colourful but seedy Times Square into a gleaming new business, media and entertainment district. As the last of its old peep shows gave way to construction sites for new skyscrapers, the *New York Times* chose to mark the moment by commissioning 19 contemporary photographers to contribute to an ambitious photo essay, to fill a special issue of the magazine. Kathy Ryan, its photo editor, recruited a broad spectrum of leading talents from across the domains of photojournalism, documentary, art and fashion photography, with each photographer working to a brief that met their own particular visual interests. In retrospect, individual signature styles effectively trump the attempt to convey the social, economic and cultural implications of this profound alteration to the city. But in terms of photography, the issue became a statement of the *Times* magazine's visual direction, and a manifesto for the future of sophisticated magazine photography. (18 May 1997, with photographs by Nan Goldin, Edward Keating, Annie Leibovitz, Mary Ellen Mark, Abelardo Morell, Michael O'Neill, Larry Towell and Lars Tunbjörk)

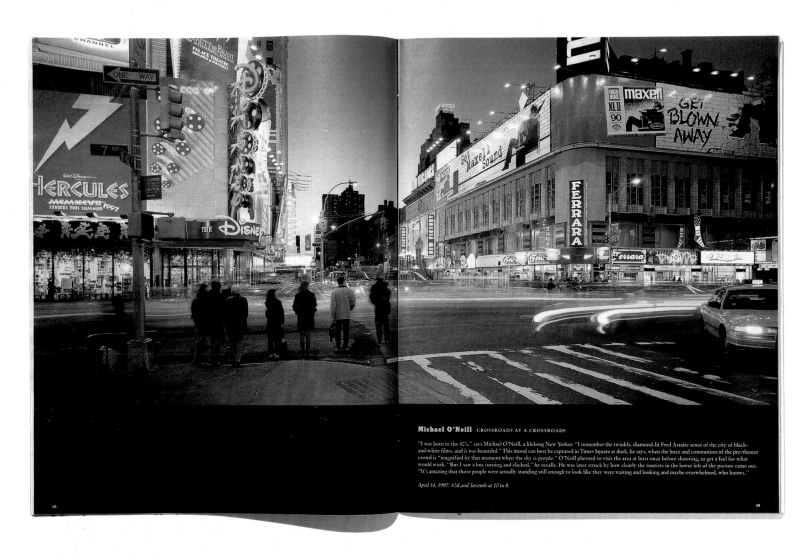

Michael O'Neill CROSSROADS AT A CROSSROADS

"I was born in the 40's," says Michael O'Neill, a lifelong New Yorker. "I remember the twinkly, diamond-lit Fred Astaire sense of the city of black-and-white films, and it was beautiful." This mood can best be captured in Times Square at dusk, he says, when the buzz and commotion of the pre-theater crowd is "magnified by that moment when the sky is purple." O'Neill planned to visit the area at least once before shooting, to get a feel for what would work. "But I saw a bus turning and clicked," he recalls. He was later struck by how clearly the tourists in the lower left of the picture came out. "It's amazing that those people were actually standing still enough to look like they were waiting and looking and maybe overwhelmed, who knows."

April 14, 1997: 42d and Seventh at 10 to 8.

48

49

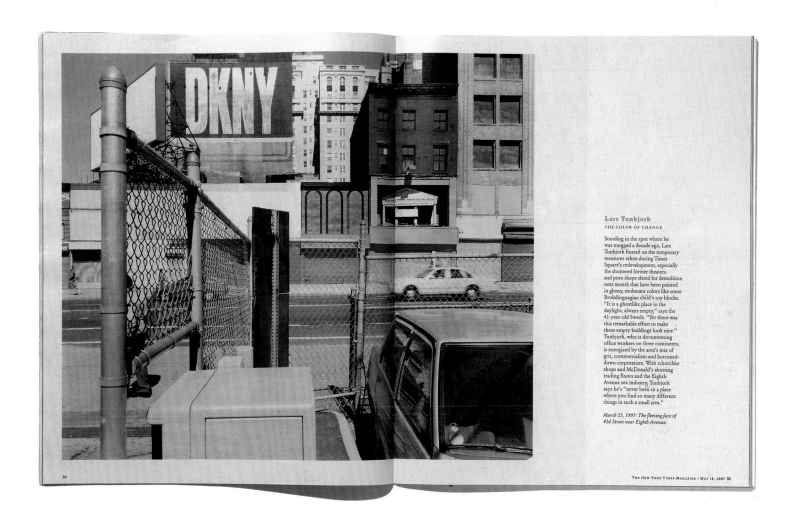

Lars Tunbjork
THE COLOR OF CHANGE

Standing in the spot where he was mugged a decade ago, Lars Tunbjork fixated on the temporary measures taken during Times Square's redevelopment, especially the shuttered former theaters and porn shops slated for demolition next month that have been painted in glossy, exuberant colors like some Brobdingnagian child's toy blocks. "It is a ghostlike place in the daylight, always empty," says the 41-year-old Swede. "Yet there was this remarkable effort to make these empty buildings look nice." Tunbjork, who is documenting office workers on three continents, is energized by the area's mix of grit, commercialism and buttoned-down corporatism. With tchotchke shops and McDonald's abutting trading floors and the Eighth Avenue sex industry, Tunbjork says he's "never been to a place where you find so many different things in such a small area."

March 23, 1997: The fleeting face of 42d Street near Eighth Avenue.

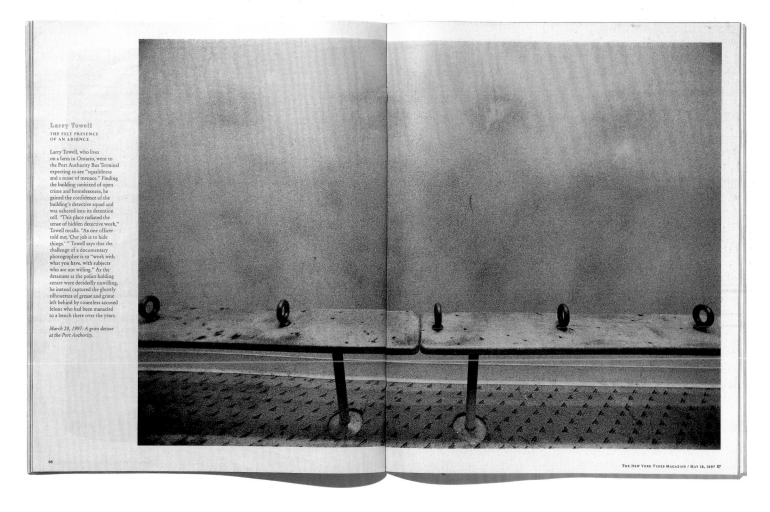

Larry Towell
THE FELT PRESENCE OF AN ABSENCE

Larry Towell, who lives on a farm in Ontario, went to the Port Authority Bus Terminal expecting to see "squalidness and a sense of menace." Finding the building sanitized of open crime and homelessness, he gained the confidence of the building's detective squad and was ushered into its detention cell. "This place radiated the sense of hidden detective work," Towell recalls. "As one officer told me, 'Our job is to hide things.'" Towell says that the challenge of a documentary photographer is to "work with what you have, with subjects who are not willing." As the detainees at the police holding center were decidedly unwilling, he instead captured the ghostly silhouettes of grease and grime left behind by countless accused felons who had been manacled to a bench there over the years.

March 28, 1997: A grim detour at the Port Authority.

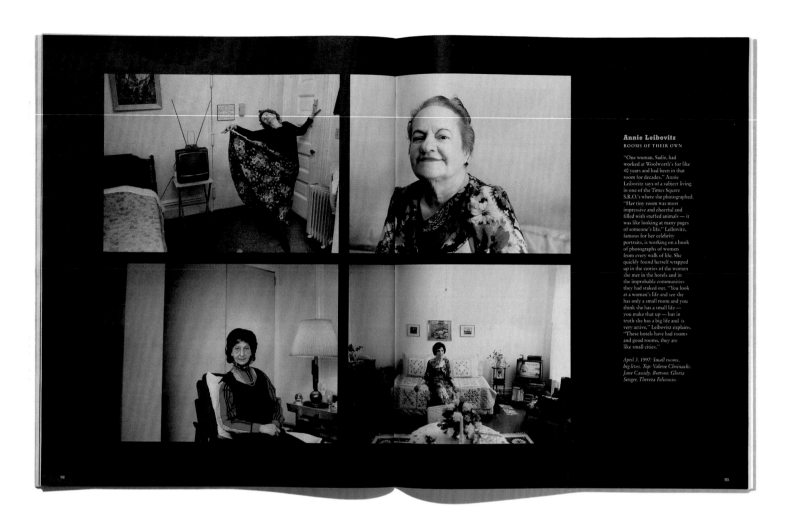

Annie Leibovitz
ROOMS OF THEIR OWN

"One woman, Sadie, had worked at Woolworth's for like 40 years and had been in that room for decades," Annie Leibovitz says of a subject living in one of the Times Square S.R.O.'s where she photographed. "Her tiny room was most impressive and cheerful and filled with stuffed animals — it was like looking at many pages of someone's life." Leibovitz, famous for her celebrity portraits, is working on a book of photographs of women from every walk of life. She quickly found herself wrapped up in the stories of the women she met in the hotels and in the improbable communities they had staked out. "You look at a woman's life and see she has only a small room and you think she has a small life — you make that up — but in truth she has a big life and is very active," Leibovitz explains. "These hotels have bad rooms and good rooms, they are like small cities."

April 3, 1997: Small rooms, big lives. Top: Valerie Chvinacki, Jane Cassidy. Bottom: Gloria Senger, Thereza Feliconio.

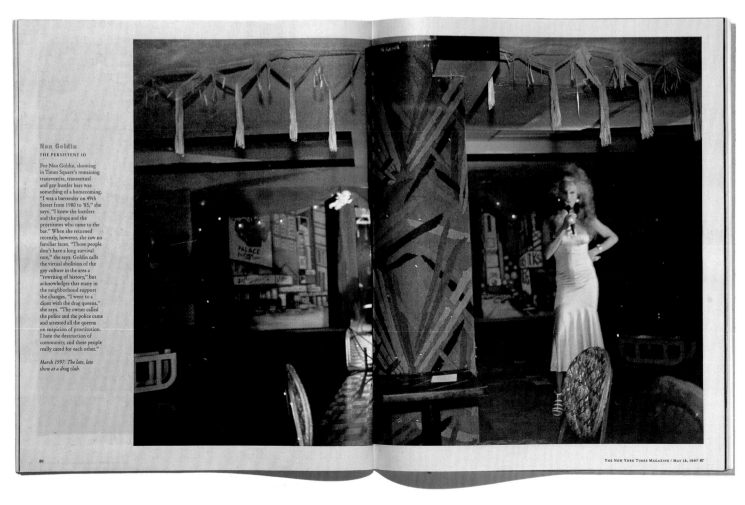

Nan Goldin
THE PERSISTENT ID

For Nan Goldin, shooting in Times Square's remaining transvestite, transsexual and gay hustler bars was something of a homecoming. "I was a bartender on 49th Street from 1980 to '85," she says. "I knew the hustlers and the pimps and the prostitutes who came to the bar." When she returned recently, however, she saw no familiar faces. "Those people don't have a long survival rate," she says. Goldin calls the virtual abolition of the gay culture in the area a "rewriting of history," but acknowledges that many in the neighborhood support the changes. "I went to a diner with the drag queens," she says. "The owner called the police and the police came and arrested all the queens on suspicion of prostitution. I hate the destruction of community, and these people really cared for each other."

March 1997: The late, late show at a drag club.

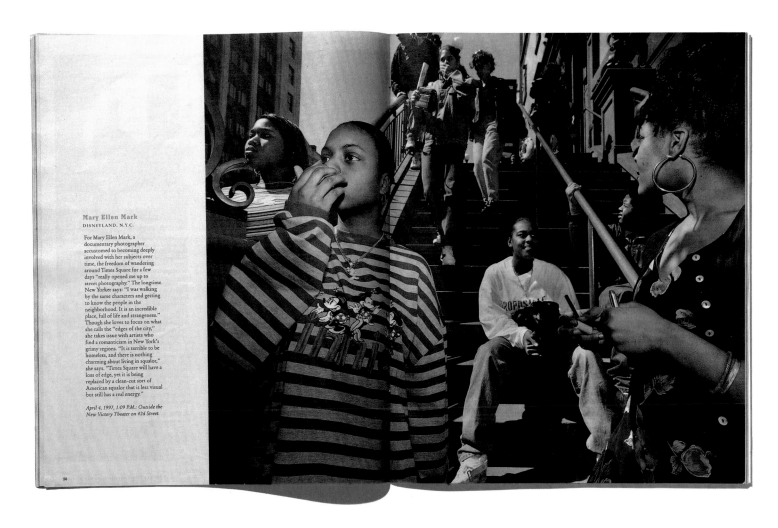

Mary Ellen Mark
DISNEYLAND, N.Y.C.

For Mary Ellen Mark, a
documentary photographer
accustomed to becoming deeply
involved with her subjects over
time, the freedom of wandering
around Times Square for a few
days "really opened me up to
street photography." The longtime
New Yorker says: "I was walking
by the same characters and getting
to know the people in the
neighborhood. It is an incredible
place, full of life and strangeness."
Though she loves to focus on what
she calls the "edges of the city,"
she takes issue with artists who
find a romanticism in New York's
grimy regions. "It is terrible to be
homeless, and there is nothing
charming about living in squalor,"
she says. "Times Square will have a
loss of edge, yet it is being
replaced by a clean-cut sort of
American squalor that is less visual
but still has a real energy."

*April 4, 1997, 1:09 P.M.: Outside the
New Victory Theater on 42d Street.*

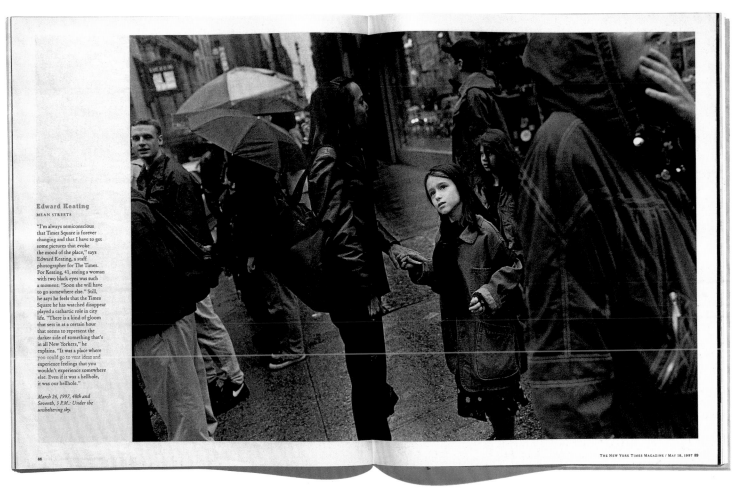

Edward Keating
MEAN STREETS

"I'm always semiconscious
that Times Square is forever
changing and that I have to get
some pictures that evoke
the mood of the place," says
Edward Keating, a staff
photographer for The Times.
For Keating, 41, seeing a woman
with two black eyes was such
a moment: "Soon she will have
to go somewhere else." Still,
he says he feels that the Times
Square he has watched disappear
played a cathartic role in city
life. "There is a kind of gloom
that sets in at a certain hour
that seems to represent the
darker side of something that's
in all New Yorkers," he
explains. "It was a place where
you could go to vent ideas and
experience feelings that you
wouldn't experience somewhere
else. Even if it was a hellhole,
it was our hellhole."

*March 26, 1997, 48th and
Seventh, 5 P.M.: Under the
unsheltering sky.*

Abelardo Morell

A SIMULATION OF SIGNS

"I want a sort of historical record of what a room sees," says Abelardo Morell, a 48-year-old Cuban immigrant who lives in Brookline, Mass. Thus his penchant for the ancient technique of the camera obscura, in this case constructed by using the room itself as a camera, blacking out all but a half-inch circle of a window — the aperture — in Room 1123 at the Marriott in Times Square. Morell then set a camera on a tripod near the aperture, directing it into the room to record the optical phenomenon. Making a single exposure over two days, he captured a scene of meditative calm — the room — superimposed with the anarchy of Broadway. "Think about how many people go through this site in two days — millions — and no one stood still long enough to get seen," he says. "It's so empty, almost a perverse picture."

March 20-21, 1997: Broadway all at once from a room at the Marriott.

50

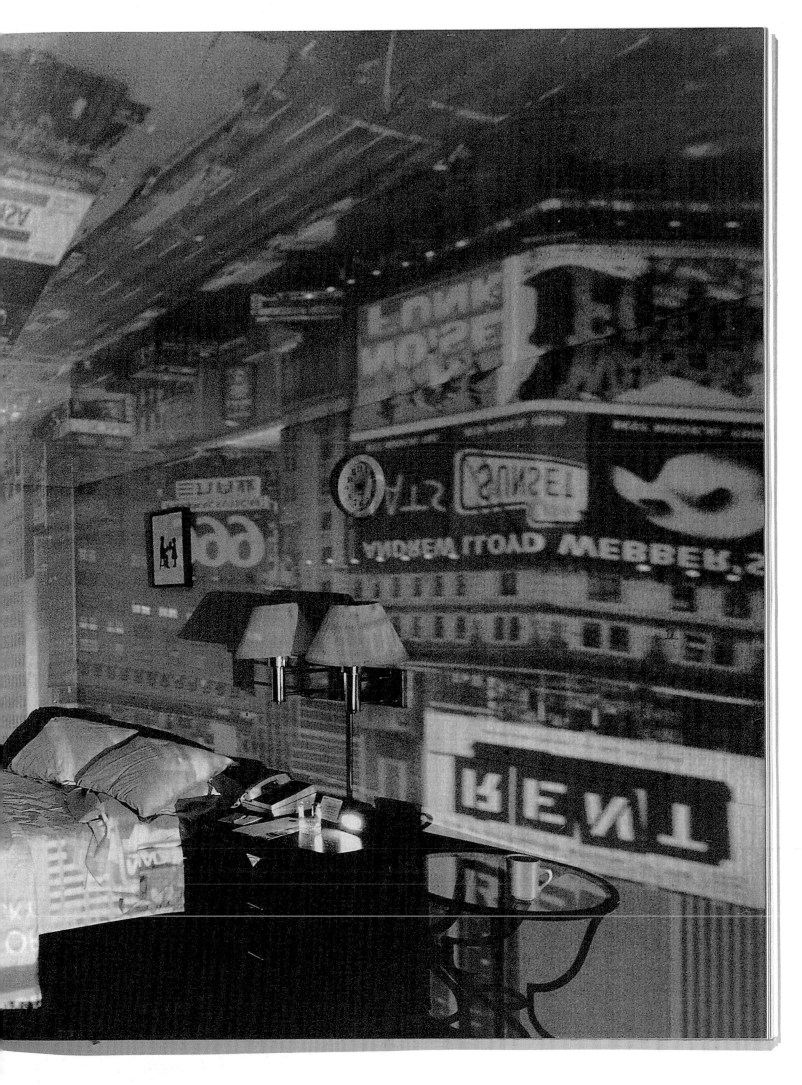

Roger Hutchings began taking photographs in 1979, the year the Conservative Party gained power in Britain and Margaret Thatcher became Prime Minister. In between current affairs assignments – Hutchings covered the civil war in Sudan, the Velvet Revolution in Prague and the war in Bosnia – he steadily documented the radical transformation of Britain under the Conservatives. In a project that echoed the pioneering 1960s documentary survey of Britain by Tony Ray-Jones, he focused on Britain's class divisions, its social types from 'yuppies' to punks, as well as the strikes, protests and social conflicts of the period. As the era of Conservative rule drew to a close, Hutchings decided his work was finished. He released an edit of photographs aimed squarely at picture editors facing the perennial problem of how to address important elections with something other than politicians' mug shots. The French news magazine *L'Express* was one of several magazines that picked up the portfolio, publishing a picture 'dossier' (one of its regular features accompanying major political events) between pages otherwise dominated by news and analysis. Hutchings completed his story with a last photograph taken at Tony Blair's and New Labour's election victory celebrations on 1 May. (7 May 1997)

>Les années tories

1979. **Mai** : victoire des conservateurs aux élections. Margaret Thatcher, Premier ministre (et première femme à ce poste en Grande-Bretagne).

1980. Lancement d'une série de lois antisyndicales.

1981. 10 républicains irlandais grévistes de la faim meurent en prison à Belfast. **Avril** : émeutes raciales dans la banlieue londonienne de Brixton.

1982. **Avril** : les Argentins envahissent les Malouines, reconquises après soixante-quatorze jours de guerre.

1984. **Mars** : début de la grève des mineurs, qui durera un an. **Octobre** : Margaret Thatcher échappe à un attentat de l'IRA contre le congrès de son parti, à Brighton. **Novembre** : privatisation de British Telecom. En une dizaine d'années, l'État vendra BP, British Airways, Rolls-Royce, les compagnies d'eau, d'électricité et de chemins de fer... **Décembre** : accord sur le retour de Hongkong à la Chine le 1er juillet 1997.

1990. **Novembre** : démission de la Dame de fer, évincée de la direction du parti. John Major lui succède.

1991. **Février** : attentat de l'IRA contre le 10 Downing Street. **Décembre** : Londres exempté du volet social de Maastricht.

1992. **Avril** : victoire surprise des tories aux élections, qu'ils remportent pour la quatrième fois consécutive.

... grèves en série, où il arriva même que l'on n'enterra plus les morts ? Les experts du Fonds monétaire international, habituellement appelés au chevet des républiques bananières, débarquèrent à Londres, alors, pour tenter de soigner ce « mal anglais » dont souffrait le royaume, et que Margaret entreprit d'éradiquer à jamais.

A observer la campagne électorale qui vient de s'achever, on découvre que les privatisations, la déréglementation et la flexibilité sociale, la limitation du rôle des syndicats et de celui de l'État dans l'économie – avec son corollaire bien-aimé, la baisse des impôts – l'ouverture des marchés et des frontières – bref, tout le socle libéral de la politique économique telle qu'elle a été menée depuis 1979 fait désormais l'objet d'un large consensus au Royaume-Uni. Certes, conservateurs et travaillistes ne s'accordent pas sur le bilan qu'il convient d'en tirer. Les premiers lisent dans la baisse du chômage, la maîtrise de l'inflation et la vigueur des investissements les signes d'une réussite incontestable du système libéral et de la supériorité de celui-ci sur le modèle continental, plus interventionniste, réglementé et protecteur. Les travaillistes, en revanche, voient dans l'écart grandissant entre les plus riches et les plus pauvres, dans le nombre important de Britanniques en âge de travailler qui se sont retirés d'eux-mêmes du marché de l'emploi, dans la multiplication des emplois précaires, à temps partiel et mal payés, dans la déliquescence, enfin, de services essentiels tels que les transports, l'éducation ou la santé, les fautes non pas du système, mais de la gestion de celui-ci par les tories. Car la cause, au sein du New Labour, est entendue : le marché est roi et Keynes n'est pas son prophète. Il convient de ne pas entraver, par des réglementations sociales et commerciales restrictives, le libre fonctionnement du premier, et d'oublier par la même occasion les leçons du second sur les bienfaits de l'interventionnisme étatique (malgré les efforts de réhabilitation menés par Will Hutton, rédacteur en chef de

Un triple héritage – libéral, eurosceptique et sentimental – qui n'a pas fini d'imprimer sa marque sur le pays.

l'*Observer* et auteur de deux livres au succès paradoxal, tant ils vont à l'encontre de l'air du temps : *The State We're in* et *The State to Come*). La gauche britannique a balayé ses axiomes anciens – socialisme, gestion collective des moyens de production, liens organiques du Labour avec les syndicats – et prône l'anorexie fiscale et la flexibilité sociale. Tony Blair, rencontrant durant la campagne électorale un aréopage d'hommes d'affaires au Corn Exchange, à Londres, leur a promis que, s'il accédait au pouvoir, non seulement il ne remettrait pas en question les privatisations des conservateurs, mais il en proposerait sans doute encore quelques-unes de son cru. « Je ne vois aucune raison de privilégier la gestion publique des biens et des services, déclarait le leader travailliste. L'activité économique se porte d'autant mieux qu'elle reste entre les mains du privé. » Margaret Thatcher n'aurait pas dit autre chose.

L'Europe est le deuxième volet de son héritage, et, là aussi, Major comme Blair s'y sont montrés fidèles. Même si elle est hostile à la monnaie unique et critique envers Maastricht, Thatcher n'a jamais adopté envers l'Europe une position de rejet de l'intégration : après tout, c'est elle qui a signé l'Acte unique et intégré le livre au sein du Système monétaire européen (cette monnaie en est ressortie, à la grande humiliation des Britanniques, en septembre 1992, et ne s'est jamais aussi bien portée depuis). Son attitude, aujourd'hui largement partagée, a plutôt été celle d'une réticence systématique et vertueuse à l'encontre d'une construction dont elle n'a jamais aimé ni les desseins fédéralistes inavoués ni les déficiences démocratiques. Contre cette Europe en devenir que ne lui plaisait guère, Thatcher s'est battue. Seule, souvent, mais de l'intérieur, toujours. Quelques jours avant le scrutin, quand Major suppliait les rebelles du parti tory de « ne pas lui lier les mains » dans la table des négociations sur la monnaie unique, de le laisser libre de rechercher avec ses partenaires le

meilleur *deal* possible pour le Royaume-Uni, il était dans le droit fil de la combativité de son prédécesseur. Il n'oublie pas que Thatcher a jamais claqué la porte de l'Union, pour y défendre farouchement les intérêts nationaux britanniques. Quitte à assumer ensuite le risque du « splendide isolement » qui n'a jamais fait peur aux Anglais. Tony Blair, qui a tenu exactement le même langage que Major sur la monnaie unique (« Attendre et voir », puis referendum si, finalement, l'euro se fait), déclarait lui aussi ne pas craindre l'« isolement » quand nos intérêts sont en jeu ».

Enfin, ce scrutin a consacré de façon éclatante la pérennité de l'héritage sentimental du thatchérisme, que l'on peut résumer ainsi : le culte d'une Grande-Bretagne égalitariste et fière d'elle-même, d'une nation patriote et sans classes. Sans aller jusqu'à prétendre que la ci-devant *baronesse*, fille d'épiciers modestes, a le cœur à gauche, on peut dire tout de même qu'elle a autant bousculé quelques bastions aristocrates – à commencer par son propre parti, fief de rejetons d'écoles « privées » et d'« Oxbridge » – qu'elle a ébranlé les forteresses ouvrières. Les années Thatcher auront été celles des vertus petites-bourgeoises : la promotion sociale par le mérite et la propriété privée. L'une des privatisations les plus remarquables, et l'une des moins controversées, de Thatcher fut la mise en vente, à leurs occupants et à des prix inférieurs au marché, de dizaines de milliers d'appartements HLM du domaine public. Désormais, près de 78 % des logements en Grande-Bretagne appartiennent à leurs occupants – record européen. Cette création ex nihilo d'un capitalisme populaire trouve son prolongement idéologique aussi bien dans le conservatisme social d'un John Major, ce *one-nation conservative* qui veut parachever le rêve thatchérien d'une société sans classes par la réforme de l'État providence, que dans le concept travailliste de *stakeholder society*, une société de détenteurs non seulement d'actions, mais aussi d'enjeux, une société de participants. « *I am fighting fit* (Je suis en pleine forme, prête à la bagarre) », déclarait il y a quelques jours Margaret Thatcher. Personne n'en doute. Mais pour quoi faire ? La bataille, *baroness*, est déjà gagnée. ● **M. F.**

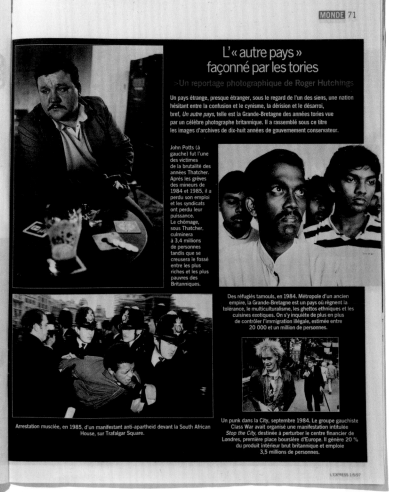

L'« autre pays » façonné par les tories

>Un reportage photographique de Roger Hutchings

Un pays étrange, presque étranger, sous le regard de l'un des siens, une nation hésitant entre la confusion et le cynisme, la dérision et le désarroi, bref, *Un autre pays*, telle est la Grande-Bretagne des années tories vue par un célèbre photographe britannique. Il a rassemblé sous ce titre les images d'archives de dix-huit années de gouvernement conservateur.

John Potts (à gauche) fut l'une des victimes de la brutalité des années Thatcher. Après les grèves des mineurs de 1984 et 1985, il a perdu son emploi et les syndicats ont perdu leur puissance. Le chômage, sous Thatcher, culminera à 3,4 millions de personnes tandis que se creusera le fossé entre les plus riches et les plus pauvres des Britanniques.

Des réfugiés tamouls, en 1984. Métropole d'un ancien empire, la Grande-Bretagne est un pays où règnent la tolérance, le multiculturalisme, les ghettos ethniques et les cuisines exotiques. On s'y inquiète de plus en plus de contrôler l'immigration illégale, estimée entre 20 000 et un million de personnes.

Arrestation musclée, en 1985, d'un manifestant anti-apartheid devant la South African House, sur Trafalgar Square.

Un punk dans la City, septembre 1984. Le groupe gauchiste Class War avait organisé une manifestation intitulée *Stop the City*, destinée à perturber le centre financier de Londres, première place boursière d'Europe. Il génère 20 % du produit intérieur brut britannique et emploie 3,5 millions de personnes.

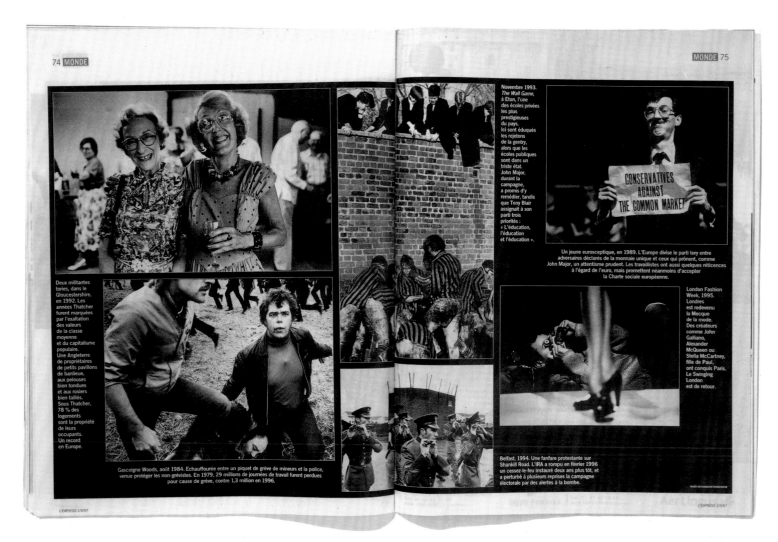

Deux militantes tories, dans le Gloucestershire, en 1992. Les années Thatcher furent marquées par l'exaltation des valeurs de la classe moyenne et du capitalisme populaire. Une Angleterre de propriétaires de petits pavillons de banlieue, aux pelouses bien tondues et aux rosiers bien taillés. Sous Thatcher, 78 % des logements sont la propriété de leurs occupants. Un record en Europe.

Gascoigne Woods, août 1984. Echauffourée entre un piquet de grève de mineurs et la police, venue protéger les non-grévistes. En 1979, 29 millions de journées de travail furent perdues pour cause de grève, contre 1,3 million en 1996.

Novembre 1993. *The Wall Game*, à Eton, l'une des écoles privées les plus prestigieuses du pays. Ici sont éduqués les rejetons de la gentry, alors que les écoles publiques sont dans un triste état. John Major, durant la campagne, a promis d'y remédier, tandis que Tony Blair assignait à son parti trois priorités : « L'éducation, l'éducation et l'éducation ».

CONSERVATIVES AGAINST THE COMMON MARKET

Un jeune eurosceptique, en 1989. L'Europe divise le parti tory entre adversaires déclarés de la monnaie unique et ceux qui prônent, comme John Major, un attentisme prudent. Les travaillistes ont aussi quelques réticences à l'égard de l'euro, mais promettent néanmoins d'accepter la Charte sociale européenne.

London Fashion Week, 1995. Londres est redevenu la Mecque de la mode. Des créateurs comme John Galliano, Alexander McQueen ou Stella McCartney, fille de Paul, ont conquis Paris. Le Swinging London est de retour.

Belfast, 1994. Une fanfare protestante sur Shankill Road. L'IRA a rompu en février 1996 un cessez-le-feu instauré deux ans plus tôt, et a perturbé à plusieurs reprises la campagne électorale par des alertes à la bombe.

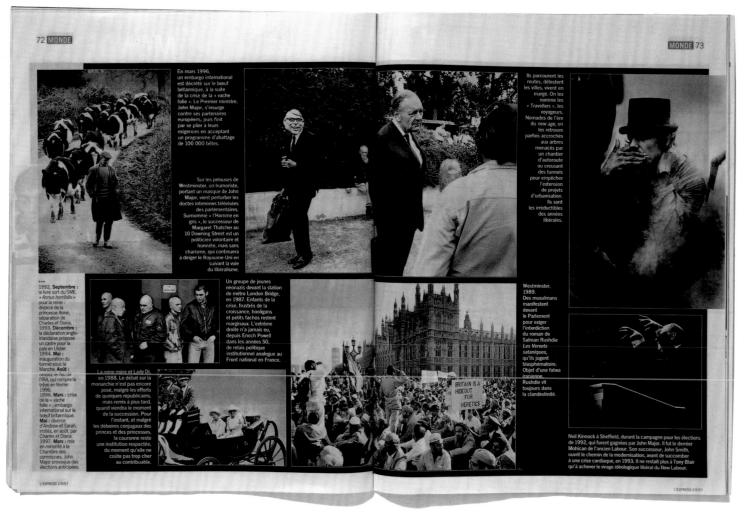

En mars 1996, un embargo international est décrété sur le bœuf britannique, à la suite de la crise de la vache folle ». Le Premier ministre, John Major, s'insurge contre ses partenaires européens, puis finit par se plier à leurs exigences en acceptant un programme d'abattage de 100 000 bêtes.

Sur les pelouses de Westminster, un humoriste, portant un masque de John Major, vient perturber les doctes interviews télévisées des parlementaires. Surnommé « l'Homme en gris », le successeur de Margaret Thatcher au 10 Downing Street est un politicien volontaire et honnête, mais sans charisme, qui continuera à diriger le Royaume-Uni en suivant la voie du libéralisme.

Ils parcourent les routes, détestent les villes, vivent en marge. On les nomme les « Travellers », les voyageurs. Nomades de l'ère du new age, on les retrouve parfois accrochés aux arbres menacés par un chantier d'autoroute ou creusant des tunnels pour empêcher l'extension de projets d'urbanisation. Ils sont les irréductibles des années libérales.

1992. Septembre : la livre sort du SME. « Annus horribilis » pour la reine : divorce de la princesse Anne, séparation de Charles et Diana. 1993. Décembre : la déclaration anglo-irlandaise propose un cadre pour la paix en Ulster. 1994. Mai : inauguration du tunnel sous la Manche. Août : cessez-le-feu de l'IRA, qui rompra la trêve en février 1996. 1996. Mars : crise de la « vache folle » ; embargo international sur le bœuf britannique. Mai : divorce d'Andrew et Sarah, imités, en août, par Charles et Diana. 1997. Mars : mis en minorité à la Chambre des communes, John Major provoque des élections anticipées.

La reine mère et Lady Di, en 1988. Le débat sur la monarchie n'est pas encore posé, malgré les efforts de quelques républicains, mais remis à plus tard, quand viendra le moment de la succession. Pour l'instant, et malgré les déboires conjugaux des princes et des princesses, la couronne reste une institution respectée, du moment qu'elle ne coûte pas trop cher au contribuable.

Un groupe de jeunes néonazis devant la station de métro London Bridge, en 1987. Enfants de la crise, frustrés de la croissance, hooligans et petits fachos restent marginaux. L'extrême droite n'a jamais eu, depuis Enoch Powell dans les années 50, de relais politique institutionnel analogue au Front national en France.

BRITAIN IS A HIDEOUT FOR HERETICS

Westminster, 1989. Des musulmans manifestent devant le Parlement pour exiger l'interdiction du roman de Salman Rushdie *Les Versets sataniques*, qu'ils jugent blasphématoire. Objet d'une fatwa iranienne, Rushdie vit toujours dans la clandestinité.

Neil Kinnock à Sheffield, durant la campagne pour les élections de 1992, qui furent gagnées par John Major. Il fut le dernier Mohican de l'ancien Labour. Son successeur, John Smith, ouvrit le chemin de la modernisation, avant de succomber à une crise cardiaque, en 1993. Il ne restait plus à Tony Blair qu'à achever le virage idéologique libéral du New Labour.

Particularly popular with young British punk and metal music fans in the late 1990s, 'moshing' involves dancers energetically throwing themselves at each other and 'surfing' the crowd in the 'mosh pit' at the front of the stage during live performances. After a period spent photographing metropolitan youth tribes, and at the start of her career in fashion, Elaine Constantine invited teenagers queuing for a London punk concert to a free gig she set up for the purpose of making this fashion story, for the magazine bible of style, the *Face*. Distributing clothes and providing alcohol for the shoot, Constantine then let the moshing take its own course, documenting it in a smart and ironic pastiche of photojournalism. The story signalled a break with the then-dominant convention of stylized fashion photography (often referred to as 'heroin chic'), with Constantine continuing to use non-professional models performing as themselves in narratives of youthful exuberance, presented in the language of reportage. Constantine's work is also an example of the reinvention of British documentary photography in the late twentieth century within the style press. (October 1997)

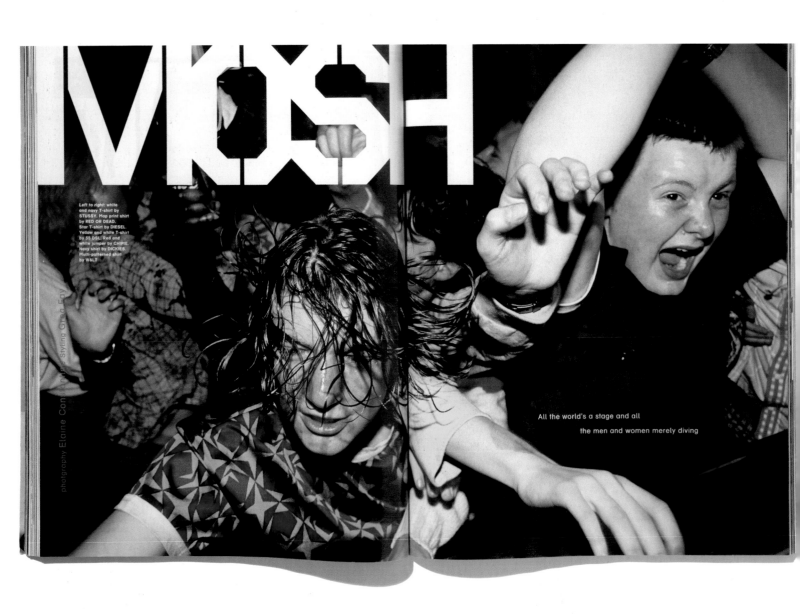

MOSH

Left to right: white and navy T-shirt by STUSSY. Map print shirt by RED OR DEAD. Star T-shirt by DIESEL. Yellow and white T-shirt by 55 DSL. Red and white jumper by CHIPIE. Navy shirt by DICKIES. Multi-patterned shirt by W<

photography Elaine Constantine Styling Greer Fry

All the world's a stage and all
the men and women merely diving

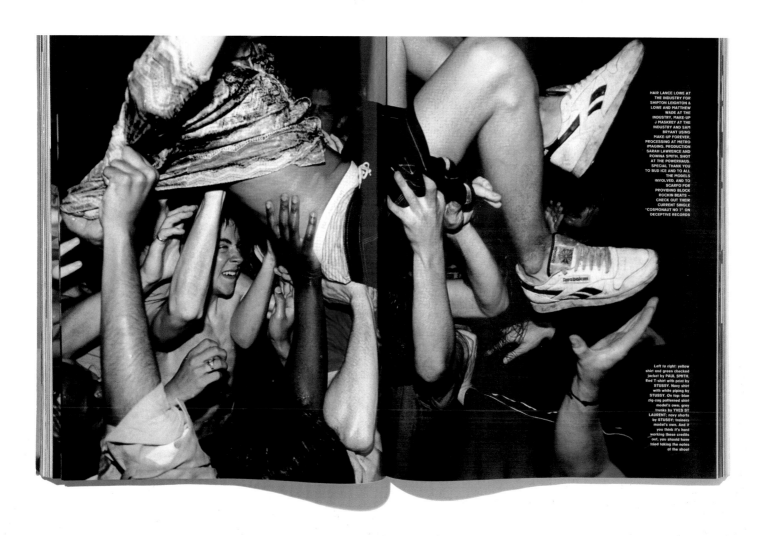

HAIR LANCE LOWE AT THE INDUSTRY FOR SHIPTON LEIGHTON & LOWE AND MATTHEW WADE AT THE INDUSTRY, MAKE-UP J MASKREY AT THE INDUSTRY AND SAM BRYANT USING MAKE-UP FOREVER, PROCESSING AT METRO IMAGING, PRODUCTION SARAH LAWRENCE AND ROWINA SMITH. SHOT AT THE POWERHAUS. SPECIAL THANK YOU TO BUD ICE AND TO ALL THE MODELS INVOLVED, AND TO SCARFO FOR PROVIDING BLOCK ROCKIN BEATS – CHECK OUT THEIR CURRENT SINGLE "COSMONAUT NO 7" ON DECEPTIVE RECORDS

Left to right: yellow shirt and green checked jacket by PAUL SMITH. Red T-shirt with print by STUSSY. Navy shirt with white piping by STUSSY. On top: blue zig-zag patterned shirt model's own; grey trunks by YVES ST LAURENT; navy shorts by STUSSY; trainers model's own. And if you think it's hard working these credits out, you should have tried taking the notes of the shoot

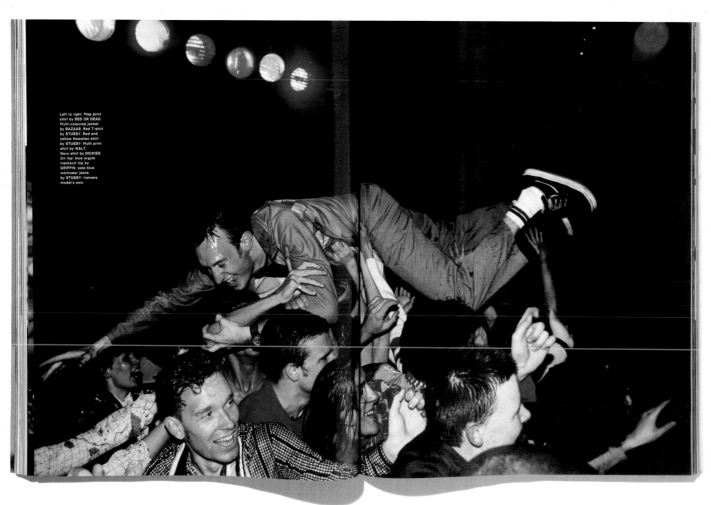

Left to right: Map print shirt by RED OR DEAD. Multi-coloured jacket by BAZAAR. Red T-shirt by STUSSY. Red and yellow Hawaiian shirt by STUSSY. Multi print shirt by WALT. Navy shirt by DICKIES. On top: blue argyle tracksuit top by GRIFFIN; pale blue workwear jeans by STUSSY; trainers model's own

'The fact that there isn't a market for photo stories in Australian magazines has dictated the way I work. Galleries now do what magazines used to: expose photographers' work.' This is how photographer Trent Parke has commented on the transformed state of photojournalism in the 1990s. Formerly employed for eight years as sports photographer for the national newspaper, the *Australian*, he left to take on more ambitious projects independently. But like the experience of many of his peers, editorial photography for magazines became an occasional sideline, with magazines publishing stories about exhibitions of his work more often than they offered him new assignments. Parke's classic and atmospheric 'Mt Pandemonium' story is an exception, itself a digression from a sports assignment; while covering the Bathurst 1,000-kilometre car race around Mt Panorama for the *Australian*, Parke documented a group of inebriated men resembling characters from the film *Mad Max*, entertaining themselves by crashing cars on the fringe of the race. It ran in the lead up to the Bathurst race the following year. (18-19 September 1999)

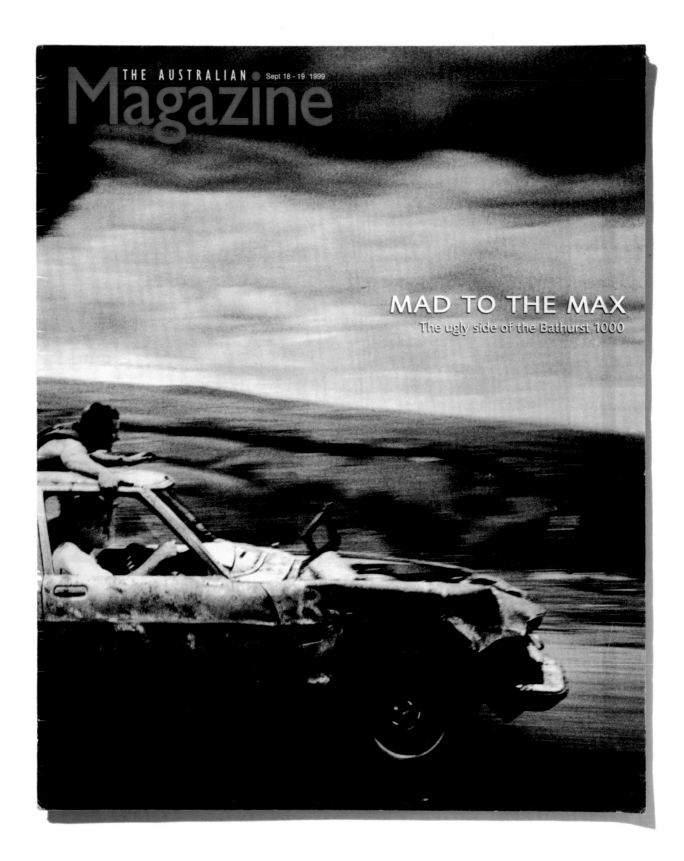

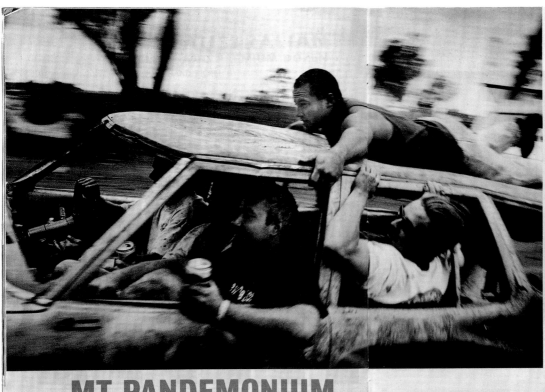

MT PANDEMONIUM

Attracted by clouds of smoke and dust coming from 'the hill', photographer **Trent Parke** got caught in the middle of a drunken demolition derby on the eve of last year's Bathurst 1000 at Mt Panorama.

THE AUSTRALIAN MAGAZINE |26| September 18 - 19 1999

THE AUSTRALIAN MAGAZINE |27| September 18 - 19 1999

Boys just want to raise hell ...
The Australian's Trent Parke won a World Press Photo award for this photograph of beer-fuelled petrolheads playing up behind the scenes at last year's V8 endurance race, the Bathurst 1000.
Billed as the day "the big men go to the mountain", the event attracts thousands of motorsport fans, not all of them with the intention of being mere spectators.
The photos on these pages were taken around Mt Panorama on the afternoon before the big race.

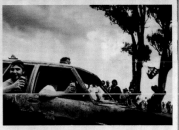

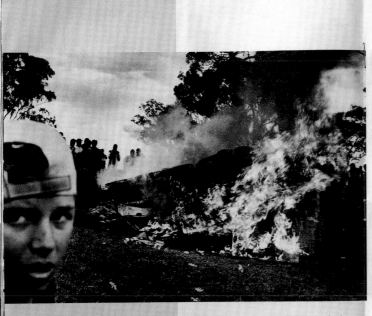

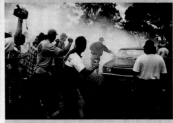

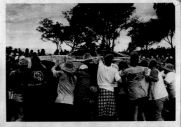

Testosterone-heavy crowds, which included many unsupervised young boys, engaged in the apparently popular sport of crash derbys, tipping and rolling cars and torching the results. Throughout the afternoon, the smoke and fumes from burning wrecks enveloped the Bathurst race circuit. Campsites were paved with empty beer cans.

Powered by high-octane beer and V8 motor madness, the male of the species runs wild on Bathurst's Mt Panorama, home to the Bathurst 1000. These award-winning photographs by Trent Parke, of *The Australian*, capture a side of the great race that those who promote and sponsor it would prefer we didn't see.

They were taken on the afternoon before last year's race, run as always on the first Sunday in October. It is now history that Swedish driver Rickard Rydell and Kiwi veteran Jim Richards went on to win the 161-lap endurance test, the nation's homegrown motoring classic. But what went on at the top of the Mt Panorama circuit outside Bathurst the afternoon before resembled a scene from another Australian classic, *Mad Max*. Clapped-out cars were raced around the campsites littered across the back of the mountain. Full of beer and bravado, their drivers happily crashed them head-on into trees, rocks or any other obstacle. Cheered on by an equally fuelled-up, almost exclusively male audience – including young boys, with nary a sober parent in attendance – the cars, mainly old Holdens and Fords, were thrashed into oblivion.

THE AUSTRALIAN MAGAZINE |28| September 18 - 19 1999

THE AUSTRALIAN MAGAZINE |29| September 18 - 19 1999

In 1993, Yann Arthus-Bertrand began the project that eventually became *La Terre vue du Ciel* (2002) – a photographic documentation of the planet seen from the air. Its goal was to 'raise public awareness of the Earth's beauty in order to better condemn its problems'. The logistics of its production were even more ambitious: each picture required enormous preparation and expense, including necessary permits, a helicopter or light aircraft, and assistants to manage eight cameras and their respective lenses. Arthus-Bertrand planned the project around the coming millennium, and with the support of UNESCO, organized detailed scientific captions to explain the ecological or social problems that each of the images referred to. *Geo* published the first major portfolio of the finished project as it rose to become a global photography and publishing phenomenon – arguably the most popular and successful work of photojournalism ever produced and far exceeding even Arthus-Bertrand's ambitious expectations. In simply revealing the patterns of the earth's surface, he had found a formula which matched even *The Family of Man*'s ability to touch a universal chord. (October 1999)

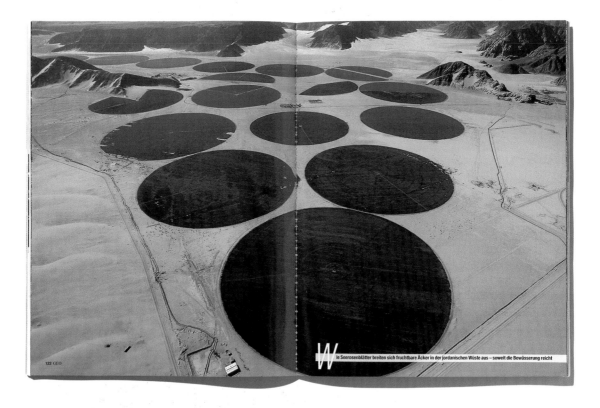

Wie Seerosenblätter breiten sich fruchtbare Äcker in der jordanischen Wüste aus – soweit die Bewässerung reicht

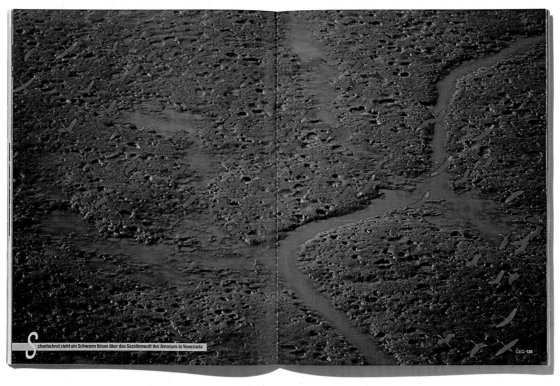

Scharlachrot zieht ein Schwarm Ibisse über das Gezeitenwatt des Amacuro in Venezuela

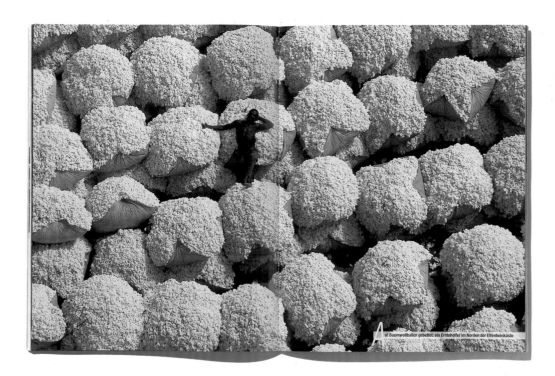
Auf Baumwollballen gebettet: ein Ernthelfer im Norden der Elfenbeinküste

Aquarelle im Großformat: Vor den Philippinen zeichnet der Abraum einer Goldmine eine sandige Spirale in die Celebes-See. Sonnenlicht taucht im Norden Kanadas Eisschollen in türkisfarbene Schatten, Salz und Quarz färben auf Island das heiße Wasser milchig. Und entlang der bretonischen Küste bewedeln Algen den Meeresgrund

128 GEO

Elfenbeinküste: Ein weißer Schatten aus Asche gibt Zeugnis von einem längst verbrannten Baum

At its inception in Madrid in 1991, the bimonthly magazine *Big* declared itself 'free from the triviality and sound bite mentality that currently exhausts our media'. Blurring the boundaries between art project and consumer magazine, it set out to offer an image of a particular city or country, showcasing in each issue the vision of an invited editor/art director and their choice of contemporary art, fashion and reportage photography. This example, focused on Rio de Janeiro, is the work of Brazilian art director Rinco Lins. High-concept visual magazines like *Big* were not a phenomenon of the late twentieth century alone – earlier examples include *Lilliput*, *Interview* and *Provoke* – but *Big* belongs to an expanding group of designer-led publications that have established themselves as laboratories for new ideas and new aproaches to reportage, including *Purple* (Paris), *Re-Magazine* (Amsterdam), *Matador* (Madrid), *Foil* (Tokyo), *Visionaire* (New York) and *Ojo de Pez* (Barcelona). Few such conceptual magazines have become successes in consumer terms – one exception is *Wallpaper* (London) – but they wield a cultural influence that far exceeds their circulation figures. (1999, with photographs by Roberto Donaire, Bob Wolfenson and Adriana Pittigliani)

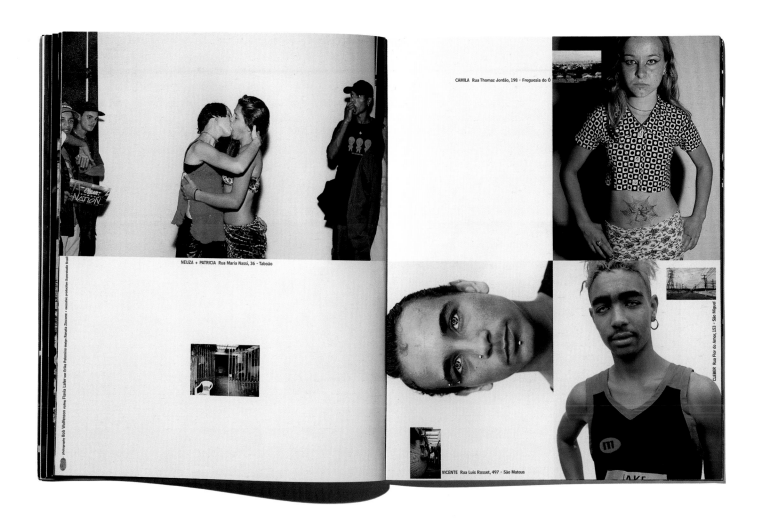

CAMILA Rua Thomaz Jordão, 198 - Freguesia do Ó

NEUZA + PATRICIA Rua Maria Nassi, 36 - Taboão

VICENTE Rua Luis Rosset, 497 - São Mateus

CLEBER Rua Flor do Amor, 153 - São Miguel

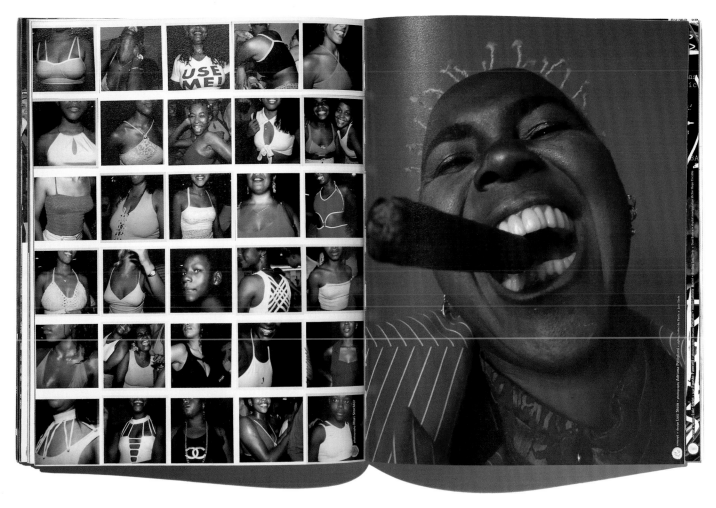

Between 2000 and 2001, *National Geographic* published three stories on the 'Megatransect', conservationist Mike Fay's massive expedition – years in the planning – across 2,000 miles of the last pristine wilderness of Central Africa. This classic explorer's tale was highly popular with *Geographic* readers, thanks to both Fay's charismatic intensity and the work of photographer Michael 'Nick' Nichols. Fay's declared goal was simple and lofty: to assemble an encyclopedia of environmental data which could serve as a resource for conservation-minded politicians and scientists. As on previous occasions, Fay recruited expedition staff from a tribe of Bambendjelle pygmies, and Nichols travelled with them over several extended periods during the year, documenting the narrative of the trek in black and white. Meanwhile, he reserved the use of colour film for his natural subjects, creating an elegant distinction between the observers and the jungle they came to study. Unlike the tightly-framed telephoto shots typical of wildlife photography competition winners, Nichols photographs wild animals with a raw and sometimes disturbing edginess, communicating the thrill and danger of entering alien territory. (October 2000)

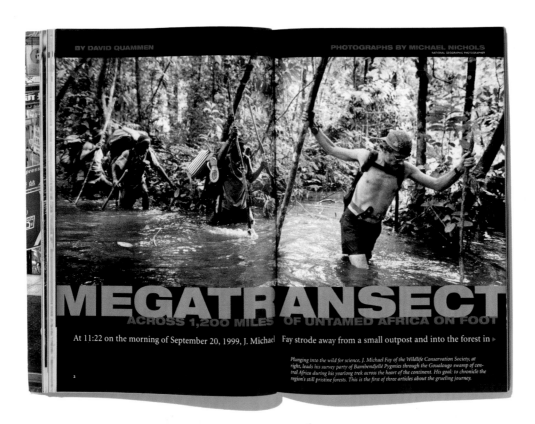

BY DAVID QUAMMEN

PHOTOGRAPHS BY MICHAEL NICHOLS
NATIONAL GEOGRAPHIC PHOTOGRAPHER

MEGATRANSECT
ACROSS 1,200 MILES OF UNTAMED AFRICA ON FOOT

At 11:22 on the morning of September 20, 1999, J. Michael Fay strode away from a small outpost and into the forest in ▷

Plunging into the wild for science, J. Michael Fay of the Wildlife Conservation Society, at right, leads his survey party of Bambendjellé Pygmies through the Goualougo swamp of central Africa during his yearlong trek across the heart of the continent. His goal: to chronicle the region's still pristine forests. This is the first of three articles about the grueling journey.

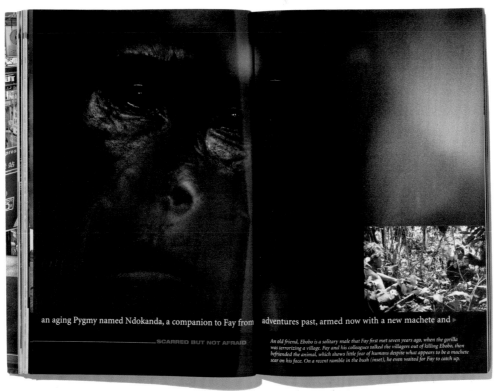

an aging Pygmy named Ndokanda, a companion to Fay from adventures past, armed now with a new machete and ▷

SCARRED BUT NOT AFRAID

An old friend, Ebobo is a solitary male that Fay first met seven years ago, when the gorilla was terrorizing a village. Fay and his colleagues talked the villagers out of killing Ebobo, then befriended the animal, which shows little fear of humans despite what appears to be a machete scar on his face. On a recent ramble in the bush (inset), he even waited for Fay to catch up.

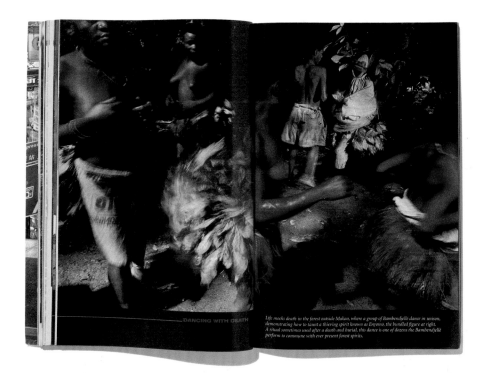

_____DANCING WITH DEATH

Life mocks death in the forest outside Makao, where a group of Bambendjellé dance in unison, demonstrating how to taunt a thieving spirit known as Enyomo, the bundled figure at right. A ritual sometimes used after a death and burial, this dance is one of dozens the Bambendjellé perform to commune with ever present forest spirits.

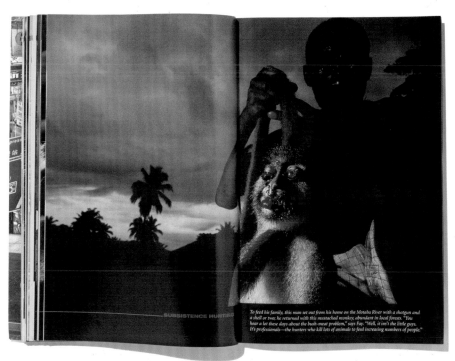

_____SUBSISTENCE HUNTING

To feed his family, this man set out from his home on the Motaba River with a shotgun and a shell or two; he returned with this mustached monkey, abundant in local forests. "You hear a lot these days about the bush-meat problem," says Fay. "Well, it isn't the little guys. It's professionals—the hunters who kill lots of animals to feed increasing numbers of people."

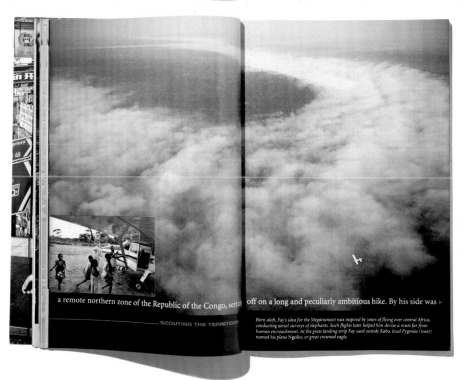

a remote northern zone of the Republic of the Congo, setting off on a long and peculiarly ambitious hike. By his side was ▶

_____SCOUTING THE TERRITORY

Born aloft, Fay's idea for the Megatransect was inspired by years of flying over central Africa, conducting aerial surveys of elephants. Such flights later helped him devise a route far from human encroachment. At the grass landing strip Fay used outside Kabo, local Pygmies (inset) named his plane Ngolio, or great crowned eagle.

In 2001, photographer Oliviero Toscani's relationship with Benetton came to an end, and two young photographers – Adam Broomberg and Oliver Chanarin – took over as the editors of *Colors*. Their first decision was to ban the use of stock photography. Instead, young photographers from the worlds of fashion and advertising with distinct stylistic approaches were commissioned to document social stories, in most cases for the first time. The first issue of the new *Colors* set the tone. Broomberg and Chanarin, along with advertising photographer Stefan Ruiz and fashion photographer James Mollison, travelled with *Loaded* journalist Michael Holden and script writer Jonathan Steinberg to a refugee camp in Tanzania, home to 120,000 refugees from the conflict in Rwanda and Burundi. Their goal was to provoke engagement with the issues of poverty in Africa without resorting to clichéd representations. Working on medium- and large-format cameras, and drawing on the inspiration of different photographic genres (including architectural photography and colonial portraiture), they produced an in-depth account of community life in the camp. Broomberg's and Chanarin's approach in turn influenced the practice of many traditional photojournalists. (December 2000)

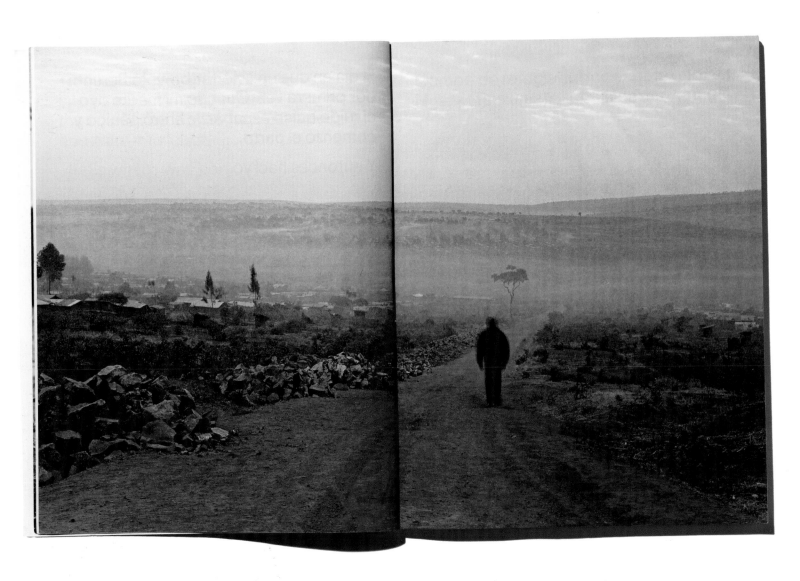

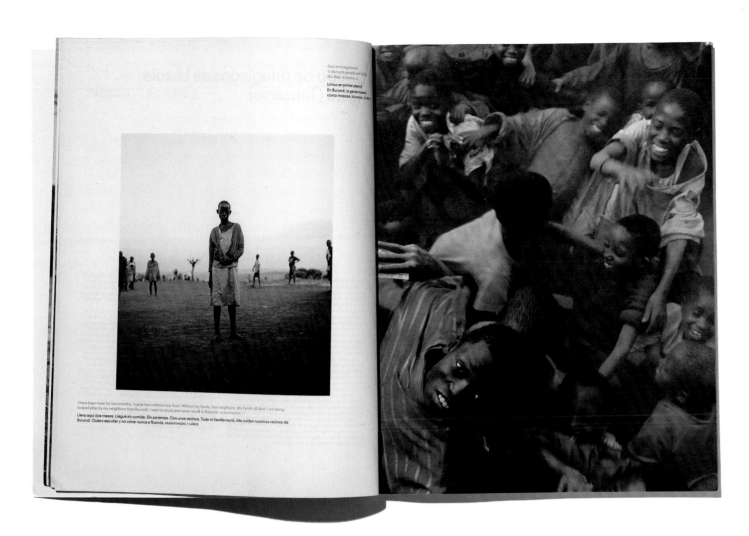

(boy in foreground)
In Burundi people are dying
like flies. RUTAHINDURWA, 13

(chico en primer plano)
En Burundi, la gente muere
como moscas. RUTAHINDURWA, 13 AÑOS

I have been here for two months. I came here without any food. Without my family. Just neighbors. My family all died. I am being looked after by my neighbors from Burundi. I want to study and never return to Rwanda. MUKANYANDWI, 11

Llevo aquí dos meses. Llegué sin comida. Sin parientes. Con unos vecinos. Toda mi familia murió. Me cuidan nuestros vecinos de Burundi. Quiero estudiar y no volver nunca a Ruanda. MUKANYANDWI, 11 AÑOS

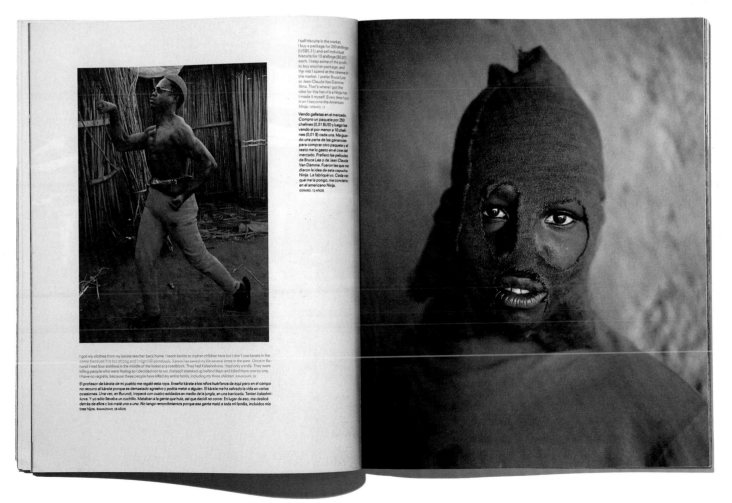

I sell biscuits in the market. I buy a package for 250 shillings (US$0.51) and sell individual biscuits for 10 shillings ($0.01) each. I keep some of the profits to buy another package, and the rest I spend at the cinema in the market. I prefer Bruce Lee or Jean Claude Van Damme films. That's where I got the idea for this hat—it's a Ninja hat. I made it myself. Every time I put it on I become the American Ninja. GERARD, 12

Vendo galletas en el mercado. Compro un paquete por 250 chelines (0,31 $US) y luego las vendo al por menor a 10 chelines (0,01 $) cada una. Me guardo una parte de las ganancias para comprar otro paquete y el resto me lo gasto en el cine del mercado. Prefiero las películas de Bruce Lee o de Jean Claude Van Damme. Fueron las que me dieron la idea de esta capucha Ninja. La fabriqué yo. Cada vez que me la pongo, me convierto en el americano Ninja. GERARD, 12 AÑOS

I got my clothes from my karate teacher back home. I teach karate to orphan children here but I don't use karate in the camp because it is too strong and I might kill somebody. Karate has saved my life several times in the past. Once in Burundi I met four soldiers in the middle of the forest at a roadblock. They had Kalashnikovs. I had only a knife. They were killing people who were fleeing so I decided not to run. Instead I sneaked up behind them and killed them one by one. I have no regrets, because these people have killed my entire family, including my three children. RAMADHAM, 28

El profesor de kárate de mi pueblo me regaló esta ropa. Enseño kárate a los niños huérfanos de aquí pero en el campo no recurro al kárate porque es demasiado agresivo y podría matar a alguien. El kárate me ha salvado la vida en varias ocasiones. Una vez, en Burundi, tropecé con cuatro soldados en medio de la jungla, en una barricada. Tenían kalashnikovs. Y yo sólo llevaba un cuchillo. Mataban a la gente que huía, así que decidí no correr. En lugar de eso, me deslicé detrás de ellos y los maté uno a uno. No tengo remordimientos porque esa gente mató a toda mi familia, incluidos mis tres hijos. RAMADHAM, 28 AÑOS

The annual pilgrimage to Plaine du Nord, north of Port-au-Prince, attracts over 10,000 Voodoo believers to pay homage to Ogoun, the god of fire and war. In the ritual 'Bath of Power', pilgrims are immersed in a sacred pool from which they emerge covered with a glistening skin of mud, a spectacular sight that has drawn hundreds of photojournalists. Cristina García Rodero's images distinguish themselves with their intensity, offering psychological insight while sensually conveying the religious ecstasy of her subjects. Typically for 21st-century photojournalism, the work was first seen as an essay in the sophisticated supplement of *La Vanguardia*, the Barcelona-based daily newspaper, only after its exhibition in the Italian pavilion of the 2001 Venice Biennale. The project was part of García Rodero's broader survey of religious folklore that began in 1974 with her 15-year study of religious rituals and practices in Spain. Her photographs draw on traditions of anthropology, art, and journalism, and offer a model for how a photographer can enter and record religious experience. (17 June 2001)

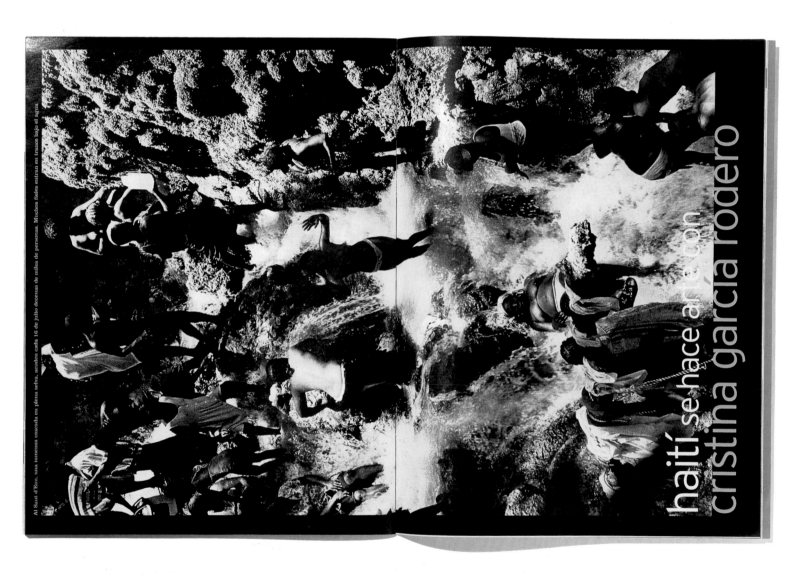

Cristina García Rodero es una menuda profesora de la Escuela de Bellas Artes de Madrid. Pero su manera de fotografiar la ha convertido en la principal fotógrafa documentalista española. Y la Bienal de Venecia lleva su obra a su más importante exposición de arte contemporáneo, titulada en esta ocasión "Platea de la humanidad", recién inaugurada.

García Rodero se convirtió hace doce años en una deslumbrante revelación, aunque llevaba años haciendo pacientemente su trabajo, que dio lugar a "La España oculta", el libro que la encumbró en 1989. Le llovieron los mejores premios y desde entonces antropólogos, editores y medios de comunicación se la disputan. Por su forma de mirar. Y sobre todo, por su forma de estar en ca-

da lugar, de meterse en esa vida que fotografía. La exposición internacional de arte contemporáneo de la Bienal de Venecia muestra sus fotos de Haití, parte de un ambicioso proyecto, "Entre el cielo y la tierra", en el que Cristina García Rodero habla de cuerpos y de espíritu, de lo religioso y lo pagano, de todo lo contrario que coexiste. En el caso de Haití, la fotógrafa muestra una religión vivida como refugio de las angustias y un sincretismo –particular de este país nacido de miles de esclavos– entre la impuesta religión católica y el vudú. Ella desaparece en sus fotografías, pero logra que quien mire esas imágenes esté allí, entre quienes han sido retratados y en ese momento en concreto. Esa es su manera de mirar.

FOTOS DE **Cristina García Rodero**

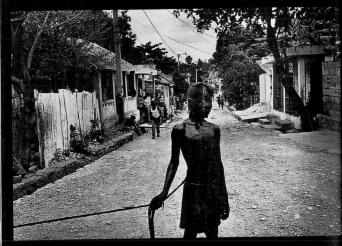

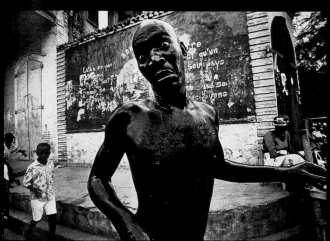

Un joven cubierto con una máscara y un hombre embadurnado con aceite durante el carnaval de Jacmel, una de las tradiciones populares con más vida del país, que recrea un mundo en el que extrañas criaturas conviven con demonios

La Bienal de Venecia lleva a su exposición internacional de arte contemporáneo la obra de la fotógrafa sobre Haití

Las fotografías de Haití muestran ese particular sincretismo del país entre el catolicismo impuesto y el vudú

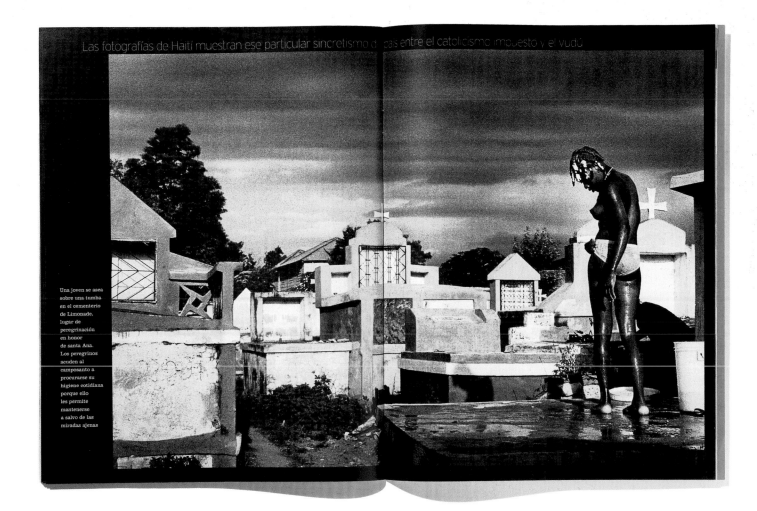

Una joven se asea sobre una tumba en el cementerio de Limonade, lugar de peregrinación en honor de santa Ana. Los peregrinos acuden al camposanto a procurarse su higiene cotidiana porque ello les permite mantenerse a salvo de las miradas ajenas

341

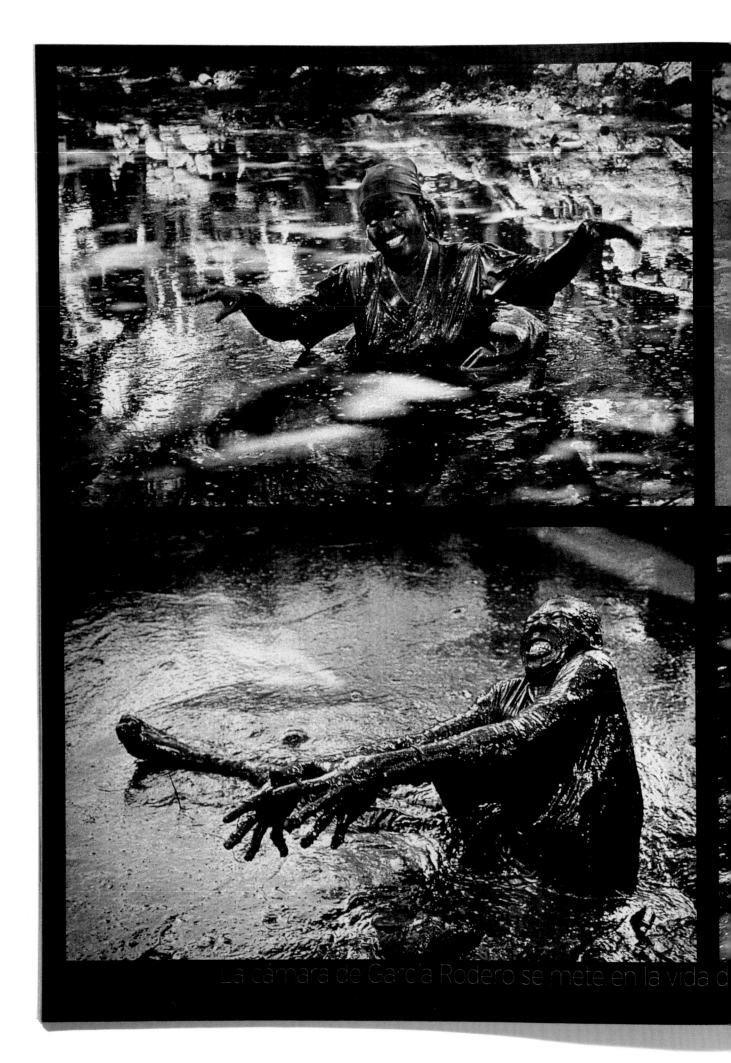

La cámara de García Rodero se mete en la vida d

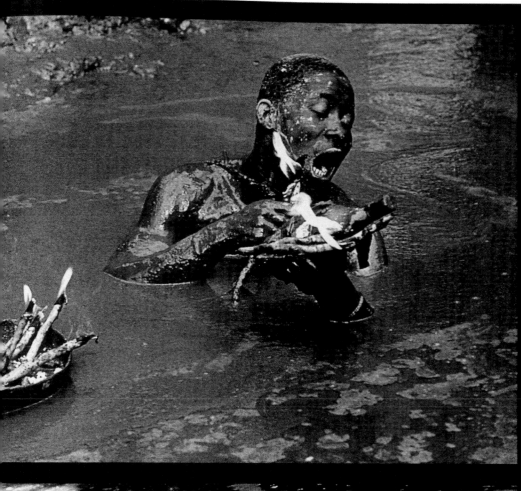

Santiago y Ogou,
dios de la guerra,
comparten lugar
sagrado en la
Planicie del
Norte, en Haití.
La laguna
Santiago es una
charca de barro
próxima a la
iglesia del mismo
nombre y allí
se sumergen
los peregrinos
cuando entran en
trance o acuden a
pedir favores, en
una fiesta que se
celebra cada año
el 25 de julio.
Para los
practicantes del
vudú, Ogou es un
espíritu guerrero
al que identifican
con Santiago
Matamoros

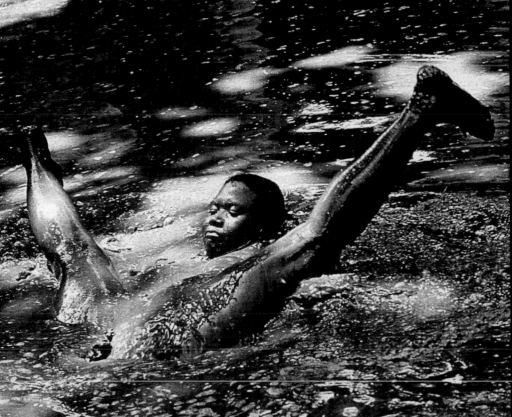

fotografía. Es su forma de mirar muy de cerca el mundo

In the early 1990s Ad van Denderen began photographing the growing underclass of unemployed workers leaving their homes and families in the developing world in search of jobs in industrialized Europe. Within immigrant communities on Europe's margins, he investigated the culture they brought from home, the slum communities where they presently lived and the way they spent their time. He also documented the risks of crossing borders illegally – navigating the Straits of Gibraltar or travelling on foot from Turkey into Greece by means of an underground railroad – revealing what happened when they were caught. Van Denderen works in the style of a traditional humanist photographer, using his camera to fight political and social discrimination, but his style does not adhere to old-fashioned documentary rules; he does not follow the conventions that once spelled 'objectivity'. These are not cool, detached images. They neither glorify their subject, nor patronize immigrants as 'other', but invite the reader's empathy by presenting them as fellow citizens of an unequal world. (October 2001)

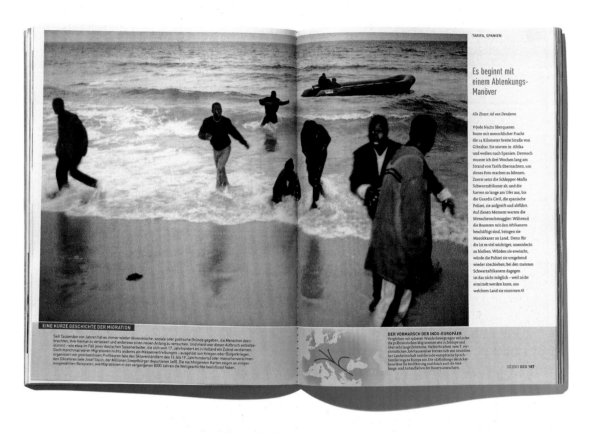

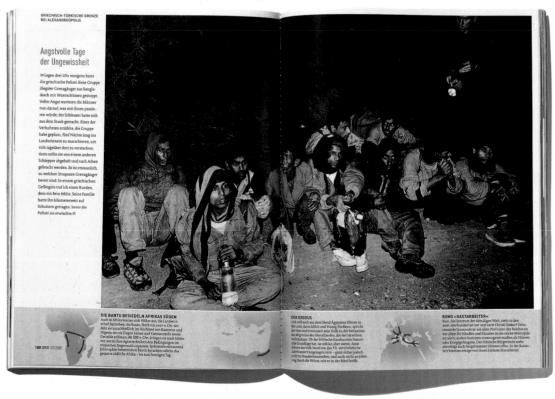

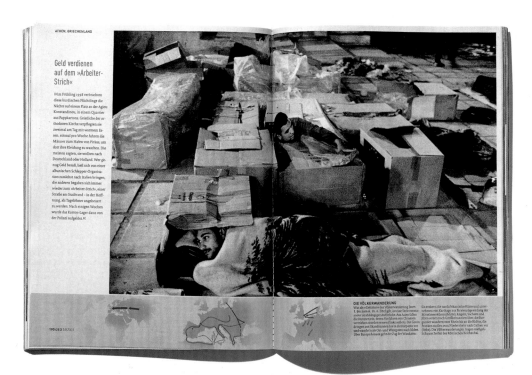

Geld verdienen auf dem »Arbeiter-Strich«

»Im Frühling 1998 verbrachten diese kurdischen Flüchtlinge die Nächte auf einem Platz an der Agiou Konstantinou, in einem Quartier aus Pappkartons. Geistliche der orthodoxen Kirche verpflegten sie zweimal am Tag mit warmem Essen, einmal pro Woche fuhren die Männer zum Hafen von Piräus, um dort ihre Kleidung zu waschen. Die meisten sagten, sie wollten nach Deutschland oder Holland. Wer genug Geld besaß, ließ sich von einer albanischen Schlepper-Organisation zunächst nach Italien bringen, die anderen begaben sich immer wieder zum Arbeiter-Strich, einer Straße am Stadtrand – in der Hoffnung, als Tagelöhner angeheuert zu werden. Nach einigen Wochen wurde das Karton-Lager dann von der Polizei aufgelöst.«

DIE VÖLKERWANDERUNG
Was als »Zeitalter der Völkerwanderung (vom 3. bis zum 6. Jh. n. Chr.)gilt, ist eine Serie verschiedener unzähliger Aufbrüche. Aus Asien fallen die Hunnen ein, deren Vorfahren von Chinesen vertrieben worden sein sollen. Die Goten dringen von Skandinavien bis in die Karpaten vor und wandern als Ost- und Westgoten nach Süden. Über Europa hinaus geht der Zug der Wandalen:

Sie erobern die nordafrikanische Küste und unternehmen von Karthago aus Piratenzüge entlang der Mittelmeerküsten. Angeln, Sachsen und Jüten setzen nach Großbritannien über, die Burgunder wandern vom Rhein bis an die Rhône, die Franken stoßen vom Niederrhein nach Gallien vor (links). Die Völkerwanderungen tragen maßgeblich zum Zerfall des Römischen Reiches bei.

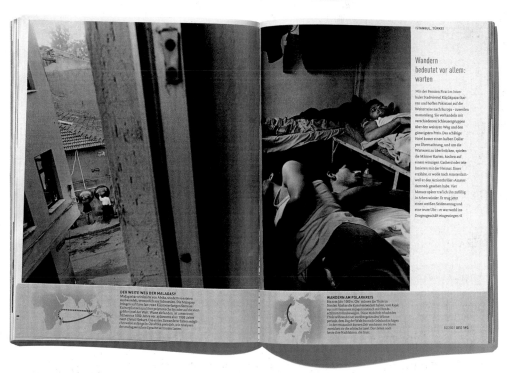

Wandern bedeutet vor allem: warten

»In der Pension Firar im Istanbuler Stadtviertel Küçükpazar harren und hoffen Pakistani auf die Weiterreise nach Europa – zuweilen monatelang. Sie verhandeln mit verschiedenen Schleusergruppen über den weiteren Weg und den günstigsten Preis. Das schäbige Hotel kostet einen halben Dollar pro Übernachtung, und um die Wartezeit zu überbrücken, spielen die Männer Karten, kochen auf einem winzigen Gasherd oder telefonieren mit der Heimat. Einer erzählte, er wolle nach Amsterdam – weil er den Actionthriller ›Amsterdamned‹ gesehen habe. Vier Monate später traf ich ihn zufällig in Athen wieder. Er trug jetzt einen weißen Seidenanzug und eine teure Uhr – er war wohl ins Drogengeschäft eingestiegen.«

DER WEITE WEG DER MALAGASY
Madagaskar wird nicht von Afrika, sondern von Asien aus besiedelt, vermutlich aus Indonesien. Die Malagasy bringen auf ihrer fast 7000 Kilometer langen Seereise Kulturpflanzen und ihre polynesische Sprache auf die vier großen Inseln der Welt. Wann sie landen, ist umstritten: frühestens 1000 Jahre vor, spätestens aber 1000 Jahre nach Christi Geburt. Die ersten Zuwanderer haben möglicherweise anfangs in Ostafrika gesiedelt, wie Analysen der malagasischen Sprache vermuten lassen.

WANDERN AM POLARKREIS
Bis zum Jahr 1000 n. Chr. müssen die Thule im Norden Alaskas die Kunst entwickelt haben, vom Kajak aus mit Harpunen zu jagen und sich mit Hundeschlitten fortzubewegen. Diese Mobilität erlaubt den Thule während einer vorübergehenden Wärmeperiode, dem Zug der Wale bis nach Grönland zu folgen – in der erstaunlich kurzen Zeit von kaum 100 Jahren erreichen sie die arktische Insel. Dort leben noch heute ihre Nachfahren, die Inuit.

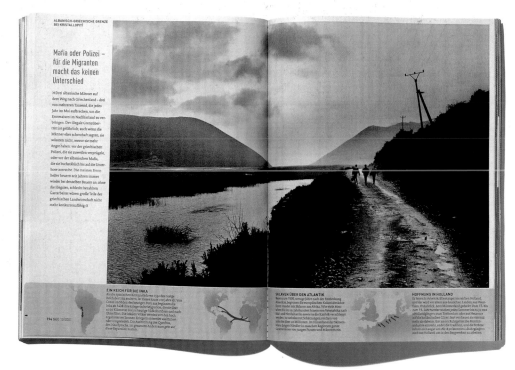

Mafia oder Polizei – für die Migranten macht das keinen Unterschied

»Drei albanische Männer auf dem Weg nach Griechenland – drei von mehreren Tausend, die jedes Jahr im Mai aufbrechen, um die Erntesaison im Nachbarland zu verbringen. Der illegale Grenzübertritt ist gefährlich; auch wenn die Männer eher scherzhaft sagten, sie wüssten nicht, wovor sie mehr Angst haben: vor der griechischen Polizei, die sie zuweilen verprügele, oder vor der albanischen Mafia, die sie buchstäblich bis auf die Unterhose ausraube. Die meisten Erntearbeiter heuern seit Jahren immer wieder bei denselben Bauern an; ohne die illegalen, schlecht bezahlten Gastarbeiter wären große Teile der griechischen Landwirtschaft nicht mehr konkurrenzfähig.«

EIN REICH FÜR DIE INKA
Als die spanischen Konquistadoren 1532 das riesige Reich der Inka eroberten, war dieses kaum 100 Jahre alt: Von Cuzco im Süden des heutigen Peru aus begannen die Inka ab 1438 ihre kriegerische Migration, die sie über 4000 Kilometer bis ins heutige Südkolumbien und nach Chile führte. Die unklen Völker werden nach Anschluss an das reich organisierte Imperium Inka, entsprechend ihres Soziales oder umgesiedelt. Die Ausbreitung der Quechua-Sprache, der Inka-Sprache, im gesamten Andenraum geht auf diese Expansion zurück.

SKLAVEN ÜBER DEN ATLANTIK
Bereits um 1500, wenige Jahre nach der Entdeckung Amerikas, beginnen die europäischen Kolonialisten mit ihrem Handel mit Sklaven aus Afrika. Wie viele Menschen bis ins 19. Jahrhundert hinein von Westafrika nach Süd- und Nordamerika sowie in die Karibik verschleppt werden, ist unbekannt; Schätzungen reichen von etwa 10 Millionen bis 50 Millionen. Im Hinterland der Sklavenküsten liefern Händler in manchen Regionen ganze Generationen von jungen Frauen und Männern ein.

HOFFNUNG IN HOLLAND
Es herrscht Arbeitskräftemangel im reichen Holland, und der wird vor allem aus deutschen Ländern und Westfalen, Osnabrück, dem Münsterland gedeckt: Vom 17. bis zum 19. Jahrhundert ziehen jedes Jahr bis zu 30 000 arbeitsfähige Männer und Frauen – die so genannten ›Hollandgänger‹ – auf die holländischen Güter, dort verdienen sie viermal mehr als daheim. Viele ziehen im Rechte die Montaurin unhalten ernteten, andere die Tradition, um die Steinmeckeln sich sogar um, oft als harten Als Wege als Holland um, in den Bergwerken zu arbeiten.

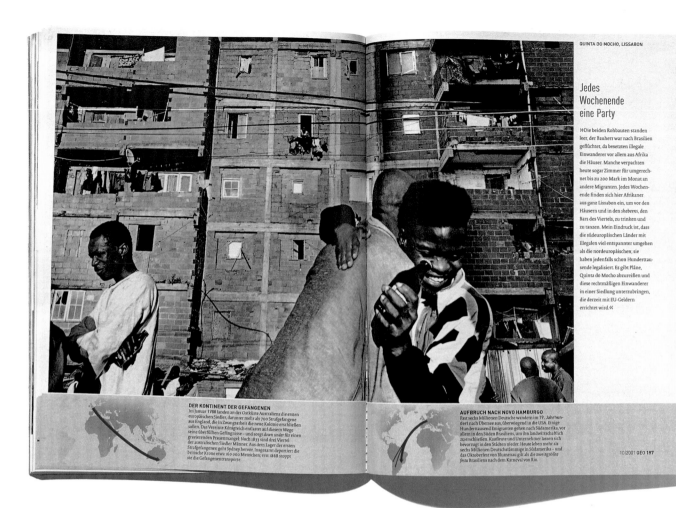

Jedes Wochenende eine Party

»Die beiden Rohbauten standen leer, der Bauherr war nach Brasilien geflüchtet, da besetzten illegale Einwanderer vor allem aus Afrika die Häuser. Manche verpachten heute sogar Zimmer für umgerechnet bis zu 200 Mark im Monat an andere Migranten. Jedes Wochenende finden sich hier Afrikaner aus ganz Lissabon ein, um vor den Häusern und in den *shebeens*, den Bars des Viertels, zu trinken und zu tanzen. Mein Eindruck ist, dass die südeuropäischen Länder mit Illegalen viel entspannter umgehen als die nordeuropäischen; sie haben jedenfalls schon Hunderttausende legalisiert. Es gibt Pläne, Quinta do Mocho abzureißen und diese rechtmäßigen Einwanderer in einer Siedlung unterzubringen, die derzeit mit EU-Geldern errichtet wird.«

DER KONTINENT DER GEFANGENEN
Im Januar 1788 landen an der Ostküste Australiens die ersten europäischen Siedler, darunter mehr als 700 Strafgefangene aus England, die in Zwangsarbeit die neue Kolonie erschließen sollen. Das Vereinte Königreich entlässt auf diesem Wege seine überfüllten Gefängnisse – und sorgt *down under* für einen gravierenden Frauenmangel. Noch 1833 sind drei Viertel der australischen Siedler Männer. Aus dem Lager der ersten Strafgefangenen geht Sydney hervor. Insgesamt deportiert die britische Krone etwa 160 000 Menschen; erst 1868 stoppt sie die Gefangenentransporte.

AUFBRUCH NACH NOVO HAMBURGO
Fast sechs Millionen Deutsche wandern im 19. Jahrhundert nach Übersee aus, überwiegend in die USA. Einige Hunderttausend Emigranten gehen nach Südamerika, vor allem in den Süden Brasiliens, um ihn landwirtschaftlich zu erschließen. Kaufleute und Unternehmer lassen sich bevorzugt in den Städten nieder. Heute leben mehr als sechs Millionen Deutschstämmige in Südamerika – und das Oktoberfest von Blumenau gilt als die zweitgrößte *festa* Brasiliens nach dem Karneval von Rio.

10|2001 GEO **197**

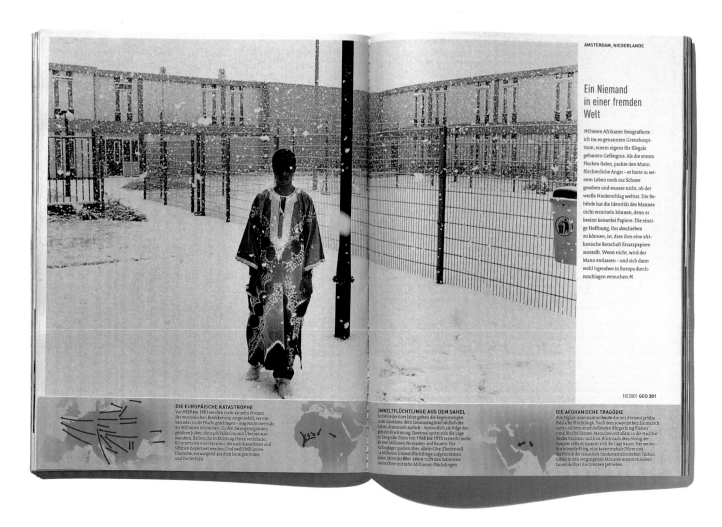

Ein Niemand in einer fremden Welt

»Diesen Afrikaner fotografierte ich im so genannten Grenshospitium, einem eigens für Illegale gebauten Gefängnis. Als die ersten Flocken fielen, packte den Mann fürchterliche Angst – er hatte in seinem Leben noch nie Schnee gesehen und wusste nicht, ob der weiße Niederschlag wehtat. Die Behörde hat die Identität des Mannes nicht ermitteln können, denn er besitzt keinerlei Papiere. Die einzige Hoffnung, ihn abschieben zu können, ist, dass ihm eine afrikanische Botschaft Ersatzpapiere ausstellt. Wenn nicht, wird der Mann entlassen – und sich dann wohl irgendwo in Europa durchzuschlagen versuchen.«

DIE EUROPÄISCHE KATASTROPHE
Von 1939 bis 1951 werden mehr als zehn Prozent der europäischen Bevölkerung umgesiedelt, vertrieben oder in die Flucht geschlagen – insgesamt mehr als 60 Millionen Menschen. Zu den Zwangsmigranten gehören Juden, die nach Palästina und Übersee auswandern, Balten, die in Richtung Osten verschickt, Krimtartaren und Ukrainer, die nach Kasachstan und Sibirien deportiert werden. Und zwölf Millionen Deutsche, vorwiegend aus dem heutigen Polen und Tschechien.

UMWELTFLÜCHTLINGE AUS DEM SAHEL
Seit Mitte der 60er Jahre gehen die Regenmengen in der Sahelzone, dem Savannengürtel südlich der Sahara, dramatisch zurück – vermutlich als Folge der globalen Erwärmung. Zweimal spitzt sich die Lage zu: Die große Dürre von 1968 bis 1973 vertreibt mehr als zwei Millionen Nomaden und Bauern. Die Auffanglager quellen über, allein in Côte d'Ivoire soll 1,4 Millionen Umweltflüchtlinge aufgenommen haben. Mitte der 80er Jahre trifft den Sahel eine zweite Dürre mit zehn Millionen Flüchtlingen.

DIE AFGHANISCHE TRAGÖDIE
Aus Afghanistan stammt heute die mit Abstand größte Zahl aller Flüchtlinge. Nach dem sowjetischen Einmarsch 1979 und dem anschließenden Bürgerkrieg fliehen rund fünf Millionen Menschen vor allem in die Nachbarländer Pakistan und Iran. Auch nach dem Abzug der Sowjets 1989 entspannt sich die Lage kaum: Der weiterhin tobende Krieg, eine katastrophale Dürre und die Politik der islamisch-fundamentalistischen Taliban haben in den vergangenen Monaten erneut Hunderttausende über die Grenzen getrieben.

10|2001 GEO **201**

On the morning of 11 September 2001, as terrorists flew two commercial passenger jets into the World Trade Center in New York, the staff of *Vanity Fair* were finalizing production of their November Music issue. Editor Graydon Carter immediately set about remaking the issue, devoting a substantial special section to the tragedy and redirecting all available staff to its coverage. Photographer Jonas Karlsson had first come to prominence shooting car advertisements for Volvo in his native Sweden. Together with photography producer Ron Beinner, the pair worked Manhattan's streets, making medium-format portraits of emergency service workers and volunteers as they responded in the aftermath of the attack. They penetrated the exclusion zone around Ground Zero by picking up tools and joining a group of volunteer community gardeners assigned to clean up Battery Park. After the terrible spectacle of the initial attack, the resulting portfolio is quiet and reflective (albeit in keeping with *Vanity Fair*'s vibrant style), capturing the shock and resilience etched onto the faces of ordinary New Yorkers. (November 2001)

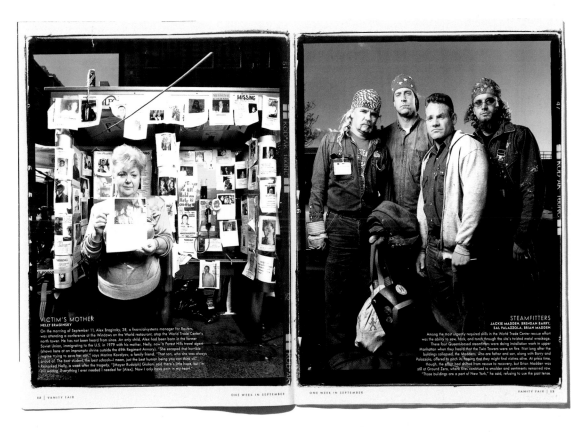

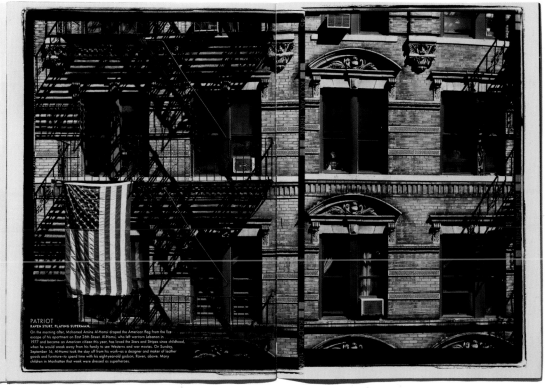

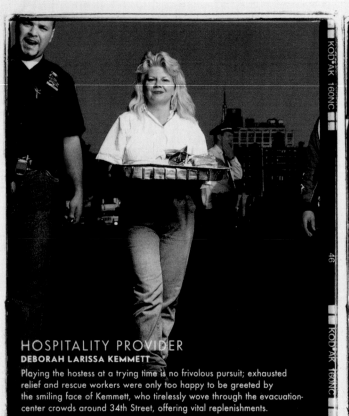

HOSPITALITY PROVIDER
DEBORAH LARISSA KEMMETT

Playing the hostess at a trying time is no frivolous pursuit; exhausted relief and rescue workers were only too happy to be greeted by the smiling face of Kemmett, who tirelessly wove through the evacuation-center crowds around 34th Street, offering vital replenishments.

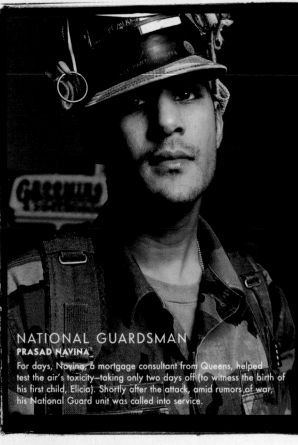

NATIONAL GUARDSMAN
PRASAD NAVINA

For days, Navina, a mortgage consultant from Queens, helped test the air's toxicity—taking only two days off (to witness the birth of his first child, Elicia). Shortly after the attack, amid rumors of war, his National Guard unit was called into service.

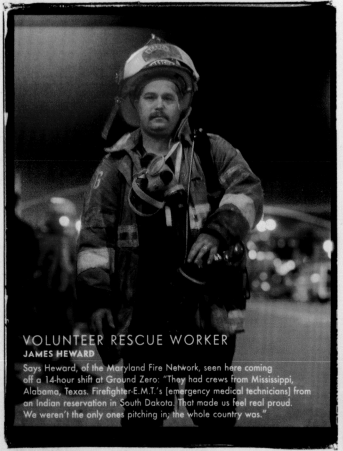

VOLUNTEER RESCUE WORKER
JAMES HEWARD

Says Heward, of the Maryland Fire Network, seen here coming off a 14-hour shift at Ground Zero: "They had crews from Mississippi, Alabama, Texas. Firefighter-E.M.T.'s [emergency medical technicians] from an Indian reservation in South Dakota. That made us feel real proud. We weren't the only ones pitching in; the whole country was."

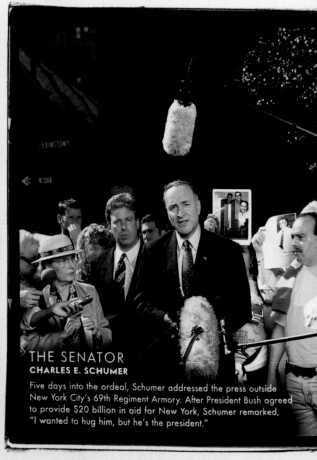

THE SENATOR
CHARLES E. SCHUMER

Five days into the ordeal, Schumer addressed the press outside New York City's 69th Regiment Armory. After President Bush agreed to provide $20 billion in aid for New York, Schumer remarked, "I wanted to hug him, but he's the president."

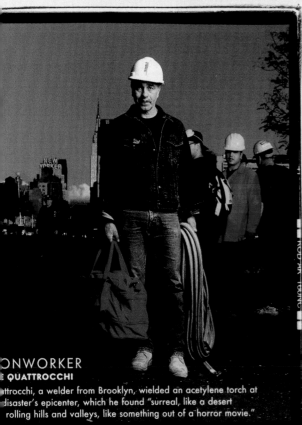

ONWORKER

E QUATTROCCHI

attrocchi, a welder from Brooklyn, wielded an acetylene torch at
disaster's epicenter, which he found "surreal, like a desert
rolling hills and valleys, like something out of a horror movie."

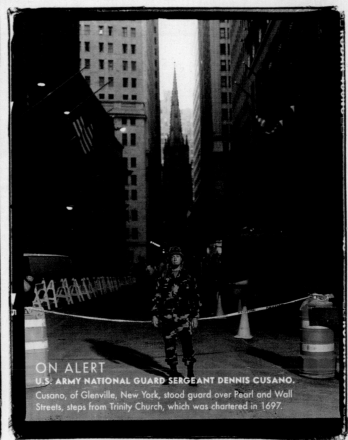

ON ALERT

U.S. ARMY NATIONAL GUARD SERGEANT DENNIS CUSANO.

Cusano, of Glenville, New York, stood guard over Pearl and Wall
Streets, steps from Trinity Church, which was chartered in 1697.

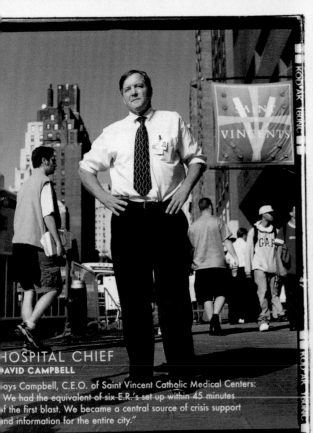

HOSPITAL CHIEF

AVID CAMPBELL

ays Campbell, C.E.O. of Saint Vincent Catholic Medical Centers:
We had the equivalent of six E.R.'s set up within 45 minutes
f the first blast. We became a central source of crisis support
nd information for the entire city."

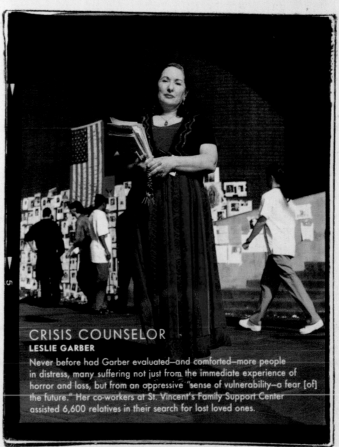

CRISIS COUNSELOR

LESLIE GARBER

Never before had Garber evaluated—and comforted—more people
in distress, many suffering not just from the immediate experience of
horror and loss, but from an oppressive "sense of vulnerability—a fear [of]
the future." Her co-workers at St. Vincent's Family Support Center
assisted 6,600 relatives in their search for lost loved ones.

National Geographic photographer William Albert Allard and writer Tom O'Neill produced a disarmingly direct story on the Untouchable caste, the elaborate Hindu hierarchy's lowest caste group, accounting for roughly 160 million people – 15 per cent of the Indian population. Saturated colours enhance the dense detail of these images, in which Allard's subjects address the camera with surprising openness – characteristics of Allard's photographs that have been a staple of *National Geographic* over 40 years. Arguably Allard is *the* quintessential *Geographic* photographer of recent times, in equal parts colourist (one of few among his generation who have only worked in colour), storyteller and ethnographer. His down-to-earth integrity and accessible personality, as well as the consistent quality of his essays, have made him a romantic model for a generation of American photographers. In his influential book, *The Photographic Essay* (1989), he defines as 'right' 'any assignment in which the photographer has a significant spiritual stake … Spiritually driven work constitutes the core of a photographer's contribution to culture.' (June 2001)

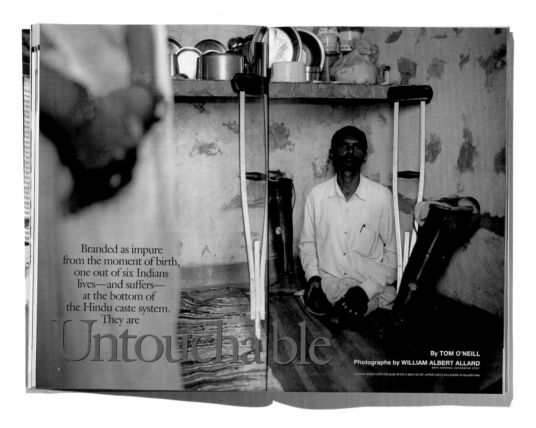

Branded as impure from the moment of birth, one out of six Indians lives—and suffers— at the bottom of the Hindu caste system. They are Untouchable

By TOM O'NEILL
Photographs by WILLIAM ALBERT ALLARD
80TH NATIONAL GEOGRAPHIC STAFF
LAXMAN SINGH LOST HIS LEGS AFTER A BEATING BY UPPER CASTE VILLAGERS IN RAJASTHAN

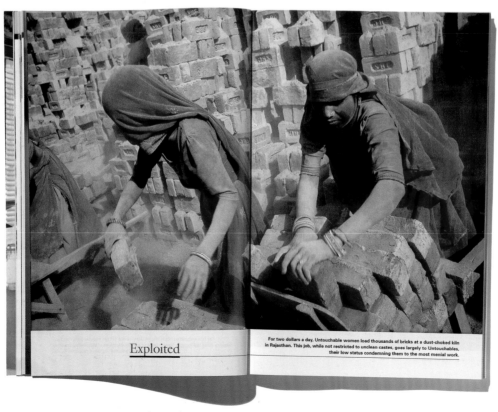

Exploited

For two dollars a day, Untouchable women load thousands of bricks at a dust-choked kiln in Rajasthan. This job, while not restricted to unclean castes, goes largely to Untouchables, their low status condemning them to the most menial work.

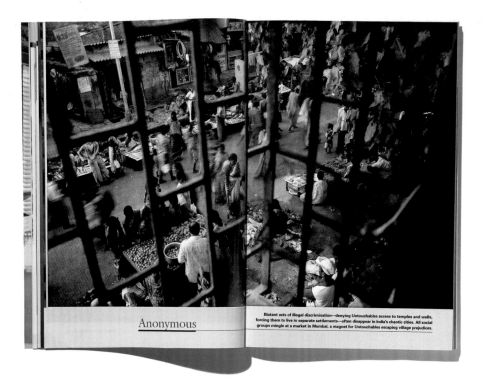

Anonymous

Blatant acts of illegal discrimination—denying Untouchables access to temples and wells, forcing them to live in separate settlements—often disappear in India's chaotic cities. All social groups mingle at a market in Mumbai, a magnet for Untouchables escaping village prejudices.

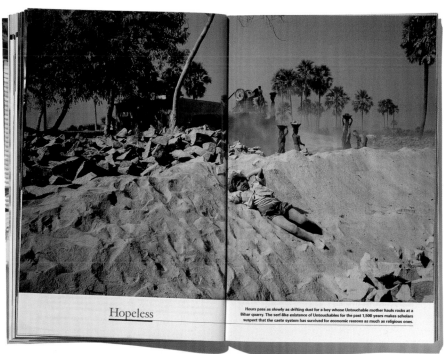

Hopeless

Hours pass as slowly as drifting dust for a boy whose Untouchable mother hauls rocks at a Bihar quarry. The serf-like existence of Untouchables for the past 1,500 years makes scholars suspect that the caste system has survived for economic reasons as much as religious ones.

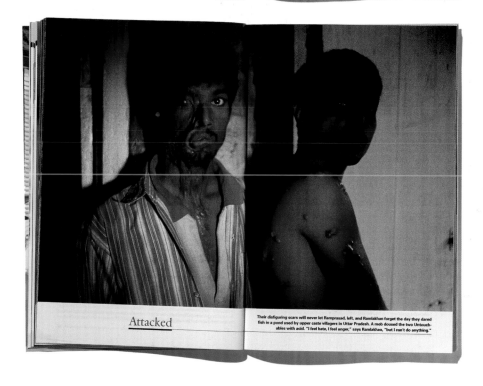

Attacked

Their disfiguring scars will never let Ramprasad, left, and Ramlakhan forget the day they dared fish in a pond used by upper caste villagers in Uttar Pradesh. A mob doused the two Untouchables with acid. "I feel hate, I feel anger," says Ramlakhan, "but I can't do anything."

In 2002, Poland's leading newspaper colour supplement published an essay of photographs made by children, with a title that translates as 'This is my teddy, this is my mum, this is my world.' Produced by the magazine's photographer, Piotr Janowski, it involved his distribution of 25 cameras and film to children in the villages of Krzywa and Jasionka in the poor region of Beskid Niski in southern Poland. Encouraged not to fear the camera (most had never held one before) and to think of it as a magician's hat that would make them invisible, the children made pictures of whatever they liked over one week. It resulted in an authentic, edgy and insightful document of Polish life drawn from 3,000 photographs. The practice of giving cameras to children in order to reveal their own view of the world was far from new – American Wendy Ewald developed an image-making practice that involved giving cameras to Appalachian children in the late 1960s – but *Gazeta Wyborcza*'s story is a strong example of a steady trend toward self-representation and the democratization of photography within the mainstream press. (3 November 2002)

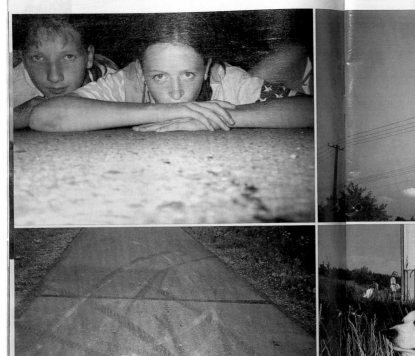
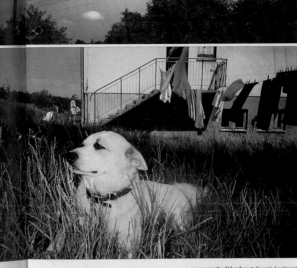

Od góry, od lewej:
Natalia, 14 lat,
Marzena, 17 lat,
Marzena, 17 lat,
Wioletta, 13 lat

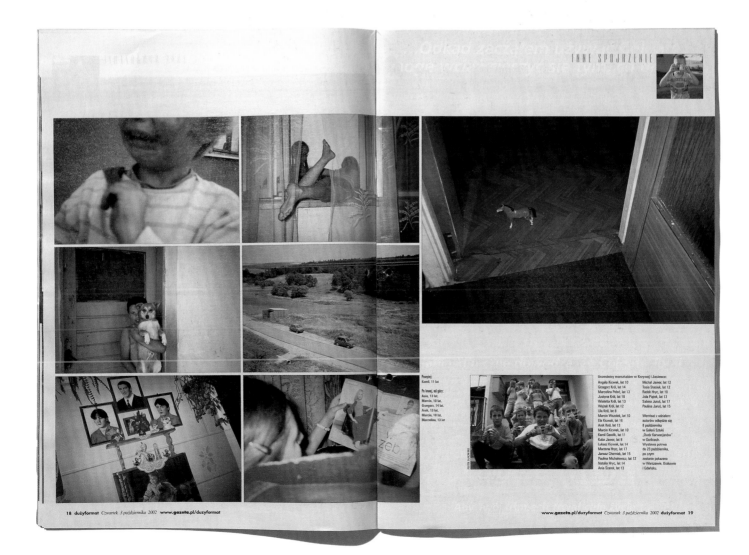

Kamil, 11 lat

Poniżej:
Kamil, 11 lat

Po lewej, od góry:
Ania, 13 lat,
Marcin, 10 lat,
Grzegorz, 14 lat,
Arek, 13 lat,
Marcin, 10 lat,
Marcelina, 13 lat

Uczestnicy warsztatów w Krzywej i Jasionce:
Angela Kicwiak, lat 10
Grzegorz Król, lat 14
Marcelina Połeć, lat 13
Justyna Król, lat 18
Wioletta Król, lat 13
Wojtek Król, lat 12
Ula Król, lat 8
Marcin Wituślak, lat 10
Ela Kicwiak, lat 16
Arek Król, lat 13
Marcin Kicwiak, lat 10
Kamil Gawlik, lat 11
Kuba Jawor, lat 9
Łukasz Kicwiak, lat 14
Mariena Hryc, lat 17
Janusz Chomiak, lat 15
Paulina Michalewicz, lat 12
Natalia Hryc, lat 14
Ania Szarell, lat 13
Michał Jawor, lat 12
Tosia Stasiuk, lat 12
Radek Hryc, lat 10
Jola Piątek, lat 13
Sabina Juruś, lat 17
Pedina Juruś, lat 15

Wernisaż z udziałem
autorów odbędzie się
8 października
w Galerii Sztuki
„Dwór Karwacjanów"
w Gorlicach.
Wystawa potrwa
do 23 października,
po czym
zostanie pokazana
w Warszawie, Krakowie
i Gdańsku.

Simon Norfolk drew on a range of references to represent the blasted landscapes he encountered on his self-initiated reportage on Afghanistan in November 2001, following the flight of the Taliban from Kabul. He recalled Romantic paintings of sublime landscapes, made to inspire terror and awe. The Afghan deserts and mountains reminded him of the illustrations in his childhood Bible, and he was prompted to remember images of Armageddon drummed into him at a Sunday school in Manchester, England. Norfolk drew on the work of Victorian archaeologist Heinrich Schliemann, who unravelled the successive dominions of the ancient city of Troy, as he set out to explore the layers of Afghanistan's recent history: abandoned tanks from the Soviet occupation of the 1980s, concrete buildings worn to skeletons by militia wars in the 1990s and cities charred by American and British bombs in 2002. Working with a large-format 4x5 camera for the first time, he established a different, more contemplative manner of storytelling compared to his prior work – which he felt was a personal breakthrough. The Afghan series was published in major magazines throughout the world. (8 September 2002)

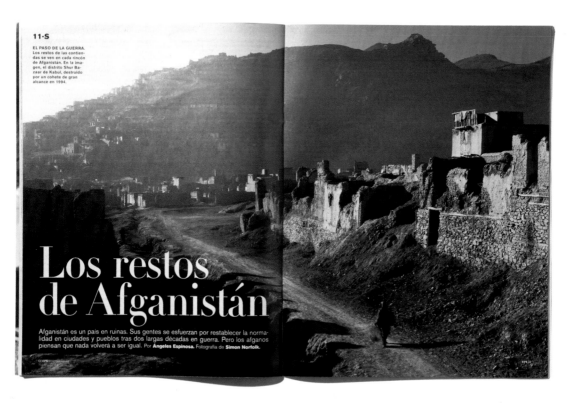

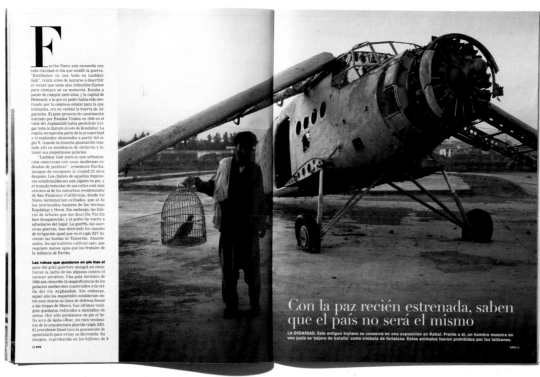

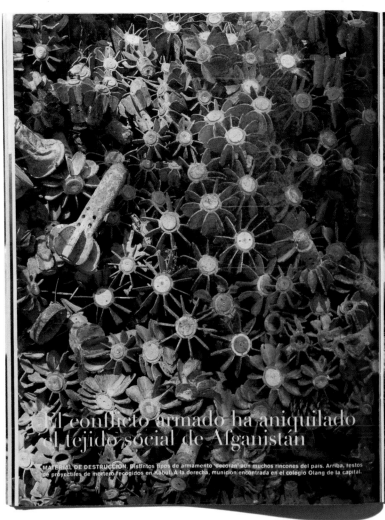
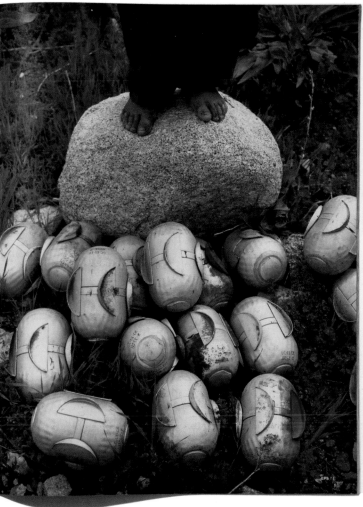

El conflicto armado ha aniquilado el tejido social de Afganistán

MATERIAL DE DESTRUCCIÓN. Distintos tipos de armamento 'decoran' aún muchos rincones del país. Arriba, restos de proyectiles de mortero recogidos en Kabul. A la derecha, munición encontrada en el colegio Olang de la capital.

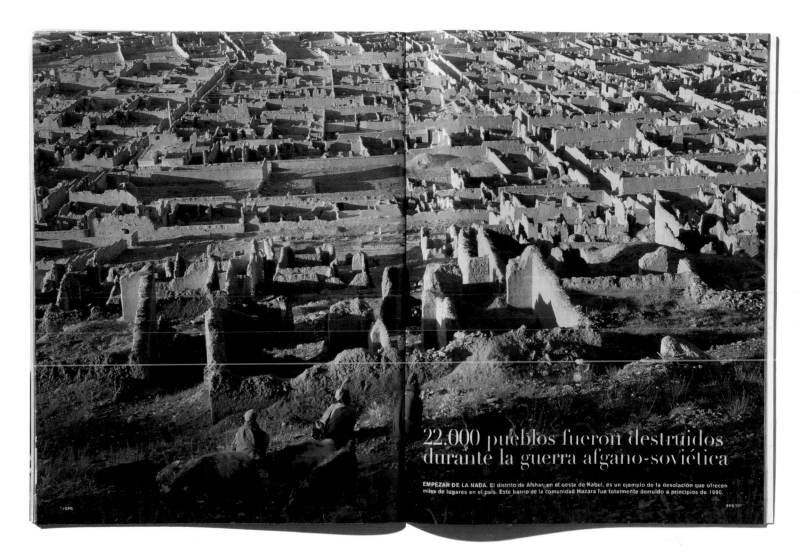

22.000 pueblos fueron destruidos durante la guerra afgano-soviética

EMPEZAR DE LA NADA. El distrito de Afshar, en el oeste de Kabul, es un ejemplo de la desolación que ofrecen miles de lugares en el país. Este barrio de la comunidad Hazara fue totalmente derruido a principios de 1990.

Masakazu Takei, the editor-in-chief of *Foil* magazine and founder of the amorphous media company Little More, has proved a lightning rod for the new Japanese visual culture embracing pop culture, punk and manga comic books. *Foil* was conceived as a transgressive magazine that would change its form and design with each issue, presenting artists' work on a theme, with neither text nor advertising. The first issue brought together two cutting-edge, increasingly popular Japanese artists; Yoshitoma Nara, known for his paintings and sculptures of vulnerable cartoon children, and photographer Rinko Kawauchi, whose melancholic images play on the transient charms and cruelties of life. On assignment for *Foil*, these unlikely reporter-artists both visited Afghanistan in the aftermath of the American invasion. Over two hundred images were woven into an impressionistic comment on the fragile re-emergence of Afghan culture and the enduring scars of its wars. This radical publication suggests both the death of traditional photojournalism as well as its sophisticated reinvention. (30 January 2003)

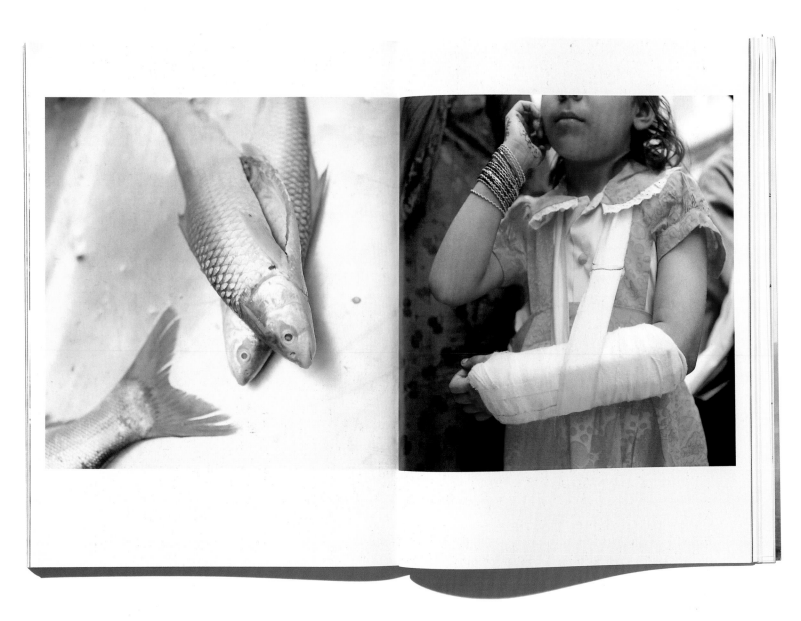

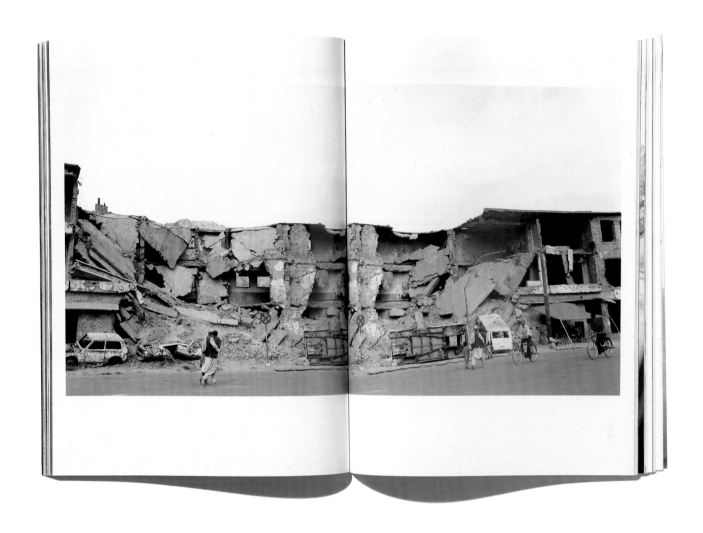

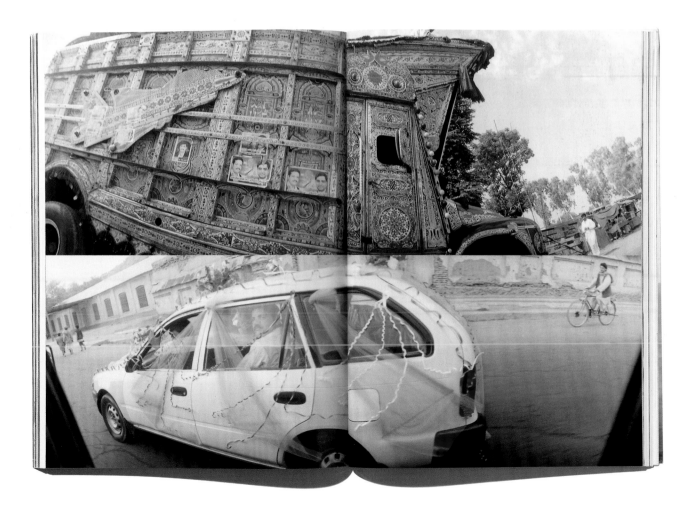

The subjects of this essay are a Hmong tribe who had lived in hiding in the Laotian jungle for thirty years, on the run since providing covert support for the US Army under the direction of the CIA during the Vietnam War. Believing Australian photographer Philip Blenkinsop and *Time*'s writer Andrew Perrin to be their American rescuers, the tribe's members greeted them on their knees and in tears. The resulting photographs were a major coup for Blenkinsop, and were published throughout the world. Previously, his brutally direct records of remote tribal wars across Southeast Asia were considered too gothic and extreme for mainstream publication. 'They saw what I do, and their first reaction was, "Christ, what a sick person – how can he photograph that?" They forgot that what I was doing was simply photographing what was there; it's life that can be painful and unjust.' In the following years, acknowledging the limitations of photojournalism, Blenkinsop has taken to writing on the surface of his prints and taking control of the 'caption' within the image itself. (5 May 2003)

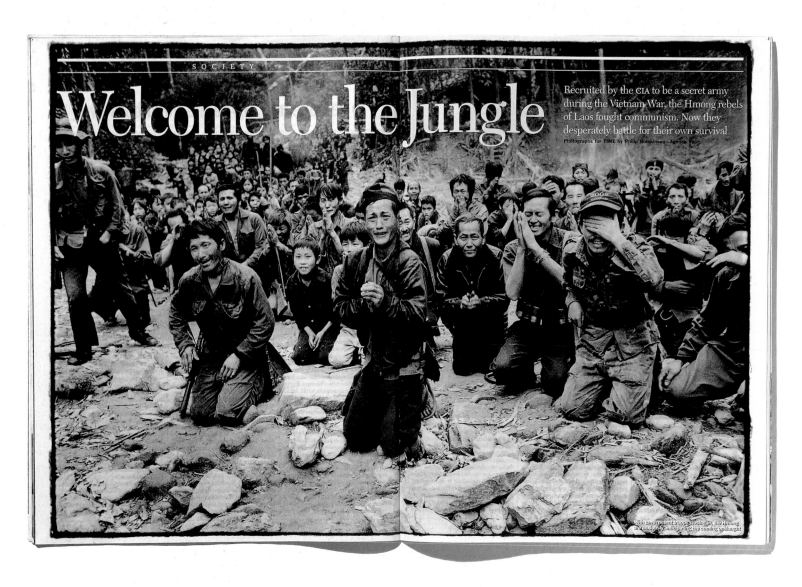

SOCIETY

Welcome to the Jungle

Recruited by the CIA to be a secret army during the Vietnam War, the Hmong rebels of Laos fought communism. Now they desperately battle for their own survival

Photographs for TIME by Philip Blenkinsop—Agence Vu

With government troops closing in, the Hmong are anxiously anticipating the coming onslaught

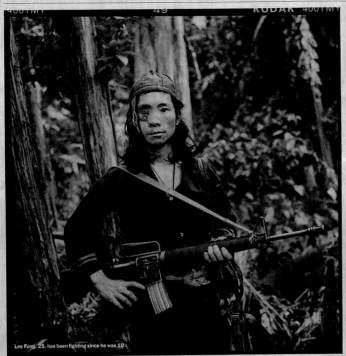

Lee Fong, 25, has been fighting since he was 10

Malnourishment pervades the militia camp

By ANDREW PERRIN
XAYSOMBOUNE SPECIAL ZONE

THERE WERE HUNDREDS OF THEM, perhaps a thousand. They wept and knelt before me on the ground, crying, "Please help us, the communists are coming." I had hiked four days to reach this forsaken place deep in the jungles of Xaysomboune, northern Laos. The Hmong rebels prostrate before me were convinced they would all soon die. They knew they were a forgotten tribe, crushed by a military campaign that is denied by the communist leaders of their small, sheltered nation.

In all my years as a journalist I had never seen anything like this: a ragtag army with wailing families in tow, beseeching me to take news of their plight to the outside world. I walked among starving children, their tiny frames scarred by mortar shrapnel. Young men, toting rifles and with dull-eyed infants strapped to their backs, ripped open their shirts to show me their wounds. An old man grabbed my hand and guided it over the contours of shrapnel buried in his gut. A teenage girl, no more than 15, whimpered at my feet, pawed at my legs and cried, "They've killed my husband. They've killed my mother, my father, my brother …" But before she could finish, others were pushing her aside to sob out their own litanies of loss. In this heart of darkness, nobody has a monopoly on grief.

Now, for the first time in nearly three decades, this dwindling group of outcasts are completely surrounded by the Lao government troops that hunt them. They are trapped in a narrow swath of jungle, with all avenues of escape blocked by either soldiers or antipersonnel mines. "This time," says Moua Toua Ther, 46, the one-armed leader of the camp and commander of its pitifully equipped fighting force, "we will not be able to run or hide. When the helicopters come we will be butchered like wild animals."

What is the crime this ragged bunch has committed? It is simply that they are Hmong, mostly the children, grandchildren or even great-grandchildren of fighters who in the 1960s sided with the U.S. to fight communism in Laos during the Vietnam War. Fabled for their resourcefulness and valor, many Hmong became members of a secret CIA-backed militia that helped rescue downed U.S. pilots and disrupted North Vietnamese supplies and troop movements along the Ho Chi Minh Trail through central Laos. The communist Pathet Lao movement—and its patrons in Hanoi—has never forgotten the Hmong's complicity with the Americans. Shortly after the Pathet Lao took power in 1975—two years after the U.S. had fled the country and left the Hmong soldiers to their fate—a communist newspaper declared the Party would hunt down the "American collaborators" and their families "to the last root." But until TIME recently reached one of the last Hmong outposts, no one truly believed that, after 28 years, the Lao government still meant it. This, then, is the final act of a war that, according to history books, ended in 1973.

The Hmong, who migrated to Laos from southwestern China in the 19th century, have always been a proud, warlike people. In the 1920s a Hmong rebellion against their French rulers erupted in much of Laos and northern Vietnam, ultimately failing but leav-

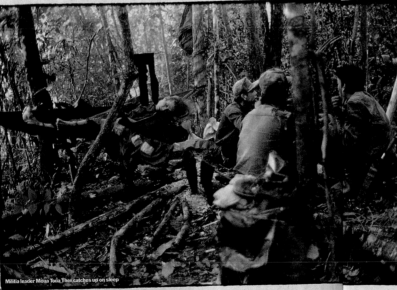

Militia leader Moua Toua Ther catches up on sleep

Three generations of resistance fighters

ing thousands dead. When the French left Laos in 1953, the Hmong found themselves fighting again—this time against the threat of communism. Among the resisters was a young Hmong general named Vang Pao, who in 1961 was commissioned by the CIA to set up a secret army to fight the advancing communists. Over the next decade nearly half of the 40,000 Hmong fighters in Vang Pao's army are thought to have perished during the fighting. The reward for their sacrifice? The Paris cease-fire agreement of 1973, which signaled an end of U.S. aid. Vang fought on for two more years, but when it became clear that the Pathet Lao would win he fled to Thailand and then to the U.S. Today, some 200,000 other Hmong live in exile communities in the U.S. But not all Hmong made it to America: 15,000 of Vang's brethren were cut off from escape and were forced to melt away into the mountainous jungles of Laos.

Even from California, where he leads the United Lao Liberation Front (ULLF), Vang, 74, casts a long shadow over his people. Moua says he reports directly to Vang—a claim the Californian denies, though he does admit to providing occasional help. From his suburban American home, the exiled general demands democracy and a reinstatement of the monarchy in Laos. Moua and his militia are among the remnants of Hmong rebel groups fighting for that disappearing dream.

Moua joined Vang's secret army at age 15. His left arm ends in a stump—his hand was removed in a 1974 jungle amputation. One of only four people in the village with some writing skills, he is a meticulous keeper of village statistics—there are 56 orphaned children, 40 widows and 11 widowers. By Moua's count, 30% of the villagers have shrapnel wounds. In 1975, when Vang fled Laos, Moua recorded his group at 7,000 people. Today there are only about 800 left.

Although the Hmong have been on the run for nearly three decades, Moua and others in his village regard the past year as the worst. In October, they say, some 500 ground troops attacked them from four directions in Xaysomboune while a gunship strafed them from above. In all, 216 Hmong were killed. Such assaults can come at any time. Last August, a mortar round landed less than a meter from nine-year-old Yeng Houa's family dinner table, killing both his parents. Yeng survived, but I count 18 shrapnel scars on his legs, his jaw is broken and there is an infected sore on his inner thigh. Since the attack, he has not spoken.

The Hmong say they are too ill-equipped to strike back. Most of their fighters are armed with ancient M-16s and AK-47s, and the heaviest weapons at their disposal are two geriatric M-79 grenade launchers.

Ammunition is mostly dug up from former U.S. air bases. According to Moua, only a third of the rounds are actually live, negating Hmong chances of launching a viable offensive. As for the Lao government, which declined to talk to TIME, it denies allegations that it is decimating Hmong rebels and blames them for much of the unrest in the country. It insists that Hmong are doubling as bandits. In February an ambush on a bus traveling the busy Highway 13 in the north left 12 people dead, including two Swiss cyclists. A calling card pinned to one of the corpses indicated the deaths were the work of Hmong rebels. And on April 20, gunmen opened fire on a passenger bus, killing at least 13 people. Eyewitnesses to this massacre say the gunmen spoke to one another in the Hmong language. Vang Pao angrily denies claims that his men are responsible for attacks on civilians. "In the past there have been several events like this that have taken place and been blamed on the ULLF," he says. "But it was not us. We believe it was organized by the government using Hmong people who serve in the Lao army." For his part, Moua portrays the Hmong as helpless innocents. "We only defend and run," he says. "If the Lao troops launch an assault, our ammo won't even last an hour."

Back in the mountains of Xaysomboune, Moua and his comrades sleep uneasily on beds of leaves inside banana-leaf huts. Most cannot recall how many times they've relocated, but they remember the people they've lost. Bhun Si, 42, says his wife and two sons were taken from him last October. His friend Soum Sai saw everything: the government troops came in, he says, and shot women and children from a distance of just five meters. Today, Bhun looks barely alive himself. Only two fingers remain on his left hand—he lost the others in a B-41 rocket attack that killed six of his fellow Hmong. His leg still bleeds from a suppurating shrapnel wound he received 13 years ago. One side of his face is a mask of melted flesh, with black sockets where an ear and an eye should be. "Everybody is dead," he says. "Sixteen people in my family are dead, all killed by the communists." In a heartbreaking refrain I heard repeatedly during my stay in the camp, he adds, "America must save us."

Commander Moua, too, wonders where his erstwhile American allies have gone. "We shed blood with the U.S.," he says. "They should remember this. They should find us a land where we're safe and have food to eat." But as the world has watched in awe of the might of the U.S. war machine in Iraq, the final scenes of a 30-year-old war in Indochina that America would rather forget are destined to play out unnoticed. ∎

Born in France of Algerian parents, Benchallal's work explores representations of colonial power and national identity, as for example in her long-term project about the role of Muslim women in war and civil strife in Algeria, Bosnia, Iran, and the Gaza Strip. In this assignment for the international edition of *Vogue Hommes*, Benchallal plays with the conventions of photojournalism, producing an essay that might be taken for a documentary account of the life of young men in rubble-strewn Ramallah, the Palestinian capital – except that this is a cast fashion shoot. By no means the first to exploit the language of photojournalism in the context of fashion, and unlikely to have either shocked or fooled an audience of *Vogue* readers, her story is set so firmly within the territory of socially concerned journalism that it offers a radical assault on its traditions. It is disturbing here because it is a work of imagination and invention that also succeeds as a convincing description of a particular time and place. Its underlying suggestion is that photojournalism was ever thus. (Autumn/Winter 2003-4)

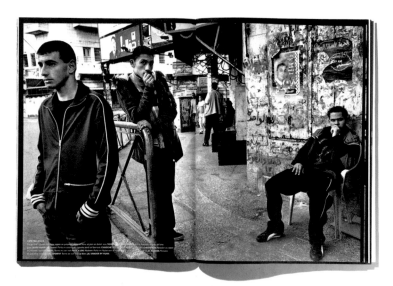

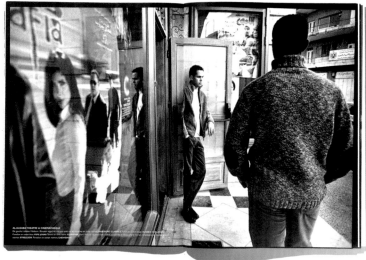

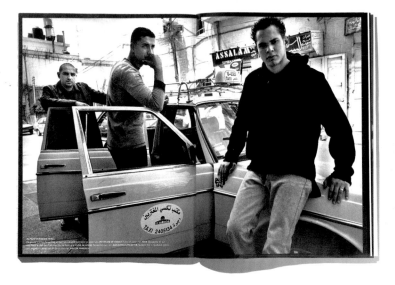

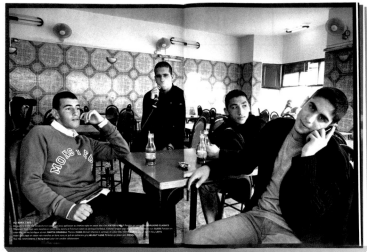

In the spring of 2004, political negotiation over the division of territory between Israel and Palestine reached a stalemate, to be replaced by a rash of military attacks and reprisals by Israeli soldiers and Palestinian guerrilla fighters. Palestinian teenage suicide bombers entered crowded markets and rode buses during rush hour, exploding home-made bombs strapped to their bodies, resulting in dozens of casualties and deaths, and fuelling a seemingly endless cycle of fear and retribution. *Days Japan*, re-launched in April 2004 as a dynamic, glossy visual news magazine, chose to address the events with strongly composed full-bleed pictures, run in saturated colours with only basic captions. Using images sourced from Reuters and Getty Images, its editors produced a story that is even-handed and brutally graphic – and quite unlike any photographic reporting seen amongst the magazine's mainstream Western equivalents. Casualties of conflict are presented frankly and without sentiment in images of a kind unlikely to be published by the Western press, where dead bodies are rarely shown and the faces of victims almost never revealed. (May 2004, with photographs by Ahmed Jadallah, top, Brian Hendler, bottom, and Yarif Katz, overleaf)

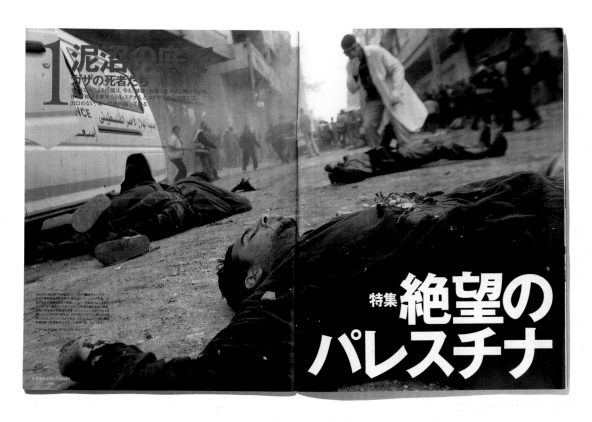

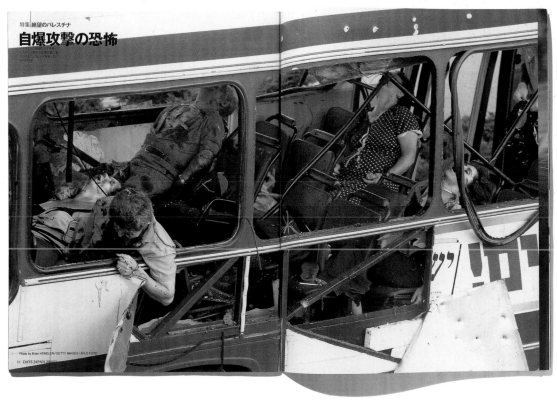

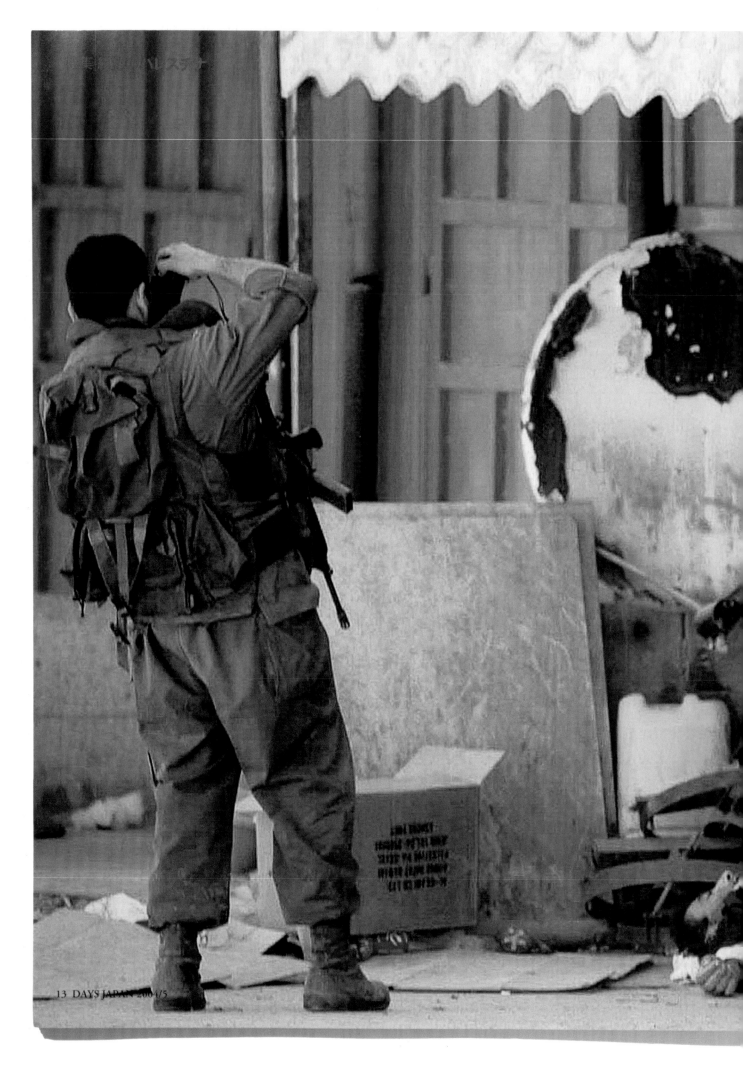

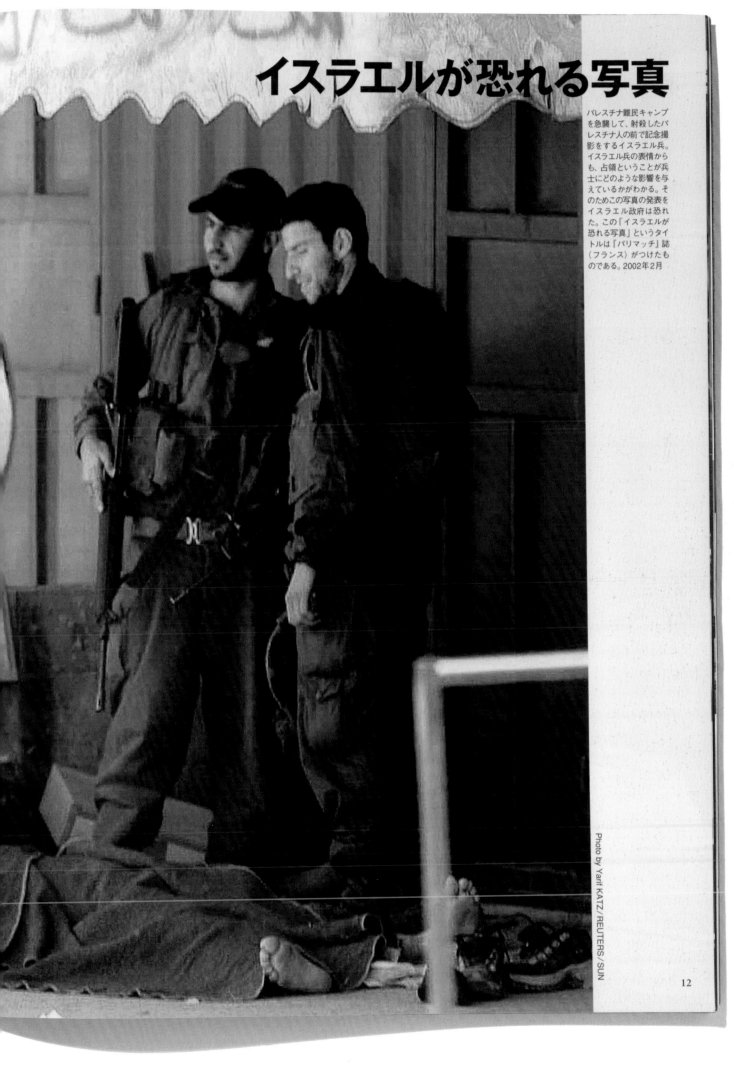

イスラエルが恐れる写真

パレスチナ難民キャンプを急襲して、射殺したパレスチナ人の前で記念撮影をするイスラエル兵。イスラエル兵の表情からも、占領ということが兵士にどのような影響を与えているかがわかる。そのためこの写真の発表をイスラエル政府は恐れた。この「イスラエルが恐れる写真」というタイトルは『パリマッチ』誌（フランス）がつけたものである。2002年2月

Photo by Yarif KATZ / REUTERS / SUN

12

Munich-based photographers Ulrike Myrzik and Manfred Jarisch used anatomical studies of the soles of their subjects' feet to tell stories about work, class, age and gender in contemporary German society. Their subjects include a soccer star, a fruit vendor, an infant with a birth defect and a prostitute, with each picture accompanied by a short autobiographical statement. One subject, born without arms, describes how she uses her feet like hands to dress and feed her children. A mountain climber blandly comments that he lost several toes to frostbite in the Himalayas. The most disconcerting feet belong to Lisa-Maree Cullum, the first soloist of the Bavarian State Ballet. She proudly tells us that 'My feet mean everything to me, I love them, they are beautiful and strong' – while the viewer is likely to interpret their distorted form as evidence of extreme pain. The work demonstrates how once-strict boundaries around journalistic storytelling have dissolved; Myrzik and Jarisch apply formal art world tactics, treating their subjects' feet as detached objects, while at the same time offering a compelling magazine story. (14 May 2004)

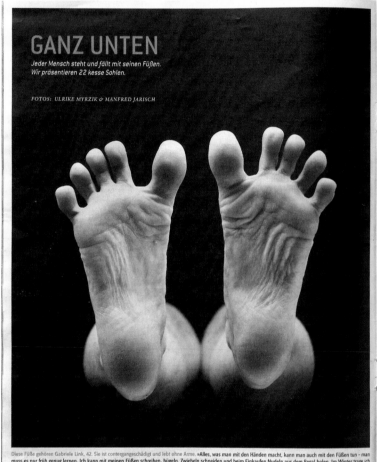

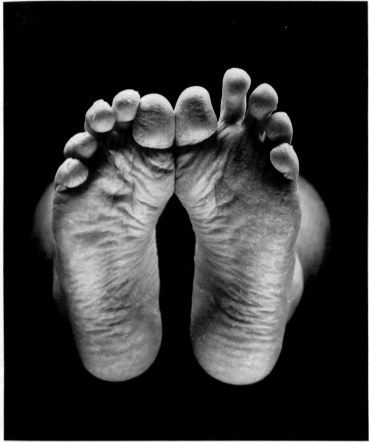

GANZ UNTEN

Jeder Mensch steht und fällt mit seinen Füßen. Wir präsentieren 22 kesse Sohlen.

FOTOS: ULRIKE MYRZIK & MANFRED JARISCH

Diese Füße gehören Gabriele Link, 42. Sie ist contergangeschädigt und lebt ohne Arme. »Alles, was man mit den Händen macht, kann man auch mit den Füßen tun – man muss es nur früh genug lernen. Ich kann mit meinen Füßen schreiben, bügeln, Zwiebeln schneiden und beim Einkaufen Nudeln aus dem Regal holen. Im Winter trage ich Socken, bei denen die Zehen frei bleiben, damit ich besser greifen kann. Früher, als meine Kinder noch klein waren, habe ich sie mit den Füßen gewickelt, angezogen und hochgehoben. Manchmal habe ich sie auch mit den Zähnen gepackt, wie eine Katze.«

Diese Füße gehören Karl-Heinz Körbel, 49. Er ist Bundesliga-Rekordspieler, in 602 Partien stand er für Eintracht Frankfurt auf dem Platz. »Meine Füße sind mein Kapital, das habe ich schon am Anfang meiner Karriere gemerkt. Deshalb bin ich in den Ferien nicht nach Mallorca geflogen wie meine Mannschaftskameraden, sondern zur Kur nach Ischia. Zwei Wochen lang hatte ich Fangopackungen auf den Füßen, danach war ich wieder fit für die nächste Saison. Mit 37 habe ich immer noch in der Bundesliga gespielt – auch weil ich auf meine Füße geachtet habe. Und auf meine Schuhe: Höchstens zwei Paar habe ich pro Saison verschlissen.«

Diese Füße gehören einer Frau, die sich für uns Gitti nennt und 38 Jahre alt ist. Sie arbeitet als Prostituierte auf dem Münchner Straßenstrich. »Es liegt mir nicht, am Bordstein zu stehen, bis einer das Fenster herunterkurbelt. Also setze ich mir den Walkman auf und tanze, zum Beispiel zu *Cannonball* von Supertramp. Auf Pfennigabsätzen ist das nicht einfach, aber es macht gute Laune. Und die brauche ich, damit die Freier anhalten. Manche von denen nehmen mich nur wegen meiner Füße mit: Einer steht stundenlang an einer Wendeltreppe und guckt zu, wie ich barfuß hoch- und runterlaufe. Andere schlürfen Champagner aus meinen Pumps oder lutschen meine Zehen.«

Diese Füße gehören John Oliver Haugg, 37. Er pilgerte schon dreimal nach Santiago di Compostela, ging 900 Kilometer von den Pyrenäen bis zum Meer. »Meistens bekomme ich Blasen, einmal entzündete sich meine Achillessehne und meine Knie schmerzten. Mein großer Zeh wurde blau und blieb es fast ein Jahr lang. Ich bin immer weitergelaufen, manchmal sogar barfuß. Denn die Pilgerwanderungen helfen mir, mein eigenes Lebenstempo zu finden. Beim Gehen tauchen Gedanken und Träume auf, die sonst verschüttet sind. Von Santiago laufe ich noch weiter bis zum Meer, um dort mit den Füßen im Wasser zu waten. Das ist der schönste Moment der Reise.«

Dieser Fuß gehört Michaela Daamen, 35. Sie gewann bei den Paralympics 2000 Gold im Kugelstoßen. »Wegen Knochenkrebs musste mir 1988 ein Bein amputiert werden. Ich musste mich lange an die Prothese gewöhnen. Heute habe ich ein ganzes Sammelsurium: für den Alltag, zum Schwimmen – und für den Sport.«

Diese Füße gehören Reinhold Messner, 59. Er unternahm mehr als 3500 Bergtouren. »Am Nanga Parbat im Himalaya sind mir die Zehen abgefroren, später mussten sie amputiert werden. Trotzdem bin ich seitdem noch ein paar Mal um die Welt gelaufen. Ich lebe und gehe, als ob meine Zehen noch da wären.«

Diese Füße gehören Joanna Braun, 29, Fußmodel. »Meine Füße sind in vielen Katalogen und Anzeigen zu sehen, ich kann ganz gut davon leben. Aber ich muss immer sehr vorsichtig sein, wenn ich mit meiner Tochter spiele. Turnschuhe trage ich selten – darin schrumpelt die Haut. Deshalb bade ich auch nur kurz.«

Diese Füße gehören Jac van Steen, 48, Dirigent der Weimarer Staatskapelle. »Beim Dirigieren muss man richtig stehen, mit beiden Füßen fest auf dem Boden. Ich muss mit dem Podest verankert sein. Es wäre tödlich für die Spannung, wenn ich zur Musik wippen würde. Der Takt muss im Herz schlagen, nicht in den Füßen.«

Diese Füße gehören Lisa-Maree Cullum, 31. Sie tanzt als Erste Solistin im Bayerischen Staatsballett. »Meine Füße bedeuten mir alles. Ich liebe sie, sie sind schön und stark. Mit drei Jahren habe ich zum ersten Mal getanzt. Meine Mutter hat mich anfangs selbst unterrichtet. Heute trainiere ich sechs Tage die Woche, von morgens bis abends. Nach stundenlangem Training schmerzen meine Füße. Aber das liegt an den Schuhen: Menschliche Füße sind einfach nicht für Ballettschuhe gemacht. In der ersten Zeit hatte ich Blasen, aber jetzt schon lange nicht mehr.«

For James Nachtwey, this issue of *Time* shows how effective photojournalism can be when a publication gives a photo essay its full support. With six full-bleed images run over twelve consecutive pages, followed by additional images illustrating the text, its cover story featuring James Nachtwey's photographs of Darfur commands a graphic power that can compete with anything appearing on the larger pages of *Paris Match*. As Nachtwey said in an interview in 2000, he sees his role as photojournalist in terms of social responsibility; its 'value … to make an appeal to the rest of the world, to create an impetus where change is possible through public opinion. Public opinion is created through awareness. My job is to help create the awareness. … I hope that people when they look at this work will engage themselves with it and not shut down, not turn away from it, but realize that their opinion counts for something, that they are part of a constituency that has the power to make decisions that affect the lives of thousands of people … and they have to do something about it.' (4 October 2004)

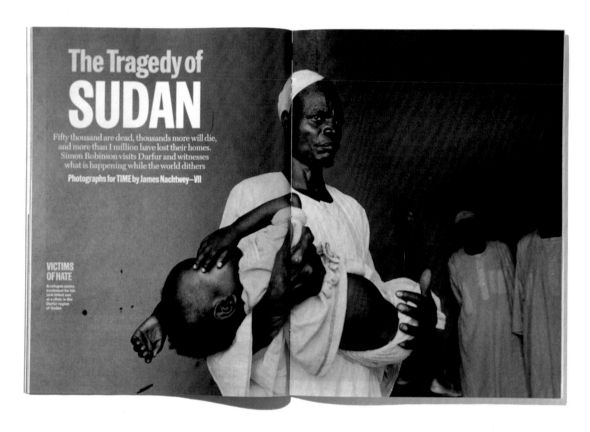

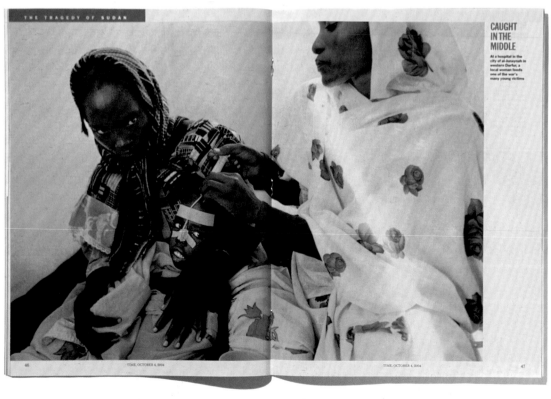

MEANS OF SURVIVAL

Rampages by Arab militiamen known as Janjaweed have turned more than 1 million non-Arab Africans into refugees. Many survivors have made their way to unforgiving settlements like this one, the Riad camp, near al-Junaynah. These women are using branches and twigs to reconstruct a hut that washed away in a storm. The woman at far right is using her teeth to cut string

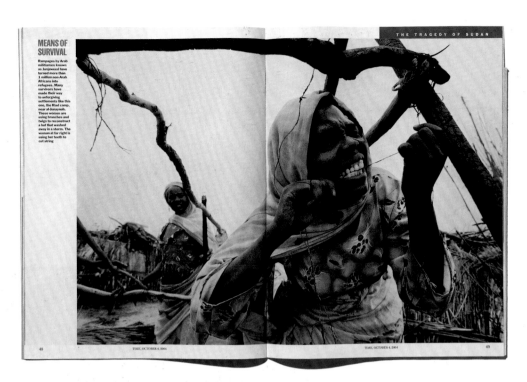

GRAINS OF SURVIVAL

Darfurian women attempt to salvage grain that has fallen from bags air-dropped by a World Food Program plane. They winnow out dust with their baskets. Too little aid is getting through: because of Janjaweed violence and seasonal rains, at least 50% of the region's 1.4 million displaced people lack access to adequate amounts of food

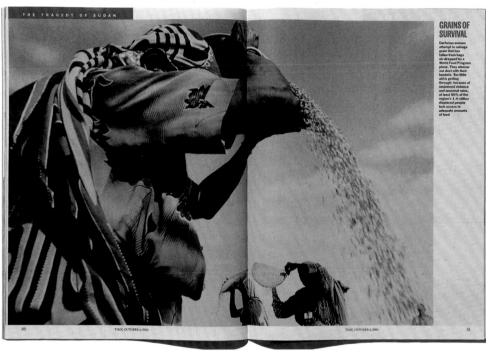

DESERT REFUGE

At a camp in the town of Tawila, this man takes shelter from the sun under a few pieces of cast-off cloth and ripped food bags. Typically the Janjaweed ride into a Darfur village, kill most of the men and boys, rape the women, destroy the crops and livestock and burn the homes. Some traumatized victims say they can never return

MEANS OF SURVIVAL

Rampages by Arab militiamen known as Janjaweed have turned more than 1 million non-Arab Africans into refugees. Many survivors have made their way to unforgiving settlements like this one, the Riad camp, near al-Junaynah.

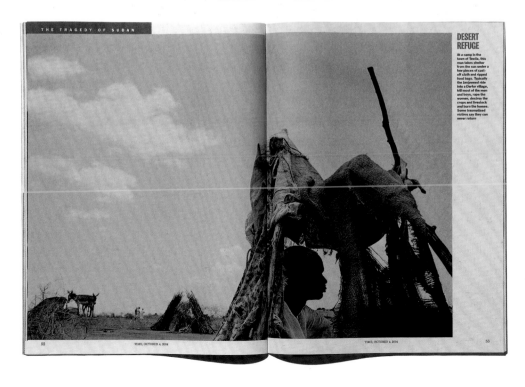

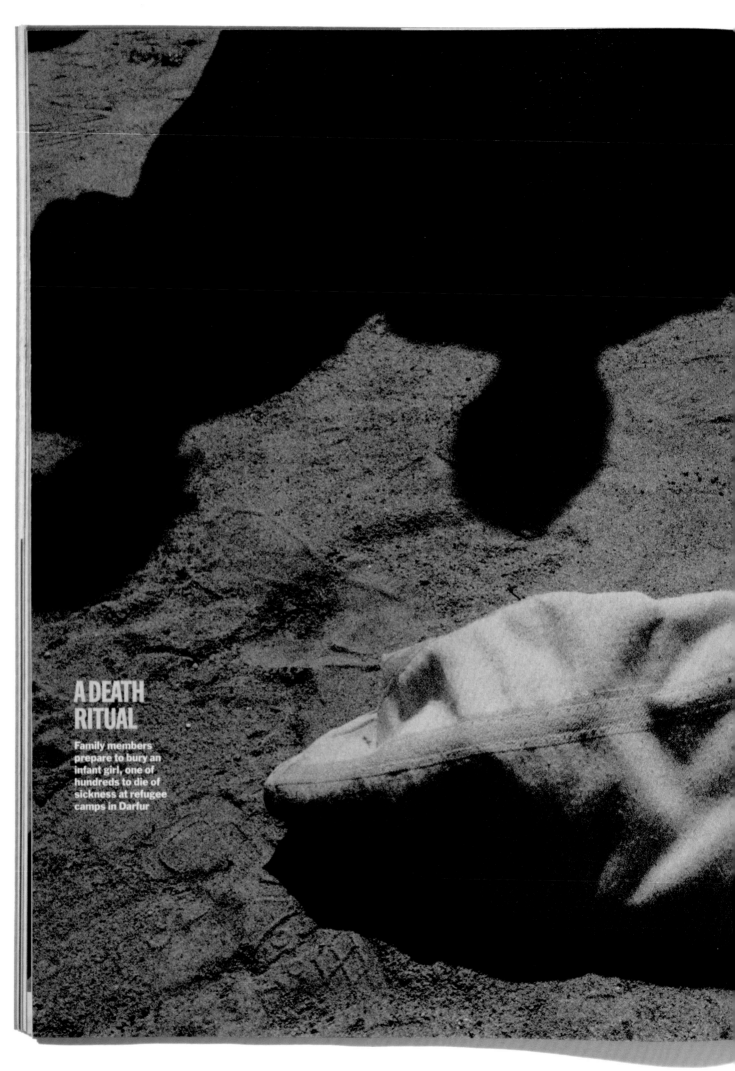

A DEATH RITUAL

Family members prepare to bury an infant girl, one of hundreds to die of sickness at refugee camps in Darfur

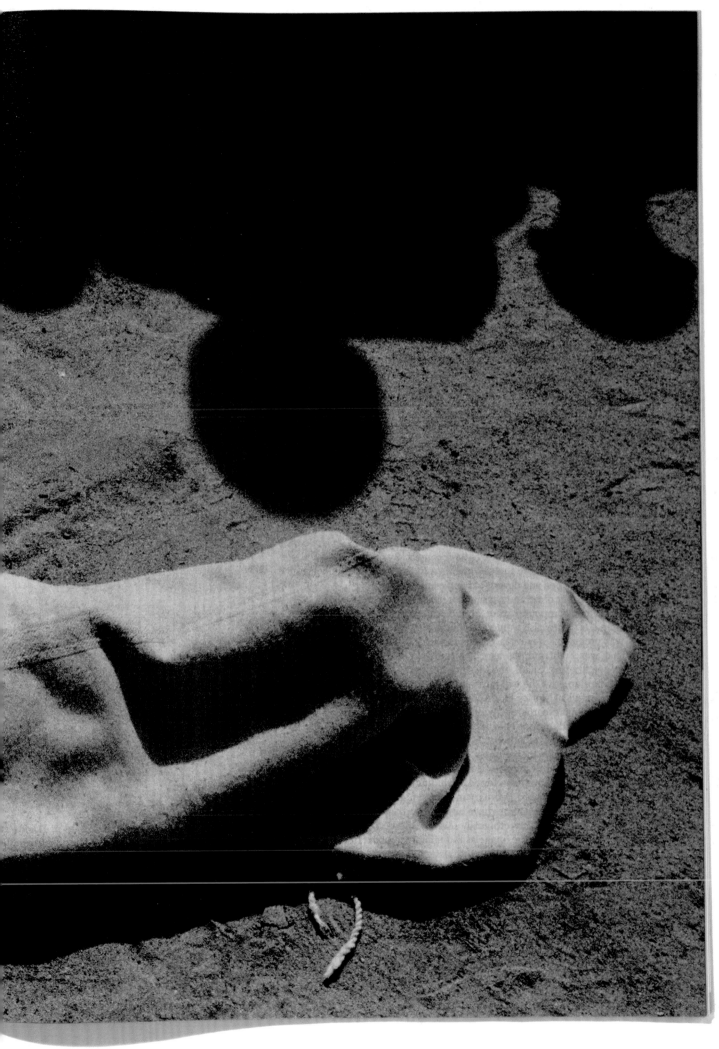

Richard Avedon's consummate skills as both portraitist and fashion photographer, and his forensic eye for nuance and detail, had been honed during a 50-year career when the *New Yorker* invited him to scrutinize America's democratic process in 2004. Republican President George W Bush and his Democrat rival Senator John Kerry were fighting a divisive election battle, at a time when the principles of democracy were being aggressively championed internationally in the 'war on terror'. Choosing to echo his 'The Family' series of 1976 (see page 204), Avedon trailed the conventions and sought out the activists, campaigners, politicians and pundits who defined the underlying issues of the campaign. On 24 September he visited the Brook Army Medical Centre, Texas, where he photographed Sergeant Joseph Washam who had suffered third-degree burns on a mission in Baghdad. The day after, Avedon was taken ill, and he died on the morning of 1 October 2004. Following the deaths of Henri Cartier-Bresson and Helmut Newton earlier the same year – together a powerful triumvirate who had ruled the magazine photography of their day – the *New Yorker* published Avedon's unfinished series as a respectful post-election epitaph. It signalled the passing of a classic era of photography. (1 November 2004)

Members of the U.S. Army's 4th Infantry Division, in training at Fort Hood, Texas: Specialist Dustin R. Yount, Specialist Aaron C. Sisk, Specialist John R. Copeland, Private Tucker J. Tracy, Specialist Jason K. Gross, Sergeant Zachary Hailey, Specialist Travis Axline. All but one of them are veterans of the Iraq war.

Specialist John R. Copeland, U.S. Army, in training at Fort Hood, Texas.

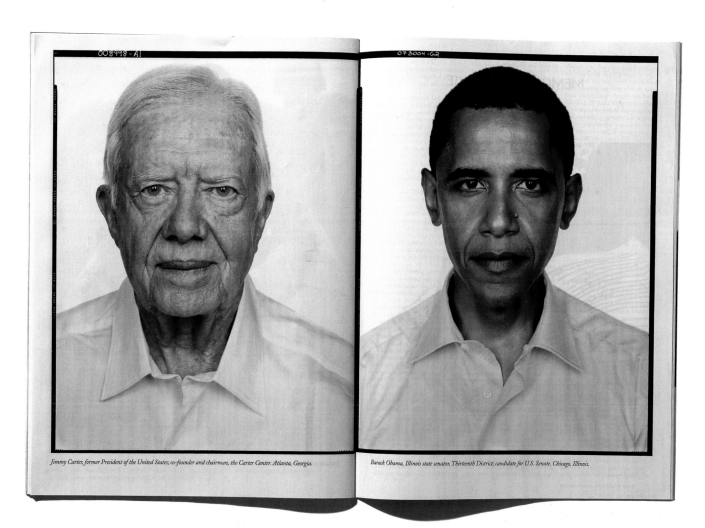

Jimmy Carter, former President of the United States; co-founder and chairman, the Carter Center. Atlanta, Georgia.

Barack Obama, Illinois state senator, Thirteenth District; candidate for U.S. Senate. Chicago, Illinois.

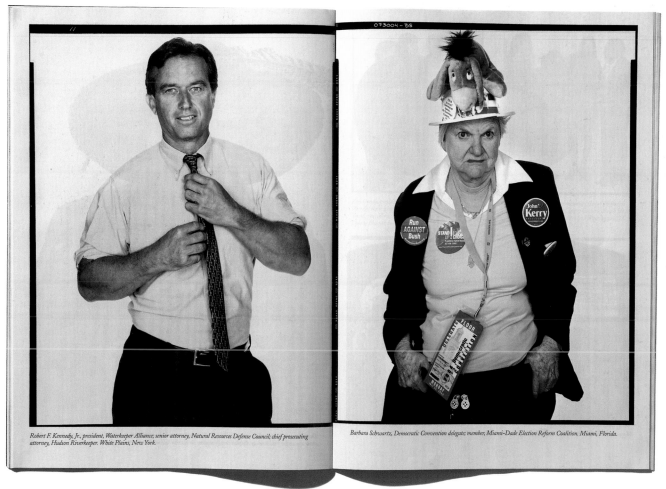

Robert F. Kennedy, Jr., president, Waterkeeper Alliance; senior attorney, Natural Resources Defense Council; chief prosecuting attorney, Hudson Riverkeeper. White Plains, New York.

Barbara Schwartz, Democratic Convention delegate; member, Miami-Dade Election Reform Coalition. Miami, Florida.

Images from journalists, tourists and local non-professionals all contribute to the *Paris Match* special issue about the impact of the tsunami tidal wave that ravaged the coastline of the Indian Ocean on 26 December 2004. The story reflects the wide range of photographic images available to publishers of the news following the introduction of digital cameras, including camera-phones, and the ease with which images could now be distributed over the internet and by phone. The professional journalists' pictures are more polished, but photographs by amateurs capture the critical moments of the tsunami's arrival. Photography had long offered amateurs the chance to contribute to public reportage of unanticipated crises; but with the publication of images of the abuse of prisoners at Abu Ghraib in 2004, and of the tsunami, coinciding with the phenomenon of self-authored 'reality' television, a new appetite for amateur reports became established within the press. While this heralded a democratization of journalism, the most powerful and informative reports continued, for the time being, to result from the collaboration of editors and professional photographers in the capture of the news. (12 January 2005, including photographs by J R Fuller, top left, and Andrew Wong, bottom left)

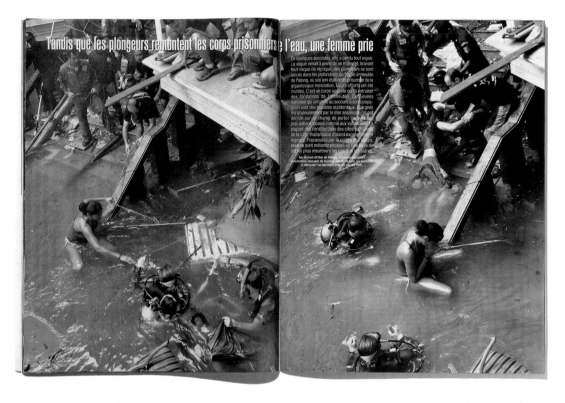

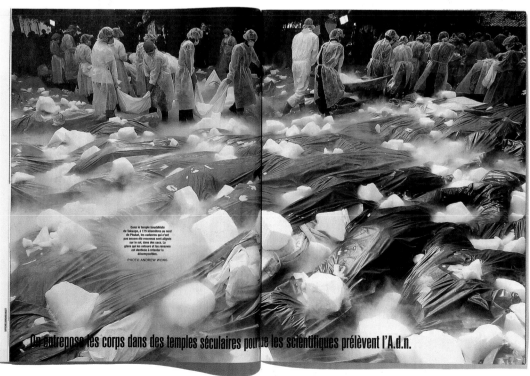

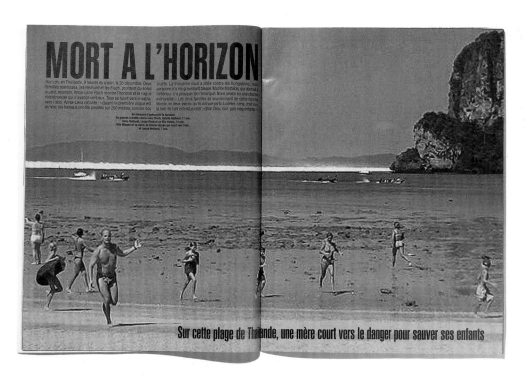

MORT A L'HORIZON

Rai Leh, en Thaïlande, 9 heures du matin, le 26 décembre. Deux familles suédoises, les Hedlund et les Flach, profitent du soleil quand, soudain, Anna-Lena Flach montre l'horizon et la vague monstrueuse qui s'avance vers eux. Tous se ruent vers le sable, vers l'abri. Anna-Lena raconte : « Quand la première vague est arrivée, les bateaux ont été projetés sur 250 mètres, comme des jouets. La troisième nous a jetés contre les bungalows, mais personne n'a été gravement blessé. Ma fille Mathilda, qui dormait à l'intérieur, n'a presque rien remarqué. Nous avons eu une chance incroyable. » Les deux familles se souviennent de cette femme blonde, en deux-pièces, qu'ils ont vue partir à contre-sens, droit vers la mer. Ils l'ont entendue crier : « Mon Dieu, non, pas mes enfants ! »

Ils s'enfuient d'épouvante le torrent. De gauche à droite : Anna-Lena Flach, Natalie Hedlund, 11 ans, Siries Hedlund, Lucas Flach et sa fille Honda, 14 ans, Nils Nilsson et sa mère, la femme blonde qui court vers l'eau, et Lucas Hedlund, 7 ans.

Sur cette plage de Thaïlande, une mère court vers le danger pour sauver ses enfants

Miracle : balayée par la vague, toute cette famille suédoise va survivre

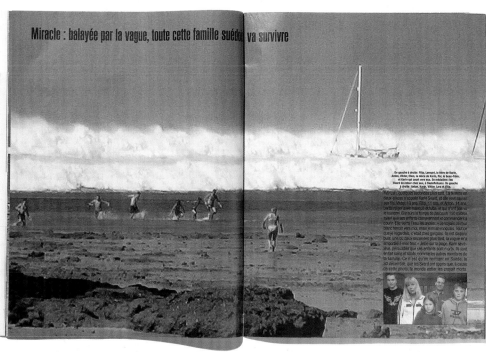

De gauche à droite : Filip, Lennart, le frère de Karin, Anton, Viktor, Ellen, la nièce de Karin, Per, le beau-frère, et Karin qui court vers eux. En médaillon : les Svard de retour chez eux, à Skelleftehamn. De gauche à droite : Anton, Karin, Viktor, Lars et Filip.

Rai Leh, quelques secondes plus tard. La femme en deux-pièces s'appelle Karin Svard, et elle veut sauver ses fils Viktor, 10 ans, Filip, 11 ans, et Anton, 14 ans, partis nager avec leur oncle et leur père... Elle aura le temps de parcourir 150 mètres avant que ses enfants comprennent et commencent à courir. Elle verra l'eau les avaler. « Je voyais ce mur blanc foncer vers eux, mais je n'en revenais. Tout ce que je regardais, c'était mes garçons. Ils ont disparu, puis, une ou deux secondes plus tard, la vague m'a emporté à mon tour. » Jetée sur la plage, Karin se retire, persuadée que ses enfants sont morts. Ils sont en fait sains et saufs, comme les autres membres de la famille. Ce n'est qu'en rentrant en Suède, le 30 décembre, que les Svard ont appris que, à cause de cette photo, le monde entier les croyait morts.

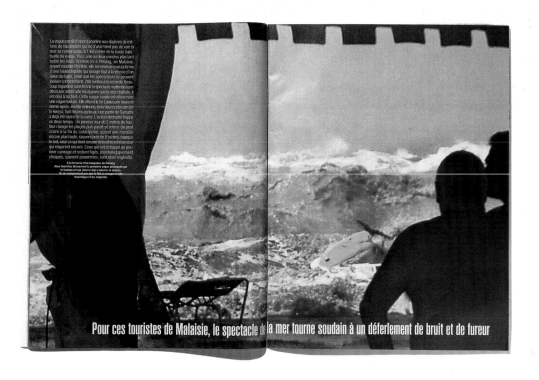

La vague paraît d'abord anodine aux dizaines de milliers de vacanciers qui ne s'alarment pas de voir la mer se retirer jusqu'à 1 kilomètre de la limite habituelle du rivage. Puis, une ou deux minutes plus tard selon les lieux, comme ici à Penang, en Malaisie, voyant soudain à l'horizon, elle est revenue sous la forme d'une falaise liquide qui ravage tout à la vitesse d'un avion de ligne, mais que les spectateurs ne peuvent évaluer correctement. 290 mètres à la seconde. Beaucoup regardent sans frémir le spectacle inattendu sans découvrir assez vite les épaves que la mer charrie. Il est déjà trop tard. Cette vague inouïe est désormais une vague basculée. Elle atteint le Sri Lanka une heure et demie après, la côte indienne, trois heures plus tard et le Kenya, huit heures après qu'une partie de Sumatra a déjà été rayée de la carte. L'océan déchaîné frappe en deux temps. Un premier mur de 2 mètres de hauteur ravage les plages puis paraît se retirer. On peut croire à la fin du cataclysme, quand une muraille encore plus haute, souvent près de 8 mètres, masque le ciel, rase ce qui tient encore debout et achève ceux qui respirent encore. Ceux qui ont échappé au premier carnage et restent figés, psychologiquement choqués, souvent assommés, sont alors engloutis.

À la terrasse d'un bungalow de Penang, deux touristes découvrent la première vague provoquée par le tsunami et qui charrie déjà cadavres et épaves. Ils ne comprennent pas que le flot va manger le café touristique et les emporter.

Pour ces touristes de Malaisie, le spectacle de la mer tourne soudain à un déferlement de bruit et de fureur

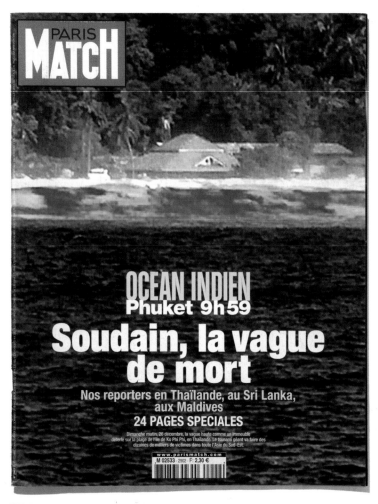

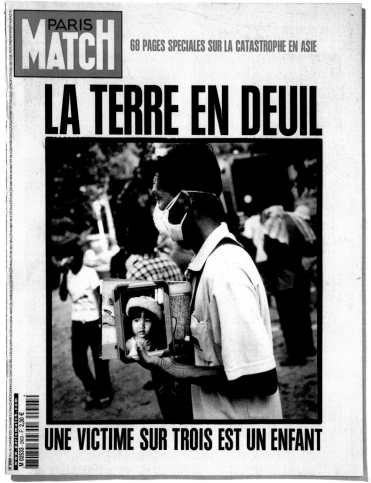

'Perhaps all of us have experienced a sort of unhappiness, if not terror, at seeing how the world and its history seem caught in an ineluctable movement, which keeps gaining momentum and which seems able to change, toward ever coarser ends, the visible manifestations of the world. This visible world is what it is, and our action on it cannot render it otherwise. So we yearn for a universe in which man, instead of acting so furiously on the appearance of things, strives to free himself from them, by refusing to act upon them, and by stripping himself down to the point where he discovers the secret place within himself from which an entirely different human adventure might possibly begin.'
Jean Genet, *L'Atelier d'Alberto Giacometti* (1958)

The last *Paris Match* cover of 2004 and its first of 2005 were devoted to the tsunami that devastated parts of Southeast Asia. Placed side by side, they tell us much more about the current state of photography and its relationship with newspapers and news magazines than many analyses. The first reproduces an image taken by an amateur photographer, while the second carries a black and white photograph framed with a white border – by Philip Blenkinsop, an incisive professional reporter – reflecting a humanist point of view that respects both the fact of the event and the victims it created.

In their different ways, each of these covers is remarkable. The first, executed in haste, retains the peculiar green and blue tones of tourist photographs vaunting the paradisiacal beauty of Thailand's southern islands, and although the text enjoins us to 'see' the approaching wave, we see nothing! There seems to be a total contradiction between this pixellated image and the amateur videos, some of them impressive, depicting a ferocious sea churning sand and soil into a brown mass and carrying everything before it. The second cover, in a layout of unusual simplicity for this magazine, is set against a pure white background, without text overlay; two simple titles announce the enormity of the tragedy and the fact that 68 pages are devoted to it. It created a powerful visual and emotional impact. The covers of all the weeklies displayed in the kiosks carried perfectly interchangeable colour photographs, but it was *Paris Match* that caught the eye. Moreover, the sales of that issue were exceptional. The juxtaposition of these two covers perfectly illustrates a tension between distinct types of contemporary imagery; between instantly transmissible digital documents produced by amateurs, and those developed by professional photojournalists working in an auteur tradition, using their point of view to assert a dialectical relation between ethics and aesthetics.

The major change, signified by the two great news stories of the final months of 2004 – the revelation of torture at Abu Ghraib prison in Iraq, and the tsunami – stems from the fact that an immediate event captured by an amateur, who now has access to global markets, is as acceptable as the same event photographed by a professional. The privileged status (and, occasionally, the arrogance) the latter once enjoyed in the field of news photography is definitively over. This is neither good nor bad – anybody is entitled to witness and record an event – but it does raise certain questions. First, the question of reliability: how can we check the veracity of images produced with an automatic digital camera or mobile phone? How can we avoid the manipulations of hoaxers – or those with more sinister motives – who will undoubtedly seize the opportunity provided by digital technology to create seemingly credible yet totally inauthentic documents? The fabrication and manipulation of false documents is not a new phenomenon. It has occurred in various media and has been employed by every totalitarian power, during purges and in the interests of propaganda. In simple terms, new digital technology facilitates such practices with ease. The media is therefore obliged to exercise greater vigilance and pay closer attention to the ways in which digital images are used.

For example, it is surprising that most magazines chose to enlarge the images from Abu Ghraib, which were of a very poor technical quality. The pixels were so conspicuous that the images acquired a fictional dimension. There is little doubt that if these pictures of naked

men being dragged around on leashes and terrorized by dogs had been accompanied by captions stating that they came from amateur sado-masochistic videos, or recordings of performances of contemporary art, we would not have been any the wiser. The only acceptable way to publish these images would have been to reproduce them in small format, grouped together in a way that emphasized the repetition and degradation of such conduct. But who, these days, thinks about the effects of meanings produced by the way in which images are presented? Very few, unfortunately, and especially in the media. At present, it seems almost indecent to ask the fundamental and absolutely essential question: for whom does the press publish these photographs?

For reasons having as much to do with space as with ignorance, our retrospective study of fifty years of photojournalism is inevitably incomplete. But by making a selection of what we believe to be important work, both in terms of the photographs and their presentation, and particularly with regard to the work presented from the last two decades, we are asserting a point of view. Readers may draw their own conclusions, whether optimistic or pessimistic, but the selection does at least confront issues vital to both photographers and their publishers. We are worlds away from spectacle and demagogy – from the facile and vain effects generated by a press whose sole imperative is economic gain; a press which is contemptuous of the readers to whom it owes its survival and which, because of its increasing focus on mediocrity, is in danger of sawing off the branch it sits on.

To avoid the myths and nostalgia that surround the subject of photojournalism, it should be remembered that the relationship between photographers and publications has always been difficult. This was true even in the 1950s and 1960s, when the weekly news magazines were enormously influential and relayed images that enabled the reader to experience a vicarious discovery of the world. In fact, there never was a golden age – one only has to read W Eugene Smith's account of his battles with *Life* magazine to be convinced of that – but simply a period in which photojournalism received considerably more exposure than it does today.

When television (now being overtaken itself by the internet) became the primary medium for the distribution of news images, few photographers or publications gave much thought to the way the rules had changed. Frightened by the competition that was depriving them of a considerable slice of their advertising income, they responded by gradually reducing the space reserved for news and photo stories, and competed with each other by according more and more prominence to 'celebrities' who, whether high-profile or relatively low-profile, were supposed to boost sales in a market avid for revelations. Celebrity culture, the pandering to voyeuristic tendencies, has always existed; but its nature has changed over the course of the last twenty years. Top models and television presenters are now more likely to appear on a magazine cover than royalty and film stars. But this has led to a situation in which a news story worth twelve pages in the *Paris Match* of the 1960s would be allotted no more than four pages today. The rates of payment offered for photographic essays have fallen proportionally.

In an even more pathetic reaction, the press attempted to fight television on its own ground by devising a print version of television. We now have daily newspapers designed to enable the reader to 'channel-hop' the contents, and have seen the appearance of sometimes successful but usually short-lived weeklies, particularly in Germany, filled with scores of very short and profusely illustrated articles. This attempt to reproduce the speed of television – which has become so fast over the last twenty years that its coverage of the news is often reduced to caricature – ignores the fact that television's arsenal contains sound and movement as well as images. There is worse: a televisual aesthetic – the frontal shots, the predilection for a supposedly neutral 'middle' distance – has contaminated the imagery chosen by the press. It is a dismal experience to pick up one's favourite newspaper in the morning and find that the front page displays a clone of the image one saw on television the night before. We are sometimes forced to question whether there is any point in buying

newspapers at all.

We know of no tool in history that has survived the loss of its practical or social function: we no longer carve meat with a sharp flint, and photography has put paid to the art of the miniaturist. The only chance of survival for the print media lies in its ability to assert its difference; to do what other media, either by their very nature or by editorial inclination, cannot do.

The print media's most striking and unique asset is the opportunity it affords the viewer to decide how long they spend on an image. Moreover, it can be revisited and reconsidered at leisure. The amount of time spent on the consumption of information and images is the prerogative of the reader rather than of a media terrified by emptiness and silence and obsessed by the supposed efficiency of speed. Nor should we forget that the degree of autonomy and flexibility available to photographers is far greater than that of television. Photographers can shoot from a variety of angles and gain access to scenes that more heavily equipped teams cannot reach. They can take different kinds of risk, and move with flexibility, if necessary disappearing from a scene, or becoming invisible – and produce outstanding documents of witness as a result.

I am a journalist and cannot predict the future, but I do wonder about certain possibilities. I wonder what the internet can do for photography, for its practitioners and the issues fundamental to it. With few exceptions, the internet in its present form is more a tool of distribution than of publication. The best sites attract a community of fans who share certain values, who seek quality and a sense of wonderment stimulated by the discovery of the new, and we can only hope that they attract more visitors as time goes on. But perhaps this is too much to expect. It should be acknowledged that the thousands of websites set up by photographers, agencies and visual institutions do not amount to more than portfolios, catalogues or other marketing vehicles. They bear little relation to the illustrated print media and do not share its fundamental characteristic: the production of meaning through the editing, sequencing and positioning of photographs in relation to text and other graphics. But I am optimistic. There is every chance that the internet will yet stimulate the invention of a totally new method of publishing photography. If this innovation does occur – if high-quality, meaningful image-based reporting is made available at little or no cost to the widest possible audience, as was the case with magazines like *Life* and *Paris Match* – it is likely that the print media will be forced to undergo a transformation. It will become a luxury product – extraordinary, elitist, sophisticated, creative, and collectible. This would be a bold project, impossible to achieve without the creation of economically viable models.

Although the mass-market magazine is in decline, it can survive if it deals appropriately with the work of the dedicated photojournalists who are still exploring, questioning and challenging the world. There is absolutely no reason why the work of such auteurs cannot appear in the press alongside relevant material produced by amateurs. To put it simply, if the press published more radical photojournalism distinguished by the kind of incisive text that exploits the tension between ethics and aesthetics, it could construct an identity, a brand, a unique position which would distinguish it from television and the internet and make its products worth buying. If that is to happen, greater attention and analysis must be devoted to every stage of the process that results in the production of meaning, including the choice of photographer, the selection of the images, the organization of the sequence and its graphic development, always bearing in mind that typography, like layout, affects the way photographs are interpreted. It is absolutely essential that we continue to ask the fundamental questions: for whom am I publishing these images? What is the point of view I am seeking to express, to render intelligible?

Some of the most brilliant photographers now prefer to work for the collectors' market, for galleries and museums. If we do not rise to the challenge, there is a strong possibility that photographers will cease to create the documents essential to our collective memory.

INDEX OF PHOTOGRAPHERS AND PUBLICATIONS

The publisher, producers and authors of this book sincerely thank all the photographers (and where relevant their estates) and the publications whose work is featured here for their consent to include it.

Every attempt has been made to trace and properly acknowledge the owners of all the copyrights involved. However, should inaccuracies or omissions have occurred, World Press Photo would kindly call on the parties in question to contact the foundation office in order that we may correct this.

This book has been published under the auspices of the Stichting World Press Photo, Amsterdam.

All the illustration material is the copyright property of the photographers and/or their estates, and the publications in which they appear, in each case. Additionally, pages: 8, 14-17 & 20, photographs from the collection of the International Center of Photography; 32, from General Research Division, The New York Public Library, Astor, Lenox and Tilden Foundations; 33, photograph originally published in Vanity Fair, 2002; 46, photographs © Robert Frank, courtesy Pace/MacGill Gallery, New York; 76-79, photographs © The Heirs of W. Eugene Smith; 82-85, Asian and Middle Eastern Division, The New York Public Library, Astor, Lenox and Tilden Foundations; 98-99 & 142-143, from the library of The Center for Cuban Studies, NYC; 110-113, photographs LIFE Magazine © 1965 Time Inc. Used with permission; 122-125, photographs LIFE Magazine © 1965 Time Inc. Used with permission; 134-137, Zapruder Film © 1967 (Renewed 1995) The Sixth Floor Museum at Dealey Plaza, Dallas, All Rights Reserved; 144-147, photographs © Ed van der Elsken/Nederlands Fotomuseum, courtesy Annet Gelink Gallery; 207-208, photographs © The Helmut Newton Estate/ Maconochie Photography, for German Vogue; 240-241 & 243-245, photographs © Sebastião Salgado/Amazonas Images/nbpictures; 302-303, photographs © The Photo Archive Group; 347-349, photographs originally published in Vanity Fair, 2001.

We would like to thank the many people whose knowledge, suggestions, advice and practical help have made this book possible, including Maria Luisa Agnese, Jassim Ahmad, Shahidul Alam, Stuart Alexander, Judy Annear, Negar Azimi, Sara Barrett, Grégoire Basdevant, Jonathan Bastable, Patrick Baz, Patrizia Benvenuti, Marie Christine Biebuyck, Katarzyna Biernacka, Elisabeth Biondi, Katie Boot, Allain Brillon, Frish Brandt, Beverly Brannan and the staff of the Library of Congress, Sue Brisk, David Brittain, Martijn van den Broek, Jeff Burak, Neil Burgess, Kate Button, Sandra Byron, Giovanna Calvenzi, Emily Caplan, Clinton Cargill, Anna Lisa Cavazzuti, Elena Ceratti, Amit Chauhan, Cinzia Cozzi, Hamish Crooks, Illonka Csillag, Verna Curtis, Pete Daniel, Dominique Deschavanne, Bruno Dondolo, Elsa Dorfman, Thomas Doubliez, Stephen Dupont, Sandy Edwards, Ruth Eichhorn, Adrian Evans, Daniela Fagnani, Prof. F S Faro, Brian Finke, Eva Fischer, Per Folkver, Alasdair Foster, Jimmy Fox, Dennis Freedman, Bevis Fusha, Rik Gadella, Nick Galvin, Laetitia Ganaye, Martin Gasser, Annet Gelink, Alice Rose George, Amir Ali Ghasemi, Daniel Girardin, Hilly Glasmacher, Rupert Godden, David Goldblatt, Ana Cecilia Gonzales-Vigil, Howard Greenberg, Mark Grosset, Arash Hanaei, Tim Hetherington, Marit Hoffman, Amanda Hopkinson, Graham Howe, Helen Hughes, Brooks Johnson, Frank Kalero, Judy Karasik, Erik Kessels, David King, Nathaniel Kilcer, Kent Kobersteen, Roberto Koch, Michael Koetzle, Ziv Koren, Peter Korniss, José Kuri, Michelle Lamuniere, Françoise Le Roch, Cordula Lebeck, Chris Lee and the staff of the British Library, Claudine Legros, Volker Lensch, Laura Leonelli, Tom Lisanti and the staff and librarians and of the New York Public Library, Roberta Lotti Lima, Celina Lunsford, Damon McCollin-Moore, Rebecca McLelland, John McMillan, Mary Ellen Mark, Ada Masella, Jacqui Masiza, Stephen Mayes, Frédérique Mersch, Maria Mayu Mohanna, Samer Mohdad, Lorraine Monk, Adriaan Monshouwer, Daniel Morel, John G Morris, Daniela Mrázková, Carlos Mustienes, William Nabers, Grazia Neri, Gael Newton, James Nicholls, Ute Noll, Junko Ogawa, Jason Orton, Philiy Page, Alessia Paladini, Prashant Panjiar, Lauren Panzo, Swapan Parekh, Sonia Pastrello, John Pelosi, Gianluca Perosillo, Peter Pfrunder, Françoise Piffard, Annie Polk, Stephné Posthumus, Astrid Proll, Daniele Protti, Walid Raad, Raghu Rai, Renza di Renzo, Tamás Révész, Reza, Phyllis Rifield, Arianna Rinaldo, Pamela Roberts, John Rohrbach, Jeff Rosenheim, Chiara Rostoni, Luc Salu, David Secchiaroli, Bree Seeley, Mike Selby, Liu Heung Shing, Erin Siegal, Agnès Sire, Rod Slemmons, Patricia Strathern, Aileen Mioko Smith, Adam Sobota, Tom Southall, Carol Squiers, Barbara Stauss, Nicola Steiner, Norma Stevens, Robert Stevens, Azmar Sukandar, John Szarkowski, Rob Taggart, Kay-Chin Tay, Shyam Tekwani, Dan Torres, Chab Touré, Anne Tucker, Tony White, Michael Wolf, Cynthia Young, and Akram Zaatari.

We would especially like to thank and recognize those people who, in addition to helping with their time and knowledge, generously loaned us valuable vintage magazines and generally provided us more assistance than we had any reason to expect, including Pablo Bartholomew, Letizia Battaglia, David Campany, Ian Denning, David Friend, Philippe Garner, Lotta and Oliver Hergesell, Anneke Hilhorst, Colin Jacobson, Elizabeth Krist, Robert Lebeck, Mikael Levin, Sandra Levinson and the staff of the Center for Cuban Studies, Meredith Lue, Susan Meiselas, Pablo Ortiz Monasterio, William Nabers, Martin Parr, Gilles Peress, Robert Pledge, Kathy Ryan, Sebastião Salgado, Gregoire Sauter, Bob Shamis, the editor and staff of the Sunday Times Magazine, Yoshiko Suzuki, Darcy Tell, Martha Takayama and Teizo Umezu.

We appreciate the support of photo agencies and photographers' representatives and would like to recognize and thank Associated Press, Black Star, Contact Press Images, Agenzia Contrasto, Corbis, Agencia EFE, Agence France Presse, Gamma, Getty Images, Laif, Tiggy Maconochie, Magnum Photos, NB Pictures, Network Photographers, Grazia Neri, Novosti, Panos Pictures, Polaris Images, Reuters, Marco Santucci, Sipa Press, Sygma, Agence Vu and VII.

This book accompanies a World Press Photo touring exhibition, curated by Christian Caujolle, opening at Foam Photography Museum, Amsterdam, in October 2005.

For Robert Lebeck.

Chapter opener photographs: page 4, *Die Woche* 17 January 1955, photograph by Waldemar Dürst; 6, *Time* 4 October 2000, photograph by James Nachtwey; 8, *Berliner Illustrirte Zeitung* 21 July 1929, photograph by Martin Munkacsi; 34, *Stern* 10 January 1959, photographs by Rolf Gillhausen; 106, *Life* 16 April 1965, photograph by Larry Burrows; 198, *New York Times* 30 July 1978, photograph by Susan Meiselas; 236, *Du* November 1992, photograph by Daniel Schwartz; 296, *Süddeutsche Zeitung* 14 May 2004, photograph by Ulrike Myrzik and Manfred Jarisch; 376 top, *Paris Match* 30 December 2004, photograph by Leila Hannach; 376 bottom, *Paris Match* 12 January 2005, photograph by Philip Blenkinsop.

Things As They Are
Photojournalism in Context Since 1955
By Mary Panzer
With an Afterword by Christian Caujolle
© World Press Photo 2005

Published in paperback 2006
First published 2005
by Chris Boot

Chris Boot Ltd
79 Arbuthnot Road
London SE14 5NP
United Kingdom
Tel. +44 (0) 20 7639 2908
Fax +44 (0) 20 7358 0519
info@chrisboot.com
www.chrisboot.com

World Press Photo
Jacob Obrechtstraat 26
1071 KM Amsterdam
The Netherlands
Tel. +31 (0)20 676 6096
Fax +31 (0)20 676 4471
office@worldpressphoto.nl
www.worldpressphoto.nl

Conceived & produced by Chris Boot
Project editors: Sophie Spencer-Wood, Bruno Ceschel
Project editors for World Press Photo: Kari Lundelin,
Marc Prüst
Additional text: Bruno Ceschel, Roger Hargreaves
Copy photography: Ian Bavington-Jones
Design by SMITH

Distribution (except North America) by
Thames & Hudson Ltd
181 High Holborn
London WC1V 7QX

A CIP catalogue record for this book is available from
the British Library

ISBN 13: 978-1-905712-01-4
ISBN 10: 1-905712-01-4

Printed in Italy by EBS